PERSPECTIVES ON WESTERN ART

Perspectives on Western Art

(VOLUME 2)

*Source Documents and Readings
from the
Renaissance to the 1970s*

Edited by

Linnea H. Wren

IconEditions
An Imprint of HarperCollins*Publishers*

HarperCollins books may be purchased for educational, business, or sales promotional use. For information please write: Special Markets Department, HarperCollins Publishers, Inc., 10 East 53rd Street, New York, NY 10022.

FIRST EDITION

Library of Congress Cataloging-in-Publication Data
(Revised for vol. 2)

Wren, Linnea Holmer.
 Perspectives on Western art.

 (Icon editions)
 Includes bibliographical references and indexes.
 Contents: [1]. Source documents and readings in social history from the ancient Near East through the Middle Ages — [2]. Source documents and readings from the Renaissance to the 1970s.
 1. Art—History. I. Wren, David. II. Carter, Janine M. III. Title. IV. Series.
N5303.W74 1986 709 85-45244
ISBN 0-06-438942-1 (cloth: v. 1)
ISBN 0-06-430154-0 (paper: v. 1)

ISBN 0-06-438943-X (cloth: v. 2)
ISBN 0-06-430191-5 (paper: v. 2)

94 95 96 97 98 CC/HC 10 9 8 7 6 5 4 3 2 1
94 95 96 97 98 CC/HC 10 9 8 7 6 5 4 3 2 (pbk.)

Contents

Acknowledgments xxi

Preface xxiii

I: Italian Renaissance Art of the Early Fifteenth Century

1. Donatello, *David,* 1430 1

 Leonardo Bruni, *The Laudatio of the City of Florence:* "Why
 Florence Is to Be Admired," 1403–4 2

2. Lorenzo Ghiberti, *Jacob and Esau (Isaac and His Sons),*
 1425–52 4

 Gregorio Dati, *History of Florence:* "The Feast Day of Saint John
 the Baptist," 1385 6
 Anonymous, *Letter of a Florentine Citizen:* "Christ Possessed
 Nothing," 1389 7

3. Masaccio, *The Tribute Money,* c. 1427 8

 Domenico Giugni to Francesco Datini, Letter: "Everyone Pays His
 Proper Share," 1401 10
 The Medici Bank Ledger: "Florentine Banking Practices," 1423–40 10
 Contract of Partnership: "A Profitable Company," 1434 11

4. Michelozzo di Bartolommeo, Palazzo Medici, Florence, begun
 1444 12

 Cosimo de' Medici, *Oration to the Signory:* "A Good and Honest
 Merchant," 1433 13

5. Donatello, *Saint George,* 1415–17 14

 Franco Sacchetti, from "A Woolworker Goes Jousting," in *Three
 Hundred Tales:* "Go Thou and Beat Wool," c. 1400 16

v

6. Fra Angelico, *Annunciation,* c. 1440–50 17

 Aeneas Silvius Piccolomini (Pius II), *The Tale of Two Lovers:*
 "Lucretia's Beauty" and "Is All This Pleasure True?" 1444 18

7. Piero della Francesca, *The Proving of the True Cross,* c. 1455 20

 Nicholas of Cusa, *On Learned Ignorance:* "Mathematics and the
 Apprehension of Divine Truth," 1440 21

8. Leon Battista Alberti, Palazzo Rucellai, Florence, 1446–51 23

 Leon Battista Alberti, *On the Family: "Virtù* Has Its Own Reward"
 and "Conditions of a Marriage," 1441 25

9. Andrea del Verrocchio, *Bartolommeo Colleoni,* 1483–88 28

 Matteo Maria Boiardo, *Orlando innamorato:* "The Combat of
 Orlando and the Giant," c. 1482 30

10. Antonio del Pollaiuolo, *Hercules and Antaeus,* c. 1475 31

 Giannozzo Manetti, *On the Dignity of Man:* "Live in the World
 Joyfully and Zestfully," c. 1440–50 33

11. Sandro Botticelli, *The Birth of Venus,* c. 1482 33

 Marsilio Ficino, *Commentary on Plato's Symposium on Love:* "The
 Two Venuses," 1484 35
 Lorenzo de' Medici, "O Lucid Star," 1476 37

12. Piero di Cosimo, *The Discovery of Honey,* 1498 37

 Girolamo Savonarola, *The Compendium of Revelations:* "A Hand in
 Heaven," 1495 39
 Luca Landucci, *A Florentine Diary from 1450 to 1516:* "The Burning
 of Savonarola," 1498 40

II: Sixteenth-Century Italian Art

1. Leonardo da Vinci, *The Last Supper,* c. 1495–98 42

 Pico della Mirandola, *Oration on the Dignity of Man:* "Man, the
 Most Fortunate of Creatures," 1487 43

2. Leonardo da Vinci, *Embryo in the Womb,* c. 1510 44

 Leonardo da Vinci, *Anatomical Observations:* "The Cause of a
 Death So Sweet," c. 1504–6 45

3. Raphael, *Galatea,* 1513 46

 Poliziano, *Stanze per la Giostra:* "The Bittersweet Cares That Are
 Born of Love," 1475–78 47

4. Donato Bramante, *Original Plan for Saint Peter's, Rome,*
1506 48

Desiderius Erasmus, *Julius Excluded from Heaven: A Dialogue:*
"You're All Belches and You Stink of Boozing and
Hangovers," 1513–14 49

5. Raphael, *Pope Leo X with His Nephews Giulio de' Medici and
Luigi de' Rossi,* c. 1518 51

Niccolò Machiavelli, *The Prince:* "We Look to Results," 1513 52

6. Raphael, *Baldassare Castiglione,* c. 1514 54

Baldassare Castiglione, *The Book of the Courtier:* "The Ideal Man,"
1508–18 55

7. Michelangelo, Saint Peter's, Rome, 1546–64 57

Nicolaus Copernicus, *On the Revolutions of Heavenly Bodies:*
"The Annual Revolution of the Earth," 1543 58
Andreas Vesalius, *The Structure of the Human Body:* "The Vital
Spirit" and "The Cerebrum and Cerebellum," 1543 59

8. Michelangelo, *The Last Judgment,* 1534–41 61

Vittoria Colonna, Sonnet: "Aspiration," c. 1525 62
Michelangelo, Sonnet: "Tell Me, O Soul," c. 1550 63

9. Parmigianino, *Madonna with the Long Neck,* c. 1535 63

Scipione Arris, Letter: "The Wretched, Miserable,
and Ill-Fated City of Rome," May 26, 1527 64

10. Correggio, *Jupiter and Io,* c. 1532 65

Ludovico Ariosto, *Orlando furioso:* "Medor Plucks the First Rose,"
1506–16 66

11. Titian, *Madonna of the Pesaro Family,* 1519–26 68

Sultan Bayezid II, Communication: "The Unwashed Gyaours and
Their Ways," c. 1500 69

12. Titian, *Sacred and Profane Love,* c. 1515 70

Titian, *Bacchanal,* 1518 70

Pietro Aretino, *Dialogues:* "What Nanna Spied in the Convent,"
1534–35 71

13. Tintoretto, *The Last Supper,* 1594 74

Canons and Decrees of the Council of Trent: "The Sacrament of the
Eucharist," 1534–63 75

14. El Greco, *The Burial of Count Orgaz,* 1586 76

Ignatius Loyola, *Spiritual Exercises:* "Meditation on the Agony of
 Death," c. 1522 77

15. Paolo Veronese, *Christ in the House of Levi,* 1573 78

Giordano Bruno, *The Expulsion of the Triumphant Beast:*
 "A Magic and Most Efficacious Doctrine," 1584 80

III: Fifteenth-Century Northern European Art

1. Stephan Lochner, *Madonna in a Rose Garden,* c. 1430–35 82

 Conrad Witz, *The Miraculous Draught of Fish,* 1444 82

 Ulrich Richental, *The Chronicle of the Council of Constance:*
 "The Unity of Holy Christendom" and "How Hus Came to
 Constance and Was Burned," c. 1420–30 83

2. Hubert and Jan van Eyck, *The Ghent Altarpiece,* completed
 1432 87

 Rogier van der Weyden, *The Escorial Deposition* (or *Descent
 from the Cross*), c. 1435 87

 Geert Groote, *Resolutions and Intentions, But Not Vows:*
 "A Useless Waste of Time," c. 1374–75 88
 Geert Groote, *On Patience and the Imitation of Christ:*
 "The Cross of Christ," c. 1380–84 89

3. Hugo van der Goes, *The Portinari Altarpiece,* c. 1476 90

 Thomas à Kempis, *The Imitation of Christ:* "O My God, I Come
 unto Thee," c. 1420 91

4. Michael Pacher, *Saint Wolfgang Forces the Devil to Hold His
 Prayerbook,* c. 1481 92

 Michael Pacher, *Coronation of the Virgin,* c. 1471–81 92

 Redentin Easter Play: "Brace Up, Brace Up, Mr. Dominie!" 1464 93

5. Martin Schongauer, *Saint Anthony Tormented by the
 Demons,* c. 1480–90 95

 Heinrich Kramer and James Sprenger, *The Witches' Hammer:*
 "An Examination by Torture," 1487 96

6. Hieronymus Bosch, *The Garden of Earthly Delights,*
 1505–10 97

 Sebastian Brant, *The Ship of Fools:* "A Temporal Pleasure" and
 "Fool's Caps" 1494 98

IV: Sixteenth-Century Northern European Art

1. Albrecht Dürer, *Adam and Eve (The Fall of Man),* 1504 100

Conrad Celtis, *Ars Versificandi et Carminum:* "To Apollo, the
Inventor of Poetry, that He May Leave Italy and Come to
Germany," 1486 101

2. Albrecht Dürer, *The Four Apostles,* 1526 102

Johann Tetzel, *Sermon on Indulgences:* "Bring Not Your Money
into the Land of Paradise," 1517 103
Martin Luther, *Ninety-Five Theses:* "The Penalty for Sin Must
Continue," 1517 104

3. Matthias Grünewald, *Crucifixion* from *The Isenheim
Altarpiece,* c. 1510–15 106

Twelve Articles: "Our Humble Petition and Desire," 1525 107
Martin Luther, *Against the Rapacious and Murdering Peasants:*
"Smite, Strangle, and Stab," 1525 108

4. Hans Holbein the Younger, *The French Ambassadors,* 1533 110

Catherine of Aragon, *Speech Protesting the Marriage Dissolution:*
"Sir, in What Have I Offended You?" 1529 111
Parliament, *Act of Supremacy:* "The Supreme Head of the Church
of England," 1534 112

5. Jean Clouet, *Francis I,* c. 1525–30 112

John Calvin, *Institutes of the Christian Religion:* "Election and
Predestination," 1536 113

6. Germain Pilon, *Descent from the Cross,* 1583 115

Duke of Sully, *Memoirs:* "That Horrible Day," c. 1600 116

7. Jean Goujon, *Nymphs,* 1545–49 117

François Rabelais, *The Histories of Gargantua and Pantagruel:*
"How Panurge Was in Love with a Lady of Paris," 1552 118

V: Baroque Art in Italy, France, and England

1. Gianlorenzo Bernini, Colonnade of Saint Peter's, Rome,
designed 1657 121

Galileo Galilei, *The Starry Messenger:* "The Revolution of the
Planets Round the Sun," 1610 122

2. Gianlorenzo Bernini, *The Ecstasy of Saint Theresa,* 1645–52 124

Saint Theresa of Ávila, *Life:* "Completely Afire with a Great Love
 for God," 1562 125

3. Giacomo della Porta and Giacomo da Vignola, *Il Gesù,* c.
 1575–84 127

Giovanni Battista Gaulli, *Triumph of the Name of Jesus,*
 1672–85 127

Saint Francis Xavier, Letters: "They Are the Best Race Yet
 Discovered" and "To Hold Forth in the Streets," 1549 128

4. Michelangelo da Caravaggio, *The Calling of Saint Matthew,*
 c. 1599–1602 129

Michelangelo da Caravaggio, *The Conversion of Saint Paul,*
 c. 1601 129

Philip Neri, Letter to Maria Vittoria: "The Ear of Obedience," 1585 130
Pietro Focile, Document: "I Went Out Full of Consolation," 1560 131

5. Claude Perrault, Louis Le Vau, and Charles Le Brun,
 East Facade of the Louvre, Paris, 1667–70 132

Jacques-Bénigne Bossuet, *Politics Drawn from Holy Scripture:*
 "The Royal Throne Is the Throne of God Himself," c. 1671–72 133

6. Louis Le Vau and Jules Hardouin-Mansart, Palace of
 Versailles, 1669–85 134

Louis XIV, *Letters:* "I Was King and Born to Be One," c. 1700 135

7. Jules Hardouin-Mansart, Église de Dôme (Hôtel des
 Invalides), Paris, 1676–1706 136

Molière, *Tartuffe:* "Oh! You Squeeze Me Too Hard," 1664 137

8. Inigo Jones, Banqueting House at Whitehall, London,
 1619–22 139

William Shakespeare, *Henry VIII:* "The High and Mighty Princess
 of England, Elizabeth," 1613 140
William Shakespeare, *Macbeth:* "Thou Shalt Get Kings, Though
 Thou Be None," c. 1606 142

9. Christopher Wren, Saint Paul's Cathedral, London,
 1675–1710 144

Isaac Newton, *Mathematical Principles of Natural Philosophy:*
 "The Forces of Gravity," 1687 145

10. Anthony Van Dyck, *Charles I Dismounted,* c. 1635 148

 Root and Branch Petition: "That Godly Design," 1640 149
 Charles I, *Last Words:* "I Am the Martyr of the People," 1649 151

VI: Baroque Art in the Netherlands and Spain

 1. Peter Paul Rubens, *The Elevation of the Cross,* 1610 152

 George Gascoigne, *The Spoyle of Antwerpe:* "Their Horrible
 Cruelty," 1576 153

 2. Frans Hals, *Malle Babbe,* c. 1650 154

 Jacob Cats, *Moral Emblems:* "None Can Clean Their Dress from
 Stain, but Some Blemish Will Remain," 1632 155

 3. Rembrandt van Rijn, *The Return of the Prodigal Son,*
 c. 1665 157

 René Descartes, *Discourse on Method:* "The First Principle of
 Philosophy," 1637 158
 Baruch Spinoza, *Ethics:* "A Confused Idea," 1660–66 161

 4. Rembrandt van Rijn, *Self-Portrait,* c. 1659 162

 Rembrandt van Rijn, *Self-Portrait,* 1658 162

 Menno Simons, *The Blasphemy of John of Leiden:* "Christians Are
 Not Allowed to Fight with the Sword," 1535 163

 5. Jan Vermeer, *Young Woman with a Water Jug,* c. 1665 165

 Jan Vermeer, *The Letter,* 1666 165

 Anton van Leeuwenhoek, Letter: "This Vast Number of
 Animalcules," 1677 166
 Christiaan Huygens, *Systema Saturnium:* "The Wonderful
 Appearance of Saturn," 1659 167

 6. Jacob van Ruisdael, *View of Haarlem from the Dunes at
 Overveen,* c. 1670 170

 Simon Nicolas Arnauld de Pomponne, *Report:* "The East India
 Company," c. 1669–71 171

 7. Diego Velázquez, *The Maids of Honor (Las Meninas),*
 1656 172

 Miguel de Cervantes, *Don Quixote:* "O Beauteous and Highborn
 Lady," c. 1597–1615 174

VII: Eighteenth-Century Art

1. Richard Boyle and William Kent, Chiswick House, near
 London, begun 1725 177

 John Locke, *An Essay Concerning Human Understanding:* "All
 Ideas Come from Sensation or Reflection," 1690 178
 John Locke, *Two Treatises of Civil Government:* "In Full Liberty
 to Resist," 1690 180

2. William Hogarth, *Breakfast Scene* from *Marriage à la
 Mode,* c. 1745 181

 William Hogarth, *The Orgy,* Scene III of *The Rake's
 Progress,* c. 1734 181

 Zacharias Konrad von Uffenbach, *Travels:* "Cock-Fighting,"
 1710 182
 César de Saussure, *Letters:* "An Extraordinary Combat,"
 c. 1725–30 183

3. Balthasar Neumann, Vierzehnheiligen, near Bamberg,
 Germany, 1743–72 185

 Dominikus Zimmermann, Die Wies, Upper Bavaria,
 Germany, 1745–54 185

 Gottfried Wilhelm Leibniz, *Theodicy:* "Better Than Every Other
 Possible Universe," 1710 186

4. Antoine Watteau, *Return from Cythera,* 1717–19 187

 François de Salignac de la Mothe Fénelon, *Adventures of
 Telemachus:* "Frolic and Feast upon the Flowery Pasture,"
 1699 188

5. Jean-Baptiste-Siméon Chardin, *Grace at Table,* 1740 190

 Jean-Baptiste-Siméon Chardin, *Back from the Market,* 1739 190

 Marquis d'Argenson, *Journal and Memoirs:* "The Misery Within
 the Kingdom," 1739–40 191

6. Jean-Honoré Fragonard, *The Swing,* 1766 193

 Jean-Honoré Fragonard, *The Bathers,* c. 1765 193

 Voltaire, *Candide:* "Everything for the Best" and "A Necessary
 Ingredient in the Best of Worlds," 1759 194

7. Jean-Baptiste Greuze, *The Son Punished,* 1765–77 197

 Jean-Baptiste Greuze, *The Village Bride,* 1761 197

 Jean-Jacques Rousseau, *Discourse on the Origin and Foundations of
 Inequality Among Men:* "Pity—a Natural Sentiment," 1754 198

8. Thomas Gainsborough, *Mrs. Richard Brinsley Sheridan,*
 c. 1785 200

 Thomas Gainsborough, *Robert Andrews and His Wife,*
 c. 1748–50 200

 Samuel Johnson, *Rambler:* "To Delight and Refresh the Senses,"
 1751 201

9. Benjamin West, *The Death of General Wolfe,* 1771 203

 John Knox, *Journal:* "The Battle of Quebec," 1759 204

10. Thomas Jefferson, Monticello, Charlottesville, Virginia,
 1770–84, 1796–1806 206

 Thomas Jefferson, *Declaration of Independence:* "Certain
 Unalienable Rights," 1776 207

11. Jacques-Louis David, *The Death of Marat,* 1793 210

 Jean-Paul Marat, *The Friend of the People:* "Traitors Who Must
 Be Immolated," August 19, 1792 211
 Maximilien Robespierre, *Report on the Principles of Public
 Morality:* "Tame the Enemies of Liberty by Terror,"
 February 5, 1794 212

12. John Henry Fuseli, *The Nightmare,* 1781 214

 John Henry Fuseli, *The Nightmare,* 1785–90 214

 Edmund Burke, *Philosophical Enquiry into the Origin of Our Ideas
 of the Sublime and Beautiful:* "The Most Powerful of All the
 Passions," 1757 215

13. Horace Walpole, Strawberry Hill, Twickenham, near
 London, 1749–77 216

 Horace Walpole, *The Castle of Otranto:* "The Impetuosity of His
 Passions," 1765 217

14. William Blake, *Ancient of Days,* 1794 219

 William Blake, *Songs of Innocence:* "The Chimney Sweeper," 1789 220
 William Blake, *Europe: A Prophecy:* "Finite Revolutions," 1794 221

VIII: Nineteenth-Century Art

1. Théodore Géricault, *Mounted Officer of the Imperial Guard,*
 1812 223

 Napoleon, *Memoirs:* "Save the General," 1815–21 224

2. Francisco José de Goya y Lucientes, *The Third of May, 1808,* 1814 225

Manuel José Quintana, *Ode to Spain—After the Revolution of March:* "The Tyrants Are No More," c. 1815 227

3. Joseph Paxton, Crystal Palace, London, 1850–51 228

Report of the Parliamentary Committee on the Bill to Regulate the Labor of Children in Mills and Factories: "Evidence of a Female Millhand" and "Evidence of a Male Millhand," 1832 229

4. Joseph Mallord William Turner, *The Slave Ship,* 1840 233

Thomas Folwell Buxton, *The African Slave Trade and Its Remedy:* "This Inhuman Proposal," 1839 234

5. John Constable, *The Haywain,* 1821 235

John Constable, *Stoke-by-Nyland,* 1836 235

William Wordsworth, *Lines Composed a Few Miles Above Tintern Abbey, on Revisiting the Banks of the Wye During a Tour:* "To Look on Nature," 1798 237

6. Eugène Delacroix, *The Massacre of Chios,* 1822–24 239

George Gordon Byron, "Song to the Suliotes," 1824 240

7. Eugène Delacroix, *Liberty Leading the People,* 1830 241

Victor Hugo, "Written after July 30, 1830," 1830 242

8. Honoré Daumier, *The Third-Class Carriage,* c. 1862 244

Auguste Comte, *The Course of Positive Philosophy:* "The Progressive Course of the Human Mind," 1830–42 245

Jules Michelet, *The People:* "The Bondage of the Factory Worker," 1846 247

9. Gustave Courbet, *Burial at Ornans,* 1849 248

Gustave Courbet, *The Stone Breakers,* 1849 248

Pierre-Joseph Prou'dhon, *What Is Property?* "This Fraudulent Denial," 1840 250

Karl Marx and Friedrich Engels, *The Communist Manifesto:* "Two Great Classes," 1848 251

10. Edouard Manet, *Déjeuner sur l'herbe,* 1863 253

Charles Baudelaire, *The Flowers of Evil:* "I Love the Thought," 1857 254

11. Claude Monet, *The River,* 1868 255

 Claude Monet, *Rouen Cathedral,* 1894 255

 Augustin-Jean Fresnel, *Memoir on the Diffraction of Light:* "An
 Immediate Consequence of the Wave-Theory," 1819 256

12. Pierre-Auguste Renoir, *Le Moulin de la Galette,* 1876 257

 Hippolyte Taine, *Notes on Paris:* "A Great Moving Circle Floats
 Around the Dancers," 1875 258

13. Edgar Degas, *Ballet Rehearsal (Adagio),* 1876 260

 Edgar Degas, *Prima Ballerina,* c. 1876 260

 Berthe Bernay, *La Danse au théâtre:* "Drag Me Along on Her
 Arm," 1890 261

14. Henri de Toulouse-Lautrec, *At the Moulin Rouge,*
 1892–95 262

 Emile Zola, *The Dram Shop:* "Will Madame Take Another?"
 1876 264

15. Paul Gauguin, *The Vision After the Sermon,* 1888 265

 Paul Gauguin, *Offering of Gratitude,* c. 1891–93 265
 Paul Gauguin, *Spirit of the Dead Watching,* 1892 265

 Breton Ballad: "The Song of the Souls in Pain," undated 267
 Tahitian Chant: "Gloomy Sacredness Is That Indeed!" undated 269

16. Thomas Eakins, *The Gross Clinic,* 1875 270

 John Simpson, *Memoirs:* "The Horror of Great Darkness,"
 undated 272
 Washington Ayer, *The First Public Operation Under Anesthesia:*
 "Gentlemen, This Is No Humbug," 1846 273
 Joseph Lister, *An Antiseptic Principle of the Practice of Surgery:*
 "In Beautiful Harmony with Pathological Principles," 1867 274

17. Mary Cassatt, *The Bath,* 1891–92 276

 Catherine Beecher, *Treatise on Domestic Economy:* "The Duties
 of Subordination," 1841 277
 Susan Brownell Anthony, *Trial Transcripts:* "This High-Handed
 Outrage upon My Citizen's Rights," 1872 279

18. Louis Sullivan, *Guaranty (Prudential) Building,* Buffalo,
 New York, 1894–95 281

 Charles Darwin, *Origin of Species:* "The Struggle for Life,"
 1859 282

Herbert Spencer, *Principles of Ethics:* "The Evolution of
Conduct," 1879–93 284

19. Edvard Munch, *The Scream,* c. 1895 286

August Strindberg, *The Link:* "I Will Scream Myself Tired
Against God," 1893 287

IX: Early Twentieth-Century Art

1. Pablo Picasso, *Les Demoiselles d'Avignon,* 1907 289

Anonymous Zulu poems, "Zulu, Son of Nogandaya" and
"Mnkabayi, Daughter of Jama," undated 290

2. Gustav Klimt, *Death and Life,* 1908 and 1911 292

Gustav Klimt, *The Kiss,* 1907–8 292

Sigmund Freud, *On the Origin of Psychoanalysis:* "The Repressed
Impulse," 1910 293

3. Emil Nolde, *Last Supper,* 1909 295

Friedrich Nietzsche, *Thus Spake Zarathustra:* "A Chosen
People—the Superman," 1883–85 296

4. Pablo Picasso, *Still Life with Chair Caning,* 1911–12 298

Pablo Picasso, *Ambroise Vollard,* 1909–10 298

Albert Einstein, *Does the Inertia of a Body Depend upon Its Energy
Content?:* "The Energy of Radiation," 1905 299

5. Marcel Duchamp, *Nude Descending a Staircase, No. 2,*
1912 301

Marcel Duchamp, *Bride Stripped Bare by Her Bachelors,*
1915–23 301

Henry Ford, Letter to the Editor, *The Automobile:* "One of the
Absolute Necessities of Our Later Day Civilization," 1906 303
Henry Ford, *My Life and Work:* "The Experiment of an Assembly
Line," 1923 303

6. Umberto Boccioni, *Unique Forms of Continuity in Space,*
1913 304

Filippo Tommaso Marinetti, *Let's Murder the Moonshine:* "Oh!
The Joy of Playing Billiards with Death," 1909 305

7. Oscar Kokoschka, *Self-Portrait,* 1913 308

Ernst Kirchner, *Street, Berlin,* 1913 308

William II, Speech: "We Take Up the Sword," August 4, 1914 309

Raymond Poincaré, Message: "France Has Become the Object of a
Brutal and Premeditated Aggression," August 14, 1914 310

8. Ernst Barlach, *War Monument,* Güstrow Cathedral, 1927 311

Erich Maria Remarque, *All Quiet on the Western Front,* "We See
Men Living with Their Skulls Blown Open," 1929 313

9. Kasimir Malevich, *Suprematist Composition: White on White,*
c. 1918 315

Kasimir Malevich, *Black Quadrilateral,* c. 1913–15 315

Leon Trotsky, *The History of the Russian Revolution:*
"The Revolution Makes Another Forward Step," 1932 317
Vladimir Lenin, Speech: "The Workmen's and Peasants'
Revolution," November 1917 318

10. Vladimir Tatlin, *Model for the Monument to the Third
International,* 1919–20 319

First Manifesto of the Third International: "The Socialist World
Order," 1919 320

11. Giorgio de Chirico, *Sooth-Sayer's Recompense,* 1913 323

Giorgio de Chirico, *Mystery and Melancholy of a Street,*
1914 323

Benito Mussolini, Speech: "It Is Blood Which Moves the Wheels of
History," December 13, 1914 324

12. Paul Klee, *Twittering Machine,* 1922 326

Carl Jung, *Psychology of the Unconscious:* "Phantastic Thinking,"
1912 327

13. Joan Miró, *Painting,* 1933 329

Joan Miró, *Composition,* 1933 329

James Joyce, *Ulysses:* "yes I said yes I will Yes," 1922 330

14. Henry Moore, *Reclining Figure,* 1939 331

Henry Moore, *Recumbent Figure,* 1938 331

D. H. Lawrence, *Women in Love:* "A Dark Flood of Electric
Passion," 1921 332

15. Kurt Schwitters, *Merz 19,* 1920 334

Franz Kafka, *The Metamorphosis:* "His Little Legs Fluttered in the
Air," 1915 335

16. Edward Hopper, *Early Sunday Morning*, 1930 — 336

T. S. Eliot, *Prufrock:* "Preludes," 1917 — 337

17. Dorothea Lange, *Migrant Mother, California*, 1936 — 339

John Steinbeck, *The Grapes of Wrath:* "The Scraped Kettle,"
1939 — 340

18. George Howe and William E. Lescaze, Philadelphia Savings
Fund Society Building, Philadelphia, 1931–32 — 342

Franklin D. Roosevelt, *First Inaugural Address:* "The Only Thing
We Have to Fear Is Fear Itself," March 4, 1933 — 343

19. Max Beckmann, *Departure*, 1932–35 — 346

Adolf Hitler, *Mein Kampf:* "Pure Blood," 1924–26 — 347

20. Pablo Picasso, *Guernica*, 1937 — 350

Ernest Hemingway, *For Whom the Bell Tolls:* "The Fascists
Purified the Town" and "The Sickles and the Reaping Hooks,"
1940 — 351

21. Arshile Gorky, *The Liver Is the Cock's Comb*, 1944 — 354

Kurt Gerstein, *Report from Belzec:* "Breathe Deeply," c. 1943 — 355
Mrs. Liuba Daniel, *Deposition on the Stutthof Concentration Camp:*
"She Wanted to Eat Only the Liver," 1945 — 356

22. Jackson Pollock, *Lucifer*, 1947 — 358

Jackson Pollock, *Autumnal Rhythm: Number 30*, 1950 — 358

United States Strategic Bombing Survey: "A Blinding Flash," 1947 — 359
Hara Tamiki, *Glittering Fragments*, c. 1951 — 361

X: Later Twentieth-Century Art

1. Alberto Giacometti, *City Square*, 1948 — 362

Alberto Giacometti, *The Palace at 4 A.M.*, 1932–33 — 362

Jean-Paul Sartre, *Existentialism and Humanism:* "Existence Comes
Before Essence," 1946 — 363
Albert Camus, *The Plague:* "This Business Is Everybody's Business,"
1947 — 365

2. Le Corbusier, Notre-Dame-du-Haut, Ronchamp, France,
1950–55 — 366

Paul Tillich, *The Courage to Be*, "Absolute Faith," 1952 — 367

3. Wallace Harrison and the International Advisory Committee
 of Architects, United Nations Headquarters, New York,
 1949–51 368

 The Universal Declaration of Human Rights: "Equal and Inalienable
 Rights," 1948 369

4. Naum Gabo, *Column,* 1922–23 372

 Victor Kravchenko, *Comments Regarding the Liquidation of Kulaks:*
 "Herded Together for Deportation," 1946 373
 Aleksandr Solzhenitsyn, *One Day in the Life of Ivan Denisovich:*
 "The Law of the Taiga," 1962 374

5. Ludwig Mies van der Rohe, Lake Shore Drive Apartment
 Houses, Chicago, 1950–52 375

 Ludwig Mies van der Rohe, Seagram Building, New York,
 1956–58 375

 J. D. Salinger, *The Catcher in the Rye:* "You Don't Like *Any*thing
 That's Happening," 1951 376

6. John Chamberlain, *Essex,* 1960 379

 Jack Kerouac, *On the Road:* "The Cars Rushed by, LA-Bound,"
 1957 380

7. Edward Kienholz, *The Wait,* 1964–65 383
 Edward Kienholz, *The State Hospital,* 1966 383

 Ken Kesey, *One Flew over the Cuckoo's Nest:* "Hostility, Hostility,
 That's the Thanks We Get," 1962 384

8. Moshe Safdie, Habitat, Montreal, 1967 386
 Aldous Huxley, *Brave New World:* "Bokanovsky's Process," 1932 386

9. Barnett Newman, *Broken Obelisk,* 1963–67 389

 Robert Frost, "The Gift Outright," c. 1950 390
 John F. Kennedy, *Inaugural Address:* "Ask What You Can Do for
 Your Country," 1961 391

10. David Smith, *Cubi XVIII,* 1964; *Cubi XVII,* 1963; and *Cubi
 XIX,* 1964 392

 David Smith, *Cubi XXVI,* 1965 392

 John Glenn, Jr., *Pilot Flight Report:* "When Lift-off Occurred," 1962 393

11. Helen Frankenthaler, *Blue Causeway,* 1963 396
 Betty Friedan, *The Feminine Mystique:* "Feminine Fulfillment," 1963 397

12. William T. Williams, *Batman,* 1979 399

Ralph Ellison, *Invisible Man:* "That's Right, Sambo," 1952 401
James Baldwin, *Go Tell It on the Mountain:* "All Niggers Had Been
 Cursed," 1953 403

13. Jasper Johns, *Target with Four Faces,* 1955 405

Jasper Johns, *Three Flags,* 1958 405

Martin Luther King, Jr., Speech: "I Have a Dream," August 28,
 1963 406

14. Robert Indiana, *The Demuth Five,* 1963 409

Lyndon B. Johnson, News Conference: "This Is a Different Kind of
 War," July 28, 1965 410
J. William Fulbright, Speech: "We Are Fighting a Double Shadow
 in Indochina," April 2, 1970 411

15. Robert Smithson, *Spiral Jetty,* 1970 413

Rachel Carson, *Silent Spring:* "Soil Exists in a State of Constant
 Change," 1962 415

Bibliography 417
Index 423

Acknowledgments

I wish to express my appreciation to the many people who have assisted me throughout the preparation of this book. The idea for this volume and the companion volume which preceded it resulted from my participation in an interdisciplinary program for teaching the humanities at Gustavus Adolphus College. Participating with me were two colleagues, Claus Buechmann, a scholar of English Renaissance literature, and Clair Johnson, a professor of religion and specialist in the history of American religion. Our discussion about the relationships among Western literature, religion, and art did much to suggest the need for a volume of this kind and to point to its eventual shape. I am indebted to many other colleagues for their assistance and insight. Kathleen Mitchell and Mark Fuehrer offered valuable advice on the documents related to Renaissance art. Marianne Berardi and Henry Adams guided me in the selection and interpretation of readings related to Baroque art. William Freiert and Cass Canfield, Jr., generously gave me their assistance in shaping the sections on nineteenth- and twentieth-century art.

I would also like to acknowledge the contributions of my students in art history who responded willingly and cheerfully to their role as the initial audience for this endeavor. Numerous students undertook additional research in areas of special interest to them. These students include Stephanie Hammerschmidt, Erica Rootness, Sarah Carter, Lisa Mahoney, Becky Billmeyer, and Alejandra Jimenez. Two students, Kimberley Becker and Julie Speck, not only devoted patient labor throughout their undergraduate years to the project, but also exhibited creative flair in searching out sources and translations. Two former students and now current colleagues, Amanda

Eggers and Joan LaValle, have assisted me throughout by their sympathetic editing of my essays and their expert researching of source materials.

I also wish to express my gratitude to the staffs of the Folke Bernadotte Library at Gustavus Adolphus College and the College of St. Catherine Library. At Gustavus, thanks to Michael Haeuser and Carole O'Rourke, who placed the resources of the library at my disposal; to Howard Cohrt and Barbara Fister, for their help in locating research materials; and, most especially, to Susan Gravelin for her unceasing efforts to locate documents and archival sources. At the second institution, my thanks go to Karen Harwood, who extended me full access to the library facilities; and to Jim Newsome and Mary Ellen Hals, who were unfailing in their efforts to assist me. I would also like to express my appreciation to the President of Gustavus Adolphus College, Axel Steuer, for the extensive support I have received from my college, and to the President of the College of St. Catherine, Anita Pampusch, for being granted full faculty status.

Assistance in the physical preparation of the manuscript was received from Carol Hanson of the Department of Art and Art History at Gustavus Adolphus College. Carol met sudden deadlines by devoting working days, late nights, and weekends to typing this volume. Her husband, James Hanson, a professor at the University of Minnesota, was gracious enough to volunteer for the task of proofreader. To both I owe my warmest thanks.

Financial support for this project was provided by the National Endowment for the Humanities and by the Committee for Research, Scholarship, and Creativity of Gustavus Adolphus College. A sabbatical leave from Gustavus further assisted the completion of this volume.

I am deeply in the debt of Cass Canfield, Jr., at HarperCollins. His encouragement and enthusiasm, his patient nurturing of the idea of this anthology, and his insightful recommendations during its preparation have been crucial contributions to the work.

I also wish to express my appreciation of the skillful editing of Ann Finlayson. On matters both of style and substance, her comments and suggestions have resulted in many improvements in the text.

Linnea H. Wren
January 1994

Preface

The purpose of this anthology is to unite the study of Western art history with the understanding of Western social and cultural history. Painting, sculpture, architecture, and other forms of the visual arts are, like literary documents, primary sources that reveal the thoughts and abilities of individuals and that record the fundamental concerns of their age and culture. Works of art and written documents are related in this volume in order to demonstrate to the undergraduate student how the visual and literary records of Western intellectual history illuminate each other. Studied together, they enlarge our knowledge of our past and present and enrich our understanding of the creative and intellectual life of the West.

Most textbooks in art history have emphasized the stylistic development of the visual arts. Examples of art have been analyzed primarily in terms of formal qualities such as line, color, light, space, and composition. The twentieth-century stress on the aesthetic qualities of art works and the enjoyments derived from them has frequently resulted in a lessened emphasis on the social purposes art has served in the past and that it continues to serve in the present. Until the nineteenth century, few works of art were created exclusively to be appreciated for their beauty. Most either depicted a subject or narrated a story to serve broader purposes: to convey the spiritual convictions of an age, to commemorate a historical event, to further the ambitions of an individual, or sometimes—though more rarely—to give shape to the personal vision of the artist. Even the works of nineteenth-century and twentieth-century artists, while often created in independent studios and as expressions of individual beliefs, respond to widely held cultural mores,

spiritual aspirations, and political viewpoints. The artistic tradition of the Western world is undeniably a strong testimony to the personal capacities of individual artists and artisans, but it is also the vivid record of the hopes, dreams, convictions, and desires that all men and women have shared. This book seeks to demonstrate that, although subjects and styles in Western painting, sculpture, and architecture have undergone radical transformations, the human impulses and emotions that art expresses have remained the same.

In this volume, source documents and readings have been selected to cover the period of Western history from the early Renaissance through the twentieth century. These selections have been drawn from many areas of intellectual and social history, including religion, philosophy, literature, science, economics, and law. They are intended to reveal the relationship between works of art and the most important ethical, social, political, and religious issues of the various periods of Western history. Each selection has been chosen to correspond to a specific work of art illustrated in H. W. Janson's *History of Art*[1] and Horst de la Croix and Richard G. Tansey's *Gardner's Art Through the Ages.*[2] Each selection is prefaced by a brief essay which discusses the reading in terms of its subject and theme, its source and usage, and its relevance to the study of a specific work of art. The essays are designed to introduce the student to social, political, economic, and aesthetic issues in as direct and accessible a way as possible. Thus the essays avoid discussion of secondary sources and modern questions of interpretation. Unfamiliar names and terms have been explained in footnotes to the text. A bibliography of sources for additional study has also been included.

This anthology is intended primarily as a supplementary text for courses in the history of Western art. But as a collection of primary sources which relates works of art to the important themes in Western social and cultural history, it should also prove useful in courses in Western civilization and the humanities.

1. H. W. Janson, *History of Art,* 4th ed., revised and expanded by Anthony F. Janson (New York: Harry N. Abrams, Inc., 1991). Cited in the text as Janson.
2. H. de la Croix and R. G. Tansey, *Gardner's Art Through the Ages,* 9th ed. (San Diego: Harcourt Brace Jovanovich, 1990). Cited in the text as Gardner.

I

Italian Renaissance Art
of the Early Fifteenth Century

1. Donatello, *David,* **1430**

Gardner, p. 591, ill. 16:12; Janson, p. 453, ill. 586

Leonardo Bruni, *The Laudatio of the City of Florence:* "Why Florence Is to Be Admired," 1403–4

Italian city-states of the fifteenth century were flourishing centers of art, literature, commerce, and science. Supported by profits earned in the mercantile sphere, Italian scholars, writers, and artists led their European contemporaries in the recovery and interpretation, indeed the reliving, of antiquity. The belief that Greece and Rome had been imbued by eternally valid and permanently correct principles fostered the deliberate and conscious revival of antiquity that is called the Renaissance.

Florence claimed preeminence for itself among the Italian city-states. Florentines compared their city with Athens in fifth-century-B.C. Greece and with Rome in the Mediterranean world. However, Florentine independence was threatened during the late fourteenth and early fifteenth century by Milan, a nearby city-state. Giangaleazzo Visconti, the ambitious lord of Pavia, had gained control of Milan and had embarked upon an aggressive plan of territorial expansion. In the face of the seemingly inexorable advance of Milanese armies, Florence offered determined military resistance. To stiffen the resolve of the populace, Florentine leaders also conducted a propaganda battle. The conflict was cast as a struggle between "tyranny" and "liberty," and Giangaleazzo was accused of aspiring to be the monarch of Italy.

The immediate danger to Florence was averted in 1402 by Giangaleazzo's fortuitous death during a plague epidemic. In the early 1420s, however, Florence was again threatened by Milan. Although the Milanese campaign was brilliantly conducted,

Florence was able to halt the Milanese armies and to maintain her independent status.

Florentines of the fifteenth century derived considerable pride and self-confidence from their willingness to make a brave stand against the more powerful state of Milan. They credited their almost miraculous salvation in 1402 not to the expeditious removal of Giangaleazzo from the scene by a fatal illness, but rather to the moral and civic virtues that they claimed were uniquely evident in the Florentine state.

Florentine pride is evident in the writings of Leonardo Bruni (1369–1444). A politician, historian, and humanist, Bruni held high posts in papal circles and in the Florentine church. In the early years of his career (c. 1403–4), Bruni wrote *The Laudatio of the City of Florence*. The *Laudatio* is the most vigorous and most complete expression of the new complex of politico-historical ideas that arose during the struggle against Giangaleazzo. Bruni, an ardent admirer of the Greco-Roman world, claimed that Florentine citizens were ennobled by their supposed descent from the ancient Roman people. He extolled the patriotism and the love of liberty that he argued had been inherited from ancient Rome and that had inspired the Florentine people in the defense of their city-state against Milan. Finally, he praised Florence as the savior of Italian liberty. A selection from the *Laudatio,* "Why Florence Is to Be Admired," is presented here.

Florentine pride is also apparent in the sculpture of Donatello (c. 1386–1466). Donatello depicted the ideals of Florentine liberty through his representations of David, in marble (1408) and in bronze (1430). David, the Old Testament hero who defeated the powerful enemy Goliath, was seen by Florentines as a symbol of their own successful struggles against Milan.

Leonardo Bruni, *The Laudatio of the City of Florence*[1]
Why Florence Is to Be Admired

But as this city is to be admired for its foreign policy, so it is for its internal organization and institutions. Nowhere else is there such order, such elegance, such symmetry. For just as there is a proportion among strings which, when they have been tightened, produces a harmony from the different pitches, than which there is nothing sweeter or more agreeable to the ear; so all the parts of this prudent city are so tempered that the resulting whole commonwealth fits together in a way that brings pleasure to the mind and eyes of men for its harmony. There is nothing in it that is out of order, nothing that is ill-proportioned, nothing that is out of tune, nothing that is uncertain. Everything has its place, and this is not only fixed, but correct in relation to the others. Offices, magistracies, courts and ranks are all separate.

1. Reprinted, by permission of the publisher, from *The Humanism of Leonardo Bruni: Selected Texts,* trans. by Gordon Griffiths, James Hankin, and David Thompson (Binghamton, N.Y.: State University of New York at Binghamton, 1987), pp. 116–17, 120, 121. Copyright by the Center for Medieval and Early Renaissance Studies, State University of New York at Binghamton.

But they are separated in such a way that they are in harmony with the whole commonwealth, as tribunes were with respect to the general.

First, every consideration is given to providing that justice shall be held sacred in the city, for without that, no city can exist or deserve the name; secondly, that there is liberty, without which this people never thought life was worth living. Toward these two ideals together, as toward a kind of ensign and haven, all the institutions and legislative acts of this republic are directed.

It is for the sake of justice that the magistracies were established, and endowed with sovereign authority and the power to punish criminals, and above all so that they may see to it that no one's power in the city will be above the law. Accordingly all private citizens, as persons of lesser rank, are enjoined to obey the magistrates and to honor their symbols of office. But lest those defenders of the law, who have been put into positions of the highest authority, should get the idea that what had been offered them was an opportunity to tyrannize over the citizens rather than to protect them, and not a measure of freedom should be lost as a result of their persecution of others, many precautions have been taken. . . .

Coming as it does from such an origin, this magistracy possesses enormous authority in the city. For it has been given the position of a sentinel and guardian, as it were, to see to it that the commonwealth shall not deviate from the course followed by our ancestors, and that the government of the commonwealth should not fall into the hands of men of opposing sentiments. Thus the function performed by the censors in Rome,[2] by the council of the Areopagus in Athens,[3] and by the ephors in Sparta[4] is performed in Florence by the captains of the party. In other words, it is from among these citizens who love the republic that the leaders are chosen to serve as guardians of the republic.

So excellent and caring is the government of this city under these magistracies that one may say that there never was a household with better discipline under the watchful *paterfamilias*.[5] Accordingly no one here can suffer injury, nor does anyone lose his property involuntarily. The courts and magistracies are always ready to hear cases; the courtroom and the supreme

2. In the ancient Roman republic, two officials, called censors, were responsible for keeping the census, awarding public contracts, and supervising manners and morals.
3. The council of elders of Athens met on a hill named Areopagus, which was west of the Acropolis. This council combined judicial and legislative functions.
4. A body of magistrates. In Sparta, they consisted of an executive, legislative, and judicial board of citizens. Appointed annually, they exercised a controlling power over the king.
5. The male head of a household in Rome.

court are open. There is the freest opportunity in this city to file a complaint against persons of any rank, but under laws that are prudent and salutary and always accessible to afford relief. There is no place on earth in which justice is fairer for all. For nowhere does such liberty flourish, nor such a balanced relationship between greater and lesser. . . .

There are in this city the most talented men, who easily surpass the limits of other men in whatever they do. Whether they follow the military profession, or devote themselves to the task of governing the commonwealth, or to certain studies or to the pursuit of knowledge, or to commerce—in everything they undertake and in every activity they far surpass all other mortals, nor do they yield first place in any field to any other nation. They are patient in the labor, ready to meet danger, ambitious for glory, strong in counsel, industrious, generous, elegant, pleasant, affable, and above all, urbane.

2. Lorenzo Ghiberti, *Jacob and Esau (Isaac and His Sons)***, 1425–52**
Gardner, p. 590, ill. 6:11; Janson, p. 452, ill. 583

Gregorio Dati, *History of Florence:* "The Feast Day of Saint John the Baptist," 1385
Anonymous, *Letter of a Florentine Citizen:* "Christ Possessed Nothing," 1389

In the early fifteenth century, European culture underwent a process of revitalization that later generations have labeled as the beginning of the modern age. However, the aim of Renaissance Italians was neither to effect a revolutionary break with the past nor to shape a new, more secular society. Rather, their aim was to infuse the religious beliefs and moral values of their contemporary world with the philosophical principles, intellectual advances, and artistic accomplishments of the idealized ancient world. In Florence, the church was one of the most venerable institutions of public and personal life. The vitality of Florentine spirituality is evidenced by the popularity of cult ceremonies, the uninterrupted flow of bequests to monasteries and charitable foundations and the outbursts of religious fervor.

The inseparability of civic pride and religious devotion among Florentine citizens is illustrated by the creation of two sets of bronze doors for the Cathedral Baptistery. Lorenzo Ghiberti (1378–1455) received the commission for the doors now installed at the northern entrance of the Baptistery as a result of his victory in a competition sponsored by a Florentine civic guild[1] in 1401. These doors, which were begun 1404 and completed 1424, consisted of twenty-eight panels. Twenty panels

1. A trade or professional association which established standards of training, price, quality, and employment.

illustrate scenes in the life of Christ; four panels depict the four Evangelists; and four panels depict the Church Fathers.[2] In 1425, Ghiberti also received a commission for a second set of doors, which were installed at the eastern entrance of the Baptistery in 1425. These doors, which were begun in 1430 and completed in 1447, illustrate ten episodes of the Old Testament.

The Baptistery, which is located at the western entrance of the cathedral, is dedicated to John the Baptist, patron saint of Florence. The eastern entrance was the portal through which the most solemn religious processions, such as those that occurred on the feast day of St. John the Baptist, would pass. In this procession, members of religious orders and professional associations would march together to display religious and civic solidarity. Among the members of these groups were the most prominent and respected citizens of Florence. A history of Florence was written in the late thirteenth century by Gregorio Dati. In his book, Dati describes the procession honoring John the Baptist as it occurred in the year 1385. Later processions in the fifteenth century were very similar. A selection from the *History of Florence*, "The Feast Day of Saint John the Baptist," is presented here.

The church represented a conservative, but vital force in the affairs of Florence and other city-states. Offering security and stability in an often volatile urban setting, it also resisted religious change and guarded against heretics and groups outside the establishment. The Inquisition was vigorous in its suppression of heretical doctrines, and in Florence one of the most vigorously persecuted groups was the Fraticelli.

The Fraticelli were an extreme offshoot of the Franciscan monastic order. Soon after the death of Saint Francis (c. 1182–1226), the Franciscan order was split by internal dissension. One group, called the Spirituals, stood for the literal observance of the rule and testament of Francis and the renunciation of some aspects of papal authority. They preached the advent of an age of the Holy Spirit, which was to be preceded by the coming of the anti-Christ. They upheld the evangelical doctrine of poverty. Urging the faithful, including church officials, who often enjoyed a luxurious lifestyle, to renounce possessions and to embrace poverty, they set a precedent for others by refusing to own any property themselves.

Because of their extreme views on poverty, as well as other aspects of their theological doctrines, the Spirituals were condemned by the church in 1283 and quickly became victims of the Inquisition.

Documents preserved in the historical archives of Florence record actions taken against the Fraticelli. One such document, *Letter of a Florentine Citizen*, describes the execution of a member of the Fraticelli sect in 1389. A selection from the letter, "Christ Possessed Nothing," is presented here.

2. In the West, the term "Four Fathers of the Church" refers to St. Ambrose (c. 340–397), St. Jerome (c. 340–420), St. Augustine (354–430), and St. Gregory the Great (c. 540–604).

Gregorio Dati, *History of Florence*[3]
The Feast Day of Saint John the Baptist

When springtime comes and the whole world rejoices, every Florentine begins to think about organizing a magnificent celebration on the feast day of St. John the Baptist [June 24]. . . . For two months in advance, everyone is planning marriage feasts or other celebrations in honor of the day. . . . Everyone is filled with gaiety; there are dances and concerts and contests and tournaments and other joyous activities. Up to the eve of the holiday, no one thinks about anything else.

Early on the morning of the day before the holiday, each guild has a display outside of its shops of its fine wares, its ornaments and jewels. . . . Then at the third hour, there is a solemn procession of clerics, priests, monks, and friars, and there are so many [religious] orders, and so many relics of saints, that the procession seems endless. [It is a manifestation] of great devotion, on account of the marvelous richness of the adornments . . . and clothing of gold and silk with embroidered figures. There are many confraternities[4] of men who assemble at the place where their meetings are held, dressed as angels, and with musical instruments of every kind and marvelous singing. They stage the most beautiful representations of the saints and of those relics in whose honor they perform. They leave from S. Maria de Fiore [the cathedral of Florence] and march through the city and then return.

Then, after midday, when the heat has abated before sunset, all of the citizens assemble under [the banner of] their district, of which there are sixteen. Each goes in the procession in turn, the first, then the second, and so on with one district following the other, and in each group the citizens march two by two, with the oldest and most distinguished at the head, and proceeding down to the young men in rich garments. They march to the church of St. John [the Baptistery] to offer, one by one, a wax candle weighing one pound. . . . The walls along the streets through which they pass are all decorated and there are . . . benches on which are seated young ladies and girls dressed in silk and adorned with jewels, pearls, and precious stones. This procession continues until sunset, and after each citizen has made his offering, he returns home with his wife to prepare for the next morning.

Whoever goes to the Piazza della Signoria on the morning of St. John's day witnesses a magnificent and triumphant sight, which the mind can

3. Reprinted by permission of the publisher, from *The Society of Renaissance Florence: A Documentary Study*, ed. by Gene Brucker (New York: Harper & Row, 1971), pp. 75–78. Copyright held by Gene Brucker, 1971.
4. Religious associations formed by lay persons for the purpose of serving the church and performing charitable works.

scarcely grasp. Around the great piazza are a hundred towers which appear to be made of gold. Some were brought on carts and others by porters. . . . [These towers] are made of wood, paper, and wax [and decorated] with gold, colored paints, and with figures. . . . Next to the rostrum of the palace [of the Signoria] are standards . . . which belong to the most important towns which are subject to the Commune: Pisa, Arezzo, Pistoia, Volterra, Cortona, Lucignano. . . .

Anonymous, *Letter of a Florentine Citizen*[5]
Christ Possessed Nothing

Now everything which I here describe, I who write both saw or heard. Fra Michele, having come into the courtyard, waited attentively to hear the condemnation. And the vicar [general of the bishop] spoke: "The bishop and the Inquisitor have sent me here to tell you that if you wish to return to the Holy Church and renounce your errors, then do so, in order that the people may see that the church is merciful." And Fra Michele replied, "I believe in the poor crucified Christ, and I believe that Christ, showing the way to perfection, possessed nothing." . . . Having read his confession, the judge turned his back upon Fra Michele . . . and the guards seized him and with great force pushed him outside of the gate of the judge's palace. He remained there alone, surrounded by scoundrels, appearing in truth as one of the martyrs. And there was such a great crowd that one could scarcely see. And the throng increased in size, shouting: "You don't want to die!" And Fra Michele replied, "I will die for Christ." And the crowd answered: "Oh! You aren't dying for Christ! You don't believe in God!" And Fra Michele replied: "I believe in God, in the Virgin Mary, and in the Holy Church!" And someone said to him, "You wretch! The devil is pushing you from behind!"

And when he arrived at the gate near the place of execution, one of the faithful began to cry, "Remain firm, martyr of Christ, for soon you will receive the crown."[6] . . . And at the place of execution, there was a great turmoil and the crowd urged him to repent and save himself and he refused. . . . And the guards pushed the crowd back and formed a circle of horsemen around the pyre so that no one could enter. I myself did not enter but climbed upon the riverbank to see, but I was unable to hear. . . . And he was bound to the stake . . . and the crowd begged him to recant, except one of the faithful, who comforted him. . . . And they set fire to the wood . . . and Fra

5. Reprinted, by permission of the publisher, from Gene Brucker, ed., *The Society of Renaissance Florence: A Documentary Study* (New York: Harper & Row, 1971), pp. 253–56. Copyright by Gene Brucker.
6. The church crown was a symbolic reward of martyrdom.

Michele began to recite the Te Deum.[7] . . . And when he had said, "In your hands, O Lord, I commend my spirit," the fire burned the cords which bound him and he fell dead . . . to the earth.

3. Masaccio, *The Tribute Money,* Brancacci Chapel; Santa Maria del Carmine, Florence, c. 1427
Gardner, p. 599, ill. 16:27; Janson, p. 460, ill. 602

Domenico Giugni to Francesco Datini, Letter: "Everyone Pays His Proper Share," 1401
The Medici Bank Ledger: "Florentine Banking Practices," 1423–40
Contract of Partnership: "A Profitable Company," 1434

Florence, one of the most prosperous cities in fifteenth-century Europe, was a pioneer in the development of merchant banking, international finance, and industry. Florentine businesses were organized as long-term family partnerships, with permanent branches in foreign cities. Florentine merchants dealt in a wide variety of products, including wine and food supplies, cloth, weapons, and metals. The profits that accumulated from these manufacturing and export businesses allowed the merchants to accumulate capital, and this capital, in turn, permitted Florentine merchants to open banking firms. By offering high rates of interest, merchant bankers were able to attract deposits from other clients. Banking firms could then reinvest their increased capital in the same industries owned by their partners, or they could lend their capital to other individuals at higher rates of interest.

In addition to acquiring vast sums of capital, Florentine banks developed ways to facilitate and protect trade. Because they held accounts in all the principal European currencies and because they maintained offices in many cities, Florentine banks were able to transfer money from one place to another without the dangerous practice of carrying cash between cities.

The growth in Florentine mercantile banking industries was paralleled by the development of textile industries. Florentine merchants were able to obtain high-quality wool from England, Scotland, France, Spain, and North Africa, instead of having to rely on the lesser-quality Italian wool. Moreover, Florentine entrepreneurs developed a refinishing industry that improved the final surface texture and the visual appearance of woven cloth. Exported for large profits, woolen cloth produced in Florence commanded the highest prices in the markets, fairs, and bazaars of three continents. At home, the woolen industry provided employment for thousands of workers.

The props that supported the Florentine economy—that is, the mercantile bank-

7. An ancient Latin hymn of praise to God, sung regularly at matins or morning prayer.

ing empire and the cloth industry—were shaken frequently in the fifteenth century. Prosperity was threatened by the efforts of Giangaleazzo, lord of Pavia, to impose an economic stranglehold on Florence. Even the unexpected death of Giangaleazzo, in 1402, did not spare Florence from warfare with the other Italian city-states and from the need to levy heavy taxes upon its citizenry. The negative effect was felt in every sphere of economic activity. The establishment of peace in 1413 resulted in a period of unparalleled prosperity, remembered by succeeding generations of merchant bankers as a golden age.

Three fifteenth-century documents illustrate different aspects of the economic life of Florence. The first document is a letter written in 1401 by a Florentine merchant, Domenico Giugni, to a friend in Bologna. In this letter, Giugni makes a patriotic appeal to his correspondent to assist the threatened city of Florence by returning and by paying his taxes. A selection from this letter, "Everyone Pays His Proper Share," is presented here.

The second document is a ledger of the Medici bank, one of the most prominent merchant banking firms in Florence. The ledger illustrates the utility of the bill of exchange, a document assigning to a payee money owed to the payer in some other, often distant, place. Invented by Florentine banks, the bill of exchange rendered the actual and cumbersome transfer of cash currency unnecessary. A selection from this ledger (1423–40), "Florentine Banking Practices," is presented here.

The third document is a contract of partnership among junior branches of the Medici family firm. The contract established a shop for the sale of wool cloth. It stipulated that the trading company would be valid for three years and that, during this time, the profit and loss would be shared in proportion to the original investment. A selection from the *Contract of Partnership* (1434), "A Profitable Company," is presented here.

The Tribute Money (c. 1427) is a mural painted by Masaccio (1401–1428) for the Brancacci Chapel, Santa Maria del Carmine, in Florence. The subject, a depiction of Saint Peter being directed by Jesus to pay a tax owed to Caesar, refers to an unavoidable feature of the Florentine economic system—that is, to the taxation system. The same year that Masaccio executed his mural, a new form of taxes was levied on the Florentine populace. This tax, called the *catasto*, required all citizens to make a declaration of possessions of every kind—gold, silver, jewels, houses, farms, rents, mortgages, animals, and capital employed in commerce. The declaration was subject to review by a tax commission, which corrected the figures and permitted deductions for debts, house rents, and family maintenance. The rest was regarded as interest-bearing capital and was taxed at an approximate rate of 10 percent. The Florentines deeply resented the *catasto*. Not only did they voice loud complaints over the size of the tax payments that were assessed by the city government, but they also attempted to claim large deductions based on the number of their children, expenses incurred in illnesses and medical treatments, and supposed business losses. Nonetheless, public compliance in making tax payments, which seemed to be blessed by Masaccio's mural, was a goal vital to the civic and financial institutions of Florence.

Domenico Giugni to Francesco Datini, Letter[1]
Everyone Pays His Proper Share

You say that you do not intend . . . to return to Florence . . . because of the excessive tax burdens which have been imposed on you by the Commune,[2] and because in your opinion, these will not be reduced. It is true that the Commune has been in disorder, but it is my feeling that at the present time order has been restored, and every day measures are taken to reduce expenditures and increase revenues. . . . Our city needs the equalization of the tax burden, so that everyone pays his proper share. I think that, with God's grace, my colleagues . . . will do everything to achieve this, and I believe that they will succeed. . . . And considering that everyone is obligated to his country, and should never abandon it, particularly in time of adversity, I tell you that I am one of those who advises you not to forsake yours. If you do, you will be censured by God and by the world, because you do not have any valid reason. Those who level taxes say that they wished to treat you equitably, and I believe that they did so, and until you have evidence to the contrary, you should not complain.

The Medici Bank Ledger[3]
Florentine Banking Practices

Entry 71 (25 Feb., 1423). The Council of the city of Siena have acknowledged that they have received of Folco Adovardi dei Portinari of Florence, associate and commissary of Cosimo and Lorenzo dei Medici, 9616 gold florins,[4] being paid in the name of Pope Martin V for the occupation of the castle and fortifications of the city of Spoleto.[5]

Entry 78 (31 May, 1424). Baldo Andrea Baldi of Piombino, unable to read or write, has appointed Gabriel and Benedict dei Borromei, merchants of Pisa, as his proxies, for the presentation to Andrea Bardi & Co., of Pisa of a bill of exchange for 100 florins, given to him by Cosimo and Lorenzo dei Medici.

Entry 95 (16 Nov., 1433). Nicolaus Lasozski, canon of Cracow [Poland], has made recognisance for the receipt of 37 florins in exchange from Albici

1. Reprinted, by permission of the publisher, from Gene Brucker, ed., *The Society of Renaissance Florence: A Documentary Study* (New York: Harper & Row, 1971), pp. 82–83. Copyright by Gene Brucker.
2. The Florentine government of the early fifteenth century.
3. Reprinted, by permission of the publisher, from G. R. Elton, ed., *Renaissance and Reformation, 1300–1648* (New York: Macmillan, 1963), p. 273. Copyright by The Macmillan Company.
4. Florentine unit of currency.
5. A city in central Italy.

dei Medici, for a payment made by the same Albici to the person of master John de Laironio, representative for Stanislas Pawlowski, bishop of Plonsk; and has promised to repay either him [Albici], or Cosimo and Lorenzo Medici & Co. in the court of Rome. . . .

Entry 123 (31 August, 1438). The president and prelates representing the German nation at the Council of Basel have agreed that of the indulgence money of the diocese of Padua 2000 florins shall be paid to Messrs. Cosimo and Lorenzo dei Medici, in settlement of the loan which they had made to the Holy Council on the occasion of the bringing over of the Greeks.

Contract of Partnership[6]
A Profitable Company

Be it known to whomsoever shall see or read the present contract made the year and month mentioned above, that it is declared in the name of God and of profit, that Bernardo d'Antonio de' Medici on the one part, and Giovenco d'Antonio de' Medici on another part, and Giovenco di Giuliano [de' Medici] on the other part, all three Florentine citizens and merchants, have made this present new Company under the *Arte di Lana,*[7] in the *Convento* of San Martino,[8] with this pact and condition and agreement that thus they make a partnership. That is:

In the first place, they are agreed that the capital of the said Company shall be, and must be, 4000 gold florins, and that this shall be contributed in cash within twelve months from now in this wise: the said Bernardo d'Antonio [shall put therein] 2200 florins; the said Giovenco d'Antonio [shall put therein] 1500 florins; and the above-said Giovenco di Giuliano shall put therein 300 for the said term of one year, as stated above, so that in all the sum [shall be] 4000 gold florins. Each one shall put in the above-said amount for the time mentioned, and whosoever shall fail to put in the stated sum within one year for the use of the said Company shall be obliged to make good to the said Company [with interest at] ten per cent of his account at the beginning of the year, according to what he has lacked.

And the said Giovenco di Giuliano promises his person and assistance and service and usefulness to the said Company and traffic under the *Arte di Lana,* and [he promises] to go to the looms and to other places generally at

6. Reprinted, by permission of the publishers, from Thomas G. Barnes and Gerald D. Feldman, eds., *Renaissance, Reformation and Absolutism, 1400–1600: A Documentary History of Modern Europe* (Lanham, Md.: University Press of America, 1979), vol. 1, pp. 33–34. Copyright by Thomas G. Barnes and Gerald D. Feldman.
7. Guild of wool manufacturers.
8. Monastery of Saint Martin.

other times, always in whatever place is necessary, without other provision or salary. And the said Bernardo and Giovenco d'Antonio are not held to any such service in the said shop more than they give voluntarily during the said time. And if it pleases Giovenco d'Antonio to withdraw himself [from the firm] for any reason during the said time, that such absence is possible, providing that it appears to Bernardo d'Antonio and to Giovenco di Giuliano that it is possible; and that such salary [as he may receive] shall be paid into the said shop and company. . . .

And they are agreed that the profit which our Lord God concedes through His mercy and grace will be divided in this manner: that is, that Bernardo d'Antonio shall draw on the basis of 1800 florins and Giovenco d'Antonio shall draw on the basis of 1300 florins, and Giovenco di Giuliano shall draw on the basis of 900 florins; and similarly during this time if any damage occurs, which God forbid, [each shall contribute on this basis]; and also each may draw out [his share] of their [joint] profits at any time, and at each withdrawal there shall be a balancing of accounts.

4. Michelozzo di Bartolommeo, Palazzo Medici, Florence, begun 1444
Gardner, p. 597, ill. 16:24–25; Janson, p. 458, ill. 597

Cosimo de' Medici, *Oration to the Signory,* "A Good and Honest Merchant," 1433

The Medici family was linked for more than three hundred years with the history of Florence and central Italy. The Medici first appeared in Florentine records at the beginning of the thirteenth century. Despite suffering a severe economic reversal at the end of the fourteenth century, the family accumulated an enormous fortune in the successive decades through trade and banking. The necessity of protecting its fortune drew the family into an ever-increasing role in Florentine politics.

During the early fifteenth century, the Medici family was led by Cosimo de' Medici (1389–1464), a man of shrewd intelligence. Because he wooed political support from the lower and middle classes, Cosimo was an object of suspicion to Rinaldo degli Albizzi (1370–1442), the ruler of Florence and a member of one of the oligarchic families which had traditionally controlled the city. Rinaldo's popularity plummeted in 1433 when the war he had waged against the neighboring city of Lucca ended in humiliating defeat. Change in government appeared imminent, and Cosimo emerged as Rinaldo's most formidable political adversary.

Rinaldo attempted to forestall his fall from political power and his rival's ascendancy by putting Cosimo under arrest. The imprisoned Cosimo, fearing that he

would be quietly poisoned, refused to eat the food brought to him in his cell. His jailer finally persuaded him to eat by offering to share his meals with him. Meanwhile Cosimo's fate—exile or execution—was debated by the Signory, an assembly of Florentine citizens chosen principally by Rinaldo. Rinaldo favored execution for Cosimo, but moderate members of the assembly argued for exile. Well-placed bribes by Cosimo resulted in a sentence consisting of a ten-year banishment from Florence.

When Rinaldo was forced to relinquish power in 1434, a newly formed city government recalled Cosimo to Florence. Cosimo, later to be called *pater patriae,* the father of his country, became virtual lord of Florence until his death thirty years later. In internal affairs, Cosimo brought stability and increased prosperity for Florentine citizens; in foreign affairs, Cosimo's first priority was to secure the safety of the city.

Cosimo's sense of patriotism emerges in the text of a speech he delivered to the assembly of Florentine citizens in 1433 after the sentence of exile had been pronounced. In the speech, Cosimo presents himself as an obedient law-abiding and honorable man who suffers from governmental injustice. A selection from the *Oration to the Signory,* "A Good and Honest Merchant," is presented here.

Interested in culture as well as politics, Cosimo spent vast sums on the arts and on public works. Among the many artists patronized by Cosimo was Michelozzo (1396–1472). In addition to erecting private villas for Cosimo in the countryside surrounding Florence, Michelozzo was the original architect of the Medici palace, the Palazzo Medici (begun 1444), in the center of the city.

Despite his wealth and power, Cosimo was spared neither the cruel private losses nor the gradual impairment of health that are the common human lot. One son, Giovanni, died without offspring in 1463; the only other son, Piero, was afflicted with poor health. To leave behind a large and prosperous family was the outstanding ambition of every Florentine citizen—an ambition Cosimo was unable to realize for himself. After Giovanni's death, the now-bedridden Cosimo had himself carried through the empty rooms of the palace designed for him by Michelozzo. He was heard to mutter sorrowfully, "Too large a house for so small a family."[1]

Cosimo de' Medici, *Oration to the Signory*[2]
A Good and Honest Merchant

If I thought that this my misfortune and terrible ruin might serve to bring peace to this blessed people, not only would exile be acceptable, but I should even welcome death, if I were sure that my descendants, O Signori, might pride themselves of my having been the cause of the wished-for union of your

1. Quoted in Ferdinand Schevill, *History of Florence from the Founding of the City Through the Renaissance* (New York: Harcourt, Brace, 1936), p. 370. Copyright by Harcourt, Brace and Co.
2. Reprinted, by permission of the publisher, from Janet Ross, ed. and trans., *The Lives of the Early Medici as Told in Their Correspondence* (London: Chattus and Windus, 1910), pp. 21–23. Copyright by Chattus and Windus.

Republic. As you have decided that I am to go to Padua, I declare that I am content to go, and to stay wherever you command, not only in the Trevisian State,[3] but should you send me to live amongst the Arabs, or any other people alien to our customs, I would go most willingly; and if your Lordships command me to discover the origin of the ill, as a beloved son is bound to obey his father's wishes and a good servant the orders of his master, so would I obey you for the peace of your people. One thing I beg of you, O Signori, that seeing you intend to preserve my life, you take care that it should not be taken by wicked citizens, and thus you be put to shame. I do not so much fear the pain of death as the abominable infamy of undeserved assassination, for a violent death is the manifest sign and outcome of a bad life, and I have not led the life of a villain, but of an honest and good merchant. Even if I have not been faultless, I have always tried to merit the love of good men, because my actions were good. . . .

Every trouble will be easy to bear as long as I know my adversity will bring peace and happiness to the city. I know, and this is no small comfort to me, that I never permitted wrong to be done to any one. I never frequented the Palace[4] save when I was summoned; I never roused hatred of the Republic amongst your subalterns,[5] because I never ill-treated them; I always declined to be nominated an official, which is often prejudicial to the body and hurtful to the soul; with no small pride I affirm that none can say my ill-behaviour ever caused a city to rebel or to be taken from you. . . .

Never have I been found wanting when the Commune could be enlarged, and although I am exiled, I shall ever be ready at the call of this people. In conclusion, O Signori, I pray God to keep you in his grace and in happiness in this fortunate Republic, and to give me patience to bear my unhappy life.

5. Donatello, *Saint George,* 1415–17
Gardner, p. 587, ill. 16:6; Janson, pp. 448–449, ills. 578–79

Franco Sacchetti, from "A Woolworker Goes Jousting," in *Three Hundred Tales:* "Go Thou and Beat Wool," c. 1400

Until the fifteenth century Florentine patrician society had avoided wasteful expenditures and extravagance. But during the fifteenth century the restraints imposed by

3. The territory controlled by Venice in the fifteenth century.
4. Visiting the palace of the Signoria was an indication that a person was untrustworthy and was constantly involved in lawsuits.
5. Subordinates.

egalitarianism were loosened, and wealthy Florentine families indulged in ostentatious displays of luxury. In addition to constructing palatial residences, well-to-do Florentines expended large sums of money on family events, such as weddings and funerals, and in lavish public entertainments.

One of the most popular entertainments was the jousting tournament. Introduced to Florence in the last quarter of the fourteenth century by visiting nobles, the jousting tournaments became increasingly popular in the fifteenth century. It was the custom for foreign knights to joust with young men from patrician families whose ancestors had been defenders of Florence. The tournaments, which were held in the square in front of Santa Croce, attracted large throngs of spectators. Combatants, dressed in the family colors and mounted upon expensive horses, entered the arena in order to fight for the glory of their ancestors and to flaunt their prowess and their riches.

Jousting is one of the many subjects described by the Florentine storyteller Franco Sacchetti (c. 1330–1401). Sacchetti, who came from nobility and whose wife was a member of the wealthy Strozzi family, served the Florentine republic as an ambassador and a magistrate. In addition, he wrote a collection of stories, known as *Three Hundred Tales,* which focus on urban, middle-class Italian life. A faithful and witty chronicler of the daily happenings in Florence and neighboring villages, Sacchetti interweaves the descriptions of his characters with kindly satire and with a strict sense of moral propriety.

One story by Sacchetti, "A Woolworker Goes Jousting," deals with the newly popularized entertainment of jousting, which was also called tilting. A woolworker, Agnolo di Ser[1] Gherardo, nurses pretensions above his social class and beyond the capacity of his advancing age. Although he is seventy years old, he decides to enter a jousting tournament. His horse, a scrawny animal more used to hard labor than elegant diversion, proves uncooperative during the tournament. Much to the amusement of the spectators, it kicks and plunges until Agnolo is thrown to the ground. The bruised Agnolo is helped home, where his wife, believing that he has been beaten, initially treats him with sympathy. Her attitude quickly changes to indignation, however, when she learns the truth. The sensible woman becomes the mouthpiece for the moral that Sacchetti draws. A selection from the story, "Go Thou and Beat Wool," is presented here.

Christian legends as well as contemporary literature added luster to the sport of jousting. The sculptor Donatello (1386–1466) carved a life-size representation of St. George (1415–17) for the Or San Michele in Florence. Below George's feet is a relief illustrating the saint mounted like a knight on horseback. By driving his lance into the dragon with the same technique used by jousters in tournaments, George slays his foe and rescues the maiden.

1. Notaries were given the title *Ser.*

Franco Sacchetti, from "A Woolworker Goes Jousting," in *Three Hundred Tales*[2]
Go Thou and Beat Wool

His wife came running to the door and began to weep, as though he had been dead, crying:

"Alas, my husband! who hath hurt thee? . . . Who hath beaten thee thus?" for his body was all mottled, as though of marble, so sorely had he been shaken.

When at last Agnolo had regained his breath, he said: "My wife, I went with a company to Peretola,[3] and it was agreed that each one should tilt; and I, that I might not be behind the others, and remembering my past days at Cerretomaggio,[4] desired to tilt also. And if the horse, which was restive and knocked me about as thou seest, had been a good horse, I should have obtained the greatest honor that any man could have, who hath not carried a lance this many years past."

The woman, who had much wisdom and was well acquainted with the follies of Agnolo, replied: "Hast thou, then, lost thy wits altogether, thou naughty old man! Cursed be the day when I was given unto thee for wife, for I wear out my arms working for thy children, whilst thou, a wicked old thing seventy years old, goest to the tilting. And what couldst thou do there, for of a surety thou weighest not ten ounces! And if thou art called Ser Benghi, art thou then a notary? Thou silly man, knowest thou not who thou art? And even if thou wert notary, how many notaries has thou ever seen at the tilting? Hast thou lost thy memory? Dost thou not remember that thou art but a woolworker and hast nothing save that which thou dost earn? Art thou mad? There now, lie down again, you poor thing! Of a certainty the children will run after thee in future and fling stones at thee!"

Then, in a faint voice, Agnolo said:

"Oh, wife! thou dost bid me lie down again; truly am I sorrowful that I am compelled to go to bed at all. But now I pray thee that thou hold thy tongue, if thou desirest not that I die outright."

She replied, "It were better for thee to die than to live so greatly shamed!"

Said Agnolo: "And am I the first who hath met with misfortune in deeds of arms?"

2. Reprinted, by permission of the publisher, from *Tales from Sacchetti*, trans. by Mary Steegman (London: J. M. Dent, 1908), pp. 44–45. Copyright by J. M. Dent.

3. A suburb of Florence.

4. A region near Florence.

"Now a plague on thee!" said his wife. "Go thou and beat wool as thou art wont to do, and leave arms to those who know how to use them!"

And the quarrel continued until it was night, and only then did they make peace together.

Agnolo never tilted again.

This woman was much wiser than her husband, for she knew her own condition in life and that of her husband, and he did not even know himself until his wife told him so much that was profitable for him to hear.

6. Fra Angelico, *Annunciation*, c. 1440–50
Gardner, p. 607, ill. 16:36; Janson, p. 465, ill. 606

Aeneas Silvius Piccolomini (Pius II), *The Tale of Two Lovers:* "Lucretia's Beauty" and "Is All This Pleasure True?" 1444

Italian Renaissance literature of the fifteenth century combined contemporary preferences for romantic subjects with the classical ideals of eloquence and style. In the late thirteenth and early fourteenth centuries, three authors, Dante, Petrarch, and Boccaccio, had established the Italian language as a legitimate medium for serious literature. In the fifteenth century, however, Latin was unmistakably reestablished as the language of literature, taste, and refinement. The typical writers of this age shared in the enthusiastic and scholarly study of classical literature, in the undertaking of extensive philological and editorial labors on classical texts, and in the writing of Latin works of their own in classicizing form and style. Elegance in Latin became the quality most admired in all written and oral expression. Among professors, princes, and popes, eloquent Latin was prized as a valuable asset for securing personal advancement, for swaying popular opinion, and for ensuring a favorable public reputation.

One of the most polished Latinists of his generation was Pope Pius II. Aeneas Silvius Piccolomini (lived 1405–1464; pope 1458–64), later known as Pius II, was born near Siena. A highly talented and unscrupulously ambitious young man, Piccolomini went to Florence, where he studied Latin rhetoric. Piccolomini's rise to prominence in the church was due in large degree to his mastery of Latin rhetorical style.

In his early years, Piccolomini indulged his love of Latin by composing a variety of literary inventions, including love poems, a witty immoral comedy called the *Chrisis,* and a society romance entitled *The Tale of Two Lovers.* The last of these, written in 1444, gained wide circulation, not only in its original Latin version but also in Italian, French, German, and English. The story is loosely based upon a love affair enjoyed by Piccolomini's friend Gaspar Schlick, the German chancellor of Vienna. Set in Siena, the romance describes the illicit passion shared by Euryalus, a handsome

member of the imperial German court, and Lucretia, the beautiful wife of the wealthy but undeserving Menelaus. In the tale, Euryalus' amorous pursuit of Lucretia is met first with indignant refusals and then by passionate surrender. The ardor of the lovers' secret meetings is fanned by the hazards posed by Lucretia's increasingly suspicious husband. The affair is finally resolved by Euryalus' decision to leave Siena with the German emperor and by Lucretia's subsequent decision to abandon her home and husband and to enter a convent.

Two selections from *The Tale of Two Lovers* are presented here. The first selection, "Lucretia's Beauty," describes the Italian ideal of female beauty. The second selection, "Is All This Pleasure True?" describes a trick arranged by Euryalus on Menelaus to tryst with Lucretia. Euryalus has lent Menelaus his horse so that the husband can visit his country estates. As Euryalus sets out to visit Lucretia, he boasts to himself, "You will mount my horse, Menelaus, but I will mount your wife."[1]

The ideal of beauty cherished by Piccolomini also appears in the paintings of the Florentine artist Fra Angelico (1387–1455). For Fra Angelico, however, beauty provided spiritual rather than physical fulfillment. Still, the elegance and delicacy of Fra Angelico's *Annunciation* (c. 1440–50) leads the viewer to contemplate the beauty of the Virgin Mary, transformed by faith, in the same way that Piccolomini's eloquent and detailed prose allows the reader to fully comprehend and appreciate Lucretia's beauty.

Aeneas Silvius Piccolomini (Pius II), *The Tale of Two Lovers*[2]
Lucretia's Beauty

And chief among [the Sienese women] shone the beauty of Lucretia. Above them all, shone the beauty of Lucretia. A young girl, barely twenty years of age, she came of the house of the Camilli, and was wife to Menelaus, a wealthy man, but quite unworthy that such a treasure should look after his home; deserving rather that his wife should deceive him or, as we say, give him horns.[3]

This lady was taller than the others. Her hair was long, the colour of beaten gold, and she wore it not hanging down her back, as maidens do, but bound up with gold and precious stones. Her lofty forehead, of good proportions, was without a wrinkle, and her arched eyebrows were dark and slender, with a due space between. Such was the splendour of her eyes that, like the sun, they dazzled all who looked on them; with such eyes she could kill whom she chose and when she would, restore the dead to life. Her nose was straight

1. Aeneas Silvius Piccolomini (Pius II), *The Tale of Two Lovers,* trans. by Flora Grierson (London: Constable, 1929), p. 112. Copyright by Constable and Co.
2. Reprinted, by permission of the publisher, from Aeneas Silvius Piccolomini (Pius II), *The Tale of Two Lovers,* trans. by Flora Grierson (London: Constable, 1929), pp. 2–4. Copyright by Constable and Co.
3. A phrase indicating that the wife has committed adultery and that her husband is unsuspecting.

in contour, evenly dividing her rosy cheeks, while nothing could be sweeter, nothing more pleasant to see than those cheeks which, when she laughed, broke in a little dimple on either side. And all who saw those dimples longed to kiss them. A small and well-shaped mouth, coral lips made to be bitten, straight little teeth, that shone like crystal, and between them running to and fro, a tremulous tongue that uttered not speech, but sweetest harmonies. And how can I describe the beauty of her mind, the whiteness of her breast?

Aeneas Silvius Piccolomini (Pius II), *The Tale of Two Lovers*[4]
Is All This Pleasure True?

Speaking together thus, they went into her room, where they passed such a night as, I imagine, the two lovers spent, when Paris had carried off Helen in his tall ship;[5] so sweet a night that both said Mars and Venus could not have been better together.[6]

"You are my Ganymede,[7] my Hippolytus,[8] my Diomedes,"[9] said Lucretia.

"And you my Polyxena,"[10] he replied, "my Aemilia,[11] Venus herself." And now he praised her mouth, now her cheeks, and now her eyes. And sometimes, raising the blanket, he gazed at those secret parts he had not seen before, and cried:

"I find more than I had expected. Thus must Diana have appeared to Actaeon when she bathed in the spring.[12] Could anything be lovelier or whiter than your body? Now I am rewarded for all perils. What would I not suffer

4. Reprinted, by permission of the publisher, from Aeneas Silvius Piccolomini (Pius II), *The Tale of Two Lovers,* trans. by Flora Grierson (London: Constable, 1929), pp. 120–21. Copyright by Constable and Co.

5. In Greek legend, lovers whose affair began the Trojan War. Paris, a prince of Troy, won the love of Helen and, with the help of the goddess Aphrodite, abducted her from Greece. Helen's husband, King Menelaus of Sparta, led the Greek armies to Troy to recover his wife. Paris died in the war.

6. In Roman mythology, Mars was the god of war and Venus the goddess of love. Although Venus was married to Vulcan, the god of fire, she preferred Mars, by whom she conceived her son, Cupid.

7. In Greek mythology, the son of Tros, the king of Troy. Zeus, attracted by his unusual beauty, sent an eagle to bring Ganymede to Olympus. There he became the gods' cupbearer.

8. In Greek mythology, the son of Theseus and Antiope. After the death of Antiope, Theseus married Phaedra. When Phaedra fell in love with her stepson, Hipplytus rejected her advances. To punish him, Phaedra wrongfully accused Hippolytus of raping her. Theseus drove Hippolytus to his death.

9. In Greek mythology, a king of Argus who had wooed Helen. Although his suit was rejected, he had vowed to protect whomever she should choose to marry. In fulfillment of his oath, he rallied to Menelaus, Helen's husband, when Helen was carried off by Paris.

10. In Greek mythology, a princess of Troy. After the death of the Greek warrior Achilles, Polyxena was claimed by his ghost and was sacrificed at his tomb.

11. A vestal virgin of Rome who was put to death for conducting a love affair with a member of her family.

12. In Roman religion, Diana was honored as the virgin goddess and as goddess of the moon, forests, animals and women in childbirth. Because Actaeon saw Diana bathing naked, she changed him into a stag, and his own dogs killed him.

for your sake? Oh lovely bosom, most glorious breasts! Can it be that I touch you, possess you, hold you in my hands? Smooth limbs, sweet-scented body, are you really mine? Now it were well to die, with such a joy still fresh, before any misfortune could befall.

"My darling, do I hold you, or is it a dream? Is all this pleasure true, or am I mad to think so? No, it is no dream, it is the very truth. Dear kisses, soft embraces, bites sweet as honey! No one was ever happier than I, no one more fortunate!"

7. Piero della Francesca, *The Proving of the True Cross*, San Francesco, Arezzo, c. 1455
Janson, p. 467, ill. 609

Nicholas of Cusa, *On Learned Ignorance:* "Mathematics and the Apprehension of Divine Truth," 1440

The revived study of Greek and Roman philosophy led, in the Renaissance, to a renewed interest in mathematics. Greek thinkers had proposed that the universe was rationally ordered and that all natural phenomena followed a precise and unvarying plan. They had further posited that the mind is the supreme power and, therefore, that the pattern of nature can be rendered intelligible by the application of human reason to the problems of the universe. The Greek philosopher and mathematician Pythagoras (fl. c. 530 B.C.) and his followers were impressed by the fact that phenomena that are physically diverse exhibit identical mathematical properties. The moon and a child's ball share the same shape and all other properties common to spheres. Similarly, a trash can and a cask for fine wine can have the same volume. It therefore seemed evident to the Pythagoreans that the universe is ordered by perfect mathematical laws and that divine reason is the organizer of nature.

The Pythagorean belief that the reality and intelligibility of the physical world could be comprehended only through mathematics was shared by two later Greek philosophers, Plato (c. 427–348 B.C.) and Aristotle (384–322 B.C.). Plato sought not only to understand nature through mathematics but also to transcend nature in order to comprehend the ideal, mathematically organized world that he believed to be the true reality. For Plato, the sensible, the impermanent, and the imperfect were to be replaced by the abstract, eternal, and perfect.

Impressed by the Greek mathematical view of nature, Renaissance artists, scholars, and theologians turned to mathematics as a means of expressing the properties and presence of God in the universe. Renaissance artists developed schemes of mathematical perspective as ways to define three-dimensional space on a two-dimensional surface. Their interest in perspective, however, derived not merely from a wish to

reproduce visual phenomena in naturalistic terms but, more fundamentally, from a desire to penetrate the surface of reality and to understand its underlying truths. Thoroughly imbued with the doctrine that mathematics is the essence of the real world, Renaissance artists viewed the universe as rationally ordered and as geometrically explicable. Hence, like Greek philosophers, they believed that to penetrate to the underlying significance of the visual subject, they had to reorder appearance in terms of mathematical relationships.

One of the best mathematicians of the fifteenth century was the Italian painter Piero della Francesca (c. 1420–1492). During the same years that he gained fame as an artist, he wrote three treatises to show how the visible world could be reduced to mathematical order by the principles of perspective and solid geometry. In his writings, he comes close to identifying painting with perspective. In his art, such as the mural *The Proving of the True Cross* (c. 1455), he united the mathematical structure of perspective with a contemplative religious spirit.

The importance of mathematics is also evident in Renaissance philosophical and theological writing, such as that of Nicholas of Cusa (1401–1464). Born in Germany, Nicholas had attended universities at Heidelberg, Padua, and Rome, and had studied art, philosophy, law, the sciences, theology, and mathematics. Consecrated as bishop of the Italian diocese of Brixen, Nicholas became a leading church intellectual.

The importance of mathematics to Renaissance thought is demonstrated by Nicholas's text *On Learned Ignorance* (1440). *On Learned Ignorance* draws upon Neoplatonic Christian thought—that is, the system of ideas that had been propounded by Plato and that had been revised by medieval church theologians. In this work, Nicholas begins with the Neoplatonic concept of God as an absolute and as an infinite unity. Because human thought is finite, humankind is separated from God by a vast chasm. But Nicholas argues that geometric symbols—particularly the triangle, circle, and sphere—are means of bridging the distance. A selection from *On Learned Ignorance,* "Mathematics and the Apprehension of Divine Truth," is presented here.

Nicholas of Cusa, *On Learned Ignorance*[1]
Mathematics and the Apprehension of Divine Truth

All our wisest and most divine teachers agree that visible things are truly images of invisible things and that from created things the Creator can be knowably seen as in a mirror and a symbolism. . . . Proceeding on [the] pathway of [Pythagoras, the Platonists, and Aristotle], I concur with them and say that since the pathway for approaching divine matters is opened to us only through symbols, we can make quite suitable use of mathematical signs because of their incorruptible certainty. . . . But since from the preced-

1. Reprinted, by permission of the publisher, from Jasper Hopkins, *Nicholas of Cusa on Learned Ignorance: A Translation and an Appraisal of De Docta Ignorantia* (Minneapolis: Arthur J. Banning Press, 1981), pp. 61, 62–63, 64, 66–67, 68–69, 72–73. Copyright by The Arthur J. Banning Press.

ing [points] it is evident that the unqualifiedly Maximum[2] cannot be any of the things which we either know or conceive: when we set out to investigate the Maximum symbolically, we must leap beyond simple likeness. For since all mathematicals are finite and otherwise could not even be imagined: if we want to use finite things as a way for ascending to the unqualified Maximum, we must first consider finite mathematical figures together with their characteristics and relations. Next, [we must] apply these relations, in a transformed way, to corresponding infinite mathematical figures. Thirdly, [we must] thereafter in a still more highly transformed way, apply the relations of these infinite figures to the simple Infinite, which is altogether independent even of all figure. At this point our ignorance will be taught incomprehensibly how we are to think more correctly and truly about the Most High as we grope by means of a symbolism.

Operating in this way, then, and beginning under the guidance of the maximum Truth, I affirm what the holy men and the most exalted intellects who applied themselves to figures have stated in various ways. The most devoted Anselm[3] compared the maximum Truth to infinite rectitude. (Let me, following him, have recourse to the figure of rectitude, which I picture as a straight line.) Others who are very talented compared, to the superblessed Trinity, a triangle consisting of three equal right angles. Since, necessarily, such a triangle has infinite sides, as will be shown, it can be called an infinite triangle. (These men I will also follow.) Others who have attempted to befigure infinite oneness have spoken of God as an infinite circle. But those who considered the most actual existence of God affirmed that He is an infinite sphere, as it were. I will show that all of these [men] have rightly conceived of the Maximum and that the opinion of them all is a single opinion. . . . I maintain, therefore, that if there were an infinite line, it would be a straight line, a triangle, a circle, and a sphere. And likewise if there were an infinite sphere, it would be a circle, a triangle, and a line. And the same thing must be said about an infinite triangle and an infinite circle. . . .

Secondly, I said that an infinite line is a maximum triangle, a maximum circle, and a [maximum] sphere. . . . Now that we have seen how it is that an infinite line is actually and infinitely all that which is in the possibility of a finite line, we likewise have a symbolism for seeing how it is that, in the case

2. A mathematical term for God. Nicholas uses other terms as well, including Infinite, Most High, Truth, Absolute Simplicity, Essence, Triune, and Unitriune.
3. Lived c. 1033–1109 and served as archbishop of Canterbury between 1093 and 1109. One of the most respected scholastic philosophers, Anselm sought to establish the existence of God by reason. Anselm argued that God must necessarily exist because He is perfect and it is more perfect to exist than not.

of the simple Maximum, this Maximum is actually and maximally all that which is in the possibility of Absolute Simplicity. . . . It follows, then, that an infinite line is the essence of a finite line. Similarly, the unqualifiedly Maximum is the Essence of all things. . . . Furthermore: Just as an infinite line, which is the essence of a finite line, is indivisible and hence immutable and eternal, so also the Essence of all things, viz., Blessed God, is eternal and immutable. . . .

Furthermore, a maximum line is just as much a triangle, a circle, and a sphere as it is a line; it is truly and incompositely all these, as was shown. Similarly, the unqualifiedly Maximum can be likened to the linear maximum, which we can call essence; it can be likened to the triangular maximum and can be called trinity; it can be likened to the circular maximum and can be called oneness; it can be likened to the spherical maximum and can be called actual existence. Therefore, the Maximum is actually one trine essence, although it is most true that the Maximum is these identically and most simply; the essence is not other than the trinity; and the trinity is not other than the oneness; and the actuality is not other than the oneness, the trinity, or the essence. Therefore, just as it is true that the Maximum exists and is one, so it is true that it is three in a way in which the truth of the trinity does not contradict the most simple oneness but is the oneness. . . . Therefore, join together antecedently, as I said, these things which seem to be opposites, and you will have not one thing and three things, or three things and one thing, but the Triune, or Unitrine.[4] And this is Absolute Truth.

8. Leon Battista Alberti, Palazzo Rucellai, Florence, 1446–51
Gardner, p. 609, ill. 16:38; Janson, p. 469, ill. 613

Leon Battista Alberti, *On the Family: "Virtù Has Its Own Reward"* and "Conditions of Marriage," 1441

Virtù was defined in the Renaissance as the personal ability of individuals to determine their own destinies through the exercise of reason. The concept of *virtù* was fundamental in Florentine humanists of the fifteenth century. During the struggle between Florence and Milan, Florentine leaders had viewed the contest as a struggle not only between freedom and tyranny but also between *virtù* and fortune. After the victory of their city-state, Florentine leaders exhorted the citizenry to be guided by

4. Three in one, constituting a trinity in unity.

virtù in order to chart the best course in both their personal and public lives and to overcome the chance occurrences of nature and the malevolent designs of others.

The intense interest of the humanists in the individual and society is manifested in numerous treatises that examine all facets of human life. One such treatise is *On the Family* (1441), written by Leon Battista Alberti (1404–1472). Alberti, the illegitimate son of a wealthy Florentine merchant, had studied law, mathematics, literature, and philosophy at the University of Bologna. A prolific author, Alberti wrote many books and pamphlets on widely diverse subjects. In *On the Family*, Alberti covers many topics, including the importance of the family for the cultivation of liberty. For Alberti, as for other humanists, *virtù* was an active rather than a static quality. It was not a possession that an individual can acquire once and for all. Instead it was a quality that had to be instilled in the individual from birth by careful and loving education from parents and that had to be maintained throughout adult life by constant struggle. The father was regarded as the chief agent in the child's education in *virtù*, which ideally provided the opportunity for full development of the child's intellectual, moral, civic, and physical capacities. The education of children was supposed to aim at the formation of individuals as citizens who would place themselves in the service of the collective good of the family and the state. Moreover, an education in *virtù* was intended to make individuals conscious of their humanity and, therefore, it was based upon the study of the classical tradition.

In *On the Family*, Alberti also discusses the criteria by which a man should choose his wife, and he describes the benefits of a happy marriage. In Florence, as in other Italian cities, the nuclear family, consisting of parents and children, averaged four persons. This was due largely to the late age at which men married. In Florence most men delayed marriage until their early thirties because of economic pressures, such as the need to establish a profession and the need to acquire a patrimony. In contrast, the common age for women to marry was fifteen. Late marriages for men limited the duration of the marital union, while high infant mortality rates further limited the number of children. The extended family, however, was large. Welded into a single economic and political unit, each member of the family was responsible for the welfare of all the other members. Two selections, *"Virtù Has Its Own Reward"* and "Conditions of Marriage," are presented here.

After many years of studying architectural monuments in Rome and elsewhere, Alberti finally began to practice as an architect in 1444. Five years after he had written *On the Family*, Alberti was commissioned to design the family residence for the Rucellai, a wealthy Florentine mercantile family. The luxury and comfort of the Palazzo Rucellai (1446–51) reveals Alberti's rejection of the medieval ideal of the life of solitude and withdrawal, asceticism and contemplation. It also reveals Alberti's exaltation of the humanistic ideal of the life of *virtù*, a life that actively involved the individual in marriage, family life, and civic life, and that was rewarded not only by spiritual gifts but also by worldly goods.

Leon Battista Alberti, *On the Family*[1]
Virtù *Has Its Own Reward*

Lorenzo: My dear children, *virtù* has its own great reward: it makes itself praised perforce. See how they value you and how great they believe you will be. It will redound to your honor if you strive with all your deeds and skill to live up to their hopes. When *virtù* is praised, it is strengthened in those with good intellect. . . . A father's duties do not consist solely in filling the granary and the cradle, as they say. The head of a family must be vigilant and observant above all. He must know all the family's acquaintances, examine all customs both within and without the house, and correct and mend the evil ways of any member of the family with words of reason rather than anger. He must use a father's authority rather than despotism, and counsel where it is of more value than commanding. He must be severe, firm, and stern when necessary, and he must always keep in mind the well-being, peace, and tranquillity of his entire family as the ultimate purpose of all his effort and counsels for the guidance of the family in virtù and honor. . . . He must strengthen the spirit of the young and prevent them from giving in to the blows of Fortune or remaining prostrate. He must never allow them to attempt any foolhardy or mad enterprise to avenge themselves or to carry out a youthful and unwise plan. He must not allow them to abandon the rudder of reason and the ways of wisdom when Fortune seems benign or neutral, and more so in stormy weather. He must foresee and prepare himself for the fog of envy, the clouds of hatred, and the thunderbolts of enmity on the part of his fellow citizens. . . .

Envy disappears if one shows modesty rather than pomp; hatred is lessened if one is affable rather than haughty; enmity disappears if one arms himself with gentleness and charm rather than scorn and anger. The family elders must keep their eyes and minds open and give great thought to all these matters. They must be ready to foresee and learn everything. They must strive with great care and diligence to make the young members of the family always more honest, virtuous, and pleasing to our fellow citizens.

Let fathers know that virtuous children give much happiness and comfort to their father at any age and that the children's *virtù* depends on the father's solicitude. Sloth and inertia make a family uncouth and undignified; solicitous fathers render it noble and graceful. Greedy, lustful, unjust, and haughty men burden the family with infamy, misfortune, and wretchedness.

1. Reprinted, by permission of the publisher, from *The Albertis of Florence: Leon Battista Alberti's "Della famiglia,"* trans. and with an introduction and notes by Guido A. Guarino (Lewisburg, Pa.: Bucknell University Press, 1971), pp. 41–44, 48–49. Copyright by Associated University Presses.

Let good men know that no matter how gentle, continent, and refined they themselves may be, unless they are solicitous, diligent, and farsighted, and take steps to guide and mend the ways of the youths of the family, they too will go down to ruin if any part of the family succumbs. . . .

I am one of those who would rather bequeath their children *virtù* than all the wealth in the world. . . . Be brave and courageous, for adversity is the proving ground of *virtù*. Is there any man who can gain as much praise and fame for his brave spirit, firm will, great intellect, zeal, and skill in favorable and peaceful circumstances, as he can in difficult times and adversity? So conquer Fortune with patience. Overcome men's iniquity by persevering in *virtù*. Adapt yourselves to the times and to necessity with wisdom and prudence. Conform to the usages and customs of men of modesty, good breeding, and discretion. Above all, strive with all your intelligence, skill, zeal, and deeds first to be virtuous, then to appear so. Let nothing be dearer to you, do not desire anything before *virtù*. You shall first determine that wisdom and knowledge are to be preferred to everything else, and then you will see that the favors of Fortune are of little value. Only honor and fame will have first place in your desires, and you will never prefer wealth to praise. To gain honor and esteem, you will never think of avoiding any undertaking, no matter how arduous and strenuous, and you will persevere in it. You will be satisfied to expect from your labors nothing more than gratitude and renown. Do not doubt, however, that the virtuous will enjoy the fruits of their labors sooner or later. Do not lose confidence and fail to persevere assiduously in the study of excellent arts and rare and praiseworthy matters. Do not fail to learn and retain good doctrines and disciplines, for late payments often include a large interest.

Leon Battista Alberti, *On the Family*[2]
Conditions of Marriage

We can name four general precepts as the firm foundation from which all the others arise: the large number of men in the family must not diminish, but multiply; wealth must not dwindle, but grow; every infamy must be avoided, while fame and reputation must be loved and sought; hatred, enmity, and envy must be avoided, while acquaintances, goodwill, and friendships must be acquired, increased, and maintained. . . .

A family becomes numerous in the same way as cities, provinces, and the

2. Reprinted, by permission of the publisher, from *The Albertis of Florence: Leon Battista Alberti's "Della famiglia,"* trans. and with an introduction and notes by Guido A. Guarino (Lewisburg, Pa.: Bucknell University Press, 1971), pp. 116–18, 121–22. Copyright by Associated University Presses.

whole world have become populous, as everyone can see for himself if he but consider how men grew from a very few to an almost infinite number through begetting and raising children. And no one can doubt that woman was necessary to man for the sake of procreation. After a child had come into this world weak and helpless, it was necessary for him to have someone who would hold him dear and faithfully care for him, someone who would nourish him and protect him from harm with diligence and love. These early few found the excessive cold and heat, torrential rains, and furious winds harmful; therefore, they first found a roof beneath which they could nourish and shelter themselves and their young children. Here, then, beneath this roof, the woman remained and busied herself in nourishing and caring for the child. It was not suitable for the woman to seek what was needed for maintaining herself and her family, since she was occupied in caring for the child. . . .

Nature, excellent and divine teacher of all things, instituted marriage with the following conditions: man shall have a steadfast companion in life, one only, with whom he shall share a home; he shall never abandon her in thought or deed but shall always return and furnish what is useful and necessary for the family; the woman shall preserve what the man brings home. We must, therefore, act in accordance with Nature's dictates and choose a woman with whom we shall share our life beneath the same roof. . . .

It would take long to speak of all the old opinions on the proper age for marriage. . . . Everyone agrees that it is harmful to let ardent youths marry before they are twenty-five, thus dissipating the ardor of an age which is better spent to establish and strengthen oneself than to bring others to life. . . . Once the young men have been persuaded through the efforts and advice of all the elders of the family, the mothers and other old relatives and friends, who know the customs and behavior of almost all the girls of the city from the time they were born, must select all the well-born and properly raised girls and propose their names to the youth who is to be married. The latter will choose the one he prefers. . . . One who wishes to marry must be even more diligent. My advice to him is to show forethought and, over a period of time and in various ways, learn what kind of woman his intended bride is, for he will be her husband and companion for the rest of his life. In his mind he must have two reasons for marrying: the first is to beget children, the other, to have a faithful and steadfast companion throughout his life. We, must, therefore, seek a woman suited to childbearing and pleasant enough to be our constant companion.

For this reason, then, they say that in a wife we must seek beauty, family, and wealth. . . . I believe that beauty in a woman can be judged not only in

the charms and refinement of the face, but even more in the strength and shapeliness of a body apt to carry and give birth to many beautiful children. The first prerequisite of beauty in a woman is good habits. It is possible for a foolish, ignorant, slovenly, and drunken woman to have a beautiful body, but no one will deem her to be a beautiful wife. The most important habits praised in a woman are modesty and cleanliness. . . . Nothing can be found so completely disgusting as a slovenly, dirty woman. What fool can doubt that a woman who does not take pleasure in appearing neat and clean, not only in her clothing and body but in all her actions and words, is not to be deemed well-bred? Is there anyone who does not know that an ill-bred woman is seldom honest? . . . In a wife, therefore, we must first seek beauty of spirit, that is, virtues and good habits. As for physical beauty, we should not only take pleasure in comeliness, charm, and elegance, but should try to have in our house a wife well-built for bearing children and strong of body to insure that they will be born strong and robust. An ancient proverb states: "As you want your children, so choose their mother."

9. Andrea del Verrocchio, *Bartolommeo Colleoni*, 1483–88
Gardner, p. 617, ill. 16:53; Janson, p. 478, ill. 629

Matteo Maria Boiardo, *Orlando innamorato:* "The Combat of Orlando and the Giant," c. 1482

The fifteenth century in Italy witnessed the emergence of humanism; it also constituted the heroic age of the Italian condottiere, or mercenary soldier. The condottiere system represented the development of professional schools of soldiery that were employed by Italian city-states in times of war. As the native profession of arms developed, all classes and all parts of Italy contributed to its ranks. Members of the lesser feudal nobility and younger sons of great houses made up the larger proportion of the condottieri. Also among them were peasants, lords, and even churchmen.

The Italian soldier of fortune brought to his profession a highly motivated study of the methods of war, a high degree of technical skills, and a boundless enthusiasm. Moreover, the condottiere regarded warfare as an opportunity to exercise his individual *virtù*.[1] He sought to demonstrate his ability to shape events rather than be shaped by external circumstances. However, the concept of *virtù*, which encouraged the condottiere to dedicate himself to the practice of warfare to his utmost level of individual skill and sagacity, also caused his downfall. At the end of the fifteenth

1. In the Renaissance, *virtù* was a term distinguished from simple "virtue." *Virtù* implies inherent qualities, including leadership, energy, and even recklessness.

century, the movements of the infantry and the use of firearms as employed by foreign armies became more crucial on the battlefield than the exploits of individuals, which were central to the condottiere's concept of *virtù*. Because the condottieri resisted these changes, the Italian armies crumbled with the French and Spanish invasions.

Two well-known condottieri of the fifteenth century were Bartolommeo Colleoni (1400–1475) and Ercole I d' Este (1431–1505). Colleoni fought in the fifteenth-century wars between Venice and Milan. Changing sides often, Colleoni earned the distrust of many Italian city-states. In 1454 he deserted Milan for the last time and became military commander of Venice, until the end of his life. Colleoni is commemorated in Venice by a life-size bronze equestrian statue (1483–88) by Andrea del Verrocchio (1435–1488).

Less successful as a condottiere was Ercole I d'Este. Ercole came from a princely Italian family that ruled Ferrara, in northern Italy, from the thirteenth to the sixteenth century. He inherited the duchy at a time when famines, floods, and an outbreak of plague had impoverished Ferrara. In 1478 Ercole accepted an offer to be commander of the Florentine troops in a war fought by Florence and Milan against Naples and the papacy. His performance as a condottiere was less than brilliant, and Naples and Pope Sixtus IV emerged victorious. A brief respite of two years was followed in 1482 by another war, in which Ferrara was pitted against Venice and the papacy. By the conclusion of this war, in 1484, Ferrara had been forced to yield an important part of her territory to the Venetians. The resultant defeat and humiliation caused Ercole to renounce war and to put his trust in diplomacy rather than combat.

But though he was mediocre as a condottiere, Ercole was distinguished in the arts. He was a great patron of poets, humanists, and scholars. His court was aristocratic in its customs and cultures; in its most typical moments it was a courtly and courteous group of knightly gentlemen and cultivated ladies.

Among the poets whom Ercole patronized was Matteo Maria Boiardo (1441–1494). Boiardo's epic *Orlando innamorato* is considered the finest Italian poem of its day. Boiardo took up residence in Ferrara in 1476 as a highly honored member of the court. His poem combines concepts of medieval chivalry of love and war with qualities of the condottiere code. The hero is Orlando, or Roland, a legendary knight of Charlemagne's court; this hero, however, is both a fighting paladin and a tormented lover. The object of his love is Angelica, daughter of the king of Cathay. Angelica, an enchantress, drinks the water of a magical stream, which causes her to love Orlando's rival, Ranaldo. Orlando's subsequent pursuit of his beloved leads him into a series of fantastic adventures. Forest flights, marvelous gardens, the storming of castles, the vanquishing of armies, rescues of maidens in distress, imprisonments, and escapes follow one another in swift succession. The glorification of personal honor in physical combat—a quality embedded in the condottiere code—surfaces repeatedly. One episode in which this quality is extolled is Orlando's duel with the giant Zambardo. A selection from *Orlando innamorato*, "The Combat of Orlando and the Giant," is presented here.

Matteo Maria Boiardo, *Orlando innamorato*[2]
The Combat of Orlando and the Giant

Lords, listen now to this great duel;
No other ever was so foul.
You heard before the force and mass
That fearsome beast Zambardo had.
And now you'll hear how fiercely he
Was fought, and what misfortune cursed
Orlando, who's a senator:
No plight was, and none will be, worse.

The daring knight climbs on the bridge;
Zambardo grips his mace in hand.
The Count comes half-way up his thigh
But with great leaps he leaves the earth,
So—often—he confronts his face.
Look here! The giant swings his club:
Orlando sees it drop, and with
One leap he lands clear of its path.

That faithless Saracen's[3] disturbed,
but Count Orlando stirs him more
Because he hit his arm so hard
He made him drop his mace to earth.
Then suddenly, he seemed a bird
As he redoubled his next blow.
So hard, though, is that serpent skin
His strokes have slight effect or none.

Zambardo'd drawn his scimitar[4]
After his mace was knocked to earth.
He saw this was a baron bold,
And he decides to use his net
But waits before employing it.
Back-hand he swings, his sword reversed,

2. Reprinted, by permission of the publishers, from Matteo Maria Boiardo, *Orlando innamorato,* trans. and ed. by Charles Stanley Ross (Berkeley: University of California Press, 1989), p. 105, canto Vi, stanzas 1–6. Copyright by the Regents of the University of California Press.
3. A term commonly used in the Middle Ages to designate the Arabs and, by extension, the Muslims in general.
4. A short, curved sword with an edge on the convex side—generally used by Arabs or Turks.

And strikes Orlando's cheek-guard hard,
Which sends him twenty steps aside.

This beating heats Orlando up;
His face begins to spark and flame,
And both his eyeballs roll, amazed.
The giant can't escape. The Count
Brings down his glinting sword so fast
That he made Durindana[5] bend,
And its width was, Turpino says,[6]
Four fingers from the hilt to tip.

Orlando strikes his hip and rends
His serpent scales and serpent skin,
And the sharp sword blade slices through
A belt he wore embossed with iron.
His hauberk[7] shields his stomach plate
But Durindana does not care
And would have cut it into halves—
Zambardo, though, had dropped to earth.

10. Antonio del Pollaiuolo, *Hercules and Antaeus*, c. 1475
Gardner, p. 618, ill. 16:54; Janson, p. 476, ill. 625

Giannozzo Manetti, *On the Dignity of Man:* "Live in the World Joyfully
and Zestfully," c. 1440–50

Renaissance philosophy augmented the confidence that Renaissance people were
developing in themselves and their society. The Florentine scholar Giannozzo
Manetti (1396–1459) wrote a eulogy on human worth, *The Dignity of Man* (c. 1440–
50), which is both persuasive and poetic. *The Dignity of Man* is based upon classical
Greek philosophy and, at the same time, is deeply Christian in conception. Manetti
offered his work as a response to the pessimistic prose of Pope Innocent III (lived c.

5. The name of Orlando's sword.
6. Boiardo initially achieved fame for his translations of classical literature. To avoid the appearance of being
an overly assiduous courtier, Boiardo attributed his poem, which includes fulsome praise of his patron,
Ercole I d'Este, to Turpin (or Turpine), an archbishop of Reims. He claims for himself the more modest
position of translator.
7. A piece of defensive armor, originally intended for shielding the neck and shoulders. In the late Middle
Ages it developed into a long coat of mail, or military tunic, which adapted readily to the motions of the
body.

1160–1216; pope 1198–1216). In a treatise called *On the Misery of Human Life,* Innocent had described humankind as "conceived in sin, . . . born to punishment, . . . [and] destined to become the fuel of the everlasting eternally painful hellfire; the food of voracious consuming worms, . . . a putrid mass that eternally emits a most horrible stench." He had argued that the human being was corrupted from birth because sexual intercourse itself was "infected . . . with the desire of the flesh, with the heat of lust, and with the foul stench of wantonness." Likewise, Innocent had argued that, because of the foul nature of conception itself, the human soul was "contaminated . . . [by] the infection of sin, the corruption of evil, the filth of iniquity." Formed of "slime," nourished in the womb on the "detestable and impure" substance of the mother's body, the human being is "evil, disgraceful and deceitful."[1]

In contrast to Innocent's characterization of the human being as the basest of the beasts, Manetti proclaimed the moral and intellectual capacities and the physical dignity of humankind. He praised the human body as revealing the beauty of the divine plan for creation. He exalted in the physical pleasures afforded to humankind. These pleasures, including eating, drinking, and sexual intercourse, were, for Manetti, evidence of God's generosity. Because of them, human life could be enjoyed as a state of almost continuous pleasure. And Manetti found the human soul to be lofty and sublime.

Throughout his essay, Manetti emphatically insisted on the overriding value of human activity. He found this value displayed in the performance of deeds of courage, in the writings of brilliant intellect, and in the creation of art of great beauty. These activities are possible, argued Manetti, because God endowed humankind with the splendid gift of freedom. Through the use of this gift in many labors, humankind shows itself worthy of freedom. And this freedom enables humankind to make all things created by God ever more beautiful and more perfect. A selection from *On the Dignity of Man,* "Live in the World Joyfully and Zestfully," is presented here.

The dignity in the human race that Manetti extolled was also portrayed in the arts by painters and sculptors. One such artist was Antonio del Pollaiuolo (active c. 1457, d. 1498). The splendor, agility, and perfectibility of the human body that Manetti argued will be fully realized by the risen persons at the Resurrection are displayed by Antonio del Pollaiuolo in his bronze sculpture of two classical Greek figures, *Hercules and Antaeus* (c. 1475). The beauty with which Pollaiuolo has endowed these nude figures validates Manetti's assertion of the worthiness of human individuals.

1. Innocent III (Lotario di Segni), *On the Misery of Human Life,* in *Two Views of Man,* trans. and with an introduction by Bernard Murchland (New York: Frederick Ungar, 1966), pp. 10, 12, 15. Copyright by Crossroad Publishing Co.

Giannozzo Manetti, *On the Dignity of Man*[2]
Live in the World Joyfully and Zestfully

We may succeed through our good works in always living in this world joyfully and zestfully and enjoying the divine Trinity from whom all the aforesaid benefits come to us afterwards in the future world. . . . We might venture to put forth the thought that we also enjoy various kinds of pleasure as well as afflictions in our ordinary and every day life. For there is no human action—wonderful to say—if we pay diligent and close attention to its nature, from which man does not draw at least some little pleasure. Nay, he at times takes such deep and intense pleasure from each and every one of his external senses—sight, hearing, taste, smell and touch—that other interests meanwhile appear superfluous, excessive and unnecessary. It would be hard, indeed impossible, to describe the intense pleasures that possess man: they derive partly from the untrammelled vision of beautiful bodies, partly from listening to sounds and symphonies and even more delightful things, partly from smelling the odors of flowers and such like, partly from tasting various sweet and succulent viands and, partly from the touch of the softest substances. . . .

Wherefore let us put an end to our work since we have in our first three books sufficient explanation, first, how great and wonderful is the dignity of the human body; secondly, how lofty and sublime the human soul, and finally, how great and illustrious is the excellence of man himself made up of these two parts.

11. Sandro Botticelli, *The Birth of Venus,* c. 1482
Gardner, p. 624, ill. 16:60; Janson, p. 483, ill. 635

Marsilio Ficino, *Commentary on Plato's Symposium on Love:* "The Two Venuses," 1484
Lorenzo de' Medici, "O Lucid Star," 1476

Venus, the Greco-Roman goddess of physical beauty and sensual love, was exalted in the Renaissance as the embodiment of ideal beauty and as the channel to spiritual love. Two men as apparently different as Marsilio Ficino (1433–1499) and Lorenzo de' Medici (1449–1492) shared the belief that a unity between spirit and beauty could be achieved through the admiration of Venus.

2. Reprinted, by permission of the publisher, from Giannozzo Manetti, *On the Dignity of Man,* in *Two Views of Man,* trans. and with an introduction by Bernard Murchland (New York: Frederick Ungar, 1966), pp. 75–77, 101–2. Copyright by Crossroad Publishing Co.

Under the patronage of Cosimo de' Medici, Ficino became the most influential exponent of Neoplatonism in fifteenth-century Italy. At Cosimo's urging, he translated many Greek texts, including Plato's dialogues, into Latin. Ficino prepared explanatory commentaries in which he interpreted Platonic thought by combining Christian doctrine with Greek and Roman ideals.

Ficino's Christian philosophy revolves around the fundamental theme of the relationship between the physical world of matter and the spiritual realm of God. For Ficino, these are not diametric opposites. Instead, they are polar extremes of a continuum of being. As Ficino conceived it, the cosmos consists of a hierarchy of being. The source of all being is God; in God all being is united in perfect harmony. This being extends from God to the physical world, which is a world of multiplicity, and of contradictory and false appearances. Every level of being has evolved from the level above it, in a descending emanation from God. Every level desires to rise to the level above it, in an ascending return to God.

The desire to return to one's source, according to Ficino, is called love. Ficino defines two kinds of love, heavenly love and earthly love, both of which are good. Heavenly love causes the individual to yearn to ascend to spiritual levels; earthly love causes the individual to yearn to procreate in the material world, and, in doing so, to nurture spiritual qualities in the physical love. The impulse of love is quickened by the presence of beauty, and beauty in the material world awakens the soul to the beauty of the spiritual world. The soul, triggered by its recognition of beauty and propelled by the desires of love, begins its ascent to God. Ficini presents his ideas on love most fully in his *Commentary on Plato's Symposium on Love* (1484). A selection, "The Two Venuses," is presented here.

The doctrine of Ficino was deeply ingrained in the thought of Lorenzo de' Medici. In 1469 Lorenzo, the grandson of Cosimo de' Medici, assumed control of Florence. Although he was primarily a statesman, Lorenzo was also a philosopher and a poet. Lorenzo respected Ficini so highly that he maintained a villa outside Florence as a comfortable setting for Ficino to live, to receive the intellectuals of his day, and to instruct them on Neoplatonic ideas. Lorenzo himself made regular visits to the villa to discuss philosophy with Ficino over elegantly served dinners. In his poetry, written in vernacular Italian rather than Latin, Lorenzo expresses his understanding of the interplay between the earthly and heavenly forms of love. This interplay was evoked for Lorenzo most strongly by his admiration for Simonetta Cattaneo. A young woman who was consumed by tuberculosis, Simonetta possessed an ethereal beauty that seemed to Lorenzo, his brother Giuliano, and others in the Medici circle to reflect spiritual perfection. The devotion caused by Simonetta's beauty was interpreted by her admirers as evidence of their ability to feel spiritual love for the Divine rather than as their wish to indulge in physical desires for a woman. Simonetta was cast in the role of Venus, whose beauty awakens the admirer's recognition of the divine beauty in the earthly realm. On the day of Simonetta's death, April 26, 1476, Lorenzo wrote the sonnet entitled "O Lucid Star." In this sonnet he describes Simonetta as a radiant goddess who sheds light on the mortal realm. The sonnet is presented here.

The exaltation of love and beauty appealed deeply to artists and writers of the Renaissance. The effect is evident in *The Birth of Venus* (c. 1482), an allegorical work by Sandro Botticelli (1445–1510). In his paintings, Botticelli exalts love as the power that draws the lover to God. He shows his indebtedness to Ficino's concept of two forms of love, spiritual and earthly, by celebrating the nude figure of Venus as an inspiration to spiritual love. He pays homage to Lorenzo de' Medici, his patron, by sharing his admiration for Simonetta Cattaneo and adopting her as the model for his depiction of Venus.

Marsilio Ficino, *Commentary on Plato's Symposium on Love*[1]
The Two Venuses

In order that we may include many things in a few words, the Good is certainly said to be that supereminent existence itself of God. Beauty is a certain act or ray from it penetrating through all things: first into the Angelic Mind, second into the Soul of the whole, and the other souls, third into Nature, fourth into the Matter of bodies. It adorns the Mind with the order of the Ideas. It fills the Soul with the series of the Reasons. It supports Nature with the Seeds. It ornaments Matter with the Forms. But just as a single ray of the sun lights up four bodies, fire, air, water, and earth, so a single ray of God illuminates the Mind, the Soul, Nature, and Matter. And just as anyone who sees the light in those four elements is looking at a ray of the sun itself and, through that ray is turned to looking at the supreme light of the sun, so anyone who looks at and loves the beauty in those four, Mind, Soul, Nature, and Body, is looking at and loving the splendor of God in them, and, through this splendor, God Himself.

Hence it happens that the passion of a lover is not extinguished by the sight or touch of any body. For he does not desire this or that body, but he admires, desires, and is amazed by the splendor of the celestial majesty shining through bodies. For this reason lovers do not know what they desire or seek, for they do not know God Himself, whose secret flavor infuses a certain very sweet perfume of Himself into His works. By which perfume we are certainly excited every day. The odor we certainly smell; the flavor we undoubtedly do not know. Since, therefore, attracted by the manifest perfume, we desire the hidden flavor, we rightly do not know what we are desiring and suffering.

Hence it also always happens that lovers fear and worship in some way the sight of the beloved. Let me even say, although I fear that some one of you will blush when you hear these things, that even brave and wise men, I

1. Reprinted, by permission of the publisher, from Marsilio Ficino, *Commentary on Plato's Symposium on Love,* trans. by Sears Jayne (Dallas: Spring, 1985), pp. 53–54. Copyright by Sears Jayne.

say, have been accustomed to suffer in the presence of the beloved, however inferior. Certainly it is not anything human which frightens them, which breaks them, which seizes them. For a human power is always stronger in braver and wiser men. But that splendor of divinity, shining in the beautiful like a statue of God, compels lovers to marvel, to be afraid, and to worship. . . .

[Plato] mentions two Venuses. . . . One Venus he certainly calls Heavenly, but the other Vulgar. That Heavenly Venus was born of Uranus,[2] without any mother. The Vulgar Venus was born of Jupiter[3] and Diane.[4]

The first Venus, which is in the Mind, is said to have been born of Uranus without a mother, because *mother,* to the physicists, is *matter.* But that Mind is a stranger to any association with corporeal matter. The second Venus, which is located in the World Soul, was born of Jupiter and Diane. "Born of Jupiter"—that is, of that faculty of the Soul itself which moves the heavenly things, since that faculty created the power which generates these lower things. They also attribute a mother to that second Venus, for this reason, that since she is infused into the Matter of the world, she is thought to have commerce with matter.

Finally, to speak briefly, Venus is twofold. One is certainly that intelligence which we have located in the Angelic Mind. The other is the power of procreation attributed to the World Soul. Each Venus has as her companion a love like herself. For the former Venus is entranced by an innate love for understanding the Beauty of god. The latter likewise is entranced by her love for procreating that same beauty in bodies. The former Venus first embraces the splendor of divinity in herself; then she transfers it to the second Venus. The latter Venus transfers sparks of that splendor into the Matter of the world. Because of the presence of these sparks, all of the bodies of the world seem beautiful according to the receptivity of their nature. The beauty of these bodies the human soul perceives through the eyes. The soul again possesses twin powers. It certainly has the power of understanding, and it has the power of procreation. These two powers are two Venuses in us, accompanied by twin loves. When the beauty of a human body first meets our eyes, our intellect, which is the first Venus in us, worships and esteems it as an image of the divine beauty, and through this is often aroused to that. But the power of procreation, the second Venus, desires to procreate a form like this. On both sides, therefore, there is a love: there a desire to contemplate beauty,

2. Uranus was the Greco-Roman personification of heaven.
3. Jupiter, the son of Uranus, supplanted Uranus as the god of the heavens and supreme ruler of the world.
4. Diane, the Roman goddess of the moon, was sometimes worshiped as an earth goddess and as the great mother of the gods.

here a desire to propagate it. Each love is virtuous and praiseworthy, for each follows a divine image. . . .

So, my friends, I encourage and entreat you to embrace love with all your strength, as a thing which is undoubtedly divine.

Lorenzo de' Medici, "O Lucid Star"[5]

O lucid star, that with transcendent light
 Quenchest of all those neighboring stars the gleam,
 Why thus beyond thine usage dost thou stream,
 Why art thou fain with Phoebus[6] still to fight?
Haply those beauteous eyes, which from our sight
 Death stole, who now doth vaunt himself supreme,
 Thou hast assumed: clad with their glorious beam,
 Well may'st thou claim the sun-god's chariot bright.
Listen, new star, new regent of the day,
 Who with unwonted radiance gilds our heaven,
 O listen, goddess, to the prayers we pray!
Let so much splendour from the sphere be riven[7]
 That to these eyes, which fain would weep alway,
 Unblinded, thy glad sight may yet be given!

12. Piero di Cosimo, *The Discovery of Honey*, 1498
Janson, p. 484, ill. 636

> Girolamo Savonarola, *The Compendium of Revelations:* "A Hand in Heaven," 1495
> Luca Landucci, *A Florentine Diary from 1450 to 1516:* "The Burning of Savonarola," 1498

Pagan gods were understood in several ways by the fifteenth-century Florentine humanists. Piero di Cosimo (1462–1521), a painter and a younger contemporary of Botticelli, depicted mythological scenes as celebrations of physical pleasures and sensual pursuits in which the gods' enjoyment is unclouded by pangs of guilt or qualms of conscience. One such depiction, *The Discovery of Honey,* was painted in

5. Reprinted, by permission of the publisher, from John Addington Symonds, *Renaissance in Italy* (New York: Charles Scribner's, 1935), vol. 2, p. 84. Copyright by Macmillan.
6. In Greek religion, Phoebus is a name for Apollo as the god of light and the sun.
7. Rent or split apart.

1498, the same year that the sternly moralistic voice of the famous preacher Girolamo Savonarola (1452–1498) was silenced by death.

Raised by prosperous parents in Ferrara, Savonarola became an avowed opponent of the humanist culture that had flourished in Florence under the aegis of the Medicis. After he entered the Dominican order, Savonarola was sent on preaching missions to many Italian cities, including Florence. During his first stay in the city, in 1482, Savonarola had little impact upon the city. But in successive years, he developed a fiery eloquence in preaching, a sincere faith in his gift of prophecy, and a burning belief in his mission to scourge the sins of the earth and to reform its people. The death of Lorenzo de' Medici (1449–1492) and the political ineffectualness of his son Piero de' Medici (1471–1503) opened the way for Savonarola to assume control of the Florentine government in 1494.

Savonarola's most powerful political tool was his preaching. Since the death of Lorenzo, Savonarola had preached with increasing vehemence that the church must be scourged, that society must be cleansed, and that the day of doom was imminent. Savonarola warned that God would inflict a terrible punishment upon Italy if the people did not repent their sins and live righteously. Convinced that the friar was an inspired prophet, the Florentine citizens turned to Savonarola to avert divine punishment.

Notwithstanding his political activities between 1494 and 1498, politics were for Savonarola subordinate to ethics. For him, holding power in government was not an end in itself but a means of moral purification. Savonarola inveighed against gambling and blasphemy; he denounced ostentatious styles of dress; he forbid rowdy carnivals and festivals, and in 1497 and again in 1498 he ordered the Florentine citizens to make a bonfire of those possessions that symbolized the vanities of worldly life. The flames of the so-called Burning of the Vanities consumed fine dress, fancy furniture, dice, obscene books, and lascivious pictures.

The new Florentine republic proved unable to resolve the growing political, financial, and economic crises of the city. Opposition to Savonarola mounted. His internal enemies were joined by a powerful opponent, Pope Alexander VI (lived c. 1431–1503; pope 1492–1503). In September 1495, Savonarola was suspended from preaching; he briefly obeyed the edict, but then disregarded it. In May 1497 Savonarola was excommunicated. In March 1498 he was challenged by his enemies in the Franciscan order to prove his godliness in public by submitting to an ordeal of fire. The city assembled to see if the prophet could walk through fire and emerge, through God's protection, unscathed. Savonarola and his challengers wrangled endlessly over the conditions of the ordeal until a thunderstorm drowned the flames. An enraged populace clamored for Savonarola's downfall. The friar was arrested and put under torture. Under repeated torments, he broke down and, at first, confessed that his prophecies had been self-serving lies. Soon, however, he regained his composure. Renouncing his confession under duress, he maintained his innocence until his execution as a heretic and schismatic in May 1498.

Selections from two documents relate to the life and death of Savonarola. The

first document, *The Compendium of Revelations* (1495), is a treatise written by Savonarola as a defense of his prophetic message against his enemies. Savonarola's dramatic style of preaching is reflected in this text. A selection from *The Compendium of Revelations,* "A Hand in Heaven," is presented here. The second document is a diary account of contemporary events written by the Florentine citizen Luca Landucci (1450–1516). Entries of 1498 describe the death of Savonarola. A selection from the diary, "The Burning of Savonarola," is presented here.

Girolamo Savonarola, *The Compendium of Revelations*[1]
A Hand in Heaven

In 1492 on the night preceding my last Advent address in Santa Reparata I saw a hand in heaven with a sword on which was written: "The sword of the Lord will come upon the earth swiftly and soon." Above the hand was written, "The judgments of the Lord are just and true." . . .

Then the hand lowered the sword toward the earth and soon the air was seen to be darkened with dense clouds. It rained swords and hailstones with dreadful-sounding thunder, as well as arrows and bolts of fire. On earth war, pestilence, famine, and countless tribulations arose. I saw the angels walking through the midst of the nations giving cups of pure wine to those clad with stoles and bearing crosses. When they had emptied them they said: "O Lord, how sweet are your words in our mouths!" The angels brought the dregs left at the bottom of the cups to those who did not want to drink, but seemed to want to do penance though unable, saying "Why have you forgotten us, Lord?" They wanted to raise their eyes to look on God, but they were hindered by the severity of the tribulation. They were like drunken men; their hearts seemed to be taken from the midst of their breasts. They sought the comfort of human pleasures and did not find them; they carried on like the senseless and insane.

Then I heard a very powerful voice from the three faces saying: "Hear the word of the Lord. I have waited for you in order to have mercy on you. Come to me because I am kind and merciful, bestowing pardon to all who call upon me. But if you do not, I will turn my eyes away from you forever." Then the voice turned to the just and said, "Rejoice, you just, and exult, because when my brief wrath has passed I will break the power of sinners and the power of the just will be exalted." And immediately the vision vanished and this word came to me: "Son, if sinners had eyes they would certainly see

1. Reprinted, by permission of the publisher, from *Apocalyptic Spirituality,* trans. and with an introduction by Bernard McGinn (New York: Paulist Press, 1979), pp. 198–201. Copyright by The Missionary Society of St. Paul the Apostle in the State of New York.

how hard and difficult this plague and sharp this sword can be." The Spirit said that the hard plague and sharp sword signified the rule of evil prelates[2] and those who preach human philosophy. They neither enter the Kingdom of Heaven nor allow others to enter. By this he indicated that the Church had fallen so far because their spiritual attack was much worse than any corporeal tribulations that could happen. The Spirit told me that I should exhort and beg the people to beseech God to send this fear on the earth, to renew the love and memory of the benefits of the Passion of his Only-Begotten Son in the hearts of men, and to give the Church good pastors and preachers of the divine word who would feed his flock and not themselves.

Luca Landucci, *A Florentine Diary from 1450 to 1516*[3]
The Burning of Savonarola

22nd May, 1498. It was decided that he should be put to death and that he should be burnt alive. In the evening a scaffold was made, which covered the whole *ringhiera*[4] of the *Palagio de' Signori,*[5] and then a scaffolding which began at the *ringhiera* next to the "lion" and reached into the middle of the Piazza . . . and here was erected a solid piece of wood many *braccia*[6] high, and round this a large circular platform. On the aforesaid piece of wood was placed a horizontal one in the shape of a cross; but people noticing it said, "They are going to crucify him"; and when these murmurs were heard, orders were given to saw off part of the wood, so that it should not look like a cross.

22nd May (Wednesday morning). The sacrifice of the three *Frati*[7] was made. They took them out of the *Palagio* and brought them on to the *ringhiera,* where were assembled the Eight and the *Collegi,*[8] the papal envoy, the General of the Dominicans, and many canons, priests and monks of divers Orders, and the Bishop . . . who was deputed to degrade the three *Frati;* and here on the *ringhiera* the said ceremony was to be performed. They were robed in all their vestments, which were taken off one by one, with the appropriate words for the degradation, it being constantly affirmed that Fra Girolamo was a heretic and schismatic, and on this account condemned to

2. Ecclesiastics of a high order, such as an archbishop or bishop.
3. Reprinted, by permission of the publishers, from Luca Landucci, *A Florentine Diary from 1450 to 1516*, trans. by Alice de Rosen Jervis (London: J. M. Dent, 1969), pp. 142–43. Copyright by J. M. Dent.
4. A platform consisting of three steps and a railing.
5. Also known as the Palazzo Vecchio; the palace stood in the center of Florence.
6. A unit of measurement approximately the length of a hand.
7. Monks.
8. A civic group, consisting of twenty-eight men, which served as a government council.

be burnt; then their faces and hands were shaved, as is customary in this ceremony.

When this was completed, they left the *Frati* in the hands of the Eight, who immediately made the decision that they should be hanged and burnt; and they were led straight onto the platform at the foot of the cross. The first to be executed was Fra Silvestro, who was hung to the post and one arm of the cross, and there not being much drop, he suffered for some time, repeating "Jesu" many times whilst he was hanging, for the rope did not draw tight nor run well. The second was Fra Domenico of Pescia, who also kept saying "Jesu"; and the third was the *Frate* called a heretic, who did not speak aloud, but to himself, and so he was hanged. This all happened without a word from one of them, which was considered extraordinary, especially by good and thoughtful people, who were much disappointed, as everyone had been expecting some signs, and desired the glory of God, the beginning of righteous life, the renovation of the Church, and the conversion of unbelievers; hence they were not without bitterness that not one of them made an excuse. Many, in fact, fell from their faith. When all three were hanged, Fra Girolamo being in the middle, facing the *Palagio,* the scaffold was separated from the *ringhiera* and a fire was made on the circular platform round the cross, upon which gunpowder was put and set alight, so that the said fire burst out with a noise of rockets and crackling. In a few hours they were burnt, their legs and arms gradually dropping off; parts of their bodies remained hanging to the chains, a quantity of stones were thrown to make them fall, as there was a fear of the people getting hold of them, and then the hangman and those whose business it was hacked down the post and burnt it to the ground, bringing a lot of brushwood, and stirring the fire up over the dead bodies, so that the very least piece was consumed. Then they fetched carts, and accompanied by the mace-bearers, carried the last bit of dust to the Arno,[9] by the Ponte Vecchio,[10] in order that no remains should be found. Nevertheless, a few good men had so much faith that they gathered some of the floating ashes together, in fear and secrecy, because it was as much as one's life was worth to say a word, so anxious were the authorities to destroy every relic.

9. A river in central Italy that flows through Florence.
10. Bridge over the Arno River.

Sixteenth-Century Italian Art

1. Leonardo da Vinci, *The Last Supper,* **Santa Maria delle Grazie, Milan, c. 1495–98**

Gardner, p. 637, ill. 17:3; Janson, p. 491, ill. 642

Pico della Mirandola, *Oration on the Dignity of Man:* "Man, the Most Fortunate of Creatures," 1487

The leading artists, scholars, and intellectuals of the High Renaissance were shaped by a sense of their powerful individuality. Antiquity had provided them with a model for the emancipation of human reason, as well as for its free exercise in all spheres of intellectual and artistic life. Enthusiastic in their admiration for ancient liberty, Renaissance individuals felt encouraged to shake off traditional controls, to criticize accepted canons of conduct, and to secure for themselves free scope in realms outside the region of authority. The spirit of open-minded inquiry guided two of Italy's leading intellectuals, the humanist Pico della Mirandola (1463–1494) and the artist Leonardo da Vinci (1452–1519).

A wealthy aristocrat by birth, the erudite Pico was welcomed into the circle of academicians who frequented Lorenzo de' Medici's palace in Florence. Marsilio Ficino's attempt to harmonize the Christian and classical traditions had deeply impressed Pico. Hoping to expand upon what Ficino had begun, Pico sought to discover the core of truth that he believed animated all systems of thought. For him, truth was to be found not only in scriptural and in classical authors, but also in the texts of Arabic philosophers and abstruse Jewish mystics. In 1486 Pico was charged with heresy, and his ideas were condemned, but in 1493 he was purged of the ban of heterodoxy.

In 1487 Pico summoned an international assembly of philosophers to Rome. In order to stimulate discussion, he wrote a speech, known as the *Oration on the Dignity of Man.* Two themes predominate in Pico's oration: first, the concept of the central position of humankind in the universe; and, second, the assertion of the fundamental

agreement among all sincere manifestations of human thought. Pico advanced the theory that individuals are not forced by their biological nature to adopt any predetermined pattern of behavior. Instead, human beings have the liberty to determine their own actions and choose their own destinies. Alone of all creatures, human beings are created in the image of God and share with God the essential quality of free will. A selection from *Oration on the Dignity of Man,* "Man, the Most Fortunate of Creatures," is presented here.

Leonardo da Vinci (1452–1519) exemplified the human being who possessed the divine gift of free choice. With his restless, inquiring spirit, Leonardo rejected traditional iconographic elements and compositional formats in his fresco *The Last Supper* (c. 1495–98). Executed for the refectory of the church of Santa Maria delle Grazie in Milan, *The Last Supper* represents one of the great figure compositions of the Renaissance. In the painting, Leonardo insisted upon the individuality and dignity of each human actor. Even the traitor Judas shares in this dignity. The painting, in spite of its much damaged condition, reaffirms Pico della Mirandola's belief in the dignity of humankind.

Pico della Mirandola, *Oration on the Dignity of Man*[1]
Man, the Most Fortunate of Creatures

At last it seems to me I have come to understand why man is the most fortunate of creatures and consequently worthy of all admiration and what precisely is that rank which is his lot in the universal chain of Being—a rank to be envied not only by brutes but even by the stars and by minds beyond this world. It is a matter past faith and a wondrous one. Why should it not be? For it is on this very account that man is rightly called and judged a great miracle and a wonderful creature indeed. But hear, Fathers, exactly what this rank is and, as friendly auditors, conformably to your kindness, do me this favor. God the Father, the supreme Architect, had already built this cosmic home we behold, the most sacred temple of His godhead, by the laws of His mysterious wisdom. The region above the heavens He had adorned with Intelligences, the heavenly spheres He had quickened with eternal souls, and the excrementary and filthy parts of the lower world He had filled with a multitude of animals of every kind. But, when the work was finished, the Craftsman kept wishing that there were someone to ponder the plan of so great a work, to love its beauty, and to wonder at its vastness. Therefore, when everything was done . . . , He finally took thought concerning the creation of man. But there was not among His archetypes that from which He could fashion a new offspring, nor was there in His treasurehouses any-

1. Reprinted, by permission of the publisher, from E. Cassirer, P. O. Kristeller, and J. H. Randall, Jr., eds., *The Renaissance Philosophy of Man* (Chicago: University of Chicago Press, 1948), pp. 223–25. Copyright by University of Chicago Press.

thing which He might bestow on His new son as an inheritance, nor was there in the seats of all the world a place where the latter might sit to contemplate the universe. All was now complete; all things had been assigned to the highest, the middle, and the lowest orders. But in its final creation it was not the part of the Father's power to fail as though exhausted. It was not the part of His wisdom to waver in a needful matter through poverty of counsel. It was not the part of His kindly love that he who was to praise God's divine generosity in regard to others should be compelled to condemn it in regard to himself. At last the best of artisans ordained that the creature to whom He had been able to give nothing proper to himself should have joint possession of whatever had been peculiar to each of the different kinds of being. He therefore took man as a creature of indeterminate nature and, assigning him a place in the middle of the world, addressed him thus: "Neither a fixed abode nor a form that is thine alone nor any function peculiar to thyself have we given thee, Adam, to the end that according to thy longing and according to thy judgment thou mayest have and possess what abode, what form, and what functions thou thyself shalt desire. The nature of all other beings is limited and constrained within the bounds of laws to prescribe by Us. Thou, constrained by no limits, in accordance with thine own free will, in whose hand We have placed thee, shalt ordain for thyself the limits of thy nature. We have set thee at the world's center that thou mayest from thence more easily observe whatever is in the world. We have made thee neither of heaven or of earth, neither mortal or immortal, so that with freedom of choice and with honor, as though the maker and molder of thyself, thou mayest fashion thyself in whatever shape thou shalt prefer. Thou shalt have the power to degenerate into the lower forms of life, which are brutish. Thou shall have the power, out of thy soul's judgment, to be reborn into the higher forms, which are divine." O supreme generosity of God the Father, O highest and most marvelous felicity of man! To him it is granted to have whatever he chooses, to be whatever he wills.

2. Leonardo da Vinci, *Embryo in the Womb*, c. 1510
Gardner, p. 639, ill. 17:5; Janson, p. 493, ill. 645

Leonardo da Vinci, *Anatomical Observations:* "The Cause of a Death So Sweet," c. 1504–6

The Renaissance spirit of free inquiry not only inspired philosophy, it also revitalized science. The renewed interest in a scientific understanding of the world and of humankind is evident in the field of medicine.

The Greek and Roman practice of medicine had been based on the theory of the humors. According to this theory, health constituted a balanced state of four fluids, or humors: blood, phlegm, yellow bile, and black bile. Fifteenth- and sixteenth-century physicians continued to base their explanation of health and disease upon the classical theory of the humors. Even so, significant strides in diagnosing and treating illnesses were made during the Renaissance. Of greatest impact to the medical profession was the removal of medieval religious restrictions that had either forbidden or severely limited the practice of human dissection. A wide range of information was learned by Renaissance scientists through human dissection, as can be seen in the notebooks of the Florentine artist and intellectual Leonardo da Vinci (1452–1519).

An artist who sought to understand the entire range of natural phenomena, Leonardo performed dissections on more than thirty corpses. Entries in his private notebooks include many detailed anatomical observations and numerous precise anatomical sketches. Among Leonardo's written observations are descriptions of the effects of aging upon the arterial system and internal organs, and comparisons between the anatomical conditions of a man who died at an age over one hundred years and a child who died at age two. A selection from *Anatomical Observations,* "The Cause of a Death So Sweet," is presented here. Among Leonardo's sketches is *Embryo in the Womb* (c. 1510), the first accurate depiction of the compact position of the human embryo.

Leonardo da Vinci, *Anatomical Observations*[1]
The Cause of a Death So Sweet

The artery and the vein which in the aged extend between the spleen and the liver, acquire so thick a covering that it contracts the passage of the blood which comes from the meseraic [mesenteric-portal] veins. By means of these veins the blood runs through the liver to the heart and the two major veins [cava] and consequently through the entire body. These veins, apart from the thickening of their covering, grow in length and twist like a snake, and the liver loses the sanguineous humor which was carried there by this vein. Thus the liver becomes desiccated and like congealed bran both in color and in substance, so that when it is subjected to the slightest friction, its substance falls away in small particles like sawdust and leaves behind the veins and arteries. The veins of the gall bladder and of the umbilicus which enter the liver through the porta hepatis remain entirely deprived of liver substance, like millet or sorghum when their grains have been separated.

The colon and the other intestines become greatly contracted in the aged, and I have found there stones in the vessels which pass beneath the

1. Reprinted, by permission of the publisher, from *Leonardo da Vinci on the Human Body,* trans. by Charles D. O'Malley and J. B. de C. M. Saunders (New York: Henry Schuman, 1952), p. 300. Copyright by Henry Schuman.

clavicles of the chest. These were as large as chestnuts, of the color and shape of truffles or of dross or clinkers of iron. These stones were extremely hard, like these clinkers, and had formed sacs attached to the said vessels, in the manner of goiters.

And this old man, a few hours before his death, told me that he had passed one hundred years, and that he was conscious of no failure of body, except feebleness. And thus sitting upon a bed in the hospital of Santa Maria Nuova[2] at Florence, without any untoward movement or sign, he passed from this life.

And I made an anatomy to see the cause of a death so sweet, which I found to proceed from debility through lack of blood and deficiency of the artery [aorta] which nourishes the heart and the other lower members. I found this artery very desiccated, shrunken and withered. This anatomy I described very carefully and with great ease owing to the absence of fat and humor which rather hinder recognition of the parts. The other anatomy was that of a child of two years in which I found everything to be the opposite to that of the old man.

3. Raphael, *Galatea*, Villa Farnesina, Rome, 1513
Gardner, p. 648, ill. 17:17; Janson, p. 507, ill. 673

Poliziano, *Stanze per la Giostra:* "The Bittersweet Cares That Are Born of Love," 1475–78

Humanist culture flourished among the aristocratic classes that gathered at the courts of princes and the palaces of kings. Cultivated persons regarded their native Italian language as a vulgar language spoken on the streets by illiterate crowds. Latin, in contrast, was esteemed by them as the language best suited for refined conversations and was used almost exclusively in elegant literary compositions.

Nonetheless, the people of Florence thirsted for culture and for a literature to express their interests, their emotions, and the events of their lives. As a result, a vernacular literature was created that consisted of humorous stories, histories, biographies, romances, and love stories.

The division between popular literature and humanist culture was mended by Angelo Ambrogini (1454–1494), known as Poliziano. Educated in Florence, Poliziano wrote popular literature in vernacular Italian and aristocratic poetry in Latin. He was welcomed into the Medici palace and was given Medici support.

One way in which Poliziano repaid his indebtedness to the Medicis was the

2. Another name for Santa Maria Novella.

composition of the poem *Stanze per la Giostra*. Begun in 1475, the *Stanze* was written by Poliziano to celebrate a tournament held by Giuliano de' Medici to honor Simonetta Cattaneo. At the opening of the poem, Giuliano is represented as hostile toward love. Cupid avenges himself by luring Giuliano to a glade where he sees Simonetta and immediately falls in love. Cupid then returns to the realm of Venus on the island of Cyprus. He reports his success to Venus, who, in her desire to make the conquest evident, decides to inspire Giuliano to give a tournament in honor of his lady. The *Stanze* concludes with two mythological encounters describing the erotic abasement of Hercules[1] and the erotic domestication of Polyphemus:[2] Hercules embodies the highest heroic achievement, while the monstrous Polyphemus appears subhuman. The love that degrades Hercules and yet uplifts Polyphemus operates on a median level between the noble and bestial sides of human nature. A selection from *Stanze*, "The Bittersweet Cares That Are Born of Love," is presented here.

Poliziano's poetic treatment of the classical myth of Polyphemus inspired the painter Raphael (1483–1520) in his choice of subjects for the frescoes of the Villa Farnesina in Rome. Commissioned in 1513 by Agostino Chigi to decorate the walls of his villa, Raphael based his mural *Galatea* upon Poliziano's earlier description of Polyphemus as the ardent pursuer of the beautiful nymph. However, Poliziano never experienced the pleasure of seeing Raphael's joyous depiction of his poem. Perhaps because of the unabashed sensuality of the *Stanze*, Poliziano attracted the attention of Savonarola, the Dominican friar who governed Florence at the end of the fifteenth century and who attempted to purge the city-state of immorality. In 1494 Poliziano was burned at the stake as a penitent[3] in the cowl[4] of a Dominican friar.

Poliziano, *Stanze per la Giostra*[5]
The Bittersweet Cares That Are Born of Love

The bristling locks of Polyphemus cover his hairy shoulders and fall onto his huge chest, fresh acorns wreathe his harsh temples: his sheep feed about him, nor can the bittersweet cares that are born of love be ever removed from his heart, but rather, weakened by weeping and grief, he sits on a cold stone at the foot of a maple.

His hairy brow makes an arch six spans long from ear to ear; beneath

1. A son of Zeus and the most popular of Greek heroes, Hercules was so enraged by his love for Iole, the daughter of the king of Oichalia, that he sacked the kingdom of Pylos and killed all the princes except Nestor. Later he was so weakened by his love for Omphale, queen of Lydia, that he allowed himself to be dressed in women's clothes and to work with the palace maids spinning wool.
2. Polyphemus was a Cyclops. A shepherd and a son of Poseidon, the brutish giant wooed the sea nymph Galatea with love songs.
3. A person who confesses sin and submits to a penance.
4. Hooded garment worn by monks.
5. Reprinted, by permission of the publisher, from Angelo Poliziano, *The Stanze per la Giostra*, trans. by David Quint (Amherst: University of Massachusetts Press, 1979), pp. 59–61, cantos 115–118. Copyright by David Quint.

his brow a broad nose, his fanglike teeth seem white with foam; his dog rests between his feet, and under his arm a shepherd's pipe of over a hundred reeds lies silent: he regards the waving sea, he seems to sing a mountain tune, as he moves his woolly cheeks,

saying that she is whiter than milk, but even prouder than a heifer, that he has made her many garlands, that he keeps for her a very beautiful doe and a bear-cub that already can fight with dogs; that he mortifies and torments himself for her, and that he had a great desire to know how to swim in order to go forth and find her even in the sea.

Two shapely dolphin pull a chariot: on it sits Galatea and wields the reins; as they swim, they breathe in unison; a more wanton flock circles around them: one spews forth salt waves, others swim in circles, one seems to cavort and play for love; with her faithful sisters, the fair nymph charmingly laughs at such a crude singer.

4. Donato Bramante, *Original Plan for Saint Peter's, Rome,* 1506
Gardner, p. 641, ill. 17:7; Janson, p. 495, ill. 649

Desiderius Erasmus, *Julius Excluded from Heaven: A Dialogue:* "You're All Belches and You Stink of Boozing and Hangovers," 1513–14

At the end of the Middle Ages, papal authority had been eroded by exile in France and by ruinous schisms. With the election of Pope Nicholas V (lived c. 1397–1455; pope 1447–55) in 1447, Rome was reborn politically, spiritually, and artistically. Once a weak pawn for the great powers, the church now established its independence. Using war and diplomacy to secure more territories and greater wealth, the church expanded its political strength. While some popes who succeeded Nicholas were chosen from the ranks of scholars and a few from the company of saints, most were chosen because they were gifted administrators and natural politicians. Worldly men with commanding personalities, the popes of this period were inclined toward action.

Julius II (lived 1443–1516; pope 1503–13), a Renaissance pope reputed for his vigor, was engaged almost constantly on the battlefield. Julius was determined to strengthen the temporal powers of the church and to establish the absolute independence of the papacy from emperors, kings, and powerful noblemen. Never happy unless he was fighting, Julius embroiled the Italian peninsula in much bloodshed. Tough, bold, and single-minded, this priest was accurately characterized both as the savior of the papacy and as the curse of Italy.

As in politics, so in art Julius never vacillated. He held a sweeping vision of the glories that papal Rome should exhibit. Among the artists he patronized was Donato

Bramante (1444–1514), a man who dreamed on the same magnificent scale as Julius did. Together, they determined upon the destruction of the early Christian basilica of Saint Peter's and upon the construction of a magnificent new basilica. Bramante's original plan for Saint Peter's was conceived in 1506.

A description of Julius II was written by the contemporary churchman Desiderius Erasmus (1466–1536). Erasmus was a Dutch-born priest who sought to correct human vice and to purify the church. Although he remained a faithful servant of the church, Erasmus wrote a biting satire, *Julius Excluded from Heaven: A Dialogue* (1513–14). In this work, he imagines that Julius meets Saint Peter at the gates of heaven and tries to achieve entry through the same tactics of force that he had employed so successfully during his pontificacy. A selection from *Julius Excluded from Heaven: A Dialogue,* "You're All Belches and You Stink of Boozing and Hangovers," is presented here.

Desiderius Erasmus, *Julius Excluded from Heaven: A Dialogue*[1]
You're All Belches and You Stink of Boozing and Hangovers

Julius. What the devil is this? The doors won't open? Someone must have changed the lock, or at least tampered with it.

Genius. Are you quite sure you haven't brought the wrong key? The key to your treasure-chest won't open this door—and anyway, why didn't you bring both of them with you? The one in your hand is the key of power, not of knowledge. . . .

Julius. I want you to open the doors, and quickly; if you did your job properly, you'd have come out to meet me—with a solemn procession of angels, too.

Peter. He's domineering enough, anyway! But first of all, tell me who you are. . . .

Julius. Stop this nonsense, if you know what's good for you; for your information, I am Julius, the famous Ligurian;[2] and, unless you've completely forgotten your alphabet, I'm sure you recognize these two letters, P.M.

Peter. I suppose they stand for Pestis Maxima.[3]

Genius. Ha ha ha! Our soothsayer has hit the nail on the head!

Julius. Of course not! Pontifex Maximus.[4]

1. Reprinted, by permission of the publisher, from *Collected Works of Erasmus,* ed. by A. H. T. Levi, trans. and annotated by Michael J. Heath (Toronto: University of Toronto Press, 1986), vol. 27, pp. 168–70. Copyright by University of Toronto Press.
2. A person from Liguria, a region in northwest Italy.
3. A Latinized phrase, meaning the biggest pest.
4. Pontifex Maximum is an official title used for the popes, meaning the most important priest.

Peter. Well, you could be thrice Maximus and even greater than Mercurius Trismegistus,[5] but you can't come in here unless you're Optimus, and by that I mean holy.

Julius. Oh, if being called "holy" has anything to do with it, it's most impertinent of you to take so long to open the doors; you may have been merely styled "holy" or "saint" for all these years, but everyone has always called me "most holy." There are thousands of bulls.[6] . . .

Genius. 'Cock-and-bulls',[7] you might say! . . .

Julius. This is very annoying: if I'd only been allowed to go on living I wouldn't envy you your holiness or your bliss.

Peter. How well your words reveal the holiness of your thoughts! But in any case, I've been watching you closely all this time, and I can see plenty of evidence of impiety, but none of saintliness. What, for instance, is the purpose of that strange escort of yours, so unlike a pope's? You've brought twenty thousand men with you, but not one of the whole mob even looks like a Christian to me. They seem to be the worst dregs of humanity, all stinking of brothels, booze, and gunpowder. I'd say they were a gang of hired thugs, or rather goblins of Tartarus[8] plucked up from hell to wage war on heaven. And the more closely I look at you yourself the less I can see any trace of an apostle. First of all, what monstrous new fashion is this, to wear the dress of a priest on top, while underneath it you're all bristling and clanking with blood-stained armour? Then again, what fierce eyes and stubborn mouth, what a fearsome expression and haughty and arrogant brows you have! I'm ashamed to say, and sorry to see, that your whole body is disfigured by the marks of monstrous and abominable appetites, not to mention that even now you're all belches and that you stink of boozing and hangovers and look as if you've just thrown up. Your whole body is in such a state that I should guess that it's been wasted, withered, and rotted less by old age and illness than by drink.

Genius. A fine portrait: Julius to the life!

Peter. Oh, I know you've been glowering at me for some time, but I can't help saying what I think. I suspect that you are that poisonous pagan Julius,

5. Mercurius Trismegistus is a name variously ascribed by Neoplatonists and others to an ancient Egyptian priest or to the Egyptian god Thoth, to some extent identified with the Greek god Hermes and the Roman god Mercury. Various mystical, religious, philosophical, astrological, and alchemical writings have been ascribed to him.
6. Bulls are papal pronouncements.
7. A slang term for nonsense.
8. In Greek mythology, Tartarus is a part of the underworld where sinners, particularly those who have personally offended the gods, are punished.

returned from hell in disguise to mock me, so closely do all your features resemble his.

Julius. Ma di si![9]

5. Raphael, *Pope Leo X with His Nephews Giulio de' Medici and Luigi de' Rossi,* c. 1518
Janson, p. 507, ill. 674

Niccolò Machiavelli, *The Prince:* "We Look to Results," 1513

In 1513 Leo X (1475–1521) succeeded Julius II as pope. Like his predecessor, Leo sought to augment the size, the power, and the wealth of the papal state. But unlike Julius, who used ferocity to intimidate foes, Leo used subtlety and cunning, combined with apparent generosity and affability, to woo allies. Moreover, he demonstrated few scruples against reneging on promises or practicing deceptions against his enemies when it suited his purposes.

The need of a ruler to preserve and enhance his power was strongly advocated by the Florentine statesman and political theorist Niccolò Machiavelli (1469–1527). Between 1498 and 1512, Machiavelli served as an official and a diplomat for the republican government of Florence. As an ally of Piero Soderini, a rival politician to the Medici family, Machiavelli lost his post when the Medicis returned to power, and he fell under suspicion of conspiracy. Arrested and tortured, Machiavelli was released only by the intervention of Leo X.

In the leisure of his newly enforced retirement, Machiavelli turned to writing. His most famous treatise is *The Prince* (1513), which Machiavelli dedicated to Leo's nephew, the younger Lorenzo de' Medici (lived 1492–1519; duke of Urbino 1516–19). In this essay, Machiavelli formulates a theory of government in which only the interests of the ruler are regarded. He posits a separation between statecraft and morality, and recommends force and fraud, wherever advantageous, as a legitimate means of attaining high political ends. For Machiavelli, success alone is the test of conduct, while the corruption, venality, and baseness of humankind at large are assumed. A selection from *The Prince,* "We Look to Results," is presented here.

Approximately six years after Leo X rescued Machiavelli from torture, the Italian Renaissance painter Raphael (1483–1520) completed the papal portrait known as *Leo X with His Nephews Giulio de' Medici and Luigi de' Rossi* (c. 1518). In this painting, Raphael hints at his subject's sensuality by depicting Leo as heavy-jawed, with thick lips and a brawny jowl. At the same time Raphael suggests Leo's powerful personality not only by the massiveness of his body but also by the contrast with the

9. A strong phrase meaning "Yes, of course!"

two less rugged forms of Leo's nephews. The young men, who had been elevated to cardinals by their uncle, are shown to behave toward the pope with the same deference that Machiavellian courtiers would treat a secular prince.

Niccolò Machiavelli, *The Prince*[1]
We Look to Results

It now remains for us to consider what ought to be the conduct and bearing of a Prince in relation to his subjects and friends. . . . It is essential . . . for a Prince who desires to maintain his position, to have learned how to be other than good, and to use or not to use his goodness as necessity requires. . . .

It may be a good thing to be reputed liberal, but, nevertheless, that liberality without the reputation of it is hurtful; because, though it be worthily and rightly used, still if it be not known, you escape not the reproach of its opposite vice. Hence, to have credit for liberality with the world at large, you must neglect no circumstance of sumptuous display; the result being, that a Prince of a liberal disposition will consume his whole substance in things of this sort, and, after all, be obliged, if he would maintain his reputation for liberality, to burden his subjects with extraordinary taxes, and to resort to confiscations and all the other shifts whereby money is raised. But in this way he becomes hateful to his subjects, and growing impoverished is held in little esteem by any. So that in the end, having by his liberality offended many and obliged few, he is worse off than when he began, and is exposed to all his original dangers. Recognizing this, and endeavoring to retrace his steps, he at once incurs the infamy of miserliness.

A Prince, therefore, since he cannot without injury to himself practise the virtue of liberality so that it may be known, will not, if he be wise, greatly concern himself though he be called miserly. Because in time he will come to be regarded as more and more liberal, when it is seen that through his parsimony his revenues are sufficient; that he is able to defend himself against any who make war on him; that he can engage in enterprises against others without burdening his subjects; and thus exercise liberality towards all from whom he does not take, whose number is infinite, while he is miserly in respect of those only to whom he does not give, whose number is few. . . .

Passing to the other qualities above referred to, I say that every Prince should desire to be accounted merciful and not cruel. Nevertheless, he should

1. Reprinted, by permission of the publisher, from Niccolò Machiavelli, *The Prince*, trans. by N. H. Thomson (Oxford: Clarendon Press, 2nd ed., 1897), pp. 109–10, 113–15, 118–19, 125–30.

be on his guard against the abuse of this quality of mercy. Cesare Borgia[2] was reputed cruel, yet his cruelty restored Romagna,[3] united it, and brought it to order and obedience; so that if we look at things in their true light, it will be seen that he was in reality far more merciful than the people of Florence, who, to avoid the imputation of cruelty, suffered Pistoia[4] to be torn to pieces by factions.

A Prince should therefore disregard the reproach of being thought cruel where it enables him to keep his subjects united and obedient. For he who quells disorder by a very few signal examples will in the end be more merciful than he who from too great leniency permits things to take their course and so to result in rapine and bloodshed; for these hurt the whole State, whereas the severities of the Prince injure individuals only. . . .

A prudent Prince neither can nor ought to keep his word when to keep it is hurtful to him and the causes which led him to pledge it are removed. If all men were good, this would not be good advice, but since they are dishonest and do not keep faith with you, you, in return, need not keep faith with them; and no Prince was ever at a loss for plausible reasons to cloak a breach of faith. . . .

It is necessary . . . to be skilful in simulating and dissembling. But men are so simple, and governed so absolutely by their present needs, that he who wishes to deceive will never fail in finding willing dupes. One recent example I will not omit. Pope Alexander VI[5] had no care or thought but how to deceive, and always found material to work on. No man ever had a more effective manner of asseverating, or made promise with more solemn protestations, or observed them less. And yet, because he understood this side of human nature, his frauds always succeeded.

It is not essential, then, that a Prince should have all the good qualities which I have enumerated above, but it is most essential that he should seem to have them; I will even venture to affirm that if he has and invariably practises them all, they are hurtful, whereas the appearance of having them is useful. Thus, it is well to seem merciful, faithful, humane, religious and upright, and also to be so; but the mind should remain so balanced that were it needful not to be so, you should be able and know how to change to the contrary. . . .

2. The illegitimate son of Pope Alexander VI, Cesare Borgia (1476–1507) acquired a reputation for murder and betrayal. He was suspected of murdering his brother and accused of poisoning his brother-in-law. He used cruelty and treachery to carve out an extensive territory for himself. Because of his ruthlessness and his success Machiavelli used him as the model for the new prince.
3. A province in northeast Italy.
4. A city in northern Italy.
5. Lived c. 1431–1503; reigned 1492–1503.

In the actions of all men, and most of all of Princes, where there is no tribunal to which we can appeal, we look to results. Wherefore if a Prince succeeds in establishing and maintaining his authority, the means will always be judged honorable and be approved by every one. For the vulgar are always taken by appearances and by results, and the world is made up of the vulgar, the few only finding room when the many have no longer ground to stand on.

6. Raphael, *Baldassare Castiglione,* c. 1514
Gardner, p. 649, ill. 17:18

Baldassare Castiglione, *The Book of the Courtier:* "The Ideal Man," 1508–18

If Machiavelli described the dealings of the court in the coldest, most calculating terms, Castiglione (1478–1529) described courtly life in its most graceful aspects. Baldassare Castiglione was born near Mantua. After a youth spent in study and in knightly training, he entered the service first of Federigo Gonzago (1500–1540), the ruler of Mantua, and then, of Guidobaldo da Montefeltro (1472–1508), duke of Urbino. When Guidobaldo died four years later, Castiglione remained in Urbino to serve the successive duke, Francesco Maria della Rovere. Between 1513 and 1516 Castiglione served as envoy to the papal court of Leo X.

In 1508, shortly after the death of Guidobaldo, Castiglione began writing *The Book of the Courtier.* Finished in 1518, the book is based upon the civilized court of the duke of Urbino, whom he had served. Guidobaldo was famous in his youth for his accomplishments of learning and his elegance of bearing. As an adult, Guidobaldo became an invalid. But even in his debilitated state, he exhibited to his court an admirable example of patience in sickness and of dignified cheerfulness. His wife, Elisabetta Gonzaga, one of the most famous women of her day, was no less a pattern of noble conduct and serene contentment.

In *The Book of the Courtier,* Castiglione introduces us to the court of Urbino and to its qualities of refinement, chivalry, wit, cultivation, and gentility. He brings together an aristocratic circle of ladies and gentlemen to discourse with the duchess during four consecutive evenings. The subject under discussion is the perfect courtier. The assembled company agrees that a courtier's requisite qualities include the prestige of noble birth, skill at the use of arms, courage in the battlefield, excellence in manly sports, gracefulness in bearing, elegance in speech, persuasion in writing, and an acquaintanceship with the arts.

It is fitting that Baldassare Castiglione's portrait (c. 1514) was painted by Ra-

phael (1483–1520). Raphael, who was born in a small town near Urbino and whose father was a provincial painter employed at the court of Urbino, possessed many of the qualities extolled by Castiglione. A selection from *The Book of the Courtier*, "The Ideal Man," is presented here.

In 1516 Leo X intervened directly in the affairs of Urbino. He replaced Francesco Maria as ruler with the younger Lorenzo de' Medici (lived 1492–1519; duke of Urbino 1516–19), the same nephew to whom Machiavelli had dedicated *The Prince*. The change in rulership caused Castiglione to return to Mantua, where he continued his career as a highly respected official.

The sixteenth century was an age dominated by despots. The differences in the characters, actions, and outlooks of these rulers are reflected in the writings of Machiavelli and Castiglione, which, in turn, have continued to mold the attitudes of the contemporary age.

Baldassare Castiglione, *The Book of the Courtier*[1]
The Ideal Man

I wish, then, that this Courtier of ours should be nobly born and of gentle race . . . for noble birth is like a bright lamp that manifests and makes visible good and evil deeds, and kindles and stimulates a virtue both by fear of shame and by hope of praise. . . .

But to come to some details, I am of [the] opinion that the principal and true profession of the Courtier ought to be that of arms; which I would have him follow actively above all else, and to be known among others as bold and strong, and loyal to whomsoever he serves. . . . Not that we would have him look so fierce, or go about blustering, or say that he has taken his cuirass[2] to wife. . . . Therefore let the man we are seeking, be very bold, stern, and always among the first, where the enemy are to be seen; and in every other place, gentle, modest, reserved, above all things avoiding ostentation and that impudent self-praise by which men ever excite hatred and disgust in all who hear them. . . .

I would have our Courtier's [appearance be] well built and shapely of limb, and would have him show strength and lightness and suppleness, and know all bodily exercises that befit a man of war. . . . One of the chief among these seems to be the chase.[3] . . . It is fitting also to know how to swim, to leap, to run, to throw stones, for besides the use that may be made of this in

1. Reprinted, by permission of the publisher, from Baldassare Castiglione, *The Book of the Courtier*, trans. by L. E. Opdycke (New York: Charles Scribner's Sons, 1903), pp. 22, 25–31, 59, 62–66, 93–95.
2. Defensive armor for the torso, consisting of a breastplate and a back plate.
3. Another term for the sport of hunting.

war, a man often has occasion to show what he can do in such matters; whence good esteem is to be won especially with the multitude, who must be taken into account withal. Another admirable exercise, and one very befitting a man at court, is the game of tennis. . . . Nor less highly do I esteem vaulting on horse.[4] . . .

I think the conversation which the Courtier ought most to try in every way to make acceptable, is that which he holds with his prince. . . . Therefore, besides daily showing everyone that he possesses the worth we have already described, I would have the Courtier strive, with all the thoughts and forces of his mind, to love and almost to adore the prince whom he serves, above every other thing, and mould his wishes, habits and all his ways to his prince's liking. . . .

Moreover it is possible without flattery to obey and further the wishes of him we serve, for I am speaking of those wishes that are reasonable and right, or of those that in themselves are neither good nor evil, such as would be a liking for play or a devotion to one kind of exercise above another. And I would have the Courtier bend himself to this even if he be by nature alien to it, so that on seeing him his lord shall always feel that he will have something agreeable to say; which will come about if he has the good judgment to perceive what his prince likes, and the wit and prudence to bend himself thereto, and a deliberate purpose to like that which perhaps he by nature dislikes. . . .

He will very rarely or almost never ask anything of his lord for himself, lest his lord, being reluctant to deny it to him directly, may sometimes grant it with an ill grace, which is much worse. Even in asking for others he will choose his time discreetly and ask proper and reasonable things; and he will so frame his request, by omitting what he knows may displease and by skilfully doing away with difficulties, that his lord shall always grant it, or shall not think him offended by refusal even if it be denied; for when lords have denied a favor to an importunate suitor, they often reflect that he who asked it with such eagerness, must have desired it greatly, and so having failed to obtain it, must feel ill will towards him who denied it; and believing this, they begin to hate the man and can never more look upon him with favor.

4. Horse jumping.

7. Michelangelo, Saint Peter's, Rome, 1546–64

Gardner, p. 662, ill. 17:32, 17:34; Janson, p. 503, ill. 666–67

Nicolaus Copernicus, *On the Revolutions of Heavenly Bodies:* "The Annual Revolution of the Earth," 1543

Andreas Vesalius, *The Structure of the Human Body:* "The Vital Spirit" and "The Cerebrum and Cerebellum," 1543

The responsibility for supervising the construction of Saint Peter's, Rome, was delegated to Michelangelo (1475–1564) in 1546. At almost the same moment, dramatic breakthroughs were made by several Renaissance scientists including Nicolaus Copernicus (1473–1543) and Andreas Vesalius (1514–1564).

Born in Thorn (Toruń), Poland, Copernicus studied astronomy by using the castle tower of his uncle's house as an observatory. His instruments were essentially no different from those used by Greek and Roman astronomers. Yet his observations about the eccentricity of the planetary orbits led Copernicus to dispute the ancient cosmological theory that the sun and planets revolved around the earth. Copernicus proposed that the eccentric orbits of the planets, including the earth, could be better understood by a heliocentric model of the universe. For thirty years, Copernicus labored on the book *On the Revolutions of Heavenly Bodies* (1543), which demonstrated that the planets revolve around the sun. A selection from *On the Revolutions of Heavenly Bodies,* "The Annual Revolution of the Earth," is presented here.

The growing freedom of scientific thought is evident in the field of biology as well as astronomy. The most brilliant of the biological investigators was Andreas Vesalius. Born in Brussels, Flanders, Vesalius introduced new methods of teaching anatomy immediately after his appointment at the University of Padua in Italy. Previously, professors had taught anatomy by repeating the text of Galen, a Roman physician of the second century. The actual process of dissection had been performed by members of more lowly professional classes, such as barbers. In contrast, Vesalius taught anatomy from the body on the table, which he personally would deftly dissect before his students' eyes.

Vesalius completed his great text *The Structure of the Human Body* at the age of twenty-eight. Vesalius's text, which corrected innumerable errors in previous anatomical treatises, transformed for all time the study of human anatomy. Two selections from *The Structure of the Human Body,* "The Vital Spirit," and "The Cerebrum and Cerebellum," are presented here.

Michelangelo's most notable contributions to the construction of the basilica of Saint Peter were his unification of the exterior appearance of the church and his design for the enormous dome over the altar (1546–64). As building supervisor, Michelangelo fully integrated architecture and sculpture. This integration reveals Michelangelo's conviction that architecture is founded upon the principles of organic beauty. For Michelangelo these principles were the same as those exhibited by the human

body, the subject of Vesalius's study. In his design for the dome, Michelangelo proposed the construction of a hemispherical form. In its hemispherical profile the dome designed by Michelangelo symbolized the planetary dome of heaven. The heavens were the subject of Copernicus's study, which was as revolutionary for the field of astronomy as Michelangelo's work was innovative for the field of art.

Michelangelo's design for a hemispherical dome was never executed. The dome that was actually constructed after Michelangelo's death by the architect Giacomo della Porta (c. 1540–1602) was heightened in its proportions. Nonetheless, this dome is one of the most beautiful and most impressive domes in Western architectural history.

Nicolaus Copernicus, *On the Revolutions of Heavenly Bodies*[1]
The Annual Revolution of the Earth

For these and similar reasons it is claimed that the earth is at rest in the center of the universe and that this is undoubtedly true. But one who believes that the earth rotates will also certainly be of the opinion that this motion is natural and not violent. . . . Whatever happens in the course of nature remains in good condition and in its best arrangement. Without cause, therefore, Ptolemy[2] feared that the earth and earthly things if set in rotation would be dissolved by the action of nature, for the functioning of nature is something entirely different from artifice, or from that which could be contrived by the human mind. But why did he not fear the same, and indeed in much higher degree, for the universe, whose motion would have to be as much more rapid as the heavens are larger than earth? . . . It is said that outside of the heavens there is no body, nor place, nor empty space, in fact, that nothing at all exists, and that, therefore, there is no space in which the heavens could expand. . . . Now whether the world[3] is finite or infinite, we will leave to the quarrels of the natural philosophers; for us remains the certainty that the earth, contained between poles, is bound by a spherical surface. Why should we hesitate to grant it a motion, natural and corresponding to its form; rather than assume that the whole world, whose boundary is not known and cannot be known, moves? And why are we not willing to acknowledge that the *appearance* of a daily revolution belongs to the heavens, its *actuality* to the earth? . . . For when a ship is sailing along quietly, everything which is outside of it will appear to those on board to have a motion corresponding to the

1. Reprinted, by permission of the publishers, from the translation of *De revolutionibus orbium coelestium* in Harlow Sharpley and Helen E. Howarth, eds., *A Source Book of Astronomy* (Cambridge, Mass.: Harvard University Press, 1925), pp. 7–12. Copyright by Harvard University Press.
2. Greek astronomer, second century A.D., whose geocentric system dominated astronomy until the triumph of Copernican ideas in the seventeenth century.
3. The universe.

movement of the ship, and the voyagers are of the erroneous opinion that they with all that they have with them are at rest. . . .

Since nothing stands in the way of the movability of the earth, I believe we must now investigate whether it also has several motions, so that it can be considered one of the planets. That it is not the center of all the revolutions is proved by the irregular motions of the planets, and their varying distances from the earth, which cannot be explained as concentric circles with the earth at the center. Therefore, since there are several central points, no one will without cause be uncertain whether the center of the universe is the center of gravity of the earth or some other central point. I, at least, am of the opinion that gravity is nothing else than a natural force planted by the divine providence of the Master of the World into its parts, by means of which they, assuming a spherical shape, form a unity and a whole. And it is to be assumed that the impulse is also inherent in the sun and the moon and the other planets, and that by the operation of this force they remain in the spherical shape in which they appear; while they, nevertheless, complete their revolutions in diverse ways. If then the earth, too, possesses other motions besides that around its center, then they must be of such a character as to become apparent in many ways and in appropriate manners; and among such possible effect we recognise the yearly revolution. If one admits the motionlessness of the sun, and transfers the annual revolution from the sun to the earth, there would result, in the same manner as actually observed, the rising and setting of the constellations and the fixed stars; and it will thus become apparent that also the haltings and backward and forward motion of the planets are not motions of these but of the earth, which lends the appearance of being actual planetary motions. Finally, one will be convinced that the sun itself occupies the center of the universe. And all this is taught us by the law of sequence in which things follow one upon another, and the harmony of the universe; that is, if we only (so to speak) look at the matter with both eyes. . . .

Andreas Vesalius, *The Structure of the Human Body*[4]
The Vital Spirit

There is in the substance of the heart the power of the *vital spirit*. In the liver is the faculty of the *natural spirit*. The liver produces thick dark blood and from that the natural spirit; while the heart produces [thin light] blood which impetuously rushes through the body with the vital spirit, from which the

4. Reprinted, by permission of the publishers, from *Vesalius on the Human Brain*, trans. by Charles Singer (London: Oxford University Press, 1952), pp. 1–2. Copyright by The Wellcome Historical Medical Museum, London.

inner organs draw their proper substances, by channels appropriate to all the bodily parts. So too the brain—containing a matter appropriate to its own function—produces, at the proper places and by those instruments which serve its function, the finest and subtlest of all [the three spirits, namely] the *animal spirit.* This it uses partly for the divine operations of the Reigning Soul, partly however it distributes it continuously to the organs of sense and motion through the nerves, as through little tubes. These organs are thus never without the spirit which is the chief author of their function. . . .

Andreas Vesalius, *The Structure of the Human Body*[5]
The Cerebrum and Cerebellum

By professors of dissection the brain is customarily divided into an anterior part, which they call *cerebrum,* and a posterior, the *cerebellum,* the anterior [being divided] into right and left. . . .

The two parts of the cerebrum are continuous with each other, right with, left, [a] by the whole length of the corpus callosum, [b] by the "tortoise" [= fornix], and [c] by the septum between right and left ventricles above their common cavity or third ventricle. . . . The right and left lobes of the cerebrum cover the cerebellum, though they are continuous with it. Further, the lower tract of the cerebellum is continuous in two places with the origin of the dorsal marrow, thus forming one body with it. . . .

The cerebellum is a tenth or eleventh part of the cerebrum. Together with the origin of the medulla dorsalis, it occupies that part of the cranial cavity which is bounded in front by the posterior part of those ridges for the organs of hearing which project into the great cavity of the head [= petrous bone], and behind by two fossae hallowed into the occipital bone which are bounded by the grooves for the first two [= lateral] sinuses. No part of the cerebellum trespasses beyond this circumscription, which limits it completely. . . .

The area of the skull, proper to the cerebellum, fully displays its site, boundaries, shape, and size. For the cerebellum, like the space it occupies, is wider than it is long or deep, and in its lower and especially its posterior part takes the form of a flattened spheroid. In its midst is a steep and rather narrow declivity given to it by a protuberance on the inner side of the occipital bone, to which [protuberance] the dura is tenaciously attached. Anteriorly, where the cerebellum approaches the nates,[6] it is drawn into a

5. Reprinted, by permission of the publishers, from *Vesalius on the Human Brain,* trans. by Charles Singer (London: Oxford University Press, 1952), pp. 21–26. Copyright by The Wellcome Historical Medical Museum, London.
6. The anterior and larger pair of the optic lobes of the brain.

sharpish point [= lingula cerebelli] limiting its formation exactly. . . .

The cavity of the skull thus bears the image of the external surface of the cerebrum, including innumerable gyri[7] and convolutions and the groove [= great longitudinal fissure] which divides it. The brain as a whole is cleft by its groove like the divided hoof of a bisulcate ungulate.[8] The groove extends over a large part of the external surface of the brain, but it disturbs its shape but little, since right and left parts are in close apposition and do not gape apart more than the thickness of the dura[9] and a double layer of tenuis.[10] For in man (otherwise than in sheep) the groove is divided by a portion or process of the dura, which, as a septum,[11] marks off two parts of the brain and, further, each part of the brain is separately enfolded by the tenuis.

Gyri and convolutions, which Erasistratus[12] most appropriately likened to coils of small intestines, are distributed over the entire surface of the brain. And there are many recesses which cut deeply into the brain substance, giving the appearance of coils of intestine, or even more to clouds as outlined by school-boys or unskilled art-students. But too much attention should not be given to the search for a resemblance since, after all, the brain of man presents nothing peculiar [in its structure] and such convolutions appear also in brains of asses, horses, oxen, and other creatures which I have so far examined. Yet perhaps it may be claimed as distinctive [of man] that Nature has in him wrought the winding sulci[13] deeper, that thereby the substance of his brain may be the richer.

8. Michelangelo, *The Last Judgment*, Sistine Chapel, Vatican, Rome, 1534–41

Gardner, p. 664, ill. 17:35; Janson, p. 500, ill. 659

Vittoria Colonna, Sonnet: "Aspiration," c. 1525
Michelangelo, Sonnet: "Tell Me, O Soul," c. 1550

During the sixteenth century, religious doubts and spiritual questions surfaced in Italy as well as in northern Europe. Many devout Catholics, anguished by the Protestant

7. Convoluted ridges of the brain.
8. Four-legged mammal with two-clefted hoof.
9. The dense, tough, outermost membraneous envelope of the brain and spinal cord.
10. Thin membrane covering the brain.
11. Thin wall dividing two cavities or masses of softer brain tissue.
12. Greek physician of the third century B.C. who rejected the then current belief in the humors as the cause of illness. Studying from dissections, he observed the convolutions of the brain, named trachea, and distinguished between motor and sensory nerves.
13. Fissures between the two convolutions of the brain.

challenges to their church's devotional practices and doctrines, searched for spiritual answers that would ignite their faith.

One such person was Vittoria Colonna (c. 1492–1547). A member of one of the wealthiest and most powerful families in Rome, Colonna was a descendant of several cardinals and the pope Martin V (1368–1431). Nonetheless, Colonna was examined for heresy about her religious beliefs by the Inquisition. Colonna came to the attention of the Inquisitors because of the religious discussions among churchmen, intellectuals, artists, and writers that she encouraged at her house in Rome.

To express her intense spiritual longings, Colonna wrote poetry. Her poems, which consist primarily of sonnets, reveal her devotion to God. Colonna dedicated her religious sonnets to the Madonna and Saint Francis. In these poems, she describes the prospect of death and the hope of salvation with the deepest outpouring of pious feeling. Her cry for a more lively faith and an evangelical purity of conviction is captured by the sonnet "Aspiration" (c. 1525), which is presented here.

Impressed by the exemplary personal character of Colonna, as well as by her intelligence, Michelangelo frequented the home of the noblewoman during the decades he lived in Rome. The religious turmoil felt by Michelangelo is reflected in art works such as *The Last Judgment*. Painted between 1534 and 1541 on the altar wall of the Sistine Chapel, this fresco includes human figures whose grotesque appearance personifies their sinful natures and who cringe in fear from a wrathful savior. The spiritual longings felt by Michelangelo are also revealed in his religious sonnets. Animated by Colonna's spirit of genuine piety, these poems describe Michelangelo's belief that the soul can be lifted to its heavenly home through its contemplation of the divine. A sonnet, "Tell Me, O Soul" (c. 1550), is presented here.

The death of Colonna reportedly affected Michelangelo so deeply that the artist became temporarily insane. Michelangelo had composed many poems for Colonna during her lifetime. After the death of the woman he trusted and admired, Michelangelo wrote many more poems, which expressed his profound sorrow for the loss of his spiritual guide and companion.

Vittoria Colonna, Sonnet[1]
Aspiration

If I have conquered self, by Heaven's strength,
'Gainst carnal reason and the senses striven,
With mind renewed and purged, I rise at length
Above the world and its false faith to heaven.
My thoughts, no longer now depressed and vain,
Upon the wings of faith and hope shall rise,
Nor sink into this vale of tears again,
But find true peace and courage in the skies.

1. Reprinted, by permission of the publisher, from Rossiter Johnson, ed., *An Anthology of Italian Authors from Cavalcanti to Fogazzaro* (New York: The National Alumni, 1907) pp. 79–80.

I fix my eye still on the better way;
I see the promise of the Eternal Day.
Yet still my trembling steps fall erringly.
To choose the right-hand path I must incline—
That sacred passage toward the life divine;
And yet I fear that life may ne'er be mine.

Michelangelo, Sonnet[2]
Tell Me, O Soul

Tell me, O soul, what file
Abrades your strength and makes it less each day?
When, freed at last from all this weary clay,
Will you return to heaven, and resume
Your innocent first smile,
After the peril of the earth, the gloom?
Being so close to the tomb,
In these remaining years
I may change outwardly, but not within,
For stronger, in weak flesh, becomes my sin.
O Love, you must be told
That I envy the dead,
And my soul is afraid
Of me, dismayed and trembling. O my Lord,
Give me, in my last hours,
Your pardoning arms! Oh steal me from myself,
And make me one of those who please you, Lord!

9. Parmigianino, *Madonna with the Long Neck,* c. 1535
Gardner, p. 669, ill. 17:41; Janson, p. 575, ill. 682; color plate 82

Scipione Arris, Letter: "The Wretched, Miserable, and Ill-Fated City of Rome," May 26, 1527

Divided as it was into small, feuding city-states, Renaissance Italy was inviting prey for foreign rulers. Between 1494 and 1515 Italy proved an easy target for the French king Louis XII (lived 1462–1515; king of France 1498–1515). In 1525 the threat of French invasion was replaced by the danger of German conquest. The Holy Roman

2. Reprinted, by permission of the publisher, from *The Complete Poems of Michelangelo,* trans. by Joseph Tusiani (London: Peter Owen, 1960). Copyright by Joseph Tusiani.

Emperor Charles V (lived 1500–1558; emperor 1519–58) assembled an army of German and Spanish mercenaries and of disaffected Italian soldiers. Since Charles was not able to raise the money to pay his mercenaries, he promised them the prospect of rich plunder. The armies of the Holy Roman Empire marched on Rome. A defenseless pope had no money with which to buy them off. On May 25, 1527, the enemy army was outside Rome. It fell upon the city of Rome with a violence that Rome had never before experienced. The city was sacked. The ferocity of the German mercenaries, in particular, was fueled not only by motives of personal gain but also by the flames of religious hatred. Many were Lutherans who harbored the deepest animosity toward the splendid capital city of the Catholic Church, toward its exalted representatives, and even toward its faithful congregations. During a week-long orgy of violence, rape, and looting, the pope was imprisoned, the cardinals were humiliated by being mockingly paraded through the streets facing backward on the backs of mules, and thousands of ordinary people were killed. The sack of Rome was described in a letter written by Scipione Arris in Urbino on May 26, 1527. He based his account upon the description of a Roman businessman who had escaped from the city after its sack and made his way to Urbino. A selection from this letter, "The Wretched, Miserable, and Ill-fated City of Rome," is presented here.

In a climate of humiliating defeat, Italian artists and humanists did their utmost to overcome national degradation and to proclaim the cosmopolitan ideal of the human family. Scholars continued to labor to recover for all Europe the heritage of Greek and Roman civilization; writers continued to explore for all Europeans the human capacities of the intellect and the spirit; artists continued to create ideals of beauty, in richly varied forms, which conveyed a message and a meaning to all European viewers, regardless of their particular nationality. The capacity demonstrated by Italian artists of the sixteenth century to create art that transcended barriers of nationality and religion is illustrated by a story told about the painter Parmigianino (1503–1540). It was reported that when the German Lutheran mercenaries broke into Parmigianino's workshop in Rome, even they were awed by the tranquil majesty of the Virgin on his easel. This majesty, combined with a sense of elegance, is evident in Parmigianino's painting *Madonna with the Long Neck* (c. 1535).

Scipione Arris, Letter[1]

The Wretched, Miserable, and Ill-Fated City of Rome

I wish I were fitter than at present, and more easy in mind, to write you of the strange, horrible, and atrocious event befallen the wretched, miserable, and ill-fated city of Rome. . . .

I therefore inform you that eight days ago last Monday, being the 18th inst., about 10:00 P.M., the . . . imperial army presented itself at the bastion

1. Reprinted, by permission of the publisher, from Edward Hutton, ed., *Memoirs of the Dukes of Urbino*, trans. by James Dennistoun (London: John Lane, 1909), vol. iii, app. II, pp. 429–32. Copyright by Random House.

of the gate. Their object was to make trial, and see how and by whom it was guarded, not having courage to attack; but after consulting together, and deciding to assault, and even to make their way into the city, they took some food, and then suddenly and all in a mass attempted with furious impetuosity to force the bastion. . . . Next day, being Tuesday, the enemy, though within the town, made no aggressions, but proceeded cautiously, dreading some ambush. Having, however, assured themselves that there was no cause for mistrust, they began to spread over the city, and to plunder the monasteries, nunneries, and hospitals, with great slaughter of those found therein. The hospital of San Spirito was destroyed, and the patients were thrown into the Tiber,[2] after which they commenced attacking the palaces of cardinals and gentlemen, with much bloodshed and cruelty. . . . The lansquenets,[3] that inhuman and villainous race of Lutheran infidels, slew without mercy those of all ages, sexes, and conditions whom they found in the streets . . . so that the dead bodies lie in heaps in the houses and palaces of the nobility, each day getting worse. Fancy the affliction of the poor ladies, seeing husbands, brothers, children massacred before their eyes, without the power of aiding them, and worse still, they were themselves killed next moment. It is not believed that had the Turk come on such an enterprise, his barbarity would have equalled that daily, continuously, and perseveringly practised by these ruffians. I cannot imagine a greater purgatory or hell than to hear the weeping and lamentation there must be in that afflicted city. . . . It is suspected that these anti-Christian dogs will put all Rome to flames; and we may anticipate that after suffering all this rapine, pillage, slaughter, and captivity, it will soon have to endure a grievous pestilence, from the number of dead bodies left in the palaces and houses, which no one removes for burial, and which are putrefying in masses, so that no one can enter, on account of the stench, without inhaling infection.

10. Correggio, *Jupiter and Io*, c. 1532
Gardner, p. 667, ill. 17:38; Janson, p. 521, ill. 694

Ludovico Ariosto, *Orlando furioso:* "Medor Plucks the First Rose," 1506–16

Sixteenth-century Italy became a battlefield of French, German, and Spanish interests. However, the spectacle of the country's woes rarely surfaced in contemporary Italian art and poetry. Instead, writers such as Ludovico Ariosto (1474–1533) and

2. A river in central Italy that flows through Rome and into the Mediterranean Sea.
3. European mercenary foot soldiers, usually armed with pikes or halberds.

painters such as Correggio (c. 1489–1534) contributed to Italian culture an appreciation for the classical past, an admiration for ideal beauty in visual and literary forms, and an acceptance of human sexuality.

Born into a patrician family, Ariosto was employed in the service of the Este family, the rulers of Ferrara. Boiardo, an Italian poet of an earlier generation who had also enjoyed Este patronage, had left unfinished his epic poem *Orlando inamorato.* Ariosto was intrigued by Boiardo's tale, in which passionate love is described as having the strength to enmesh Orlando, the greatest warrior of Christendom, in a web of sensual desire. Ariosto decided to continue the narrative.

The underlying plot of *Orlando furioso* (1506–16), the epic poem written by Ariosto, is still the Christian-Saracen struggle utilized by Boiardo. In Ariosto's poem, the Saracens, under Agramante, are besieging Paris. The threat to Christendom is met by three Christian warriors, Orlando (Roland), Oliver, and Brandimarte. Their success in defeating the pagan warriors puts an end to pagan power and ensures the peace of Western Europe.

Orlando is the hero around whom the plot of *Orlando furioso* revolves. Orlando loves Angelica, the Saracen daughter of Agramante. Held under guard in the court of Charlemagne, Angelica escapes. Orlando pursues her, only to learn that she has fallen in love with Medor, a young Saracen warrior. An enraged Orlando wreaks destruction on everything around him until he finally regains his sanity and resumes his place as the foremost Christian champion.

One section of Ariosto's poem describes Angelica upon her first encounter with the young Medor, who has been wounded in combat. The Saracen maiden nurses him back to health in a herdsman's cottage and falls in love with him. A selection from *Orlando furioso,* "Medor Plucks the First Rose," is presented here.

The eloquence of Ariosto in describing love is matched by the evocativeness of Correggio. The painter received a commission from the Duke of Mantua to paint the classical tales about the loves of the pagan god Jupiter. One work in this series, *Jupiter and Io* (c. 1532), depicts the ravishingly beautiful nymph Io yielding to the embrace of Jupiter, who comes to her in the form of a cloud.

Combining fantasy with passion, the poetry of Ariosto and the paintings of Correggio brought great delight to their patrons. In the courts of Ferrara and Mantua, poetry and art were cherished resources that provided pleasure to their cultivated and aristocratic audiences.

Ludovico Ariosto, *Orlando furioso*[1]
Medor Plucks the First Rose

Not until he was returned to health would she leave him, so much did he mean to her—for such was the tenderness which pity had evoked in her when

1. Reprinted, by permission of the publisher, from Ludovico Ariosto, *Orlando furioso,* trans. by Guido Waldman (Oxford: Oxford University Press, 1983), pp. 219–20, canto 19, stanzas 27–37. Copyright by Guido Waldman.

she had first set eyes on the prostrate youth. And later, seeing how graceful he was, and how comely, she felt her heart being grazed as by some unseen file; she felt her heart abraded and little by little smoulder and ignite with love. / The herdsman lived with his wife and children in an extremely pleasant cottage hidden in the woods between two hills; his home was newly built. Here Medor's wound, thanks to the damsel, was soon restored to wholeness—but not before she began to notice a deeper wound than his in her own heart. / In her own heart she felt a far wider, deeper wound made by an unseen arrow shot by the Winged Archer[2] from the dazzling eyes and golden curls of Medor. She felt herself on fire, devoured in flames, but it was Medor's plight she heeded, not her own. Her own she did not treat, and thought of nothing except to cure the very one who was wounding and tormenting her. / Her wound enlarged and festered in measure as his dwindled and healed. The boy grew better, she languished with a strange fever which made her hot and cold by turns. Day by day, beauty flowered in him, while the poor damsel wasted away, as a patch of snow out of season will waste when exposed on open ground to the sun. /

If she was not to die of longing, she would have to help herself without delay: it was clear to her that there was no time to wait until she was invited to take what she craved. So, snapping the reins of modesty, she spoke out as boldly with her tongue as with her eyes and asked for mercy there and then—which he, perhaps unknowingly, conceded to her. / O Count Orlando! O King of Circassia! Tell me just what good your eminent valor has gained you, what account has been taken of your honor and nobility, what reward your attentions have merited! Show me one single kindness the damsel ever did to you, at any time, to requite and reward you for all you have suffered for her sake! / O King Agrican, if you could return to life, how you would be pained, after the cruel, merciless way she rejected your advances! And Ferrau, and all you others I'll not mention, who have done great deeds without number for this thankless one, and all in vain—what a bitter blow it would be if you saw her now in this boy's arms! / Angelica let Medor pluck the first rose, hitherto untouched—no one had yet enjoyed the good fortune of setting foot in this garden.

To clothe what they had done in the trappings of virtue they were married with holy rites, Cupid standing sponsor to the bridegroom, the herdsman's wife, to the bride. / The nuptials were performed with all possible solemnity under that humble roof, and the tranquil lovers passed more than a month there in pleasurable enjoyment. The damsel could look no further than the youth. She could never have enough of him: though she clung

2. Cupid.

constantly round his neck, her appetite for him never cloyed. / Whether she remained in the shade of the house or went out of doors, day and night she kept the comely youth beside her. Morning and evening she would wander hither and yon, exploring the bank of some stream or seeking some green meadow. At noontide a cave would shelter them, doubtless no less handy and hospitable than the one which offered Dido and Aeneas[3] shelter from the rain and proved a trusty witness to their secrets. / Amid so many pleasures, whenever she saw a tree which afforded shade or a spring or limpid stream, she would hasten to carve it with a knife or pin; she did the same on any rock unless it was too hard. A thousand times out of doors, and another thousand indoors, all over the walls, Angelica's and Medor's names were inscribed, bound together in various ways with different knots.

3. In Roman mythology, Dido was the queen of Carthage and Aeneas was a Trojan prince, the son of Anchises and Venus. After the fall of Troy, he escaped. When Aeneas was shipwrecked at Carthage, he and Dido fell in love. At Jupiter's command, Aeneas left Carthage to continue his journey to Italy. Dido threw herself on a burning pyre.

11. Titian, *Madonna of the Pesaro Family*, 1519–26
Gardner, p. 685, ill. 17:61; Janson, p. 510, ill. 677

Sultan Bayezid II, Communication: "The Unwashed Gyaours and Their Ways," c. 1500

Venice had a distinctive character among the Italian city-states of the Renaissance. An important mercantile power, Venice controlled the major trade routes between Asia Minor and Europe, and reaped enormous profits from lucrative imports such as cotton, silk, drugs, slaves, fruits, wine, and spices.

By the middle of the fifteenth century, Venice had become the greatest individual power in Italy. However, the expansion of the Ottoman Empire threatened Venetian dominance of marine trade routes. After the Ottoman conquest of Constantinople in 1453, conflict between the Turks and Venetians became inevitable. Between 1464 and 1716, the Venetian republic went to war four times with the Turks. The continued struggle proved exhausting to the Venetians, who found their sovereignty over the Adriatic Sea[1] and the pathway to the Levant[2] becoming increasingly precarious.

In 1502, however, an expedition led by Jacopo Pesaro resulted in a Venetian victory. As a thanksgiving for his victory, Pesaro commissioned Titian (c. 1490–1576) to paint an altarpiece, *Madonna of the Pesaro Family* (1519–26). Included by Titian

1. Arm of the Mediterranean Sea, lying between the Italian and Balkan peninsulas. Control over the islands and peninsulas of the Adriatic was the subject of a constant duel between Venice and the Ottoman Empire.
2. Countries along the eastern Mediterranean shores associated with Venetian and other trading ventures and the establishment of commerce with cities in what is now southern Lebanon.

in the painting is a depiction of a turbaned Turk behind a soldier carrying a banner with the insignia of Pope Alexander VI. This figure may be a representation of a Turkish prisoner, Jem. The brother of Sultan Bayezid II, Jem had unsuccessfully attempted to seize the throne from his brother. Although he managed to escape his wrathful brother, Jem ended up a captive of Alexander VI.

Sultan Bayezid II was not only the brother of the hapless Jem, he was also the opponent of Jacopo Pesaro. In an official communication written during the military campaign of 1499–1502, Bayezid encourages his viziers and pashas[3] to resist a threatened Venetian invasion by deriding the courage, valor, and honor of his European foes. A selection from this communication, "The Unwashed Gyaours and Their Ways," is presented here.

Sultan Bayezid II, Communication[4]
The Unwashed Gyaours and Their Ways

You know well the unwashed Gyaours and their ways and manners, which certainly are not fine. They are indolent, sleepy, easily shocked, inactive; they like to drink much and to eat much; in misfortunes they are impatient, and in times of good fortune proud and overbearing. They are lovers of repose and do not like to sleep without soft feather-beds; when they have no women with them they are sad and gloomy; and without plenty of good wine they are unable to keep counsel among themselves. They are ignorant of any military stratagems. They keep horses only to ride while hunting with their dogs; if one of them wishes to have a good war-horse, he sends to buy it from us. They are unable to bear hunger or cold, or heat, effort and menial work. They let women follow them in the campaigns, and at their dinners give them the upper places; and they want always to have warm dishes. In short, there is no good in them. . . .

And then the Christians fight constantly among themselves, because everyone desires to be a king, or a prince, or the first amongst them. One says to another, "Brother, help thou me today against this Prince, and to-morrow I will help thee against that one." Fear them not, there is no concord amongst them. Everyone takes care of himself only; no one thinks of the common interest. They are quarrelsome, unruly, self-willed and disobedient. Obedience to their superiors and discipline they have none, and yet everything depends on that.

When they lose a battle they always say, "We were not well-prepared";

3. High-ranking officials in the Ottoman government.
4. Reprinted, by permission of the publisher, from C.R.N. Routh, ed., *They Saw It Happen in Europe: An Anthology of Eyewitnesses' Accounts of Events in European History, 1450–1600* (New York: Barnes and Noble, 1966), pp. 396–97. Copyright by Blackwell and Mott.

or, "This or that traitor has betrayed us"; or, "We were too few in number and the Turks were far more numerous"; or, "The Turks came upon us without previous declaration of war, by misleading representations and treachery. They have occupied our country by turning our internal difficulties to their own advantage."

Well, that is what they say, being not willing to confess truly and rightly: "God is on the side of the Turks. It is God who helps them and therefore they conquer us."

12. Titian, *Sacred and Profane Love*, 1513
Gardner, p. 648; ill. 17:60

Titian, *Bacchanal*, 1518 Janson, p. 509, ill. 676

Pietro Aretino, *Dialogues:* "What Nanna Spied in the Convent," 1534–35.

Venice offered a greater degree of liberty to writers and artists than did any other sixteenth-century Italian city. So long as their political allegiance to the state was beyond suspicion, individuals were essentially free to do as they chose. Because this freedom was extended to literature and the visual arts, Venice was an appealing residence for the writer Pietro Aretino (1492–1556) and for the painter Titian (c. 1490–1576), both of whom explored the subject of human sexuality.

The illegitimate son of a prostitute, Aretino determinedly set out to exchange poverty for riches. In his early years he entered the service of Agostino Chigi, where his willingness to satisfy every type of sexual appetite made him a popular courtier in a group of wealthy Italian noblemen. In his later years he fashioned an elaborate system of blackmail that furnished him with an opulent Venetian palace, a stable of magnificent horses, and a harem of women.

But Aretino's outward success cost him any faith in the goodness of human nature. As a writer, Aretino reveals himself to be a terrible pessimist who sees in his age only a miserable and distorted picture of depravity, repulsiveness, and obscenity. Love is treated by him as a grotesque masquerade in which men and women are goaded by their lust and greed into indiscriminate acts of human copulation.

The most famous of Aretino's writings is the two-volume book called the *Dialogues* (1534–35). The first volume consists of three conversations between Nanna, a woman of wide experience, and her friend Antonia. In these conversations, Nanna describes the lives of nuns, of married women, and of courtesans. The second volume includes two conversations between Nanna and her daughter Pippa. In these conversations, Nanna offers instructions for becoming a successful whore and for foiling the wicked ruses and rogueries of men.

According to her account of her own life, Nanna has spent periods of time as a nun, a wife, and a courtesan. In her first conversation with Antonia, Nanna recalls her entry into a convent as a young girl, and she describes the curious events she witnessed through a peephole on her first night in the convent. A selection from the first volume of the *Dialogues,* "What Nanna Spied in the Convent," is presented here.

Aretino was a close friend of the painter Titian. In paintings such as *Sacred and Profane Love* (1513) and *Bacchanal* (1518), Titian probes the human capacity for sensual pleasure and physical fulfillment that is the predominant theme in the *Dialogues.* In that book, the Venetian author describes human sensuality as evidence of the vileness of human nature, the perfidy of all human attachments, and the hypocrisy of any profession of spiritual belief. In contrast, the Venetian painter accepted sensuality as a beneficial drive in human nature and associated the expression of physical love with an individual's aspirations toward the attainment of spiritual beauty and divine love.

Pietro Aretino, *Dialogues*[1]
What Nanna Spied in the Convent

As I was torn by these conflicting thoughts, I heard a loud peal of laughter, so carefree that it would have cheered up a dead man. Since the sound kept growing louder and louder, I decided to find out where it was coming from. Rising to my feet, I put my eye to a crack in the wall, and since one sees better in the dark with one eye rather than two, I stood on tiptoe, shut my left eye, and looking with my right through the slit between the bricks, I saw . . .

Antonia What did you see? Tell me, please!

Nanna In the cell I saw four sisters, the General, and three milky-white and ruby-red young friars, who were taking off the reverend father's cassock[2] and garbing him in a big velvet coat. They hid his tonsure[3] under a small golden skullcap, over which they placed a velvet cap ornamented with crystal droplets and surmounted by a white plume. Then, having buckled his sword at his side, the blissful General, to speak frankly, started strutting back and forth with the big-balled stride of a Bartolommeo Colleoni.[4] In the meantime the sisters removed their habits and the friars took off their tunics. The latter put on the sisters' robes and the sisters—that is, three of them—put on the friars'. The fourth nun rolled herself up in the General's cassock, seated

1. Reprinted, by permission of the publisher, from *Aretino's Dialogues,* trans. by Raymond Rosenthal (New York: Stein and Day, 1971), pp. 27–29. Copyright by Raymond Rosenthal.
2. A long, close-fitting tunic worn by a clergyman.
3. The part of a priest's or monk's head left bare by shaving.
4. A famous condottiere who fought for both Milan and Venice and who tried to carve out his own state in northern Italy.

herself pontifically, and began to imitate a superior laying down the law for the convent.

Antonia What pretty pranks!

Nanna Now it becomes prettier.

Antonia Why?

Nanna Because the reverend father summoned the three friars and leaning on the shoulder of one of them, a tall, soft-skinned rascal who had shot up prematurely, he ordered the others to take his little sparrow, which was resting quietly, out of its nest. Then the most adept and attractive young fellow of the bunch cradled the General's songster in the palm of his hand and began stroking its back, as one strokes the tail of a cat which first purrs, then pants, and soon cannot keep still. The sparrow lifted its crest, and then the doughty General grabbed hold of the youngest, prettiest nun, threw her tunic over her head, and made her rest her forehead against the back of the bed. Then deliberately prying open with his fingers the leaves of her asshole Missal[5] and wholly rapt in his thoughts, he contemplated her crotch, whose form was neither close to the bone with leanness nor puffed out with fat, but something in between—rounded, quivering, glistening like a piece of ivory that seems instinct with life. Those tiny dimples one sees on pretty women's chins and cheeks could also be seen on her dainty buttocks, whose softness was softer than that of a mill mouse born and raised in flour, and that nun's limbs were all so smooth that a hand placed gently on her loins would have slid down her leg as quickly as a foot slides on ice, and hair no more dared grow on her than it would on an egg.

Antonia So the father General consumed his day in contemplation, eh?

Nanna No, I wouldn't say he consumed it, because placing his paintbrush, which he first moistened with spit, in her tiny color cup, he made her twist and turn as women do in the birth throes or the mother's malady. And to be doubly sure that his nail would be driven more tightly into her slit, he motioned to his back and his favorite punk pulled his breeches down to his heels and applied his clyster[6] to the reverend's *visiblium,* while all the time the General himself kept his eyes fixed on the two other young louts, who, having settled the sisters neatly and comfortably on the bed, were now pounding the sauce in the mortar to the great despair of the last little sister. Poor thing, she was so squint-eyed and swarthy that she had been spurned by all. So she filled the glass tool with water heated to wash the messer's hands, sat on a pillow on the floor, pushed the soles of her feet against the cell wall, and then came

5. Missal refers to the Mass or to a priest who performs the Mass.
6. A pipe or syringe injected in the rectum.

straight down on that great crozier,[7] burying it in her body as a sword is thrust into a scabbard. Overcome by the scent of their pleasure, I was more worn out than pawns[8] are frayed by usury,[9] and began rubbing my dear little monkey with my hand like cats in January rub their backsides on a roof.

Antonia Ha ha ha! And how did the game end?

Nanna When they had pushed and squirmed and twisted for half an hour, the General suddenly cried: "Now all at the same time, and you, my dear boys, kiss me, and you too, my dove!" and holding one hand on the lovely angel's box and with the other fondling the cherub's behind, now kissing him, now kissing her, he wore that frowning look the marble statue at the Vatican Museum gives the snakes that are strangling him between his sons.[10] In the finale the nuns on the bed with the two young men, the General and the sister he was mounted on, together with the fellow at his behind, and, last of all, the nun with her Murano[11] prodder, all agreed to do it together as choristers sing in unison, or more to the point, as blacksmiths hammer in time, and so, each attentive to his task, all that one heard was: "Oh my God, oh my Christ!" "Hug me!" "Ream me!" "Push out that sweet tongue!" "Give it to me!" "Take it!" "Push harder!" "Wait, I'm coming!" "Oh Christ, drive it into me!" "Holy God!" "Hold me!" and "Help!" Some were whispering, others were moaning loudly—and listening to them you would have thought they were running the scales, *sol, fa, me, re, do*—their eyes popping out of their heads, their gasps and groans, their twistings and turning making the chests, wooden beds, chairs, and chamber pots shake and rattle as if the house had been hit by an earthquake.

Antonia My goodness!

Nanna Then eight great sighs rose all at once, straight from the liver, lungs, heart, and soul of the reverend et cetera, the sisters and the little friars, raising so strong a wind that it would have snuffed out eight great torches. And as they sighed they collapsed from weariness, like drunks drop to the floor from too much wine. And I who had been almost unstrung by the discomfort of watching them, adroitly withdrew and, sitting down, stared at that glass affair.

Antonia Wait a minute. How could you count eight sighs?

Nanna Now you're being too picky. . . .

7. A pastoral staff, or cross, of a bishop or abbot.
8. Things that are exchanged as security for a loan of money.
9. The practice of lending money at an exorbitant rate of interest.
10. The Laocoön.
11. A Venetian island famous for its glassworks.

13. Tintoretto, *The Last Supper,* **1594**
Gardner, p. 689, ill. 17:66; Janson, p. 518, ill. 689

Canons and Decrees of the Council of Trent: "The Sacrament of the Eucharist," 1534–63

As the Protestant Reformation gained ground in northern Europe, the Catholic Church realized the need for action. Between 1536 and 1545, Pope Paul III (lived 1468–1549; pope 1534–49) repeatedly called for a general council, but was forced to postpone it for political reasons. The council finally met in Trent, a city in the Italian Alps, on December 15, 1545. Its meetings extended over an eighteen-year period.

Ostensibly an assembly of all Christendom, the council in fact rejected reconciliation with the Protestants and instead responded aggressively to the Lutheran challenge. One of its most important actions was to reassert the Catholic position on all major points of theological controversy.

A sharply disputed doctrine concerned the nature of the Eucharist, or Lord's Supper. The words of Christ's institution of the sacrament, "This is my body . . . this is my blood," had been the subject of much speculation in the medieval church. Theologians had puzzled over the meaning of the transformation of bread and wine into the flesh and blood of Christ. After much debate, the church had, in 1215, accepted the doctrine of transubstantiation. This doctrine states that, after the words of consecration, there is a change in the substance of the Eucharistic elements to Christ's actual body and blood.

Luther, however, rejected the church position on the Eucharist and formulated the doctrine of consubstantiation. This doctrine states that, after the words of consecration, the substances of bread and wine remain, along with Christ's body and blood.

The Council of Trent reaffirmed the doctrine of transubstantiation and denounced the doctrine of consubstantiation as heresy. A selection from the *Canons and Decrees of the Council of Trent* (1545–63), "The Sacrament of the Eucharist," is presented here.

Christ's institution of the Eucharist was depicted by the Venetian artist Tintoretto (1518–1594) in *The Last Supper* (1594). This painting, commissioned by the Catholic church of San Giorgio Maggiore in Venice, shows Christ administering the sacrament to his disciples in a pose that suggests the priest's gestures toward his congregation. In the painting, Tintoretto has emphasized the miraculous nature of the sacrament in accordance with the pronouncements of the Council of Trent.

Canons and Decrees of the Council of Trent[1]
The Sacrament of the Eucharist

On the most holy sacrament of the eucharist.

If anyone denies that, in the sacrament of the most holy eucharist, are contained truly, really and substantially, the body and blood together with the soul and divinity of our Lord Jesus Christ, and consequently the whole Christ; but says that He is only therein as in a sign, or in figure, or virtue; let him be anathema.[2]

If anyone says that, in the sacred and holy sacrament of the eucharist, the substance of the bread and wine remains conjointly with the body and blood of our Lord Jesus Christ, and denies that wonderful and singular conversion of the whole substance of the bread into the Body, and of the whole substance of the wine into Blood—the species only of the bread and wine remaining—which conversion indeed the Catholic Church most aptly calls Transubstantiation; let him be anathema. . . .

If anyone says that, after the consecration is completed, the body and blood of our Lord Jesus Christ are not in the admirable sacrament of the eucharist, but are there during the use, whilst it is being taken, and not either before or after; . . . let him be anathema. . . .

If anyone says that Christ, given in the eucharist, is eaten spiritually only, and not also sacramentally and really; let him be anathema. . . .

If anyone says that faith alone is sufficient preparation for receiving the sacrament of the most holy eucharist; let him be anathema. And for fear lest so great a sacrament may be received unworthily, and so unto death and condemnation, this holy Synod ordains and declares that sacramental confession, when a confessor may be had, is of necessity to be made beforehand by those whose conscience is burdened with mortal sin, how contrite even so ever they may think themselves. But if any one shall presume to teach, preach or obstinately to assert, or even in public disputation to defend the contrary, he shall be thereupon excommunicated.

1. Reprinted, by permission of the publisher, from *The Canons and Decrees of the Council of Trent,* trans. by James Waterworth (Chicago: The Christian Symbolic Publication Society, 1848), pp. 82–84.
2. The great curse of the church, cutting off a person from the communion of the church and formally handing him or her over to Satan.

14. El Greco, *The Burial of Count Orgaz,* 1586
Gardner, p. 746, ill. 18:59; Janson, p. 519, ill. 691

Ignatius Loyola, *Spiritual Exercises:* "Meditation on the Agony of Death," c. 1522

Even before the meeting of the Council of Trent, the pope had acquired an army to combat heresy and to spread Catholicism—the Jesuits. The Society of Jesuits, a monastic order of religious men, was founded in 1541 by Ignatius Loyola (1491–1556).

A Spanish aristocrat, Loyola had been a soldier in his youth. While recovering from a crippling war wound, he determined to be a knight in the service of God. He dedicated seven years to theological studies at the Sorbonne University in Paris, after which he and six companions went to Rome. Vowing to serve Christ and the pope as his vicar on earth, Loyola and his devout group asked permission from Pope Paul III (lived 1468–1549; pope 1534–49) to found an order to carry on spiritual and charitable works.

Upon winning the pope's approval, Loyola became the first head of the Society of Jesuits. Although religious, the order under Loyola's direction was organized along a quasi-military plan, with its members being subject to rigorous demands and being required to offer unquestioning obedience.

About 1522 Loyola wrote a treatise, *Spiritual Exercises,* in which he enunciated for his followers a program of spiritual discipline. The book is intended to be read not so much as a theological document but rather as a handbook for the practice of self-denial and self-denigration. It instructs believers to consider the circumstances of human sinfulness and unworthiness; it directs believers to deepen their meditations; it charges believers to turn themselves into instruments of God's will. The object of this text is entirely practical—to create for God soldiers astute in combat and faithful unto death. A long line of Jesuit martyrs proved to be both. A selection from the *Spiritual Exercises,* "Meditation on the Agony of Death," is presented here.

The Catholic Church in Spain was admired for the high moral level it maintained even when standards in Rome had fallen to abysmal depths. Ignatius Loyola exhibits a fervent dedication to the cause of Catholic Christianity that originated in Spain and became international. The same fervent commitment to spiritual ideals is exhibited by the artist El Greco (c. 1547–1614). Born in Greece, El Greco emigrated to Italy as a young man. When he was approximately thirty years old, he moved to Spain and adopted Toledo as his permanent home. His painting *The Burial of Count Orgaz* (1586) is testimony to the ardor that Catholic tenets of faith inspired in El Greco, as they had done earlier in Ignatius Loyola.

Ignatius Loyola, *Spiritual Exercises*[1]
Meditation on the Agony of Death

Contemplate—(1) Your apartment faintly lighted by the last rays of day, or the feeble light of a lamp; your bed which you will never leave except to be laid in your coffin; all the objects which surround you and seem to say, You leave us for ever! (2) The persons who will surround you: Your servants, sad and silent; a weeping family, bidding you a last adieu; the minister of religion, praying near you and suggesting pious affections to you. (3) Yourself stretched on a bed of pain, losing by degrees your senses and the free use of your faculties, struggling violently against death, which comes to tear your soul from the body and drag it before the tribunal of God. (4) At your side the devils, who redouble their efforts, to destroy you; your good angel, who assists you for the last time with his holy inspirations. . . .

Listen to the monotonous sound of the clock which measures your last hours, and says at each movement, Behold yourself a second nearer to the tribunal of God; the sound of your painful labored breathing, and that terrible rattle, the forerunner of death; the stifled sobs of those who surround you; the prayers of the Church recited in the midst of tears. . . .

Imagine yourself holding in your feeble hands the crucifix, which the priest presents to you; imagine yourself touching your own body, which will soon be only a corpse. How cold your feet! Your arms, shrivelled by sickness, begin to stiffen. How painfully your chest labors with your unequal breathing, which soon will cease! Your heart, which beats with a scarcely perceptible movement, your face hollowed by fever and covered with cold sweat—is it not in this state you have seen friends, near relatives, dying? It is in this state your friends and relatives will see you before long. Make these reflections to-day, which your agony will soon inspire in those who witness it. . . .

Consider—1. A few moments after your death. Your body laid on a funeral bed, wrapped in a shroud, a veil thrown over your face; beside you the crucifix, the holy water, friends, relatives, a priest kneeling by your sad remains, and reciting the holy prayers, "De profundis clamavi ad te, Domine";[2] the public officer who writes in the register of the dead all the particulars of your decease,—such a death, such a year, such a day, such an hour,—the servants all occupied with the preparation for your funeral.

The day after your death. Your inanimate body enclosed in a coffin, covered with a pall, taken from your apartment, sadly carried to the foot of

1. Reprinted, by permission of the publisher, from *Manresa: Or the Spiritual Exercises of St. Ignatius,* new ed. (London: Burns, Oates and Washbourne, 1881), pp. 84–89.
2. "Out of the depths I have cried to you, O Lord."

the altar, received by the priest of Jesus Christ; deposited before the Lord present in the Tabernacle;[3] then, the Holy Sacrifice over, laid in its last home, the grave. Consider well the dismal field where the eye sees nothing but tombs; this open grave where they are laying your body, the priest who blesses you for the last time, your relatives and friends who contemplate the spectacle with fear, the grave-digger who ends the scene by throwing earth on your coffin.

Some months after your death. Contemplate this stone already blackened by time, this inscription beginning to be effaced; and under that stone, in that coffin which is crumbling bit by bit, contemplate the sad state of your body; see how the worms devour the remains of putrid flesh; how all the limbs are separating; how the bones are eaten away by the corruption of the tomb! See what remains of the body you have loved so much!—a something which has no name in any tongue, and on which we cannot think without disgust. . . .

Imagine yourself respiring the odor your body exhales when the soul is departed; the infection it would give out, if it were taken from the coffin a few months after your death. Imagine you touch this damp earth, where they have laid you; this shroud in which they have wrapped you, and which is now in rags; this bare skull, once the seat of thought; these dismembered limbs, which once obeyed all orders of your will;—in fine, this mass of corruption, which the sepulchre has enclosed a few months, and the sight of which is horrible. In [the] presence of this terrible scene, ask yourself what are health, fortune, friendship of the world, pleasures of the senses, life itself: "Vanity of vanities, all is vanity" (Eccles. i. 2).

End by a colloquy with our Saviour dying: "Into Thy hands I commend my spirit, O Lord."

15. Paolo Veronese, *Christ in the House of Levi*, 1573
Gardner, p. 690, ill. 17:67; Janson, p. 522, ill. 696

Giordano Bruno, *The Expulsion of the Triumphant Beast:* "A Magic and Most Efficacious Doctrine," 1584

Among the weapons used by the Catholic Church to defend its orthodox faith was the Roman Inquisition. As an arm of the church, the Inquisition had been in existence for many centuries, but in 1542 Pope Paul III (lived 1468–1549; pope 1534–49) instituted

3. Portable sanctuary recalling the sanctuary constructed by Moses as a place of worship for the Hebrew tribes during the period of wandering that preceded their arrival in Israel, their promised land.

the Inquisition on Italian soil and granted the inquisitors-general wide discretion and great authority in rooting out heresy. No one was immune. Nobles, cardinals, and scholars alike were charged, imprisoned, tortured, and executed. Fear gripped whole sections of the Italian people and paralyzed intellectual life.

The Inquisition enforced orthodoxy in art as well as in literature, philosophy, and theology. The Venetian artist Paolo Veronese (1528–1588) was taken to trial by the Inquisition when he painted a depiction of the Last Supper in 1573. Following a long-standing tradition of embellishing Scriptural representations with figures invented by the artist, Veronese included servants, clowns, dwarfs, and dogs in the company of Christ and the disciples. The Council of Trent, however, had advised artists to confine themselves strictly to representations of Biblical scenes as they were described in Scriptural texts; Veronese was therefore ordered to make changes. Rather than do so, he changed the name of his painting to the title by which it is now known, *Christ in the House of Levi*.

The Inquisition was less permissive to the writer Giordano Bruno (1548–1600). Bruno had a reputation for controversial ideas and flamboyant behavior. A lapsed member of the Dominican order, Bruno had become fascinated by a collection of texts called the *Corpus hermeticum*. These treatises, which had been located by Cosimo de' Medici in 1460, were incorrectly believed by Renaissance scholars to have been written about 1500 B.C. by an Egyptian priest named Hermes Trismegistus. A mixture of astrology, alchemy, magic, number mysticism, pagan myth, and secret lore, the writings were regarded by Renaissance intellectuals as a direct vehicle of spiritual truth.

Deeply impressed by the Hermetical texts, Bruno propounded a pantheistic view of the universe in which he proposed that all nature and all existence, both animate and inanimate, were suffused with divinity. Moreover, he claimed that the concept of God was revealed as clearly in pagan religions as in Christianity.

The most complete discussion by Bruno of Hermetic theology is found in his book *The Expulsion of the Triumphant Beast* (1584). In one section of the text, Sophia, the Byzantine goddess of wisdom, explains to Saul, the wise man of the Old Testament, that spiritual truth is to be found in Egyptian and Greek worship. A selection from *The Expulsion of the Triumphant Beast,* "A Magic and Most Efficacious Doctrine," is presented here.

While he was living in Venice, Bruno was denounced to the Inquisition. After serving seven years in prison, he was condemned on multiple charges of heresy, apostasy, blasphemy, and misconduct. One of Bruno's books, which was regarded as heretical, was entitled *Ash Wednesday Supper* (1584). Ironically, Bruno's last night on earth was Ash Wednesday (February 17), 1600.[1]

1. Ash Wednesday is the first day of Lent, the period of forty weekdays preceding Easter. The beginning of this period of fasting and repentance is symbolized by placing ashes on the heads of each member of the religious congregation.

Giordano Bruno, *The Expulsion of the Triumphant Beast*[2]
A Magic and Most Efficacious Doctrine

Those worshipers, then, in order to procure certain benefits and gifts from the gods through the knowledge of profound magic, entered into the midst of certain natural things in which, in such manner, Divinity was latent and through which she was able to and wanted to impart herself to such effects. Therefore, those ceremonies were not vain fantasies, but live words which touched the very ears of [the] gods. Just as [the gods] want to be understood by these worshipers, not through utterances of language, which they may be able to contrive, but through utterances of natural effects, they wished to strive to be understood by [the gods] through these utterances, as well as through acts of ceremonies. . . .

Those wise men knew God to be in things, and Divinity to be latent in Nature, working and glowing differently in different subjects and succeeding through diverse physical forms, in certain arrangements, in making them participants in her, I say, in her being, in her life and intellect; and they therefore, with equally diverse arrangements, used to prepare themselves to receive whatever and as many gifts as they yearned for. Then, for victory, they libated[3] to magnanimous Jove[4] in the eagle, where, in accordance with such an attribution, Divinity is latent. For prudence, in their sacrifices to sagacious Jove, they libated to the serpent; against betrayal, they libated to menacing Jove in the crocodile. So for other innumerable ends, they libated to other innumerable species. All of this was done not without a magic and most efficacious doctrine. . . .

Thus the eternal gods (without placing any inconvenience against that which is true and divine substance) have temporal names, some in some times and nations, others in others. As you can see from revealing stories, Paul of Tarsus was named Mercury[5] and Barnabas the Galilean was named Jove, not because they were believed to be those gods themselves, but because men believed that that divine virtue that was found in Mercury and in Jove in other times then found itself present in these, because of the eloquence and persuasion that were in the one and because of the useful effects that proceeded from the other.

2. Reprinted, by permission of the publisher, from Giordano Bruno, *The Expulsion of the Triumphant Beast*, trans. and ed. by Arthur D. Imerti (Brunswick, N.J.: Rutgers University Press, 1964), pp. 236–39. Copyright by Arthur D. Imerti.
3. Poured out an offering in honor of a god.
4. In Roman religion, the supreme god. Associated with rain and agriculture, he developed into the great father god and prime protector of the state.
5. In Roman religion, the god of commerce and the messenger of the gods.

Here then is why it is the crocodiles, roosters, onions, and turnips were worshiped, but were worshiped as gods and Divinity in crocodiles, in roosters, and in other things. This Divinity in certain times and periods, places, and regions, successively and at the same time, found, finds, and will find herself in various subjects, which, although they are mortal, have a relationship with Divinity according to how close to and familiar she is with them, not according to what she is in herself, that is, most exalted, absolute, and without association with things produced. You see then that there is one simple Divinity found in all things, one fecund Nature, preserving mother of the universe insofar as she diversely communicates herself, casts her light into diverse subjects, and assumes various names. See how we must diversely ascend to her by partaking of various endowments; otherwise we, in vain, attempt to contain water in nets and catch fish with a shovel.

Then they attribute the life that gives form to things to two most important principles, that is to say, to the two bodies that are most important in the neighborhood of our globe and maternal divinity, the sun and the moon. Afterward, they construed that life according to seven other principles, distributed it among seven lights called wandering lights, to which, as like unto an original principle and fecund cause, they reduced the difference of species of any genus whatsoever, saying of plants, of animals, of rocks, of influences, and of many other things that these were Saturn's,[6] these Jove's, these Mars's, these and those things of this and the other. So it is with parts, with members, with colors, with seals, with characters, with signs, with images, which are distributed into seven species. But they did not fail, because of this, to construe that there is found in all things, Divinity, who, since she diffuses and imparts herself in innumerable ways, has innumerable names and who, by innumerable paths with principles pertaining and appropriate to each way, is sought after as we honor and cultivate her with innumerable rites, because we seek to receive from her innumerable kinds of favors.

6. In Roman religion, the god of harvests.

Fifteenth-Century Northern European Art

1. Stephan Lochner, *Madonna in a Rose Garden,* **c. 1430–35**
Gardner, p. 718, ill. 18:25

Conrad Witz, *The Miraculous Draught of Fishes,* **1444**
Gardner, p. 719, ill. 18:26; Janson, p. 436, ill. 561

Ulrich Richental, *The Chronicle of the Council of Constance:* "The Unity of Holy Christendom" and "How Hus Came to Constance and Was Burned," c. 1420–30

In northern Europe, the Renaissance brought innovations in philosophical thought, literary language and style, scientific attitudes, and approaches to art. At the same time, however, the spiritual temper of the Middle Ages was largely unaffected by the new humanist ideas that had emerged in Europe. This religious continuity is evident in northern European paintings. Be it through the gentle charm of the altarpiece *Madonna in the Rose Garden* (c. 1430–35) by Stephan Lochner (c. 1400–1451) or through the studied realism and sculptural forms of the painting *The Miraculous Draught of Fishes* (1444) by Conrad Witz (c. 1400–1447), northern painters expressed their sincere conviction in the Christian faith.

The spirituality expressed by these artists was, nonetheless, threatened by divisions within the Western church. At the beginning of the fifteenth century, the prestige of the institutional church reached a low ebb. The circumstance that most damaged the authority of the papacy was the Great Schism.

Through the political maneuvering of the French, German, Italian, and English rulers, three churchmen became claimants to the papal throne: Benedict XIII, who was supported by France; Urban VI, who was recognized by England and Germany; and John XXIII, who was backed by Italian factions.

The rivalry among three supposed popes, each claiming to hold the keys to heaven,[1] made a mockery of the church's self-proclaimed role as a path to salvation. As religious insecurity among the faithful mounted, calls for reform of the church intensified. Finally, a general church council met in Constance, Germany, between 1414 and 1418. This council achieved its objective of ending the schism by obtaining the abdication of Gregory XII, deposing Benedict XIII, and convicting John XXIII on fifty-four counts of fornication, adultery, incest, sodomy, and other offenses. A conclave of cardinals elected a new leader, the Roman cardinal Colonna, who took the name Martin V (lived 1368–1431) and who held the papacy from 1417 until his death in 1431.

In addition to restoring the unity of the church under a single pope, the Council of Constance declared its intention of wiping out heresy. One person against whom the council directed its efforts was the Czech reformer John Hus (c. 1370–1415).

Born in southern Bohemia, Hus advocated universal literacy so that devout ordinary people could read the Bible themselves and, thereby, obtain personal salvation without the intercession of the organized church. Hus and his followers also criticized the supremacy exercised by German rulers over secular and church affairs in Bohemia. The German emperor Sigismund (ruled 1411–37) feared his authority in Bohemia was threatened by the surge of Czech nationalistic fervor unleashed by Hus. He therefore urged Hus to appear before the Council of Constance to defend himself against charges of heresy. As presiding officer of the council, he promised Hus a safe-conduct, and, then, having taken Hus into his custody, repudiated his own guarantee of safety. The result of Hus's trial was certain from the outset. He was condemned and burned at the stake.

A diplomatic member of Sigismund's legation, Ulrich Richental (died 1439), witnessed the actions of the Council of Constance. Sometime between 1420 and 1430, he wrote a lengthy account of the participants' deliberations and deeds. Two selections from Richental's *Chronicle of the Council of Constance* are presented here. The first selection, "The Unity of Holy Christendom," describes the council's successful efforts to end the schism. The second selection, "How Hus Came to Constance and Was Burned," describes the council's dealings with John Hus.

Ulrich Richental, *The Chronicle of the Council of Constance*[2]
The Unity of Holy Christendom

These kingdoms, composing the five nations, all had excellent and fitting ambassadors at Constance, whether Christian or not. Their ambassadors

1. According to Christian tradition, the disciple Peter had been given the "keys to heaven" by Jesus himself (Matthew 16:18–19). The pope receives his authority as direct successor to Peter, first bishop of Rome and holder of the keys.
2. Reprinted, by permission of the publisher, from John Hine Mundy and Kennedy M. Woody, eds., *The Council of Constance*, trans. by Louise Ropes Loomis (New York: Columbia University Press, 1961), pp. 108, 109, 127, 167–68. Copyright by Columbia University Press.

were fit and learned folk, spiritual and temporal, Christian or not, and they each and all had full and sufficient authority from their lords, with letters and seals.

The nations met every day, each nation in a conclave, that is, in a hall. And each nation had its proper delegates, who were learned in theology and who were sent from one nation to another whenever a plan was being discussed. . . .

Now begin I to tell of the Council, how the nations, the cardinals, the universities, and the archbishops debated with the King as to what was next and best to do to unite Holy Christendom. . . .

On the eve [May 29] of Corpus Christi,[3] a session was held and all the spiritual and temporal princes and lords were present with one harmonious accord, for they all were of the same mind and no man spoke to the contrary. They deposed the popes and put them under bonds and took their authority from them. The first was John XXIII, who is now called Baldassare Cossa, the next Gregory XII, now called Angelo Corario, and the last Benedict XIII, now called Pedro de Luna. Baldassare Cossa was brought from Radolfzell to Gottlieben, below Constance, and there the heinous articles and charges of wrongdoing that had been proved against him were read to him, and he was sentenced to perpetual imprisonment. . . .

On Friday [November 12] after St. Martin's Day, Our Holy Father Pope Martin V was consecrated evangelist[4] in the palace and took the name of Martin. On the Saturday [November 13] after St. Martin's Day, he was consecrated priest in the palace. On Sunday morning, he was consecrated bishop. On the Monday [November 15] after St. Martin's Day, all the patriarchs, archbishops, and secular clergy did him obedience. On the Tuesday [November 16] after St. Martin's, all the black monks (that is Benedictines and Cistercians) and abbots and monks of every order did him obedience. On Wednesday, all the mendicant orders, our lord King, all the temporal princes and lords, and all the envoys of kings, lords, and prelates, in their lords' names did him obedience.

Then on Friday and Saturday before St. Catherine's Day, November 20, anno Domini 1417, for two days, they put up seats, benches, and tables in the choir and nave of the cathedral of Constance. The next day, the Sunday [November 21] before St. Catherine's Day . . . they consecrated Our Holy Father Pope Martin V as pope. Between the cupboard and the tabernacle

3. A church festival in honor of the real presence of Christ in the Eucharist, observed on the Thursday after Trinity Sunday.
4. In addition to referring to any of the writers of the Gospels, the world evangelist can designate a patriarch or pope of the church.

where the Sacrament was kept a beautiful throne had been set up, on which the Pope sat. Beyond the tabernacle was a table on which stood twelve burning candles, the Sacrament, the holy oil, the chrism,[5] and many wisps of flax.[6] Before the high altar was a table on which stood four burning candles, two loaves of white bread, and two silver vessels of wine. On the altar were placed all the relics[7] that were then in Constance, a white miter,[8] a miter encircled with three crowns, and the golden rose that Pope John gave the King. In the middle of the nave another throne was set up, where the Pope sat and rested when first they brought him into the cathedral and where they offered him the burning wisps of flax, with the chant *Pater Sancte, sic transit gloria mundi* [Holy Father, so passes the glory of the world].

Ulrich Richental, *The Chronicle of the Council of Constance*[9]
How Hus Came to Constance and Was Burned

Now leave we the Council until you hear how Hus and Jerome[10] came to Constance and were burned. When first the Council came to Constance and began its sessions, it was determined to condemn unbelief and extirpate heresy in Bohemia. A summons was sent to Hus and Jerome to appear before its court, and they were put under excommunication.[11] But they paid no heed and refused to yield to the ban and the sentence. So the Council wrote to King Wenzel of Bohemia to perform a service for the Christian faith and send the two to Constance, since the foundations and doctrines of all Christendom were there assembled. They requested our lord King of the Romans[12] also to write his brother about it. He did so, but still they would not come. Then our lord, the Roman King, dispatched to Master John Hus a free safe-conduct, with document and seal, to ensure his coming and return. He sent him also an escort. . . .

5. Consecrated oil used in various rites of anointment and in certain sacraments.
6. Small bundles of flax, from which the linen fiber is produced and which has been twisted for use as torches.
7. A relic is a part of the body or some personal memorial of a saint, martyr, or other sacred person.
8. The official headdress of a bishop, the miter is a tall cap that rises to a point.
9. Reprinted, by permission of the publisher, from John Hine Mundy and Kennedy M. Woody, eds., *The Council of Constance*, trans. by Louise Ropes Loomis (New York: Columbia University Press, 1961), pp. 129, 130, 132–33, 134. Copyright by Columbia University Press.
10. Jerome of Prague (c. 1370–1416) was a Bohemian religious reformer who joined forces with Hus. Jerome went to the Council of Constance to defend Hus. Arrested while trying to escape from Constance, Jerome was imprisoned. After the burning of Hus, he recanted his defense. But his sincerity was doubted and he was not released. In 1416 he withdrew his recantation, and was burned as a heretic.
11. Being cut off by ecclesiastical sentence from communion or membership, especially from the sacraments and services of the church.
12. The German emperor Sigismund held the title Holy Roman Emperor, and was sometimes known as King of the Romans.

At the stroke of one after dinner, Lord Henry Latzenborck took Hus and his chaplain on horseback, with himself and many other Bohemians, and brought them to the upper court of the palace, to Pope John. Then Hus said they should not throw him into prison because he had a safe-conduct. Latzenborck replied: "You must set yourself right, or you may die of this." Thereupon Hus leaped suddenly from his horse and tried to run in among the Bohemians, for there were more than eighteen thousand people in the court who had heard that they were bringing him before the Pope. When the Pope's guards, who carry the silver staves[13] and drums, saw this, they caught and brought him into the palace and shut him in, leaving the chaplain to get away. While Hus was being held there our lord the King wanted to help him, and thought it would be a great disgrace to him if his safe-conduct were broken. But the learned men told him there was and could be no law by which a heretic had safe-conduct, and, when he heard their severity, he let it be. . . .

On the Saturday after St. Ulrich's Day, July 8, 1415, there was a session. Our lord King was present and Duke Louis of Bavaria-Heidelberg and many other temporal princes and lords, and the session was held the sixth hour after midnight. Master John Hus of Bohemia, the heretic, was brought in, and the reverend, devout Master John Dachery, rector in divinity at the High School of Paris, preached to him of his wicked heresy. And Hus was confuted by holy, divine teaching from Holy Writ, proving that the articles which he had preached and taught were truly false heresy and that the sentence passed on him was just.

Since he was a consecrated priest, he was first degraded[14] and his consecration stripped from him. Lord Nicholas, grandmaster and the lord Archbishop of Milan, two cardinals, two bishops, and two bishops-elect stood up and dressed him in a priest's habit and took it off again with prayers and divested him of his office. But he made only a mock of that. When it was done, they pronounced sentence upon him, that he was a heretic and must be punished for his iniquity. Then they delivered him over to the civil justice, requesting our lord King and the civil court not to put him to death but to keep him imprisoned.

They led him out of Constance with more than a thousand armed men, and the princes and lords went also armed. . . . They led him into the middle of the small outer field. On the way out, he uttered only the prayer: *"Jesu Christe, fili Dei Vivi, miserere mei"* [Jesus Christ, Son of the Living God, have

13. Thin rods.
14. Reduced in rank from an ecclesiastic to a lay person—that is, from the position of holding an official rank in the church to holding no rank in the church.

mercy upon me!]. When he came to the outer field and saw the pyre, the wood and straw, he fell three times on his knees and cried aloud: *"Jesu Christie, fili Dei Vivi, qui passus es pro nobis, miserere mei!"* [Jesus Christ, Son of the Living God, who suffered for us, have mercy upon me!].

They asked him if he wished to confess[15] and he answered: "I would gladly, but there is no space here." For now he was ringed about with people. They made the ring wider, and then I asked him if he wished to confess. There was a priest there, called Lord Ulrich Schorand, who had authority from the Council and the bishop. I called this Lord Ulrich, and he came to Hus and said to him: "Dear lord and master, if you will renounce the unbelief and heresy for which you must suffer, I will gladly hear your confession. But if you will not, you yourself know well that the spiritual law forbids us to perform any divine service for a heretic." And Hus replied: "I do not need it. I am no mortal sinner." Then he started to preach in German, but Duke Louis would not permit that and ordered them to burn him. The executioner then took and bound him hurriedly in his gown to an upright stake, set a stool under his feet, piled wood and straw around him, scattering a little pitch over it, and lighted the fire. He began to cry out terribly but soon was burned.

2. Hubert and Jan van Eyck, *The Ghent Altarpiece,* **completed 1432**

Gardner, pp. 701–2, ills. 18:6, 18:7; Janson, pp. 428–29, ills. 549–551

Rogier van der Weyden, *The Escorial Deposition* **(or** *Descent from the Cross***), c. 1435** Gardner, p. 707, ill. 18:12; Janson, p. 432, ill. 555

Geert Groote, *Resolutions and Intentions, But Not Vows:* "A Useless Waste of Time," c. 1374–75
Geert Groote, *On Patience and the Imitation of Christ:* "The Cross of Christ," c. 1380–84

In northern Europe, the religious impulse expressed itself outside the institutional church. The pietistic yearnings of the common people were compellingly voiced by the layman Geert Groote (1340–1384). Born into a wealthy Dutch merchant family, Groote had, at the age of thirty-four, abandoned his comfortable material existence and embarked upon a mission of preaching throughout the Netherlands. His message stressed that the duty of each Christian was to imitate the lives of Christ and the early Christians as closely as possible.

Groote quickly won a number of followers, who became known as the Devotio

15. The sacrament of declaring one's sins to a priest in order to receive divine forgiveness.

Moderna, or New Devotion. Some followers joined the Augustine monastic order,[1] while others, calling themselves the Brethren of the Common Life, formed communities in which they could lead pious lives without taking formal monastic vows. Individuals, who were not permitted to own property, were expected to cultivate habits of devout and humble submission to God's will.

The literary works of the Brethren reveal the independent character of northern European culture. During the early Renaissance, this culture was infused more by the spirit of religious devotion and less by the Greco-Roman past, as was true of Italy.

Two selections from the writings of Geert Groote are presented here. The first selection, "A Useless Waste of Time," is an excerpt from *Resolutions and Intentions, But Not Vows*. This document, which contains a series of proposals or guidelines, outlines a religious way of life that mediates between seclusion in the cloister and immersion in the secular world. In it, Groote repudiates many of the fields of learning, including geometry, rhetoric, and dialectic, which Italian scholars regarded as absolute sources of wisdom, made authoritative by their classical origin in Greece and Rome. The second selection, "The Cross of Christ," is an excerpt from a letter that had been written by Groote and that was circulated as religious discourse among his followers. The letter, popularly known by the title *On Patience and the Imitation of Christ*, illustrates an aspect of Groote's spiritual belief, that suffering, trials, and temptations should be borne humbly as a necessary part of becoming Christlike.

Both the independent character and the religious spirit of northern European culture emerged in fifteenth-century northern art. In *The Ghent Altarpiece*, completed in 1432, Hubert (c. 1370–1426) and Jan (c. 1390–1441) van Eyck demonstrate the vigor with which independent cultural traditions were maintained in the Netherlands. The composition employs a literal exactitude and detailed realism in its depiction of its subjects, which parallels Groote's literal interpretation of the Bible. In *The Escorial Deposition*, executed in approximately 1435, Rogier van der Weyden (c. 1400–1464) displays the intensity of religious sentiment that motivated northern European religious reformers such as Groote. This composition invites the viewer, as Groote's letter invites the reader, to share Christ's cross as a means of achieving a truly devout life.

Geert Groote, *Resolutions and Intentions, But Not Vows*[2]
A Useless Waste of Time

Man is corrupted by the honors, favors, and especially the greed that drives everyone. Through the lucrative arts he becomes so tainted and enflamed that his natural uprightness is forgotten and his appetites infected; he no longer

1. A religious order of men or women that follows the rule of Augustine (354–430), one of the Latin fathers of the early Christian church.
2. Reprinted, by permission of the publisher, from *Devotio Moderna: Basic Writings*, trans. by John van Engen (New York: Paulist Press, 1988), pp. 67–68. Copyright by John van Engen.

looks to the things of God, of virtue, or of bodily good. Whence it is the rarest thing for someone given over to one of the lucrative disciplines—medicine, civil law, or canon law—to be found upright, or balanced in reason, or just, or tranquil, or of genuine insight.

Spend no time at geometry, arithmetic, rhetoric, dialectic, grammar, lyric poetry, civil law, or astrology. For Seneca[3] already reproached all these things as something the good man should look on with a wary eye: How much more ought they to be repudiated by the spiritual man and the Christian!

It is all a useless waste of time, and of no profit for life.

Geert Groote, *On Patience and the Imitation of Christ*[4]
The Cross of Christ

Most Beloved in Christ.

. . . I always and nearly everywhere teach that the passion of our Lord Jesus Christ is ever to be before our minds. Reflect upon it as often as possible, for in this way no adversity can strike that will not be borne with an even-tempered soul. Nor should we grasp it in our minds only through meditation but even more through the desire of our affections. By imitating his suffering, abuse, and labors we may come to be configured to Christ in work and in effect. For through desire and affection the mind is moved, as it finds opportunity, toward Christ's crucifixion, suffering, and rejection. And this is the end to which meditation upon Christ's Passion[5] is finally and principally directed, remembrance of the passion alone avails little, if it is not accompanied by an overpowering desire to imitate Christ. . . .

The cross of Christ is every voluntary assumption of the labors, pains and reproaches by which the world is crucified to man, that is, the things of the world held in contempt by a man, and he to the world (Galatians 6:14), that is, he [is] despised and afflicted by worldly men. This is the cross of the Lord Jesus Christ, this is, conformity to the cross, and from it, as a stream from a fount, as rays from the sun, it flows into us.

Alas, many of us freely take up a cross which we have made for our-

3. Seneca (4 B.C.–A.D. 65) was a Roman philosopher and politician. As the tutor for the young Nero, he was a highly influential political figure in the first years of the emperor's reign. He also wrote many philosophical essays, including *Natural Questions,* in which he argues that people should be ethical by living austere and noble lives, by controlling their emotions, and by putting integrity and duty ahead of lesser interests and feelings.

4. Reprinted, by permission of the publisher, from *Devotio Moderna: Basic Writings,* trans. by John van Engen (New York: Paulist Press, 1988), pp. 87–89. Copyright by John van Engen.

5. The sufferings of Christ subsequent to the Last Supper and on the cross.

selves, such as a hair-shirt or private prayers or extraordinary fasts, but that which God makes for us, also truly ours to be borne and embraced, we not only fail to take up voluntarily but cast from us in horror. For truly whatever pain we suffer at the hands of some greater, equal, or lesser power, and with whatever intention, just or unjust on the part of the doers, they also come upon us justly and piously from the hand of God, even as they were ordained to come as in that saying, "Nothing happens on earth without cause." It is therefore all the more meritorious and salvation-bringing, indeed all the more necessary, that we bear such crosses without resistance or murmuring and hold for naught by comparison all those things others subject us to, however laudable in their own time. For what is more forceful than to break your own will? What more divine, what richer than to conform to the will of God? There is nothing in heaven above or hell below that is able to overthrow us if we deny our own will and commit ourselves entirely into the hands of God.

3. Hugo van der Goes, *The Portinari Altarpiece*, c. 1476
Gardner, pp. 710–11, ills. 18:16, 18:17; Janson, p. 437, ill. 562

Thomas à Kempis, *The Imitation of Christ:* "Oh My God, I Come unto Thee," c. 1420

Geert Groote and his followers laid a firm basis for a dynamic reform movement in the Netherlands and in Germany. One of the most influential pieces of religious writing in Europe, *The Imitation of Christ,* was written by a follower of Groote, Thomas à Kempis (1380–1471).

Thomas à Kempis was born in Germany in the town of Kempen, near Cologne. During his childhood, he attended a school run by the Brethren of the Common Life. After his entrance into a monastery in the Netherlands, Thomas devoted most of his life to scholarly work. He is generally believed to be the author of *The Imitation of Christ,* written approximately 1420.

Intended as a collection of teachings for the novices at Thomas's monastery, *The Imitation of Christ* became one of the most widely read books in Europe. In it, Thomas expresses the essence of northern European mysticism. He encourages the individual to experience direct communion with God and to return to a simple, Christlike goodness. The individual, whom Thomas urges to adopt a life of morality and piety, is depicted as a pilgrim, imprisoned by the flesh and longing to rejoin the Godhead in imitation of Christ. A selection from *The Imitation of Christ,* "O My God, I Come unto Thee," is presented here.

Thomas urged increased spirituality among Christian believers but remained unswervingly loyal to the Catholic Church. Thomas's respect for traditional church

doctrine and practice, and his intense desire for a revival of spiritual fervor, were evidently shared by Hugo van der Goes (c. 1440–1482), the painter of *The Portinari Altarpiece* (c. 1476). Hugo's depiction of the hierarchical structure of the spiritual realm parallels Thomas's acceptance of the earthly hierarchy of the church institutions. Hugo's representation of the patron saints of the Portinari family is in accord with Thomas's belief in the veneration of the saints. Hugo's symbolic reference to the Eucharist[1] through the inclusion of a sheaf of wheat is suggestive of Thomas's espousal of a traditional interpretation of the Eucharist. Finally, Hugo's reverential treatment of the pious shepherds evokes the values and beliefs of the Brethren of the Common Life, whose ideals Thomas shared.

Thomas à Kempis, *The Imitation of Christ*[2]
O My God, I Come unto Thee

O my God, I come unto thee, putting my confidence in thy mercy and bounty. I [am] sick and come unto my Saviour; hungry and thirsty, unto the fountain of life; poor and needy, unto the King of Heaven; the servant unto his lord; the creature unto his maker; the person desolate unto his piteous comforter. But whereof is this that thou comest unto me? Who am I that thou wilt thus give thine own self to? How dare I, a sinner, behold to appear before thee? And how may it please thee to come unto such a wretch? Thou knowest thy servant and well understandest that nothing good is in him. Wherefore shouldst thou do this grace unto me? Then I confess mine unworthiness and acknowledge thy bounty and praise thy charity. Thou dost this for thyself, good Lord, and not for my merit, to the end that thy bounty may the more be known unto me. Thy charity is more largely verified and thy meekness commended more perfectly, since that it thus pleases thee, and so thou has commanded it to be done. This thy pleasure contents me, and with my will my wickedness shall not resist thee.

O sweet and benign Jesus! How great reverence and giving [of] thanks with perpetual praises be due unto thee, my good Lord Jesus Christ, that by thy pleasure and will I may receive thy blessed body. Whose worthiness no man is found able to declare or express. But what shall I think of this communion when I shall come unto thee, my Lord God, which I cannot duly honor? And yet I desire devoutly to receive thee. What may I think better and more profitable for me than to make myself holy before thee and to praise thy infinite bounty above all things? I praise thee, my Lord God, everlastingly, and dispraise and submit me unto the deepness of my wretchedness. O

1. The sacrament of Communion.
2. Reprinted, by permission of the publisher, from Thomas à Kempis, *The Imitation of Christ*, trans. by Lady Margaret Beaufort, ed. by John K. Ingram (London: Early English Text Society, 1893), pp. 262–64.

my God, thou art saint of all saints, and I the filth of all sinners; yet thou inclinest thyself unto me that am not worthy to behold thee.

Alas my sweet creature that so meekly comest unto me, and willest to be with me, and desirest me unto thy dinner, and givest unto me the meat of heaven and the bread of angels, which is bread of life, and no less thing than thyself which is descended from heaven and gave life to the world. Let me see here what great love proceeds from thee and what gentleness does shine upon us. . . . Thou Lord of all hast no need of anything, yet thou has willed to inhabit within us by this thy holy sacrament. . . .

O my soul, rejoice and give thanks unto thy God for his noble gift and singular comfort, that it list him here in this vale of tears thus to comfort thee. For as oftentimes as thou rememberest this mystery and receivest thus the blessed body of our Lord: so often thou receivest the work of thy redemption and art made partner of all the merits of our Lord Jesus Christ. . . .

4. Michael Pacher, *Saint Wolfgang Forces the Devil to Hold His Prayerbook,* **c. 1481**
Gardner, p. 720, ill. 18:29

Michael Pacher, *Coronation of the Virgin,* **c. 1471–81** Janson, p. 440, ill. 567

Redentin Easter Play: "Brace Up, Brace Up, Mr. Dominie!" 1464

Drama, which once had been a popular form of entertainment in Greece and Rome, was revived in medieval Europe in the context of church ritual. About the year 900, short dialogues sung by choruses were introduced into the Easter Mass. Over the course of the next several centuries, these Easter liturgical passages evolved into dramatic spectacles. Passion plays came to cover the history of the world from the creation to the Resurrection and the Last Judgment. Written in the vernacular languages rather than Latin, the plays were acted by large casts of amateur male actors who assumed both the male and the female roles. The performances often lasted several full days, and typically were attended by the entire town. The popularity of the passion play resulted from the incorporation of a panorama of village life into the presentation of biblical events.

The *Redentin Easter Play* was written in 1464. Its elaborate plot was composed entirely in German. Written at the monastery of Redentin near the Baltic Sea, it was probably performed in Wismar in gratitude for the city's escape from the plague. The play describes the efforts of Lucifer and his deputy, Satan, to repopulate hell after the resurrected Christ has opened the gates of hell and released its forgiven sinners. Numerous persons from all walks of life, including the butcher, the baker, the inn-

keeper, and the tailor, are brought before Lucifer for accusation and judgment. While these scenes abound in ribald humor, they also contain moral lessons that were rendered serious by the then current belief in the tortures of hell. The play concludes with Lucifer lamenting bitterly, as he is being carried off to hell, that he is unable to defeat the forces of Christ.

A selection from the *Redentin Easter Play* is presented here. This selection, "Brace Up, Brace Up, Mr. Dominie!" is taken from a scene in which Satan brings a priest to hell. A droll figure, this cleric is by no means a saint. On the contrary, he is described as being at ease not only at the church altar but also at the local tavern, where he drinks everyone else under the table. When it comes to meeting Lucifer face to face, the boisterous priest does anything but cringe. His rude retorts so unnerve Lucifer that the priest is released and allowed to make his noisy way into heaven.

The defeat of the devil by a clergyman is the subject of a painting by the German artist Michael Pacher (c. 1435–1498). In his painting *Saint Wolfgang Forces the Devil to Hold His Prayerbook* (c. 1481), Pacher presents a confrontation between a priest and the devil that recalls the spirited episode in the *Redentin Easter Play* in which the hard-drinking cleric subdues Satan with his bold language and fearless manner. A sculptor as well as a painter, Pacher designed the shrine of the *Coronation of the Virgin* (c. 1471–81). Densely packed with many figures, the shrine recalls the richly elaborated theatrical spectacles, such as the *Redentin Easter Play,* which were presented in cities, towns, and villages across Europe.

Redentin Easter Play[1]
Brace Up, Brace Up, Mr. Dominie!

Then comes Satan carrying a clergyman and saying to him in a soft voice.
Brace up, brace up, Mr. Dominie![2]
I fear me my lord will scold.
Cut your prayers just a bit shorter.
What boots[3] it that I wait here so long?
Your prayers weigh no more with me than wood shavings;
Now you must dance as I pipe.
You move your lips a lot,
But so far as I can observe
Your heart is not in it at all.
Come on, Mr. Baldpate,[4] follow me.

1. Reprinted, by permission of the publisher, from the *Redentin Easter Play,* trans. by A. E. Zucker (New York: Columbia University Press, 1941), pp. 103–4, 106–7, 109. Copyright by Columbia University Press.
2. Priest or minister.
3. To gain an advantage, to receive help or a remedy.
4. Person with a bald head; reference to the shaved head of the priest.

Priest. Now in the name of the Holy Christ,
I adjure you tell me who you are.
You might well have let me be
And allowed me to read my vespers;[5]
I was occupied with holy words.
God will never permit
That you with your wicked desires
Do me the least bit of harm.

Satan. Now then, what's the use of so much talk?
By my troth, you must come along.
You are trying to paint yourself as altogether too holy;
I know about some other things, too.
It makes no difference to me what you are reading,
Very often you forget your hours;[6]
You enjoy being in continual gluttony
And never want to leave the tavern;
You swill your beer down like water.
Go on, you're a toddling elephant!

Priest. I believe—may the good Lord help me—
You are just trying to make a mockery of me.
Verily you'd better beware of me!
I shall have to try a different way.
Wait, my good man, wait, wait!
If I only had holy water and blessed salt,
I certainly would tame your levity,
So that you'd very quickly turn tail. . . .

Lucifer to Satan. Satan, let this go!
I cannot stand this scorching another minute.
Couldn't he possibly be a holy man?
Holy water is dripping from his nose.
And incense is on his back.
Take away this old pigeon-toes.
He has read so many psalters[7]
That we'd better be spared his presence;
In no way could we profit from him.
Don't you want to let him go? . . .

Satan. See, my good man, here is your psalm book.

5. Prayers read or recited in the evening.
6. The seven designated times of the day for prayer and devotion.
7. A version of the biblical book of Psalms, used in religious services.

Drat it, you old run-around-the-altar,
Go on, I hope you won't live much longer!
I've had a lot of trouble on your account
And have lost my lord's favor.
Go on, and may the hangman take you in charge! . . .
 Priest. Lucifer, you yourself had better be careful,
Otherwise I'll do something to you, too.
If Jesus appears once more before your gates,
He will then destroy the whole of hell.
Of one thing I am sure:
That God is more powerful than the devil.

5. Martin Schongauer, *Saint Anthony Tormented by the Demons*, c. 1480–90

Gardner, p. 721, ill. 18:30; Janson, p. 442, ill. 571

Heinrich Kramer and James Sprenger, *The Witches' Hammer:* "An Examination by Torture," 1487

At the same time that humanist influences began to infiltrate the life and thought of Western Europe, witchcraft was regarded by the church and the state as an increasingly serious problem. Pagan beliefs and rites that had been inherited from the pre-Christian beliefs of the Germanic, Celtic, Slavic, and Mediterranean peoples had never been totally supplanted by the Christian faith. Once dismissed as misguided but harmless vagaries, peasant beliefs in witchcraft were now regarded as active attacks upon orthodox religion and upon the church faithful.

Frightened by the rumored activities of evil powers, church officials responded by intensifying the persecution of witches. James Sprenger (died 1494) and Heinrich Kramer (died 1500), two Dominicans who were appointed as general inquisitors in Germany, were especially vigorous in their campaign to extirpate witchcraft. In 1487 Sprenger and Kramer wrote a virulent attack against witchcraft, *The Witches' Hammer*. The book describes the traits by which witches could be identified, the methods supposedly used by witches in their wicked work, and the judicial steps to be used in combating the suspected evil. Witches were regarded as criminals by the state, and torture was routinely employed during questioning in order to force confessions. Condemned witches were executed by strangulation, hanging, beheading, or being burned at the stake. A selection from of *The Witches' Hammer,* "An Examination by Torture," is presented here.

The belief in the power of demonic beings that motivated Sprenger and Kramer to write *The Witches' Hammer* is also apparent in fifteenth-century northern Euro-

pean art. The German artist Martin Schongauer (c. 1450–1490) was an engraver. In his *Saint Anthony Tormented by the Demons* (c. 1480–90), Schongauer illustrates the attacks by supernatural beings that the early Christian saint (c. 251–356) reported he had experienced in his visions and that contemporary Germans feared were threatening their present-day lives and their future salvation.

Heinrich Kramer and James Sprenger, *The Witches' Hammer*[1]
An Examination by Torture

The method of beginning an examination by torture is as follows: First, the jailers prepare the implements of torture, then they strip the prisoner (if it be a woman, she has already been stripped by other women, upright and of good report).[2] This stripping is lest some means of witchcraft may have been sewed into the clothing—such as often, taught by the Devil, they prepare from the bodies of unbaptized infants, [murdered] that they may forfeit salvation. And when the implements of torture have been prepared, the judge . . . tries to persuade the prisoner to confess the truth freely; but, if he will not confess, he bids attendants make the prisoner fast to the strappado[3] or some other implement of torture. The attendants obey forthwith, yet with feigned agitation. Then, at the prayer of some of those present, the prisoner is loosened again and is taken aside and once more persuaded to confess, being led to believe that he will in that case not be put to death. . . .

But if, neither by threats nor by promises such as these, the witch can be induced to speak the truth, then the jailers must carry out the sentence, and torture the prisoner according to the accepted methods, with more or less of severity as the delinquent's crime may demand. And, while he is being tortured, he must be questioned on the articles of accusation, and this frequently and persistently, beginning with the lighter charges—for he will more readily confess the lighter than the heavier. And, while this is being done, the notary must write down everything in his record of the trial—how the prisoner is tortured, on what points he is questioned, and how he answers.

And note that, if he confesses under the torture, he must afterward be conducted to another place, that he may confirm it and certify that it was not due alone to the force of the torture.

1. Reprinted, by permission of the publisher, from James Harvey Robinson and Merrick Whitcomb, eds., *Translations and Reprints from the Original Sources of European History* (Philadelphia: University of Pennsylvania Press, 1897–1902), vol. III, pp. 11–13.
2. Sometimes, in place of the prisoner's clothing, a garment furnished by the court was supplied, to be worn during the torture.
3. An instrument of torture. The victim was hoisted by a rope fastened to his wrists and then abruptly dropped to a point just short of the ground.

But, if the prisoner will not confess the truth satisfactorily, other sorts of tortures must be placed before him, with the statement that, unless he will confess the truth, he must endure these also. But, if not even thus he can be brought into terror and to the truth, then the next day or the next but one is to be set for a *continuation* of the tortures—not a *repetition*,[4] for they must not be repeated unless new evidences be produced.

The judge must then address to the prisoners the following sentence: We, the judge, etc., do assign to you,————, such and such a day for the continuation of the tortures, that from your own mouth the truth may be heard, and that the whole may be recorded by the notary.

And during the interval, before the day assigned, the judge, in person or through approved men, must in the manner above described try to persuade the prisoner to confess, promising her[5] (if there is aught to be gained by this promise) that her life shall be spared.

The judge shall see to it, morever, that throughout this interval guards are constantly with the prisoner, so that she may not be left alone; because she will be visited by the Devil and tempted into suicide.

6. Hieronymus Bosch, *The Garden of Earthly Delights,* 1505–10
Gardner, pp. 713–15, ills. 18:20, 18:21; Janson, pp. 434–35, ills. 559–560

Sebastian Brant, *The Ship of Fools:* "A Temporal Pleasure" and "Fool's Caps," 1494

Satire was popular in northern Europe on the eve of the Reformation. The foibles and follies of humankind were a subject for both artists and writers of the period. Among the artists who gave visual expression to the satirical attitudes about the human condition was Hieronymus Bosch (c. 1450–1516). In the triptych *The Garden of Earthy Delights* (1505–10), Bosch drew upon his teeming imagination to paint fetid scenes filled with small, squirming figures.

Among the writers who described the corruption of humankind and the baseness of human nature was the German poet Sebastian Brant (1457–1521). A university professor and a scholar of both Latin and Greek, Brant revealed his true genius in German poetry and in his ability to reflect the popular temper. In his masterpiece, *The Ship of Fools,* Brant aimed his barbs at men and women of all social classes. By exposing the weaknesses of every type of person, Brant sought to change his genera-

4. This was a legal fiction to avoid the legal restriction against the repetition of torture.
5. The authors alternate between the male and female genders of the pronoun.

tion and to improve its moral condition. Two selections from *The Ship of Fools* are presented here. The first selection, "A Temporal Pleasure," censures the sins caused by lust. The second selection, "Fool's Caps," castigates school students for their laziness.

Sebastian Brant, *The Ship of Fools*[1]
A Temporal Pleasure

A temporal pleasure's like unto
A brazen, sensual woman who
Infests the street and plies her trade,
Inviting every amorous blade[2]
To come and practice fornication
At bargain rates—a great temptation—
She begs all men in shameless fashion
To join and quench her evil passion.
Fools seek her out, indifferent, low,
As oxen would to slaughter go,
Or like a harmless, frisky wether[3]
That does not know about the tether
Until it feels the deadly dart
That's shot to penetrate its heart.
Remember, fool, your soul's at stake
And soon in deepest hell you'll bake
If such lewd women you frequent.

Sebastian Brant, *The Ship of Fools*[4]
Fool's Caps

Students should likewise not be skipped,
With fool's caps they are well equipped,
When these are pulled about the ear
The tassel flaps and laps the rear,
For when of books they should be thinking
They go carousing, roistering, drinking.

1. Reprinted, by permission of the publisher, from Sebastian Brant, *The Ship of Fools,* trans. by Edwin Zeydel (New York: Columbia University Press, 1944), pp. 178–79. Copyright by Dover Press.
2. A dashing, swaggering young man.
3. A castrated male sheep.
4. Reprinted, by permission of the publisher, from Sebastian Brant, *The Ship of Fools,* trans. by Edwin Zeydel (New York: Columbia University Press, 1944), pp. 124–25. Copyright by Dover Press.

A youth puts learning on the shelf,
He'd rather study for himself
What's useless, vain—an empty bubble;
And teachers too endure this trouble,
Sensible learning they'll not heed,
The talk is empty, vain indeed.
Could this be night or is it day?
Did mankind fashion monkeys, pray?
Was't Plato, Socrates who ran?
Such is our modern teaching plan.

Sixteenth-Century Northern European Art

1. Albrecht Dürer, *Adam and Eve (The Fall of Man)*, 1504
Gardner, p. 727, ill. 18:36; Janson, p. 536, ill. 716

Conrad Celtis, *Ars Versificandi et Carminum:* "To Apollo, the Inventor of Poetry, that He May Leave Italy and Come to Germany," 1486

In the late fifteenth and early sixteenth centuries, the conservative forces of northern European culture gradually succumbed to the enthusiasm for the new Renaissance thought of Italy. The spread of humanism was facilitated by the close political connection between Germany and Italy, which frequently prompted the Holy Roman Emperor and his German army to intervene directly in Italian city-state politics. Furthermore, Germany and Italy were linked by economic ties, which constantly brought German merchants to the cities of northern Italy. The social, artistic, and intellectual achievements of the south also became known to Germans through educational contacts. Many German students attended Italian universities. Consequently, upon their return, they were often impatient with the traditional forms of thought and literature, and were eager to introduce innovations.

Conrad Celtis (1459–1508) was one of the leading figures in the first generation of northern European humanists. A wandering scholar, Celtis went to Italy in order to perfect his knowledge of Greek and Latin, to collect manuscripts, and to become immersed in Italian Renaissance thought. Driven by his sense of national obligation, Celtis returned to Germany so that he might fulfill a mission that he claimed had been revealed to him in a vision. This was to compose poetry that would illuminate Germany with the brilliance of humanist culture. A clear exposition of Celtis's sense of mission can be found in the poem "To Apollo, the Inventor of Poetry, That He

May Leave Italy and Come to Germany," from the book *Ars Versificandi et Carminum* (1486). In this ode, Celtis invites Apollo, the classical god of poetry, to come to Germany and to spread the art of song.

Celtis was a friend of Albrecht Dürer (1471–1528). Dürer esteemed Celtis so highly that he executed illustrations for his friend's poems. Like Celtis, Dürer was fascinated with the classical world and with the Italian Renaissance art that was inspired by it. He traveled to Italy in 1495, less than ten years after Celtis had journeyed to Italy, in order to study the work of Italian Renaissance artists. His engraving *Adam and Eve* (1504) demonstrates the success that Dürer achieved in transmitting concepts of Italian humanist culture to northern Europe.

Conrad Celtis, *Ars Versificandi et Carminum*[1]
To Apollo, the Inventor of Poetry,
that He May Leave Italy and Come to Germany

Phoebus,[2] who invented the sweet lyre,[3] answer our prayers; leave your beloved Helicon[4] and Pindus[5] and come to our land invoked by the poetry you love;

you see how our country-bred muses hasten to meet you and with what charm they sing under our cold sky. Do you yourself come, visit this country as yet untutored by the lofty music of your lyre.

So must the barbarian, born of warrior or rustic stock, ignorant of Latin culture, now learn beneath your guidance the speech of poetry,

singing as Orpheus[6] sang to the Pelasgians,[7] when beasts of prey, nimble deer and tall forest trees followed him as he plucked the strings.

You it was who designed to leave Greece, passing swiftly and gladly over the wide sea to visit Latium[8] with the Muses in your train; your pleasure it was to reveal the arts you love.

1. Reprinted, by permission of the publisher, from *Selections from Conrad Celtis, 1459–1508,* ed. and trans. by Leonard Forster (Cambridge: Cambridge University Press, 1948), p. 21. Copyright by Cambridge University Press.
2. The name of Apollo as god of sun and light.
3. A harp-like instrument of ancient Greece, used especially to accompany singing and the recitation of poetry.
4. A mountain in south central Greece regarded by the ancient Greeks as the home of Apollo and the muses.
5. The Greek mountain range in which Helicon is located.
6. Orpheus was a mythical musician with magical powers.
7. The Pelasgians were early Aegean inhabitants of Greece.
8. Region of central Italy surrounding Rome.

So now we pray you: Come to us as you came to Italy. Let barbarian speech be driven out and the whole fabric of darkness collapse.

2. Albrecht Dürer, *The Four Apostles,* 1526
Gardner, p. 730, ill. 18:40; Janson, p. 537, ill. 718

Johann Tetzel, *Sermon on Indulgences:* "Bring Not Your Money into the Land of Paradise," 1517
Martin Luther, *Ninety-Five Theses:* "The Penalty for Sin Must Continue," 1517

On October 31, 1517, the German churchman Martin Luther (1483–1546) posted his *Ninety-Five Theses* on the door of the Castle Church at Wittenberg. Initially intended by Luther to goad the Catholic Church into correcting institutional abuses, the *Ninety-Five Theses* began the religious upheaval known as the Reformation. Its momentous impact would be felt throughout Europe in many ways: the religious unity of Western Christendom would be shattered; Protestant churches would be formed; religious wars would convulse the developing nation-states of Europe; and a new understanding of the Christian faith would emerge.

A devout Christian and a member of the Augustinian monastic order, Luther was also a doctor of theology and a professor at the University of Wittenberg. He was provoked into his attack on the Catholic Church by the actions of the Dominican pardoner Johann Tetzel (1465?–1519). Tetzel had received papal dispensation for the sale, in Germany, of indulgences, documents that he claimed guaranteed their purchasers an automatic remission from punishment for their sins and an immediate release from purgatory.[1] Luther was enraged that Tetzel was prying money from poor German folk through his persuasive preaching and his exaggerated promises, and that this money was being used by a young German archbishop for the repayment of his debts and by the pope for the construction of Saint Peter's in Rome.

Luther's complaint against indulgences, however, went beyond his distaste about the purposes for which the money raised by Tetzel was being spent. Luther objected to the whole concept of spiritual bookkeeping with God. Driven by a sense of his infinite personal unworthiness, Luther had spent many years searching for a way out of his spiritual agony. He finally found it in the conviction that believers are saved only by their faith and not by their good works.

The doctrine of justification by faith alone that was formulated by Luther was to exert enormous influence in the religious thinking of the Reformation and succeed-

1. A condition or a place in which, according to Catholic doctrine, the souls of those persons who died penitent are purified from venial sins or undergo the remaining temporal punishment for mortal sins forgiven on earth.

ing centuries. Its innovative character lay in the implication that if salvation comes only through the believer's personal faith in the merits of Christ, then each person becomes his or her own priest. Thus, a mediatory priesthood becomes unnecessary. This greatly diminished the authority and importance of the traditional institutions of the church. It was a revolution of the first magnitude, which affected many people, including the prominent German artist Albrecht Dürer (1471–1528). His painting *The Four Apostles* (1526) reveals the artist's sympathies for the Protestant cause. John and Peter are shown on the left panel, Mark and Paul on the right panel. The frames of the panels are inscribed with passages from Luther's German translation of the New Testament, which warn of the perilous times ahead.

Two documents related to the Reformation in Germany are presented here. The first document is a selection from a sermon on indulgences given by Tetzel in 1517 to parochial clergy, "Bring Not Your Money into the Land of Paradise." The second document is a selection from *Ninety-Five Theses,* in which Luther set forth his doubts about the practices of indulgences, "The Penalty for Sin Must Continue."

Johann Tetzel, *Sermon on Indulgences*[2]
Bring Not Your Money into the Land of Paradise

Venerable Sir, I pray you that in your utterances you may be pleased to make use of such words as shall serve to open the eyes of the mind and cause your hearers to consider how great a grace and gift they have had and now have at their very doors. Blessed eyes indeed, which see what they see, because already they possess letters of safe-conduct by which they are able to lead their souls through that valley of tears, through that sea of the mad world, where storms and tempests and dangers lie in wait, to the blessed land of Paradise. Know that the life of man upon earth is a constant struggle. We have to fight against the flesh, the world and the devil, who are always seeking to destroy the soul. In sin we are conceived,—alas! what bonds of sin encompass us, and how difficult and almost impossible it is to attain to the gate of salvation without divine aid; since He causes us to be saved, not by virtue of the good works which we accomplish, but through His divine mercy; it is necessary then to put on the armor of God.

You may obtain letters of safe-conduct from the vicar of our Lord Jesus Christ, by means of which you are able to liberate your soul from the hands of the enemy, and convey it by means of contrition and confession, safe and secure from all pains of Purgatory, into the happy kingdom. For know that

2. Reprinted, by permission of the publisher, from James Harvey Robinson and Merrick Whitcomb, eds., *Translations and Reprints from the Original Sources of European History* (Philadelphia: University of Pennsylvania Press, 1897–1902), vol. II, no. 6, pp. 9–10.

in these letters are stamped and engraven all the merits of Christ's passion there laid bare. Consider, that for each and every mortal sin[3] it is necessary to undergo seven years of penitence after confession and contrition, either in this life or in Purgatory.

How many mortal sins are committed in a day, how many in a week, how many in a month, how many in a year, how many in the whole course of life! They are well-nigh numberless, and those that commit them must needs suffer endless punishment in the burning pains of Purgatory.

But with these confessional letters you will be able at any time in life to obtain full indulgence for all penalties imposed upon you, in all cases except the four reserved to the Apostolic See.[4] Therefore throughout your whole life, whenever you wish to make confession, you may receive the same remission, except in cases reserved to the Pope, and afterwards, at the hour of death, a full indulgence as to all penalties and sins, and your share of all spiritual blessings that exist in the church militant and all its members.

Do you not know when it is necessary for anyone to go to Rome, or undertake any other dangerous journey, he takes his money to a broker and gives a certain per cent—five or six or ten—in order that at Rome or elsewhere he may receive again his funds intact, by means of the letters of this same broker? Are you not willing, then, for the fourth part of a florin,[5] to obtain these letters, by virtue of which you may bring, not your money, but your divine and immortal soul safe and sound into the land of Paradise?

Martin Luther, *Ninety-Five Theses*[6]
The Penalty for Sin Must Continue

1. Our Lord and Master Jesus Christ in saying "Repent ye" . . . intended that the whole life of believers should be penitence.

2. This word cannot be understood as sacramental penance, that is, the confession and satisfaction which are performed under the ministry of priests.

3. A mortal sin is a transgression against the law of God that causes spiritual death; a venial sin is a transgression against the law of God that does not deprive of divine grace, either because it is a minor offense or because it was committed without full understanding of its seriousness or without full consent of the will.

4. The papacy.

5. A gold coin first issued in Florence in 1252.

6. Reprinted, by permission of the publisher, from *First Principles of the Reformation; or, The Ninety-five Theses and the Three Primary Works of Luther*, trans. by Henry Wace and C. A. Buchheim (London: J. Murray, 1883), pp. 6–11.

3. It does not, on the other hand, refer solely to inward penitence; nay, such inward penitence is naught, unless it outwardly produces various mortifications of the flesh.

4. The penalty [for sin] must thus continue as long as the hatred of self—that is, true inward penitence; namely, till our entrance into the kingdom of heaven.

5. The pope has neither the will nor the power to remit any penalties except those which he has imposed by his own authority, or by that of the canons.

6. The pope has no power to remit any guilt, except by declaring and warranting it to have been remitted by God; or at most by remitting cases reserved for himself; in which cases, if his power were despised, guilt would certainly remain.

7. Certainly God remits no man's guilt without at the same time subjecting him, humbled in all things, to the authority of his representative, the priest. . . .

20. Therefore the pope, when he speaks of the plenary remission of all penalties,[7] does not mean really of all, but only of those imposed by himself.

21. Thus those preachers of indulgences are in error who say that by the indulgences of the pope a man is freed and saved from all punishment. . . .

28. It is certain that, when the money rattles in the chest, avarice and gain may be increased, but the effect of the intercession of the Church depends on the will of God alone. . . .

40. True contrition seeks and loves punishment, while the ampleness of pardons relaxes it and causes men to hate it, or at least give occasion for them to do so. . . .

43. Christians should be taught that he who gives to the poor man, or lends to a needy man, does better than if he bought pardons. . . .

50. Christians should be taught that, if the pope were acquainted with the exactions of the preachers of pardons, he would prefer that the basilica of St. Peter should be burnt to ashes rather than that it should be built up with the skin, flesh, and bones of his sheep. . . .

62. The true treasure of the Church is the holy gospel of the glory and grace of God. . . .

7. Absolute or full revocation of all punishment of sin.

3. Matthias Grünewald, *Crucifixion* **from** *The Isenheim Altarpiece,*
c. 1510–1515

Gardner, p. 724, ill. 18:33; Janson, p. 532, ill. 710

Twelve Articles: "Our Humble Petition and Desire," 1525
Martin Luther, *Against the Rapacious and Murdering Peasants:* "Smite,
Strangle, and Stab," 1525

In Germany, the early decades of the sixteenth century were marked by growing
discontent among the peasants. Occupying a legal status midway between that of
freeman and serf, the agricultural population was squeezed by the increasing burdens
placed upon it by the aristocratic class. The steadily mounting cost of living faced by
the nobility was reflected in the rising rents that peasants were forced to pay for
croplands and in the revocation of ancient rights to hunt game and to gather wood
in forested areas, to fish in lakes and streams, and to graze cattle on open pastures.

Encouraged by Luther's success in defying authority and inspired by some of his
religious ideals, the peasants of southwest and central Germany raised the standard
of revolt in 1524. A colleague of Luther, Thomas Münzer (1490–1525), had commit-
ted himself to the cause of extreme reform. Münzer, regarding himself as the voice of
the oppressed, openly preached rebellion. Luther, however, responded to the growing
disorder and violence with harshness. He urged the nobility to feel no compunction
in adopting any form of violence to dampen the uprising. While acknowledging that
peasants did suffer grievous wrongs, Luther argued that no revolt was justified and
that the Gospel itself admonished Christians to accept suffering with humble forbear-
ance. Luther declared, "Suffering, suffering, cross, cross: this is a Christian's only
right."[1]

Encouraged by Luther's stance, the authorities collected troops and engaged the
peasants and their allied townsfolk in a decisive battle at Frankhausen on May 15,
1525. The superior equipment and discipline of the nobility ensured an easy victory.
Over five thousand peasants and townsfolk lay dead on the field; three hundred more
were beheaded before the town hall. Münzer was caught and beheaded on May 27.
There were several other pitched battles, always with the same result. In all, it is
calculated that more than 100,000 lives were lost during the Peasants' Revolt.

Because of Luther's harsh stand against them, many peasants concluded that the
reformer was a false prophet. They would have no more of him and henceforth sought
solace in their traditional faith. Thus, much of central and southern Germany re-
mained Catholic.

A dramatic picture of the cross and suffering was executed by the German artist
Matthias Grünewald (fl. 1500–1530). The *Crucifixion* from *The Isenheim Altarpiece*

1. Quoted in Henry S. Lucas, *The Renaissance and the Reformation* (New York: Harper & Bros., 1934), p. 157.
 Copyright by Harper & Bros.

(c. 1510–1515) is a closely observed and deeply felt depiction of intense human suffering. Grünewald is thought to have had sympathies for Luther and his doctrines. He was involved in the Peasants' Revolt and had to flee to northern Germany. The agony that he represented in his crucifixion was shared by the peasants before, during, and after their ill-fated Peasants' Revolt.

Two documents related to the Peasants' Revolt are presented here. The first document, the *Twelve Articles*, consists of the demands published in 1525 by the peasant leadership. By contemporary standards, this list of demands seems modest. A selection, "Our Humble Petition and Desire," is presented here. The second document, *Against the Rapacious and Murdering Peasants*, is a pamphlet written hurriedly by Luther in 1525 in response to the revolt. A selection, "Smite, Strangle and Stab," is presented here.

Twelve Articles[2]
Our Humble Petition and Desire

The First Article. First, it is our humble petition and desire . . . that in the future we should have power and authority so that each community should choose and appoint a pastor. . . .

The Second Article. According as the just tithe[3] is established by the Old Testament and fulfilled in the New, we are ready and willing to pay the fair tithe of grain.

The Third Article. It has been the custom hitherto for men to hold us as their own property,[4] which is pitiable enough, considering that Christ has delivered and redeemed us all, without exception, by the shedding of his precious blood, the lowly as well as the great. Accordingly . . . we take it for granted that you will release us from serfdom, as true Christians, unless it should be shown us from the Gospel that we are serfs.

The Fourth Article. In the fourth place, it has been the custom heretofore, that no poor man should be allowed to touch venison or wild fowl, or fish in flowing water, which seems to us quite unseemly and unbrotherly, as well as selfish and not agreeable to the word of God.

The Fifth Article. In the fifth place, we are aggrieved in the matter of woodcutting, for the noble folk have appropriated all the woods to themselves alone.

2. Reprinted, by permission of the publisher, from James Harvey Robinson, ed., *Readings in European History* (Boston: Ginn, 1906), vol. II, pp. 95–99.
3. A levy of 10 percent on agricultural produce, goods, or income, which is set apart as an offering to God.
4. A condition of servitude, called serfdom, in which peasants were required to render services to their lords. Peasants held in serfdom were called serfs and were commonly attached to the lord's land and prevented by law from leaving it. Serfs could be transferred with the sale of the land from one owner to another.

The Sixth Article. Our sixth complaint is in regard to the excessive services[5] demanded of us, which are increasing from day to day. We ask that this matter be properly looked into so that we shall not continue to be oppressed in this way. . . .

The Seventh Article. Seventh, we will not hereafter allow ourselves to be farther oppressed by our lords, but will let them demand only what is just and proper according to the word of agreement between the lord and the peasant.

The Eighth Article. In the eighth place, we are greatly burdened by holdings[6] which cannot support the rent exacted from them. The peasants suffer loss in this way and are ruined; and we ask that the lords may appoint persons of honor to inspect these holdings, and fix a rent in accordance with justice. . . .

The Ninth Article. In the ninth place, we are burdened with a great evil in the constant making of new laws. We are not judged according to the offense, but sometimes with great ill will, and sometimes much too leniently. In our opinion we should be judged according to the old written law, so that the case shall be decided according to its merits, and not with partiality.

The Tenth Article. In the tenth place, we are aggrieved by the appropriation by individuals of meadows and fields which at one time belonged to a community. These we will take again into our own hands.

The Eleventh Article. In the eleventh place, we will entirely abolish the due called *Todfall* [i.e., heriot],[7] and will no longer endure it, nor allow widows and orphans to be thus shamefully robbed against God's will, and in violation of justice and right, as has been done in many places, and by those who should shield and protect them. . . .

Conclusion. In the twelfth place, it is our conclusion and final resolution, that if one or more of the articles here set forth should not be in agreement with the word of God, as we think they are, such article we will willingly recede from, when it is proved really to be against the word of God by a clear explanation of the Scripture.

Martin Luther, *Against the Rapacious and Murdering Peasants*[8]
Smite, Strangle, and Stab

In my preceding pamphlet [on the *Twelve Articles*] I had no occasion to condemn the peasants, because they promised to yield to law and better

5. The unpaid labor or services exacted by lords from their serfs.
6. Lands owned by lords and rented to peasants for cultivation or pasture.
7. A feudal service or tribute due to the lord on the death of a tenant.
8. Reprinted, by permission of the publisher, from James Harvey Robinson, ed., *Readings in European History* (Boston: Ginn, 1906), vol. II, pp. 107–8.

instruction, as Christ also demands (Matt. vii. 1). But before I can turn around, they go out and appeal to force, in spite of their promises, and rob and pillage and act like mad dogs. . . .

With threefold horrible sins against God and men have these peasants loaded themselves, for which they have deserved a manifold death of body and soul.

First, they have sworn to their true and gracious rulers to be submissive and obedient, in accord with God's command (Matt. xxii. 21), "Render therefore unto Cæsar the things which are Cæsar's," and (Rom. xiii. 1), "Let every soul be subject unto the higher powers." But since they have deliberately and sacrilegiously abandoned their obedience, and in addition have dared to oppose their lords, they have thereby forfeited body and soul, as perfidious, perjured, lying, disobedient wretches and scoundrels are wont to do. Wherefore St. Paul judges them, saying (Rom. xiii. 2), "And they that resist shall receive to themselves damnation." The peasants will incur this sentence, sooner or later; for God wills that fidelity and allegiance shall be sacredly kept.

Second, they cause uproar and sacrilegiously rob and pillage monasteries and castles that do not belong to them, for which, like public highwaymen and murderers, they deserve the twofold death of body and soul. It is right and lawful to slay at the first opportunity a rebellious person, who is known as such, for he is already under God's and the emperor's ban. Every man is at once judge and executioner of a public rebel; just as, when a fire starts, he who can extinguish it first is the best fellow. Rebellion is not simply vile murder, but is like a great fire that kindles and devastates a country; it fills the land with murder and bloodshed, makes widows and orphans, and destroys everything, like the greatest calamity. Therefore, whosoever can, should smite, strangle, and stab, secretly or publicly, and should remember that there is nothing more poisonous, pernicious, and devilish than a rebellious man. Just as one must slay a mad dog, so, if you do not fight the rebels, they will fight you, and the whole country with you.

Third, they cloak their frightful and revolting sins with the gospel, call themselves Christian brethren, swear allegiance, and compel people to join them in such abominations. Thereby they become the greatest blasphemers and violators of God's holy name, and serve and honor the devil under the semblance of the gospel, so that they have ten times deserved death of body and soul, for never have I heard of uglier sins.

4. Hans Holbein the Younger, *The French Ambassadors*, 1533
Gardner, p. 731, ill. 18:41

Catherine of Aragon, *Speech Protesting the Marriage Dissolution:* "Sir, in What Have I Offended You?" 1529
Parliament, *Act of Supremacy:* "The Supreme Head of the Church of England," 1534

In 1520 Luther had urged princes to throw off the authority claimed by Rome over churches within their territorial control. Rulers were quick to profit from this invitation. In 1529 all the Lutheran states and towns in Germany affixed their names to a "Protestation," in which they declared that the right to determine a country's religion rested with the ruler rather than with the pope.

The prerogatives claimed by Protestant rulers in Germany were soon to be also exercised by the English monarch Henry VIII (lived 1491–1547; reigned 1509–47). Initially an orthodox Catholic, Henry was troubled by the absence of a male heir. In order to wed his pregnant mistress, Anne Boleyn, and secure an heir, Henry was forced to repudiate his marriage to his wife of twenty years, Catherine of Aragon. A Spanish princess, Catherine had been widowed after a brief marriage to Henry's older brother, Arthur, and had borne Henry many children, all of whom except Mary had died in infancy.

Henry now claimed that his conscience was troubled by his union with his deceased brother's wife—a union he now characterized as incestuous and illegal. Complex negotiations between the monarch and the papacy, however, resulted in a papal decision that denied Henry an annulment. In July 1533 a sentence of excommunication was pronounced against Henry for his desertion of Catherine and his cohabitation with Anne. Henry responded by persuading Parliament to cooperate with him in reducing the authority of the church in England and in expanding the royal power. In 1534 the *Act of Supremacy* transferred supreme power over the English church from the pope in Rome to the king.

Two documents related to the rupture between Henry and Pope Clement VII are presented here. The first document is a selection from a speech made in 1529 by Catherine to Henry, in which the queen protests the dissolution of their marriage. The second document is a selection from the *Act of Supremacy*, in which the king is declared to be the highest authority over the church in England.

Hans Holbein the Younger (1497–1543) served Henry VIII as court painter. In 1533 Holbein painted *The French Ambassadors*, a double portrait of two French ambassadors to England, Jean de Dinteville and Georges de Selve. The painting includes an open hymnbook, with Luther's translation of a hymn and of the Ten Commandments. Although Henry had repudiated papal authority in England, he had remained staunchly Catholic in doctrine. He savagely punished any adherents of Luther or any other reformers, and adamantly reasserted his theological orthodoxy.

Nonetheless, while Henry may have objected to the traces of Lutheran influence that Holbein's portrait attributes to the French ambassadors, the king assiduously courted the French king, Francis I, in an attempt to persuade him to join cause against the pope. Francis, however, pursued his own course and, in 1533, arranged the marriage of his son, Henry, duke of Orléans, to the pope's niece, Catherine de' Medici.

Catherine of Aragon, *Speech Protesting the Marriage Dissolution*[1]
Sir, in What Have I Offended You?

"Sir, in what have I offended you? or what occasion of displeasure have I given you, intending thus to put me from you? I take God to be my judge, I have been to you a true and humble wife, ever conformable to your will and pleasure; never contradicting or gainsaying you in anything; being always contented with all things wherein you had any delight or took any pleasure, without grudge, or countenance of discontent or displeasure. I loved, for your sake, all them whom you loved, whether I had cause or no; whether they were my friends or my enemies.

"I have been your wife these twenty years or more, and you have had by me divers children; and when you had me first, I take God to be my judge, that I was a maid. Whether it be true or no, I put it to your own conscience. If there be any just cause that you can allege against me, either of dishonesty, or matter lawful to put me from you, I am content to depart, to my shame and confusion; and if there be none, then I pray you to let me have justice at your hands.

"The king, your father, was, in his time, of such an excellent wit, that he was accounted amongst all men for wisdom to be a second Solomon; and the king of Spain, my father, Ferdinand, was accounted one of the wisest princes that had reigned in Spain for many years. It is not, therefore, to be doubted, but that they had gathered as wise counselors unto them, of every realm, as in their wisdom they thought meet. And I conceive that there were in those days as wise and well-learned men, in both the realms, as to be now at this day, who thought the marriage between you and me good and lawful. Therefore it is a wonder to me what new inventions are now invented against me. And now to put me to stand to the order and judgment of this court seems very unreasonable. . . . I humbly pray you to spare me until I may know what counsel my friends in Spain will advise me to take: and if you will not, then your pleasure be fulfilled." And with that she rose up and departed, nevermore appearing in any court.

1. Reprinted, by permission of the publisher, from James Harvey Robinson, ed., *Readings in European History* (Boston: Ginn, 1906), vol. II, pp. 138–39.

Parliament, *Act of Supremacy*[2]
The Supreme Head of the Church of England

Albeit the king's Majesty justly and rightfully is and ought to be the supreme head of the Church of England, and so is recognized by the clergy of this realm in their convocations, yet nevertheless, for corroboration and confirmation thereof, and for increase of virtue in Christ's religion within this realm of England, and to repress and extirpate all errors, heresies, and other enormities and abuses heretofore used in the same, be it enacted, by authority of this present Parliament, that the king, our sovereign lord, his heirs and successors, kings of this realm, shall be taken, accepted, and reputed the only supreme head [on] earth of the Church of England, called *Anglicana Ecclesia;* and shall have and enjoy, annexed and united to the imperial crown of this realm, as well the title and style thereof, as all honors, dignities, preëminences, jurisdictions, privileges, authorities, immunities, profits, and commodities to the said dignity of the supreme head of the same Church belonging and appertaining; and that our said sovereign lord, his heirs and successors, kings of this realm, shall have full power and authority from time to time to visit, repress, redress, record, order, correct, restrain, and amend all such errors, heresies, abuses, offenses, contempts, and enormities, whatsoever they be, which by any manner of spiritual authority or jurisdiction ought or may lawfully be reformed, repressed, ordered, redressed, corrected, restrained, or amended, most to the pleasure of Almighty God, the increase of virtue in Christ's religion, and for the conservation of the peace, unity, and tranquillity of this realm; any usage, foreign law, foreign authority, prescription, or any other thing or things to the contrary hereof notwithstanding.

5. Jean Clouet, *Francis I*, c. 1525–30
Gardner, p. 738, ill. 18:48; Janson, p. 541, ill. 724

John Calvin, *Institutes of the Christian Religion:*
"Election and Predestination," 1536

In France, while the majority of the population remained faithful to the Catholic Church, a dedicated band of reformers spread the Protestant movement. The French king Francis I (lived 1494–1547; reigned 1515–47) responded to the religious dissent within his kingdom by following the path of political expediency. A policy of persecu-

2. Reprinted, by permission of the publisher, from James Harvey Robinson, ed., *Readings in European History* (Boston: Ginn, 1906), vol. II, pp. 141–42.

tion was severely enforced against Protestants when Francis needed papal support and was conveniently suspended when the monarch needed help from German Protestant rulers.

The French Protestants found an eloquent champion in the person of John Calvin (1509–1564). A student of law and the classics at the University of Paris, Calvin had been converted to Protestantism about 1533. To escape persecution in his native France, he had fled to Switzerland, where he made his home in Geneva for most of the remaining years of his life.

Calvin was only twenty-seven when he published his masterful synthesis of Christian thought, *Institutes of the Christian Religion.* Its preface consists of a letter that Calvin addressed to Francis I. In this letter, Calvin does not implore religious toleration for the oppressed but, instead, claims religious freedom for Protestants as their spiritual right. In addition, Calvin urges Francis to study the new doctrines and to accept their validity.

In many respects, the doctrines espoused by Calvin are similar to those of Luther. Calvin accepted Luther's doctrine of justification by faith alone, but he differed in his persistent emphasis on the terrible majesty of God and in his insistence upon the utter inability of individuals to bring about their salvation. According to Calvin, individuals have a sense of God, but their wills are enslaved because of the inheritance from Adam and the taint of the fall. God, in Calvin's view, has chosen certain persons, the elect, by an immutable decree from all eternity, and they alone will be saved. This election is the cause of faith, and those who are not among the elect are doomed to hell. There is no infallible way of determining who are among the elect and who are not, but those who seem to be carrying out God's purpose can take it as a hopeful sign. Calvin expounded his doctrine of predestination in the *Institutes on the Christian Religion.* A selection from the *Institutes,* "Election and Predestination," is presented here.

The character of the French king whom Calvin addressed earlier in his life is revealed in a portrait by Jean Clouet (c. 1485–1541) painted between 1525 and 1530. It is diametrically opposed to that of Calvin. In contrast to the stern austerity of Calvinist preaching, Francis exhibits a love of magnificent display in his costume, a suavity in his manner, and an amused detachment in his expression. Francis is known to have cherished sensual pleasures rather than spiritual pursuits. It is, therefore, little wonder that he could not conform to the directives of John Calvin.

John Calvin, *Institutes of the Christian Religion*[1]
Election and Predestination

The covenant of life not being equally preached to all, and among those to whom it is preached not always finding the same reception, this diversity

1. Reprinted, by permission of the publisher, from John Calvin, *Institutes of the Christian Religion,* trans. by John Allen (Philadelphia: Presbyterian Board of Publication, 1843), vol. II, pp. 170, 175–76.

discovers the wonderful depth of the Divine judgment. Nor is it to be doubted that this variety also follows, subject to the decision of God's eternal election. If it be evidently the result of the Divine will, that salvation is freely offered to some, and others are prevented from attaining it,—this immediately gives rise to important and difficult questions, which are incapable of any other explication, than by the establishment of pious minds in what ought to be received concerning election and predestination—a question, in the opinion of many, full of perplexity; for they consider nothing more unreasonable, than that, of the common mass of mankind, some should be predestinated to salvation, and others to destruction. . . . We shall never be clearly convinced as we ought to be, that our salvation flows from the fountain of God's free mercy, till we are acquainted with his eternal election, which illustrates the grace of God by this comparison, that he adopts not all promiscuously to the hope of salvation, but gives to some what he refuses to others. . . . Predestination, by which God adopts some of the hope of life, and adjudges others to eternal death, no one, desirous of the credit of piety, dares absolutely to deny. But it is involved in many cavils,[2] especially by those who make foreknowledge the cause of it. We maintain, that both belong to God; but it is preposterous to represent one as dependent on the other. When we attribute foreknowledge to God, we mean that all things have ever been, and perpetually remain, before his eyes, so that to his knowledge nothing is future or past, but all things are present; and present in such a manner, that he does not merely conceive of them from ideas formed in his mind, as things remembered by us appear present to our minds, but really beholds and sees them as if actually placed before him. And this foreknowledge extends to the whole world, and to all the creatures. Predestination we call the eternal decree of God, by which he has determined in himself, what he would have to become of every individual of mankind. For they are not all created with a similar destiny; but eternal life is foreordained for some, and eternal damnation for others. Every man, therefore, being created for one or the other of these ends, we say, he is predestinated either to life or to death. This God has not only testified in particular persons, but has given a specimen of it in the whole posterity of Abraham, which should evidently show the future condition of every nation to depend upon his decision.

2. Frivolous or quibbling objections.

6. Germain Pilon, *Descent from the Cross,* 1583
Gardner, p. 742, ill. 18:53

Duke of Sully, *Memoirs:* "That Horrible Day," c. 1600

Religious strife within France was intensified by the Saint Bartholomew's Day Massacre of August 24, 1572. The widowed queen of France, Catherine de Médici (1519–1589), was alarmed by the increasing influence exerted by Admiral Gaspard de Coligny over her son, the youthful king of France, Charles IX (lived 1550–1574; reigned 1560–74). A leader of the French Protestants, who were called Huguenots, Coligny became the target of an assassination plot. When the assassination attempt failed and Catherine's complicity in the plot was about to be discovered, she persuaded Charles to order the deaths of the Huguenots.

Early on the morning of August 24, the church bells began to toll, and royal henchmen began to murder all the Huguenots they could find. About 3,000 Huguenots were massacred in Paris, and, as the fever spread to the provinces, another 10,000 Protestants were killed. The savagery of the religious conflict is described in the *Memoirs* of the Duke of Sully, a Protestant nobleman. A selection from the *Memoirs,* "That Horrible Day," is presented here.

The Saint Bartholomew's Day Massacre horrified Protestant countries and solidified Huguenot opposition to the crown in France. Religious warfare raged during the reign of Charles's brother, Henry III (lived 1551–1589; reigned 1574–89). On his deathbed in 1589, the Catholic king designated a Huguenot nobleman, Henry of Navarre (1553–1610), as his successor. To lessen resistance to his accession, Henry of Navarre renounced Protestantism and joined the Catholic Church.

In 1594 Henry defeated his enemies and entered Paris in triumph. Four years later, Henry, now acknowledged as the French king, issued the Edict of Nantes (1598). This royal edict granted the Huguenots political rights and religious freedom. Thus, France became the first great European power to accept the principle of religious liberty for its citizens.

The fervor with which religious issues were felt in sixteenth-century France was captured by the sculpture of the French artist Germain Pilon (c. 1535–1590). The bronze relief *Descent from the Cross* was executed in 1583 during a brief lull in the religious wars when Henry III had made peace with the Huguenots. The following year, religious enmity once again divided France into hostile military factions. Because he had attempted to make peace with the Huguenots, Henry III was assassinated by a Catholic fanatic. Because he had ended religious strife, Henry of Navarre, in his turn, was assassinated by a religious fanatic. The anguish of death, which is so evocatively conveyed in Pilon's relief, was felt by both Protestants and Catholics alike in France during the long period of religious strife.

Duke of Sully, *Memoirs*[1]
That Horrible Day

If I were inclined to increase the general horror inspired by an action so barbarous as that perpetrated on the 24th of August, 1572, and too well known by the name of the *massacre of St. Bartholomew,* I should in this place enlarge upon the number, the rank, the virtues, and great talents of those who were inhumanly murdered on that horrible day, as well in Paris as in every other part of the kingdom; I should mention at least the ignominious treatment, the fiend-like cruelty, and savage insults these miserable victims suffered from their butchers, whose conduct was a thousand times more terrible than death itself. I have writings still in my hands which would confirm the report, of the court of France having made the most pressing solicitations to the court of England and Germany, to the Swiss and the Genoese, to refuse any asylum to those Huguenots who might fly from France; but I prefer the honor of the nation to the satisfying [of] a malignant pleasure, which many persons would take, in lengthening out a recital wherein might be found the names of those who were so lost to humanity as to dip their hands in the blood of their fellow-citizens, and even of their own relations. I would, were it [in] my power, for ever obliterate the memory of a day that Divine vengeance made France groan for, by a continual succession of miseries, blood, and horror, during six-and twenty years; for it is impossible to judge otherwise, when one reflects on all that happened from that fatal moment till the peace of 1598. It is even with regret that I cannot omit what happened upon this occasion to the prince who is the subject of these Memoirs, and to myself.

Intending on that day to wait upon the king my master,[2] I went to bed early on the preceding evening; about three in the morning I was awakened by the cries of people and the alarm-bells, which were everywhere ringing. M. de Saint Julian, my tutor, and my valet, who had also been aroused by the noise, ran out of my apartments to learn the cause of it, but never returned, nor did I ever after hear what became of them. Being thus left alone in my room, my landlord, who was a Protestant, urged me to accompany him to mass in order to save his life, and his house from being pillaged; but I determined to endeavor to escape to the Collège de Bourgogne, and to effect this I put on my scholar's gown, and taking a book under my arm, I set out. In the streets I met three parties of the Life-guards; the first of these, after handling me very roughly, seized my book, and most fortunately for me,

1. Reprinted, by permission of the publishers, from *The Memoirs of the Duke of Sully,* trans. by Charlotte Lennox (London: William Miller, 1810), pp. 36–40.
2. Henry of Navarre, who became King Henry IV of France.

seeing it was a Roman Catholic prayer-book, suffered me to proceed, and this served me as a passport with the two other parties. As I went along I saw the houses broken open and plundered, and men, women, and children butchered, while a constant cry was kept up of, "Kill! Kill! O you Huguenots! O you Huguenots!" This made me very impatient to gain the college, where, through God's assistance, I at length arrived, without suffering any other injury than a most dreadful fright. The porter twice refused me entrance, but at last, by means of a few pieces of money, I prevailed on him to inform M. La Faye, the principal of the college and my particular friend, that I was at the gate, who, moved with pity, brought me in, though he was at a loss where to put me, on account of two priests who were in his room, and who said it was determined to put all the Huguenots to death, even the infants at the breast, as was done in the Sicilian vespers.[3] However, my friend conveyed me to a secret apartment, where no one entered except his valet, who brought me food during three successive days, at the end of which the king's proclamation prohibiting any further plunder or slaughter, was issued. . . .

7. Jean Goujon, *Nymphs,* 1545–49

Gardner, p. 741, ill. 18:52; Janson, p. 547, ills. 734–735

François Rabelais, *The Histories of Gargantua and Pantagruel:* "How Panurge Was in Love with a Lady of Paris," 1552

All the French writers of the sixteenth century in one way or another repudiated the culture of the Middle Ages. As the spirit of Renaissance humanism began to permeate French literature, French authors placed an increasing emphasis on the qualities of self-awareness, individualism, and innovation. One of the most courageous and distinguished of all French writers was François Rabelais (c. 1494–c. 1553).

At his father's insistence, Rabelais entered a monastery as a young man. His irreverent humor, however, made him unsuited for monastic life, which he abandoned in order to study medicine. Upon receiving an appointment as a hospital physician at Lyons, Rabelais enhanced his reputation by editing and translating medical treatises written in Italian, Latin, and Greek.

But Rabelais's urge to write entertaining fiction was stronger than his medical curiosity. During the last two decades of his life Rabelais published a flow of vivid, hedonistic tales revolving around the antics of two giant kings, Gargantua and

3. The massacre of the French in 1282, which began the Sicilian revolt against Charles I, the French ruler of Naples-Sicily. The massacre of 2,000 French began at vespers on Easter Monday in response to oppressive French policies.

Pantagruel. Among the great fiction of all times, these stories are monuments of prodigious buffoonery. In them every action is exaggerated, and every motive is ridiculous. The author uses boisterous laughter and irreverent satire to deride the formal conventions of Renaissance literature and to deflate the social pretensions of myriad characters. A selection from *The Histories of Gargantua and Pantagruel,* "How Panurge Was in Love with a Lady of Paris," is presented here. In this selection, Rabelais jests at the courtship habits of men and women.

Although popular with most readers, Rabelais's satire provoked the ire of theologians. Rabelais had to flee Paris several times for his safety. But as an author who had made laughter his principal aim, Rabelais was undeterred. He jocularly pointed out that more of his books were printed and sold in two months than Bibles were distributed in nine years.

In his writing, Rabelais brilliantly reflects the gaiety, sensuality, and modernity of the French Renaissance. These qualities are also evident in the art of Jean Goujon (c. 1510–1565). The reliefs, *Nymphs,* created by Goujon for the Fountain of the Innocents in Paris in 1545–49 bubble with beauty and joy. Unlike Rabelais, Goujon remained an admirer of classical sources and of tradition, but, like Rabelais, he infused his art with native wit and warmth.

François Rabelais, *The Histories of Gargantua and Pantagruel*[1]
How Panurge Was in Love with a Lady of Paris

Panurge began to be in great reputation in the city of Paris by means of this disputation wherein he prevailed against the Englishman, and from thenceforth made his codpiece to be very useful to him. To which effect he had it pinked[2] with pretty little embroideries after the Romanesca fashion. And the world did praise him publicly, in so far that there was a song made of him, which little children did use to sing when they were to fetch mustard. He was withal made welcome in all companies of ladies and gentlewomen, so that at last he became presumptuous, and went about to bring to his lure one of the greatest ladies in the city. And, indeed, leaving a rabble of long prologues and protestations, which ordinarily these indolent contemplative lent-lovers make who never meddle with the flesh, one day he said unto her, Madam, it would be a very great benefit to the commonwealth, delightful to you, honorable to your progeny, and necessary for me, that I cover you for the propagation of my race, and believe it, for experience will teach it you. The lady at this word thrust him back above a hundred leagues, saying, You mischievous fool, is it for you to talk thus unto me? Whom do you think you have in hand?

1. Reprinted, by permission of the publisher, from *The Works of Rabelais,* trans. by Thomas Urquhart and Peter le Motteux (London: D. Nutt, 1900), vol. 1, pp. 263–66.
2. Finished at the edge with a scalloped, notched, or, in this case, embroidered pattern.

Begone, never to come in my sight again; for, if one thing were not, I would have your legs and arms cut off. Well, said he, that were all one to me, to want both legs and arms, provided you and I had but one merry bout together at the brangle-buttock game;[3] for herewithin is—in showing her his long cod-piece—Master John Thursday, who will play you such an antic that you shall feel the sweetness thereof even to the very marrow of your bones. He is a gallant, and doth so well know how to find out all the corners, creeks, and ingrained inmates in your carnal trap, that after him there needs no broom, he'll sweep so well before, and nothing to his followers to work upon. Whereunto the lady answered, Go, villain go. If you speak to me one such word more, I will cry out and make you to be knocked down with blows. Ha, said he, you are not so bad as you say—no, or else I am deceived in your physiognomy. For sooner shall the earth mount up unto the heavens, and the highest heavens descend unto the hells, and all the course of nature be quite perverted, than that in so great beauty and neatness as in you is there should be one drop of gall or malice. They say, indeed, that hardly shall a man ever see a fair woman that is not also stubborn. Yet that is spoke only of those vulgar beauties; but yours is so excellent, so singular, and so heavenly, that I believe nature hath given it you as a paragon and masterpiece of her art, to make us know what she can do when she will employ all her skill and all her power. There is nothing in you but honey, but sugar, but a sweet and celestial manna. To you it was to whom Paris[4] ought to have adjudged the golden apple,[5] not to Venus,[6] no, nor to Juno,[7] nor to Minerva,[8] for never was there so much magnificence in Juno, so much wisdom in Minerva, nor so much comeliness in Venus as there is in you. O heavenly gods and goddesses! How happy shall that man be to whom you will grant the favour to embrace her, to kiss her, and to rub his bacon with hers! By G—, that shall be I, I know it well; for she loves me already her bellyful, I am sure of it, and so was I predestined to it by the fairies. And therefore, that we lose no time, put on, thrust out your gammons![9]—and would have embraced her, but she made as if she would put out her head at the window to call her neighbors for help. Then Panurge on a sudden ran out, and in his running away said, Madam, stay here till I come again; I will go call them myself; do not you take so much

3. Anatomical parts set into agitated motion.
4. The Trojan prince whose abduction of Helen led to the Trojan War.
5. The golden apple was the prize that Paris was instructed to award to the most beautiful of the three goddesses Juno, Minerva, and Venus.
6. Roman goddess of love and beauty.
7. Roman goddess of heaven, protectress of women and marriage, wife and sister of Jupiter.
8. Roman goddess of wisdom and arts.
9. Thighs.

pains. Thus went he away, not much caring for the repulse he had got, nor made he any whit the worse cheer for it. The next day he came to the church at the time she went to mass. At the door he gave her some holy water, bowing himself very low before her. Afterwards he kneeled down by her very familiarly and said unto her, Madam, know that I am so amorous of you that I can neither piss nor dung for love. I do not know, lady, what you mean, but if I should take any hurt by it, how much you would be to blame! Go, said she, go! I do not care; let me alone to say my prayers; Ay but, said he, equivocate upon this: *à beau mont le viconte,* or, to fair mount the prick-cunts. I cannot, said she. It is, said he, *à beau con le vit monté,* or to a fair c. . . the pr. . . mounts. And upon this, pray to God to give you that which your noble heart desireth, and I pray you give me these paternosters.[10] Take them, said she, and trouble me no longer. This done, she would have taken off her paternosters, which were made of a kind of yellow stone called cestrin, and adorned with great spots of gold, but Panurge nimbly drew out one of his knives, wherewith he cut them off very handsomely, and whilst he was going away to carry them to the brokers, he said to her, Will you have my knife? No, no, said she. But, said he, to the purpose. I am at your command-ment, body and goods, tripes and bowels.

In the meantime the lady was not very well content with the want of her paternosters, for they were one of her implements to keep her countenance by in the church; then thought with herself, This bold flouting roister is some giddy, fantastical, light-headed fool of a strange country. I shall never re-cover my paternosters again. What will my husband say? He will no doubt be angry with me. But I will tell him that a thief had cut them off from my hands in the church, which he will easily believe, seeing the end of the ribbon left at my girdle. After dinner Panurge went to see her, carrying in his sleeve a great purse full of palace-crowns, called counters, and began to say unto her, Which of us two loveth other a little? A turd for you! You do not deserve so much good nor so much honor; but, by G—, I will make the dogs ride you;—and with this he ran away as fast as he could, for fear of blows, whereof he was naturally fearful.

10. Large beads in a rosary indicating that the Lord's Prayer is to be said.

Baroque Art in Italy, France, and England

1. Gianlorenzo Bernini, Colonnade of Saint Peter's, Rome, designed 1657
Gardner, p. 753, ill. 19:3; Janson, p. 556, ill. 747

Galileo Galilei, *The Starry Messenger:* "The Revolution of the Planets Round the Sun," 1610

In the early seventeenth century the principles of modern science came consciously into use in the work of Galileo Galilei (1564–1642). These principles can be summarized as the reliance on experiment and on critical observation to test, confirm, refine, modify, or disprove theories concerning the natural world.

The sixteenth-century scholar Nicolaus Copernicus (1473–1543) had defined the workings of the solar system. Galileo both enunciated the first precise understanding of the movement of objects on earth and substantiated Copernicus's theories concerning the movement of the earth in space. Born and educated in Pisa, Italy, Galileo initially studied medicine. According to legend, Galileo deduced the formula for the oscillations of a pendulum from his observations of a swinging lamp in the cathedral. Subsequent contributions to the laws of motion included Galileo's demonstration that all objects fall at the same speed and his discovery of the parabolic flight of projectiles.

An astronomer as well as a physicist and an engineer, Galileo was the first scientist to use the telescope as a scientific instrument. In 1610 Galileo published a short book entitled *Starry Messenger,* which provides a concise account of his discoveries of lunar craters, Jupiter's satellites and the phases of Mercury. These discoveries offered further support for the Copernican view of a heliocentric universe. A selection

from *Starry Messenger*, "The Revolution of the Planets Round the Sun," is presented here.

The heliocentric explanation of the universe as expounded by Copernicus and Galileo was declared a heresy by Pope Pius V (lived 1504–1572; pope 1566–72). Twenty-two years later, the defiant Galileo made his ideas more explicit in *Dialogue Concerning the Two Chief Systems of the World* (1632). As a result, Galileo, at the age of seventy, was brought before the Inquisition. While publicly recanting, he is said to have muttered, "Even so the earth *does move.*" For his remaining years he was silenced by the church.

Galileo expanded the Western concept of space. He demonstrated that the magnitude of the universe was vastly greater than anything previously imagined. Five decades later Bernini (1598–1680) expanded the ritual space of the monumental piazza (designed 1657) fronting the basilica of Saint Peter in Rome. The immense oval, outlined by long colonnades, consists of intersecting geometrical shapes. In contrast to Renaissance buildings, which were compact, self-contained entities, the colonnade of Saint Peter's typifies Baroque structures, which were designed to interact with their environments.

Galileo Galilei, *The Starry Messenger*[1]
The Revolution of the Planets Round the Sun

About ten months ago a report reached my ears that a Dutchman had constructed a telescope, by the aid of which visible objects, although at a great distance from the eye of the observer, were seen distinctly as if near; and some proofs of its most wonderful performances were reported, which some gave credence to, but others contradicted. A few days after, I received confirmation of the report in a letter . . . which finally determined me to give myself up first to inquire into the principle of the telescope, and then to consider the means by which I might compass the invention of a similar instrument. . . . At length, by sparing neither labor nor expense, I succeeded in constructing for myself an instrument so superior that objects seen through it appear magnified nearly a thousand times, and more than thirty times nearer than if viewed by the natural powers of sight alone. . . .

There remains the matter, which seems to me to deserve to be considered the most important in this work, namely, that I should disclose and publish to the world the occasion of discovering and observing four planets,[2] never seen from the very beginning of the world up to our own times, their posi-

1. Reprinted, by permission of the publishers, from Harlow Shapley, Samuel Rapport, and Helen Wright, eds., *A Treasury of Science* (New York: Harper & Brothers, 1943), pp. 58–61. Copyright 1943 by Harper & Brothers.

2. Twelve natural satellites are now known to orbit Jupiter. The four largest—Io, Europa, Ganymede, and Callisto—were discovered by Galileo shortly after he built a telescope.

tions, and the observations made during the last two months about their movements and their changes of magnitude. . . .

On the 7th day of January in the present year, 1610, in the first hour of the following night, when I was viewing the constellations of the heavens through a telescope, the planet Jupiter presented itself to my view, and as I had prepared for myself a very excellent instrument, I noticed a circumstance which I had never been able to notice before, owing to want of power in my other telescope, namely, that three little stars, small but very bright, were near the planet. . . .

I, therefore, concluded, and decided unhesitatingly, that there are three stars in the heavens moving about Jupiter, as Venus and Mercury round the Sun; which at length was established as clear as daylight by numerous other subsequent observations. These observations also established that there are not only three, but four, erratic sidereal bodies performing their revolutions round Jupiter. . . .

These are my observations upon the four Medicean planets, recently discovered for the first time by me; and although it is not yet permitted me to deduce by calculation from these observations the orbits of these bodies, yet I may be allowed to make some statements, based upon them, well worthy of attention.

And, in the first place, since they are sometimes behind, sometimes before Jupiter, at like distances, and withdraw from this planet towards the east and towards the west only within very narrow limits of divergence, and since they accompany this planet alike when its motion is retrograde and direct, it can be a matter of doubt to no one that they perform their revolutions about this planet while at the same time they all accomplish together orbits of twelve years' length about the center of the world. Moreover, they revolve in unequal circles, which is evidently the conclusion to be drawn from the fact that I have never been permitted to see two satellites in conjunction when their distance from Jupiter was great, whereas near Jupiter two, three, and sometimes all four, have been found closely packed together. Moreover, it may be detected that the revolutions of the satellites which describe the smallest circles round Jupiter are the most rapid, for the satellites nearest to Jupiter are often to be seen in the east, when the day before they have appeared in the west, and contrariwise. Also, the satellite moving in the greatest orbit seems to me, after carefully weighing the occasions of its returning to positions previously noticed, to have a periodic time of half a month. Besides, we have a notable and splendid argument to remove the scruples of those who can tolerate the revolution of the planets round the Sun in the Copernican system, yet are so disturbed by the motion of one Moon

about the Earth, while both accomplish an orbit of a year's length about the Sun, that they consider that this theory of the universe must be upset as impossible; for now we have not one planet only revolving about another, while both traverse a vast orbit about the Sun, but our sense of sight presents to us four satellites circling about Jupiter, like the Moon about the Earth, while the whole system travels over a mighty orbit about the Sun in the space of twelve years.

2. Gianlorenzo Bernini, *The Ecstasy of Saint Theresa,* **Cornaro Chapel, Santa Maria della Vittoria, Rome, 1645–52**
Gardner, p. 760, ill. 19:12; Janson, p. 558, ill. 750

Saint Theresa of Ávila, *Life:* "Completely Afire with a Great Love for God," 1562

The Counter Reformation was often marked by the banning of heretical books, by church control of education, and by the suppression of Protestant doctrines, worship, and congregations. However, the Counter Reformation was also characterized by the reawakening of spiritual fervor.

One of the great forces of the Counter Reformation was the Spanish nun Theresa of Ávila (1515–1582). Born in Ávila, Spain, Theresa exhibited fervent piety in her early life. As a child she was found by her uncle at the outskirts of Ávila. Her intention had been to journey to southern Spain, where she planned to evangelize the Moors and where she anticipated that she would meet with martyrdom. As a teenager she entered a Carmelite monastery,[1] where she adopted a regimen of silence, seclusion, abstinence, and austerity.

Shortly after she received the Carmelite habit, Theresa began to have transitory mystical visions. At the age of thirty-nine she had a deeply moving experience of the nearness of Christ, which she considered to be the moment of her true spiritual conversion. Thereafter she embarked upon a program of spiritual reform within the Catholic Church. She began to found monasteries in Europe that aimed at restoring the austerity and contemplative character of early Carmelite life, and she directed missions outside Europe in distant areas, including Persia, the Congo, and the Middle East. Members of Theresa's reformed communities were known as the Discalced, or Barefooted, Carmelites, because they wore sandals in place of shoes and stockings.

1. The Order of Our Lady of Mount Carmel is a religious order founded by Saint Berthold in Palestine in 1154. The Order of Carmelite Sisters was founded in 1452. The primitive rule stressed poverty, vegetarianism, and solitude.

Theresa initially faced suspicion within the church about the genuineness of her visions. Opponents whispered that her visions were the work of the devil. In order to describe her spiritual state for her confessor,[2] Theresa wrote her autobiography, *Life* (1562). The book, which was later enlarged in scope for public audiences, reveals the capacity for ecstatic worship.

In *Life,* Theresa describes the trances and visions that she experienced during and after her conversion. She also devotes much of her attention to a discussion of prayer. Theresa depicts the different stages of the life of prayer in metaphorical terms, taken from the manner of securing water to irrigate a garden. A selection from Theresa's *Life,* "Completely Afire with a Great Love for God," is presented here.

Theresa was proclaimed Patroness of Spain by the Spanish parliament in 1617 and was canonized—that is, declared a saint—by Pope Gregory XV (lived 1554–1623; pope 1621–23) in 1622. The sculptor Bernini (1598–1680) created a dramatic representation of Saint Theresa transported by her spiritual joy, *The Ecstasy of Saint Theresa* (1645–52), for the Cornaro Chapel of Santa Maria della Vittoria in Rome. In this sculpture, the saint is represented in the sandals that she and the members of her reformed communities adopted. Her influence was felt not only in Spain but throughout Europe and in much of the non-European world.

Saint Theresa of Ávila, *Life*[3]
Completely Afire with a Great Love for God

I spent some days, though only a few, with [a] vision continually in my mind, and it did me so much good that I remained in prayer unceasingly and contrived that everything I did should be such as not to displease Him Who, as I clearly perceived, was a witness of it. . . . One day, when I was at prayer, the Lord was pleased to reveal to me nothing but His hands, the beauty of which was so great as to be indescribable. . . . A few days later I also saw that Divine face, which seemed to leave me completely absorbed. . . .

Your Reverence may suppose that it would have needed no great effort to behold those hands and that beauteous face. But there is such beauty about glorified bodies that the glory which illumines them throws all who look upon such supernatural loveliness into confusion. . . .

It is not a radiance which dazzles, but a soft whiteness and an infused radiance which, without wearying the eyes, causes them the greatest delight; nor are they wearied by the brightness which they see in seeing this Divine beauty. . . .

2. A person authorized to hear confessions.
3. Reprinted, by permission of the publisher, from *The Life of St. Theresa of Ávila,* trans. by E. Allison Peers (London: Sheed and Ward, 1979), pp. 192–93. Copyright by Sheed and Ward.

It pleased the Lord that I should sometimes see the following vision. I would see beside me, on my left hand, an angel in bodily form—a type of vision which I am not in the habit of seeing, except very rarely. Though I often see representations of angels, my visions of them are of the type which I first mentioned. It pleased the Lord that I should see this angel in the following way. He was not tall, but short, and very beautiful, his face so aflame that he appeared to be one of the highest types of angel who seem to be all afire. They must be those who are called cherubim:[4] they do not tell me their names but I am well aware that there is a great difference between certain angels and others, and between these and others still, of a kind that I could not possibly explain. In his hands I saw a long golden spear and at the end of the iron tip I seemed to see a point of fire. With this he seemed to pierce my heart several times so that it penetrated to my entrails. When he drew it out, I thought he was drawing them out with it and he left me completely afire with a great love for God. The pain was so sharp that it made me utter several moans; and so excessive was the sweetness caused me by this intense pain that one can never wish to lose it, nor will one's soul be content with anything less than God. It is not bodily pain, but spiritual, though the body has a share in it—indeed, a great share. So sweet are the colloquies of love which pass between the soul and God that if anyone thinks I am lying I beseech God, in His goodness, to give him the same experience.

During the days that this continued, I went about as if in a stupor. I had no wish to see or speak with anyone but only to hug my pain, which caused me greater bliss than any that can come from the whole of creation. I was like this on several occasions, when the Lord was pleased to send me these raptures, and so deep were they that, even when I was with other people, I could not resist them. . . . When this pain of which I am now speaking begins, the Lord seems to transport the soul and to send it into an ecstasy, so that it cannot possibly suffer or have any pain because it immediately begins to experience fruition. May He be blessed for ever, Who bestows so many favors on one who so ill requites such great benefits.

4. A celestial being considered to be a member of the second order of angels, often represented as a winged child.

3. Giacomo della Porta and Giacomo da Vignola, *Il Gesù*, Rome, c. 1575–84

Gardner, pp. 752–53, ills. 19:1; 19:2

Giovanni Battista Gaulli, *Triumph of the Name of Jesus,* **1672–85**
Janson, p. 560, ill. 753

Saint Francis Xavier, Letters: "They Are the Best Race Yet Discovered" and "To Hold Forth in the Streets," 1549

In 1622, the same year that Theresa of Ávila was canonized, Pope Gregory XV (lived 1554–1623; pope 1621–23) also canonized another Spaniard, Francis Xavier (1506–1552). A Jesuit, Francis had, more than anyone else, dedicated himself to the mission of converting non-European peoples to Christianity.

Born in the castle of Xavier in the Basque province of Navarre, Francis spent ten years at the University of Paris, where he studied philosophy and theology. In 1534 he helped Ignatius Loyola found the Jesuit order. When King John III of Portugal requested Jesuit help to evangelize the Portuguese colonies in Asia, Francis was one of the missionaries chosen by Ignatius. Between April 8, 1541, when he sailed from Lisbon for India, and December 1552, when he died on the island of Chang-chuen, close to the coast of China, Francis traveled over 62,000 miles.

The first and greatest of the distant Jesuit missions, Francis Xavier's journeys had a special quality of heroism, scarcely attainable in the familiar landscapes of Europe. Later Jesuit missionaries, whether they followed his trail or headed for Brazil or the Congo, could not fail to impress some measure of Francis's fervor upon European Catholicism. They helped the center of the church to emulate the standards achieved on her frontiers, for in Rome and elsewhere the narratives sent back by the missionaries were read with a mounting sense of pride and confidence, as if they had been dispatches from the fronts of a war.

The letters written by Francis Xavier, especially, aroused widespread zeal for the missions. Through Francis's written accounts, the imagination of readers could follow the Jesuit missionaries into strange and exotic lands. Selections from two of Francis Xavier's letters of Japan, where the Jesuit labored between 1549 and 1552, are presented here. The first selection, "They Are the Best Race Yet Discovered," describes Francis's initial response to the Japanese people. The second selection, "To Hold Forth in the Streets," describes Francis's efforts at evangelism in the streets of Yamaguchi.[1]

The mother church of the Jesuit order, Il Gesù, was built in Rome between approximately 1575 and 1584. Two architects, Giacomo da Vignola (1507–1573) and Giacomo della Porta (1537–1602), collaborated in the design, which became a proto-type for Catholic churches worldwide, particularly in Latin America. Il Gesù's ceiling

1. A city located on the extreme western end of Honshu, the main island of Japan.

decoration, *Triumph of the Name of Jesus,* was painted between 1672 and 1685 by Giovanni Battista Gaulli (1639–1709). The sense of infinite space reflects the universal mission embraced by Jesuit missionaries.

Saint Francis Xavier, Letters[2]
They Are the Best Race Yet Discovered

They are the best race yet discovered, and I think that among non-Christians their match will not easily be found. Admirable in their social relationships, they have an astonishing sense of honor and esteem it above all other things. In general, they are not a wealthy people, but neither among nobles or plebeians is poverty regarded as a disgrace. A very poor nobleman would not dream of marrying a woman not of his own class, however wealthy she might be, for he thinks he would lose his honor by so doing, and he esteems honor far above riches, which is something, so far as I know, that cannot be said of Christian peoples. The Japanese are full of courtesy in their dealings with one another. The men set great store by weapons, and nobles and plebeians alike always carry sword and dagger from the age of fourteen. They will not endure to be treated slightingly or addressed in contemptuous terms. The ordinary people hold the military class [samurai] in great respect, and they for their part glory in serving their lord [daimyo], on whom they greatly depend, not I think, from fear of anything he could do to them, but because it would mean loss of honor to fail in duty to him. They are a moderate people as regards food, but they indulge a good deal in an intoxicating liquor made from rice [sake], as the [grape] vine does not grow in Japan. They never play games of chance, considering them to be a form of theft and therefore highly dishonorable. Swearing is little heard and when they do swear it is by the sun. A good proportion of the people can read and write, which is a great help towards teaching them quickly the prayers and the things of God. They are monogamists, and they abominate thieving and punish robbers invariably with death. Of all the peoples I have seen in my life, Christians included, the Japanese are the most rigorously opposed to theft, and there are few robbers in the country. They are a well-meaning people and very sociable and anxious to learn. They take pleasure in hearing of the things of God, especially such as they can understand, and they have no idols made in the shape of beasts, but believe in men of ancient times who, as far as I can make out, lived as philosophers. Many Japanese adore the sun and others the moon. They like to be appealed to on rational grounds, and are ready to agree that what reason vindicates is right. In my view, the ordinary lay people commit fewer

2. Reprinted, by permission of the publishers, from James Brodrick, *Saint Francis Xavier* (New York: Wicklow Press, 1952), pp. 361–63. Copyright by Pellegrini and Cudahy.

sins and are more obedient to reason than those they call Bonzes and regard as their spiritual fathers. The Bonzes are addicted to unnatural vice, and readily admit it, for it is so notorious and well known to everybody that men and women of every condition take it for granted and show no abhorrence to it. Still, the laity are very pleased to hear us denounce this abominable sin.

Saint Francis Xavier, Letters[3]
To Hold Forth in the Streets

We decided to hold forth in the streets twice a day reading from the book we had brought with us and then giving a sermon on the subject. . . . Crowds gathered to listen to us, some of whom seemed pleased to hear the law of God, while others derided it, and a certain number pondered over it. On our way through the streets, children and their elders also harassed us a great deal, making a mock of us and shouting: "These fellows say that we have to adore *Deus* to be saved and none other can save us but the Creator of all things." Others cried: "These men teach that nobody can have more than one wife." And there were some who said: "Look at the two who tell us that sodomy is a sin!" for it is a very common vice among them. In a similar way they named other Commandments in order to make us a laughing-stock. . . . We continued thus to preach in the streets and houses of the city for many days, . . . and we made a few Christians.

4. Michelangelo da Caravaggio, *The Calling of Saint Matthew,* c. 1599–1602
Janson, p. 550, ill. 739

Michelangelo da Caravaggio, *The Conversion of Saint Paul,* c. 1601
Gardner, p. 769, ill. 19:27

Philip Neri, Letter to Maria Vittoria: "The Ear of Obedience," 1585
Pietro Focile, Document: "I Went Out Full of Consolation," 1560

The spiritual revival of Rome during the Counter Reformation was, in large part, associated with Philip Neri (1515–1595). Born in Florence, Philip went to Rome for academic study of philosophy and theology. Both before and after his ordination, Philip directed his efforts to the service of lay people and to the rehabilitation of the priesthood. To accomplish the former goal, Philip organized a confraternity to assist the poor, sick, and convalescent pilgrims who thronged the city streets of Rome. To

3. Reprinted, by permission of the publisher, from James Brodrick, *Saint Francis Xavier* (New York: Wicklow Press, 1952), p. 420. Copyright by Pellegrini and Cudahy.

accomplish the latter goal, Philip expanded the normal role of a priest to include informal afternoon discussions and prayers in a room above his church for penitents and other concerned members of his congregation.

In 1564 Philip and several of his followers formed the Congregation of the Oratory. The distinctive feature of the Oratory was a continuation of Philip's popular afternoon discussions, which were expanded to four daily informal talks. These talks concerned the spiritual life, the Scriptures, church history, and the study of saints' lives. Prayers and hymns recited and sung in the vernacular Italian language were interspersed with discussion. Sacred dramatic works of music, named oratorios after the Oratory, were composed for use in the services directed by Philip. With the financial support of a wealthy cardinal, Philip began rebuilding the church of Santa Maria in Vallicella, assigned to him by Pope Gregory XIII (lived 1502–1585; pope 1572–85). Houses of Oratorians spread throughout Italy and the rest of Europe.

Philip Neri spent his life preaching rather than writing; however, letters to family members by Neri do survive. These letters reveal the humility of Neri even when, in his old age, he had become famous for his arduous work with the poor of Rome. Philip had two nieces, one of whom, Maria Vittoria, was a nun in the convent of San Pietro Martyr. A selection from a letter to her, "The Ear of Obedience" (1585), is presented here. A description of Philip and of the impact of the Oratory is provided by Pietro Focile, a working-class man in Rome. Pietro Focile recounts an occasion in November 1560 when he went to confession at the imposing church of Saint John Lateran. Going into the adjoining hospital, he found his friend Giovanni Battista Venitiano working as an attendant. Venitiano proposed to take Focile to a place of "magnificent prayer"; the story of Focile's subsequent encounter with Neri is recorded in a document submitted to the Vatican during the process of Philip Neri's canonization. A selection from Focile's document, "I Went Out Full of Consolation," is presented here.

The teachings of Philip Neri influenced the Italian painter Michelangelo da Caravaggio (c. 1571–1610). In paintings such as *The Calling of Saint Matthew* (c. 1599–1602) and *The Conversion of Saint Paul* (c. 1601), Caravaggio has depicted the Christian faith as a spontaneous experience open to all and untouched by theological dispute. The poor and humble who had first been invited to Philip Neri's Oratories subsequently became the principal actors in the Christian dramas depicted on Caravaggio's canvases.

Philip Neri, Letter to Maria Vittoria[1]
The Ear of Obedience

[The] holy mother of God is called the Star of the Sea; wherefore I conclude that not without deep meaning was this name given you, because in coming forth from the world you were by the hand of God drawn out of the waters

1. Reprinted, by permission of the publisher, from Alfonso Capecelatro, *The Life of Saint Philip Neri*, trans. by Thomas Pope (London: Burns and Oates, 1894), pp. 191–94.

of that sea, in crossing over which so many hapless souls perish, the greater part sunk deep in the waters, and so few comparatively escape. But you, like another Peter, have been taken by the hand and upheld, so that you have not so much walked through the waters as upon them. . . .

Now, my daughter, you have with your little bark almost reached the shore of the land of promise, that blessed country promised to the elect of God. . . . And, O my most beloved daughter in Christ, since you are so near a felicity so great, turn not back, nor strike your oar into the earth; draw not off from the shore, look not back in thought or affection to the world; for the world is a thicket in which all who wander are waylaid and slain, or a forest full of savage monsters, or a plain full of soldiers, full of robbery, of violence, and of injustice, always excepting the good, of whom there are some, though few. . . . The Holy Spirit speaks to you thus in the psalm: Listen, O daughter, and from the words receive light and effulgence of grace, and in that light look around you. When you see the fair and peaceful land that is pointed out to you, forget the other land full of toil and weariness, which brings forth only thorns and briars; have no memory more of your country and your father's house, but incline the ear of obedience to my words, and stoop your shoulders to the cross of true mortification, exterior and interior both, of all evil ways and thoughts and all delusive loves. Put in me thy trust, thy hope, and all thy affection; so will I take these for my bride, and have delight in thy modesty and humility. I give thee from my table every manner of food I am wont to give to those who serve and love me faithfully, such as the temptations I permit, the tribulations which at first will seem to thee bitter, but after, when thou growest used to them, will be sweet to thy taste. And thou wilt learn and know that this way, the way I take with those I love, is the true espousal of thy soul to me.

Pietro Focile, Document[2]
I Went Out Full of Consolation

I went and found [Venitiano] in the Pellegrini at the door of his shop, the shop with the sign of the Corallo d'Oro, which belonged, I think, to Bartolomeo Rusconi. He took me to San Girolamo, and to an Oratory upstairs which is still there. . . . Padre Messer Filippo [Philip Neri] then came. He began to look at me, because I was dressed as a young fop,[3] and both he and Tarugi looked at me a great deal, and it was as though they had both of them

2. Reprinted, by permission of the publisher, from Louis Ponnelle and Louis Bourdet, *St. Philip Neri and the Roman Society of His Times (1515–1595)*, trans. by Ralph Francis Kerr (London: Sheed and Ward, 1932), pp. 247–48. Copyright by Sheed and Ward.
3. A man who is excessively vain and concerned about his manners and appearance.

inflicted great wounds on my heart, so that I was ashamed to look them in the face, and I felt ashamed because it seemed to me that they were reading me and saw all my sins. I felt a great compunction when I heard the kind things they said in rebuke of sin and for the encouragement of their hearers. It seemed to me that what they were saying they were saying for my benefit, and when the Oratory was over I went out full of consolation. The aforesaid Padre Filippo [Philip Neri] especially looked at me with great affection. When I had got outside I waited in the vestibule of the Oratory, and it seemed to me that I could not go away. They went downstairs and into the church of San Girolamo by the sacristy[4] door, made a prayer and then got up, and I began to follow them, always remaining at a little distance. I took courage from the fact that there were others as well who had been at the Oratory who were following them. So I followed them too, and accompanied them to the Minerva, where we heard the conference given by Padre Messer Paolino, who was preaching and was a great friend of Padre Filippo. . . . [When the conference was over Philip took his people to Santa Maria degli Angeli, at the Terme.] There [Philip] ordered some of the priests who had followed him to speak. He asked them a number of questions, and the priests spoke of the salvation of souls. . . . [They went back to San Girolamo at the Ave Maria. In the hall of the Oratory Focile found Philip praying with a number of laymen and priests. Upon the end of the day, Focile returned home.]

It seemed to me that during that day I had been with the angels, so lighthearted and happy in mind did I feel, and it seemed to me as though a sinful man had been changed into a mortified man. I could not speak, and people tried in vain to rouse me to make the jokes I used to make, but I could not bring myself to do so; people asked me what had happened to me, but I remained dumb, and could not speak as I had been accustomed to do.

5. Claude Perrault, Louis Le Vau, and Charles Le Brun, East Facade of the Louvre, Paris, 1667–70
Gardner, p. 806, ill. 19:64; Janson, p. 592, ill. 808

Jacques-Bénigne Bossuet, *Politics Drawn from Holy Scripture:* "The Royal Throne Is the Throne of God Himself," c. 1671–72

The "age of absolutism" in the second half of the seventeenth century was both a reaction against the turmoil of the Thirty Years' War (1618–48) and a reflection of

4. A room in a church in which sacred vessels, vestments, etc. are kept.

the increasing desire among European peoples for the stability and security that had been absent earlier. Convinced that weak governments led to anarchy, most seventeenth-century Europeans were prepared to accept that good government was achievable only by monarchs who wielded absolute powers. Most seventeenth-century Europeans were also willing to believe that the ruler of a nation was a representative who was appointed by God and who governed according to God's will.

Louis XIV (1638–1715; reigned 1643–1715) of France embodied the seventeenth-century ideal of the absolutism of kings. The long-awaited child of Louis XIII of France and Anne of Austria, Louis became king at the age of four upon his father's unexpectedly early death. During the early years of Louis's life, the survival of the French monarch was threatened both by internal revolts among the middle and upper classes and by protracted wars with Germany and Spain. In the middle of a night in 1651, the thirteen-year-old king was awakened in his bedchamber by an angry Parisian mob that had stormed the royal palace in search of the monarch. Louis never forgot the fear and turmoil of his childhood. He resolved that France would be a powerful nation second to none and that he would be the foremost ruler in Europe.

Louis's concept of kingship was elegantly expounded by the French bishop Jacques-Bénigne Bossuet (1627–1704). Historian and orator as well as churchman, Bossuet was appointed by Louis XIV in 1671 as tutor to the royal heir and as court preacher. During the period when he held the royal appointment, Bossuet wrote *Politics Drawn from Holy Scripture*, a work that was published posthumously in 1709. In it Bossuet outlined a theory of the divine right of kings, which must have been congenial to his employer, Louis XIV. A selection from *Politics Drawn from Holy Scripture*, "The Royal Throne Is the Throne of God Himself," is presented here.

Louis celebrated his absolute power by organizing art and architecture in the service of the state. One of the first projects of the king was the completion of the east side of the Louvre court. Three architects, Claude Perrault (1613–1688), Louis Le Vau (1612–1670), and Charles Le Brun (1619–1690), collaborated on the design (1667–70), which merged French and Italian classical elements. The result was a royal palace that, in its grandeur, was an appropriate symbol for the centralized state being formed by Louis XIV.

Jacques-Bénigne Bossuet, *Politics Drawn from Holy Scripture*[1]
The Royal Throne Is the Throne of God Himself

It is God who establishes kings . . . Princes act as the ministers of God and his lieutenants on earth. It is through them that He rules. . . . Hence we have seen that the royal throne is not that of a man, but the throne of God Himself. . . . It is apparent from this that the person of kings is sacred, and to move against them is sacrilege. . . . Serving God and honoring kings are

1. Reprinted, by permission of the publisher, from Gary Martin Best, ed., *Seventeenth-Century Europe* (London: Macmillan Education, 1982), p. 66. Copyright by Gary Martin Best.

things united. St. Peter groups these two duties together: "Fear God; Honor the king." . . .

As their power comes from on high, kings should not believe that they are its masters and may do as they wish; they should use their power with fear and restraint as something which has come to them from God, and for which God will demand an account. . . . God gave His power to kings only to guarantee the public welfare and uphold the people's interests. . . . Princes are gods and share somehow in divine independence . . . only God may judge over their judgments and their persons. . . . The prince may correct himself when he knows he has done evil, but there is no remedy against the prince's authority other than his own authority. . . . Majesty is the image of the greatness of God in the prince . . . who is a public personage, because the whole state is in him; the will of the entire people is embodied in his will. . . .

What is there that a wise prince cannot achieve? Under him wars are successful, peace is established, justice reigns, religion flourishes, trade makes the realm rich, and the earth itself seems to bring forth fruit more readily.

6. Louis Le Vau and Jules Hardouin-Mansart, Palace of Versailles, 1669–85

Gardner, pp. 808–9, ill. 19:67, 19:68; Janson, pp. 593–94, ills. 810–812

Louis XIV, *Letters:* "I Was King and Born to Be One," c. 1700

At the age of twenty-three, Louis XIV (1638–1715; reigned 1643–1715) surprised his French subjects by declaring his intention to assume direct control of the French government rather than delegating the administration of the country to a prime minister. Guided by a firm conception of the nature of kingship, Louis devoted himself unremittingly to his self-imposed task. For the next fifty-four years, he spent six to eight hours every day laboring patiently at state affairs. In a departure from the French crown's traditional practice, he governed without depending upon the nobility. Instead, Louis employed middle-class administrators, organized according to an elaborate bureaucratic system of councils and offices. As a result, the government became increasingly effective in performing its functions and increasingly secure from the threat of revolt.

For Louis, the renown of the sovereign and the prestige of France were identical. Louis's belief in the importance of the monarchy is seen most clearly in the magnificent setting he created for his court at Versailles, twelve miles southwest of Paris.

Versailles (1669–85), begun by Louis Le Vau (1612–1670) and continued by Jules Hardouin-Mansart (1646–1708), originally consisted of a small brick château on a marshy, sandy plain, but soon became a symbol of the supreme power of France in terms of beauty, sumptuousness, and grandeur.

Louis's concept of kingship also emerges in a series of letters, in which the concerned monarch hoped to pass on to his successors the lessons he had learned about kingship. In these letters, Louis reveals his ideas on the control of the state and on the appropriate conduct of a monarch. A selection (c. 1700), "I Was King and Born to Be One," is presented here.

Louis XIV, *Letters*[1]
I Was King and Born to Be One

Two things without doubt were absolutely necessary: very hard work on my part, and a wise choice of persons capable of seconding it. . . . I laid a rule on myself to work regularly twice every day, and for two or three hours each time with different persons, without counting the hours which I passed privately and alone, nor the time which I was able to give on particular occasions to any special affairs that might arise. There was no moment when I did not permit people to talk to me about them, provided that they were urgent; with the exception of foreign ministers who sometimes find too favorable moments in the familiarity allowed to them, either to obtain or to discover something, and whom one should not hear without being previously prepared.

I cannot tell you what fruit I gathered immediately I had taken this resolution. I felt myself, as it were, uplifted in thought and courage; I found myself quite another man, and with joy reproached myself for having been too long unaware of it. This first timidity, which a little self-judgment always produces and which at the beginning gave me pain, especially when I had to speak in public, disappeared in less than no time. The only thing I felt then was that I was King and born to be one. . . . A King, however skilful and enlightened be his ministers, cannot put his own hand to work without its effect being seen. Success, which is agreeable in everything, even in the smallest matters, gratifies us in these as well as in the greatest, and there is no satisfaction to equal that of noting every day some progress in glorious and lofty enterprises, and in the happiness of the people which has been

1. Reprinted, by permission of the publisher, from J. Longnon, *A King's Lessons in Statecraft: Louis XIV, Letters to His Heirs,* trans. by H. Wilson (London: T. Fisher Unwin, 1914), pp. 48–57. Copyright by HarperCollins.

planned and thought out by oneself. All that is most necessary to this work is at the same time agreeable; for, in a word, my son, it is to have one's eyes open to the whole earth; to learn each hour the news concerning every province and every nation, the secrets of every court, the mood and the weakness of each Prince and of every foreign minister; to be well-informed on an infinite number of matters about which we are supposed to know nothing; to elicit from our subjects what they hide from us with the greatest care; to discover the most remote opinions of our own courtiers and the most hidden interests of those who come to us with quite contrary professions. I do not know of any other pleasure we would not renounce for that. . . .

I resolved at all costs to have no prime minister. . . . To effect this, it was necessary to divide my confidence and the execution of my orders without giving it entirely to one single person, applying these different people to different spheres according to their diverse talents, which is perhaps the first and greatest gift that Princes can possess. . . . I could, doubtless, have discovered men of higher consideration, but not of greater capacity than these three [Lionne,[2] Le Tellier,[3] Colbert[4]]; . . . to lay bare to you all that was in my mind, it was not to my interest to choose subjects of a more eminent quality. Before all else it was needful to establish my own reputation, and to let the public know from the very rank from which I chose them, that it was my intention not to share my authority with them.

7. Jules Hardouin-Mansart, Église de Dôme (Hôtel des Invalides), Paris, 1676–1706

Gardner, p. 810, ills. 19:70, 19:71; Janson, p. 595, ills. 813, 814

Molière, *Tartuffe:* "Oh! You Squeeze Me Too Hard," 1664

A devout Catholic, Louis XIV displayed his allegiance to his religion by commissioning the construction of new church buildings. One such church is the Église de Dôme (Hôtel des Invalides), in Paris, designed by Jules Hardouin-Mansart and built between 1676 and 1706. This church is attached to the veterans' hospital constructed by Louis for disabled soldiers.

2. Hugh de Lionne (1611–1671) was the secretary of state for foreign affairs under Louis. He laid the groundwork enabling Louis to initiate war against Spain.
3. François-Michel Le Tellier (1639–1691) was the secretary of state for war under Louis. He was responsible for reorganizing the French army.
4. Jean-Baptist Colbert (1619–1683) was the minister of finance under Louis. He carried out the successful economic reconstruction of France.

An avid theater-goer, Louis incurred the hostility of the Catholic clergy by his patronage of the dramatist Jean-Baptiste Poquelin (1622–1673), known by the name Molière. Trained as a lawyer, Molière abandoned the legal profession when he was twenty-one years old and joined an amateur dramatic group. In 1658 Molière's company, L'Illustre Théâtre, made its Parisian debut with a performance of the comedy *The Lovelorn Doctor,* written by Molière. Louis, who was in attendance, was delighted. He authorized Molière to install his company in the theater of the Petit-Bourbon, near the Louvre.[1]

With the king's approval, Molière undertook the formidable task of reforming French morals and manners through the medium of comic laughter. Molière's comedies exposed upper-class and middle-class hypocrisies through the ridicule of character types such as the miser, the hypochondriac, the social climber, and the neurotic pessimist.

Tartuffe (1664) is one of Molière's best comedies of character. In the play, Molière shows how a religious hypocrite can dupe the unsuspecting people around him. Tartuffe is a sanctimonious villain and pietistic con-man while Orgon is his naively trusting victim. As Tartuffe gains ascendancy over his prey, Orgon becomes so weakly submissive that he fails to see that his wife, Elmire, has been seduced by the villain; even worse, he forces his daughter to marry Tartuffe, who has corrupted and destroyed the family. In one scene Tartuffe attempts to seduce Elmire, whose daughter he is about to wed. A selection from *Tartuffe,* "Oh! You Squeeze Me Too Hard," is presented here.

Molière was taking a great risk when he suggested that the appearance of religious saintliness might be no more than a cloak for greed, gluttony, deceit, and lust, and that the vocabulary of religious piety might be no less than a form of casuistry to gloss over gross inequities. *Tartuffe* succeeded in infuriating the French Catholic clergy, and, after a few performances, it had to be withdrawn.

Molière, *Tartuffe*[2]
Oh! You Squeeze Me Too Hard

Tartuffe [*Taking Elmire's hand, and squeezing her fingers*]. Yes, madame, without doubt, and such is the fervour of my—

Elmire. Oh! you squeeze me too hard.

Tartuffe. 'This out of excess of zeal; I never intended to hurt you. I had much rather—[*puts his hand upon her knee.*]

1. Palace of French royal family in Paris; constructed in 1546 on the site of a twelfth-century fortress and palace.
2. Reprinted, by permission of the publisher, from Molière, *Tartuffe,* trans. by H. Baker and J. Miller (New York: Heritage Press, 1963), pp. 43–45. Copyright by the George Macy Companies.

Elmire. What does your hand do there?

Tartuffe. I'm only feeling your clothes, madame; the stuff is mighty rich.

Elmire. Oh! Pray give over; I am very ticklish. [*She draws away her chair, and Tartuffe follows with his.*]

Tartuffe. Bless me! How wonderful it is the workmanship of this lace! They work to a miracle nowadays. Things of all kinds were never better done.

Elmire. 'Tis true; but let us speak of our affair a little. They say that my husband has a mind to set aside his promise, and to give you his daughter. Is that true? Pray tell me.

Tartuffe. He did hint something towards it. But, madame, to tell you the truth, that is not the happiness I sigh after. I behold elsewhere the wonderful attractions of the felicity that engages every wish of mine.

Elmire. That is, you love no earthly things.

Tartuffe. My breast does not enclose a heart of flint.

Elmire. I am apt to think that your sighs tend all to Heaven, and that nothing here below can detain your desires.

Tartuffe. The love which engages us to eternal beauties does not extinguish in us the love of temporal ones. Our senses may easily be charmed with the perfect works Heaven has formed. Its reflected charms shine forth in such as you. But in your person it displays its choicest wonders. It has diffused such beauties o'er your face as surprise the sight and transport the heart; nor could I behold you, perfect creature, without admiring in you the Author of nature,[3] and feeling my heart touched with an ardent love at sight of the fairest of portraits wherein he has delineated himself. At first I was under apprehensions lest this secret flame might be a dexterous surprise of the foul fiend; and my heart ever resolved to avoid your eyes, believing you an obstacle to my future happiness. But at length I perceived, most lovely beauty, that my passion could not be blameable, that I could reconcile it with modesty, and this made me abandon my heart to it. It is, I confess, a very great presumption in me to make you the offer of this heart; but, in my vows, I rely wholly on your goodness, and not on anything in my own weak power. In you center my hope, my happiness, my quiet; on you depend my torment or my bliss; and I am on the point of being, by your sole decision, happy if you will, or miserable if you please.

3. God.

8. Inigo Jones, Banqueting House at Whitehall, London, 1619–22
Gardner, p. 813, ill. 19:74; Janson, p. 602, ill. 826

William Shakespeare, *Henry VIII:* "The High and Mighty Princess of England, Elizabeth," 1613
William Shakespeare, *Macbeth:* "Thou Shalt Get Kings, Though Thou Be None," c. 1606

For the British, the reigns of Queen Elizabeth I (lived 1533–1603; reigned 1558–1603) and of King James I (lived 1566–1625; reigned 1603–25) constituted an age of great achievement. Not only did they forge a wealthy and powerful state, these monarchs also fostered the creation of a distinctive national culture. One of the most brilliant manifestations of this culture was the production of plays and masques. The stage attracted the talents of writers such as William Shakespeare (1564–1616) and of architects and designers such as Inigo Jones (1573–1642).

Shakespeare entered the London theatrical world in 1590. In addition to writing thirty-eight plays, Shakespeare was a member of the Lord Chamberlain's (later King's) Men, an acting group that became a favorite of Elizabeth and James.

In his writing, Shakespeare was careful to pay homage to the English sovereigns who patronized his theatrical company. In the play *Henry VIII* (1613), Shakespeare retroactively prophesied blessings for the reign of the last Tudor monarch, Elizabeth, by imagining the blessings that might have been bestowed upon the infant princess at her christening. Without naming him, Shakespeare referred to James as Elizabeth's "star-like" successor. In the play *Macbeth* (c. 1606), Shakespeare indirectly celebrated the reign of the first Stuart monarch, James, by retelling the legend that traced Stuart genealogy back through Banquo to the first king of Scotland, Kenneth Macalpine. Two selections from the plays of Shakespeare are presented here. The first selection, "The High and Mighty Princess of England, Elizabeth," is taken from *Henry VIII;* the second selection, "Thou Shalt Get Kings, Though Thou Be None," is taken from *Macbeth.*

Most of Shakespeare's dramas, including *Macbeth,* were written for the public theater. A popular form of entertainment, the theaters of London attracted an estimated weekly attendance of 21,000 people. Some of Shakespeare's plays, including *Henry VIII,* may have been intended as masques. An aristocratic form of entertainment, the masque was an allegorical form of drama that combined poetry, including satirical verse, with songs and dances. The royal nuptials of Elizabeth, the daughter of James I, to the elector of the Palatine,[1] may have been adorned by the performance of *Henry VIII* as a courtly masque.

Inigo Jones, an architect, collaborated with playwrights throughout his career

1. Ruler of a rich agricultural district in western Germany in the Rhineland. The electors of the Palatine became leaders of the Protestants on the Continent.

by designing elaborate settings, costumes, and machinery for masques. A carpenter early in his life, Jones held a royal appointment from James I. As a result of his travels to Italy, Jones developed an architectural style that combined classical motives with vigorous expression. The Banqueting House at Whitehall, constructed between 1619 and 1622, was commissioned by James I as part of a new palace there. With its perfect proportions and elegant articulation, the building is considered Jones's masterpiece.

William Shakespeare, *Henry VIII*[2]
The High and Mighty Princess of England, Elizabeth

[Location: London. The Royal Palace]

Cranmer[3] [*Kneeling*]. And to your royal Grace and the good Queen,[4]
My noble partners and myself thus pray
All comfort, joy, in this most gracious lady
Heaven ever laid up to make parents happy
May hourly fall upon ye!

King. Thank you, good Lord Archbishop.
What is her name?

Cranmer. Elizabeth.

King. Stand up, lord.

[*The King kisses the child.*]

With this kiss take my blessing: God protect thee!
Into whose hand I give thy life.

Cranmer. Amen.

King. My noble gossips,[5] y' have been too prodigal.[6]
I thank ye heartily; so shall this lady,
When she has so much English

Cranmer. Let me speak, sir,
For heaven now bids me; and the words I utter

2. Reprinted, by permission of the publisher, from G. Blakemore Evans, ed., *The Riverside Shakespeare* (Boston: Houghton Mifflin, 1974), pp. 1016–17.

3. Thomas Cranmer (1489–1556) was an English churchman who helped Henry VIII to obtain a divorce from Catherine of Aragon. In 1533 Henry VIII named Cranmer archbishop of Canterbury, and as soon as the appointment was confirmed, Cranmer proclaimed Henry's marriage to Catherine invalid. Completely subservient to Henry, Cranmer validated and invalidated the successive marriages of Henry. Strongly influenced by the Protestant Reformation, Cranmer shaped the doctrinal and liturgical transformation of the Church of England during the reign of Henry's young son and successor, Edward VI. Upon the accession (1553) of the Roman Catholic Queen Mary I, he was tried for treason, convicted of heresy, and executed.

4. Anne Boleyn (c. 1507–1536) was the second queen consort of Henry VIII and mother of Elizabeth. Married in a secret ceremony to Henry in 1533, Anne disappointed Henry by giving birth to a daughter instead of a son. In 1536, after the miscarriage of a son, Anne was brought to trial for adultery and incest, was condemned, and was beheaded.

5. Godparents.

6. Extremely generous in giving gifts.

Let none think flattery, for they'll find 'em truth.
This royal infant—heaven still move about her!—
Though in her cradle, yet now promises
Upon this land a thousand thousand blessings,
Which time shall bring to ripeness. She shall be
(But few now living can behold that goodness)
A pattern to all princes living with her,
And all that shall succeed. Saba[7] was never
More covetous of wisdom and fair virtue
Than this pure soul shall be. All princely graces
That mould up such a mighty piece[8] as this is,
With all the virtues that attend the good,
Shall still be doubled on her. Truth shall nurse her,
Holy and heavenly thoughts still counsel her.
She shall be lov'd and fear'd: her own shall bless her;
Her foes shake like a field of beaten corn.[9]
And hang their heads with sorrow. Good grows with her;
In her days every man shall eat in safety
Under his own vine what he plants, and sing
The merry songs of peace to all his neighbors.
God shall be truly known, and those about her
From her shall read[10] the perfect [ways] of honor.
And by those claim their greatness,[11] not by blood.
Nor shall this peace sleep[12] with her; but as when
The bird of wonder dies, the maiden phoenix,[13]
Her ashes new create another heir
As great in admiration[14] as herself,
So shall she leave her blessedness to one[15]
(When heaven shall call her from this cloud of darkness)
Who from the sacred ashes of her honor
Shall star-like rise as great in fame as she was,
And so stand fix'd. Peace, plenty, love, truth, terra[16]

7. The queen of Sheba, who made a long journey to visit Solomon because of his reputation for wisdom (1 Kings 10).
8. Personage.
9. Wind-beaten grain.
10. Learn.
11. Nobility.
12. Die.
13. A fabulous bird said to live five hundred years and then die and rise again from its own ashes.
14. As greatly admired.
15. Referring to James I of England.
16. Land.

That were the servants to this chosen infant,
Shall then be his, and like a vine grow to him.
Where ever the bright sun of heaven shall shine,
His honor and the greatness of his name
Shall be, and make new nations. He shall flourish,
And like a mountain cedar reach his branches
To all the plains about him. Our children's children
Shall see this, and bless heaven.
 King. Thou speakest wonders.
 Cranmer. She shall be, to the happiness of England,
An aged princess; many days shall see her,
And yet no day without a deed[17] to crown it.
Would I had known no more! but she must die,
She must, the saints must have her; yet a virgin,
A most unspotted lily shall she pass
To th' ground, and all the world shall mourn her.
 King. O Lord Archbishop,
Thou has made me now a man! never, before
This happy child, did I get any thing.
This oracle of comfort has so pleas'd me
That when I am in heaven I shall desire
To see what this child does, and praise my Maker.
I thank ye all. To you, my good Lord Mayor,
And you, good brethren, I am much beholding;
I have receiv'd much honor by your presence,
And ye shall find me thankful. Lead the way, lords.
Ye must all see the Queen, and she must thank ye.
She will be sick[18] else. This day, no man think
H'as business at his house; for all shall stay:[19]
This little one shall make it Holy-day.

William Shakespeare, *Macbeth*[20]
Thou Shalt Get Kings, Though Thou Be None

 Macbeth. So foul and fair a day I have not seen.
 Banquo. How far is't call'd to [Forres]? What are these

17. A notable deed.
18. Unhappy.
19. Cease work.
20. Reprinted, by permission of the publisher, from G. Blakemore Evans, ed., *The Riverside Shakespeare* (Boston: Houghton Mifflin, 1974), p. 1314.

So wither'd and so wild in their attire,
That look not like th' inhabitants o' th' earth,
And yet are on't? Live you? or are you aught
That man may question?[21] You seem to understand me,
By each at once her choppy[22] finger laying
Upon her skinny lips. You should be women,
And yet your beards forbid me to interpret
That you are so.

> *Macbeth.* Speak, if you can: what are you?
>
> *1. Witch.* All hail, Macbeth, hail to thee, Thane[23] of Glamis!
>
> *2. Witch.* All hail, Macbeth, hail to thee, Thane of Cawdor!
>
> *3. Witch.* All hail, Macbeth, that shalt be King hereafter!
>
> *Banquo.* Good sir, why do you start, and seem to fear

Things that do sound so fair?—I' th' name of truth,
Are ye fantastical,[24] or that indeed
Which outwardly ye show?[25] My noble partner
You greet with present grace,[26] and great prediction
Of noble having and of royal hope,
That he seems rapt[27] withal;[28] to me you speak not.
If you can look into the seeds of time,
And say which grain will grow, and which will not,
Speak then to me, who neither beg nor fear
Your favors nor your hate.[29]

> *1. Witch.* Hail!
>
> *2. Witch.* Hail!
>
> *3. Witch.* Hail!
>
> *1. Witch.* Lesser than Macbeth, and greater.
>
> *2. Witch.* Not so happy, yet much happier.
>
> *3. Witch.* Thou shalt get[30] kings, though thou be none.

So all hail, Macbeth and Banquo!

> *1. Witch.* Banquo and Macbeth, all hail!
>
> *Macbeth.* Stay, you imperfect[31] speakers, tell me more:

21. Converse with.
22. Chapped.
23. A thane was a warrior who held lands of the king by military service.
24. Imaginary.
25. Appear to be.
26. By his present title, as Thane of Glamis.
27. Carried out of himself.
28. With (by) it.
29. Beg . . . hate—beg your favors nor fear your hate.
30. Beget.
31. Giving an incomplete account.

By Sinel's[32] death I know I am Thane of Glamis,
But how of Cawdor? The Thane of Cawdor lives
A prosperous gentleman; and to be king
Stands not within the prospect of belief,
No more than to be Cawdor. Say from whence
You owe[33] this strange intelligence, or why
Upon this blasted[34] heath you stop our way
With such prophetic greeting? Speak, I charge you.
 [*Witches vanish.*]
 Banquo. The earth hath bubbles, as the water has,
And these are of them. Whither are they vanish'd?
 Macbeth. Into the air; and what seem'd corporate melted,
As breath into the wind. Would they had stay'd!
 Banquo. Were such things here as we do speak about.
Or have we eaten of the insane[35] root
That takes the reason prisoner?
 Macbeth. Your children shall be kings.
 Banquo. You shall be king.
 Macbeth. And Thane of Cawdor too; went it not so.
 Banquo. To th' self-same tune and words.

9. Christopher Wren, Saint Paul's Cathedral, London, 1675–1710
Gardner, p. 814, ill. 19:75; Janson, pp. 602–3, ills. 827–829

Isaac Newton, *Mathematical Principles of Natural Philosophy:* "The Forces of Gravity," 1687

In the seventeenth century modern science began to take its present form. As their numbers increased, scientists were able to band together to further their cause. By the 1660s, national scientific societies had been organized in England and France where scientists could meet to perform experiments, to test experiments made by others, and to hear accounts of new advances made by their colleagues. Scientific journals began to be published at regular intervals to further the dissemination of scientific knowledge. Whereas science in previous centuries had been subservient to religion or philosophy, the new science became an independent pursuit. For example, the mem-

32. Sinel was Macbeth's father.
33. Owe—Possess. Intelligence—information.
34. Blighted, barren.
35. Causing insanity.

bers of the Royal Society of England agreed that politics, theology, and metaphysics would no longer be discussed at its meetings. Moreover, the members also agreed that the purpose of the developing sciences would be to serve the practical needs of humankind in dealing with the natural world and in improving the material aspects of life.

An undisputed triumph of modern science is embodied by the treatise *Mathematical Principles of Natural Philosophy,* written by Isaac Newton (1642–1727). A professor of mathematics at Cambridge University, Newton made his greatest discoveries during an eighteen-month period in 1664–65, when a plague epidemic forced the university to close. He developed the binomial theorem and the method of fluxions on which all calculus is based; he invented infinitesimal calculus, of which the two divisions are differential, and integral calculus; and he derived the inverse square law.

His application of mathematics to the natural world made it possible for Newton to codify the laws of dynamics (force and matter) and to set forth the principle and quantitative law of universal gravitation. Published in 1687, more than twenty years after Newton made his discoveries, the *Mathematical Principles* came to represent the ideal of science for centuries to come. In it, Newton showed how a single principle could explain an enormous variety of phenomena: the falling of bodies on earth, the motion of the moon, the motion of comets and their periodic return, the movement of the tides, and the action of the sun in keeping the solar system together. A selection from *Mathematical Principles of Natural Philosophy,* "The Forces of Gravity," is presented here.

An artist, mathematician, and professor of anatomy, Christopher Wren (1632–1723) was highly esteemed by Isaac Newton. Until the London fire of 1666, which devastated the city, Wren practiced architecture as an amateur. Upon his appointment to the royal commission charged with rebuilding London, however, Wren became a proficient and innovative architect. He is best known for his design for Saint Paul's Cathedral (1675–1710), which, with its magnificent dome, is a triumph of structural complexity.

Isaac Newton, *Mathematical Principles of Natural Philosophy*[1]
The Forces of Gravity

We offer this work as the mathematical principles of philosophy; for all the difficulty of philosophy seems to consist in this—from the phenomena of motions to investigate the forces of nature, and then from these forces to demonstrate the other phenomena; and to this end the general propositions in the first and second book are directed. In the third book we give an example of this in the explication of the System of the World; for by the

1. Reprinted, by permission of the publisher, from *Sir Isaac Newton's Mathematical Principles of Natural Science,* trans. and edited by Andrew Motte, revised by Florence Cajori (Berkeley, Calif.: University of California Press, 1962), pp. 398–400, 13–14. Copyright by the Regents of the University of California Press.

propositions mathematically demonstrated in the former books, we in the third derive from the celestial phenomena the forces of gravity with which bodies tend to the sun and the several planets. Then from these forces, by other propositions which are also mathematical, we deduce the motions of the planets, the comets, the moon, and the sea. I wish we could derive the rest of the phenomena of nature by the same kind of reasoning from mechanical principles; for I am induced by many reasons to suspect that they may all depend upon certain forces by which the particles of bodies, by some causes hitherto unknown, are either mutually impelled towards each other, and cohere in regular figures, or are repelled and recede from each other; which forces being unknown, philosophers have hitherto attempted the search of nature in vain; but I hope the principles here laid down will afford some light either to this or some truer methods of philosophy. . . .

RULES OF REASONING IN PHILOSOPHY

Rule I. *We are to admit no more causes of natural things than such as are both true and sufficient to explain their appearances.*

To this purpose the philosophers say that Nature does nothing in vain, and more is in vain when less will serve; for Nature is pleased with simplicity, and affects not the pomp of superfluous causes.

Rule II. *Therefore to the same natural effects we must, as far as possible, assign the same causes.*

As to respiration in a man and in a beast; the descent of stones in Europe and in America; the light of our culinary fire and of the sun; the reflection of light in the earth, and in the planets.

Rule III. *The qualities of bodies, which admit neither intension nor remission of degrees, and which are found to belong to all bodies within the reach of our experiments, are to be esteemed the universal qualities of all bodies whatsoever.*

For since the qualities of bodies are only known to us by experiments, we are to hold for universal all such as universally agree with experiments and such as are not liable to diminution can never be quite taken away. We are certainly not to relinquish the evidence of experiments for the sake of dreams and vain fictions of our own devising; nor are we to recede from the analogy of Nature, which uses to be simple, and always consonant to itself. We know no other way to know the extension of bodies than by our senses, nor do these reach it in all bodies; but because we perceive extension in all that are sensible, therefore we ascribe it universally to all others also. The abundance of bodies are hard, we learn by experience; and because the hardness of the whole arises from the hardness of the parts, we therefore justly infer the

hardness of the undivided particles not only of the bodies we feel but of all others. That all bodies are impenetrable, we gather not from reason, but from sensation. The bodies which we handle we find impenetrable, and thence conclude impenetrability to be an universal property of all bodies whatsoever.

Lastly, if it universally appears, by experiments and astronomical observations, that all bodies about the earth gravitate towards the earth, and that in proportion to the quantity of matter which they severally contain; that the moon likewise, according to the quantity of its matter, gravitates towards the earth; that, on the other hand, our sea gravitates toward the moon; and all the planets mutually one towards another; and the comets in like manner towards the sun; we must, in consequence of this rule, universally allow that all bodies whatsoever are endowed with a principle of mutual gravitation. For the argument from the appearances concludes with more force for the universal gravitation of all bodies than for their impenetrability; of which, among those in the celestial regions, we have no experiments, nor any manner of observation. Not that I affirm gravity to be essential to bodies: by their *vis insita* [inherent force] I mean nothing but their *vis inertia* [force of inertia]. This is immutable. Their gravity is diminished as they recede from the earth.

Rule IV. *In experimental philosophy we are to look upon propositions collected by general induction from phenomena as accurately or very nearly true, notwithstanding any contrary hypotheses that may be imagined, till such time as other phenomena occur, by which they may either be made more accurate, or liable to exceptions.*

This rule must follow, that the argument of induction may not be evaded by hypotheses.

THE LAWS OF MOTION

Law I: *Every body continues in its state of rest, or of uniform motion, in a right line, unless it is compelled to change that state by forces impressed upon it.*

Projectiles continue in their motions, so far as they are not retarded by the resistance of the air, or impelled downwards by the force of gravity. A top, whose parts by their cohesion are continually drawn aside from rectilinear motions, does not cease its rotation, otherwise than as it is retarded by the air. The greater bodies of the planets and comets, meeting with less resistance in freer spaces, preserve their motion both progressive and circular for a much longer time.

Law II: *The change of motion is proportional to the motive force impressed; and is made in the direction of the right line in which that force is impressed.*

If any force generates a motion, a double force will generate double the motion, a triple force triple the motion, whether that force be impressed altogether and at once or gradually and successively. And this motion (being always directed the same way with the generating force), if the body moved before, is added to or subtracted from the former motion, according as they directly conspire with or are directly contrary to each other; or obliquely joined, when they are oblique, so as to produce a new motion compounded from the determination of both.

Law III: *To every action there is always opposed an equal reaction: or, the mutual actions of two bodies upon each other are always equal, and directed to contrary parts.*

Whatever draws or presses another is as much drawn or pressed by that other. If you press a stone with your finger, the finger is also pressed by the stone. If a horse draws a stone tied to a rope, the horse (if I may say so) will be equally drawn back towards the stone; for the distended rope, by the same endeavor to relax or unbend itself, will draw the horse as much toward the stone as it does the stone towards the horse, and will obstruct the progress of the one as much as it advances that of the other. If a body impinge upon another, and by its force change the motion of the other, that body also (because of the equality of the mutual pressure) will undergo an equal change in its own motion, towards the contrary part. The changes made by these actions are equal, not in the velocities but in the motions of the bodies; that is to say, if the bodies are not hindered by any other impediments. For because the motions are equally changed, the changes of the velocities made toward contrary parts are inversely proportional to the bodies.

10. Anthony Van Dyck, *Charles I Dismounted*, c. 1635
Gardner, p. 785, ill. 19:44; Janson, p. 571, ill. 777

Root and Branch Petition: "That Godly Design," 1640
Charles I, *Last Words:* "I Am the Martyr of the People," 1649

James I, the first Stuart king, was succeeded in 1625 by his son Charles I (1600–1649). In a reign fraught with crises, Charles antagonized the most powerful classes in his kingdom. In addition to making an unpopular marriage to a Catholic princess, Henrietta Maria of France, he waged inglorious war against France, levied new taxes without Parliamentary approval, and suspended Parliament for eleven years. In addition, Charles's insistence on elaborate religious rituals and ceremonies was regarded by many Puritans as the first step toward the restoration of Catholicism.

Civil war broke out in 1642. The royalist army was defeated in 1645 by a

well-trained army under the Puritan leader Oliver Cromwell (1599–1658). Charles surrendered, but his intrigues during his imprisonment led to a second civil war, in 1648. Charles's army was again defeated, and Charles was tried and beheaded.

Selections from two documents are presented here. The first selection, "That Godly Design," is taken from the *Root and Branch Petition*. The petition, presented to Parliament in 1640, demonstrates the suspicions felt by Puritans toward rituals and ceremonies that resembled Catholic practices and also reveals the disapproval felt by the Puritans toward secular learning and literature. The second selection, "I Am the Martyr of the People," is taken from the last words spoken by Charles at his execution. Fearing that the king's eloquence might win him public support, the Puritans had not permitted Charles to speak at any time during his trial. Finally allowed to speak at the execution block, Charles demonstrated magnanimity toward all his subjects, including the Puritans.

Approximately five years before the outbreak of civil war, the Flemish artist Anthony Van Dyck (1599–1641) had painted Charles's portrait. The painting *Charles I Dismounted* (c. 1635) captures the haughty composure, the autocratic bearing, and the cool courage that the monarch exhibited both during his tumultuous reign and at the moment of his execution.

Root and Branch Petition[1]
That Godly Design

A Particular of the manifold evils, pressures, and grievances caused, practised and occasioned by the Prelates and their dependents. . . .

The faint-heartedness of ministers to preach the truth of God, lest they should displease the prelates; as namely, the doctrine of predestination, of free grace, of perseverance, of original sin remaining after baptism,[2] [and] of the sabbath.[3] . . .

The great increase of idle, lewd and dissolute, ignorant and erroneous men in the ministry, which swarm like the locust of Egypt over the whole kingdom; and will they but wear a canonical coat,[4] a surplice,[5] a hood,[6] bow at the name of Jesus, and be zealous of superstitious ceremonies, they may

1. Reprinted, by permission of the publisher, from Samuel R. Gardiner, ed., *The Constitutional Documents of the Puritan Revolution, 1625–1660* (Oxford: Clarendon Press, 1889), pp. 138–43.
2. In Christian theology, the sin of Adam by which all humankind fell from grace. In effect it is the fundamentally graceless nature of man requiring redemption to save it. The purpose of baptism is to wash away original sin and to restore people to their innocent state, but even after baptism original sin leaves a tendency to sin.
3. The last day of the week, set aside to mark God's rest after his work. For Roman Catholics, Sunday is a liturgical feast day on which most penitential rules are relaxed. For Protestants, the Sabbath is a day on which all but pious activity is forbidden.
4. Vestments prescribed by the church.
5. A loose vestment of white linen having wide sleeves and reaching the feet. Worn by clerics and others taking part in church services.
6. A mark of a religious office, worn over a surplice.

live as they list, confront whom they please, preach and vent what errors they will, and neglect preaching at their pleasures without control.

The discouragement of many from bringing up their children in learning; the many schisms, errors, and strange opinions which are in the Church; great corruptions which are in the Universities; the gross and lamentable ignorance almost everywhere among the people; the want of preaching ministers in very many places both in England and Wales; the loathing of the ministry, and the general defection to all manner of profaneness.

The swarming of lascivious, idle, and unprofitable books and pamphlets, play-books and ballads; as namely, Ovid's "Fits of Love,"[7] "The Parliament of Women," which came out at the dissolving of the last Parliament; Barns's "Poems," Parker's "Ballads," in disgrace of religion, to the increase of all vice, and withdrawing of people from reading, studying, and hearing the Word of God, and other good books. . . .

The growth of Popery[8] and increase of Papists.[9] . . .

The great conformity and likeness both continued and increased of our Church to the Church of Rome. . . .

The standing up at *Gloria Patri*[10] and at the reading of the Gospel, praying towards the East, the bowing at the name of Jesus, the bowing to the altar towards the East, the cross in baptism, the kneeling at the Communion. . . .

The great increase and frequency of whoredoms and adulteries, occasioned by the prelates' corrupt administration of justice in such cases. . . .

The general hope and expectation of the Romish party, that their superstitious religion will ere long be fully planted in this kingdom again, and so they are encouraged to persist therein, and to practise the same openly in divers places, to the high dishonor of God, and contrary to the laws of the realm.

7. Ovid was a Roman poet who lived 43 B.C.–A.D. 18. Much of his verse is about erotic love. His love poems include *Amores* (Loves) and forty-nine short poems, many of which extol the charms of the poet's mistress Corinna. *Ars amatoria* (Art of Love) provides complete instructions on how to acquire and keep a lover. Ovid's work so offended the emperor Augustus that the poet was exiled. His work later offended Protestant reformers.

8. Popery refers to the doctrines, practices, and ceremonies associated with the pope as head of the Roman Catholic Church.

9. Adherents of the pope; more generally, members of the Roman Catholic Church.

10. *Gloria Patri*—the doxology beginning "Glory be to the Father," which follows the recitation of the psalms and certain canticles.

Charles I, *Last Words*[11]
I Am the Martyr of the People

[As] for the people—truly I desire their liberty and freedom as much as anybody whosoever. But I must tell you that their liberty and freedom consists in having of government those laws by which their lives and goods may be most their own. It is not for having share in government. That is nothing pertaining to them. A subject and a sovereign are clean different things, and therefore, until they do that—I mean that you do put the people in that liberty as I say—certainly they will never enjoy themselves.

Sirs, it was for this that now I am come here. If I would have given way to an arbitrary way, for to have all laws changed according to the power of the sword, I needed not to have come here. And therefore I tell you (and I pray God it be not laid to your charge) that I am the martyr of the people.

11. From *England's Black Tribunal* (London, 1720). Cited in Brian Tierney and Joan Scott, eds., *Western Societies: A Documentary History* (New York: Alfred A. Knopf, 1984), vol. 1, p. 504.

Baroque Art in the Netherlands and Spain

1. Peter Paul Rubens, *The Elevation of the Cross,* **1610**
Gardner, p. 781, ill. 19:39; Janson, p. 569, ill. 773

George Gascoigne, *The Spoyle of Antwerpe:* "Their Horrible Cruelty,"
1576

In the sixteenth century, the Netherlands became a province in the vast empire controlled by Spain. The repressive policies enacted by the Spanish monarch Philip II (lived 1527–1598; reigned 1556–98) quickly alienated large segments of the Netherlandish population. The Spanish were vehemently disliked by the Protestants, who suffered religious persecution; by the lower class, which had economic grievances; and by the wealthy noblemen, who resented Philip's usurpation of authority. The rebellious Netherlanders soon found a leader in William I, Prince of Orange (1533–1584).

When rebellion broke out in 1568, William began to organize resistance to the Spanish forces. Allegiances quickly divided along religious lines. The northern provinces of the Netherlands, a region in which Protestants predominated, joined the rebellion; the southern provinces of the Netherlands, a region in which Catholics predominated, remained loyal to Philip. Both sides demonstrated a ruthless determination in their actions. Protestants burned Catholic abbeys, plundered Catholic churches, and destroyed Catholic statues, paintings, and stained-glass windows. Catholics responded with equal fervor. Most vicious of all were the actions of the Spanish troops. His treasury depleted by constant warfare, Philip was unable to pay his soldiers for almost two years. Mutinous Spanish troops pillaged the cities of the Netherlands, including Antwerp.

George Gascoigne (died 1577), an English diplomat who served William of

Orange, was present when Spanish troops entered Antwerp. In his pamphlet *The Spoyle of Antwerpe,* Gascoigne describes the brutal treatment meted out by the Spanish troops against the citizens of Antwerp. A selection from *The Spoyle of Antwerpe,* "Their Horrible Cruelty," is presented here.

The city of Antwerp changed hands many times during the rebellion in the Netherlands. In 1576 it welcomed William of Orange with tempestuous joy when he triumphantly entered the city. Yet thirty-four years later, when the painter Peter Paul Rubens (1577–1640) painted *The Elevation of the Cross* for Antwerp's Cathedral, the city was in Spanish hands. Rubens emerged as the leading Flemish painter of his age. In addition to being an artist, he was a friend of Philip II and the permanent court painter to the Spanish governors of Flanders. The drama and conviction of his religious paintings reflect the intensity of the religious and political strife that divided the Netherlands.

George Gascoigne, *The Spoyle of Antwerpe*[1]
Their Horrible Cruelty

They neither spared age, nor sex: time nor place: person nor country: professions nor religion: young nor old: rich nor poor: strong nor feeble: but without any mercy did tyrannously triumph, when there was neither man nor mean to resist them. They slew great numbers of young children. The rich was spoil because he had, and the poor were hanged because they had nothing: neither strength could prevail to make resistance, nor weakness more pity to refrain their horrible cruelty. And this was not only done when the chase was hot, but (as I heard said) when the blood was cold and they now victors without resistance. I refrain to rehearse the heaps of dead carcasses which lay at every trench where they entered, the thickness whereof did in many places exceed the height of a man.

I forbear also to recount the huge numbers drowned in the new town. I list not to reckon the infinite numbers of poor Alamains[2] who lay burned in their armor: some, the entrails scorched out, and all the rest of the body into the bulk and breast. I may not pass over with silence the wilful burning and destroying of the stately town-houses, and all the monuments and records of the city: neither can I refrain to tell their shameful rapes and outrageous forces presented unto sundry honest Dames and Virgins . . . and as great respect they had to the church and churchyard as the butcher has to his shambles. They spared neither friend nor foe, Portingal nor Turk: the Jesuit

1. Reprinted from George Gascoigne, *The Spoyle of Antwerpe* (London, 1576), ch. II, p. 8; ch. III, p. 3. Reprinted by Da Capo Press, New York, 1969.
2. A term for northern European peoples of Germanic descent. Because Gascoigne is English, rather than European, he considers the Netherlanders to be synonymous with Germans.

must give their ready coin, and all other religious houses both corn[3] and plate.[4] It is also a ruthful remembrance that a poor English merchant (who was but a servant), having once redeemed his master's good for three hundred crowns,[5] was yet hanged until he was half dead, because he had not two hundred more to give them: and the halter being cut down and he come to himself again, besought them with bitter tears to give him leave to seek and to try his credit and friends in the town for the rest of their unreasonable demand. At his return, because he sped not (as indeed no monies was then to be had) they hanged him again outright and afterwards (of exceeding courtesy) procured the Friars Minors[6] to bury him.

Within three days Antwerpe, which was one of the richest towns in Europe, had now no money nor treasure to be found therein, but only in the hands of murderers and strumpets: for every Don Diego[7] must walk jetting up and down the streets with his harlot by his side in her chain and bracelets of gold. And the notable Bourse,[8] which was wont to be a safe assembly for merchants, had now none other merchandise therein but as many dicing tables as might be placed round it.

2. Frans Hals, *Malle Babbe*, c. 1650
Janson, p. 573, ill. 780

Jacob Cats, *Moral Emblems:* "None Can Clean Their Dress from Stain, but Some Blemish Will Remain," 1632

Freed from Spanish control, the Dutch quickly became an important maritime and commercial power. But more than this, the Dutch achieved preeminence in the domains of learning and letters, and of science and the arts. An extraordinary burst of intellectual activity placed the Dutch in the forefront of European civilization.

The many-sided culture developed by the Dutch included a vigorous and original body of literature. Jacob Cats (1577–1660), one of the most widely read Dutch authors, applied his talents simultaneously to the practice of law and to the composition of poetry. Cats's most famous work, *Moral Emblems* (1632), illustrates a form of literature that was popular in the seventeenth century. Written in the vernacular language, *Moral Emblems* consists of a collection of epigrammatic poems that were

3. Supplies of grain.
4. Stock of silver and other precious metals.
5. A name of various coins; originally one bearing the imprint of a crown.
6. Members of the Franciscan order.
7. Derogatory term for Spaniard.
8. The exchange, or meeting place, for merchants; the money market of a town.

intended to inculcate virtue throughout all levels of Dutch society. In each poem, Cats offers a moral maxim related to one aspect of civil or personal life, including then current religious, political, and economic practices. At the end of each poem, Cats appends a set of pertinent quotations drawn from ancient authors and a number of popular adages that address the same subject. To enhance the effectiveness of the literary epigrams further, each poem is paired with a visual image. A selection from *Moral Emblems,* "None Can Clean Their Dress from Stain, but Some Blemish Will Remain," is presented here.

The same penetrating observation of everyday life—its comedy, excesses, and virtues—surfaces in the art of the Dutch painter Frans Hals (c. 1580–1666). Hals was a master of psychological perception combined with comic vision. The immediacy of his portraiture is exemplified by his depiction of a drunken women in a tavern, *Malle Babbe,* painted approximately 1650.

Jacob Cats, *Moral Emblems*[1]
None Can Clean Their Dress from Stain, But Some Blemish Will Remain

Now I've splashed and soiled my gown,
With this gadding through the town!
How bedraggled is my skirt,
Traipsing through the by-street's dirt:
In what a state for me to be,
From this Town-life gaiety!

Come girls here, come all I know,
Playmates mine, advise me, show
In this plight that I'm come to,
What is best for me to do?
How shall I remove this stain,
And restore my gown again?

If to wash it out I try—
Washing shrinks the cloth when dry;
Makes the color often fade,
Or else gives a darker shade:
If I cut it out, there'll be
Such a hole that all must see:
If I rub it hard, it will take
All the nap off then, and make

1. Reprinted, by permission of the publisher, from Jacob Cats, *Moral Emblems,* trans. and ed. by Richard Pigot (London: Longmass, Green, Reader and Dyer, 1865), pp. 3–6. Copyright by Longmass, Green, Reader and Dyer.

Yet more plain, the stain that never
Honest maiden's dress should bear.
Pray then tell me, some of you,
What in this mishap to do?
Thus so slut-like to be stained,
Makes me of myself ashamed;
For where ever I may go,
People will look at me so,—
And think perhaps,—such dirt to see,
I'm not what I ought to be.

Say, can none of you suggest,
What in such a case is left?
No?—then this I plainly see,
You must warning take by me!
If you would not soil your gown,
Go not gadding through the town:
In the streets who plays the flirt,
Never yet escaped some dirt:—
Run not therefore East and West,
Home for girls is much the best.

Maidens, where so ever you go,
Walking, travelling to and fro;
Over land or over sea,
In whatever way it be;
In the Country or the Town,
Over meadow, dale or down,[2]
Over hill or over moor,
In the house or out of door,
Over road or over street,
Girls, where ever you bend your feet,
Keep your Clothes and Kirtles[3] neat.

A good name is rather to be chosen than great riches, and loving favor
 rather than silver and gold. —Proverbs xxii:i

Although the wound be *healed,* it always leaves a scar. —Seneca[4]

2. Lowland and upland.
3. The skirt or outer petticoat of a woman's gown.
4. Seneca (c. 3 B.C.–A.D. 65) was a Roman statesman and philosopher. His essays on ethics recommend a high,
 unselfish nobility that would have been at considerable variance to his lifetime, in which greed and
 expediency figured prominently.

Who comes to an evil repute is half hanged. —Old Dutch proverb

Give a dog a bad name and hang him. —Old Dutch proverb

Conduct yourself always with the same prudence, as though you were observed by ten eyes, and pointed at by ten fingers. —Confucius[5]

Put a curb on your desires if you would not fall into some disorder. —Aristotle[6]

It is better to be poor, and not have been wanting in discretion, than to attain the summit of our wishes by a loose conduct. —Diogenes[7]

Be discreet in your discourse, but much more in your actions; the first evaporates, the latter endures for ever. —Phocylides[8]

Shun the society of the depraved, for fear that you will follow their pernicious example, and lose yourself with them. —Plato[9]

Honor is tender. The finest silk will spoil the soonest. —French proverb

3. Rembrandt van Rijn, *The Return of the Prodigal Son,* **c. 1665**
Gardner, p. 791, ill. 19:50; Janson, p. 577, ill. 787

René Descartes, *Discourse on Method:* "The First Principle of Philosophy," 1637
Baruch Spinoza, *Ethics:* "A Confused Idea," 1660–66

Philosophy flourished on Dutch soil as much as scholarship and the arts. The policy of religious toleration, the guarantee of intellectual freedom, and the respect for education provided an atmosphere in which traditional beliefs and ideas could be challenged by new systems of thought. Two of the most influential philosophers of the modern age, René Descartes (1596–1650) and Baruch Spinoza (1632–1677), lived in the Dutch republic.

Born in France, Descartes moved to Holland in 1629 to secure the tranquil

5. Confucius (c. 551–479 B.C.) was a Chinese sage who urged a system of morality on the state and on individuals.
6. Aristotle (384–322 B.C.) was a Greek philosopher whose writings on ethics were very influential. He argued that the goodness or virtue of a thing lay in the realization of its specific nature. The highest good for a person is the complete and habitual exercise of reason.
7. Diogenes (c. 412–323 B.C.) was a Greek philosopher who lived in Athens and taught that the virtuous life is the simple life. He dramatically illustrated his maxim by discarding all conventional comforts, and by living in a tub.
8. Phocylides (fl. sixth century B.C.) was a Greek poet who wrote aphoristic verse.
9. Plato (427–347 B.C.) was a Greek philosopher. His works describe virtue, happiness, and the art of living and knowing.

setting he regarded necessary for his intellectual endeavors. A famous mathematician as well as a philosopher, Descartes sought to apply the mathematical method to all fields of human knowledge. In philosophy, Descartes discards the authoritarian and traditional systems of earlier philosophers and begins with universal doubt. But there is one thing that cannot be doubted: doubt itself. This is the core expressed in his famous aphorism "I think, therefore I am." From the certainty of a thinking being, he passes to a demonstration of the existence of God. Upon this base, he reaches the reality of the physical world through God, who would not deceive the thinking mind by illusory perceptions. Therefore, the external world, which we perceive, must exist. For Descartes, the physical world is mechanistic and entirely divorced from mind. Only by the intervention of God are matter and mind connected.

Descartes expounds his ideas most fully in *Discourse on Method* (1637). A selection from *Discourse on Method,* "The First Principle of Philosophy," is presented here.

Many of Spinoza's most influential ideas are discussed in the treatise *Ethics,* which was written between 1660 and 1666 and published posthumously in 1677. Spinoza's philosophy is deductive, rational, and monist. He shared with Descartes an intensely mathematical approach to the universe. Things make sense, for Spinoza, when understood in relation to a total structure. Truth, like geometry, follows from first principles with a logic that is accessible to the human mind. Unlike Descartes, Spinoza felt no discrepancy between the mind and the body, or between ideas and the physical universe. The two are only different aspects of a single substance, which he alternately calls God and Nature.

A selection from *Ethics,* "A Confused Idea," is presented here. In this selection, Spinoza refers to his view of the intellect as active. Ideas are active and move us to act; an absence of action may be regarded as an absence of insight. For Spinoza, knowledge, virtue, and action are one.

The inward examination of the self, which occupied both Descartes and Spinoza, also inspired the paintings of Rembrandt (1606–1669). Rembrandt explored the inner emotions and the external events that result from them. In works such as *The Return of the Prodigal Son* (c. 1665), Rembrandt reveals an understanding of his fellow human beings that carries no moral opprobrium but rather exemplifies the deepest compassion. Like Descartes, Rembrandt focuses on the inner life of the individual; like Spinoza, he seeks for himself and his subjects an active intellect as the basis of knowledge and virtue.

René Descartes, *Discourse on Method*[1]
The First Principle of Philosophy

But like one walking alone and in the dark, I resolved to proceed so slowly and with such circumspection, that if I did not advance far, I would at least

1. Reprinted from René Descartes, *Discourse on the Method of Rightly Conducting the Reason and Seeking Truth in the Sciences,* trans. by John Veitch (Edinburgh: Sutherland and Knox, 1853), pp. 59–63, 74–77.

guard against failing. I did not even choose to dismiss summarily any of the opinions that had crept into my belief without having been introduced by Reason, but first of all took sufficient time carefully to satisfy myself of the general nature of the task I was setting myself, and ascertain the true Method by which to arrive at the knowledge of whatever lay within the compass of my powers.

Among the branches of Philosophy, I had, at an earlier period, given some attention to Logic, and among those of the Mathematics to Geometrical Analysis and Algebra—three Arts and Sciences which ought, as I conceived, to contribute something to my design. . . . By these considerations I was induced to seek some other Method which would comprise the advantages of the three and be exempt from their defects. And as a multitude of laws often only hamper justice, so that a state is best governed when, with few laws, these are rigidly administered; in like manner, instead of the great number of precepts of which Logic is composed, I believe that the four following would prove perfectly sufficient for me, provided I took the firm and unwavering resolution never in a single instance to fail in observing them.

The *first* was never to accept anything for true which I did not clearly know to be such; that is to say, carefully to avoid precipitancy and prejudice, and to comprise nothing more in my judgment than what was presented to my mind so clearly and distinctly as to exclude all ground of doubt.

The *second,* to divide each of the difficulties under examination into as many parts as possible, and as might be necessary for its adequate solution.

The *third,* to conduct my thoughts in such order that, by commencing with objects the simplest and easiest to know, I might ascend by little and little, and, as it were, step by step, to the knowledge of the more complex; assigning in thought a certain order even to those objects which in their own nature do not stand in a relation of antecedence and sequence.

At the *last,* in every case to make enumerations so complete, and reviews so general, that I might be assured that nothing was omitted.

The long chains of simple and easy reasonings by means of which geometers are accustomed to reach the conclusions of their most difficult demonstrations, had led me to imagine that all things, to the knowledge of which man is competent, are mutually connected in the same way, and that there is nothing so far removed from us as to be beyond our reach, or so hidden that we cannot discover it, provided only we abstain from accepting the false for the true, and always preserve in our thoughts the order necessary for the deduction of one truth from another. And I had little difficulty in determining the objects with which it was necessary to commence, for I was

already persuaded that it must be with the simplest and easiest to know, and considering that of all those who have hitherto sought truth in the Sciences, the mathematicians alone have been able to find any demonstrations, that is, any certain and evident reasons, I did not doubt but that such must have been the rule of their investigations. I resolved to commence, therefore, with the examination of the simplest objects, not anticipating, however, from this any other advantage than that to be found in accustoming my mind to the love and nourishment of truth, and to a distaste for all such reasonings as were unsound. . . . And as I observed that this truth, *I think, hence I am,* was so certain and of such evidence, that no ground of doubt, however extravagant, could be alleged by the Sceptics[2] capable of shaking it, I concluded that I might, without scruple, accept it as the first principle of the Philosophy of which I was in search.

In the next place, I attentively examined what I was, and as I observed that I could suppose that I had no body, and that there was no world nor any place in which I might be; but that I could not therefore suppose that I was not; and that, on the contrary, from the very circumstances that I thought to doubt of the truth of all things, it most clearly and certainly followed that I was; while, on the other hand, if I had only ceased to think, although all the other objects which I had ever imagined had been in reality existent, I would have had no reason to believe that I existed; I thence concluded that I was a substance whose whole essence or nature consisted only in thinking, and which, that it may exist, has no need or place, nor is dependent on any material thing; so that "I," that is to say, the mind by which I am what I am, is wholly distinct from the body, and is even more easily known than the latter, and is such, that although the latter were not, it would still continue to be all that it is.

After this I inquired in general into what is essential to the truth and certainty of a proposition; for since I had discovered one which I knew to be true, I thought that I must likewise be able to discover the ground of this certitude. And as I observed that in the words *I think, hence I am,* there is nothing at all which gives me assurance of their truth beyond this, that I see very clearly that in order to think it is necessary to exist, I concluded that I might take, as a general rule, the principle, that all the things which we very clearly and distinctly conceive are true, only observing, however, that there is some difficulty in rightly determining the objects which we distinctly conceive.

2. Philosophers who hold that the possibility of knowledge is limited either because of the limitations of the mind or because of the inaccessibility of its object.

In the next place, from reflecting on the circumstances that I doubted, and that consequently my being was not wholly perfect (for I clearly saw that it was a greater perfection to know than to doubt), I was led to inquire whence I had learned to think of something more perfect than my self; and I clearly recognized that I must hold this notion from some Nature which in reality was more perfect. As for the thoughts of many other objects external to me, as of the sky, the earth, light, heat, and a thousand more, I was less at a loss to know whence these came; for since I remarked in them nothing which seemed to render them superior to myself, I could believe that, if these were true, they were dependencies on my own nature, in so far as it possessed a certain perfection, and if they were false, that I held them from nothing, that is to say, that they were in me because of a certain imperfection of my nature. But this could not be the case with the idea of a Nature more perfect than myself; for to receive it from nothing was a thing manifestly impossible; and, because it is not less repugnant that the more perfect should be an effect of, and dependence on the less perfect, than that something should proceed from nothing, it was equally impossible that I could hold it from myself: accordingly, it but remained that it had been placed in me by a Nature which was in reality more perfect than mine, and which even possessed within itself all the perfection of which I could form any idea: that is to say, in a single word, which was God. . . .

Baruch Spinoza, *Ethics*[3]
A Confused Idea

The emotion called a passive experience is a confused idea whereby the mind affirms a greater or less force of existence of its body, or part of its body, than was previously the case, and by the occurrence of which the mind is determined to think of one thing rather than another.

I say in the first place that an emotion, or passivity of the mind, is a "confused idea." For we have demonstrated that the mind is passive only to the extent that it has inadequate or confused ideas. Next, I say "whereby the mind affirms a greater or less force of existence than was previously the case." For all ideas that we have of bodies indicate the actual physical state of our own body rather than the nature of the external body. Now the idea that constitutes the specific reality of an emotion must indicate or express the state of the body or of some part of it, which the body or some part of it possesses

3. Reprinted, by permission of the publisher, from Baruch Spinoza, *The Ethics and Selected Letters*, trans. by Samuel Shirley and ed. by Seymour Feldman (Indianapolis: Hackett, 1982), pp. 151–52. Copyright by Hackett Publishing Co.

from the fact that its power of activity or force of existence (vis existendi) is increased or diminished, assisted or checked. But it should be noted that when I say "a greater or less force of existence than was previously the case," I do not mean that the mind compares the body's present state with its past state, but that the idea that constitutes the specific reality of the emotion affirms of the body something that in fact involves more or less reality than was previously the case. And since the essence of the mind consists in this, that it affirms the actual existence of its body, and by perfection we mean the very essence of a thing, it therefore follows that the mind passes to a state of greater or less perfection when it comes about that it affirms of its body, or some part of it, something that involves more or less reality than was previously the case. So when I said above that the mind's power of thinking increases or diminishes, I meant merely this, that the mind has formed an idea of its body or some part of it that expresses more or less reality than it had been affirming of it. For the excellence of ideas and the actual power of thinking are measured by the excellence of the object. Lastly, I added "by the occurrence of which the mind is determined to think of one thing rather than another" in order to express the nature of desire in addition to the nature of pleasure and pain as explicated in the first part of the definition.

4. Rembrandt van Rijn, *Self-Portrait,* **c. 1659**
Gardner, p. 792, ill. 19:51

Rembrandt van Rijn, *Self-Portrait,* **1658**
Janson, p. 576, ill. 786

Menno Simons, *The Blasphemy of John of Leiden:* "Christians Are Not Allowed to Fight with the Sword," 1535

In the seventeenth century, a Christian sect known as the Anabaptists exerted a strong influence over the beliefs and lives of many Netherlandish citizens. A Protestant religious denomination that originated in northern Europe in the sixteenth century, the Anabaptists rejected the efficacy of infant baptism. Basing their conviction on a literal interpretation of the Scriptures, members of the sect insisted that baptism be withheld until a person had made a profession of faith. This concept appeared monstrous to Roman Catholics and to most Protestants, who viewed rebaptism as sacrilegious and heretical. The very name "Anabaptists," meaning "to rebaptize," had a disdainful connotation. Yet the Anabaptists, with few exceptions, were peace-loving, law-abiding people imbued with an idealistic vision of uncompromising Christian love.

The leader of the Anabaptists in the Low Countries was Menno Simons (c. 1496–1561). Ordained a priest in the Roman Catholic Church, Simons assumed the functions of an Anabaptist preacher in 1537 and went on to unite a large and flourishing sect of Dutch Anabaptists.

Simons thought that Christ had a divine nature that precluded his assumption of a human nature. He rejected infant baptism and would baptize only those who made a personal profession of faith in Christ. He emphasized the church's power of excommunication as an instrument to create a pious and pure spiritual kingdom of the godly on earth. Understanding the New Testament to teach that Christians can operate only on the basis of love, Simons felt that war was unlawful. Believing that Christians could be citizens only of a spiritual kingdom and not of a political nation, Menno decreed that his followers must abstain from military service, from law enforcement, from judicial positions, and even from oaths of allegiance to secular institutions or political states. Additionally, Simons regarded human science as useless, even pernicious, to a Christian.

Simons spread his ideas through writing as well as preaching. Among the two dozen books and pamphlets written by Simons is *The Blasphemy of John of Leiden* (1535), a denunciation of the Münserites, a radical sect that sought to establish a theocracy, or religious government, by force of arms. A selection from *The Blasphemy of John of Leiden*, "Christians Are Not Allowed to Fight with the Sword," is presented here.

Rembrandt van Rijn (1606–1669) was drawn to the teachings of Menno Simons and his followers. In his own life, the artist endured great personal suffering. The compassion, charity, and humility that Rembrandt learned are stamped in his visage in many self-portraits, such as those painted in 1658 and c. 1659. Apparently the Anabaptists practiced a form of spiritual understanding and love that struck a deep resonance in Rembrandt.

Menno Simons, *The Blasphemy of John of Leiden*[1]
Christians Are Not Allowed to Fight with the Sword

By the grace of God we will also write a little about warfare, that Christians are not allowed to fight with the sword, that we may all of us leave the armor of David[2] to the physical Israelites and the sword of Zerubbabel[3] to those who built the temple of Zerubbabel in Jerusalem, which was a figure of them and a shadow of things to come. For the body itself is in Christ, as Paul says. . . .

1. Reprinted, by permission of the publisher, from J. C. Wenger, ed., *The Complete Writings of Menno Simons*, trans. by Leonard Verduin (Scottdale, Penn.: Herald Press, 1956), pp. 42–46. Copyright by Mennonite Publishing House.
2. Hebrew king and warrior.
3. Prince of Judah of the house of David and governor of Jerusalem. Zerubbabel finished rebuilding the Temple in Jerusalem.

If we take this view of it we shall easily understand with what kind of arms Christians should fight, namely, with the Word of God, which is a two-edged sword, of which we will by the assistance of God say a few things. . . .

Now the Spirit of God speaks thus through Paul: "My brethren, be strong in the Lord, and in the power of his might. Put on the whole armor of God, that ye may be able to stand against the wiles of the devil. For we wrestle not against flesh and blood, but against principalities, against powers, against the rulers of the darkness of this world, against spiritual wickedness in high places. Wherefore take unto you the whole armor of God, that ye may be able to withstand in the evil day, and having done all, to stand. Stand, therefore, having your loins girt about with truth, and having on the breastplate of righteousness; and your feet shod with the preparation of the gospel of peace. Above all, take the shield of faith, wherewith ye shall be able to quench all the fiery darts of the wicked; and take the helmet of salvation, and the sword of the Spirit, which is the word of God." At another place: "For the weapons of our warfare are not carnal, but mighty through God to the pulling down of strongholds; cast down imaginations, and every high thing that exalteth itself against the knowledge of God, and bring into captivity every thought to the obedience of Christ. And [live] in readiness to revenge all disobedience, when your obedience is fulfilled."

Now he that is not blind will understand with what weapons the Christian is to fight, namely, with the Word of God; with this he should be well armored. For thus speaks the holy church: "Behold his bed, which is Solomon's;[4] threescore valiant men are about it, of the valiant of Israel; they all hold swords, being expert in war; every man hath his sword upon his thigh because of fear in the night; that is, each is armed with the sword of the Spirit against all the wiles of the devil, against all false doctrine." Concerning Christ it is written: "Gird thy sword upon thy thigh, O most Mighty, with thy glory and thy majesty. And in thy majesty ride prosperously, because of truth and meekness and righteousness; and thy right hand shall teach thee terrible things. Thine arrows are sharp in the heart of the king's enemies; whereby the people fall under thee."

Here the Scriptures say that Christ shall have a sword. But which sword? He Himself tells us in the Apocalypse[5] in these words, "Repent; or else I will come unto thee quickly, and will fight against thee with the sword of my mouth. . . ."

4. King of the ancient Hebrews. Solomon, proverbial for his wisdom, built the first Hebrew temple in Jerusalem.

5. In the New Testament the book of Revelation is often called Apocalypse.

Christ did not want to be defended with Peter's sword. How can a Christian then defend himself with it? Christ wanted to drink the cup which the Father had given Him; how then can a Christian avoid it? . . .

And if we are to take prophets as an example to suffer persecution, then we must put on the apostolic armor, and the armor of David must be laid aside. How can it be harmonized with the Word of God that one who boasts of being a Christian could lay aside the spiritual weapons and take up the carnal ones, for Paul says: "The servant of the Lord must not strive; but be gentle unto all men, apt to teach, patient; in meekness instructing those that oppose themselves; if God peradventure will give them repentance to the acknowledging of the truth. And that they may recover themselves out of the snare of the devil, who are taken captive by him at his will."

5. Jan Vermeer, *Young Woman with a Water Jug*, c. 1665
Gardner, p. 796, ill. 19:54

Jan Vermeer, *The Letter*, 1666
Janson, p. 581, ill. 794

Anton van Leeuwenhoek, Letter: "This Vast Number of Animalcules," 1677
Christiaan Huygens, *Systema Saturnium:* "The Wonderful Appearance of Saturn," 1659

The originality of Netherlandish culture was apparent in science as well as literature, philosophy, and religious thought. The invention of the microscope in the early seventeenth century equipped scientists with an important new tool and brought new branches of biology into existence.

One of the most important microscopists of the seventeenth century was the Netherlander Anton van Leeuwenhoek (1632–1723). Leeuwenhoek, born in Delft, turned his hobby of grinding lenses into his principal occupation. Using microscopes that magnified up to 270 times, Leeuwenhoek was the first to describe protozoa and bacteria. In a classic study of capillary circulation, Leeuwenhoek also discovered red blood cells.

One of Leeuwenhoek's most dramatic contributions to science was his discovery, in 1677, of spermatozoa in the semen of animals and man. He anticipated, incorrectly, that future microscopes, with greater powers of magnification, would reveal that each sperm contained the entire form of an adult in miniature and that this adult form merely unfolded and grew during the embryonic period. Leeuwenhoek described his discovery of spermatozoa and suggested that he could see bodily shapes within the sperm in a letter dated November 1677 to W. Brouncker, the president of the Royal

Society in London. A selection from Leeuwenhoek's letter, "This Vast Number of Animalcules," is presented here.

Impelled by a rich sense of curiosity, Leeuwenhoek made wide-ranging microscopic examinations. He helped to refute the widespread belief that living things could evolve from lifeless matter, and he opened up a previously unimaginable world of life.

While Leeuwenhoek was improving the microscope, another Dutch scientist, Christiaan Huygens (1629–1695), was improving the telescope. Huygens, born to a distinguished literary family, was a mathematician and a physicist, as well as an astronomer. By developing a new method of grinding and polishing lenses, Huygens obtained a definition of astronomical phenomena unavailable to earlier observers, such as Galileo. He recognized several features of the planet Saturn, including its ring system and one of its satellites. In addition, he observed the nebula of Orion. Huygens published his observations in *Systema Saturnium* (1659). A selection from *Systema Saturnium*, "The Wonderful Appearance of Saturn," is presented here.

The Dutch passion for exactitude in visual observation led to new scientific observations and to the development of an artistic style that combined precision with exquisite beauty. Jan Vermeer (1632–1675), an artist of the northern Netherlands, was also consumed by interest in the exact recording of visual phenomena. Some paintings by Vermeer may have been executed with the use of a camera obscura; all paintings by Vermeer, including *Young Woman with a Water Jug* (c. 1665) and *The Letter* (1666), are impressive for their sense of photographic authenticity. A friend of Anton van Leeuwenhoek, Vermeer served as the trustee for the scientist's estate.

Anton van Leeuwenhoek, Letter[1]
This Vast Number of Animalcules

I have divers times examined the same matter [human semen] from a healthy man, not from a sick man, nor spoiled by keeping for a long time and not liquefied after the lapse of some time; but immediately after ejaculation before six beats of the pulse had intervened: and I have seen so great a number of living animalcules in it, that sometimes more than a thousand were moving about in an amount of material the size of a grain of sand. I saw this vast number of animalcules not all through the semen, but only in the liquid matter adhering to the thicker part. In the thicker matter of the semen, however, the animalcules lay apparently motionless, and I conceived the reason of this to be, that the thicker matter consists of so many coherent particles that the animalcules could not move in it. These animalcules were smaller than the corpuscles which impart a red color to the blood; so that I judge a million of them would not equal in size a large grain of sand. Their

1. Reprinted, by permission of the publisher, from *The Collected Letters of Antoni van Leeuwenhoek*, ed. by the Committee of Dutch Scientists (Amsterdam: Swets and Zeitlinger, 1941), vol. 2, pp. 283–95.

bodies, which were round, were blunt in front and ran to a point behind. They were furnished with a thin tail, about five or six times as long as the body, and very transparent and with the thickness of about one twenty-fifth that of the body; so that I can best liken them to a small earth-nut with a long tail. They moved forward owing to the motion of their tails like that of a snake or an eel swimming in water; but in the somewhat thicker substance they would have to lash their tails at least 8 or 10 times before they could advance a hair's bredth.

I have sometimes fancied that I could even discern different parts on the bodies of these animalcules: but since I have not always been able to do so, I will say no more. Among these animalcules there were also smaller ones, to which I can ascribe nothing but a globular form.

I remember that some three or four years ago I examined seminal fluid at the request of the late Mr. Oldenburg, and that I then considered those animalcules to be globules. Yet as I felt averse from making further investigations and still more so from describing them, I did not continue my observations. What I investigate is only what, without sinfully defiling myself, remains as a residue after conjugal coitus. And if your Lordship should consider that these observations may disgust or scandalize the learned, I earnestly beg your Lordship to regard them as private and to publish or destroy them, as your Lordship thinks fit.

As regards the parts themselves of which the denser substance of the semen is mainly made up, as I have many times observed with wonder, they consist of all manner of great and small vessels, so various and so numerous that I have not the least doubt that they are nerves, arteries and veins. Indeed I have observed these vessels in such great numbers that I believe that I have seen more of them in one single drop of semen than an anatomist will observe when dissecting a whole day. And seeing this, I felt convinced that in no full-grown human body there are any vessels which may not likewise be found in sound semen.

Christiaan Huygens, *Systema Saturnium*[2]
The Wonderful Appearance of Saturn

When Galileo made use of the telescope, noblest invention of our Belgic nation, for observation of the heavenly bodies, and, before all other men, disclosed to mortals those very celebrated phenomena of the planets, the

2. Reprinted, by permission of the publisher, from Harlow Shapley and Helen E. Howarth, eds., *A Source Book in Astronomy* (New York: McGraw-Hill, 1929), pp. 63–68. Copyright by McGraw-Hill.

most wonderful of his discoveries, it would seem, were those relating to the star of Saturn. For all the other phenomena, though justly calling for our wonder and admiration, were still not of a kind to make it necessary to question strongly the causes of their existence. But Saturn's changing forms showed a new and strange device of nature, the principle of which neither Galileo himself nor, in all the time since, any of the astronomers (with their permission be it said) has succeeded in divining. . . .[3]

And so I was also drawn by an urgent longing to behold these wonders of the heavens. But I had only the ordinary form of telescope, which measured five or six feet in length. I, therefore, set myself to work with all the earnestness and seriousness I could command to learn the art by which glasses are fashioned for these uses, and I did not regret having put my own hand to the task. After overcoming great difficulties (for this art has in reserve more difficulties than it seems to bear on its face), I at last succeeded in making the lenses which have provided me with the material for writing this account. For upon immediately directing my telescope at Saturn, I found that things there had quite a different appearance from that which they had previously been thought by most men to have. For it appeared that the two neighboring appendages clinging to Saturn were by no means two planets, but rather something different, while, distinct from these, there was a single planet, at a greater distance from Saturn and revolving around him in sixteen days; and the existence of this planet had been unknown through all the centuries up to that time. . . . But it was my observation in regard to his satellite that gave me the information about the velocity of his rotative motion. The fact that the satellite completes its orbit in sixteen days leads to the conclusion that Saturn, being in the center of the satellite's orbit, rotates in much less time. Furthermore, the following conclusion seemed reasonable: that all the celestial matter that lies between Saturn and his satellite is subject to the same motion, in this way that the nearer it is to Saturn, the nearer it approaches Saturn's velocity. Whence, finally, the following resulted: the appendages also, or arms, of Saturn are either joined and attached to the globular body at its middle and go around with it, or, if they are separated by a certain distance, still revolve at a rate not much inferior to that of Saturn.

3. That Saturn differs in appearance from other planets was seen at once by Galileo when he viewed it through his small telescope in 1610. But his instrument was not sufficiently powerful to reveal the nature of what he saw. He noticed the planet had protrusions on each side and accordingly represented it as a triple body. Other observers thought they were seeing arms stretching out from the sides of the planet or curving handles. The true explanation was derived by Huygens, who was aided by his more powerful telescope.

Furthermore, while I was considering these facts in connection with the motion of the arms, these arms appeared under the aspect which was exhibited at the time of my previous observations of the year 1655. The body of Saturn at its middle was quite round, while the arms extended on either side along the same straight line, as though the planet were pierced through the middle by a kind of axis; although, as indicated in the first figure of all, these arms, as seen through the twelve-foot telescope that I was then using, appeared a little thicker and brighter towards the ends on either side of the planet than they did where they joined the middle of the sphere. When, therefore, the planet continued day after day to present this same aspect, I came to understand, inasmuch as the circuit of Saturn and the adhering bodies was so short, this could happen under no other condition than that the globe of Saturn were assumed to be surrounded equally on all sides by another body, and that thus a kind of ring encircled it about the middle; for so, with whatever velocity it revolved, it would always present the same aspect to us, if, of course, its axis were perpendicular to the plane of the ring.

And so this established the reason for the phase which continued through that period. Therefore, after that, I began to consider whether the other phases that Saturn was said to have could be accounted for by the same ring. I was not long in coming to a conclusion on this point through noting in frequent observations the obliquity of Saturn's arms to the ecliptic. For when I had discovered that the straight line along which on either side these arms projected did not follow the line of the ecliptic, but cut it at an angle of more than 20 degrees, I concluded that in the same way the plane of the ring which I had imagined was inclined at about the same angle to the plane of the ecliptic—with a permanent and unchanging inclination, be it understood, as is known to be the case on this Earth of ours with the plane of the equator. From this inclination it necessarily followed that in its different aspects the same ring showed to us at one time a rather broad ellipse, at another time a narrower ellipse, and sometimes even a straight line. As regards the handle-like formations, I understand that this phenomenon was due to the fact that the ring was not attached to the globe of Saturn, but was separated from it the same distance all around. These facts, accordingly, being thus brought into line, and the above-mentioned inclination of the ring being also assumed, all the wonderful appearance of Saturn, I found, could be referred to this source, as will presently be shown. And this is that very hypothesis which, in the year 1656, on the 25th day of March, I put forth in confused letters, together with my observation on the Saturnian Moon.

6. Jacob van Ruisdael, *View of Haarlem from the Dunes at Overveen,*
c. 1670
Gardner, p. 798, ill. 19:56

Simon Nicolas Arnauld de Pomponne, *Report:* "The East India Company," c. 1669–71

Dutch wealth was achieved by determined labor, persistent effort, and frugality. Living in a country that was small and lacked natural resources, the Dutch waged a continual struggle for survival. Among the important industries developed within the Dutch republic were commercial fishing and cloth production. In the sixteenth and seventeenth centuries, one fifth of the Dutch population earned its livelihood from the herring fisheries, which produced 300,000 tons of salt fish every year. A large proportion of Dutch people were also employed in the manufacture of cloth, particularly linen.

During the seventeenth century, Dutch prosperity was further boosted by the expansion of trade on a worldwide basis. Of particular value were the natural resources of India. Stimulated by the potential of reaping high profits from the sale of silks, muslins, spices, and metals, Dutch merchants and sea captains created the East India Company.

Formed in 1602, the East India Company commanded great resources, both financial and military. Through it, the Dutch worked aggressively to eliminate European rivals, particularly the Portuguese and the English, and to establish trade monopolies. The first Dutch success was in the spice trade. The East India Company regulated spice production in India by various means, including setting cheap prices for the purchase of spices, exterminating native spice growers, parceling out spice areas to Dutch settlers to be worked by slaves, and destroying plantations owned by rival companies. At the same time, the East India Company controlled the spice market in Europe by equally various means, including initially selling spices at undercost prices and subsequently warehousing spices. The initial low prices drove rivals into bankruptcy while the later artificial shortages drove market prices high, recouped earlier losses and realized enormous returns. By the second half of the sixteenth century, the Dutch had largely acquired the spice monopoly they had sought and had begun to extend their trading practices to other Indian commodities, including cotton, silk, and porcelain.

An account of Dutch economic practices is provided by Simon Nicolas Arnauld de Pomponne, the French ambassador to Holland. In a report that he submitted to his government, Arnauld described the trading practices of the East India Company. A selection from the report, "The East India Company," is presented here.

A depiction of another of the important industries of the northern lowlands is provided by Jacob van Ruisdael (1628–1682) in his painting *View of Haarlem from the*

Dunes at Overveen (c. 1670). The painting shows a cloud-filled sky above the fields surrounding Haarlem, where linen was laid out for bleaching.

Simon Nicolas Arnauld de Pomponne, *Report*[1]
The East India Company

It must be granted that this little republic can now be numbered among the mightiest powers of Europe. In this we have reason to admire the fruits of industry, shipping and trade, for these are the sources from which all their wealth flows with an abundance which is all the more remarkable because until now the skill and ability of Holland have kept this flow almost completely away from the other nations of Europe. . . .

Having struck down the Portuguese, the Dutch were for many years the sole masters of the Indies trade. The English had indeed established some trading posts after the Dutch example, but were content to confine their establishments to the lands of the princes with whom they traded, and their profits were moderate, hence the Dutch felt little rivalry with them. Since then the Royal [East India] Company which has been formed in London has grown larger; its ships now return in great numbers and with rich cargoes; and the trading establishments which it has already made in various places in the Indies, and to which it seeks to add, cause the Dutch much anxiety. This trade, to which both nations aspire equally, was the real cause of the war which broke out in 1653–1654 between Cromwell and the States General; it also caused the war between the Dutch and the king of England in 1665, which ended with the treaty of Breda; and in the future it will be a constant source of friction and disputes between them.

Following their examples, the other nations of Europe have also wished to take their shares of the treasures and envisioned the profits to be made from sending their ships to such far-off places. The Danes made their efforts quite a while back and still maintain a fort and a colony on the Coromandel coast.[2] The Swedes have also sent their ships to the Indies, but with repeated failure. Various French vessels have made the voyage at different times, but as these were only the endeavors of individuals or a small company too weak for great undertakings, even when they made a profit, it was not such as to arouse a desire in others to follow them upon such distant journeys. At the

1. Simon Nicolas Arnauld de Pomponne, *Relation de mon ambassade en Hollande, 1669–1671,* ed. by Herbert H. Rowen, in *Werken uitgegeven door net Historisch Genootschap te Utrecht,* 4th series, no. 2 (Utrecht: Kemink & Zoon, 1955), pp. 36, 39–42. Trans. from the French by Herbert H. Rowen. Reprinted, by permission of the publisher, from Herbert H. Rowen, ed., *From Absolutism to Revolution, 1648–1848* (New York: Macmillan, 1963), pp. 88–90. Copyright by Macmillan.
2. The coast of southeast India.

present time the East India Company [of France] which has been established under the authority of the King and enjoys his special protection, and in which His Majesty and individual persons have invested a considerable capital, gives hopes both great and legitimate, and perhaps not the least reason to anticipate its substantial success is that the Dutch have become concerned about its competition. . . .

The wares which they bring back are distributed upon their arrival among the cities of Holland, Zeeland and Friesland[3] where the Company has its chambers. One part is sold publicly on days which are carefully publicized by notices distributed to the merchants of all Europe. The rest is kept in storehouses, and the Dutch shrewdly draw out only as much as other nations need, but not so much as would reduce prices.

The same cleverness which prompts this policy of restriction sometimes results in their selling wares in profusion. When another country, such as Spain or England, receives the same wares which they sell, the Dutch release their stores at a very low price, although they suffer considerable loss in doing so. They are satisfied if the loss is shared by those whose expansion in trade they fear, whom they compel to sell at the same price as themselves. They soon make good the loss which they suffer, and by discouraging competitors who do not have the same great wealth or the same head start as themselves, they remain the masters over a trade which others abandon to them.

This same desire to avoid a fall in the prices of their wares from the Indies as a result of oversupply has repeatedly caused them to throw overboard whole cargoes of pepper and to burn great piles of cinnamon, cloves and nutmeg which would have met the needs of all Europe for several years.

The profits from the sale of these goods provides the funds for refitting the ships which they send to the Indies. Apart from some cloth and brandy, they bring few wares from Europe. Trading there is conducted almost solely by means of gold, and as great quantities of gold are shipped there and little of it returns, we may say that with the passage of time the larger part of the gold which comes from America and Peru will pass on to the East Indies.

Once the Company has met its expenses, the remainder of its profits [is] distributed among those who share in its ownership. These dividends are greater or lesser depending on the value of the returning fleets and on whether or not wars, such as the last one with England [1665–1667], have prevented them from undertaking the voyage. During the time of my stay in Holland, I saw dividends issued amounting to 12 and 40 per cent upon the shares in the Company.

3. Three provinces of the Netherlands.

7. Diego Velázquez, *The Maids of Honor (Las Meninas),* 1656

Gardner, p. 779, ill. 19:38; Janson, p. 585, ill. 799

Miguel de Cervantes, *Don Quixote:* "O Beauteous and Highborn Lady,"
1597–1615

Once a nation unrivaled in wealth and power, Spain was beset during the seventeenth century by economic instability, agricultural declines, population decreases, and incompetent political leadership. The Spanish people were filled with a sense of longing for the unattainable grandeur of the remembered past and with a sense of anxiety about the shifting realities of the present. The perplexities of seventeenth-century Spanish life surface in the writings of Miguel de Cervantes (1547–1616) and the paintings of Diego Velázquez (1599–1660).

The Jesuit-educated novelist Cervantes lived an existence more colorful than any of his fictional characters. In his youth, Cervantes was an adventurer who spent three years as a mercenary soldier in Italy and, after being captured by pirates, endured five years as a slave in Algiers. In his middle age, Cervantes became a bureaucrat who mismanaged government funds so badly that he was excommunicated by the church, brought to trial several times in the secular courts, and sentenced to at least two terms of imprisonment.

Cervantes began to write his great novel, *Don Quixote de la Mancha,* during his imprisonment in 1597. A burlesque of chivalric romances, the novel combines tragedy and comedy in its portrayal of the adventures of an elderly country gentleman, Don Quixote, and a peasant, Sancho Panza. An avid reader of chivalric tales, Don Quixote imagines himself to be an idealistic knight of old and sets out to redress the world's wrongs. The pragmatist Sancho can only ruefully watch as his master bumbles through an unending sequence of mishaps and misunderstandings. In one adventure the weary and bruised travelers, Don Quixote and Sancho, have stopped at a country inn that is run by a landlord and his daughter, Maritornes. In the episode that follows, Cervantes draws together the dreams and illusions of his knight-errant with the earthy desires and direct actions of common people. A selection from *Don Quixote,* "O Beauteous and Highborn Lady," is presented here.

Don Quixote, a profoundly human work, anticipates the painting of Velázquez. Court painter to Philip IV, Velázquez, like Cervantes, splendidly captures the sense of seventeenth-century Spanish life. In his painting *The Maids of Honor* (1656), Velázquez depicts the young Princess Margarita. His interest in the human scene is similar to that of Cervantes. Just as the writer describes a varied cast of characters, the painter surrounds the princess with different figures, who represent a wide range of ages and social classes. The world of dreams that is the ambience in which Don Quixote lives becomes, in Velázquez's painting, a world of ambiguous and shifting light.

The word *quixotic* in the English language derives from the name of the central

character of Cervantes' novel. The tension between idealism and practicality suggested by the word characterizes seventeenth-century Spain.

Miguel de Cervantes, *Don Quixote*[1]
O Beauteous and Highborn Lady

But to go on with our story, the mule driver, after he had looked in on his beasts and had given them their second feeding, came back and stretched out on his packsaddles to await that model of conscientiousness, Maritornes. Sancho, having been duly poulticed,[2] had also lain down and was doing his best to sleep, but the pain in his ribs would not let him. As for Don Quixote, he was suffering so much that he kept his eyes open like a rabbit. The inn was silent now, and there was no light other than from a lantern which hung in the middle of the gateway.

This uncanny silence, and our knight's constant habit of thinking of incidents described at every turn in those books that had been the cause of all his troubles, now led him to conceive as weird a delusion as could well be imagined. He fancied that he had reached a famous castle—for, as has been said, every inn where he stopped was a castle to him—and that the daughter of the lord (innkeeper) who dwelt there, having been won over by his gentle bearing, had fallen in love with him and had promised him that she would come that night, without her parents' knowledge, to lie beside him for a while. And taking this chimerical fancy which he had woven out of his imagination to be an established fact, he then began to be grieved at the thought that his virtue was thus being endangered, and firmly resolved not to be false to his lady Dulcinea del Toboso, even though Queen Guinevere[3] with her waiting-woman Quintañona should present themselves in person before him.

As he lay there, his mind filled with such nonsense as this, the hour that had been fixed for the Asturian's[4] visit came, and an unlucky one it proved to be for Don Quixote. Clad in her nightgown and barefoot, her hair done up in a fustian[5] net, Maritornes with silent, cautious steps stole into the room where the three were lodged, in search of the muleteer. She had no sooner crossed the threshold, however, than the knight became aware of her pres-

1. Reprinted, by permission of the publisher, from Miguel de Cervantes, *Don Quixote*, trans. by Samuel Putnam (New York: The Viking Press, 1949), pp. 117–21. Copyright by The Viking Press.
2. The application of warm, wet bandages to the skin as an emollient for a sore or irritation.
3. Wife of King Arthur and lover of Sir Launcelot.
4. A person from northwest Spain.
5. A coarse cloth made of cotton and flax.

ence; and sitting up in bed despite his poultices and the pain from his ribs, held out his arms as if to receive the beautiful maiden. The latter, all doubled up and saying nothing, was groping her way to her lover's cot when she encountered Don Quixote. Seizing her firmly by the wrists, he drew her to him, without her daring to utter a sound.

Forcing her to sit down upon the bed, he began fingering her nightgown, and although it was of sackcloth, it impressed him as being of the finest and flimsiest silken gauze. On her wrists she wore some glass beads, but to him they gave off the gleam of oriental pearls. Her hair, which resembled a horse's mane rather than anything else, he decided was like filaments of the brightest gold of Araby whose splendor darkened even that of the sun. Her breath without a doubt smelled of yesterday's stale salad, but for Don Quixote it was a sweet and aromatic odor that came from her mouth.

The short of it is, he pictured her in his imagination as having the same appearance and manners as those other princesses whom he had read about in his books, who, overcome by love and similarly bedecked, came to visit their badly wounded knights. So great was the poor gentleman's blindness that neither his sense of touch nor the girl's breath nor anything else about her could disillusion him, although they were enough to cause anyone to vomit who did not happen to be a mule driver. To him it seemed that it was the goddess of beauty herself whom he held in his arms.

Clasping her tightly, he went on to speak to her in a low and amorous tone of voice. "Would that I were in a position, O beauteous and highborn lady, to be able to repay the favor that you have accorded me by thus affording me the sight of your great loveliness; but Fortune, which never tires of persecuting those who are worthy, has willed to place me in this bed where I lie so bruised and broken that, even though my desire were to satisfy yours, such a thing would be impossible. And added to this impossibility is another, greater one: my word and promise given to the peerless Dulcinea del Toboso, the one and only lady of my most secret thoughts. If this did not stand in the way, I should not be so insensible a knight as to let slip the fortunate opportunity which you out of your great goodness of heart have placed in my way."

Maritornes was extremely vexed and all a-sweat at finding herself held fast in Don Quixote's embrace, and without paying any heed to what he was saying she struggled silently to break away. Meanwhile, the mule driver, whose evil desires had kept him awake, had been aware of his wench's presence ever since she entered the door and had been listening attentively to everything that Don Quixote said. Jealous because the Asturian lass, as he

thought, had broken her word and deserted him for another, he came up to the knight's cot and, without being able to make head or tail of all this talk, stood there waiting to see what the outcome would be.

When he saw that the girl was doing her best to free herself and Don Quixote was trying to hold her, he decided that the joke had gone far enough; raising his fist high above his head, he came down with so fearful a blow on the gaunt jaws of the enamored knight as to fill the poor man's mouth with blood. Not satisfied with this, the mule driver jumped on his ribs and at a pace somewhat faster than a trot gave them a thorough going-over from one end to the other. The bed, which was rather weak and not very firm on its foundations, was unable to support the muleteer's added weight and sank to the floor with a loud crash.

Eighteenth-Century Art

1. Richard Boyle and William Kent, Chiswick House, near London, begun 1725

Gardner, p. 821, ill. 20:2; Janson, p. 627, ills. 847–48

John Locke, *An Essay Concerning Human Understanding:* "All Ideas Come from Sensation or Reflection," 1690
John Locke, *Two Treatises of Civil Government:* "In Full Liberty to Resist," 1690.

The Age of Enlightenment is identified with the wave of new ideas that swept over Europe in the early eighteenth century. These ideas originated in the scientific and rationalistic movements of the seventeenth century. The spirit of rational inquiry that typified the writers and thinkers of the eighteenth century prompted them to make radical criticisms of existing political and religious institutions, as well as of traditional philosophical and ethical systems. Thus the ideas promulgated by Enlightenment thinkers have had important repercussions on all spheres of modern life.

John Locke (1632–1704) can be considered an initiator of the Age of Enlightenment in England, an inspirer of the federal constitution of the United States, and an influential philosophical and political force in Europe. After studying at Oxford University, Locke served as a physician to the Earl of Shaftesbury. His opposition to the English king, Charles II, forced Locke into exile in Holland between 1683 and 1689. A year after his return, Locke published two works, one of which, *An Essay Concerning Human Understanding,* was philosophical and the other of which, *Two Treatises of Civil Government,* was political.

An Essay on Human Understanding can be regarded as the first great work of British empiricism. In it, Locke argues a position directly contradictory to that of Descartes, and, indeed, to that of most philosophers since the time of Plato. Reversing the view that the mind acts upon the senses, Locke was convinced that the senses act

upon the mind. He compares the mind at birth to a blank slate void of any moral, ethical, or intellectual predispositions. According to Locke's view, all human knowledge, which includes persuasions, attitudes, and ideas, derives from whatever marks are inscribed on the mental slate by experience. As the marks are combined, knowledge is developed.

Two Treatises of Civil Government can be regarded as one of the landmarks of political science. In it Locke argues a political theory radically different from that of Bossuet and of most theorists since the Middle Ages. Rejecting the belief that a monarch exercises rulership through divine right, Locke argues that government rests on a contract, either explicit or implicit, between a ruler and his subjects. He defines the sovereignty of a monarch as being inherently limited, and he advocates the right of the citizenry to restore liberty where threatened.

The philosophical and political concepts defined by Locke were attractive beliefs for eighteenth-century theorists who wanted to change humankind and its institutions. Locke's premise about the operation of sensory experience on the mind made it logical to argue that improvements in the external world, such as better housing, better nutrition, and better education, could make individuals into better people. Locke's premise that a monarch has moral and political responsibilities toward his subjects made it appropriate to regard government as the chief instrument by which to effect the betterment of humankind.

Two selections from the writings of John Locke are presented here. The first selection, "All Ideas Come from Sensation or Reflection," is taken from *An Essay Concerning Human Understanding.* The second selection, "In Full Liberty to Resist," is taken from *Two Treatises of Civil Government.*

The clarity that Locke sought in understanding the human mind was achieved in architecture by Richard Boyle and William Kent in the design for Chiswick House (begun in 1725). A symmetrical harmony and simple shape composed of comprehensible elements is evident throughout Chiswick House. This house was one of many such aristocratic residences in which Locke's ideas were discussed and debated by the upper-class and educated circles of English society.

John Locke, *An Essay Concerning Human Understanding*[1]
All Ideas Come from Sensation or Reflection

The way shown how we come by any knowledge, sufficient to prove it not innate.[2] —It is an established opinion among some men, that there are in the understanding certain innate principles; some primary notions, . . . characters, as it were, stamped upon the mind of man, which the soul receives in its very first being, and brings into the world with it. It would be sufficient to

1. Reprinted from John Locke, *An Essay Concerning Human Understanding* (New York: Dover, 1959), pp. 37, 121–24.
2. Innate refers to the philosophical doctrine that some ideas are inborn in the human mind, as contrasted with those received or compiled from experience.

convince unprejudiced readers of the falseness of this supposition, if I should only show (as I hope I shall in the following part of this discourse) how men, barely by the use of their natural faculties, may attain to all the knowledge they have, without the help of any innate impressions, and may arrive at certainty, without any such original notions or principles. . . .

All Ideas come from Sensation or Reflection. —Let us then suppose the mind to be, as we say, white paper, void of all characters, without any ideas; how comes it to be furnished? Whence comes it by that vast store which the busy and boundless fancy of man has painted on it with an almost endless variety? Whence has it all the materials of reason and knowledge? To this I answer, in one word, from experience; in that all our knowledge is founded, and from that it ultimately derives itself. Our observation, employed either about external sensible objects, or about the internal operations of our minds, perceived and reflected on by ourselves, is that which supplies our understandings with all the materials of thinking. These two are the fountains of knowledge, from whence all the ideas we have, or can naturally have, do spring.

The Objects of Sensation one Source of Ideas. —First, our senses, conversant about particular sensible[3] objects, do convey into the mind several distinct perceptions of things, according to those various ways wherein those objects do affect them; and thus we come by those ideas we have, of yellow, white, heat, cold, soft, hard, bitter, sweet, and all those which we call sensible qualities; which when I say the senses convey into the mind, I mean they from external objects convey into the mind what produces there those perceptions. This great source of most of the ideas we have, depending wholly upon our senses, and derived by them to the understanding, I call "sensation."

The Operations of our Minds, the other Source of them. —Secondly, the other fountain, from which experience furnishes the understanding with ideas, is the perception of the operations of our own mind within us, as it is employed about the ideas it has got; which operations, when the soul comes to reflect on and consider, do furnish the understanding with another set of ideas, which could not be had from things without; and such are perception, thinking, doubting, believing, reasoning, knowing, willing, and all the different actings of our own minds; which we being conscious of, and observing in ourselves, do from these receive into our understandings as distinct ideas, as we do from bodies affecting our senses. This source of ideas every man has wholly in himself; and though it be not sense, as having nothing to do with external objects, yet it is very like it, and might properly enough be called "internal sense." But as I call the other "sensation" so I call this "reflection,"

3. Capable of being perceived by the physical senses.

the ideas it affords being such only as the mind gets by reflecting on its own operation within itself. By reflection, then, in the following part of this discourse, I would be understood to mean that notice which the mind takes of its own operations, and the manner of them; by reason whereof there come to be ideas of these operations in the understanding. These two, I say, viz.,[4] external material things, as the objects of sensation, and the operation of our own minds within, as the objects of reflection, are to me the only originals from whence all our ideas take their beginnings. The term "operations" here I use in a large sense, as comprehending not barely the actions of the mind about its ideas, but some sort of passions arising sometimes from them, such as is the satisfaction or uneasiness arising from any thought.

John Locke, *Two Treatises of Civil Government*[5]
In Full Liberty to Resist

. . . Governments are dissolved from within:

First. When the legislative is altered, civil society being a state of peace amongst those who are of it, from whom the state of war is excluded by the umpirage which they have provided in their legislative for the ending all differences that may arise amongst any of them; it is in their legislative that the members of a commonwealth are united and combined together into one coherent living body. This is the soul that gives form, life, and unity to the commonwealth; from hence the several members have their mutual influence, sympathy, and connection; and therefore when the legislative is broken, or dissolved, dissolution and death follows. For the essence and union of the society consisting in having one will, the legislative, when once established by the majority, has the declaring and, as it were, keeping of that will. The constitution of the legislative is the first and fundamental act of society, whereby provision is made for the continuation of their union under the direction of persons and bonds of laws, made by persons authorised there-unto, by the consent and appointment of the people, without which no one man, or number of men, amongst them can have authority of making laws that shall be binding to the rest. When any one, or more, shall take upon them to make laws whom the people have not appointed so to do, they make laws without authority, which the people are not therefore bound to obey; by which means they come again to be out of subjection, and may constitute to themselves a new legislative, as they think best, being in full liberty to resist

4. An abbreviation for *videlicet*, Latin: meaning that is to say; namely.
5. Reprinted from John Locke, *Two Treatises of Civil Government* (New York: E. P. Dutton 1924), pp. 225–27.

the force of those who, without authority, would impose anything upon them. Every one is at the disposure of his own will, when those who had, by the delegation of the society, the declaring of the public will, are excluded from it, and others usurp the place who have no such authority or delegation.

This being usually brought about by such in the commonwealth, who misuse the power they have, it is hard to consider it aright, and know at whose door to lay it, without knowing the form of government in which it happens. Let us suppose, then, the legislative placed in the concurrence of three distinct persons:—First, a single hereditary person having the constant, supreme, executive power, and with it the power of convoking and dissolving the other two within certain periods of time. Secondly, an assembly of hereditary nobility. Thirdly, an assembly of representatives chosen, *pro tempore*[6], by the people. Such a form of government supposed, it is evident:

First, that when such a single person or prince sets up his own arbitrary will in place of the laws which are the will of the society declared by the legislative, then the legislative is changed. . . .

Secondly, when the prince hinders the legislative from assembling in its due time, or from acting freely, pursuant to those ends for which it was constituted, the legislative is altered. . . .

Thirdly, when, by the arbitrary power of the prince, the electors or ways of election are altered without the consent and contrary to the common interest of the people, there also the legislative is altered. . . .

Fourthly, the delivery also of the people into the subjection of a foreign power, either by the prince or by the legislative, is certainly a change of the legislative, and so a dissolution of the government. For the end why people entered into society being to be preserved one entire, free, independent society, to be governed by its own laws, this is lost whenever they are given up into the power of another.

2. William Hogarth, *Breakfast Scene* from *Marriage à la Mode*, c. 1745
Gardner, p. 841, ill. 20:30

William Hogarth, *The Orgy*, Scene III of *The Rake's Progress*, c. 1734
Janson, p. 604, ill. 831

Zacharias Konrad von Uffenbach, *Travels:* "Cock-Fighting," 1710
César de Saussure, *Letters:* "An Extraordinary Combat," c. 1725–30

6. Latin, meaning temporarily; for the time being.

During the eighteenth century, capital cities such as London, Paris, and Vienna grew in population, wealth, and power. Merchant cities, such as Liverpool and Bordeaux, also grew in size and in commercial and political importance. As a result, the upper and middle classes secured new standards of comfort.

But despite the increased prosperity enjoyed by the well-to-do, harshness and squalor remained the lot of the poor. For the lower rungs of urban society, deteriorating living conditions meant poor incomes, miserable housing, unsanitary food, and short life expectancy. Crime, despite the savageness of the punishments, was rife, while drunkenness, abetted by cheap liquor, was rampant.

A wide gamut of entertainments and recreations was available to the urban classes. The enjoyment of sophisticated forms of art, literature, and music was limited to the leisured and educated members of the middle and upper classes. But the strong stimulus of violence and bloodshed drew large crowds of all social ranks to many events. Cockfighting was one of the many forms of recreation that drew excited crowds. Gladiatorial combats between armed fighters was another form of popular entertainment. Executions were public spectacles and attracted large crowds.

The seamy side of eighteenth-century urban life is conveyed in the accounts of two foreigner travelers to England. Zacharias Konrad von Uffenbach (1683–1734), a German tourist, kept a diary of his travels in England in 1710. César de Saussure (c. 1700–1750), a French visitor, wrote to his family during his stay in England. A selection from the *Travels* of von Uffenbach, "Cock-Fighting," and a selection from the *Letters* of de Saussure, "An Extraordinary Combat," are presented here.

Another commentator on eighteenth-century urban conditions was the English painter William Hogarth (1697–1764). While he often depicted the desperation of the London slums, Hogarth also satirized the elegance of the aristocratic milieu. In series such as *Marriage à la Mode* and *The Rake's Progress,* Hogarth reveals a dark undercurrent of debauchery and licentiousness beneath the sophisticated surface of upper-class existence. He suggests the falsity of the substitution of external qualities of status, position, and pleasure for personal ethical values.

Zacharias Konrad von Uffenbach, *Travels*[1]
Cock-Fighting

In the afternoon we went to see the cock-fighting. This is a sport peculiar to the English, which appears to foreigners very foolish, in spite of the pleasure this people takes in it. A special building has been made for it near "Gras Inn." When a fight is going to take place, printed bills are distributed and sometimes invitations to fanciers appear in the news-sheets as well as notices of the amount of the wagers and the number and species of cocks that are to fight. The building is round like a tower, and inside it resembles a "theatrum

1. Reprinted, by permission of the publisher, from *London in 1710: From the Travels of Zacharias Konrad von Uffenbach,* trans. and ed. by W. H. Quarrell and Margaret Mare (London: Faber and Faber, 1934), pp. 48–49. Copyright by Faber and Faber.

anatomicum," for all round it there are benches in tiers, on which the specta-tors sit. In the middle is a round table, which is covered with mats, on which the cocks have to fight. When it is time to start, the persons appointed to do so bring in the cocks hidden in two sacks, and then everyone begins to shout and wager before the birds are on view. The people [upper-class and lower-class] . . . act like madmen, and go on raising the odds to twenty guineas[2] and more. As soon as one of the bidders calls "done," . . . the other is pledged to keep to his bargain. Then the cocks are taken out of the sacks and fitted with silver spurs, such as we bought. As soon as the cocks appear, the shout-ing grows even louder and the betting is continued. When they are released, some attack, while others run away from the rest, and, as we ourselves saw, are impelled by terror to jump down from the table among the people; they are then, however, driven back on to the table with great yells (in particu-lar by those who have put their money on the lively cocks which chase the others) and are thrust at each other until they get angry. Then it is amazing to see how they peck at each other, and especially how they hack with their spurs. Their combs bleed terribly and they often slit each other's crop and abdomen with the spurs. There is nothing more diverting than when one seems quite exhausted and there are great shouts of triumph and monstrous wagers; and then the cock that appeared to be quite done for suddenly recovers and masters the other. When one of the two is dead, the conqueror invariably begins to crow and to jump on the other, and it often happens that they sing their paean[3] before the victory and the other wins after all. Sometimes, when both are exhausted and neither will attack the other again, they are removed and others take their place; in this case the wagers are cancelled. But if one of them wins, those who put their money on the losing cock have to pay up immediately, so that an hostler[4] in his apron often wins several guineas from a Lord. If a man has made a bet and is unable to pay, for a punishment he is made to sit in a basket fastened to the ceiling, and is drawn up in it amidst peals of laughter. The people become as heated about their betting as the cocks themselves.

César de Saussure, *Letters*[5]
An Extraordinary Combat

The day I went to see the gladiators fight I witnessed an extraordinary combat, two women being the champions. As soon as they appeared on the

2. A British gold coin used in expensive dealings.
3. A song of triumph, joy, or praise.
4. A person who takes care of horses, particularly at an inn.
5. Reprinted, by permission of the publisher, from *A Foreign View of England in the Reigns of George I and George II: The Letters of Monsieur César de Saussure to His Family,* trans. and ed. by Madame van Muyden (London: John Murray, 1902), pp. 277–79. Copyright by John Murray.

stage they made the spectators a profound reverence; they then saluted each other and engaged in a lively and amusing conversation. They boasted that they had a great amount of courage, strength, and intrepidity. One of them regretted she was not born a man, else she would have made her fortune by her powers; the other declared she beat her husband every morning to keep her hand in, etc. Both these women were very scantily clothed, and wore little bodices and very short petticoats of white linen. One of these amazons was a stout Irishwoman, strong and lithe to look at, the other was a small Englishwoman, full of fire and very agile. The first was decked with blue ribbons on the head, waist, and right arm; the second wore red ribbons. Their weapons were a sort of two-handed sword, three or three and a half feet in length; the guard was covered, and the blade was about three inches wide and not sharp—only about half a foot of it was, but then that part cut like a razor. The spectators made numerous bets, and some peers[6] who were there some very large wagers. On either side of the two amazons a man stood by, holding a long staff, ready to separate them should blood flow. After a time the combat became very animated, and was conducted with force and vigour with the broad side of the weapons, for points there were none. The Irishwoman presently received a great cut across her forehead, and that put a stop to the first part of the combat. The Englishwoman's backers threw her shillings[7] and half-crowns[8] and applauded her. During this time the wounded woman's forehead was sewn up, this being done on the stage; a plaster was applied to it, and she drank a good big glass of spirits[9] to revive her courage, and the fight began again, each combatant holding a dagger in her left hand to ward off the blows. The Irishwoman was wounded a second time, and her adversary again received coins and plaudits from her admirers. The wound was sewn up, and for the third time the battle recommenced, the women holding wicker shields as defensive weapons. This third combat was fought for some time without result, but the poor Irishwoman was destined to be the loser, for she received a long and deep wound all across her neck and throat. The surgeon sewed it up, but she was too badly hurt to fight any more, and it was time, for the combatants were dripping with perspiration, and the Irishwoman also with blood. A few coins were thrown to her to console her, but the victor made a good day's work out of the combat. Fortunately it is very rarely one hears of women gladiators.

6. A nobleman; in Britain, a duke, marquess, earl, viscount, or baron.
7. A cupronickel coin of Great Britain, equal to the twentieth part of a pound.
8. A cupronickel coin of Great Britain, equal to 2 shillings, 6 pence.
9. A strong, distilled alcoholic beverage.

3. Balthasar Neumann, Vierzehnheiligen, near Bamberg, Germany, 1743–72
Gardner, p. 830, ills. 20:15–20:17

Dominikus Zimmermann, Die Wies, Upper Bavaria, Germany, 1745–54
Janson, p. 567, ills. 771–772

Gottfried Wilhelm Leibniz, *Theodicy:* "Better Than Every Other Possible Universe," 1710

Profound religious questions had been raised by Newton's mechanistic model of the universe and by Locke's empirical interpretation of the mind. One eighteenth-century thinker who addressed the new religious concerns was the German intellectual Gottfried Wilhelm Leibniz (1646–1716). A student of jurisprudence, an emissary of diplomacy, and a mathematician as well as a philosopher, Leibniz shared with Newton the honor for the invention of calculus.

An idealist, Leibniz regarded philosophy as an interpretation of divine thought. For him, human reason was the imitation of the logic of God. Reason, therefore, had an authority independent of experience. Opposed alike to the pantheism of Spinoza and the empiricism of Locke, Leibniz built up an interpretation of the universe on a theory of matter known as "monadology." Monads, for Leibniz, were centers of force and consciousness that were capable of action and perception. The soul was considered by Leibniz to be a monad that had consciousness of itself.

Leibniz outlined his religious beliefs in a text entitled *Theodicy* (1710). The keynote of Leibniz's thought was optimism. Believing in a predetermined harmony between the activities of the human soul and body, Leibniz taught that of infinite possible worlds, God had created the best. In this theory, the soul is absolutely free from all external constraint, and its immortality is guaranteed by the fact of its independence and imperishable individuality. In theology, Leibniz argued the rational possibility of revelation and miracles. In ethics, he believed that contemplation should be directed to the beauty and perfection of the future life, and that piety should be hopeful and serene. The great moral teachers of the past had each, in his view, been awarded a share of truth; with the selection of the best of them, philosophy became eclectic and continued progress toward a permanent and satisfying interpretation of life.

In *Theodicy*, Leibniz presents his ideas in the form of a dialogue in which objections are raised to his views. The objections are answered first with a brief statement. A second objection, called a prosyllogism, is presented and followed by another answer. A selection from *Theodicy*, "Better Than Every Other Possible Universe," is presented here.

The optimism that Leibniz expressed in his philosophical speculations about God and the universe is reflected in eighteenth-century architecture. Churches such as

Vierzehnheiligen (1743–72), designed by Balthasar Neumann, and Die Wies (1745–54), designed by Dominikus Zimmermann, abound in light and gaiety. Somber intensity of feeling is dissolved into a brilliantly lit interior in which decorative flights of fancy delight the imagination of the viewer. These churches cheerfully restate Leibniz's axiom that God has created the best possible world and that he has bequeathed it to humankind.

Leibniz, *Theodicy*[1]
Better Than Every Other Possible Universe

I. *Objection.* Whoever does not choose the best is lacking in power, or in knowledge, or in goodness.

God did not choose the best in creating this world.

Therefore, God has been lacking in power, or in knowledge, or in goodness.

Answer. I deny the minor, that is, the second premise of this syllogism; and our opponent proves it by this

Prosyllogism. Whoever makes things in which there is evil, which could have been made without any evil, or the making of which could have been omitted, does not choose the best.

God has made a world in which there is evil; a world, I say, which could have been made without any evil, or the making of which could have been omitted altogether.

Therefore, God has not chosen the best.

Answer. I grant the minor of this prosyllogism; for it must be confessed that there is evil in this world which God has made, and that it was possible to make a world without evil, or even not to create a world at all, for its creation has depended on the free will of God; but I deny the major, that is, the first of the two premises of the prosyllogism, and I might content myself with simply demanding its proof; but in order to make the matter clearer, I have wished to justify this denial by showing that the best plan is not always that which seeks to avoid evil, since it may happen that *the evil be accompanied by a greater good.* For example, a general of an army will prefer a great victory with a slight wound to a condition without wound and without victory. We have proved this more fully in the large work by making it clear, by instances taken from mathematics and elsewhere, that an imperfection in the part may be required for a greater perfection in the whole. In this I have followed the opinion of St. Augustine, who has said a hundred times, that

1. Reprinted from *The Philosophical Works of Leibniz,* trans. by George Martin Duncan (New Haven: Tuttle, Morehouse and Taylor, 1908, second edition), pp. 284–85.

God has permitted evil in order to bring about good, that is, a greater good; and that of Thomas Aquinas, . . . that the permitting of evil tends to the good of the universe. I have shown that the ancients called Adam's fall *felix culpa,* a happy sin, because it had been retrieved with immense advantage by the incarnation of the Son of God, who has given to the universe something nobler than anything that ever would have been among creatures except for it. And in order to a clearer understanding, I have added, following many good authors, that it was in accordance with order and the general good that God allowed to certain creatures the opportunity of exercising their liberty, even when he foresaw that they would turn to evil, but which he could so well rectify; because it was not fitting that, in order to hinder sin, God should always act in an extraordinary manner. To overthrow this objection, there- fore, it is sufficient to show that a world with evil might be better than a world without evil; but I have gone even farther, in the work, and have even proved that this universe must be in reality better than every other possible universe.

4. Antoine Watteau, *Return from Cythera,* 1717–19
Gardner, p. 824, ill. 20:6; Janson, p. 597, ill. 818

François de Salignac de la Mothe Fénelon, *Adventures of Telemachus:* "Frolic and Feast upon the Flowery Pasture," 1699

Intellectuals of the eighteenth century believed that the environment molded individu- als according to rational and predictable principles and that a supreme being regu- lated the universe according to benevolent and harmonious laws. The optimistic glow created by these convictions about the present gave rise to a glorious vision about the future. Intellectuals began to suggest that, in the future, the environment could be altered to improve the human condition on earth and to assure human progress toward moral perfectibility. One expression of this optimism can be found in the literary descriptions and visual depictions of utopias.

A description of utopia is provided by the French churchman and writer Fran- çois de Salignac de la Mothe Fénelon (1651–1715). A student of philosophy and theology, Fénelon became tutor to Louis, duke of Burgundy and eldest son of Louis XIV. During the seven years in which he held this post, Fénelon composed a large number of fables, stories, dialogues, and biographical stories for the education of the prince. Among the stories is *Adventures of Telemachus,* which was published in 1699. Written in the form of a political novel, the book is, on one level, a narrative that recounts the adventures of the Greek prince Telemachus in search of his father, Ulysses. On another level, the book is a political essay that contains Fénelon's fundamental ideas about sovereignty and the state. These ideas reveal an abhorrence

of despotism and a yearning for a future community of peoples in accordance with the spirit of the Gospels. Fénelon's utopia is characterized by the establishment of prosperity and the absence of luxury, by the necessity of healthful occupation and the abolition of idleness, by the flourishing of amicable relations among all inhabitants, and by the banishment of envy, rancor, and spite. It is guarded by classical deities and ruled by a benevolent monarch who exercises authority through the willing consent of the people rather than through oppression.

Fénelon presents his description of utopia in the form of a dialogue between Mentor and Idomeneus. Mentor, who serves Telemachus as a wise guide, is Aphrodite, the goddess of wisdom, in disguise. Idomeneus is the ruler of the city Salentum in Hesperia, a city that Telemachus and Mentor visit in their journeys. A selection from *Adventures of Telemachus,* "Frolic and Feast upon the Flowery Pasture," is presented here.

Utopia was also pictured by Antoine Watteau (1684–1721), a Flemish-born artist who spent much of his career in France. *Return from Cythera,* a subject painted in two versions (1717–19), represents a group of lovers regretfully leaving the sacred island of Aphrodite. On this island of eternal youth and charm, love is shown as a beneficent agent that calms the wild passions of the heart, curbs the evil impulses of the mind, and soothes the souls of men and women. The visitors to Cythera are domesticated by love and are reformed so that they may partake of the progressive moral perfectibility of the human race.

François Salignac de la Mothe Fénelon, *Adventures of Telemachus*[1]
Frolic and Feast upon the Flowery Pasture

"But what shall I do," said Idomeneus, "if the people that I scatter over this fertile country should neglect to cultivate it?"

"You must do," said Mentor, "just contrary to what is commonly done. Rapacious and inconsiderate princes think only of taxing those who are most industrious to improve their land; because, upon these, they suppose a tax will be more easily levied; and they spare those whom idleness has made indigent. Reverse this mistaken and injurious conduct, which oppresses virtue, rewards vice, and encourages a supiness[2] that is equally fatal to the king and to the State. Let your taxes be heavy upon those who neglect the cultivation of their lands, and add to your taxes fines, and other penalties if it is necessary. Punish the negligent and the idle, as you would the soldier who should desert his post. On the contrary, grant to those who, in proportion as their families multiply, cultivate their lands with the greater diligence, special

1. Reprinted from François Salignac de la Mothe Fénelon, *Adventures of Telemachus,* trans. by J. Hawkesworth (Boston: Houghton Mifflin, 1859), pp. 359–61, 363–64.
2. Inactivity or passivity.

privileges and immunities. Every family will then become numerous, and every one will be animated to labor, not only by the desire of gain, but of honor. The state of husbandry[3] being no longer wretched, will no longer be contemptible. The plough, once more held in honor, will be guided by the victorious hands that have defended the country. It will not be less glorious to cultivate a paternal inheritance in the security of peace, than to draw the sword in its defence when it is endangered by war. The whole country will bloom around you; the golden ears of ripe corn will again crown the temples of Ceres;[4] Bacchus[5] will tread the grapes in rich clusters under his feet, and wine, more delicious than nectar, will flow from the hills like a river; the valleys will resound to the song of the shepherds, who, dispersed along the banks of a transparent stream, shall join their voices with the pipe;[6] while their flocks shall frolic round them, and feast upon the flowery pasture without fear of the wolf.

"O Idomeneus, will it not make you supremely happy to be the source of such prosperity—to stretch your protection, like the shadow of a rock, over so many people, who will repose under it in security and peace? Will you not, in the consciousness of this, enjoy a noble elevation of mind, a calm sense of superior glory, such as can never touch the bosom of the tyrant who lives only to desolate the earth, and who diffuses, not less through his own dominions than those which he conquers from others, carnage and tumult, horror and anguish, consternation, famine and despair? Happy, indeed, is the prince, whom his own greatness of soul and the distinguishing favor of the gods shall render thus the delight of his people, and the example of succeeding ages! The world, instead of taking up arms to oppose his power, will be found prostrate at his feet, and suing to be subject to his domination."

"But," said Idomeneus, "when the people shall be thus blessed with plenty and peace, will not their happiness corrupt their manners? will they not turn against me the very strength I have given them?"

"There is no reason to fear that," said Mentor; "the sycophants[7] of prodigal[8] princes have suggested it as a pretence for oppression; but it may easily be prevented. The laws which we have established with respect to agriculture will render life laborious; and the people, notwithstanding their plenty, will abound only in what is necessary, for we have prohibited the arts that furnish superfluities; and the plenty even of necessaries will be restrained

3. The cultivation and production of crops and animals.
4. Roman goddess of agriculture.
5. Roman god of wine.
6. A musical wind instrument, such as a flute, consisting of a single tube of wood or other material.
7. A self-seeking, servile flatterer.
8. Wastefully or recklessly extravagent.

within due bounds, by the facility of marriage and the multiplication of families. In proportion as a family becomes numerous, their portion of land being still the same in extent, a more diligent cultivation will become necessary, and this will require incessant labor. It is luxury and idleness that render people insolent and rebellious. They will have bread, indeed, and they will have bread enough; but they will have nothing more, except what they can gain from their own ground, by the sweat of their brow. . . ."

Idomeneus then hastened to distribute his uncultivated lands, to people them with useful artificers,[9] and to carry all the counsels of Mentor into execution,—reserving for the builders such parts as had been allotted them, which they were not to cultivate till they had finished the city.

5. Jean-Baptiste-Siméon Chardin, *Grace at Table*, 1740
Gardner, p. 840, ill. 20:29

Jean-Baptiste-Siméon Chardin, *Back from the Market*, 1739
Janson, p. 600, ill. 823

Marquis d'Argenson, *Journal and Memoirs:* "The Misery Within the Kingdom," 1739–40

The optimism engendered by the intellectual and philosophical attitudes of the eighteenth century encouraged people to define the purpose of life as the achievement of happiness. Happiness was a condition for the present rather than a dream to be attained only in the future afterlife. Not something that was freely bestowed, happiness was something individuals had to win by their own exertions. A practical, rather than an ideal, goal, happiness consisted of making the most of the limited measure of well-being that was attainable in the present world and not vainly striving for some ideal state of perfection beyond reach. While recognizing that the achievement of happiness was assisted by the possession of good health and material comfort, the optimists believed that happiness could be achieved by a modest degree of contentment. It therefore seemed reasonable that happiness could be attained by the simple folk of the countryside as well as the wealthy inhabitants of the city.

Such a belief is conveyed by the paintings of the French artist Jean-Baptiste-Siméon Chardin (1699–1779). In works such as *Grace at Table* (1740), Chardin depicts a plain middle-class family whose sincerity of faith and feeling result in a quiet, glowing happiness. In works such as *Back from the Market* (1739), Chardin portrays a servant girl whose tranquility assures her happiness even as she witnesses the greater material wealth of the household in which she is employed.

9. A person who is clever in devising ways to make or to do things.

In contrast to the prospect of happiness promised by French philosophers and depicted by French artists, the French peasantry was suffering from severe poverty. Burdened by the feudal dues it had to pay the aristocracy and lacking enough land to provide security from bad harvests, the peasants starved during years of poor harvests and barely survived during better years.

In 1739–40, the despair felt among the poor of France was deepened by monetary devaluation, high taxation, and food shortages. This crisis was understood by few aristocrats or bureaucrats, with the exception of the French official the Marquis d'Argenson, René-Louis de Voyer de Paulmy (1694–1757). Born in Paris, d'Argenson spent almost three decades as a government official. In 1732 he began to write a journal, a habit that he continued until his death. This journal includes revelations about his personal life, gossip about court scandals, observations about national concerns, and remarks about political, economic, and social developments. His *Journal and Memoirs* is an important source for the literary and political history of Louis XV's reign. A selection from the journal entries made in 1739–40 by d'Argenson, "The Misery Within the Kingdom," is presented here.

Marquis d'Argenson, *Journal and Memoirs*[1]
The Misery Within the Kingdom

[1739] Within the kingdom things are going in a manner to make one tremble; no morality, selfish interests everywhere; hypocrisy and the zeal . . . torment the poor subjects of the king and honest men. . . .

The interior of the kingdom is in a state without example; the towns, particularly the capital, have drawn everything into them, especially since the diminution of the currency. . . .

The misery within the kingdom has increased during the last year to an incredible degree; people are dying off like flies from poverty, eating grass, especially in the provinces of Touraine, Maine, Angoumois, Haut-Poitou, Périgord, Orléannais, Berry, even up to the environs of Versailles. It is in vain to tell all this; the impression made is momentary. . . .

This *political evil,* the full import of which is not known, through the conditions of the currency which I have just stated is a phenomenon which our best reasoners hold to be incomprehensible; for it is not seen that there is famine everywhere; it has occurred only biennially in the most ill-used provinces, with prosperous years in others; it is the lack of money, the lack of *means* to buy provisions which does the harm. Whence comes it? With all this poverty, grains and provisions are getting dearer everywhere; no one employs labor. But M. Orry enforces the taxes with more rigor than ever, the

1. Reprinted, from *Journal and Memoirs of the Marquis d'Argenson,* ed. by E. J. B. Rathery, trans. by Katherine Prescott Wormeley (Boston: Hardy, Pratt, 1902), vol. 1, pp. 141, 163–67, 241–43.

taille-tax[2] is raised very high; he shows the cardinal an abundance in the treasury, which makes the latter congratulate himself and continue his political projects; and so the same thing goes on. . . .

Famine has occasioned three uprisings in the provinces; at Ruffec, Caen, and Chinon. They murdered women on the high-roads who were carrying bread. That simple food is more coveted to-day than purses of gold in former times, and indeed, pressing hunger and the desire to preserve life excuses crime more than the avarice of accumulating for needs to come. Normandy, that excellent country, succumbs under excessive taxes and the extortions of the collectors. The race of farmers is extinct. . . . The Duc d'Orléans brought to the Council the other day a bit of bracken bread; at the opening of the session he laid it on the table before the king saying, "Sire, see the sort of bread on which your subjects are fed to-day."

The Bishop of Chartres made some singularly bold statement at the *levée*[3] of the king and at the queen's dinner yesterday; everybody has urged him to continue them. The king questioned him as to the state of his people; he answered that famine and mortality prevailed; that men were eating grass like sheep and dying like flies, and that soon there would be a pestilence, which would be for all, even his Majesty. The queen having offered him a hundred *louis*[4] for his poor, the good bishop answered: "Madame, keep your money till the king, his finances, and mine are exhausted; then your Majesty shall assist my poor people, if you have any money left." . . .

[1740] Things are coming to a crisis: famine in the interior of the kingdom; Paris about to lack bread, which grows dearer day by day, riots everywhere, the provinces at their last gasp, and still the *tailles* are increased and the kingdom being depopulated. . . .

Fear is felt for next Wednesday, September 21. There is no bread in Paris, except some damaged flour which has arrived and is being parched. They are working day and night at the mills in Belleville to make over this old decaying flour. The people know it, and the cry is everywhere that the government wants to poison them. All are rising and everything is to fear. The danger is that on Wednesday floods of people may rush to Issy, where the cardinal is, or even to Choisy, where the king is. The two villages are close to Paris, and hunger knows no law.

[September 23.] They have sent for quantities of wheat; two thousand hogsheads are arriving from Havre; and more is ordered from Sicily and

2. A tax levied by the French king on his subjects and on the lands held by him.
3. A reception of visitors held by a king or another royal personage on rising from bed.
4. Gold coins issued in France from 1640 to 1795.

Dantzig. If only it comes in time; but the fear is, as winter is approaching, that the rivers may rise and the sea be too boisterous; yet, only that provision can be relied on if the supply should fail suddenly in Paris. . . . The people know this, and all is ready for revolt. Bread grows dearer here by a sou[5] a day; no merchant dares to bring in his wheat. On Wednesday, the market being almost in revolt, there was no bread after seven in the morning. The commissaries went about haranguing the people and telling them that the controller had come expressly to Paris to consult with M. de Marville; on which the people cried out: "Hey, the dogs! we have only to set fire to that Orry's house and burn him and his people, and we shall have bread. It is that old dog of a cardinal who hinders laborers from working, and that is what makes us go without bread."

The king stopped on Sunday at Issy to see the cardinal on his way to Choisy. He passed through the faubourg[6] Saint-Victor; it was known, and the people collected in masses shouting—not "Vive le roi!" but "Misery! misery! bread! bread!" . . .

[September 25.] All is crumbling on every side.

6. Jean-Honoré Fragonard, *The Swing*, 1766
Gardner, p. 825, ill. 20:8

Jean-Honoré Fragonard, *The Bathers*, c. 1765
Janson, p. 599, ill. 822

Voltaire, *Candide:* "Everything for the Best" and "A Necessary Ingredient in the Best of Worlds," 1759

The pursuit of happiness and the belief in its attainment permeate the paintings of the French artist Jean-Honoré Fragonard (1732–1806). In *The Swing* (1766) Fragonard depicts, with delicious wit, a lovers' assignation. The lovers exchange smiles in a luxurious bower as the young woman's unsuspecting uncle, a bishop, furthers the affair by swinging his niece enticingly close to her paramour. In *The Bathers* (c. 1765) Fragonard revels in the display of female nudity and in the promise of sensual pleasures.

This optimism was assailed by the leading French intellectual of the Enlightenment, François-Marie Arouet (1694–1778), who preferred to be called Voltaire. Known for his penetrating wit and brilliant style, Voltaire survived a turbulent career

5. A bronze coin of France.
6. A part of the city outside, or once outside, the city walls: a suburb.

that resulted in two periods of incarceration in the Bastille[1] and in three years of exile in England.

A champion of the principle of reason, Voltaire reacted sharply against the optimistic philosophical theories of Leibniz. In his satirical novel *Candide* (1759), Voltaire seized upon Leibniz's axiom that this was the best of all possible worlds. Candide, the central character of the novel, is a youthful disciple of Doctor Pangloss, who is a disciple of Leibniz. Candide and a beautiful young woman, Cunegund, fall in love, but are separated by her parents, who consider Candide too lowly in birth to court their highborn daughter. Stumbling through a world of ignorance, cruelty, and violence, Candide, Cunegund, and Pangloss each endure beatings, torture, rape, imprisonment, slavery, disease, and disfigurement. At the end of their misadventures, the much-sobered trio retires to the shores of the Pronpontis, there to discover that the secret to happiness was "to cultivate one's garden."

Two selections from *Candide* are presented here. In the first selection, "Everything for the Best," Candide has been expelled from Westphalia by Cunegund's father, a local baron, and has arrived in Holland. There his ill-treatment affords him an unwanted opportunity to affirm Leibniz's view that evil is necessary in a benevolent world in order to excite goodness. In the second selection, "A Necessary Ingredient in the Best of Worlds," Candide is reunited with Pangloss. He learns of the horrors inflicted upon Cunegund by Bulgarian soldiers. Pangloss's optimism is unabated, even though he is dying of syphilis. He assures a somewhat dubious Candide that the good produced by the introduction of chocolate and cochineal[2] from the New World far outweighs the evil produced by the simultaneous introduction of a new, virulent form of venereal disease. Despite his mounting misfortunes, Candide never repudiates the optimism fostered by Leibniz among European intellectuals. Instead, Candide asks himself with an air of innocent wonder, "If this is the best of all possible worlds, what are the others like?"

Voltaire, *Candide*[3]

Everything for the Best

When he arrived in Holland his provision failed him; but having heard that the inhabitants of that country were all rich and Christians, he made himself sure of being treated by them in the same manner as at the baron's castle, before he had been driven thence through the power of Miss Cunegund's bright eyes.

He asked charity of several grave-looking people, who one and all

1. A prison in Paris where political prisoners were held.
2. A red dye prepared from the dried bodies of female cochineal insects, a type of scale insect.
3. Reprinted from Voltaire, *Candide, or The Optimist*, in *Works*, trans. by William F. Fleming (Akron, Ohio: Werner, 1904), vol. 1, pp. 69–71.

answered him, that if he continued to follow this trade they would have him sent to the house of correction, where he should be taught to get his bread.

He next addressed himself to a person who had just come from haranguing a numerous assembly for a whole hour on the subject of charity. The orator, squinting at him under his broad-brimmed hat, asked him sternly, what brought him thither and whether he was for the good old cause? "Sir," said Candide, in a submissive manner, "I conceive there can be no effect without a cause; everything is necessarily concatenated[4] and arranged for the best. It was necessary that I should be banished from the presence of Miss Cunegund; that I should afterwards run the gauntlet; and it is necessary I should beg my bread, till I am able to get it: all this could not have been otherwise." "Hark ye, friend," said the orator, "do you hold the pope to be Antichrist?"[5] "Truly, I never heard anything about it," said Candide, "but whether he is nor not, I am in want of something to eat." "Thou deservest not to eat or to drink," replied the orator, "wretch, monster, that thou art! hence! avoid my sight, nor ever come near me again while thou livest." The orator's wife happened to put her head out of the window at that instant, when, seeing a man who doubted whether the pope was Antichrist, she discharged upon his head a utensil full of [piss]. Good heavens, to what excess does religious zeal transport womankind!

A man who had never been christened,[6] an honest anabaptist named James, was witness to the cruel and ignominious treatment showed to one of his brethren, to a rational, two-footed, unfledged[7] being. Moved with pity he carried him to his own house, caused him to be cleaned, gave him meat and drink, and made him a present of two florins,[8] at the same time proposing to instruct him in his own trade of weaving Persian silks, which are fabricated by Holland. Candide, penetrated with so much goodness, threw himself at his feet, crying, "Now I am convinced that my Master Pangloss told me truth when he said that everything was for the best in this world; for I am infinitely more affected with your extraordinary generosity than with the inhumanity of that gentleman in the black cloak, and his wife."

4. Linked together in a series or chain.
5. A satanic power or being who is identified as the principal antagonist of Christ.
6. Baptized.
7. Young, immature.
8. Gold coins of the Netherlands, also called guldens.

Voltaire, *Candide*[9]

A Necessary Ingredient in the Best of Worlds

The next day, as Candide was walking out, he met a beggar all covered with scabs, his eyes sunk in his head, the end of his nose eaten off, his mouth drawn on one side, his teeth as black as a cloak, snuffling and coughing most violently, and every time he attempted to spit, out dropped a tooth.

Candide, divided between compassion and horror, but giving way to the former, bestowed on this shocking figure the two florins which the honest anabaptist, James, had just before given to him. The spectre looked at him very earnestly, shed tears and threw his arms about his neck. Candide started back aghast. "Alas!" said the one wretch to the other, "don't you know your dear Pangloss?" "What do I hear? Is it you, my dear master! you I behold in this piteous plight? What dreadful misfortune has befallen you? What has made you leave the most magnificent and delightful of all castles? What has become of Miss Cunegund, the mirror of young ladies, and nature's master-piece?" "Oh Lord!" cried Pangloss, "I am so weak I cannot stand," upon which Candide instantly led him to the anabaptist's stable, and procured him something to eat. As soon as Pangloss had a little refreshed himself, Candide began to repeat his inquiries concerning Miss Cunegund. "She is dead," replied the other. "Dead!" cried Candide, and immediately fainted away; his friend restored him by the help of a little bad vinegar, which he found by chance in the stable. Candide opened his eyes, and again repeated: "Dead! is Miss Cunegund dead? Ah, where is the best of worlds now? But of what illness did she die? Was it of grief on seeing her father kick me out of his magnificent castle?" "No," replied Pangloss, "her body was ripped open by the Bulgarian soldiers, after they had subjected her to as much cruelty as a damsel could survive; they knocked the baron, her father, on the head for attempting to defend her; my lady, her mother, was cut in pieces; my poor pupil was served just in the same manner as his sister, and as for the castle, they have not left one stone upon another; they have destroyed all the ducks, and the sheep, the barns, and the trees; but we have had our revenge, for the Abares have done the very same thing in a neighboring barony, which belonged to a Bulgarian lord."

At hearing this, Candide fainted away a second time, but, having come to himself again, he said all that it became him to say; he inquired into the cause and effect, as well as into the sufficing reason that had reduced Pangloss to so miserable a condition. "Alas," replied the preceptor, "it was love; love,

9. Reprinted from Voltaire, *Candide, or The Optimist,* in *Works,* trans. by William F. Fleming (Akron, Ohio: Werner, 1904), vol. 1, pp. 71–74.

the comfort of the human species; love, the preserver of the universe; the soul of all sensible beings; love! tender love!" "Alas," cried Candide, "I have had some knowledge of love myself, this sovereign of hearts, this soul of souls; yet it never cost me more than a kiss and twenty kicks on the backside. But how could this beautiful cause produce in you so hideous an effect?"

Pangloss made answer in these terms: "O my dear Candide, you must remember Pacquette, that pretty wench, who waited on our noble baroness; in her arms I tasted the pleasures of paradise, which produced these hell-torments with which you see me devoured. She was infected with an ailment, and perhaps has since died of it; she received this present of a learned cordelier,[10] who derived it from the fountain head; he was indebted for it to an old countess, who had it of a captain of horse, who had it of a marchioness, who had it of a page, the page had it of a Jesuit, who, during his novitiate, had it in a direct line from one of the fellow-adventurers of Christopher Columbus; for my part I shall give it to nobody, I am a dying man."

"O sage Pangloss," cried Candide, "what a strange genealogy is this! Is not the devil the root of it?" "Not at all," replied the great man, "it was a thing unavoidable, a necessary ingredient in the best of worlds; for if Columbus had not caught in an island in America this disease, which contaminates the source of generation, and frequently impedes propagation itself, and is evidently opposed to the great end of nature, we should have had neither chocolate or cochineal."

7. Jean-Baptiste Greuze, *The Son Punished,* **1765–1777**
Gardner, p. 842, ill. 20:31

Jean-Baptiste Greuze, *The Village Bride,* **1761**
Janson, p. 619, ill. 837

Jean-Jacques Rousseau, *Discourse on the Origin and Foundations of Inequality Among Men:* "Pity—a Natural Sentiment," 1754

The primacy of reason was challenged by the French philosopher and author Jean-Jacques Rousseau (1712–1778). Rousseau's thought ran counter to that of Voltaire and other Enlightenment thinkers. To these thinkers, recent advances in science and technology were regarded as proof of the superiority of the rational intellect over instinct and emotion, while future advances in science and technology were expected to provide the basis for material progress. Material progress, in turn, was viewed by

10. A Franciscan friar of a strict rule, identifiable by the knotted cord worn around the waist.

most Enlightenment thinkers as the means by which morality and happiness could be increased among individuals.

Rousseau, in contrast, was skeptical about material progress, which he regarded as destructive of an individual's moral well-being and happiness. Rousseau, though never doubting the attainments of the human intellect, regarded science and technology as the products of complex civilizations. In Rousseau's view, complex civilizations corrupted, rather than improved, individuals, by introducing luxury, avarice, sloth, and decadence. Individuals, according to Rousseau, became the victims rather than the masters of machines; they became part of communities that promoted war to further their accumulation of wealth and their acquisition of territory; and they surrendered their independence to leaders who developed elaborate systems of government and law. Rousseau was convinced that, with the advent of complex civilizations, individuals had ceased to cherish their original sentiments of liberty and equality and had become alienated from their natural instincts of kindness, charity, and pity.

Rousseau expounded many of his major ideas in his *Discourse on the Origin and Foundations of Inequality Among Men* (1754). In this work, Rousseau defines the natural state of the individual prior to the establishment of political societies. Rousseau argues that people living according to purely natural impulses are motivated by the principle of self-preservation, moderated by natural pity or compassion, and are incapable of pride, hatred, falsehood, and vice. He further argues that society, because of its creation of inequalities in property, wealth, and education, has corrupted the natural good. A selection from the *Discourse,* "Pity—a Natural Sentiment," is presented here.

Rousseau's emphasis on natural sentiments as the source of goodness is reflected in the paintings of Jean-Baptiste Greuze (1735–1805). In works such as *The Son Punished,* (1765–1777) a study for the painting, *The Return of the Prodigal Son* (1777–78), and *The Village Bride* (1761), Greuze presents his characters as motivated by strong natural sentiments. Freed of the artificial constraints of urban society, Greuze's figures become archetypes of natural goodness in a morality play. These paintings present scenes of moral virtue, which their patrons are urged to enter by shedding the civilized conventions that have come to stifle their simpler and purer natures.

Jean-Jacques Rousseau, *Discourse on the Origin and Foundations of Inequality Among Men*[1]
Pity—A Natural Sentiment

It seems at first that men in that state [of nature], not having among themselves any kind of moral relationship or known duties, could be neither good

1. Reprinted, by permission of the publisher, from Jean-Jacques Rousseau, *The First and Second Discourses,* ed. by Roger D. Masters, trans. by Roger D. Masters and Judith R. Masters (New York: St. Martin's Press, 1964), pp. 128, 130–33. Copyright by St. Martin's Press.

nor evil, and had neither vices nor virtues: unless, taking these words in a physical sense, one calls vices in the individual the qualities that can harm his own preservation, and virtues those that can contribute to it; in which case, it would be necessary to call the most virtuous the one who least resists the simple impulses of nature. . . . I do not believe I have any contradiction to fear in granting man the . . . natural virtue . . . of pity, a disposition that is appropriate to beings as weak and subject to as many ills as we are; a virtue all the more universal and useful to man because it precedes in him the use of all reflection; and so natural that even beasts sometimes give perceptible signs of it. . . . From this quality alone flow all the social virtues. . . . In fact, what are generosity, clemency, humanity, if not pity applied to the weak, to the guilty, or to the human species in general? Benevolence and even friendship are, rightly understood, the products of a constant pity fixed on a particular object: for is desiring that someone not suffer anything but desiring that he be happy? Even should it be true that commiseration is only a sentiment that puts us in the position of him who suffers—a sentiment that is obscure and strong in savage man, developed but weak in civilized man—what would this idea matter to the truth of what I say, except to give it more force? In fact, commiseration will be all the more energetic as the observing animal identifies himself more intimately with the suffering animal. Now it is evident that this identification must have been infinitely closer in the state of nature than in the state of reasoning. Reason engenders vanity and reflection fortifies it; reason turns man back upon himself, it separates him from all that bothers and afflicts him. Philosophy isolates him; because of it he says in secret, at the sight of a suffering man: Perish if you will, I am safe. No longer can anything except dangers to the entire society trouble the tranquil sleep of the philosopher and tear him from his bed. His fellow-man can be murdered with impunity right under his window; he has only to put his hands over his ears and argue with himself a bit to prevent nature, which revolts within him, from identifying him with the man who is being assassinated. Savage man does not have this admirable talent, and for want of wisdom and reason he is always seen heedlessly yielding to the first sentiment of humanity. In riots or street fights the populace assembles, the prudent man moves away; it is the rabble, the marketwomen, who separate the combatants and prevent honest people from murdering each other.

It is very certain, therefore, that pity is a natural sentiment which, moderating in each individual the activity of love of oneself, contributes to the mutual preservation of the entire species. It carries us without reflection to the aid of those who we see suffer; in the state of nature, it takes the place of laws, morals, and virtue, with the advantage that no one is tempted to

disobey its gentle voice; it will dissuade every robust savage from robbing a weak child or an infirm old man of his hard-won subsistence if he himself hopes to be able to find his own elsewhere. Instead of that sublime maxim of reasoned justice, *Do unto others as you would have them do unto you,* it inspires all men with this other maxim of natural goodness, much less perfect but perhaps more useful than the preceding one: *Do what is good for you with the least possible harm to others.* In a word, it is in this natural sentiment, rather than in subtle arguments, that we must seek the cause of the repugnance every man would feel in doing evil, even independently of the maxims of education.

8. Thomas Gainsborough, *Mrs. Richard Brinsley Sheridan,* c. 1785
Gardner, p. 835, ill. 20:22

Thomas Gainsborough, *Robert Andrews and His Wife,* c. 1748–50
Janson, p. 605, ill. 833

Samuel Johnson, *Rambler:* "To Delight and Refresh the Senses," 1751

The study of nature in the eighteenth century was regarded as a path toward virtue. According to the views held by many observers, morality was to be based not on the dogma of any particular religious sect but on the universal conditions of the natural world. Morality, it was argued, was but an emanation of nature, since the instinct that enabled individuals to distinguish truth from falsehood and good from evil was a natural, rather than learned, impulse. Because each person is invested with a natural urge to acknowledge the natural good, life conducted in accordance with natural wishes, desires, and motivations would necessarily be a model of virtue.

As trust in natural morality supplanted more traditional beliefs, aristocrats and intellectuals were drawn to the natural world. Psyches wearied by city life and souls tainted by urban corruptions could, it was believed, be revived and refreshed by rustic recreations. In the summer months, the well-to-do closed their splendid houses in the capitals of England and Continental Europe and retreated to their estates in the countryside. There they ambled at leisurely pace through gardens carefully planted to imitate untouched fields and forests; they stood in awestruck admiration before sweeping landscape vistas; and they sat in pensive musing by brooks and waterfalls.

The enchantment with the natural world is revealed in many of the portraits painted by Thomas Gainsborough (1727–1788). The double portrait *Robert Andrews and His Wife* (c. 1748–50) depicts the squire and his wife seated on a bench in the midst of the fields of their country estate. The portrait *Mrs. Richard Brinsley Sheridan* (c. 1785) depicts a young woman at rest in a natural setting that is untamed but unthreatening.

The quality of enchantment combined with a belief in the moral efficacy of the natural world is suggested in tone ranging from respect to satire by the contemporary English essayist Samuel Johnson (1709–1784). A journalist by profession, Johnson intended that his by-weekly publication, the *Rambler,* serve the public as an instructive missive. In accord with his belief that a writer bore the duty of making the world better, Johnson discussed both timeless moral and ethical issues and the contemporary conditions of his age on the pages of his journal.

Several essays published in the *Rambler* describe the eagerness of Johnson's compatriots to sojourn in the country. Johnson satirically suggests that most of these fugitives from the city are too raucous in their thoughts and feelings to absorb any benefits from the natural world. Yet he also conveys the pleasures that nature offered to eighteenth-century sensibilities. A selection from the *Rambler,* "To Delight and Refresh the Senses," is presented here.

Samuel Johnson, *Rambler*[1]
To Delight and Refresh the Senses

At this time of universal migration, when almost every one, considerable enough to attract regard, has retired, or is preparing with all the earnestness of distress to retire, into the country; when nothing is to be heard but the hopes of speedy departure, or the complaints of involuntary delay; I have often been tempted to enquire what happiness is to be gained, or what inconvenience to be avoided, by this stated recession. . . .

I believe that many of these fugitives may have heard of men whose continual wish was for the quiet of retirement, who watched every opportunity to steal away from observation, to forsake the crowd, and delight themselves with "the society of solitude." There is indeed scarcely any writer who has not celebrated the happiness of rural privacy, and delighted himself and his reader with the melody of birds, the whisper of groves, and the murmur of rivulets; nor any man eminent for extent of capacity, or greatness of exploits, that has not left behind him some memorials of lonely wisdom, and silent dignity.

But almost all absurdity of conduct arises from the imitation of those whom we cannot resemble. Those who thus testified their weariness of tumult and hurry, and hasted with so much eagerness to the leisure of retreat, either men overwhelmed with the pressure of difficult employments, harassed with importunities, and distracted with multiplicity; or men wholly engrossed by speculative sciences, who have no other end of life but to learn and teach,

1. Reprinted, by permission of the publisher, from Samuel Johnson, *Rambler,* ed. by W. J. Bate and Albrecht B. Strauss (New Haven: Yale University Press, 1969), vol. 2, pp. 351–54. Copyright by Yale University Press.

found their searches interrupted by the common commerce of civility, and their reasonings disjointed by frequent interruptions. Such men might reasonably fly to that ease and convenience which their condition allowed them to find only in the country. The statesman who devoted the greater part of his time to the public, was desirous of keeping the remainder in his own power. The general ruffled with dangers, wearied with labors, and stunned with acclamations, gladly snatched an interval of silence and relaxation. The naturalist was unhappy where the works of providence were not always before him. The reasoner could adjust his systems only where his mind was free from the intrusion of outward objects.

Such examples of solitude very few of those who are now hastening from the town, have any pretensions to plead in their own justification, since they cannot pretend either weariness of labor, or desire of knowledge. They purpose nothing more than to quit one scene of idleness for another, and after having trifled in public, to sleep in secrecy. The utmost that they can hope to gain is the change of ridiculousness to obscurity, and the privilege of having fewer witnesses to a life of folly. He who is not sufficiently important to be disturbed in his pursuits, but spends all his hours according to his own inclination, and has more hours than his mental faculties enable him to fill either with enjoyment or desires, can have nothing to demand of shades and valleys. As bravery is said to be a panoply, insignificancy is always a shelter.

There are however pleasures and advantages in a rural situation, which are not confined to philosophers and heroes. The freshness of the air, the verdure of the woods, the paint of the meadows, and the unexhausted variety which summer scatters upon the earth, may easily give delight to an unlearned spectator. It is not necessary that he who looks with pleasure on the colors of a flower should study the principles of vegetation, or that the Ptolemaic and Copernican system should be compared before the light of the sun can gladden, or its warmth invigorate. Novelty is itself a source of gratification, and Milton[2] justly observes, that to him who has been long pent up in cities no rural object can be presented, which will not delight or refresh some of his senses.

Yet even these easy pleasures are missed by the greater part of those who waste their summer in the country. Should any man pursue his acquaintances to their retreats, he would find few of them listening to Philomel,[3] loitering

2. Milton (1608–1674) was an English poet, whose most famous work was *Paradise Lost*.
3. Philomel is a poetic name for a nightingale. According to Greek mythology, Philomela was the daughter of Pandion, the king of Athens. Tereus, the king of Thrace, was married to Philomela's sister but contrived an occasion to be alone with Philomela. After raping her, he cut out her tongue to prevent her from telling. The gods punished Tereus and turned Philomela into a nightingale.

in woods, or plucking daisies, catching the healthy gale of the morning, or watching the gentle coruscations[4] of declining day. Some will be discovered at a window by the road side, rejoicing when a new cloud of dust gathers towards them, as at the approach of a momentary supply of conversation, and a short relief from the tediousness of unideal vacancy. Others are placed in the adjacent villages, where they look only upon houses as in the rest of the year, with no change of objects but what a remove to any new street in London might have given them. The same set of acquaintances still settle together, and the form of life is not otherwise diversified than by doing the same things in a different place. They pay and receive visits in the usual form, they frequent the walks in the morning, they deal cards at night, they attend to the same tattle, and dance with the same partners; nor can they at their return to their former habitation congratulate themselves on any other advantage than that they have passed their time like others of the same rank; and have the same right to talk of happiness and beauty of the country, of happiness which they never felt, and beauty which they never regarded.

To be able to procure its own entertainments, and to subsist upon its own stock, is not the prerogative of every mind. There are indeed understandings so fertile and comprehensive, that they can always feed reflection with new supplies, and suffer nothing from the preclusion of adventitious amusements; as some cities have within their own walls enclosed ground enough to feed their inhabitants in a siege. But others live only from day to day, and must be constantly enabled, by foreign supplies, to keep out the encroachments of languor and stupidity. Such could not indeed be blamed for hovering within reach of their usual pleasures, more than any other animal for not quitting its native element, were not their faculties contracted by their own fault. But let not those who go into the country, merely because they dare not be left alone at home, boast their love of nature, or their qualifications for solitude; nor pretend that they receive instantaneous infusions of wisdom from the Dryads,[5] and are able, when they leave smoke and noise behind, to act, or think, or reason for themselves.

9. Benjamin West, *The Death of General Wolfe*, 1771
Gardner, p. 843, ill. 20:32; Janson, p. 622, ill. 840

John Knox, *Journal:* "The Battle of Quebec," 1759

4. Gleams or flashes of light.
5. Deities or nymphs of the woods.

The overseas expansion of eighteenth-century European states brought Britain and France into direct conflict over which country would exercise supremacy of the growing world economy, dominion of foreign empires, and command of the seas. The French and Indian Wars (1754–63), a series of wars fought in colonial North America, were part of a larger conflict, the Seven-Year War (1756–63). In the French and Indian Wars, British troops and American colonists were pitted against French Canadian colonists and their Indian allies. Hostilities began when the Virginia governor sent a small army under the command of George Washington into the disputed Ohio Valley to dislodge French Canadian forces from Fort Duquesne. The American colonial forces were unsuccessful in their attack, and were compelled to withdraw. Numerous subsequent setbacks were suffered by the British until the course of the war was reversed by the British prime minister, William Pitt (1708–1778).

The French were decisively defeated in North America at Quebec. On September 13, 1759, the British general James Wolfe (1727–1759) planned and executed a courageous attack against the French forces commanded by the Marquis de Montcalm (1712–1759). Under the cover of darkness, Wolfe brought his forces upstream to Quebec, on the Saint Lawrence River. He and his soldiers then stealthily scaled the high cliffs along the riverbank. Appearing by surprise on the Plains of Abraham outside the Quebec fort, the British forced the French into battle. Both Wolfe and Montcalm were killed, but Canada fell into the hands of the British.

Wolfe's daring exploit was described by John Knox, a British soldier under Wolfe's command. Knox kept a journal in which he provided detailed accounts of his experiences in North America. A selection from his journal (1759), "The Battle of Quebec," is presented here.

Wolfe's bold attack on Quebec was also commemorated by the artist Benjamin West (1738–1820). An American-born painter, West went to Europe at the age of twenty-two. After several years in Italy, he settled in London, where he soon became a success. In 1771 he created a sensation with his *Death of General Wolfe,* in which he combined the format of historical painting with the depiction of a contemporary hero.

John Knox, *Journal*[1]
The Battle of Quebec

Before day-break this morning we made a descent upon the north shore, about half a quarter of a mile to the eastward of Sillery; . . . we had, in this debarkation, thirty flat-bottomed boats, containing about sixteen hundred men. This was a great surprise on the enemy, who, from the natural strength of the place, did not suspect, and consequently were not prepared against, so bold an attempt. . . . As fast as we landed, the boats put off for reinforce-

1. Reprinted, by permission of the publisher, from T. Charles-Edwards and B. Richardson, eds., *They Saw It Happen: An Anthology of Eyewitness's Accounts of Events in British History, 1689–1897* (Oxford: Basil Blackwell, 1958), pp. 64–65. Copyright by Basil Blackwell.

ments. . . . The General, with Brigadiers Monckton and Murray, were a-shore with the first division. We lost no time here, but clambered up one of the steepest precipices that can be conceived, being almost a perpendicular, and of an incredible height. As soon as we gained the summit, all was quiet, and not a shot was heard, owing to the excellent conduct of the light infantry under Colonel Howe; it was by this time clear day-light. Here we formed again. . . . We then faced to the right, and marched towards the town by files, till we came to the plains of Abraham; an even piece of ground which Mr. Wolfe had made choice of, while we stood forming upon the hill. Weather showery: about six o'clock the enemy first made their appearance upon the heights, between us and the town; whereupon we halted, and wheeled to the right, thereby forming the line of battle. . . . The enemy had now likewise formed the line of battle, and got some cannon to play on us, with round and canister shot; but what galled us most was a body of Indians and other marksmen they had concealed in the corn opposite to the front of our right wing . . . but Colonel Hale . . . advanced some platoons . . . which, after a few rounds, obliged these skulkers to retire. We were now ordered to lie down, and remained some time in this position. About eight o'clock we had two pieces of short brass six-pounders playing on the enemy, which threw them into some confusion. . . . About ten o'clock the enemy began to advance briskly in three columns, with loud shouts and recovered arms, two of them inclining to the left of our army, and the third towards our right, firing obliquely at the two extremities of our line, from the distance of one hundred and thirty, until they came within forty yards; which our troops withstood with the greatest intrepidity and firmness, still reserving their fire, and paying the strictest obedience to their Officers: this uncommon steadiness, together with the havoc which the grape-shot from our field pieces made among them, threw them into some disorder, and was most critically maintained by a well-timed, regular and heavy discharge of our small arms, such as they could not longer oppose; hereupon they gave way, and fled with precipitation, so that, by the time the cloud of smoke was vanished, our men were again loaded, and profiting by the advantage we had over them, pursued them almost to the gates of the town, and the bridge over the little river, redoubling our fire with great eagerness, making many Officers and men prisoners. The weather cleared up, with a comfortably warm sunshine. . . . Our joy at this success is inexpressibly damped by the loss we sustained of one of the greatest heroes which this or any other age can boast of—General James Wolfe, who received his mortal wound as he was exerting himself at the head of the grenadiers[2] of Louisbourg. . . . The officers who are prisoners say that Quebec

2. Specially selected foot soldiers in elite units.

will surrender in a few days: some deserters, who came out to us in the evening, agreed in that opinion, and inform us, that the Sieur de Montcalm is dying, in great agony, of a wound he received today in their retreat. . . .

After our late worthy general, of renowned memory, was carried off wounded, to the rear of the front line, he desired those who were about him to lay him down; being asked if he would have a Surgeon, he replied, "It is needless; it is all over with me." One of them then cried out, "They run, see how they run." "Who runs?" demanded our hero, with great earnestness, like a person roused from sleep. The Officer answered, "The enemy, Sir, Egad they give way everywhere." Thereupon the General rejoined, "Go one of you, my lads, to Colonel Burton; tell him to march Webb's regiment with all speed down to Charles's river, to cut off the retreat of the fugitives from the bridge." Then, turning on his side, he added, "Now, God be praised, I will die in peace": and thus expired.

10. Thomas Jefferson, Monticello, Charlottesville, Virginia, 1770–84, 1796–1806
Gardner, p. 851, ill. 20:42; Janson, p. 628, ills. 853–54

Thomas Jefferson, *Declaration of Independence:* "Certain Unalienable Rights," 1776

The last years of the eighteenth century were a time of great upheaval. A series of revolutions challenged the old order of kings and aristocrats. The ideas of liberty and equality excited revolutionary leaders throughout the Western world.

One of the most conspicuous champions of freedom was Thomas Jefferson (1743–1826). Born in the British colony of Virginia in North America, Jefferson received an excellent education in the classical languages, and in the literature and philosophy of Greece and Rome. He also absorbed the political ideals of the contemporary theorists John Locke and Jean-Jacques Rousseau. Jefferson became a consummate political draftsman whose matchless phrasing and eloquent style spread the influence of his writing throughout the colonies.

Jefferson studied law, and was admitted to the Virginia bar in 1767. Elected to the Virginia House of Burgesses in 1769, Jefferson soon led the patriot faction. In 1775 he became a delegate to the Continental Congress,[1] where he was chosen to draft the Declaration of Independence. A formal document justifying the separation of the

1. The Continental Congress (1774–89) was the body of delegates who spoke and acted collectively for the people of the colony-states that later became the United States of America.

thirteen colonies from Britain, the Declaration of Independence was adopted by the Continental Congress on July 4, 1776.

In a brief paragraph that has been regarded ever since as a charter of human liberties, Jefferson summarized current revolutionary philosophy. He presented to the world the case of the colonists in a series of burning charges against the king. He confidently proclaimed the natural rights of man and the sovereignty of the American states. He stated that "all Men are created equal, that they are endowed by their Creator with certain unalienable Rights, that among these are Life, Liberty, and the Pursuit of Happiness."

In addition to being a politician and diplomat, Jefferson was a musician, inventor, botanist, and architect. He designed his country house, Monticello, at Charlottesville, Virginia (1770–84, 1796–1806). An admirer of Greco-Roman art, Jefferson incorporated into his residence both a temple facade deriving from Greek prototypes and a saucer dome deriving from Roman structures. If the Declaration of Independence was an exciting statement of contemporary philosophical and political beliefs, Monticello was, for Jefferson, a beautiful visual symbol of the classical source for the lofty principles of life proclaimed by the Enlightenment.

Thomas Jefferson, *Declaration of Independence*[2]
Certain Unalienable Rights

When, in the Course of human Events, it becomes necessary for one People to dissolve the Political Bands which have connected them with another, and to assume among the Powers of the Earth, the separate and equal Station to which the Laws of Nature and of Nature's God entitle them, a decent Respect to the Opinions of Mankind requires that they should declare the causes which impel them to the Separation.

We hold these Truths to be self-evident, that all Men are created equal, that they are endowed by their Creator with certain unalienable Rights, that among these are Life, Liberty, and the Pursuit of Happiness—That to secure these Rights, Governments are instituted among Men, deriving their just Powers from the Consent of the Governed, that whenever any Form of Government becomes destructive of these Ends, it is the Right of the People to alter or to abolish it, and to institute new Government, laying its Foundation on such Principles, and organizing its Powers in such Form, as to them shall seem most likely to effect their Safety and Happiness. Prudence, indeed, will dictate that Governments long established should not be changed for light and transient Causes; and accordingly all Experience hath shewn, that Mankind are more disposed to suffer, while Evils are sufferable, than to right

2. Reprinted in Crane Brinton, ed., *The Portable Age of Reason Reader* (New York: Viking Press, 1956), pp. 194–99.

themselves by abolishing the Forms to which they are accustomed. But when a long Train of Abuses and Usurpations, pursuing invariably the same Object, evinces a Design to reduce them under absolute Despotism, it is their Right, it is their Duty, to throw off such Government, and to provide new Guards for their future Security. Such has been the patient Sufferance of these Colonies; and such is now the Necessity which constrains them to alter their former Systems of Government. The History of the present King of Great-Britain is a History of repeated Injuries and Usurpations, all having in direct Object the Establishment of an absolute Tyranny over these States. To prove this, let Facts be submitted to a candid World.

He has refused his Assent to Laws, the most wholesome and necessary for the public Good.

He has forbidden his Governors to pass Laws of immediate and pressing Importance, unless suspended in their Operation till his Assent should be obtained; and when so suspended, he has utterly neglected to attend to them.

He has refused to pass other Laws for the Accommodation of large Districts of People, unless those People would relinquish the Right of Representation in the Legislature, a Right inestimable to them, and formidable to Tyrants only.

He has called together Legislative Bodies at Places unusual, uncomfortable, and distant from the Depository of their public Records, for the sole Purpose of fatiguing them into Compliance with his Measures.

He has dissolved Representative Houses repeatedly, for opposing with manly Firmness his Invasions on the Rights of the People.

He has refused for a long Time, after such Dissolutions, to cause others to be elected; whereby the Legislative Powers, incapable of Annihilation, have returned to the People at large for their exercise; the State remaining in the mean time exposed to all the Dangers of Invasion from without, and Convulsions within.

He has endeavoured to prevent the Population of these States; for that Purpose obstructing the Laws of Naturalization of Foreigners; refusing to pass others to encourage their Migrations hither, and raising the Conditions of new Appropriations of Lands.

He has obstructed the Administration of Justice, by refusing his Assent to Laws for establishing Judiciary Powers.

He has made Judges dependent on his Will alone, for the Tenure of their Offices, and the Amount and Payment of their Salaries.

He has erected a Multitude of new Offices, and sent hither Swarms of Officers to harrass our People, and eat out their Substance.

He has kept among us, in Times of Peace, Standing Armies, without the consent of our Legislatures.

He has affected to render the Military independent of and superior to the Civil Power.

He has combined with others to subject us to a Jurisdiction foreign to our Constitution, and unacknowledged by our Laws; giving his Assent to their Acts of pretended Legislation:

For quartering large Bodies of Armed Troops among us:

For protecting them, by a mock Trial, from Punishment for any Murders which they should commit on the Inhabitants of these states:

For cutting off our Trade with all Parts of the World:

For imposing Taxes on us without our Consent:

For depriving us, in many Cases, of the Benefits of Trial by Jury:

For transporting us beyond Seas to be tried for pretended Offences:

For abolishing the free System of English Laws in a neighbouring Province, establishing therein an arbitrary Government, and enlarging its Boundaries, so as to render it at once an Example and fit Instrument for introducing the same absolute Rule into these Colonies:

For taking away our Charters, abolishing our most valuable Laws, and altering fundamentally the Forms of our Governments:

For suspending our own Legislatures, and declaring themselves invested with Power to legislate for us in all Cases whatsoever. . . .

In every state of these Oppressions we have Petitioned for Redress in the most humble Terms: Our repeated Petitions have been answered only by repeated Injury. A Prince, whose Character is thus marked by every act which may define a Tyrant, is unfit to be the Ruler of a free People.

Nor have we been wanting in Attentions to our British Brethren. We have warned them from Time to Time of Attempts by their Legislature to extend an unwarrantable Jurisdiction over us. We have reminded them of the Circumstances of our Emigration and Settlement here. We have appealed to their native Justice and Magnanimity, and we have conjured them by the Ties of our common Kindred to disavow these Usurpations, which would inevitably interrupt our Connections and Correspondence. They too have been deaf to the Voice of Justice and of Consanguinity. We must, therefore, acquiesce in the Necessity, which denounces our Separation, and hold them, as we hold the rest of Mankind, Enemies in War, in Peace, Friends.

We, therefore, the Representatives of the United States of America, in General Congress, Assembled, appealing to the Supreme Judge of the World for the Rectitude of our Intentions, do, in the Name, and by Authority of the good People of these Colonies, solemnly Publish and Declare, that these United Colonies are, and of Right ought to be, Free and Independent States; that they are absolved from all Allegiance to the British Crown, and that all political Connection between them and the State of Great-Britain, is and

ought to be totally dissolved; and that as Free and Independent States, they have full Power to levy War, conclude Peace, contract Alliances, establish Commerce, and to do all other Acts and Things which Independent States may of right do. And for the support of this Declaration, with a firm Reliance on the Protection of divine Providence, we mutually pledge to each other our Lives, our Fortunes, and our sacred Honor.

11. Jacques-Louis David, *The Death of Marat,* 1793
Gardner, p. 850, ill. 20:41; Janson, p. 620, ill. 839

Jean-Paul Marat, *The Friend of the People:* "Traitors Who Must Be Immolated," August 19, 1792
Maximilien Robespierre, *Report on the Principles of Public Morality:* "Tame the Enemies of Liberty by Terror," February 5, 1794

The success of the American Revolution sharply highlighted the contrast between the American ideals of liberty and democracy and the continued existence of repression and privilege in most of Europe. In 1789 a popular uprising began in France that would result in the overthrow of the monarchy and the establishment of a brief-lived republic. The revolutionary period ended with the formation of an empire in 1804.

The most violent period of the French Revolution is called the Reign of Terror (1793–94). It involved a military dictatorship directed by a circle of revolutionaries known as the Committee of Public Safety. In an effort to crush internal rebellion, the committee adopted harsh tactics. Over 40,000 men and women were accused of treason and executed. Another 300,000 suspects were crowded into prisons and often brushed close to death in a revolutionary court.

For two men, the guillotine[1] was not only a means of execution but also a necessary instrument for the protection of liberty. These men were Maximilien Robespierre (1758–1794) and Jean-Paul Marat (1743–1793).

An obscure lawyer from the provinces, Robespierre became a leader of the radical wing of revolutionary deputies in the National Assembly.[2] As a member of the Committee of Terror, Robespierre was implacable in his zeal to root out anyone who wavered in his support for the revolution. Partly in revenge for his past executions, he himself was guillotined in the Thermidorean Reaction[3] of July 1794.

A Swiss-born philosopher and doctor, Marat chose journalism as his method of spreading revolution. At the outbreak of the French Revolution he founded the inflammatory journal *The Friend of the People.* He was forced to flee to London in

1. A device for beheading persons by means of a heavy blade that is dropped between two posts that serve as guides.
2. French assembly that consisted of representatives elected by districts of the nation.
3. The uprising against Robespierre.

1790 and, upon his subsequent return, to hide in the Paris sewers. Backed by Robespierre, he came out of hiding, and was elected to the National Assembly, where he joined the radical political faction. He was stabbed to death in his bath by Charlotte Corday.[4]

Two selections related to the Reign of Terror are presented here. The French people are urged to violence by Marat in an edition of *The Friend of the People* published on August 19, 1792. In the selection presented here, "Traitors Who Must Be Immolated," Marat urges the people to put to the sword all prisoners suspected of being intriguers and traitors. The French people are exhorted by Robespierre to support terror as a defense of virtue in a speech, *Report on the Principles of Public Morality,* delivered to the National Assembly on February 5, 1794. In the selection presented here, Robespierre extolls the blessings of the new society that he is trying to forge, and he exalts terror as a necessary component.

For the painter Jacques-Louis David (1748–1825), Robespierre was one of the greatest heroes of the French Revolution, and Marat was one of its most grieved martyrs. Upon his election to the National Assembly, David joined his political fortunes to those of Robespierre. As well as becoming intimate with Robespierre, David also became a friend of Marat. The painting *The Death of Marat* (1793) commemorates David's friend and fellow revolutionary.

Unlike Robespierre and Marat, David survived the revolution. Soon after, he was consumed by a new political fervor—this time for Napoleon.

Jean-Paul Marat, *The Friends of the People*[5]
Traitors Who Must Be Immolated

What is the people's duty? . . . In the last resort, indeed the surest and wisest measure it can take, is to present itself armed at the Abbaye,[6] to pull the traitors out from within it, particularly the Swiss officers and their accomplices, and to put them under the edge of the sword. What stupidity to consider trying them! It's all over; you took them prisoner arms in hand against the [French nation] and you massacred the soldiers; why then spare their officers, incomparably more culpable? The stupid thing is to have listened to the appeasers who advised taking them prisoners of war. They are traitors who must be immolated[7] immediately, for they could never be considered from any other point of view.

4. Charlotte Corday (1768–1793) was an aristocrat by birth. Corday assassinated Marat because of his persecution of more moderate politicians.
5. Reprinted, by permission of the publishers, from J. Gilchrist and W. J. Murray, eds., *The Press in the French Revolution* (New York: St. Martin's Press, 1971), p. 269. Copyright by St. Martin's Press.
6. A monastery in Paris which had been converted into a prison.
7. Killed as sacrificial victims in fire.

Maximilien Robespierre,
Report on the Principles of Public Morality[8]
Tame the Enemies of Liberty by Terror

What is the end of our revolution? The tranquil enjoyment of liberty and equality; the reign of that eternal justice, the laws of which are graven, not on marble or stone, but in the hearts of men, even in the heart of the slave who has forgotten them, and in that of the tyrant who disowns them. . . .

Republican virtue may be considered as it respects the people and as it respects the government. It is necessary in both. When however, the government alone wants it, there exists a resource in that of the people; but when the people themselves are corrupted liberty is already lost.

Happily virtue is natural in the people, [despite] aristocratical prejudices. A nation is truly corrupt, when, after having, by degrees lost its character and liberty, it slides from democracy into aristocracy or monarchy; this is the death of the political body by decrepitude.[9] . . .

But, when, by prodigious effects of courage and of reason, a whole people break asunder the fetters of despotism to make of the fragments trophies to liberty; when, by their innate vigor, they rise in a manner from the arms of death, to resume all the strength of youth; when, in turns forgiving and inexorable, intrepid and docile, they can neither be checked by impregnable ramparts, nor by innumerable armies of tyrants leagued against them, and yet of themselves stop at the voice of the law; if then they do not reach the heights of their destiny it can only be the fault of those who govern.

Again, it may be said, that to love justice and equality the people need no great effort of virtue; it is sufficient that they love themselves. . . .

If virtue be the spring of a popular government in times of peace, the spring of that government during a revolution is virtue combined with terror; virtue, without which terror is destructive; terror, without which virtue is impotent. Terror is only justice prompt, severe and inflexible; it is then an emanation of virtue; it is less a distinct principle than a natural consequence of the general principle of democracy, applied to the most pressing wants of the country.

It has been said that terror is the spring of despotic government. Does yours then resemble despotism? Yes, as the steel that glistens in the hands of the heroes of liberty resembles the sword with which the satellites of tyranny are armed. Let the despot govern by terror his debased subjects; he is right

8. Reprinted from M. Robespierre, *Report Upon the Principles of Political Morality Which Are to Form the Basis of the Administration of the Interior Concerns of the Republic* (Philadelphia, 1794), pp. 10–11.
9. Weakness.

as a despot: conquer by terror the enemies of liberty and you will be right as founders of the republic. The government in a revolution is the despotism of liberty against tyranny. Is force only intended to protect crime? Is not the lightning of heaven made to blast vice exalted?

The law of self-preservation, with every being whether physical or moral, is the first law of nature. Crime butchers innocence to secure a throne, and innocence struggles with all its might against the attempts of crime. If tyranny reigned one single day not a patriot would survive it. How long yet will the madness of despots be called justice, and the justice of the people barbarity or rebellion?—How tenderly oppressors and how severely the oppressed are treated! Nothing more natural; whoever does not abhor crime cannot love virtue. Yet one or the other must be crushed. Let mercy be shown the royalists! exclaim some men. Pardon the villains! No: be merciful to innocent, pardon the unfortunate, show compassion for human weakness.

The protection of government is only due to peaceable citizens; and all citizens in the republic are republicans. The royalists, the conspirators, are strangers, or rather enemies. Is not this dreadful contest, which liberty maintains against tyranny, indivisible? Are not the internal enemies the allies of those in the exterior? The assassins who lay waste the interior; the intriguers who purchase the consciences of the delegates of the people; the traitors who sell them; the mercenary libelists[10] paid to dishonor the cause of the people, to smother public virtue, to fan the flame of civil discord, and bring about a political counter revolution by means of a moral one; all these men, are they less culpable or less dangerous than the tyrants whom they serve? . . .

To punish the oppressors of humanity is clemency; to forgive them is cruelty. The severity of tyrants has barbarity for its principle; that of a republican government is founded on beneficence. Therefore let him beware who should dare to influence the people by that terror which is made only for their enemies! Let him beware, who, regarding the inevitable errors of civism[11] in the same light, with the premediated crimes of perfidiousness,[12] or the attempts of conspirators, suffers the dangerous intriguer to escape and pursues the peaceable citizen! Death to the villain who dares abuse the sacred name of liberty or the powerful arms intended for her defence, to carry mourning or death to the patriotic heart.

10. Persons who defame or misrepresent the character or actions of other persons.
11. Good citizenship.
12. Treacherousness.

12. John Henry Fuseli, *The Nightmare,* **1781**
Gardner, p. 856, ill. 20:47

John Henry Fuseli, *The Nightmare,* **1785–90**
Janson, p. 642, ill. 876

Edmund Burke, *Philosophical Enquiry into the Origin of Our Ideas of the Sublime and Beautiful:* "The Most Powerful of All the Passions," 1757

The admiration for the rational faculties of the human mind led early-eighteenth-century intellectuals to distrust the role played by passions and emotions. In the later eighteenth century, the admiration for reason was countered by a growing emphasis on the relationship between the emotions and morality. This emphasis resulted in the affirmation of benevolent emotions—such as pity, gratitude, generosity, and love—and in the exploration of the dark emotions—such as anger, shame, jealousy, envy, despair, lust, and madness. Writers began to exult in human passions and to propose that, through them, the soul is thrilled by the realization of its own excellence and amazed by the view of its surpassing power. The stronger the passion, it was argued, the more vividly a person comprehended the greatness of the human soul. Transported by the overwhelming power of deep emotion, the individual was able to experience the sublime.

The concept of the sublime, which originated in Greek philosophy, was popularized in the eighteenth century by Edmund Burke (1729–1797). Burke was later to become an important statesman, parliamentary orator, and political thinker in Britain. As a young man, however, Burke traveled widely in France and immersed himself in art and literature. In 1757 he published an essay on aesthetics, *A Philosophical Enquiry into the Origin of Our Ideas of the Sublime and Beautiful.* In this essay, Burke explores the value of the stronger emotions and of the irrational powers of the mind on human life and on art. Burke defines a system of aesthetic experience based on the antithesis of pain and pleasure, the former being the foundation of the sublime and the latter of the beautiful. He proposes that aesthetic experience derives from the subjective physical sensations when an individual encounters art. He contrasts the traditional ideal of beauty with the newer ideal of the sublime. Beauty, for Burke, rests primarily on love and its attendant emotions, while the sublime rests primarily on terror. In Burke's view terror causes astonishment in the soul and fills the mind completely with a single overwhelming sensation; its strong emotive power becomes the agent by which the soul is awakened.

In praising the emotion of terror, Burke opened the way for the inclusion of ideas and images in art that had previously been considered as lying outside the sphere of aesthetic pleasure. This is especially apparent in the paintings of John Henry Fuseli (1741–1824). Born in Switzerland, Fuseli studied theology and was ordained as a minister as a young man. His radical religious and political views, as well as his

unsettled life, caused him to renounce his religious vocation and to become an artist. In 1764 he settled in England, where he became a well-known instructor at the Royal Academy of Arts.

Fuseli's two most famous paintings, both of which are entitled *The Nightmare* (1781 and 1785–90), reveal the artist's fascination with anti-rational qualities and with situations of emotional extremity. The sleeping figure in the paintings can be identified as the woman who had rejected Fuseli as a suitor and who had soon afterward married another man. The demons and horses that have entered her bedchamber suggest the irrational sexual forces that constantly lurk in the human mind. The fact that Fuseli painted several versions of this subject suggests that his own emotions, both of love and of bitterness, continued to overwhelm him long after his courtship of the woman represented in the painting had been ended.

Edmund Burke, *Philosophical Enquiry into the Origin of Our Ideas of the Sublime and Beautiful*[1]
The Most Powerful of All the Passions

Most of the ideas which are capable of making a powerful impression on the mind, whether simply of pain or pleasure, or of the modifications of those, may be reduced very nearly to these two heads, *self-preservation,* and *society;* to the ends of one or the other of which all our passions are calculated to answer. The passions which concern self-preservation, turn mostly to *pain* or *danger.* The ideas of *pain, sickness,* and *death,* fill the mind with strong emotions of horror; but *life* and *health,* though they put us in a capacity of being affected with pleasure, make no such impression by the simple enjoyment. The passions therefore which are conversant about the preservation of the individual turn chiefly on *pain* and *danger,* and they are the most powerful of all the passions. . . .

Whatever is fitted in any sort to excite the ideas of pain and danger, that is to say, whatever is in any sort terrible, or is conversant about terrible objects, or operates in a manner analogous to terror, is a source of the *sublime;* that is, it is productive of the strongest emotion which the mind is capable of feeling. . . . When danger or pain press too nearly, they are incapable of giving any delight, and are simply terrible; but at certain distances, and with certain modifications, they may be, and they are, delightful, as we every day experience. . . . The passion caused by the great and sublime in *nature,* when those causes operate most powerfully, is astonishment: and astonishment is that state of the soul in which all its motions are suspended,

1. Reprinted from Edmund Burke, *Philosophical Enquiry into the Origin of Our Ideas of the Sublime and Beautiful,* in *The Works of the Right Honorable Edmund Burke* (Boston: Little, Brown, 1889), ninth edition, vol. 1, pp. 110–11, 130.

with some degree of horror. In this case the mind is so entirely filled with its object, that it cannot entertain any other, nor by consequence reason on that object which employs it. Hence arises the great power of the sublime, that, far from being produced by them, it anticipates our reasonings, and hurries us on by an irresistible force. Astonishment, as I have said, is the effect of the sublime in its highest degree; the interior effects are admiration, reverence, and respect.

No passion so effectually robs the mind of all its powers of acting and reasoning as *fear*. For fear being an apprehension of pain or death, it operates in a manner that resembles actual pain. Whatever therefore is terrible, with regard to sight, is sublime too, whether this cause of terror be endued[2] with greatness of dimensions or not; for it is impossible to look on anything as trifling, or contemptible, that may be dangerous. There are many animals, who, though far from being large, are yet capable of raising ideas of the sublime, because they are considered as objects of terror, as serpents and poisonous animals of almost all kinds. And to things of great dimension, if we annex an adventitious idea of terror, they become without comparison greater. A level plain of a vast extent on land, is certainly no mean idea; the prospect of such a plain may be as extensive as a prospect of the ocean; but can it ever fill the mind with anything so great as the ocean itself? This is owing to several causes; but it is owing to none more than this, that the ocean is an object of no small terror. Indeed terror is in all cases whatsoever, either more openly or latently, the ruling principle of the sublime.

13. Horace Walpole, Strawberry Hill, Twickenham, near London, 1749–77

Gardner, p. 844, ill. 20:33; Janson, p. 653, ills. 892–93

Horace Walpole, *The Castle of Otranto:* "The Impetuosity of His Passions," 1765

The desire to experience the sublime was connected with the taste for the occult, the fantastic, the grotesque, the macabre, the erotic, and the mysterious. This taste was expressed in literature by the Gothic novel and in the visual arts by the so-called Gothic style, characterized by elements originating in the Middle Ages.

The revolt against classical canons in art, literature, and thought is epitomized by the work of Horace Walpole (1717–1797). The fourth earl of Oxford, Walpole was famous in England as a connoisseur of the arts and as a novelist. In 1747 Walpole

2. Invested or endowed with some faculty or quality.

purchased a small farm called Strawberry Hill at Twickenham.[1] He soon began to convert the house on the estate into a miniature Gothic castle. Over the next thirty years he added to his house a series of Gothic motifs, including a cloister, chapel, round tower, gallery,[2] refectory,[3] and stair turret, as well as stained-glass windows and three sets of battlements.[4] The medieval architectural features adapted by Walpole were inconsistent in terms of their original date and function. But accuracy in the re-creation of the Gothic style was less important than the emotional ambience created by the visual evocation of the medieval world.

Walpole's enthusiasm for architecture was matched by his interest in writing. Walpole wrote the first English Gothic novel, *The Castle of Otranto* (1765), an exemplar of melancholy romanticism. The forerunner of countless romances of mystery and horror, the novel unfolds in a setting similar to that of Walpole's residence. The fictional castle, like the house that Walpole renovated, is replete with turrets, towers, battlements, and long galleries. In it supernatural powers and evil passions collide at fever pitch with the natural goodness imbedded in the hearts of the novel's heroes and heroines.

Like many of the Gothic novels that followed it, *The Castle of Otranto* is built around a plot that defies reason. The novel begins with the effort of Manfred, an evil prince, to strengthen his hold on the castle and lordship of Otranto. In order to do so, Manfred has arranged the marriage of his only son, Conrad, a sickly youth, to Isabella, the beautiful daughter of the marquis of Vicenza. As an aristocratic wedding party gathers at the chapel, an act of divine intervention thwarts Manfred's design. An enormous helmet comes loose from the black marble statue that represents Alfonso the Good, a former prince of Otranto. The helmet falls upon Conrad and crushes him to death. Undeterred, Manfred demands that the virtuous Isabella now yield herself to him and to his incestuous desires. Isabella resists and flees. Manfred's pursuit of the unwilling Isabella forms the remainder of the plot of the novel. It is elaborated by several secondary romances and is enlivened by skeletal apparitions, ghostly knights, and a resurrected ancestor who steps down from his portrait.

The plot, however, is of secondary concern; the novel aims at stimulating the passions, which are dark and terrifying but simultaneously energizing. A selection from *The Castle of Otranto*, "The Impetuosity of His Passions," is presented here.

Horace Walpole, *The Castle of Otranto*[5]
The Impetuosity of His Passions

It was now evening; the servant who conducted Isabella bore a torch before her. When they came to Manfred, who was walking impatiently about the

1. A town in the county of Middlesex, in southeast England.
2. A long corridor or covered space used for walking, often partly open at side.
3. Hall or long room used for meals and refreshments.
4. Indented parapet at the top of a wall.
5. Reprinted from Horace Walpole, *The Castle of Otranto* (London: Oxford University Press, 1964), pp. 22–25.

gallery, he started and said hastily, "Take away that light, and begone." Then shutting the door impetuously, he flung himself upon a bench against the wall, and bade Isabella sit by him. She obeyed trembling. "I sent for you, lady," said he,—and then stopped under great appearance of confusion. "My lord!"—"Yes, I sent for you on a matter of great moment," resumed he:— "Dry your tears, young lady—you have lost your bridegroom:—yes, cruel fate, and I have lost the hopes of my race!—But Conrad was not worthy of your beauty."—"How! my lord," said Isabella; "sure you do not suspect me of not feeling the concern I ought? My duty and affection would have always"—"Think no more of him," interrupted Manfred; "he was a sickly, puny child, and heaven has perhaps taken him away that I might not trust the honors of my house on so frail a foundation. The line of Manfred calls for numerous supports. My foolish fondness for that boy blinded my eyes of my prudence—but it is better as it is. I hope in a few years to have reason to rejoice at the death of Conrad."

Words cannot paint the astonishment of Isabella. At first she apprehended that grief had disordered Manfred's understanding. Her next thought suggested that this strange discourse was designed to ensnare her: she feared that Manfred had perceived her indifference for his son: and in consequence of that idea she replied, "Good my lord, do not doubt my tenderness; my heart would have accompanied my hand. Conrad would have engrossed all my care; and wherever fate shall dispose of me, I shall always cherish his memory, and regard your highness and the virtuous Hippolita as my parents." "Curse on Hippolita!" cried Manfred: "forget her from this moment, as I do. In short, lady, you have missed a husband undeserving of your charms: they shall now be better disposed of. Instead of a sickly boy, you shall have a husband in the prime of his age, who will know how to value your beauties, and who may expect a numerous offspring." "Alas, my lord," said Isabella, "my mind is too sadly engrossed by the recent catastrophe in your family to think of another marriage. If ever my father returns, and it shall be his pleasure, I shall obey, as I did when I consented to give my hand to your son: but until his return permit me to remain under your hospitable roof, and employ the melancholy hours in assuaging yours [and] Hippolita's . . . affliction."

"I desired you once before," said Manfred angrily, "not to name that woman; from this hour she must be a stranger to you, as she must be to me:—in short, Isabella, since I cannot give you my son, I offer you myself."— "Heavens!" cried Isabella, waking from her delusion, "what do I hear! You, my lord! You! My father-in-law! the father of Conrad! the husband of the virtuous and tender Hippolita!"—"I tell you," said Manfred imperiously,

"Hippolita is no longer my wife; I divorce her from this hour. Too long has she cursed me by her unfruitfulness: my fate depends on having sons,—and this night I trust will give a new date to my hopes." At those words he seized the cold hand of Isabella, who was half-dead with fright and horror. She shrieked, and started from him. Manfred rose to pursue her; when the moon, which was now up, and gleamed in at the opposite casement, presented to his sight the plumes of the fatal helmet, which rose to the height of the windows, waved backwards and forwards in a tempestuous manner, and accompanied with a hollow and rustling sound. Isabella, who gathered courage from her situation, and who dreaded nothing so much as Manfred's pursuit of his declaration, cried, "Look, my lord! see heaven itself declares against your impious intentions!"—"Heaven nor hell shall impede my designs," said Manfred, advancing again to seize the princess. At that instant the portrait of his grandfather, which hung over the bench where they had been sitting, uttered a deep sigh and heaved its breast. Isabella, whose back was turned to the picture, saw not the motion, nor knew whence the sound came, but started and said, "Hark my lord! what sound was that?" and at the same time made towards the door. Manfred, distracted between the flight of Isabella, who had now reached the stairs, and his inability to keep his eyes from the picture, which began to move, had however advanced some steps after her, still looking backwards on the portrait, when he saw it quit its panel, and descend on the floor with a grave and melancholy air. "Do I dream?" cried Manfred returning, "or are the devils themselves in league against me? Speak, infernal specter! Or, if thou art my grandsire, why dost thou too conspire against thy wretched descendant, who too dearly pays for"—Ere he could finish the sentence the vision sighed again, and made a sign to Manfred to follow him. "Lead on!" cried Manfred; "I will follow thee to the gulf of perdition."

14. William Blake, *Ancient of Days*, 1794
Gardner, p. 856, ill. 20:48; Janson, p. 643, ill. 877

William Blake, *Songs of Innocence:* "The Chimney Sweeper," 1789
William Blake, *Europe: A Prophecy,* "Finite Revolutions," 1794

In the later part of the eighteenth century, the classical order came under an increasing number of attacks. Romanticism elevated the emphasis on individualism into subjectivism. Rejecting rationalism, it exalted emotion as the source of truth and as the basis of belief.

In England, the poet and painter William Blake (1757–1827) identified the unconscious as the source of true art and made sincerity the most important test of artistic value. An engraver by training, Blake found the mechanical work of his trade to be completely uncongenial to his temperament. He turned instead to writing poetry and designing richly colored illustrations in response both to his visionary faith and to his political ideals.

Two selections from the poems of Blake are presented here. The first selection, "The Chimney Sweeper," is from *Songs of Innocence* (1789). In this poem, a suffering child is granted a vision of the bliss that awaits him and his friend in heaven, and an angel appears to set the souls of sufferers free.

The second selection, "Finite Revolutions," is from *Europe: A Prophecy* (1794). In this poem, Blake uses the image of a serpent to represent the transformation of the human imagination by the materialistic science of Locke and Newton. Blake also describes the material universe as dominated by a dark power, which he calls Urizen. Urizen, who stands for the deadening power of reason, is represented by Blake as the creator in *Ancient of Days,* the frontispiece of *Europe: A Prophecy.* The print shows Blake's visual style which relies upon line and gesture and evokes Blake's spirituality.

Blake died in 1827. His life had been a financial failure; his poetry was regarded by the general public as obscure; and his art was treated by most critics with scorn. Yet he was deeply admired by his friends and associates as a person without guile or material desire. He had led a life that rejected the skepticism made fashionable by rationalism, and his spirit had triumphed over the cynicism and materialism of his age.

William Blake, *Songs of Innocence*[1]
The Chimney Sweeper

When my mother died I was very young,
And my Father sold me while yet my tongue
Could scarcely cry " 'weep! 'weep! 'weep! 'weep!' "
So your chimneys I sweep, & in soot I sleep.

There's little Tom Dacre, who cried when his head,
That curl'd like a lamb's back, was shav'd: so I said
"Hush, Tom! never mind it, for when your head's bare
"You know that the soot cannot spoil your white hair."

And so he was quiet & that very night
As Tom was a-sleeping, he had such a sight!
That thousands of sweepers, Dick, Joe, Ned & Jack,
Were all of them lock'd up in coffins of black.

1. Reprinted from *Blake: Complete Writings,* ed. by Geoffrey Keynes (London: Oxford University Press, 1969), pp. 117–18.

And by came an Angel who had a bright key,
And he open'd the coffins & set them all free;
Then down a green plain leaping, laughing, they run,
And wash in a river, and shine in the Sun.

Then naked & white, all their bags left behind,
They rise upon clouds and sport in the wind;
And the Angel told Tom, if he'd be a good boy,
He'd have God for his father, & never want joy.

And so Tom awoke; and we rose in the dark,
And got with our bags & our brushes to work.
Tho' the morning was cold, Tom was happy & warm;
So if all do their duty they need not fear harm.

William Blake, *Europe: A Prophecy*[2]
Finite Revolutions

In thoughts perturb'd they rose from the bright ruins, silent following
The fiery King, who sought his ancient temple, serpent-form'd,
That stretches out its shady length along the Island white.
Round him roll'd his cloud of war; silent the Angel went
Along the infinite shores of the Thames[3] to golden Verulam.[4]
There stand the venerable porches that high-towering rear
Their oak-surrounded pillars, form'd of massy stones, uncut
With tool, stones precious, such eternal in the heavens,
Of colours twelve, few known on earth, give light in the opake,
Plac'd in the order of the stars, when the five senses whelm'd
In deluge o'er the earth-born man; then turn'd the fluxile[5] eyes
Into two stationary orbs,[6] concentrating all things:
The ever-varying spiral ascents to the heavens of heavens
Were bended downward, and the nostrils' golden gates shut,
Turn'd outward, barr'd and petrify'd against the infinity.

Thought chang'd the infinite to a serpent, that which pitieth
To a devouring flame; and man fled from its face and hid
In forests of night: then all the eternal forests were divided

2. Reprinted from *Blake: Complete Writings,* ed. by Geoffrey Keynes (London: Oxford University Press, 1969), pp. 241–42.
3. The principal river of England.
4. A Roman town in Britain about 20 miles northwest of London.
5. Moving, active.
6. Eye or eyeball.

Into earths rolling in circles of space, that like an ocean rush'd
And overwhelmed all except this finite wall of flesh.
Then was the serpent temple form'd, image of infinite
Shut up in finite revolutions, and man became an Angel,
Heaven a mighty circle turned, God a tyrant crown'd.
Now arriv'd the ancient Guardian at the southern porch
That planted thick with trees of blackest leaf & in a vale
Obscure enclos'd the Stone of Night; oblique it stood, o'erhung
With purple flowers and berries red, image of that sweet south

Once open to the heavens, and elevated on the human neck,
Now overgrown with hair and cover'd with a stony roof.
Downward 'tis sunk beneath th' attractive north, that round the feet,
A raging whirlpool, draws the dizzy enquirer to his grave.

Nineteenth-Century Art

1. Théodore Géricault, *Mounted Officer of the Imperial Guard,* **1812**
Janson, p. 633, ill. 860

Napoleon, *Memoirs:* "Save the General," 1815–21

In Europe, the beginning of the nineteenth century was marked by the dramatic rise to power of Napoleon Bonaparte (1769–1821). By the age of thirty, the Corsican-born Napoleon had demonstrated his brilliance as a military general. In 1799 he was named first consul[1] of the French republic; in 1804 he was crowned emperor.

The essence of Napoleon's domestic policy was to use dictatorial powers to maintain order and to put an end to civil strife. To restore social stability after a decade of revolution, Napoleon efficiently reorganized France's laws, finances, bureaucracy, and churches. At the same time, he suppressed freedom of speech, undermined democratic elections, reinstituted black slavery in French colonies, organized a secret police system, and imprisoned thousands of citizens whom he suspected of political subversiveness.

The essence of Napoleon's foreign policy was to expand French domination across Europe. Napoleon saw himself as the successor of Charlemagne, the ninth-century emperor who ruled more European territory than has any subsequent head of state. Napoleon's so-called Grand Empire, which included France, Belgium, Holland, much of Germany, and northern Italy, had a considerable impact upon the European peoples. In the areas under his control, Napoleon did more than impose heavy taxes to support his armies. He also introduced the French penal code, abolished feudal dues, and outlawed serfdom.

In 1812 Napoleon embarked upon a Russian campaign. The devastating loss of nearly half a million men in Russia contributed to Napoleon's defeat, in 1814, by the

1. The supreme magistrate of the First Republic during the period 1799–1804.

allied powers of Russia, Prussia, Austria, and Great Britain. Napoleon was forced to abdicate and was exiled to the island of Elba, near his native Corsica. But, after escaping only one year later, Napoleon rallied a new army and once again plunged Europe into war. The battle of Waterloo, in 1815, ended with another French defeat and another sentence of exile for Napoleon.

This time, the allies prudently deposited Napoleon on the distant island of Saint Helena in the South Atlantic. There he spent the rest of his life writing his memoirs. Using them to cast himself as a tragic hero in a moral drama, Napoleon depicted himself as a lawgiver devoted to liberty and equality, and as the savior of the French Revolution. Napoleon also attributed to himself the qualities of immense personal courage and reckless bravery, which would be elaborated into legend.

The image fashioned by Napoleon emerges in his description of his victory at the battle of Arcole[2] during the Italian campaign of 1796–97. Napoleon was in danger of losing his life as he led his small, tired contingent of troops against a much larger Austrian army. Never modest, Napoleon refers to himself as "the general" and recounts how he inspired his hard-pressed troops by his own example of courage. A selection from the *Memoirs*, "Save the General," is presented here.

The furious courage that Napoleon displayed in battle is suggested by the painting *Mounted Officer of the Imperial Guard* (1812), executed by Théodore Géricault. Géricault (1791–1824) was only twenty-one years old when he exhibited this painting at the French Salon in Paris. Having spent his childhood and adolescence in Napoleonic France, Géricault shared the admiration of his generation for military success and the willingness of the French people to glorify the cavalier who shared in the Napoleonic adventures.

Napoleon, *Memoirs*[3]
Save the General

The operations [of Alvinzi, general of the Austrian forces] were crowned with the most brilliant success [in Italy]. . . . [At Arcole], the fires of the bivouacs[4] and the reports of spies and prisoners left no doubt respecting Alvinzi's intentions: he meant to receive the battle and had fixed himself firmly in these fine positions, resting his left on the marsh of Arcole, and his right on Mount Olivetto and the village of Colognola. This position is good in both directions. He had covered himself by some redoubts and formidable batteries. At daybreak the enemy's line was perceived: his left was impregnable; his right seemed ill supported. . . . The enemy, now apprised of their error, immediately rectified their position; and it was no longer possible to attack them with any hope of success. In the meantime the whole line engaged, and the fire was

2. A town in northern Italy.
3. Reprinted, by permission of the publishers, from *Napoleon's Memoirs,* ed. by Somerset de Chair (New York: Howard Fertig, 1988), pp. 114–19. Copyright by Howard Fertig.
4. Military encampments made of tents or improvised shelters and usually unprotected from enemy fire.

maintained throughout the day. The rain fell in torrents; the ground was so completely soaked that the French artillery could make no movement, while that of the Austrians, being in position and advantageously placed, produced its full effect. . . .

It [was] of the utmost importance to gain possession of Arcole, for, by debouching[5] thence on the enemy's rear, we should have seized the bridge of Villa-Nuova over the Alpon, which was his only retreat, and established ourselves there before it could be occupied against us; but Arcole withstood several attacks. I determined to try a last effort in person; I seized a flag, rushed on the bridge, and there planted it; the column I commanded had reached the middle of the bridge, when the flanking fire and the arrival of a division of the enemy frustrated the attack; the grenadiers at the head of the column, finding themselves abandoned by the rear, hesitated, but being hurried away in the flight, they persisted in keeping possession of their General;[6] they seized me by my arms and by my clothes, and dragged me along with them amidst the dead, the dying, and the smoke; I was precipitated into a morass, in which I sunk up to the middle, surrounded by the enemy. The grenadiers perceived that their General was in danger; a cry was heard of "Forward, soldiers, to save the General!" These brave men immediately turned back, ran upon the enemy, drove him beyond the bridge, and I was saved. This was the day of military devotedness. Lannes, who had been wounded at Governolo, had hastened from Milan; he was still suffering; he threw himself between the enemy and myself, covering me with his body, and received three wounds, determined never to abandon me. Muiron, my aide-de-camp, was killed in covering his General with his own body. Heroic and affecting death! Belliard and Vignolles were wounded in rallying the troops forward. The brave General Robert was killed; he was a soldier who never shrunk from the enemy's fire.

2. Francisco José de Goya y Lucientes, *The Third of May, 1808,* 1814
Gardner, p. 887, ill. 21:26; Janson, p. 631, ill. 857

Manuel José Quintana, *Ode to Spain—After the Revolution of March:* "The Tyrants Are No More," c. 1815

On May 5, 1808, Napoleon forced Ferdinand VII (lived 1784–1833; reigned 1808, 1813–33), the monarch of Spain and the son of the ex-king Charles IV (lived 1748–

5. Marching out from a narrow or confined place into open country.
6. General was the term by which Napoleon referred to himself.

1819; reigned 1788–1808) to abdicate in favor of his father; the French emperor then forced Charles to abdicate in favor of himself. In exchange for cooperation by the Spanish royal family, Napoleon promised that Spain would remain Catholic and independent, albeit under a ruler whom he would name. Napoleon then chose his brother, Joseph Bonaparte (lived 1768–1844; king of Spain 1808–13).

The regime of the new Corsican monarch was an arbitrary imposition of French arms upon Spain. Once in power, the Bonapartist administration tried to enact a series of reforms, including reorganizing legal and administrative systems, abolishing the Inquisition, and bringing the church under closer state regulation. Yet, for much of the country, these were mere paper reforms that could not be put into effect because of the war that raged during the years of French domination. The reaction of the Spanish people to French domination resulted in the great revolt of May 1808—the broadest popular uprising anywhere in Europe during that era. The bloody rebellion, known as the Spanish War of Independence (1808–1813), began in Madrid and spread throughout the country within a few weeks. The whole experience was incomprehensible to Napoleon, for nothing comparable had happened in any other area occupied by French troops.

The Spanish cause drew its strength not from the maneuvering of the field armies but from the popular resistance of all classes. French occupation policy was harsh, and savage reprisals were exacted in areas in which rebellion flared. Whole towns were sacked. Riot and rape by the French soldiers were common. Thousands of civilians were shot in a futile effort to weaken the popular resolve. But the suffering and heroics of the Spanish resistance became an inspiration to other peoples held under Napoleonic imperialism. The struggle that Napoleon had begun in an optimistic bid to control the Iberian peninsula of Portugal and Spain proved to be a costly mistake. Not only did it result in savage conflict and in massive devastation in Spain, but it also contributed heavily to Napoleon's eventual downfall.

The struggle for independence against the French invaders was joined by the writers and artists of Spain. The poet Manuel José Quintana (1772–1856) gained national respect by writing powerful, patriotic odes that declared his opposition to French dominion in Spain. A poem by Quintana that suggests the fervor of the Spanish resistance effort is *Ode to Spain—After the Revolution of March* (c. 1815). In this composition, Quintana refers to Napoleon as the tyrant who threatens Western Europe, and he urges the Spanish people to continue their resistance. A selection from *Ode to Spain—After the Revolution of March,* "The Tyrants Are No More," is presented here.

Spanish patriotism is also evident in the art of Francisco José de Goya (1746–1828). Goya commemorated the rebellion of the people of Madrid against Napoleon's soldiers on May 2–3, 1808, in his huge canvas *The Third of May, 1808.* In this painting no trace remains of the graceful style that had once made him portraitist to the royal and aristocratic circles of pre-Napoleonic Spain. Instead, the artist depicts the scene with harsh colors and lights that convey the brutality of the French slaughter of the nameless Spanish victims.

After the restoration of Ferdinand VII to the Spanish throne, Goya painted several portraits of the monarch. However, the rule of Ferdinand became so oppressive that Goya spent the last years of his life in voluntary exile in France.

Manuel José Quintana,
Ode to Spain—After the Revolution of March[1]
The Tyrants Are No More

The Tyrant threatening the west, exclaims:
"Behold, thou now art mine, O Western Land!"
His brow with barbarous lightning flames,
As from the cloud the summer tempest brings
The Horror spreading bolt's appalling wings.
His warriors afar
Fill the great winds with pæans of their war;
The anvils groan, the hammers fall.
The forges blaze. O shame, and dost thou dream
To make their swords their toil, and that is all?
See'st thou not where within their fiery gleams
'Tis chains and bars and shackles they prepare
To bind the arms that lie so limp and bare?
Yea, let Spain tremble at the sound,
And let her outrage ire
From the volcano of her bosom bound,
High justice for its fire,
And 'gainst her despots turn,
Where in their dread they hide,
And let the echoes learn
And all the banks of Tagus[2] wide
Hear the great sound of rage outcried,—
"Vengeance!"—Where, sacred river, where
The titans[3] who with pride and wrong
Opposed our weal[4] so long?
Their glories are no more, while ours prepare;
And thou so fierce and proud

1. Reprinted, by permission of the publisher, from *Hispanic Anthology,* ed. and trans. by Thomas Walsh (New York: G. P. Putnam's Sons, 1920), pp. 381–83. Copyright by The Hispanic Society of America.
2. A river in southwest Europe, flowing west through central Spain and Portugal to the Atlantic.
3. Persons of enormous strength, power, and influence; in this case, the French occupation army and politicians.
4. The national state.

Seeing Castile and thy Castilians there
Urgest thy ruddy waves in seaward pour,
Crying aloud:—"The tyrants are no more!"

3. Joseph Paxton, Crystal Palace, London, 1850–51
Gardner, p. 946, ill. 21:95; Janson, p. 680, ill. 938

*Report of the Parliamentary Committee on the Bill to Regulate the Labor
of Children in Mills and Factories:* "Evidence of a Female Millhand" and
"Evidence of a Male Millhand," 1832

At about the time the French Revolution was opening a new political era, another revolution was transforming economic and social life. This was the industrial revolution, which began in Europe in the 1780s and subsequently spread around the world.

The industrial revolution can be characterized by the substitution of steam power for the power of water, wind, and animal and human exertion; by the use of many labor-saving machines that greatly increased productivity; and by the employment of workers in factories rather than in their homes. Technological innovations in industry, such as the invention of the steam engine, necessitated the building of factories, the improvement of transportation systems to carry raw materials and finished goods to and from the factories, and the raising of capital to finance these projects. This in turn led to a whole new system of production and social relationships.

England was the leader of the industrial revolution for several reasons. Its colonial empire and prosperous internal economy provided a growing market for English manufactured goods. Its effective central bank and well-developed credit markets provided capital for development, while a stable and predictable government encouraged economic investment. In addition, England's expanding population both created an insatiable demand for manufactured goods and provided a potential industrial labor force for capitalist entrepreneurs.

The world's first factories were created for the English textile industry. Although other industries developed more slowly than did textile manufacture, few did not profit by the invention of power-driven machines and better tools. Architecture, for instance, was dramatically changed by the standardization and prefabrication of iron and of sheet glass. One of the most dramatic examples of the impact of industrialism on construction can be seen in the Crystal Palace.

Designed by Joseph Paxton (1801–1865), the Crystal Palace was built in London to house the Great Exposition of 1851.[1] Paxton, a gardener turned architect, based

1. An exhibition of industrial and artistic products designed to promote trade, display technological innovations, and reflect cultural developments. Held in London, the Great Exposition was the first exhibition to be international in scope.

his design on an iron and glass conservatory he had built for the Duke of Devonshire. Because it was largely prefabricated, the enormous structure was built in record time, a technological feat greatly appreciated by contemporary observers.

While some sectors of the population enjoyed and benefited from technological advances such as the building of the Crystal Palace, many did not. Those who worked in the factories faced dismal conditions; the buildings were hot and damp, ventilation was poor, and sanitation was primitive. Women and children made up a large part of the labor force; their workday began at dawn six days a week and continued until dark.

The problems created by industrialization produced demands that the government intervene and correct the worst abuses of unregulated capitalism. Reformers persuaded Parliament at intervals to appoint committees to hear testimony on the working conditions of children and, if necessary, to propose remedial legislation. An early attempt to pass protective legislation resulted in an act in 1819 that forbade all employment, although in cotton mills only, of children under the age of nine, and that limited the workday to twelve hours for children between the ages of nine and sixteen.

The next legislative act regulating child employment in factories was passed in 1833. Although opposition from the manufacturing interests was intense, the evidence that Parliamentary committees gathered from over eighty-nine witnesses, about half of whom were factory workers, supported the case for reform. The Factory Act of 1833 prohibited the employment in all industries of children under nine years of age and limited the workday to ten hours, Monday through Friday, and to eight hours on Saturday for children between nine and thirteen years of age.

Children and juveniles employed in textile mills had now been given some measure of protection in their working lives, but there were great numbers of juvenile workers employed in other jobs under appalling circumstances. Faced with greater public concern in the 1840s, Parliament passed increasingly strict bills to redress the glaring evils in the treatment of child workers, although it was not until 1847 that a ten-hour day for all workers under the age of eighteen was enacted. Two selections from the *Report of the Parliamentary Committee on the Bill to Regulate the Labor of Children in Mills and Factories* (1832) are presented here.

Report of the Parliamentary Committee on the Bill to Regulate the Labor of Children in Mills and Factories[2]
Evidence of a Female Millhand

Elizabeth Bentley, age 23, lives at Leeds,[3] began work at the age of six in Mr. Busk's flax-mill,[4] as a little doffer.[5] Hours 5 A.M. till 9 P.M. when they were

2. *British Parliamentary Papers,* 1831–32, vol. 15, pp. 195–99. Reprinted in John Carey, ed., *Eyewitness to History* (Cambridge, Mass.: Harvard University Press, 1988), pp. 295–98.
3. A city in central Yorkshire, in northern England.
4. A factory for spinning and weaving linen thread and cloth.
5. A textile worker who removes the bobbins or spindles when filled with finished spun thread to make room for empty ones.

"thronged,"[6] otherwise 6 A.M. to 7 at night, with 40 minutes for meal at noon.

Do you consider doffing a laborious employment? Explain what you had to do.—When the frames are full, they have to stop the frames, and take the flyers off, and take the full bobbins off, and carry them to the roller; and then put empty ones on, and set the frame going again.

Does that keep you constantly on your feet?—Yes, there are so many frames, and they run so quick. Your labor is very excessive?—Yes; you have not time for anything. Suppose you flagged[7] a little, or were too late, what would they do?—Strap[8] us. Girls as well as boys?—Yes. Have you ever been strapped?—Yes. Severely?—Yes.

Were the girls so struck as to leave marks upon their skin?—Yes, they have had black marks many a time, and their parents dare not come to him about it, they were afraid of losing their work. If the parents were to complain of this excessive ill-usage, the probable consequence would be the loss of the situation of the child?—Yes.

In what part of the mill did you work?—In the card-room. It was exceedingly dusty?—Yes. Did it affect your health?—Yes; it was so dusty, the dust got upon my lungs, and the work was so hard: I was middling strong[9] when I went there, but the work was so bad; I got so bad in health, that when I pulled the baskets down, I pulled my bones out of their places.

You dragged the baskets?—Yes, down the rooms to where they worked. And so you had been weakened by excessive labor, you could not stand that labor?—No. It has had the effect of pulling your shoulders out?—Yes, it was a great basket that stood higher than this table a good deal. It was a very large one, that was full of weights up-heaped, and pulling the basket pulled my shoulders out of its place, and my ribs have grown over it.—You are considerably deformed in your person in consequence of this labor?—Yes, I am.

At what time did it arise?—I was about 13 years old when it began coming, and it has got worse since; it is five years since my mother died, and my mother was never able to get me a pair of good stays[10] to hold me up, and when my mother died I had to do for myself, and got me a pair.

Were you perfectly straight and healthy before you worked in a mill?—Yes, I was as straight a little girl as ever went up and down to work. . . .

Where are you now?—In the poorhouse,[11] at Hunslet.

6. Overwhelmed with work.
7. Became tired.
8. To beat or strap with a narrow strip of leather.
9. Of medium strength.
10. Braces to support the body.
11. An institution in which paupers are maintained at public expense.

Did you receive anything from your employers when you became afflicted?—When I was at home Mr Walker made me a present of 1s or 2s[12] but since I have left my work and gone to the poorhouse, they have not come nigh[13] me.

You are utterly incapable now of any exertion of that sort?—Yes. You were very willing to have worked as long as you were able, from your earliest age?—Yes. And to have supported your widowed mother as long as you could?—Yes. State what you think as to the circumstances in which you have been placed during all this time of labor, and what you have considered about it as to the hardship and cruelty of it.

(The witness was too much affected to answer the question.)

Report of the Parliamentary Committee on the Bill to Regulate the Labor of Children in Mills and Factories[14]
Evidence of a Male Millhand

Joseph Hebergam, Called in and Examined

Where do you reside?—At North Great Huddersfield, in Yorkshire.[15]

What age are you?—I was 17 on the 21st of April.

Are your father and mother living?—No; I have been without a father six years on the 8th of August.

Your mother survives?—Yes.

Have you worked in factories?—Yes.

At what age did you commence?—Seven years of age.

At whose mill?—George Addison's, Bradley Mill, near Huddersfield.

What was the employment?—Worsted-spinning.[16]

What were your hours of labor at that mill?—From 5 in the morning till 8 at night.

What intervals had you for refreshment and rest?—Thirty minutes at noon.

Had you no time for breakfast or refreshment in the afternoon?—No, not one minute; we had to eat our meals as we could; standing or otherwise.

You had fourteen and a half hours of actual labor at 7 years of age?—Yes.

12. 1 shilling or 2 shillings. A shilling is a cupronickel coin worth the twentieth part of a pound in English currency; equal to 12 pence or 12 pennies.
13. Near.
14. British Parliamentary Papers, vol. 15, pp. 157–59, 163–64. Reprinted in Brian L. Blakeley and Jacquelin Collins, eds., *Documents in English History: Early Times to Present* (New York: John Wiley and Sons, 1975), pp. 323–26.
15. A county in northern England.
16. The manufacture of woolen cloth.

What wages had you at that time?—Two shillings and six pence a week.

What means were taken to keep you at your work so long?—There were three overlookers; there was a head overlooker, and then there was one man kept to grease the machines, and then there was one kept on purpose to strap.

Was the main business of one of the overlookers that of strapping the children up to this excessive labor?—Yes, the same as strapping an old restive horse that has fallen down and will not get up.

Was that the constant practice?—Yes, day by day.

Were the straps regularly provided for that purpose?—Yes, he is continually walking up and down with it in his hand.

Where is your brother John working now?—He died three years ago.

What age was he when he died?—Sixteen years and eight months.

To what was his death attributed by your mother and the medical attendants?—It was attributed to this, that he died from working such long hours, and that it had been brought on by the factory. They have to stop the flies[17] with their knees because they go so swift they cannot stop them with their hands; he got a bruise on the shin by a spindle-board,[18] and it went on to the degree that it burst; the surgeon cured that, then he was better; then he went to work again; but when he had worked about two months more his spine became affected, and he died.

What effect had this labor upon your own health?—It had a great deal; I have had to drop it several times in the year.

How long was it before the labor took effect on your health?—Half a year.

And did it at length begin to affect your limbs?—When I had worked about half a year, a weakness fell into my knees and ankles; it continued, and it has got worse and worse.

How far did you live from the mill?—A good mile.

Was it very painful for you to move?—Yes, in the morning I could scarcely walk, and my brother and sister used out of kindness to take me under each arm, and run with me to the mill, and my legs dragged on the ground in consequence of the pain; I could not walk.

Were you sometimes too late?—Yes, and if we were five minutes too late, the overlooker would take a strap, and beat us till we were black and blue.

The overlooker nevertheless knew the occasion of your being a little too late?—Yes.

Did you state to him the reason?—Yes, he never minded that; and he used to watch us out of the windows.

Did the pain and weakness in your legs increase?—Yes.

17. The spindles.
18. A slender round rod, tapering toward each end, which is made to revolve and twist fiber into thread.

Just show the Committee the situation in which your limbs are now.—
[*The Witness accordingly stood up, and showed his limbs.*]

4. Joseph Mallord William Turner, *The Slave Ship,* **1840**
Gardner, p. 884, ill. 21:23; Janson, p. 645, ill. 881

Thomas Folwell Buxton, *The African Slave Trade and Its Remedy:* "This
Inhuman Proposal," 1839

In the nineteenth century, Great Britain held the foremost position not only in the
industrial revolution but also in the Atlantic slave trade. Although certainly not the
cause of slavery, the industrial revolution undoubtedly fueled the slave trade. Europe,
especially Britain, exported manufactured wares to Africa, and also accrued wealth
from the slave-produced agricultural staples of the Americas and the West Indies. It
is estimated that more than ten million Africans were brought to the Americas to
provide the manual labor necessary for plantation agriculture. Slave merchants pros-
pered, and their trade stimulated shipbuilding, marine insurance, and other financial
enterprises.

Although others took part in the commerce, the English became the most
significant importers of slaves in the eighteenth and early nineteenth centuries. Ships
would sail from Britain to the Gulf of Guinea, a region in Africa which became known
as the Slave Coast. There they would exchange manufactured goods for slaves. The
ships would then sail toward the West Indies or the American continents. This
tortuous leg of the trip was the slave trade proper. Individuals taken as slaves were
closely packed in the ship hull to save space, and were often chained in order to avoid
rebellion or to prevent deliberately suicidal plunges into the sea. Food was inade-
quate, water scarce, and there was little or no ventilation or sanitary installations.
Those who survived this journey were either directly delivered to their buyers or, more
often, kept in stockades to await a purchaser. After delivering their human cargo, the
ships sailed homeward, laden with products from the American plantations. If all
went well, the profit was enormous.

The anti-slavery movement in Great Britain began in the second half of the
seventeenth century, principally through the efforts of the Society of Friends, or
Quakers. However, it was not until after the Napoleonic wars, in 1814, that an active
fight against the slave trade began. One of the important leaders in the campaign to
abolish the institution of slavery and the slave trade was Thomas Folwell Buxton
(1786–1845). Raised by a Quaker mother, Buxton entered Parliament in 1818 at the
age of thirty-two, and four years later was asked to assume leadership of the anti-
slavery crusade.

Working diligently, Buxton succeeded in passing a bill that ensured the libera-
tion of slaves in the West Indies by 1838. His immediate objective gained, he then
turned his attention to the suppression of the international slave trade.

Buxton began this phase of his anti-slavery crusade with the publication of a book, *The African Slave Trade and Its Remedy* (1839). In it he described the systematic manhunts that were undertaken in Africa and that resulted in the capture of hundreds of thousands of men, women, and children. He recounted the toll of these manhunts, not only on those enslaved, but also on those left behind—wounded, maimed, and deprived of all livelihood. He reported inhumane practices, such as the chaining and flogging of Africans and the castration of boys and young males. To make his view compelling, Buxton printed eyewitness accounts of incidents that demonstrated the cruelty inherent in the institutions of slavery and the slave trade. One such incident was the account of an English slave ship captain who, in 1783, ordered 132 slaves to be thrown alive into the sea in order to collect insurance from the loss of the human cargo; the incident is described in the selection presented here, "This Inhuman Proposal."

Among the many who read Buxton's book was Joseph Mallord William Turner (1775–1851). The shocking revelations inspired Turner to paint *The Slave Ship* (1840), which illustrates the incident of 1783. By the turbulence of his brush stroke, the dissonance of his color, and the violent activity of his composition, Turner conveyed his belief that the cosmos itself rose in revulsion against the barbarity of the slave trade.

Thomas Folwell Buxton, *The African Slave Trade and Its Remedy*[1]
This Inhuman Proposal

The circumstance of this case could not fail to excite a deep interest. The master of a slave-ship trading from Africa to Jamaica, and having 440 slaves on board, had thought fit, on a pretext that he might be distressed on his voyage for want of water, to lessen the consumption of it in the vessel, by throwing overboard 132 of the most sickly among the slaves. On his return to England, the owners of the ship claimed from the insurers the full value of those drowned slaves, on the ground that there was an absolute necessity for throwing them into the sea, in order to save the remaining crew, and the ship itself. The underwriters contested the existence of the alleged necessity; or, if it had existed, attributed it to the ignorance and improper conduct of the master of the vessel. This contest of pecuniary interest brought to light a scene of horrid brutality which had been acted during the execution of a detestable plot. From the trial it appeared that the ship Zong, Luke Collingwood master, sailed from the island of St. Thomas on the coast of Africa, September 6, 1781, with 440 slaves and fourteen whites on board, for

1. Reprinted from Thomas Folwell Buxton, *The African Slave Trade and Its Remedy* (London: Frank Cass, 1967), pp. 130–32.

Jamaica, and that in the November following she fell in with that island; but instead of proceeding to some port, the master, mistaking, as he alleges, Jamaica for Hispaniola, ran her to leeward. Sickness and mortality had by this time taken place on board the crowded vessel: so that, between the time of leaving the coast of Africa and the 29th of November, sixty slaves and seven white people had died; and a great number of the surviving slaves were then sick and not likely to live. On that day the master of the ship called together a few of the officers, and stated to them that, if the sick slaves died a natural death, the loss would fall on the owners of the ship; but, if they were thrown alive into the sea, on any sufficient pretext of necessity for the safety of the ship, it would be the loss of the underwriters, alleging, at the same time, that it would be less cruel to throw sick wretches into the sea, than to suffer them to linger out a few days under the disorder with which they were afflicted.

To this inhuman proposal the mate, James Kelsal, at first objected; but Collingwood at length prevailed on the crew to listen to it. He then chose out from the cargo 132 slaves, and brought them on deck, all or most of whom were sickly, and not likely to recover, and he ordered the crew by turns to throw them into the sea. "A parcel" of them were accordingly thrown overboard, and, on counting over the remainder the next morning, it appeared that the number so drowned had been fifty-four. He then ordered another parcel to be thrown over, which, on a second count on the succeeding day, was proved to have amounted to forty-two.

On the third day the remaining thirty-six were brought on deck, and, as these now resisted the cruel purpose of their masters, the arms of twenty-six were fettered with irons, and the savage crew proceeded with the diabolical work, casting them down to join their comrades of the former days. Outraged misery could endure no longer; the ten last victims sprang disdainfully from the grasp of their tyrants, defied their power, and leaping into the sea, felt a momentary triumph in the embrace of death.

5. John Constable, *The Haywain,* 1821
Gardner, p. 890, ill. 21:30

John Constable, *Stoke-by-Nayland,* 1836
Janson, p. 645, ill. 880

William Wordsworth, *Lines Composed a Few Miles Above Tintern Abbey:* "To Look on Nature," 1798

A profound current of humanitarianism surfaced in the nineteenth century. The humanitarian impulses in Europe and the United States can be largely attributed to a heightened sense of the cruelty inflicted upon others. Because people were moved by the misery of pauper children, of women in the mines, and of black slaves, reformers were able to marshal public opinion and to effect improvements in the conditions in prisons, hospitals, insane asylums, and orphanages. The sense of the inviolability of the human person became the foundation of social and political campaigns to relieve the sufferings of humanity.

The effects of the growth of modern industry dismayed not only humanitarian reformers but also artists, writers, and other intellectuals of romantic inclinations. "Romanticism" is a term used in English in the 1840s to describe a movement then half a century old. A theory of literature and the arts, Romanticism raised basic questions about the nature of significant truth, the importance of various human faculties, the relationship between thought and feeling, and the meaning of the past and of time itself. By proclaiming a new way of perceiving and expressing human experience, the Romantics found an alternative to the bleakness of industrialism and the despair of poverty and vice.

Possibly the most fundamental Romantic attitude was the insistence on the value of feeling as well as of reason. Acutely aware of the importance of the subconscious, the Romantics were fascinated by the mysterious, the unknown, the exotic, and the forbidden. Among the hallmarks of Romanticism were the appreciation of nature and the belief that this appreciation, when coupled with the use of imagination and the exercise of emotion, could become a means to pass beyond the bounds of humanity and into the realm of the infinite.

Britain was the first country where Romanticism flowered fully in poetry and prose, and the writer William Wordsworth (1770–1850) was its leading proponent. As a young man Wordsworth had been thrown into turmoil in part because of his personal uncertainties about his vocation and livelihood and in part because of his disillusionment with the political events of the French Revolution. After much unhappiness, the writer was able to find renewal by imbuing his senses with the pastoral beauty of the English countryside. The tranquil meditation afforded him by rural scenes gave Wordsworth his best moments of poetic vision.

Wordsworth described his recovery in the lyrical poem *Lines Composed a Few Miles Above Tintern Abbey, on Revisiting the Banks of the Wye During a Tour* (1798). In the poem, Wordsworth makes an easy transition from an accurate description of the landscape to a feeling of deep spiritual understanding. A selection from the poem, "To Look on Nature," is presented here.

The interplay among the divine, the human, and the natural worlds, which profoundly touched Wordsworth, was also deeply felt by John Constable (1776–1837). Constable's approach to painting was inspired by an approach to nature similar to that of Wordsworth. Both regarded every form in nature as a facet of a single, underlying spirit. This meant that study and understanding of even the simplest natural phenomenon could reveal the unity to which it belonged. Thus, the

naturalism of Constable goes beyond the record of what the eye sees, to a love and understanding achieved by intense contemplation.

Born in the countryside, Constable chose subjects throughout his career that had the pastoralism of the scenes from his childhood. In his sketches of familiar places he achieved natural color and rich atmospheric qualities, as in *The Haywain* (1821), a scene from the banks of the River Stour painted in a serene period of Constable's life. He painted *Stoke-by-Nayland* (1836) fifteen years later, when he was struggling with depression following the death of his wife; the serenity of his earlier painting has here given way to a more agitated view of the landscape.

William Wordsworth,
Lines Composed a Few Miles Above Tintern Abbey, on Revisiting the Banks of the Wye During a Tour[1]
To Look on Nature

Five years have passed; five summers, with the length
Of five long winters! and again I hear
These waters, rolling from their mountain-springs
With a soft inland murmur.—Once again
Do I behold these steep and lofty cliffs,
That on a wild secluded scene impress
Thoughts of more deep seclusion; and connect
The landscape with the quiet of the sky.
The day is come when I again repose
Here, under this dark sycamore, and view
These plots of cottage-ground, these orchard-tufts,
Which at this season, with their unripe fruits,
Are clad in one green hue, and lose themselves
'Mid groves[2] and copses.[3] Once again I see
These hedge-rows,[4] hardly hedge-rows, little lines
Of sportive[5] wood run wild: these pastoral farms,
Green to the very door; and wreaths of smoke
Sent up, in silence, from among the trees!
With some uncertain notice, as might seem
Of vagrant dwellers in the houseless woods,
Or of some Hermit's cave, where by his fire

1. Reprinted in *The Complete Poetical Works of William Wordsworth* (London: Macmillan, 1930), pp. 93–94.
2. Small wooded or forested areas.
3. Thickets of small trees or bushes.
4. Rows of bushes or trees forming hedges.
5. Playful or frolicsome.

The Hermit sits alone.
 These beauteous forms,
Through a long absence, have not been to me
As is a landscape to a blind man's eye:
But oft, in lonely rooms, and 'mid the din
Of towns and cities, I have owed to them
In hours of weariness, sensations sweet,
Felt in the blood and felt along the heart;
And passing even into my purer mind,
With tranquil restoration:—feelings too
Of unremembered pleasure: such, perhaps,
As have no slight or trivial influence
On that best portion of a good man's life,
His little, nameless, unremembered, acts
Of kindness and of love. Nor less, I trust,
To them I may have owed another gift,
Of aspect more sublime; that blessed mood,
In which the burthen of the mystery,
In which the heavy and the weary weight
Of all this unintelligible world,
Is lightened:—that serene and blessed mood,
In which the affections gently lead us on,—
Until, the breath of this corporeal frame
And even the motion of our human blood
Almost suspended, we are laid asleep
In body, and become a living soul:
While with an eye made quiet by the power
Of harmony, and the deep power of joy,
We see into the life of things. . . .
 For I have learned
To look on nature, not as in the hour
Of thoughtless youth; but hearing often-times
The still, sad music of humanity,
Nor harsh or grating, though of ample power
To chasten and subdue. And I have felt
A presence that disturbs me with joy
Of elevated thoughts; a sense sublime
Of something far more deeply interfused.
Whose dwelling is the light of setting suns,
And the round ocean and the living air,

And the blue sky, and in the mind of man;
A motion and a spirit, that impels
All thinking things, all objects of all thought,
And rolls through all things. Therefore am I still
A lover of the meadows and the woods,
And mountains; and of all that we behold
From this green earth; of all the mighty world
Of eye, and ear,—both what they half create,
And what perceive; well pleased to recognise
In nature and the language of the sense,
The anchor of my purest thoughts, the nurse,
The guide, the guardian of my heart, and soul
Of all my moral being.

6. Eugène Delacroix, *The Massacre of Chios*, 1822–24
Janson, p. 636, ill. 866

George Gordon Byron, "Song to the Suliotes," 1824

At the same time that the classic tenets of literature and art were being challenged by Romanticism, European conservatism was being battered by liberal, national, and socialist forces. Beginning in 1820 and lasting for a century, popular revolts, rebellions, and revolutions stirred the Western world. These struggles were staged in France, Germany, Italy, Holland, Flanders, Russia, Poland, the Austrian empire, and elsewhere. One of the first arenas in which a national, liberal revolution succeeded was Greece. Since the fifteenth century, Greece had been under the domination of the Ottoman Turks. In spite of centuries of foreign rule, the Greeks had survived as a people, united by their language and the Greek Orthodox religion. Inspired by their desire for independence, the Greeks in 1821 rose up in rebellion under the leadership of a Greek patriot, Alexander Ypsilanti.

European political leaders initially refused to support the Greek revolt for fear that it would fuel rebellions within their own states. Yet for the European peoples the Greek cause became a holy crusade. The culture of ancient Greece stirred the admiration of educated persons everywhere. The atrocities committed by the Turks against contemporary Greeks fanned European and American outrage. In 1827 Turkey was forced by the European powers to sign an armistice; in 1830 Greece was recognized as an independent state.

Moved by the Romantic impulse toward rebellion, writers and artists responded enthusiastically to the populist revolt in Greece. The flamboyant English poet Lord Byron (1788–1824) went to Greece and died there in the struggle.

George Gordon Byron captured the imagination of Europe both by his deep romantic melancholy and by his extravagant behavior. Tortuous sexual relationships with his wife, his half-sister, his mistresses, and young men embroiled him in ceaseless turmoil. Longing for an opportunity to perform some noble action that would redeem him in the eyes of his countrymen, Byron sailed to Greece to aid in the struggle for independence. He worked unsparingly with patriot forces in western Greece, but died of a fever in the town of Missolonghi only nine months after his arrival.

In his final poems, written in Greece, Byron expressed both his personal yearnings for self-fulfillment and his political concern for the liberty of all peoples. The poem "Song to the Suliotes" records Byron's exhortations to the Greek soldiers whom he planned to lead in an attack.

The revolutionary sympathies of many Romantic artists is also evident in the art of the French painter Eugène Delacroix (1798–1863). The painting by Delacroix, *The Massacre of Chios* (1822–24), refers directly to the Greek war of independence. This painting depicts the ruthless massacre on the island of Chios in which the Turks slaughtered 100,000 Greeks. Two years later, Delacroix painted *Greece on the Ruins of Missolonghi* (1826). This painting is a direct reference to the town of Missolonghi, where Greek forces had turned back the Turkish army in 1822 and 1823, only to fall into Turkish hands in 1826, and an indirect reference to the place where Byron died.

George Gordon Byron
"Song to the Suliotes"[1]

1.

Up to battle! Sons of Suli[2]
Up, and do your duty duly!
There the wall—and there the Moat is:
Bouwah![3] Bouwah! Suliotes![4]
There is booty—there is Beauty,
Up my boys and do your duty

2.

By the sally and the rally
Which defied the arms of Ali;[5]

1. Reprinted from *The Works of Lord Byron, Poetry*, vol. 7, ed. by Ernest Hartley Coleridge (New York: Octagon Books, 1966), pp. 83–84.
2. Suli is a small mountainous district in northern Greece.
3. "Bouwah!" is the war cry of the Suliotes.
4. Inhabitants of Suli, the Suliotes were famous as fierce warriors. They lived in fortlike villages in the mountains and remained independent during most of the occupation of Greece by the Ottoman Turks. They fought successfully (1790–1802) against Ali Pasha, the Turkish governor. In 1803, however, Ali Pasha massacred many of them after concluding a false truce. In 1820 they rebelled again.
5. A reference to Ali Pasha (1741–1822), the Turkish pasha and ruler of Albania and part of Greece.

By your own dear native Highlands,
By your children in the islands,
Up and charge, my Stratiotes,[6]
Bouwah!—Bouwah!—Suliotes!

<div align="center">3.</div>

As our ploughshare is the Sabre:
Here's the harvest of our labor;
For behind those battered breaches
Are our foes with all their riches:
There is Glory—there is plunder—
Then away despite of thunder!

7. Eugène Delacroix, *Liberty Leading the People*, 1830
Gardner, p. 879, ill. 21:19

Victor Hugo, "Written After July 30, 1830," 1830

Charles X (lived 1757–1836; reigned 1824–30), the brother of King Louis XVI, was crowned king of France in 1824. His reign was characterized by many attempts to restore the *ancien régime,* as the pre-revolutionary order was called. These attempts culminated in 1830 with the dissolution of the elected government assembly, called the Chamber of Deputies, and with the July Ordinances. By these ordinances, Charles attempted to establish rigid control of the press, to dissolve the newly elected chamber, and to restrict suffrage.

The reaction of the people was an immediate insurrection. For three days, from July 27 through July 29, Paris roiled with revolutionary excitement. A swarming populace threw up barricades throughout the city and defied the army and police. Most of the army refused to fire upon the protestors. Amidst the disorder, Charles, who was disinclined to become a captive and martyr like his long-dead brother Louis XVI, precipitously abdicated and fled for safety to England.

The spirit of revolution and Romanticism infused the writing of the French author Victor Hugo (1802–1885). The son of a Napoleonic general, Hugo spent his childhood traveling through Europe with the imperial family. As a consequence, his writings restate the problems of his age. He integrated political and philosophical problems with the religious and social disquiet of the period. His works form an epic of the French people through a sympathetic portrayal of every social type, from the poorest orphan and street urchin to the wealthiest aristocrat.

Hugo believed that there was a link between political and social liberty and

6. A reference to the Greeks.

artistic freedom. Deeply stirred by the revolutionary struggle that overturned the July Ordinances and ended Charles's reign, Hugo composed the poem "Written After July 1830" (1830). In it he lauds the people who thronged to the barricades in defense of liberty. The poem is presented here.

The revolutionary ardor that surfaced in Hugo also inspired the French painter Eugène Delacroix (1798–1863). The son of a diplomat, Delacroix, like Hugo, was drawn to revolutionary causes both abroad and at home. In 1830 he celebrated the July Revolution with his painting *Liberty Leading the People.* In this painting, figures representing all segments of Parisian society charge into the fray of battle to defend their rights as citizens and to resist the tyranny that would vanquish liberty.

Victor Hugo
"Written After July 1830"[1]

Oh! friends of your country, immortal in story,
 Adorn'd with the laurels[2] ye won in the fight;
When thousands around you fell cover'd with glory,
 Ye turn'd not away from the enemy's might;
And ye rais'd up your banners all tatter'd and torn,
Like those that your sires had at Austerlitz[3] borne.

Ye have rivall'd those sires—ye have conquer'd for France—
 The rights of her people from tyrants are sav'd:
Ye beckon'd to Freedom—ye saw her advance—
 And danger was laugh'd at, and peril was brav'd'
Then, if you were admir'd who destory'd the Bastille,
What for you should not France in her gratitude feel.

Ye are worthy your fathers—your souls are the same,
 Ye add to their glory, their pride, and renown;
Your arms are well nerv'd—ye are noted by Fame
 That the laurel and oak[4] may unite for your crown:
Your mother—'t is France, who for ever will be
The mother of heroes, the great, and the free! . . .
Too long by tyrant hand restrain'd,
Too long in slavery enchain'd,

1. Reprinted from Victor Hugo, *Songs of Twilight,* trans. by George W. M. Reynolds (Paris: Paul Renourd, 1836), pp. 5–6, 9, 13–16.
2. The foliage of a laurel was used as a mark of distinction or honor.
3. A town in Moravia at which Napoleon I defeated Russian and Austrian armies in 1805.
4. The foliage of the laurel and oak tree were woven into wreaths of honor and were worn as crowns.

Paris awoke—and in his breast,
Each his ideas at once confest:
"Vainly may despots not essay[5]
"To lead a mighty race astray;
"True to themselves, the French shall bring
"Such treason home unto the King![6] . . ."

And France has awaken[ed] from stupor profound,
And the watch-word has rais'd all her champions around;
And the din of their weapons struck loud on the ear,
As it hearken'd the tread of the cavalry near.
But the tyrant has marshall'd his warriors in vain,
And his culverins[7] thunder'd again and again,
For the stones, that the citizens tore from the street,
Laid the cohorts of royalty dead at their feet;
And their number increas'd—for they fought to be free—
And they pour'd on the foe like the waves of the sea;
While the din of the tocsin,[8] that echo'd on high,
Was drown'd in the fervor of liberty's cry!

Three dismal days the battle rag'd—
Three weary nights the war was wag'd:
Iena's[9] lance was bath'd in gore—
The banner show'd its dyes no more!
Vainly the King might re-inforce
His arms with chosen troops of horse—
To meet a certain overthrow,
Headlong the royal squadrons go;
And as they one by one dropt dead,
They seem'd like leaves in autumn shed.

Oh! yes—they were conquer'd—but how have you vanquish'd,
 Fair city, the glory of France and the world?
Three times has the sun set, since lately you languish'd—
 You have fought—you have won—and your banners are furl'd!
And wise were your counsels succeeding the strife,
 Revenge even smil'd with the rest;

5. Try, attempt.
6. Charles X.
7. Heavy cannon.
8. A bell used as a signal of alarm.
9. Iena was the Roman divinity of war.

For Clemency bade her surrender the knife,
 Ere 't was plung'd in the enemy's breast!

Ask ye why Paris gain'd the day?—
Her choicest offspring form'd th' array
That hurl'd the tyrant from his sky,
And broke the bonds of Slavery!
Henceforth, whatever ills await,
One gen'ral feeling guards the state:
Oh! let us then the period bless,
That rais'd us up from nothingness,
And, casting off our servile chain,
Proclaim'd us freemen once again!

8. Honoré Daumier, *The Third-Class Carriage,* **c. 1862**
Gardner, p. 889, ill. 21:29; Janson, p. 638, ill. 870

Auguste Comte, *The Course of Positive Philosophy:* "The Progressive
Course of the Human Mind," 1830–42
Jules Michelet, *The People:* "The Bondage of the Factory Worker," 1846

Europe was convulsed by revolutions in 1848. From Copenhagen to Palermo and
from Paris to Budapest, governments collapsed all over the continent. But the revolu-
tions of 1848, although they shook the ruling forces of almost every European nation,
lacked basic driving strength. After achieving initial successes, they almost immedi-
ately succumbed to military repression.

While the optimism of revolutionary reformers quickly faded, one consequence
of the 1848 revolutions was long-lasting. This was the emergence of a new philosophi-
cal outlook called positivism.

Positivism originated with the French theorist August Comte (1798–1857).
Skeptical about the value of religion, Comte trusted science, instead, for insights into
the true meaning of humanity and society. According to Comte, definite scientific laws
governed the evolution of the human mind. Comte argued that in the first stage of
their development, people had given supernatural explanations for phenomena; in the
second stage, people had given metaphysical explanations for phenomena; in the
present and highest stage, people were finally prepared to give positive—that is,
scientific—explanations for phenomena.

Comte thought that the revolutions in France, both of 1789 and 1848, suffered
from an excess of metaphysical abstractions, empty words, and unverifiable high-
flying principles. Comte considered that the highest branch of science was the study
of society, for which he coined the word "sociology." He felt that those who worked

for the improvement of society had to adopt the strictly scientific outlook of sociology. This new science was to build upon observation of actual facts to develop broad scientific laws of social progress.

Comte outlined his system for achieving social betterment in *The Course of Positive Philosophy* (1830–42). A selection from it, "The Progressive Course of the Human Mind," is presented here.

Positivism became a strong influence upon many nineteenth-century intellectuals, including the French professor of history Jules Michelet (1798–1874). A childhood spent in the slums of Paris had led Michelet to recognize the serious problems that underlay the sophisticated and affluent appearance of the Parisian boulevards. Like Comte, Michelet believed that the crises of his age had to be solved through scientific study. In his book *The People* (1846), Michelet attempted to provide the sociological analysis called for by positivism.

The People is an unsurpassed portrait of nineteenth-century France and, by extension, of European society in general. In it Michelet examines the social classes of France from the lowliest workers to the most powerful and the most wealthy aristocrats. The book provides a depiction of the social change and social dislocation that peasants, workers, factory owners, officials, and all other groups of France experienced during the transition from agrarian to industrial society. Moreover, the book traces the evolution of each group over time. Finally, the book analyzes the causes of France's social dislocation and division, and offers love for family and love for country as a cure for the common ills. A selection from *The People*, "The Bondage of the Factory Worker," is presented here.

Positivism also was a strong influence upon many nineteenth-century writers and artists, including the French artist Honoré Daumier (1808–1879). An illustrator by trade, Daumier undertook a general examination of modern life. Inclined to satirize the professions of the powerful and wealthy, Daumier demonstrated great compassion for the poor. The qualities of familial love and generous spiritedness that Michelet attributed to the Parisian poor and that he praised as the source of redemption for the French nation are found by Daumier on the faces of the humble and dispossessed. Such people are portrayed sitting in a crowded railway compartment in Daumier's canvas *The Third-Class Carriage* (c. 1862).

Auguste Comte, *The Course of Positive Philosophy*[1]
The Progressive Course of the Human Mind

A general statement of any system of philosophy may be either a sketch of a doctrine to be established, or a summary of a doctrine already established. . . . In order to understand the true value and character of the Positive Philosophy, we must take a brief general view of the progressive course of the

1. Reprinted from *The Positive Philosophy of Auguste Comte,* trans. by Harriet Martineau (New York: D. Appleton, 1853), vol. 1, pp. 1–3, 5–8.

human mind, regarded as a whole; for no conception can be understood otherwise than through its history.

From the study of the development of human intelligence, in all directions, and through all times, the discovery arises of a great fundamental law, to which it is necessarily subject, and which has a solid foundation of proof, both in the facts of our organization and in our historical experience. This law is this:—that each of our leading conceptions,—each branch of our knowledge,—passes successively through three different theoretical conditions: the Theological, or fictitious; the Metaphysical, or abstract; and the Scientific, or positive. In other words, the human mind, by its nature, employs in its progress three methods of philosophizing, the character of which is essentially different, and even radically opposed: viz., the theological method, the metaphysical, and the positive. Hence arise three philosophies, or general systems of conceptions on the aggregate of phenomena, each of which excludes the others. The first is the necessary point of departure of the human understanding; and the third is a fixed and definitive state. The second is merely a state of transition.

In the theological state, the human mind, seeking the essential nature of beings, the first and final causes (the origin and purpose) of all effects,—in short, Absolute knowledge,—supposes all phenomena to be produced by the immediate action of supernatural beings.

In the metaphysical state, which is only a modification of the first, the mind supposes, instead of supernatural beings, abstract forces, veritable entities (that is, personified abstractions) inherent in all beings, and capable of producing all phenomena. What is called the explanation of phenomena is, in this state, a mere reference of each to its proper entity.

In the final, the positive state, the mind has given over the vain search after Absolute notions, the origin and destination of the universe, and the causes of phenomena, and applies itself to the study of their laws,—that is, their invariable relations of succession and resemblance. Reasoning and observation, duly combined, are the means of this knowledge. What is now understood when we speak of an explanation of facts is simply the establishment of a connection between single phenomena and some general facts, the number of which continually diminishes with the progress of science. . . .

All good intellects have repeated, since Bacon's[2] time, that there can be no real knowledge but that which is based on observed facts. As we have

2. Francis Bacon (1561–1626), an English philosopher, who upheld the inductive method of science. This method, which established general laws on the basis of observations of particular facts, differed from the a priori method of medieval scholasticism, which established the validity of general laws independently of direct observations.

seen, the first characteristic of the Positive Philosophy is that it regards all phenomena as subjected to invariable natural Laws. Our business is,—seeing how vain is any research into what are called Causes, whether first or final,— to pursue an accurate discovery of these Laws, with a view to reducing them to the smallest possible number. By speculating upon causes, we could solve no difficulty about origin and purpose. Our real business is to analyze accurately the circumstances of phenomena, and to connect them by the natural relations of succession and resemblance.

Jules Michelet, *The People*[3]
The Bondage of the Factory Worker

But now new occupations have been created which require scarcely any apprenticeship and welcome any man. The real worker in these trades is the machine, and the man does not need much strength or skill; he is there only to watch and aid that iron workman.

This unfortunate class of people enslaved to machinery comprises four hundred thousand souls, or a little more. This is about one-fifteenth of our workmen. All those who have no skill come and offer themselves at the factories to serve machines. The more they come, the lower are their wages, and the more miserable they grow. On the other hand, goods produced cheaply in this way fall within reach of the poor, so that the misery of the machine-worker of the factory diminishes somewhat the misery of the artisan and peasant, who are probably seventy times more numerous. . . .

The factory is the reign of fate and necessity. . . .

Physical weakness and mental impotence. The feeling of impotence is one of the great miseries of this condition. This man, who is so weak in the face of the machine and who must follow its every motion, is dependent on the factory owner, and even more on the thousand unknown forces which may suddenly create unemployment and take away his bread. . . .

That crowd is not evil in itself. Its disorders spring in large measure from its condition, from its subjection to the mechanical order which is itself a disorder and a death for living bodies and which thereby provokes a violent return to life in the few moments of freedom. If fatality ever existed, it is surely this. How heavily, how almost invincibly, does this fate weigh upon the women and children! The woman is pitied less, but perhaps she should be pitied more. She is in double bondage: she is a slave to work, but she earns so little with her hands that the poor creature must also earn with her youth

3. Reprinted, by permission of the publisher, from Jules Michelet, *The People,* trans. by John P. McKay (Urbana: University of Illinois Press, 1973), pp. 42–43, 48–51.

and the pleasure she gives. When old, what becomes of her? Nature has ordained that woman cannot live unless she leans on man for support. . . .

The mental void, the absence of every intellectual interest, is as we have said, one of the principal causes of the debasement of the factory worker. His is a work which requires neither strength nor skill and never asks for thought! Nothing, nothing, and always nothing! No moral force could withstand that! . . . The factory worker carries all his life a heavy burden.

9. Gustave Courbet, *Burial at Ornans*, 1849
Gardner, p. 898, ill. 21:37

Gustave Courbet, *The Stone Breakers*, 1849
Janson, p. 663, ill. 911

Pierre-Joseph Prou'dhon, *What Is Property?:* "This Fraudulent Denial," 1840
Karl Marx and Friedrich Engels, *The Communist Manifesto:* "Two Great Classes," 1848

Socialism arose in the late eighteenth and early nineteenth centuries as a response to the economic and social changes brought about by the industrial revolution. While factory owners accumulated wealth, the laboring force was overworked, underpaid, poorly fed, and badly housed. As this capitalist system spread, alternative systems for the distribution of economic resources and political power were proposed by socialist thinkers.

The most important nineteenth-century socialist theorists were Pierre-Joseph Prou'dhon (1809–1865), Karl Marx (1818–1883), and Friedrich Engels (1820–1895). A self-educated printer from a poor family, Prou'dhon achieved prominence through his pamphlet *What Is Property?* (1840). In it he condemned the abuses of private property and called for the end of the existing social, political, and economic order. A specific reform proposed by Prou'dhon was the establishment of a national bank for the reorganization of credit in the interests of the workers. A more general reform proposed by Prou'dhon was the development of a governmental system based on a theory of "mutualism." Prou'dhon envisioned that such a system would consist of small, loosely federated groups that would agree upon fundamental principles but would bargain with one another over economic and political issues. As an anarchist, Prou'dhon hoped that humankind would progress to a higher ethical plane, which would eventually make government unnecessary. As a pacifist, Prou'dhon rejected the use of force to impose any system. A selection from *What Is Property?*, "This Fraudulent Denial," is presented here.

Prou'dhon set out a full exposition of his economic reform program in his book, *The Philosophy of Poverty* (1847). This socialist program was attacked by Karl Marx in 1847 in *The Poverty of Philosophy*. Marx attacked Prou'dhon on the grounds that finance capital, which Prou'dhon sought to abolish, and industrial capitalism, which Prou'dhon wished to strengthen, were inextricably intertwined. In the Marxist view, the unplanned nature of capitalist production sets the stage for economic instability, under which speculation thrives, as well as for concentration of economic power and exploitation of labor. Thus, the working harmony among producers that Prou'dhon sought to foster cannot, in Marxist terms, come into existence in any capital scheme.

In 1848 the thirty-year-old Karl Marx and his twenty-eight-year-old friend Friedrich Engels published *The Communist Manifesto,* the central document of socialism. Marx was born in Germany, but his liberal political views forced him into exile in Paris. There he met and established a lifelong friendship with Engels, who was working as a foreign business agent for his father, a wealthy German textile manufacturer.

Prou'dhon had argued that the middle class and the poor could, together, create a better society. In contrast, Marx and Engels believed that the interests of the middle class, or capitalist class, and those of the industrial working class are inevitably opposed to each other. Indeed, Marx and Engels characterized the history of society as the history of class struggle. In their view, one class, driven by naked self-interest, had always exploited the other. With the advent of modern industry, the split between the economic classes had become more pronounced than ever before. In the current epoch, the capitalist class—or bourgeoisie—had flourished at the direct expense of the modern working class—the proletariat. So brutal and shameless was this exploitation that the proletariat was now reduced to a mere commodity. Deprived of their humanity, paid shamelessly low wages in exchange for their labor, pacified into acceptance of inequity by the illusions of religion and political ideology, working-class people were excluded from reaping any profits of the capitalist system. Instead, these profits, which in reality represented the labor of the workers, had been appropriated by the bourgeoisie.

Marx and Engels were convinced that the bourgeoisie had outlived its historic usefulness and that the stage was now set for the overthrow of the capitalist system. Workers, when they became aware that their economic welfare had been sacrificed by their politicians, clergy, and employers, would realize that they had no loyalties to country or religion. They would recognize that they were bound, instead, to their own class, which, in the international scene, had the same problems and confronted the same enemy everywhere. *The Communist Manifesto* ends with the prediction that a future revolution will sweep Europe and create a classless society. A selection from *The Communist Manifesto,* "Two Great Classes," is presented here.

Socialist thought had a profound effect upon the French artist Gustave Courbet (1819–1877). The oldest child of a well-to-do rural landowner, Courbet was always at odds with vested authority, whether political or aesthetic. Prou'dhon and Courbet became friends, while the writer made Courbet the pivotal personality in his book *The*

Principle of Art and the Social Destiny (published posthumously in 1865), the painter presented Prou'dhon's social beliefs in paintings such as *The Stone Breakers* (1849) and *Burial at Ornans* (1849), which celebrate the laboring class. Enjoying his role as a rebel, Courbet, as a republican who had opposed the empire, refused the Cross of the Legion of Honor when it was offered to him by Napoleon III in 1872.

Pierre-Joseph Prou'dhon, *What Is Property?*[1]
This Fraudulent Denial

"The capitalist," they say, "has paid the laborers their *daily wages.*" To be accurate, it must be said that the capitalist has paid as many times one day's wage as he has employed laborers each day,—which is not at all the same thing. For he has paid nothing for that immense power which results from the union and harmony of laborers, and the convergence and simultaneousness of their efforts. Two hundred grenadiers stood the obelisk of Luxor[2] upon its base in a few hours; do you suppose that one man could have accomplished the same task in two hundred days? Nevertheless, on the books of the capitalist, the amount of wages paid would have been the same. Well, a desert to prepare for cultivation, a house to build, a factory to run,—all these are obelisks to erect, mountains to move. The smallest fortune, the most insignificant establishment, the setting in motion of the lowest industry, demand the concurrence of so many different kinds of labor and skill, that one man could not possibly execute the whole of them. It is astonishing that the economists never have called attention to this fact. Strike a balance, then, between the capitalist's receipts and his payments. . . .

But he who lends his services,—what is his basis of cultivation? The proprietor's presumed need of him, and the unwarranted supposition that he wishes to employ him. Just as the commoner once held his land by the munificence and condescension of the lord, so to-day the working-man holds his labor by the condescension and necessities of the master and proprietor: that is what is called possession by a precarious title. But this precarious condition is an injustice, for it implies an inequality in the bargain. The laborer's wages exceed but little his running expenses, and do not assure him wages for to-morrow; while the capitalist finds in the instrument produced by the laborer a pledge of independence and security for the future.

Now, this reproductive leaven—this eternal germ of life, this prepara-

1. Reprinted from Pierre-Joseph Prou'dhon, *What Is Property?*, trans. by Benjamin R. Tucker (New York: Howard Fertig, 1966), pp. 116–20.
2. A reference to the ancient Egyptian monument which had been taken by Napoleon's troops from Luxor, a town in upper Egypt. An obelisk is a tall, four-sided shaft of stone, the tapering sides of which are surmounted by a pyramidal apex. The obelisk was erected in Paris in the Place de la Concorde in 1836.

tion of the land and manufacture of implements for production—constitutes the debt of the capitalist to the producer, which he never pays; and it is this fraudulent denial which causes the poverty of the laborer, the luxury of idleness, and the inequality of conditions. This it is, above all other things, which has been so fitly named the exploitation of man by man. . . .

Labor leads us to equality. Every step that we take brings us nearer to it; and if laborers had equal strength, diligence, and industry, clearly their fortunes would be equal also. Indeed, if, as is pretended,—and as we have admitted,—the laborer is proprietor of the value which he creates, it follows:—

1. That the laborer acquires at the expense of the idle proprietor;

2. That all production being necessarily collective, the laborer is entitled to a share of the products and profits commensurate with his labor;

3. That all accumulated capital being social property, no one can be its exclusive proprietor.

These inferences are unavoidable; these alone would suffice to revolutionize our whole economical system, and change our institutions and our laws.

Karl Marx and Friedrich Engels, *The Communist Manifesto*[3]
Two Great Classes

[The] history of all hitherto existing society is the history of class struggles.

Freeman and slave, patrician and plebeian, lord and serf, guild-master and journeyman, in a word, oppressor and oppressed, stood in constant opposition to one another, carried on uninterrupted, now hidden, now open fight, a fight that each time ended, either in a revolutionary reconstitution of society at large, or in the common ruin of the contending classes. . . .

Our epoch, the epoch of bourgeoisie, possesses, however, this distinctive feature; it has simplified the class antagonisms. Society as a whole is more and more splitting up into two great hostile camps, into two great classes directly facing each other: Bourgeoisie and Proletariat.

The bourgeoisie, wherever it has got the upper hand, has put an end to all feudal, patriarchal, idyllic relations. It has pitilessly torn asunder the motley feudal ties that bound man to his "natural superiors," and has left no other nexus between man and man than naked self-interest, than callous

3. Reprinted, by permission of the publisher, from *The Essentials of Marx,* ed. by Algernon Lee and trans. by Samuel Moore (New York: Vanguard Press, 1926), pp. 30–32, 34, 37–41. Copyright by Vanguard Press.

"cash payment." It has drowned the most heavenly ecstasies of religious fervor, of chivalrous enthusiasm, of philistine sentimentalism, in the icy water of egotistical calculation. It has resolved personal worth into exchange value, and in place of the numberless indefeasible chartered freedoms, has set up that single, unconscionable freedom—Free Trade. In one word, for exploitation, veiled by religious and political illusions, it has substituted naked, shameless, direct, brutal exploitation.

The Bourgeoisie has stripped of its halo every occupation hitherto honored and looked up to with reverent awe. It has converted the physician, the lawyer, the priest, the poet, the man of science, into its paid wage laborers.

The bourgeoisie has torn away from the family its sentimental veil, and has reduced the family relation to a mere money relation. . . .

The bourgeoisie cannot exist without constantly revolutionizing the instruments of production, and thereby the relations of production, and with them the whole relations of society. Conservation of the old modes of production in unaltered form was, on the contrary, the first condition of existence for all earlier industrial classes. Constant revolutionizing of production, uninterrupted disturbance of all social conditions, everlasting uncertainty and agitation distinguish the bourgeois epoch from all earlier ones. All fixed, fast-frozen relations, with their train of ancient and venerable prejudices and opinions, are swept away, all new-formed ones become antiquated before they can ossify. All that is solid melts into the air, all that is holy is profaned, and man is at last compelled to face with sober senses, his real conditions of life, and his relations with his kind. . . .

But not only has the bourgeoisie forged the weapons that bring death to itself; it has also called into existence the men who are to wield those weapons—the modern working class—the proletarians.

In proportion as the bourgeoisie,—that is, as capital, is developed, in the same proportion is the proletariat, the modern working class, developed, a class of laborers who live only so long as they find work, and who find work only so long as their labor increases capital. These laborers, who must sell themselves piecemeal, are a commodity, like every other article of commerce, and are consequently exposed to all the vicissitudes of competition, to all the fluctuations of the market.

Owing to the extensive use of machinery and to division of labor, the work of the proletarians has lost all individual character, and, consequently, all charm for the workman. He becomes an appendage of the machine, and it is only the most simple, most monotonous, and most easily acquired knack that is required of him. Hence, the cost of production of a workman is restricted almost entirely to the means of subsistence that he requires for his

maintenance, and for the propagation of his race. But the price of a commodity, and also of labor, is equal to its cost of production. In proportion, therefore, as the repulsiveness of the work increases the wage decreases. Nay more, in proportion as the use of machinery and division of labor increase, in the same proportion the burden of toil increases, whether by prolongation of the working hours, by increase of the work enacted in a given time, or by increased speed of the machinery, and so forth. . . .

But with the development of industry the proletariat not only increases in number; it becomes concentrated in greater masses, its strength grows and it feels that strength more. The various interests and conditions of life within the ranks of the proletariat are more and more equalized, in proportion as machinery obliterates all distinction of labor, and nearly everywhere reduces wages to the same low level. The growing competition among the bourgeois, and the resulting commercial crises, make the wages of the workers ever more fluctuating; the unceasing improvement of machinery, ever more rapidly developing, makes their livelihood more and more precarious; the collisions between individual workmen and individual bourgeois take more and more the character of collisions between two classes. . . .

Of all the classes that stand face to face with the bourgeoisie today the proletariat alone is a really revolutionary class. The other classes decay and finally disappear in the face of modern industry; the proletariat is its special and essential product. . . . Let the ruling classes tremble at a communist revolution. The proletarians have nothing to lose but their chains. They have a world to win. Workingmen of all countries, unite!

10. Edouard Manet, *Déjeuner sur l'herbe*, 1863
Gardner, pp. 920–21; ills. 21:65–21:66; Janson, p. 48, ill. 4

Charles Baudelaire, *The Flowers of Evil:* "I Love the Thought," 1857

In reaction to the naturalism and realism of much of nineteenth-century literature, some French writers sought to convey impressions by suggestion rather than by direct statement. These writers, who were called Symbolists, emphasized imagination rather than external events as the principal reality, and they often explored sensory images that critics considered decadent and morbid.

One of the most prominent Symbolist writers was Charles Baudelaire (1821–1867). A poet whose verse unremittingly reflects inner despair, Baudelaire struggled throughout his life with moodiness, rebelliousness, financial trouble, alcoholic excesses, and illness. He died of venereal illness at the age of forty-six.

Baudelaire published only one volume of poetry in his lifetime, *The Flowers of Evil* (1857). Publicly condemned as obscene, the poems dwell on the inseparable nature of beauty and corruption. A selection from *The Flowers of Evil,* "I Love the Thought," is presented here.

The painter Edouard Manet (1832–1883) was an intimate friend of Baudelaire and shared with him a fascination with the disturbing undercurrents of modern life. His daring style is evident in *Déjeuner sur l'herbe* (1863), a painting of two fully dressed men picnicking with unclad women. Like the poetry of his friend, Manet's painting was sharply criticized as an indecent illustration.

Charles Baudelaire, *The Flowers of Evil*[1]
I Love the Thought

I love the thought of those old naked days
When Phoebus[2] gilded torsos with his rays,
When men and women sported, strong and fleet,
Without anxiety or base deceit,
And heaven caressed them, amorously keen
To prove the health of each superb machine.
Cybele[3] then was lavish of her guerdon[4]
And did not find her sons too gross a burden:
But, like a she-wolf, in her love great-hearted,
Her full brown teats to all the world imparted.
Bold, handsome, strong, Man rightly might evince
Pride in the glories that proclaimed him prince—
Fruits pure of outrage, by the blight unsmitten,
With firm, smooth flesh that cried out to be bitten.

Today the Poet, when he would assess
Those native splendors in the nakedness
Of man or woman, feels a sombre chill
Enveloping his spirit and his will.
He meets a gloomy picture, which he loathes,
Wherein deformity cries out for clothes.
Oh comic runts! Oh horror of burlesque!
Lank, flabby, skewed, pot-bellied, and grotesque!

1. Reprinted, by permission of the publisher, from Charles Baudelaire, *The Flowers of Evil,* trans. by Roy Campbell, ed. by Marthiel and Jackson Mathews (Norfolk, Conn.: New Directions, 1965), pp. 13–14.
2. Phoebus is a name of the Greek god Apollo in his capacity as god of the sun.
3. Cybele was the greek goddess of fertility, the mountains and wild nature. She is symbolized by her attendant lions.
4. Reward, recompense.

Whom their smug god, Utility (poor brats!),
Has swaddled in his brazen clouts "ersatz"
As with cheap tinsel. Women tallow-pale,
Both gnawed and nourished by debauch, who trail
The heavy burden of maternal vice,
Or of fecundity the hideous price.

We have (corrupted nations), it is true,
Beauties the ancient people never knew—
Sad faces gnawed by cancers of the heart
And charms which morbid lassitudes impart.
But these inventions of our tardy muse
Can't force our ailing peoples to refuse
Just tribute to the holiness of youth
With its straightforward mien, its forehead couth,
The limpid gaze, like running water bright,
Diffusing, careless, through all things, like light
Of azure skies, the birds, the winds, the flowers,
Its songs, and perfumes, and heart-warming powers.

11. Claude Monet, *The River*, 1868
Janson, p. 665, ill. 913

Claude Monet, *Rouen Cathedral*, 1894
Gardner, p. 924, ill. 21:69

Augustin-Jean Fresnel, *Memoir on the Diffraction of Light:* "An Immediate Consequence of the Wave-Theory," 1819

The scientific debate over the nature of light occupied much attention in nineteenth-century laboratories and lecture rooms. In 1690 Christiaan Huygens had proposed a theory that explained light as a wave phenomenon. However, a rival theory had been offered by Isaac Newton in 1704. Newton argued that light is composed of tiny particles, which he called emissions or corpuscles, emitted by luminous bodies. By combining his corpuscular theory with his laws of mechanics, Newton was able to explain many optical phenomena. For more than one hundred years, Newton's emission theory of light was favored over the wave theory, partly because of Newton's great prestige and partly because few experiments had been conducted to compare the validity of the two theories.

Experimentation in the nineteenth century culminated with the triumph of the wave theory of light. The French engineer Augustin-Jean Fresnel (1788–1827) was

instrumental in demonstrating the validity of the wave theory to a scientific community dominated by the Newtonian tradition. Fresnel, a government civil engineer, set out to prove the wave theory of light by studying the phenomena of diffraction, reflection, and refraction. In some experiments that he devised, Fresnel used a double prism that he had invented and that is now called the Fresnel biprism. At the conclusion of his experimentation, Fresnel was successful in accounting for all the phenomena of light then known and in expressing all these phenomena with the qualitative precision that had become a necessary condition for an acceptable theory.

One of Fresnel's most important writings is *Memoir on the Diffraction of Light,* published in 1819. In this book Fresnel refutes the emission theory of light and proves the wave theory. A selection from *Memoir on the Diffraction of Light,* "An Immediate Consequence of the Wave-Theory," is presented here.

Concentration upon light is a hallmark of the paintings of Claude Monet (1840–1926). Seeking a spontaneous perceptual response to nature, Monet broke with traditional studio practices and became a plein air painter—painting outdoors. In works ranging from *The River* (1868), done early in his career, to *Rouen Cathedral* (1894), done in his late career, Monet replaces medium tones of gray and brown with the pure spectrum of a prism. Monet's extraordinary sensitivity to light transformed art from a depiction of solid physical masses to a rendering of the quiver of light during a passing moment of time.

Augustin-Jean Fresnel, *Memoir on the Diffraction of Light*[1]
An Immediate Consequence of the Wave-Theory

The phenomena of diffraction cannot be explained on the emission-theory. . . . The corpuscular theory, and even the principle of interference when applied only to direct rays and to rays *reflected or inflected at the very edge of the opaque screen,* is incompetent to explain the phenomena of diffraction. I . . . propose to show that we may find a satisfactory explanation and a general theory in terms of waves, without recourse to any auxiliary hypothesis, by basing everything upon the principle of Huygens and upon that of interference, both of which are inferences from the fundamental hypothesis.

Admitting that light consists in vibrations of the ether similar to sound-waves, we can easily account for the inflection of rays of light at sensible distances from the diffracting body. For when any small portion of an elastic fluid undergoes condensation, for instance, it tends to expand in all directions; and if throughout the entire wave the particles are displaced only along the normal, the result would be that all points of the wave lying upon the same spherical surface would simultaneously suffer the same condensation or

1. Reprinted from *The Wave Theory of Light: Memoirs by Huygens, Young and Fresnel,* ed. and trans. by Henry Crew (New York: American Book Company, 1900), pp. 99–100, 108, 81, 87.

expansion, thus leaving the transverse pressures in equilibrium; but when a portion of the wave-front is intercepted or retarded in its path by interposing an opaque or transparent screen, it is easily seen that this transverse equilibrium is destroyed and that various points of the wave may now send out rays along new directions. . . . We propose rather to compute the relative intensities of different points of the wave-front only after it has gone a large number of wave-lengths beyond the screen. Thus the positions at which we study the waves are always to be regarded as separated from the screen by a distance which is very considerable compared with the length of a light-wave. . . . Having determined the resultant of any number of trains of light-waves, I shall now show how by the aid of these interference formulæ and by the principle of Huygens alone it is possible to explain, and even to compute, all the phenomena of diffraction. This principle, which I consider as a rigorous deduction from the basal hypothesis, may be expressed thus: *The vibrations at each point in the wave-front may be considered as the sum of the elementary motions which at any one instant are sent to that point from all parts of this same wave in any one side of its previous positions, each of these parts acting independently the one of the other.* . . . It might appear that on the emission-theory nothing would be simpler than the phenomena of shadows, especially when the source of light is merely a point; but, on the contrary, nothing is more complicated. . . . The law of interference, or the mutual influence of rays of light, is an immediate consequence of the wave-theory; not only so, but it is proved or confirmed by so many different experiments that it is really one of the best-established principles of optics.

12. Pierre-Auguste Renoir, *Le Moulin de la Galette*, 1876
Gardner, p. 926, ill. 21:72; Janson, p. 666, ill. 915

Hippolyte Taine, *Notes on Paris:* "A Great Moving Circle Floats Around the Dancers," 1875

While urban life brought increased anxieties to many citizens and resulted in dire poverty for others, it also offered a wide range of exciting entertainment to fill people's leisure hours. The urban working classes sought pleasure and recreation in cafés, pubs, dance halls, and vaudeville theaters, and at sports events. By the late nineteenth century, the popularity of the "cruel sports," such as bull-baiting and cockfighting, had declined throughout Europe. Their place was filled by modern spectator sports, the most popular of which were racing and soccer. Music halls and vaudeville theaters became enormously popular among working-class people. Married couples and

sweethearts spent evenings together in the cafés and pubs. Pleasure gardens that offered dancing, drinks, and supper were favored by large numbers of young people. Admission to the pleasure garden was modest. In some pleasure halls, the different social classes were assigned different parts of the garden to minimize conflict; in others, different days were reserved for different clientele. In many, an open-air garden was utilized for dancing in the summer, and a ballroom in the winter.

The pleasure gardens were places where the young urban population could find gaiety, animation, and romance. For young people of the working class, the pre-industrial pattern of lengthy courtship and mercenary marriage was virtually eliminated. In its place the ideal of romantic love triumphed. Couples refused to accept marriages arranged by their families and insisted upon independent courtship. The city provided them with freedom from traditional constraints, while pleasure gardens and other places of recreation provided them with opportunities to meet partners. A description of the Parisian pleasure garden and of the dancing was provided by the French philosopher Hippolyte Taine (1828–1893). Adopting the pen name of Frederic Thomas Graindorge for his book *Notes on Paris,* Taine recorded his observations of Parisian life as an anecdotal account of the French capital. A well-to-do man, Taine has a constant tone of condescension and weary cynicism in his observations about the life and pursuits of working-class men and women. A selection from *Notes on Paris* (1875), "A Great Moving Circle Floats Around the Dancers," is presented here.

A much more joyful depiction of the Parisian pleasure garden is provided by the French artist Pierre-Auguste Renoir (1841–1919). The painting *Le Moulin de la Galette* (1876) shows a richness of form, a fluidity of brush stroke, a flickering light, and a sense of evanescent color. In contrast to Graindorge's characterization of the pleasure gardens, Renoir presents *Le Moulin de la Galette* as a setting in which young Parisians court each other with the freshness, grace, and optimism of youth.

Hippolyte Taine, *Notes on Paris*[1]
A Great Moving Circle Floats Around the Dancers

At ten o'clock in the evening, I go to Mabille.[2] It is a grand ball night. Two-francs entrance for men, one franc for women; numerous sergeants-de-ville[3]—a crowd to see the people go in.

A grand alley-way variegated with colored glass; diminutive groves, round plots of illuminated green. Small blue jets of gas[4] stretch along the ground through the flowers. Light and transparent vases are mixed in rings over the grass. There is a faint odor of grease and oil. The trees, wan and dim

1. Reprinted from Hippolyte Taine, *Notes on Paris,* trans. by John Austin Stevens (New York: Henry Holt, 1888), pp. 40–43.
2. A dance hall in Paris.
3. Policemen or security guards.
4. Artificial gas lights.

in the oblique light, look strange and unearthly. The imitation corinthian vases, the scenes painted in deception to give an appearance of length to the alleys, are simply contemptible. Above this rural arrangement jut out the sharp corners and heavy masonry of an enormous building. The rough ground hurts the feet. Decidedly, I am not enthusiastic.

In the center, a kiosk for the musicians; they are above the average, but the leader marks his time too noisily.

Around the orchestra a flagged circular platform for the dancers. They are actually dancing and wiping the perspiration from their faces in this horrible heat.

The men are said to be hired; the women exhibit themselves gratis[5] though they feel that they are despised. How odd that people can take any pleasure in staring at these poor girls, most of them faded, all looking degraded or half scared, as they dance in their hats and cloaks and black bottines![6] One is tempted to give them twenty francs, and send them all to the kitchen to eat a beefsteak and drink a glass of beer.

The men are worse; they frisk about, a miserable mob of loafers, tap-house pimps, slovenly, greasy, weary-looking, and all with their hats on.

A great moving circle floats around the dancers. Women, some accompanied, some alone, in white gauze, in small hats with little black patches on their faces; the most of them too fat or too thin. Suspicious toilettes,[7] nearly all extravagant or tumbled, in bad taste, the toilette of an over-dressed shop-woman, of a dressmaker with the remains of her shop on her back.

The conversations are curious; a tall dashing woman with large hoops,[8] and hair crimped and powdered, elbows a gentleman, who says to her:

"What! is that you, Theodora?"

"Yes! and you; you are back again?"

"Yes."

"In Paris?"

"Yes."

"You are coming to see me?"

"Where?"

"Rue des Martyrs, 68."

"Always the same name?"

"Always."

"At what time?"

5. Free, without charge.
6. Buttoned half-boots.
7. Styles or ways of dressing.
8. Circular bands of stiff material used to expand and display a woman's skirt.

"Any time in the afternoon."

"Very well! one of these days."

"When?"

"We will see."

"Soon?"

"We will see."

"This week?"

"We will see."

"Well! good-night. Miserable wretch! They all put you off just so."

Many strangers, Germans, Italians, English, especially the latter, who chuck them under the chin. Addresses are exchanged, and prices are disputed as at the Bourse.[9] Here and there a touch of nature, a genuine expression of feeling; a beautiful girl, fresh, daintily gloved, and charming in her light blue silk dress, almost a lady in appearance, cries out in a loud tone to the gentleman who is with her, and in hearing of the whole Café. "Leave me alone, will you, I won't be bothered so!"

13. Edgar Degas, *Ballet Rehearsal (Adagio)*, 1876
Gardner, p. 927, ill. 21:73

Edgar Degas, *Prima Ballerina*, c. 1876
Janson, p. 668, ill. 918

Berthe Bernay, *La Danse au théâtre:* "Drag Me Along on her Arm," 1890

While Parisian working-class people spent their leisure time in cafés and pleasure gardens, the middle class and upper class frequented classical theater, opera, and ballet. Nineteenth-century audiences were particularly fascinated by ballet, perhaps because of the rapid transformations that had occurred in this art form.

Classical ballet has its origins in the entertainments of the ducal courts of fifteenth-century Italy. During the seventeenth century, the academic principles of classical ballet were firmly instituted in France when Louis XIV established the Royal Academy of Dancing in Paris in 1661. The nineteenth century witnessed the full development of the ballerina's technique and the emergence of the ballerina as the visual focus of classical dance. The technical innovation of dancing *en pointe,* that is, on wooden points placed in the toe of dance shoes, and the corresponding elevation of the female dancer were introduced in the early decades of the century. The aesthetic possibilities permitted by the addition of wooden *pointes* to ballet slippers were explored in more and more spectacular forms throughout the century. Choreogra-

9. The stock exchange in Paris.

phers exploited the tremendous expansion that the *pointe* had brought to the dancer's vocabulary by giving the ballerina an impalpable lightness. The public, dazzled by the novel visual effects and by the feats of technical difficulty, awarded the ballerina the status of a modern heroine.

Paris held undisputed supremacy in the world of ballet. The leading ballet company was housed at the Paris Opéra. It consisted of one hundred fifty members, and was organized on a quasi-military basis. Dancers, both male and female, were trained at the ballet school attached to the Opéra, the Conservatoire de Danse. Admittance to the school was highly competitive, and a long period of training, practice, and experience was necessary for a dancer to rise through the ranks of the corps de ballet and, finally, to achieve recognition as a prima ballerina.

The years of training were extremely demanding. Berthe Bernay, who became a prima ballerina and a teacher later in the century, published an account of her career, entitled *La Danse au théâtre,* in 1890. In it she recalled the early stages of her career as a period of unrelieved exhaustion. A selection from *La Danse au théâtre,* "Drag Me Along on Her Arm," is presented here.

Large, enthusiastic crowds sought admission to the Paris Opéra to attend ballet performances. Wealthy patrons, however, exercised the privilege of admission backstage during the performance. A select few had the right of entry into the Foyer de la Danse. The room, situated immediately behind the stage, was unpretentious. Modestly decorated, it had been originally designed exclusively for the use of the dancers. Among the patrons, writers, and artists who visited the Foyer de la Danse was Edgar Degas (1834–1917).

The eldest son of a banker, Degas was raised in the world of artists, musicians, and connoisseurs. As an artist, Degas was preoccupied with the human figure, which he wished to represent in a manner as objective and as truthful as possible. More than any of his contemporaries, Degas studied the infinite variety of the particular movements that make up continuous motion. Ballerinas in arrested movements—a splitsecond pose cut from the sequence of a dance—were among his favorite subjects. In *Ballet Rehearsal* (1876), Degas captures both the grace that the dancer exhibited onstage and also the anxiety and weariness that was part of the ballerina's life. In *Prima Ballerina* (c. 1876), Degas suggests the ethereal quality of form achieved by the ballerina and the acclaim awarded to the leading female dancers by their nineteenthcentury audiences.

Berthe Bernay, *La Danse au théâtre*[1]
Drag Me Along on Her Arm

I was seven when, on April 7th, 1863, after the compulsory medical examination, I began to study dancing at the Opéra. My parents, who were not well off, lived at Belleville, on the heights of the Rue du Faubourg-du-Temple,

1. Reprinted, by permission of the publisher, from Ivor Guest, *The Ballet of the Second Empire* (London: Pitman, 1974), pp. 7–8. Copyright by Pitman.

now near the Buttes-Chaumont. Nearly all my little companions—I might even say, all—lived, like me, with their parents at a similar distance from the Opéra, and in the same sort of district. I have said that I was seven years old. Winter and summer, my mother used to wake me up at half past seven in the morning to go to work [as a ballet student], and I had to leave home so as to be dressed and ready to dance in the scenery-store in the Rue Richer, where the classes were then held, on the stroke of nine o'clock. Needless to say, omnibus fares were beyond my small means, and I had to walk. What journeys those were, the reader can judge for himself!

The morning lesson lasted from nine o'clock until half past ten. Afterwards, I changed and returned home for lunch at midday. But I was not always sure that I would be finished after my lesson. I was not always so lucky as to get back so early. Often I had to take part in rehearsals at the Opéra itself, for the young pupils such as myself were employed as supers.[2] When this happened, I used to have lunch in the Rue Richer with my mother off the modest ration we had brought in our basket—never have I forgotten that basket!—and afterwards we went to the Rue Drouot to attend the rehearsal, which lasted until two o'clock. Only then was I free to make my return journey to Belleville. Then, if I was appearing on the stage in the evening, we walked back once again to be in time for the call at eight o'clock. Finally, when the performance had finished at midnight, I set out for home. My poor mother literally used to drag me along on her arm, and at one o'clock in the morning, worn out, we arrived home, where my father was waiting up for us. We slept hastily, and set out once again for my class at eight o'clock the next morning.

I used to earn a fee of one franc for the rehearsal, and the same for the performance in the evening. I followed this calling, at this price and in these conditions, from the age of seven to the age of thirteen.

14. Henri de Toulouse-Lautrec, *At the Moulin Rouge*, 1892–95
Gardner, p. 939, ill. 21:87; Janson, p. 693, ill. 956

Emile Zola, *The Dram-Shop:* "Will Madame Take Another?" 1876

The urban working-class people sought recreation and enjoyment in their leisure time, and they found both in the cities. In addition to attending sports events and cramming

2. Supers were students who rehearsed and performed with the corps de ballet for a small fee. In contrast to supers, most students received only their tuition and dance-slippers. Such students signed a legal contract obligating them to complete a five-year training period, but received no regular wages.

the music halls and vaudeville theaters, working people devoted increasing amounts of time and money to drinking. Drinking, in the nineteenth century, became a more public and more social activity. Cafés and pubs became increasingly bright, friendly places in which married couples and sweethearts gathered.

However, while much of the working class drank moderately, for others drinking became deadly serious business. Heavy drinking led to physical violence and dire poverty for many working-class persons. The consequence of drink as a sign of social dislocation and a source of popular suffering was scrutinized by the French writer Emile Zola (1840–1902).

The son of an Italian father and a French mother, Zola was raised in Marseille. At the age of eighteen, he moved to Paris to start his writing career. His experience of poverty at the outset of his career would later prove of great value to him as a novelist.

An ardent admirer of science, Zola believed that everything was scientifically determined. Zola sought to demonstrate this belief by designing his novels as social and personal documents. Zola's novels are a microcosm in which every facet of human nature, from sin and corruption to love and redemption, is described. Alcoholism, alienation, and despair are graphically described in the novel *The Dram-Shop,* which appeared in serial form in 1876 and was published in book form in 1877. Zola saw the city of the poor as a gloomy world, echoing the roar of modern times and suggesting an apocalyptic aspect of the industrialization of the world. He denounced one of the vices of the working class: alcoholism. He painted a dark picture of the working-class neighborhoods of Paris, in which the skies are cloudy, the streets are dark, and the houses poignantly ugly.

Despair, helplessness, hopelessness, and cruelty are chillingly conveyed in the plot of *The Dram-Shop.* Gervaise, the central character, is married to Coupeau. Gervaise is enticed by her husband to start drinking. Despite her compliance to all of Coupeau's wishes, eventually Gervaise is abandoned by him. Overcome by hunger and yearning for drink, she tries in vain to prostitute herself and dies of starvation.

One scene from *The Dram-Shop* is set on the evening of payday. Gervaise has gone to wait for her husband at the door of the bar L'Assommoir. Realizing that Coupeau has no intention of coming out, she goes in to join him and, for the first time, has a drink. The aniseed[1] flavor of absinthe, a then-popular alcoholic beverage, sickens her, but Gervaise accepts more and more until she is drunk. A selection from *The Dram-Shop*—"Will Madame Take Another?"—is printed here.

The Parisian night world of bars, cafés, and music halls was chronicled by the artist Henri de Toulouse-Lautrec (1864–1901). A member of an aristocratic family, Toulouse-Lautrec received childhood injuries that severely stunted the growth of his legs. Like many of the artist's paintings, *At the Moulin Rouge* (1892–95) suggests the twin poles of artificial gaiety and underlying despair that characterized the popular

1. Aniseed is the seed of the anise, which was used in the alcoholic beverage absinthe for its licoricelike flavor. Absinthe was 70 percent to 80 percent alcohol. Because of its poisonous effect on the nerves, it was banned in most countries in the early twentieth century.

world of cabarets and that haunted Toulouse-Lautrec's alcoholic existence. In 1899, his health ruined by excessive drinking, Toulouse-Lautrec was placed in a nursing home outside Paris. He was discharged the same year and died only two years later.

Emile Zola, *The Dram-Shop*[2]
"Will Madame Take Another?"

"Ah, well!" cried Coupeau, suddenly turning his wife's empty glass upside down, "you get rid of it pretty quickly. Just look, you others, she doesn't take long over it, does she?"

"Will madame take another?" asked Salted-Chops, otherwise Drink-without-Thirst.

No, she had had enough. Yet she hesitated. The aniseed seemed to have a sickening effect. She would rather have taken something stiffer to keep her hungry stomach quiet. And she glanced askance at the fuddling machine near her. The sight of that horrible pot-bellied cauldron, with its long twisted nose, sent a shiver down her back, a commingling of fear and desire. You might have thought the thing to be some round fat witch slowly throwing off liquid fire. A fine poison source it was, a brazen abomination which ought to have been hidden away in a cellar! But all the same Gervaise would have liked to poke her nose inside it, sniff and taste its contents, even if in doing so the skin should peel off her burnt tongue like the rind off an orange.

"What's that you're drinking?" she slyly asked the men, her eyes brightening as she noticed the beautiful golden color of the liquid in their glasses.

"That, old woman," answered Coupeau, "is papa Colombe's camphor. Now don't be stupid, we'll just let you taste it."

And when they had brought her a glass of the "vitriol," and her jaws contracted at the first mouthful, the zinc-worker resumed, slapping his thighs: "Eh! it tickles your gullet! Come, drink it off at a go. Each glassful cheats the doctor of six francs."

At the second glass, Gervaise no longer felt the hunger which had been tormenting her. She was now good friends again with Coupeau, no longer angry with him for having failed to keep his word. They would go to the circus some other day; after all it was not so funny to see a lot of mountebanks[3] galloping about on horses. There was no rain inside old Colombe's, and if the money did go in brandy, one at least had it in one's body; one

2. Reprinted, by permission of the publisher, from Marc Bernard, *Zola,* trans. by Jean M. Leblon (Westport, Conn.: Greenwood Press, 1977), pp. 55–57. Copyright by Grove Press.
3. Hucksters or frauds.

drank it limpid, glittering like beautiful liquid gold. Ah! she was ready to send the whole world to blazes! Life didn't offer so many pleasures; besides, it seemed to her some consolation to have her share in squandering the cash. As she was comfortable, why shouldn't she remain? There might be a discharge of artillery; for her part she never cared to stir, once she had settled down. She was simmering as it were in what seemed to her a pleasant warmth, her bodice clinging to her back, whilst a sensation of comfort stole through her, benumbing her limbs. She laughed all to herself, her elbows resting on the table, and a vacant look in her eyes, as she gazed, highly amused, at two customers, a fat heavy fellow and a dwarf, who sat at a neighboring table, so very drunk that they were actually kissing one another. Yes, she laughed at the "Assommoir," at old Colombe's full moon face, at the customers smoking, yelling and spitting, and at the big gas flames which set the looking-glasses and bottles of liqueurs fairly ablaze. The smell no longer inconvenienced her; on the contrary, it tickled her nose, and she thought it very pleasant. Her eyes closed somewhat whilst she breathed very slowly, but without the least feeling of oppression, enjoying indeed the gentle slumber which was overcoming her. Then, after her third glass, she let her chin fall on her hands, and saw nothing apart from Coupeau and his mates, with whom she remained cheek by jowl, warmed by their breath, and gazing at their dirty beards as though she were counting the hairs. They were very drunk by this time. My-Boots, his pipe still between his teeth, was drivelling with the dumb grave air of a dozing ox. Bibi-the-Smoker was telling how he emptied a quart bottle at a draught, while Salted-Chops, otherwise Drink-without-Thirst, went to fetch the wheel of fortune[4] from the counter, in order to play Coupeau for drinks.

15. **Paul Gauguin,** *The Vision After the Sermon,* **1888**
Janson, p. 688, ill. 949

Paul Gauguin, *Offerings of Gratitude,* **c. 1891–93**
Janson, p. 689, ill. 950

Paul Gauguin, *Spirit of the Dead Watching,* **1892**
Gardner, p. 938, ill. 21:86

Breton ballad: "The Song of the Souls in Pain," undated
Tahitian chant: "Gloomy Sacredness Is That Indeed!" undated

4. A disk-like gambling device that is spun or rotates to determine the winners.

The deepening discontent of Europeans with their urban society at the end of the nineteenth century resulted in a search for vitality in new peoples and intensified the yearning to find an untainted and incorruptible manner of life. For some, the possibility of such a life was imagined to exist in a distant geographical place that was untouched by the decay and vice of Western society. For others, it was imagined to exist in an interior state of grace that was provided protection from the temptations and pitfalls of moral dilemmas.

One person who traveled in search of such a place was the French painter Paul Gauguin (1848–1903). The son of a journalist, Gauguin spent four years of his childhood in Peru, where his wealthy grandfather lived. Success in adulthood as a stockbroker brought Gauguin few satisfactions. Abandoning his wife and five children, Gauguin spent extended periods of time in Brittany in 1886, 1888, 1890, and 1894. Still searching for an uncorrupted society, Gauguin left France altogether in 1891 and set sail for Tahiti.

Although geographically distant from each other, both Brittany and Tahiti held out to Westerners in general and to Gauguin in particular the promise of an earthly paradise where people lived in a state of nature and innocence.

Brittany, an ancient province in the northwestern peninsula of France, had remained isolated from France until the twentieth century. A tradition of fierce independence survived centuries of vain effort by the French national government to bring Brittany under direct rule. Local patriotism maintained provincial and cultural autonomy more strongly than in other provinces. Bretons preserved their distinctive social structure; they continued to speak the Breton language, to dress in regional costumes, to follow local customs and tradition, and to express their intense religiosity in colorful pageants, processions, and ceremonies.

Interest in Brittany's customs was stimulated in the nineteenth century at the very moment when the central government was trying to impose control over the region. One manifestation of this interest was the enthusiasm for Breton literature. Consisting principally of ballads and poems, it frequently expresses the fervent religious aspirations of the people. One such ballad is "The Song of the Souls in Pain." This ballad derives from Breton beliefs about November, which the Bretons called the "black month" because they believed it to be the month of the dead. On All Saints' Eve (Halloween), families remembered their dead in many ways, including leaving the remains of their supper on the table, so that the souls of the dead could take their seats about the board, and by banking the fire on the hearth, so that the dead could warm their thin hands at the embers.

Tahiti, the largest of the French islands in the South Pacific, was unknown to Europeans until it was visited in the eighteenth century by the English navigator Samuel Wallis and by the English captain James Cook. English and French missionaries arrived in the latter part of the eighteenth century. In 1843 the Tahitian queen Pomare IV was forced to agree to the establishment of a French protectorate.

Until contact with Europeans and the introduction of foreign diseases, Tahitians enjoyed a long life, relatively free from disease. When they became ill, Tahitians

thought they had offended the gods, and the family took offerings of food to the ancestral *marae,* or shrine. A tribal priest was called to invoke the gods to remove their anger and to remove the sickness. The family placed other offerings, including valuable objects, around the bed of the sick one in hopes that the gods would take pity and would spare the patient.

If the illness proved fatal, the family began a long period of intense grieving. The mourners kept the body in the house for three or four days while they wailed and tried to awaken the dead. Then the corpse was raised upon a high altar in a temporary house erected at the family shrine. Finally the body was buried in a coffin hewn from a tree trunk and interred first in a shrine vault and later in a mountain cave.

Tahitian chants, rituals, and folktales were recorded between 1817 and 1856 by J. M. Orsmond, a British missionary to Polynesia. Orsmond's granddaughter, Teuira Henry, edited the material recorded by her grandfather. One chant, "Gloomy Sacredness Is That Indeed!" is a song of mourning from a woman named Tepua, upon the discovery that her husband Ta'arei has murdered her lover Ma'irûrû. This song mingles reverence for the gods with dignified expression of personal grief. Its tone is evoked by such paintings as *Spirit of the Dead Watching* (1892), painted by Paul Gauguin in Tahiti.

Gauguin was deeply attracted to the intense spiritualism of Brittany and Tahiti. Paintings done by Gauguin in Brittany, such as *The Vision After the Sermon* (1888), suggest the rapture that Gauguin witnessed in the peasants around him. Works of art done by Gauguin in Tahiti, such as *Offerings of Gratitude* (c. 1891–93), suggest the moral purity that Gauguin attributed to societies that were removed from the influence of Paris and other urban centers of Europe.

Breton Ballad
The Song of the Souls in Pain[1]

By Father, Son and Holy Ghost,
We greet his house, its head and host,
Greeting and health to great and small—
And bid you straight to praying fall.

When Death knocks with his hand so thin,
At midnight, asking to come in,
No heart but with a quake doth say,
Who is it Death would take away?

But you, be not amazed, therefore,
If we the Dead stand at the door;

1. Reprinted from Théodore Hersart de la Villemarqué, ed., *Barzas-Breiz,* trans. by Tom Taylor (London: Macmillan, 1865), pp. 213–16.

'Tis Jesus bade us hither creep
To waken you, if chance you sleep.

To wake you in this house that bide,
To wake you, old and young beside,
If ruth,[2] alack, live under sky,
For succor in God's name we cry!

Brothers and friends and kinsmen all,
In God's name hear us when we call;
In God's name pray for us, pray sore,[3]
Our children, ah, they pray no more!

They that we fed upon the breast,
Long since to think of us have ceast:
They that we held in our heart's core,
Hold us in loving thought no more!

My son, my daughter, daintily,
On warm soft feather beds ye lie,
Whilst I your mother, I your sire,[4]
Scorch in the purgatory fire.

All soft and still and warm you lie,
The poor souls toss in agony:
You draw your breaths in quiet sleep,
Poor souls in pain their watching keep.

A white shroud and five planks for bed,
A sack of straw beneath the head,
And over it five feet of clay,
Are all Earth's goods we take away.

We lie in fire and anguish-sweat,—
Fire over head, fire under feet,
Fire all above, fire all below—
Pray for the souls that writhe in woe!

Aforetime when on earth we moved,
Parents we had and friends that loved,

2. Pity or compassion.
3. Pray strongly, fervently.
4. Father.

But now that we are dead and gone,
Parents and lovers we have none.

Succor, in God's name, you that may:
Unto the blessèd Virgin pray,
A drop of her dear milk to shed,
One drop, on poor souls sore bestead.

Up from your beds, and speediliè
And throw yourselves on bended knee,
Save those whom ailments sore make lame,
Or Death, already, calls by name!

Tahitian Chant
Gloomy Sacredness Is That Indeed![5]

The *maire*[6] grew for the hard curse,
But a curse with requiem in peace,
Sacredness following thee, O my dear friend!
The 'ie'ie[7] that stretched forth is divided,
Is cut away, alas.
I indeed am clinging [to it]
Like the maire fern.
Oh, our attachment was [firm] as the earth!
Snatched away! Mourning is inadequate
To the sorrow for a lover!
Overwhelmed amid the surf,
Am I struggling unconsoled,
For him leveled, cut off by crime.
A man of long errand was Ma'irûrû,
I awaited him and he still delayed,
Delayed by falling delayed.
But the requiem by my little bird singing,
Oh, the requiems! To break the evil spell
Of the errand to sacred border,
Gloomy sacredness is that indeed!
From anger kindled, in haste consumed.

5. Reprinted, by permission of the publisher, from Teuria Henry and J. M. Orsmond, *Ancient Tahiti* (Honolulu: Bernice P. Bishop Museum, 1928), pp. 591–92. Copyright by Bernice P. Bishop Museum.
6. A type of tree with a close-grained wood.
7. A climbing screw-pine.

On the seaside was my lover,
Standing; Oh, he was standing
For the morning prayer!
He stood in the midst
Of great rage, of great rage brooding [for the]
Great errand of sacrifice,
In the land of many friends!
For the departed spirit, the departed spirit,
Is thy woman friend now weeping,
With requiem of birds.
But frightful was his deed,
To strike [thee] down full length,
To cut, still worse to cause to bite;
These are horrifying little birds [deeds]!
As for the great rage towards us,
My lover has gone away
With short requiem to sky space.
Many prayers are for the outraged,
Loudly did I bewail; I weep, weep,
Mourn, mourn, O I weep for the friend.
Lonely, from many deceptions!
Cling together as the maire fern
Shall we two, as [firm as] land.

16. Thomas Eakins, *The Gross Clinic,* 1875
 Gardner, p. 901, ill. 21:41

 John Simpson, *Memoirs:* "The Horror of Great Darkness," undated
 Washington Ayer, *The First Public Operation Under Anesthesia:* "Gen-
 tlemen, This Is No Humbug," 1846
 Joseph Lister, *An Antiseptic Principle of the Practice of Surgery:* "In
 Beautiful Harmony with Pathological Principles," 1867

The nineteenth-century emphasis on observation and experimentation resulted in
dramatic advances in the field of medicine. Although medical knowledge had in-
creased in such areas as anatomy, medicine remained, until the nineteenth century, a
crude science. Bloodletting was the chief remedy for many diseases; surgical methods
were brutal and painful. Epidemics, aided by the unsanitary conditions of most urban
centers, were recurrent. At the end of the eighteenth century, life expectancy was
about thirty-five years. However, a century later, it had jumped to forty-nine years.

Two of the major gifts of science to humankind were the introduction of anesthesia and antiseptics in medical practice. Anesthesia, first used in surgery in the form of ether in the 1840s, made it possible for patients to survive painful operations without succumbing to shock and for surgeons to develop complex surgical techniques without inflicting torturous pain. Antiseptics made it possible for patients to recuperate from surgery without developing gangrenous and fatal infections.

An American dentist, William Morton (1819–1868), is credited with the adoption of anesthesia by the medical world. Morton proved the efficacy of anesthesia, which had been used for several years in isolated cases of surgery, by a public demonstration at Massachusetts General Hospital in Boston. In October 1846 he administered ether to a patient, Gilbert Abbott, who was scheduled to undergo the surgical removal of a vascular tumor from the left side of his neck. To the astonishment of the surgeon, John Collins Warren, and of the other attendant physicians, the patient felt no pain.

Two different documents clarify the effect of anesthesia on surgical practice. The first document, the *Memoirs* (undated) of an English doctor, John Simpson, includes a description of a leg amputation that he underwent in 1846 before anesthesia became widely known and used. A selection from *Memoirs*, "The Horror of Great Darkness," is presented here. The second document, *The First Public Operation Under Anesthesia*, is a description by a doctor, Washington Ayer, of a public demonstration of ether conducted by Morton; a selection, "Gentlemen, This Is No Humbug," is presented here.

An English surgeon, Joseph Lister (1827–1912), is responsible for the discovery of antiseptics. Building upon Louis Pasteur's theory that bacteria cause infections, Lister began, in 1865, to apply carbolic acid as an antiseptic on wounds. Soon afterward he began to use heat sterilization on surgical instruments. In addition, he developed absorbable ligatures and the drainage tube, both of which eventually came into general use for wounds and incisions.

Lister promoted the principles of antisepsis in a series of scientific papers published in medical journals. One such paper, *An Antiseptic Principle of the Practice of Surgery*, appeared in 1867; a selection, "In Beautiful Harmony with Pathological Principles," is presented here.

In 1875 the Philadelphia surgeon Samuel Gross (1805–1884) was painted by Thomas Eakins (1844–1916). Shown as he conducts surgery in the operating amphitheater of the Jefferson Medical College in Philadelphia, Gross is celebrated by Eakins as a modern hero. Yet Eakins's painting also reveals the uneven acceptance of modern medical knowledge within the scientific community. While Morton's use of ether had been disseminated quickly, Pasteur's germ theory of infection and disease was initially greeted with derision. The painting *The Gross Clinic* shows one of the surgeon's assistants holding an ether-soaked dressing over the patient's face. At the same time, Gross ignores the recent developments on antiseptics in operating theaters and wears his street clothes.

Gross was a prolific writer on medical practices. As late as the 1870s he endeav-

ored to prove that the recent use of antiseptics on wounds was an ill-considered craze and that medications were useless for many types of diseases, including smallpox, scarlatina, measles, typhus, and typhoid fever. Citing the authority of tradition, he lamented the increasing disuse of bloodletting and strongly encouraged his fellow doctors to revive the ancient practice as a therapeutic agent in the treatment of disease.

John Simpson, *Memoirs*[1]
The Horror of Great Darkness

I at once agreed to submit to the operation, but asked a week to prepare for it, not with the slightest expectation that the disease would take a favorable turn in the interval, or that the anticipated horrors of the operation would become less appalling by reflection upon them, but simply because it was so probable that the operation would be followed by a fatal issue that I wished to prepare for death, and what lies beyond it, while my faculties were clear and my emotions were completely undisturbed.

The week, so slow and yet so swift in its passage, at length came to an end, and the morning of the operation arrived. The operation was a more tedious one than some which involved much greater mutilation. It necessitated cruel cutting through inflamed and morbidly sensitive parts, and could not be despatched by a few strokes of the knife.

Of the agony it occasioned I will say nothing. Suffering so great as I underwent cannot be expressed in words, and thus fortunately cannot be recalled. The particular pangs are now forgotten; but the blank whirlwind of emotion, the horror of great darkness, and the sense of desertion by God and man, bordering close upon despair, which swept through my mind and overwhelmed my heart, I can never forget, however gladly I would do so. Only the wish to save others some of my suffering makes me deliberately recall and confess the anguish and humiliation of such a personal experience, nor can I find language more sober or familiar than that which I have used to express feelings, which, happily for us all, are too rare as matters of general experience to have been shaped in the household words.

During the operation, in spite of the pain it occasioned, my senses were preternaturally acute, as I have been told they generally are in patients under such circumstances. I watched all that the surgeon did with fascinated intensity.

I still recall with unwelcome vividness the spreading out of the instru-

1. Reprinted, by permission of the publisher, from Louis L. Snyder, ed., *Fifty Major Documents of the Nineteenth Century* (Princeton, N.J.: D. Van Nostrand, 1955), pp. 69–70. Copyright by Louis L. Snyder.

ments, the twisting of the tourniquet, the first incision, the fingering of the sawed bone, the sponge pressed on the flap, the tying of the blood vessels, the stitching of the skin, and the bloody dismembered limb lying on the floor. Those are not pleasant remembrances. For a long time they haunted me, and even now they are easily resuscitated; and though they cannot bring back the suffering attending the events which gave them a place in my memory, they can occasion a suffering of their own, and be the cause of a disquiet which favors neither mental nor bodily health.

Washington Ayer, *The First Public Operation Under Anesthesia*[2]
Gentlemen, This Is No Humbug

The day arrived; the time appointed was noted on the dial, when the patient was led into the operating-room, and Dr. Warren, with a board of the most eminent surgeons in the State were gathered around the sufferer. All is ready—the stillness oppressive. It had been announced that a test of some preparation was to be made, for which the *astonishing* claim had been made, that it would render the person operated upon free from pain. Those present were incredulous, and as Dr. Morton had not arrived at the time appointed, and fifteen minutes had passed, Dr. Warren said, with significant meaning:

"I presume he is otherwise engaged."

This was followed with a derisive laugh, and Dr. Warren grasped his knife and was about to proceed with the operation; at that moment Dr. Morton entered a side door, when Dr. Warren turned to him, and in a strong voice said:

"Well, Sir, your patient is ready."

In a few minutes he was ready for the surgeon's knife, when Dr. Morton said:

"*Your* patient is ready, Sir."

The operation was for a congenital tumor on the left side of the neck, extending along the jaw to the maxillary gland and into the mouth, embracing the margin of the tongue. The operation was successful; and when the patient recovered he declared that he had suffered no pain.

Dr. Warren then turned to those present and said:

"*Gentlemen, this is no humbug.*"

The conquest of pain had been achieved.

2. Reprinted, by permission of the publisher, from Louis L. Snyder, ed., *Fifty Major Documents of the Nineteenth Century* (Princeton, N.J.: D. Van Nostrand, 1955), pp. 70–71. Copyright by Louis L. Snyder.

Joseph Lister, *An Antiseptic Principle of the Practice of Surgery*[3]
In Beautiful Harmony with Pathological Principles

In the course of an extended investigation into the nature of inflammation, and the healthy and morbid conditions of the blood in relation to it, I arrived several years ago at the conclusion that the essential cause of suppuration[4] in wounds is decomposition brought about by the influence of the atmosphere upon blood or serum retained within them, and, in the case of contused[5] wounds, upon portions of tissue destroyed by the violence of the injury.

To prevent the occurrence of suppuration with all its attendant risks was an object manifestly desirable, but till lately apparently unattainable, since it seemed hopeless to attempt to exclude the oxygen which was universally regarded as the agent by which putrefaction[6] was effected. But when it had been shown by the researches of Pasteur that the septic[7] properties of the atmosphere depended not on the oxygen, or any gaseous constituent, but on minute organisms suspended in it, which owed their energy to their vitality, it occurred to me that decomposition in the injured part might be avoided without excluding the air, by applying as a dressing some material capable of destroying the life of the floating particles. Upon this principle I have based a practice of which I will now attempt to give a short account.

The material which I have employed is carbolic or phenic acid,[8] a volatile organic compound, which appears to exercise a peculiarly destructive influence upon low forms of life, and hence is the most powerful antiseptic with which we are at present acquainted.

The first class of cases to which I applied it was that of compound fractures, in which the effects of decomposition in the injured part were especially striking and pernicious. The results have been such as to establish conclusively the great principle that all local inflammatory mischief and general febrile[9] disturbances which follow severe injuries are due to the irritating and poisonous influence of decomposing blood or sloughs.[10] For these evils are entirely avoided by the antiseptic treatment, so that limbs which would otherwise be unhesitatingly condemned to amputation may be retained, with confidence of the best results.

3. Reprinted from Charles Eliot, ed., *The Harvard Classics: Scientific Papers* (New York: D. F. Collier and Son, 1897), pp. 271–72, 277–78.
4. Pus.
5. Bruised.
6. The decomposition of organic matter, including by bacteria.
7. Causing contamination by producing bacterial decomposition.
8. A white, poisonous mass obtained from coal tar, or a hydroxyl derivative of benzene.
9. Pertaining to or marked by fever; feverish.
10. Masses or layers of dead tissue separated from the underlying or surrounding tissue.

In conducting the treatment, the first object must be the destruction of any septic germs which may have been introduced into the wounds, either at the moment of the accident or during the time which has since elapsed. This is done by introducing the acid of full strength into all accessible recesses of the wound by means of a piece of rag held in dressing forceps and dipped into the liquid. This I did not venture to do in the earlier cases; but experience has shown that the compound which carbolic acid forms with the blood, and also any portions of tissue killed by its caustic action, including even parts of the bone, are disposed of by absorption and organisation, provided they are afterwards kept from decomposing. We are thus enabled to employ the antiseptic treatment efficiently at a period after the occurrence of the injury at which it would otherwise probably fail. . . .

The next class of cases to which I have applied the antiseptic treatment is that of abscesses.[11] Here also the results have been extremely satisfactory, and in beautiful harmony with the pathological principles indicated above. The pyogenic[12] membrane, like the granulations of a sore, which it resembles in nature, forms pus, not from any inherent disposition to do so, but only because it is subjected to some preternatural[13] stimulation. In an ordinary abscess, whether acute or chronic, before it is opened the stimulus which maintains the suppuration is derived from the presence of pus pent up within the cavity. When a free opening is made in the ordinary way, this stimulus is got rid of, but the atmosphere gaining access to the contents, the potent stimulus of decomposition comes into operation, and pus is generated in greater abundance than before. But when the evacuation is effected on the antiseptic principle, the pyogenic membrane, freed from the influence of the former stimulus without the substitution of a new one, ceases to suppurate (like the granulations of a sore under metallic dressing), furnishing merely a trifling amount of clear serum, and, whether the opening be dependent or not, rapidly contracts and coalesces. At the same time any constitutional symptoms previously occasioned by the accumulation of the matter are got rid of without the slightest risk of the irritative fever or hectic[14] hitherto so justly dreaded in dealing with large abscesses.

11. Localized collections of pus in the tissues of the body, often accompanied by swelling and inflammation and often caused by bacteria.
12. Pus-producing.
13. Out of the ordinary course of nature; abnormal.
14. A fever attended by hot skin and wasting away of the flesh.

17. Mary Cassatt, *The Bath,* 1891–92
Gardner, p. 929, ill. 21:77; Janson, p. 670, ill. 920

Catherine Beecher, *Treatise on Domestic Economy:* "The Duties of Subordination," 1841
Susan Brownell Anthony, Trial Transcript: "This High-Handed Outrage upon My Citizen's Rights," 1872

Industrialization and the growth of modern cities brought great changes to the lives of European and American women. The rigid division of labor that developed between the sexes in the industrialized world meant that women faced great injustice if they tried to move into the man's world, the world of employment outside the home. Unsympathetic or hostile employers denied women well-paying jobs, and women's wages were almost always lower than a man's, even for the same work.

One response to the restricted opportunities afforded women in the workplace was the idealization of home and family. Married women of the middle class were urged to regard their relationships with their husbands and children as the focus of all their interests and efforts.

Catherine Beecher (1800–1878), the daughter of the famous preacher Lyman Beecher and the sister of Harriet Beecher Stowe and Henry Ward Beecher, made a name for herself by promoting her deep belief that the woman's sphere was the home. She argued that the subordination of a wife to her husband was both democratic and Christian. A selection from her *Treatise on Domestic Economy* (1841), "The Duties of Subordination," is presented here.

Another response to the restricted opportunities afforded women in the workplace was the re-invigoration of the campaign to achieve equal rights. The demand for recognition of women's rights surfaced in the suffrage movement. The right to vote became the basic demand, because electoral power was regarded as the basis for betterment of all aspects of women's political, legal, and financial status.

One of the important leaders of the women's suffrage movement in the United States was Susan Brownell Anthony (1820–1906). An influential speaker and writer, Anthony was also a skilled organizer and an effective initiator of action. For more than fifty years she contributed, despite continuous opposition, to the struggle for equality for women.

In 1872 Anthony challenged the legality of the Fourteenth Amendment, which granted the vote to all "male inhabitants." She claimed the right of women to vote by registering and voting in Rochester, New York, an act that resulted in her being arrested, tried, and fined for violating the law. Anthony's trial created as much furor as her arrest. Judge Hunt, the judge who presided over her trial, denied Anthony the right to testify in her own defense, and ruled that the Fourteenth Amendment was inapplicable. He further informed the jury that there was no question about the substantiation of the charges and then directed the jury to return a verdict of guilt. Finally, Hunt rejected a request for a new trial and imposed a fine on the defendant,

which Anthony, because of her belief that the law was wrong, refused to pay. A selection from the transcript (1872) of Anthony's trial, "This High-Handed Outrage upon My Citizen's Rights," is presented here. In the final moments of her courtroom trial, Anthony vehemently argued that a system of government that disenfranchises half of its citizens represents a system of political subjection.

The emotional satisfaction that many women achieved through their focus on their homes and families was celebrated by Mary Cassatt (1844–1926) in paintings such as *The Bath* (1891–92). At the same time that she captured the deep bonds of love that united the women in her own family to their children, Cassatt rejected marriage for herself and chose, instead, a life of personal independence and a career in art.

Catherine Beecher, *Treatise on Domestic Economy*[1]
The Duties of Subordination

There are some reasons why American women should feel an interest in the support of the democratic institutions of their country, which is important that they should consider. The great maxim, which is the basis of all our civil and political institutions, is, that "all men are created equal," and that they are equally entitled to "life, liberty, and the pursuit of happiness."

But it can readily be seen, that this is only another mode of expressing the fundamental principle which the Great Ruler of the Universe has established, as the law of His eternal government. "Thou shall love thy neighbor as thyself"; and "Whatsoever ye would that men should do to you, do ye even so to them." These are the Scripture forms, by which the Supreme Lawgiver requires that each individual of our race shall regard the happiness of others, as of the same value as his own; and which forbids any institution, in private or civil life, which secures advantages to one class, by sacrificing the interests of another.

The principles of democracy, then, are identical with the principles of Christianity.

But, in order that each individual may pursue and secure the highest degree of happiness within his reach, unimpeded by the selfish interests of others, a system of laws must be established, which sustain certain relations and dependencies in social and civil life. What these relations and their attending obligations shall be, are to be determined, not with reference to the wishes and interests of a few, but solely with reference to the general good of all; so that each individual shall have his own interest, as much as the public benefit, secured by them.

For this purpose, it is needful that certain relations be sustained, that

1. Reprinted from Catherine Beecher, *Treatise on Domestic Economy*, revised third edition (New York: Harper and Brothers, 1847), pp. 1–3, 4, 9–10, 13–14.

involve the duties of subordination. There must be the magistrate and the subject, one of whom is the superior, and the other the inferior. There must be the relations of husband and wife, parent and child, teacher and pupil, employer and employed, each involving the relative duties of subordination. The superior in certain particulars is to direct, and the inferior is to yield obedience. Society could never go forward, harmoniously, nor could any craft or profession be successfully pursued, unless these superior and subordinate relations be instituted and sustained.

But who shall take the higher, and who the subordinate, stations in social and civil life? This matter, in the case of parents and children, is decided by the Creator. He has given children to the control of parents, as their superiors, and to them they remain subordinate, to a certain age, or so long as they are members of their household. And parents can delegate such a portion of their authority to teachers and employers, as the interests of their children require. . . .

The tendencies of democratic institutions, in reference to the rights and interest of the female sex, have been fully developed in the United States; and it is in this aspect, that the subject is one of peculiar interest to American women. In this country, it is established, both by opinion and by practice, that women have an equal interest in all social and civil concerns; and that no domestic, civil, or political institution, is right, that sacrifices her interest to promote that of the other sex. But in order to secure her the more firmly in all these privileges, it is decided, that, in the domestic relation, she take a subordinate station, and that, in civil and political concerns, her interests be intrusted to the other sex, without her taking any part in voting, or in making and administering laws. . . .

It appears, then, that it is in America, alone, that women are raised to an equality with the other sex; and that, both in theory and practice, their interests are regarded as of equal value. They are made subordinate in station, only where a regard to their best interests demands it, while, as if in compensation for this, by custom and courtesy, they are always treated as superiors. Universally, in this country, through every class of society, precedence is given to woman, in all the comforts, conveniences, and courtesies, of life. . . .

If this be so, as none will deny, then to American women, more than to any others on earth, is committed the exalted privilege of extending over the world those blessed influences, that are to renovate degraded man, and "clothe all climes[2] with beauty."

2. Tracts or regions of the earth.

No American woman, then, has any occasion for feeling that hers is an humble or insignificant lot. The value of what an individual accomplishes, is to be estimated by the importance of the enterprise achieved, and not by the particular position of the laborer. The drops of heaven that freshen the earth are each of equal value, whether they fall in the lowland meadow, or the princely parterre.[3] The builders of a temple are of equal importance, whether they labor on the foundations, or toil upon the dome.

Thus, also, are those labors that are to be made effectual in the regeneration of the earth. The woman who is rearing a family of children; the woman who labors in the schoolroom; the woman who, in her retired chamber, earns, with her needle, the mite[4] to contribute for the intellectual and moral elevation of her country; even the humble domestic, whose example and influence may be molding and forming young minds, while her faithful services sustain a prosperous domestic state;—each and all may be cheered by the consciousness, that they are agents in accomplishing the greatest work that ever was committed to human responsibility. It is the building of a glorious temple, whose base shall be coextensive with the bounds of the earth, whose summit shall pierce the skies, whose splendor shall beam on all lands, and those who hew the lowliest stone, as much as those who carve the highest capital, will be equally honored when its top-stone shall be laid, with new rejoicings of the morning stars, and shouting of the sons of God.

Susan Brownell Anthony, *Trial Transcripts*[5]
This High-Handed Outrage upon My Citizen's Rights

Judge Hunt (Ordering the defendant to stand up)—Has the prisoner anything to say why sentence shall not be pronounced?

Miss Anthony—Yes, your honor, I have many things to say; for in your ordered verdict of guilty, you have trampled under foot every vital principle of our government. My natural rights, my civil rights, my political rights, my judicial rights, are all alike ignored. Robbed of the fundamental privilege of citizenship, I am degraded from the status of a citizen to that of a subject; and not only myself individually, but all of my sex, are, by your honor's verdict, doomed to political subjection under this, so-called, form of government.

Judge Hunt—The Court cannot listen to a rehearsal of arguments the prisoner's counsel has already consumed three hours in presenting.

3. An ornamental arrangement of flower beds of different shapes and sizes.
4. A very small sum of money.
5. *Account of . . . the Trial of Susan B. Anthony*, pp. 81–85. Reprinted in Judith Papachristou, *Women Together* (New York: Alfred A. Knopf, 1976), pp. 102–3.

Miss Anthony—May it please your honor, I am not arguing the question, but simply stating the reasons why sentence cannot, in justice, be pronounced against me. Your denial of my citizen's right to vote, is the denial of my right of consent as one of the governed, the denial of my right of representation as one of the taxed, the denial of my right to a trial by a jury of my peers as an offender against law, therefore, the denial of my sacred rights to life, liberty, property and—

Judge Hunt—The Court cannot allow the prisoner to go on.

Miss Anthony—But your honor will not deny me this one and only poor privilege of protest against this high-handed outrage upon my citizen's rights. May it please the Court to remember that since the day of my arrest last November, this is the first time that either myself or any person of my disfranchised class has been allowed a word of defense before judge or jury—

Judge Hunt—The prisoner must sit down—the Court cannot allow it.

Miss Anthony—All my prosecutors, from the 8th ward corner grocery politician, who entered the complaint, to the United States Marshal, Commissioner, District Attorney, District Judge, your honor on the bench, not one is my peer, but each and all are my political sovereigns; and had your honor submitted my case to the jury, as was clearly your duty, even then I should have had just cause of protest, for not one of those men was my peer; but, native or foreign born, white or black, rich or poor, educated or ignorant, awake or asleep, sober or drunk, each and every man of them was my political superior; hence, in no sense, my peer. Even, under such circumstances, a commoner in England, tried before a jury of Lords, would have far less cause to complain than should I, a woman, tried before a jury of men. Even my counsel, the Hon. Henry R. Selden, who has argued my cause so ably, so earnestly, so unanswerably before your honor, is my political sovereign. Precisely as no disfranchised person is entitled to sit upon a jury, and no woman is entitled to the franchise, so, none but a regularly admitted lawyer is allowed to practice in the courts, and no woman can gain admission to the bar—hence, jury, judge, counsel, must all be the superior class.

Judge Hunt—The Court must insist—the prisoner has been tried according to the established forms of law.

Miss Anthony—Yes, your honor, but by forms of law all made by men, interpreted by men, administered by men, in favor of men, and against women; and hence, your honor's ordered verdict of guilty, against a United States citizen for the exercise of *"that citizen's right to vote,"* simply because that citizen was a woman and not a man. . . . As . . . the slaves who got their freedom must take it over, or under, or through the unjust forms of law, precisely so, now, must women, to get their right to a voice in this govern-

ment, take it and I have taken mine, and mean to take it at every possible opportunity.

18. Louis Sullivan, *Guaranty (Prudential) Building,* **Buffalo, New York, 1894–95**
Gardner, p. 948, ill. 21:98

Charles Darwin, *Origin of Species:* "The Struggle for Life," 1859
Herbert Spencer, *Principles of Ethics:* "The Evolution of Conduct," 1879–93

Science and psychology contributed heavily toward making the last half of the nineteenth century an age of materialism. They also provided scientific evidence in support of two convictions of the Enlightenment: that people were molded by their environment and that progress toward human perfection was possible. Of the sciences, biology loomed as the most important; and of the biologists, Charles Darwin stood above all his colleagues.

The English naturalist Charles Darwin (1809–1882) studied first for a medical career and then for the ministry, but became uninterested in both professions during training. His interest in natural history, however, brought him an official appointment aboard the *Beagle.* During the five-year scientific voyage to Latin America and the South Pacific (1831–36), Darwin studied geological specimens of the different animal species he encountered. Upon his return, he carefully and methodically worked over the information from his copious notes, and he assimilated additional data from every other source he could find. The result was the formulation of his concept of organic evolution.

A modest man, Darwin nonetheless was willing to propose and defend controversial ideas, which brought him worldwide attention. Questioning the then current belief in the special creation of each species, Darwin proposed that all life descended from a common ancestral origin. He suggested that all organisms are engaged in a constant struggle for existence. Variations among members of the same species, which proved useful to a plant or animal in its struggle for survival, were transmitted to offspring and eventually were spread to the entire species. This process he called natural selection. Darwin published his theory, along with a massive body of evidence, in *Origin of Species* (1859). A selection from it, "The Struggle for Life," is presented here.

One of the phrases most commonly associated with evolution, "the survival of the fittest," was coined not by Darwin but by Herbert Spencer (1820–1903), an English philosopher. Spencer had become imbued with the theory of evolution even before Darwin published a full account of his findings. Spencer determined to apply evolutionary concepts to societies. Societies, he thought, were organisms that had

evolved from primitive, warlike organizations to industrialized, affluent states. Because this evolution occurred as a result of their struggle with their environment, Spencer believed that human societies, like natural organisms, must be governed by the principle of "the survival of the fittest." Therefore, progress required that individuals who were strong and able should move forward unimpeded by social obligations, while individuals who were weak and disadvantaged should fall, unaided, by the wayside. "Pervading all Nature we may see at work a stern discipline which is a little cruel that it may be very kind," he declared. "It seems hard that an unskillfulness which with all his efforts he cannot overcome, should entail hunger upon the artisan. It seems hard that a laborer incapacitated by sickness from competing with his stronger fellows should have to bear the resulting privations. It seems hard that widows and orphans should be left to struggle for life or death. Nevertheless, when regarded not separately but in connection with the interests of universal humanity, these harsh fatalities are seen to be full of beneficence—the same beneficence which brings to early graves the children of diseased parents, and singles out the intemperate and the debilitated as the victims of an epidemic."

Spencer set forth his ideas in a two-volume work, *Principles of Ethics* (1879–93). A selection from it, "The Evolution of Conduct," is presented here.

Spencer's belief that the poor were the ill-fated weak and that the prosperous were the chosen strong was appealing to industrialists throughout the Western world. In the United States, prominent champions of social Darwinism included Andrew Carnegie (1835–1919) and John D. Rockefeller (1839–1937). Economic competitiveness led such men to borrow the phrase "survival of the fittest" to justify their business practices. It also led them to construct the tall steel structures called skyscrapers.

Louis Sullivan (1856–1924) has been called the first modern architect. In structures such as the *Guaranty (Prudential) Building* (1894–95), Sullivan employed the contemporary materials and techniques that made possible the construction of commercial buildings of enormous size.

Charles Darwin, *Origin of Species*[1]
The Struggle for Life

If under changing conditions of life organic beings present individual differences in almost every part of their structure, and this cannot be disputed; if there be, owing to their geometrical rate of increase, a severe struggle for life at some age, season, or year, and this certainly cannot be disputed; then considering the infinite complexity of the relations of all organic beings to each other and to their conditions of life, causing an infinite diversity in structure, constitution, and habits, to be advantageous to them, it would be a most extraordinary fact if no variation had ever occurred useful to each

1. Reprinted from Charles Darwin, *The Origin of Species* (New York: Random House, 1962), pp. 98–99.

being's own welfare, in the same manner as so many variations have occurred useful to man. But if variations useful to any organic being ever do occur, assuredly individuals thus characterised will have the best chance of being preserved in the struggle for life; and from the strong principle of inheritance, these will tend to produce offspring similarly characterised. This principle of preservation, or the survival of the fittest, I have called Natural Selection. It leads to the improvement of each creature in relation to its organic and inorganic conditions of life; and consequently, in most cases, to what must be regarded as an advance in organisation. Nevertheless, low and simple forms will long endure if well fitted for their simple conditions of life.

Natural selection, on the principle of qualities being inherited at corresponding ages, can modify the egg, seed, or young, as easily as the adult. Amongst many animals, sexual selection will have given its aid to ordinary selection, by assuring to the most vigorous and best adapted males the greatest number of offspring. Sexual selection will also give characters useful to the males alone, in their struggles or rivalry with other males; and these characters will be transmitted to one sex or to both sexes, according to the form of inheritance which prevails.

Whether natural selection has really thus acted in adapting the various forms of life to their several conditions and stations, must be judged by the general tenor and balance of evidence given in the following chapters. But we have already seen how it entails extinction; and how largely extinction has acted in the world's history, geology plainly declares. Natural selection also leads to divergence of character; for the more organic beings diverge in structure, habits, and constitution, by so much the more can a large number be supported on the area,—of which we see proof by looking to the inhabitants of any small spot, and to the productions naturalised in foreign lands. Therefore, during the modification of the descendants of any one species, and during the incessant struggle of all species to increase in numbers, the more diversified the descendants become, the better will be their chances of success in the battle for life. Thus the small differences distinguishing varieties of the same species, steadily tend to increase, till they equal the greater differences between species of the same genus, or even of distinct genera.

We have seen that it is the common, the widely-diffused and widely-ranging species, belonging to the larger genera within each class, which vary most; and these tend to transmit to their modified offspring that superiority which now makes them dominant in their own countries. Natural selection, as has just been remarked, leads to divergence of character and to much extinction of the less improved and intermediate forms of life. On these principles, the nature of the affinities, and the generally well-defined distinc-

tions between the innumerable organic beings in each class throughout the world, may be explained. It is a truly wonderful fact—the wonder of which we are apt to overlook from familiarity—that all animals and all plants throughout all time and space should be related to each other in groups, subordinate to groups, in the manner which we everywhere behold—namely, varieties of the same species most closely related, species of the same genus less closely and unequally related, forming sections and sub-genera, species of distinct genera much less closely related, and genera related in different degrees, forming sub-families, families, orders, sub-classes and classes. The several subordinate groups in any class cannot be ranked in a single file, but seem clustered round points, and these round other points, and so on in almost endless cycles. If species had been independently created, no explanation would have been possible of this kind of classification; but it is explained through inheritance and the complex action of natural selection, entailing extinction and divergence of character, as we have seen illustrated in the diagram.

Herbert Spencer, *Principles of Ethics*[2]
The Evolution of Conduct

We have become quite familiar with the idea of an evolution of structures throughout the ascending types of animals. To a considerable degree we have become familiar with the thought that an evolution of functions has gone on *pari passu*[3] with the evolution of structures. Now advancing a step, we have to frame a conception of the evolution of conduct, as correlated with this evolution of structures and functions. . . .

Evolution in conduct considered under its moral aspect, is, like all other evolution, towards equilibrium. I do not mean that it is towards the equilibrium reached at death, though this is, of course, the final state which the evolution of the highest man has in common with all lower evolution; but I mean that it is towards a moving equilibrium.

We have seen that maintaining life, expressed in physical terms, is maintaining a balanced combination of internal actions in face of external forces tending to overthrow it; and we have seen that advance towards a higher life, has been an acquirement of ability to maintain the balance for a longer period, by the successive additions of organic appliances which by their action counteract, more and more fully, the disturbing forces. Here, then, we

2. Reprinted from Herbert Spencer, *Principles of Ethics* (New York: A. Appleton, 1896), vol. 1, pp. 8, 41–74.
3. Latin term for side by side, at equal pace.

are led to the conclusion that the life called moral is one in which this maintenance of the moving equilibrium reaches completeness, or approaches most nearly to completeness.

This truth is clearly disclosed on observing how those physiological rhythms, which vaguely show themselves when organization begins, become more regular as well as more various in their kinds, as organization advances. Periodicity is but feebly marked in the actions, inner and outer, of the rudest types. Where life is low there is passive dependence on the accidents of the environment; and this entails great irregularities in the vital processes. . . . Much higher up we still find very imperfect periodicities; as in the inferior molluscs which, though possessed of vascular systems, have no proper circulation, but merely a slow movement of the crude blood, now in one direction through the vessels and then, after a pause, in the opposite direction. Only with well-developed structures do there come a rhythmical pulse and a rhythm of the respiratory action. . . .

So it is as we ascend from savage to civilized and from the lowest among the civilized to the highest. The rhythm of external actions required to maintain the rhythm of internal actions, becomes at once more complicated and more complete; making them into a better moving equilibrium. The irregularities which their conditions of existence entail on primitive men, continually cause wide deviations from the mean state of the moving equilibrium—wide oscillations; which imply imperfection of it for the time being, and bring about its premature overthrow. In such civilized men as we call ill-conducted, frequent perturbations of the moving equilibrium are caused by those excesses characterizing a career in which the periodicities are much broken; and a common result is that the rhythm of the internal actions being often deranged, the moving equilibrium, rendered by so much imperfect, is generally shortened in duration, while one in whom the internal rhythms are best maintained is one by whom the external actions required to fulfil all needs and duties, severally performed on the recurring occasion, conduce to a moving equilibrium that is at once involved and prolonged.

Of course the implication is that the man who thus reaches the limit of evolution, exists in a society congruous with his nature—is a man among men similarly constituted, who are severally in harmony with that social environment which they have formed. This is, indeed, the only possibility. For the production of the highest type of man, can go on only *pari passu* with the production of the highest type of society. The implied conditions are those before described as accompanying the most evolved conduct—conditions under which each can fulfil all his needs and rear the due number of progeny, not only without hindering others from doing the like, but while aiding them

in doing the like. And evidently, considered under its physical aspect, the conduct of the individual so constituted, and associated with like individuals, is one in which all the actions, that is the combined motions of all kinds, have become such as duly to meet every daily process, every ordinary occurrence, and every contingency in his environment. Complete life in a complete society is but another name for complete equilibrium between the co-ordinated activities of each social unit and those of the aggregate of units. . . .

Conduct as actually known to us in perception and not as interpreted into the accompanying feelings and ideas, consists of combined motions. On ascending through the various grades of animate creatures, we find these combined motions characterized by increasing coherence, increasing definiteness considered singly and in their co-ordinated groups, and increasing heterogeneity; and in advancing from lower to higher types of man, as well as in advancing from the less moral to the more moral type of man, these traits of evolving conduct become more marked still. Further, we see that the increasing coherence, definiteness, and heterogeneity, of the combined motions, are instrumental to the better maintenance of a moving equilibrium. Where the evolution is small this is very imperfect and soon cut short; with advancing evolution, bringing greater power and intelligence, it becomes more steady and longer continued in face of adverse actions; in the human race at large it is comparatively regular and enduring; and its regularity and enduringness are greatest in the highest.

19. Edvard Munch, *The Scream*, c. 1895
Gardner, p. 944, ill. 21:92; Janson, p. 694, ill. 958

August Strindberg, *The Link:* "I Will Scream Myself Tired Against God," 1893

As the nineteenth century drew to a close, the optimism fostered by the advances in science gave way to a pessimism about the fundamental elements of human nature. Despair was a theme that surfaced in the thought of many writers and artists.

One such writer was the Swedish playwright, novelist, and short-story writer August Strindberg (1849–1912). A childhood marred by emotional insecurity, poverty, neglect, and the religious fanaticism of his grandmother resulted in a deep unhappiness that haunted Strindberg throughout adulthood.

Many of Strindberg's plays reflect the emotional stress of the playwright's life, a stress that was intensified by alcoholism, three divorces, and the loss of the custody of his children. One such work is *The Link* (1893). *The Link* centers on the problems

of marriage and divorce. A nobleman, Baron Sprengel, and his wife seek a divorce. But they are linked by their child. In their court battle to obtain custody, the husband and wife both vilify each other in such bitter terms that the judge makes their son a ward of the court. In the final scene, the baron and baroness lament the loss of their child and the misery and loneliness and despair that await them. A selection from the last scene of *The Link*, "I Will Scream Myself Tired Against God," is presented here.

Despair invaded the personal life and permeated the work of the Norwegian artist Edvard Munch (1863–1944). The second eldest of five children, he endured a childhood of deep sorrow. His mother died of tuberculosis when he was five years old, and his eldest sister died of the same disease ten years later. His father and brother also died while Munch was a youth. Another sister became mentally ill. The specter of terminal illness and death that filled his childhood was to preoccupy him throughout his life.

A friend of August Strindberg, Munch invested his works with emotive power and a concentrated energy that made it deeply expressive of the basic misery and fears of human existence; one such painting is *The Scream* (c. 1895). The painting presages the mental breakdown that Munch experienced in 1908. At the same time it conveys the unbearable anguish and ultimate loneliness of the modern individual.

August Strindberg, *The Link*[1]
I Will Scream Myself Tired Against God

BARON. Both of us are to be pitied. We tried to avoid the rocks that beset the marriage by living unmarried as husband and wife; but nevertheless we quarreled, and we were sacrificing one of life's greatest joys, the respect of our fellow-men—and so we were married. But we must needs steal a march on the social body and its laws. We wanted no religious ceremony, but instead we wriggled into a civil marriage. We did not want to depend on each other—we were to have no common pocket-book and to insist on no personal ownership of each other—and with that we fell right back into the old rut again. Without wedding ceremony, but with a marriage contract! And then it went to pieces. I forgave your faithlessness, and for the child's sake we lived together in voluntary separation—and freedom! But I grew tired of introducing my friend's mistress as my wife—and so we had to get a divorce. Can you guess—do you know against whom we have been fighting? You call him God, but I call him nature. And that was the master who egged us on to hate each other, just as he egged people on to love each other. And now we are condemned to keep on tearing each other as long as a spark of life remains. New proceedings in the higher court, reopening of the case, report

1. Reprinted, by permission of the publisher, from August Strindberg, *Plays,* trans. by Edwin Björkman (New York: Charles Scribner's Sons, 1912), pp. 141–43. Copyright by Charles Scribner's Sons.

by the Vestry Board, decision by the Supreme Court. Then comes my complaint to the Attorney-General, my application for a guardian, your objections and counter-suits: From pillory to post! Without hope of a merciful executioner! Neglect of the property, financial ruin, scamped education for the child! And why do we not put an end to these two miserable lives? Because the child stays our hands! You cry, but I cannot! Not even when my thoughts run ahead to that night that is waiting for me in a home laid waste! And you, poor Helen, who must go back to your mother! That mother whom you once left with such eagerness in order to get a home of your own. To become her daughter once more—and perhaps find it worse than being a wife! One year! Two years! Many years! How many more do you think we can bear to suffer?

BARONESS. I shall never go back to my mother. Never! I shall go out on the high-roads and into the woods so that I may find a hiding-place where I can scream—scream myself tired against God, who has put this infernal love into the world as a torment for us human creatures—and when night comes, I shall seek shelter in the Pastor's barn, so that I may sleep near my child.

BARON. You hope to sleep to-night—you?

IX

Early Twentieth-Century Art

1. Pablo Picasso, *Les Demoiselles d'Avignon,* **1907**
Gardner, p. 960, ill. 22:6; Janson, p. 717, ill. 998

Anonymous Zulu poems, "Zulu, Son of Nogandaya," and "Mnkabayi, Daughter of Jama," undated

Between 1880 and 1914 the colonial empires of European nations expanded rapidly. The most spectacular manifestation of this new phase of imperialism was the seizure of Africa.

As late as 1880, European nations controlled only 10 percent of the African continent. During the following two decades, however, the situation changed rapidly. Improvements in transportation systems, technological changes in weaponry, and advances in tropical medicine made it easier for Europeans to enter, conquer, and control the continent. Once explorers such as Henry Morton Stanley (1841–1904) had charted the routes, European armies, administrators, and colonists moved quickly into Africa. Britain, France, Germany, and Italy scrambled for African possessions, with voracious appetites to acquire land, natural resources, and new markets. By 1900 almost the entire continent had been partitioned and placed under European rule. Only Ethiopia in northwest Africa and Liberia on the west African coast remained independent.

European nations received many benefits from Western colonial expansion, but the impact upon the lives of the African peoples was profoundly disruptive. Not only were traditional patterns of rulership and trade threatened by the imposition of colonial government and by the establishment of Western mercantile practices, but the established beliefs, values, and cultural mores were weakened by the spread of Christian religion and European secular ideology. African people underwent a crisis of identity—a crisis made more acute by the assumption of superiority on the part of the white intruders.

But at the same time that the colonization of Africa encroached upon native culture, it brought new forms of oral and visual expression to Western attention. Westerners were attracted, for instance, to the oral poetry of Africa. One region in which poetry thrived was among the Zulu people of South Africa. The Zulu lived in homesteads or kraals consisting of simple huts arranged in a circle around a cattle-fold. The homesteads were under control of the male head of the family. Groups of homesteads acknowledged their obedience to the lineage heads, who, in turn, submitted to the authority of the clan head or tribal chief. One of the most common forms of Zulu literature was the praise-poem. While most praise-poems extolled the qualities of the tribal chief or warrior, some vaunted the strengths of women. These women generally were individuals who combined royal blood with outstanding personalities. Two examples of Zulu praise-songs are presented here. The first, "Zulu, Son of Nogandaya," praises a tribal chief; the second, "Mnkabayi, Daughter of Jama," praises a royal woman.

Westerners were also fascinated by African sculpture. One artist whose work shows this fascination was Pablo Picasso (1881–1973). Throughout his long career, Picasso absorbed elements from many visual sources. His works reveal not only his admiration for masters in the Western tradition but also his excitement about art from non-Western traditions. In 1907 he visited the ethnographic museum in Paris, where he saw African sculpture. The impact of this visit is apparent in the painting *Les Demoiselles d'Avignon* (1907). The two figures on the right side of the painting are depicted in an incisive manner that reflects the dynamic angles and edges of African art.

Anonymous Zulu Poem
Zulu, Son of Nogandaya[1]

Storm[2] that thundered in the open,
Where there was neither thorn-tree nor wattle for shelter;
Zulu who is like Ntima[3] of the Yimaneni[4] kraal,
Double defender who is like the son of Jobe;[5]
Tall grass that cannot be penetrated anywhere,
Grass that has not been burnt;[6]
Runner that eventually arrived at Nkilimbeni.[7]

1. Reprinted, by permission of the publisher, from Trevor Cope, ed., *Izibongo: Zulu Praise-Poems*, collected by James Stuart and translated by Daniel Malcolm (Oxford: Oxford University Press, 1968), pp. 178–180. Copyright by Oxford University Press.
2. A pun on his name: *UZulu* is a personification derived from *izulu* ("sky" or "storm"), which controls *lilla* concords. *UZulu,* his name, controls the concords of the personal gender.
3. A hero of the Mthethwa tribe.
4. One of the kraals of Dingiswayo, the Mthethwa chief.
5. The Mthethwa chief; his son was Dingiswayo.
6. Last season's grass is impenetrable until it has been burnt.
7. An important battle which he almost missed.

Big crowd that consumed fermenting beer,
Whey that was left over in the little huts;[8]
Exploder like a flame of fire,
Fly of great courage,
He who exclaimed at the insulting language[8]
That was directed against Shaka at Mbelebeleni.[9]
Well-built warrior that covered himself with branches,
And when he arose he captured the children of Nxaba of the Gobe clan;
Grass of many hues and shades,
Ant-bear that digs a burrow in which it does not lie,[10]
Trampler across the burnt grass of the enemy,
Giant that raided the Pondos,
He who refused to be limited for he imposed no limit on himself.
Huge chest on which tears were shed,[11]
Arm that defended the vitals
From the warriors of Mzilikazi;[12]
Huge frame that was like Kranskop,[13]
Fire that raged like a furnace.
Raider of fat while it is still boiling,[14]
Wailing that was heard before and after an event,
Because he ate up Mbanzana in the servants' quarters;
News that came first[9] to Shaka[10] at Mbelebeleni,[11]
Coming with Kholiwe, the headman of Makhasana.[12]
Hungry one that captured a small parcel of Mzilikazi's cattle,
Decorated one that plunges into the deep pools,[13]
The first in the van of the Zulu attack.
Milk of numberless cattle;
Earth split open that I may dig and come in![14]
Hero on both fronts,
That of the enemy and that of the home,[15]
Black one that swept through the court of Dibandlela.[16]

8. The significance of this praise is obscure.
9. An expression indicating his fame.
10. *Dlungwana*, the ferocious one.
11. Shaka's main military kraal.
12. Chief of the Thembe tribe in Tongaland.
13. He was reputed to plunge through pools or rivers when in pursuit of an enemy.
14. This praise indicates the only escape from such a warrior.
15. His fame spread far and wide.
16. The grandfather of the Magaye, chief of the Cele clan.

Anonymous Zulu Poem
Mnkabayi, Daughter of Jama[17]

Father of guile![18]
 Cunning one of the Hoshoza people,
Who devours a person tempting him with a story;
She killed Bhedu amongst the medicine men,
And destroyed Mkhongoyiyiyana amongst the Ngadinis,
And killed Bheje amongst the diviners.
Morass of Menzi,[19]
That caught people and finished them off;
I saw by Nohela son of Mlilo, the fire-that-burns-on-every-hill,[20]
For it caught him and he disappeared.
Beast that lows on Sangoyana,[21]
It lowed and its voice pierced the sky,
It went and was heard by Gwabalanda[22]
Son of Mndaba of the Khumalo clan.
 Maid that matured and her mouth dried up,
And then they criticized her amongst the old women.[23]
She who allays for people their anxiety,
They catch it and she looks at it with her eyes.[24]
The opener of all the main gates so that people may enter,
The owners of the home enter by the narrow side-gates.[25]
Sipper for others of the venom of the cobra,[26]
The Mhlathuzi river will flood at midday.
Little mouse that started the runs at Malandela's,[27]
And thought it was the people of Malandela
Who would thereby walk along all the paths.[28]

17. Reprinted by permission of the publisher, from Trevor Cope, ed., *Izibongo: Zulu Praise Poems,* collected by James Stuart and translated by Daniel Malcolm (Oxford: Oxford University Press, 1968), p. 172. Copyright by Oxford University Press.
18. Mnkabayi is addressed as a man in the praise-name *Soqili,* as the prefix *uso-* indicates a man. This is significant as a reflection of character.
19. A praise-name used for Zulu royalty, meaning "Creator."
20. The praise-name of Nohela, who was evidently destroyed by Mnkabayi.
21. A hill overlooking Mgungundlovu, the capital kraal of Dingane.
22. She brought about his destruction too.
23. This praise is extremely obscure, but it seems to refer to her rejection of men and marriage.
24. She was willing and able to settle people's problems for them.
25. She was easily approachable and an avenue of advancement for people, regardless of status.
26. She protected people from the displeasure of the chief.
27. The father of Zulu, the founder of the Zulu clan.
28. A reference to the plots she laid to determine the course of history for the people of Malandela.

2. Gustav Klimt, *Death and Life*, 1908 and 1911
Gardner, p. 956, ill. 22:2

Gustav Klimt, *The Kiss*, 1907–8
Janson, p. 695, ill. 959

Sigmund Freud, *On the Origin of Psychoanalysis:* "The Repressed Impulse," 1910

The scientific and intellectual revolutions of the seventeenth century had a profound impact upon nearly every aspect of human society. By the early twentieth century, it was evident that a new revolution in scientific and intellectual thought was occurring. One revolutionary thinker was Sigmund Freud (1856–1939).

The founder of psychoanalysis, Freud was born in Moravia, a province of Austria. As a child, he moved to Vienna, where he spent nearly his entire life. Although trained as a physician, Freud soon developed an interest in treating mental disorders. Freud's approach assigned primary importance to the non-rational, unconscious forces within the personality. His treatment was based upon the analysis of his patient's discourse, which he encouraged by creating relaxed settings for his treatment.

His research and practice led Freud to develop a theory explaining the psychical apparatus of the human mind. The primary mental apparatus he called the id. Present at birth, the id is the unconscious self, which contains the instinctual drives and impulses repressed from consciousness. A second mental apparatus is the superego. The superego is the conscience, the collection of conscious and unconscious values derived from culture, which restricts and condemns the impulses of the id. The third mental apparatus is the ego. The ego is the conscious self, which tries to maintain a balance between the id and the superego, and, at the same time, seeks to maximize pleasure and minimize pain. Our mental health, according to Freud, depends upon the interaction of these three apparatuses. Too great a conflict between the id and the superego is one cause for a mental breakdown. In addition, Freud argued that unhealthy childhood relationships with one's parents were a common source of mental illness.

The most controversial aspects of Freud's ideas concern human sexuality. Freud viewed sexuality as a crucial determinant in either the normal or abnormal development of an individual. He argued that sexual drives begin in infancy and end only with death. And he cautioned that the strictures of rational thought and traditional moral values, if too strongly enforced, could distort natural sexual impulses and cripple individuals and even entire peoples with guilt and neurotic fears.

A selection from the writings of Freud is presented here. "The Repressed Impulse" is an excerpt from the book *On the Origin of Psychoanalysis* (1910). A forceful lecturer as well as a prolific writer, Freud outlined many of his ideas in 1909 in a series

of five lectures delivered at Clark University in Worcester, Massachusetts. The following year, the lectures were published under the title *On the Origin of Psychoanalysis.* This book drew a storm of vituperation, particularly for its discussion of infantile sexuality.

Not only was human sexuality discussed frankly by Freud, it was also depicted explicitly by Gustav Klimt (1862–1918). Both a contemporary and a compatriot of the psychiatrist, Klimt was a successful Austrian mural painter and portraitist. Klimt's paintings, such as *The Kiss* (1907–8) and *Death and Life* (1908 and 1911), integrate sensuous nudes with richly colored decorative patterns and illustrate a keen awareness of sexual passion as a powerful motivation of human behavior.

Six years younger than Freud, Klimt died in 1918, shortly before Freud had achieved general acceptance. At the end of World War I, European nations urgently needed to implement humane methods of treatment for veterans suffering from battle-induced mental breakdowns. Because Freud's approach avoided the utilization of drugs, verbal intimidation, and electric-shock treatments, which had previously been the standard techniques used on mentally ill patients, it won widespread adoption.

Sigmund Freud, *On the Origin of Psychoanalysis*[1]
The Repressed Impulse

Psychoanalytic investigations trace back the symptoms of disease with really surprising regularity to impressions from the sexual life, show us that the pathogenic wishes are of the nature of erotic impulse-components, and necessitate the assumption that to disturbances of the erotic sphere must be ascribed the greatest significance among the etiological factors of the disease. This holds true of both sexes. . . .

Is there an infantile sexuality? you will ask. Is childhood not rather a period of life which is distinguished by the lack of the sexual impulse? No . . . it is not at all true that the sexual impulse enters into the child at puberty, as the devils in the gospel entered into the swine. The child has his sexual impulses and activities from the beginning, he brings them with him into the world, and from these the so-called normal sexuality of adults emerges by a significant development through manifold states. It is not very difficult to observe the expression of this childish sexual activity; it needs rather a certain art to overlook them or to fail to interpret them. . . .

The relation of the child to his parents is, as both direct observation of the child and later analytic investigation of adults agree, not at all free from

1. Reprinted, with permission of the publisher, from Sigmund Freud, *The Origin and Development of Psychoanalysis* (New York: Henry Regnery, 1965), pp. 46, 49, 55–56. Copyright by the *American Journal of Psychology.*

elements of sexual accessory-excitation. The child takes both parents, and especially one, as an object of his erotic wishes. Usually he follows in this the stimulus given by his parents, whose tenderness has very clearly the character of a sex manifestation, though inhibited as far as its goal is concerned. As a rule, the father prefers the daughter, the mother the son; the child reacts to this situation, since, as son, he wishes himself in the place of his father; as daughter, in the place of the mother. The feelings awakened in these relations between parents and children, and, as a resultant of them, those among the children in relation to each other, are not only positively of a tender, but negatively of an inimical sort. The complex built up in this way is destined to quick repression, but it still exerts a great and lasting effect from the unconscious. We must express the opinion that this with its ramifications presents the *nuclear complex* of every neurosis, and so we are prepared to meet with it in a not less effectual way in the other fields of mental life. . . .

Now what is the fate of the wishes which have become free by psychoanalysis, by what means shall they be made harmless for the life of the individual? There are several ways. The general consequence is that the wish is consumed during the work by the correct mental activity of those better tendencies which are opposed to it. The repression is supplanted by a condemnation carried through with the best means at one's disposal. . . . A second issue of the work of psychoanalysis may be that the revealed unconscious impulses can now arrive at those useful applications which, in the case of undisturbed development, they would have found earlier. The extirpation of the infantile wishes is not at all the ideal aim of development. The neurotic has lost, by his repressions, many sources of mental energy whose contributions would have been very valuable for his character building and his life activities. We know a far more purposive process of development, the so-called *sublimation,* by which the energy of infantile wish-excitations is not secluded, but remains capable of application, while for the particular excitations, instead of becoming useless, a higher, eventually no longer sexual, goal is set up. The components of the sexual instinct are especially distinguished by such a capacity for the sublimation and exchange of their sexual goal for one more remote and socially more valuable. We probably owe the highest achievements of our culture to energy which has been liberated in this way. A repression taking place at an early period precludes the sublimation of the repressed impulse; after the removal of the repression the way to sublimation is again free.

3. Emil Nolde, *Last Supper*, 1909
Janson, p. 714, ill. 993

Friedrich Nietzsche, *Thus Spake Zarathustra:* "A Chosen People—the Superman," 1883–85

In the early twentieth century, Western society began to doubt and then to reject many values and beliefs that had been cherished since the Enlightenment of the eighteenth century. The philosophical optimism of Enlightenment thought was apparently confirmed during the nineteenth century by increasing economic prosperity, by improving standards of living, and by expanding political and personal rights for the middle and lower classes. From the 1880s on, however, a small group of serious thinkers and creative writers began to challenge these venerable, optimistic views. These critics abandoned the general faith in progress and the power of the rational human mind. One of the most influential of these intellectuals was the German philosopher Friedrich Nietzsche (1844–1900).

Nietzsche, the son of a Lutheran minister, was trained as a classical philologist. He espoused a view of life and history that was tragic and pessimistic, believing that Western civilization had lost its creativity and had decayed into mediocrity. Christianity's "slave morality" had glorified weakness and humility. Furthermore, human beings in the West had overstressed rational thinking at the expense of passion and emotion. Nietzsche viewed the pillars of conventional morality—reason, progress, respectability—as outworn social and psychological constructs whose influence was suffocating creativity. He attacked the growing industrial democracy because it was a means whereby "cattle became masters." The only hope of revival, in Nietzsche's mind, was for a few superior individuals to free themselves from the humdrum thinking of the masses and to embrace life passionately. Such individuals would become true heroes, supermen capable of leading the dumb herd of inferior men and women. Able both to endure torture and to inflict pain, these supermen would be the models of the human beings of the future.

Nietzsche wrote most of his major works between 1880 and 1889. During this period he suffered from poverty and loneliness; in 1889 he became insane. Nietzsche regarded his chief work, *Thus Spake Zarathustra* (1883–85), as a kind of bible for a new age. Composed in a rhapsodic style, the book is written as if it were a transcription of the sayings of a visionary prophet, whom Nietzsche calls Zarathustra. A selection from *Thus Spake Zarathustra,* "A Chosen People—the Superman," is presented here.

The defeat of traditional values of kindness and compassion and the triumph of depraved passions and evil instincts are portrayed in the paintings of Emil Nolde (1867–1956). A German Expressionist, Nolde frequently painted Christian subjects, such as the *Last Supper* (1909). In his paintings, physical distortions of the human figure and harsh contrasts of color convey the brutality and cruel instincts of human nature.

Nietzsche's ethics of violence were realized in the twentieth century by the rise of totalitarian regimes. Fascism in Italy, Stalinism in the Soviet Union, and most especially Nazism in Germany borrowed ideas from Nietzsche and other prewar writers. Safe and civilized, these theoreticians had declared that people should live dangerously, avoid the flabby weakness of too much thought, and throw themselves with red-blooded vigor into a life of action. Nietzsche's fantasy of creating a super race became a nightmare visited by Adolf Hitler (1889–1945) upon Europe.

Friedrich Nietzsche, *Thus Spake Zarathustra*[1]
A Chosen People—the Superman

Here I sit waiting, broken old tablets around me and new tablets half covered with writing. When will my hour come? The hour of my descent among men, to whom I must go once more. But first, the signs must come to me that it is *my* hour. . . . Meanwhile I talk to myself having much time. Nobody tells me anything new, so I myself tell it to myself.

When I arrived among men I found that they were clinging to an old illusion: all of them imagined that they have long known what is good and evil for man. All talk of virtue seemed an old and weary matter to them, and whoever wanted to sleep well, talked of good and evil before going to sleep.

I disturbed this sleepiness when I taught: no one knows yet what is good and evil, unless it be the creative man, the man who sets man's goal and gives the earth its meaning and its future. He is the one who makes that anything at all is good and evil.

I ordered them to overthrow the old academic chairs and wherever that old illusion had been sitting; I ordered them to laugh at their great teachers of virtue, saints, poets and world redeemers. I ordered them to laugh at their gloomy sages and at those who ever sat on the tree of life warning them like a black scarecrow. I sat down by their great tomb-road among corpses and vultures, and I laughed at all their past and its brittle decaying glory. . . .

When there are planks across the water and bridges and railings cover the river, then no one believes the man who says "Everything is in flux." Even the stupid people speak out against him. "How now?" they say. "Everything should be in flux? After all, planks and railings are over the river. Thus over

1. Reprinted, by permission of the publisher, from *The Complete Works of Friedrich Nietzsche,* ed. by Oscar Levy and trans. by Thomas Common, vol. 11 (Edinburgh: T. N. Foulis, 1910), pp. 8–11.
 Zarathustra is the name given by Nietzsche to the prophet in his book *Thus Spake Zarathustra.* Nietzsche's choice of the name is also a reference to the historic Zarathustra, or Zoroaster, who lived in the 6th century B.C. and who founded the religion of Persia. Zarathustra proclaimed a monotheistic concept of God. He placed his god, Ahura Muzda, at the center of a kingdom that promised immortality and bliss. Like Nietzsche, who regarded himself as the victim of persecution, Zarathustra was strongly opposed by civil and religious authorities.

the river everything is firm, all the values of things, the bridges, the concepts, all 'good' and 'evil'—all that is firm."

And when the hard winter comes, the tamer of the river-animal, then . . . not only the stupid people say, "Does not everything stand still?"

"At bottom everything stands still"—that is truly a winter doctrine, a good thing for sterile times, a good comfort for those who hibernate or sit behind the warm stove.

But the thaw-wind preaches against "At bottom everything stands still." The thaw-wind, . . . a raging bull, a destroyer who breaks the ice with wrathful horns. Ice breaks bridges!

Is not everything in flux now, my brothers? Have not all railings and bridges fallen into the water? Who can continue to cling to "good" and "evil"?

O my brothers, I dedicate and direct you to a new nobility. You shall procreate and cultivate . . . , not a nobility that you could buy like shopkeepers and with shopkeepers' gold: for whatever has its price is of little value.

Not whence you come shall from now on be your pride and honor but whither you are going. Your will and your foot which wishes to go beyond yourselves—they should create your new honor. . . . Your nobility should not look backward but forward! You shall be exiled from all fatherlands and all ancestral lands! You shall love your children's land: this love shall be your new nobility—the undiscovered land in the most distant sea. For that I order your sails search and search. . . .

Am I really cruel? But I say that man should push what is falling. Who would try to hold today all that falls and decays? But I—I wish to push it.

Do you know the voluptuous delight which rolls stones into steep depths? Look at these men of today, how they roll into my depth.

I am a prelude of better players, o my brothers, I am a precedent. Follow my precedent! And those whom you cannot teach to fly, teach to fall faster! . . .

O my brothers, where do you find the greatest danger for man's future: is it not with the good and the just? With those who say and feel in their heart, "We already know what is good and just, and we have it too; woe unto those who still seek here!" Whatever harm the evil may do, the harm done by the good is the most harmful harm. . . .

Whom do they hate most? They hate most the creative mind who breaks tablets and old values. They call him a law breaker. For the good cannot create; they are always the beginning of the end: they crucify him who writes new values on new tablets; they sacrifice the future to themselves—they crucify all man's future. . . .

The kitchen-coal once asked the diamond: "Why so hard? Are we not close kin?!"

But I ask you, my brothers, why so soft? Are you not my brothers? If your hardness will not flash and sever and cut to pieces, how can you one day create with me? For creators are hard. To impress your hand on millennia as on wax, must appear to you as bliss. I place over you, o my brothers, this new tablet: become hard!

4. Pablo Picasso, *Still Life with Chair Caning*, 1911–12
Gardner, p. 962, ill. 22:9

Pablo Picasso, *Ambroise Vollard*, 1909–10
Janson, p. 718, ill. 999

Albert Einstein, *Does the Inertia of a Body Depend upon Its Energy Content?:* "The Energy of Radiation," 1905

In the early twentieth century, physics was revolutionized by Albert Einstein (1879–1955). Born in Ulm, Germany, of Jewish parents, Einstein had won international fame by the time he was thirty-five years old.

In his earliest scientific papers Einstein developed the special theory of relativity. This theory is based on a number of postulates: 1) that measurements of length and time will be relative to the motion of the observer; 2) that the limiting speed of all bodies having mass is the speed of light; 3) that energy and mass are proportional. This last postulate was expressed by Einstein in the famous equation $E = Mc^2$ and was pivotal in the later development of the atom bomb.

Approximately one decade after he presented the special theory of relativity, Einstein formulated the general theory of relativity. This theory shows that gravity is a determiner of the curvature of the space-time continuum. He then began work on his unified field theory, which attempts to explain gravity, electromagnetism, and subatomic and other phenomena in one set of laws.

The recipient of a Nobel Prize, Einstein was, nonetheless, persecuted by the Nazi government of Germany. In 1934 his property was confiscated, and Einstein was deprived of his German citizenship. Einstein moved to the United States, where he became a citizen. In 1939, at the urging of a group of scientists, he wrote to President Franklin Delano Roosevelt to stress the urgency of investigating the possible use of atomic energy in bombs. An ardent pacifist, however, Einstein was active throughout his life in the cause of world peace.

Einstein presented his special theory of relativity in a scientific paper, *Does the Inertia of a Body Depend upon Its Energy Content?* which appeared in the German journal *Annalen der Physik* (1905). A selection from the paper, "The Energy of Radiation," is presented here.

From Einstein's theory of relativity emerged the profoundly revolutionary no-

tion that time, space, and motion are not absolute but are all relative to the observer and to the observer's own movement in space.

Although few nonscientists understood the revolution in physics, the implications of the new theories and discoveries, as presented by newspapers and popular writers, were disturbing to lay people. The new universe was strange and troubling. It lacked any absolute, objective reality. Everything was "relative." Because everything depended on the observer's shifting frame of reference, the universe seemed uncertain and unstable.

The artist Pablo Picasso (1881–1973) also created a strange and troubling universe. In the canvases that date from his Cubist period, Picasso rejected the Renaissance depiction of space according to one-point or two-point perspective. Instead, he invented a new depiction of space, based upon geometric forms and a shifting point of view, that incorporated multiple angles of vision and simultaneous presentations of discontinuous planes. Thus, in paintings such as *Still Life with Chair Caning* (1911–12) and *Ambroise Vollard* (1909–10), Picasso suggests the Einsteinian vision of the physical world.

Albert Einstein, Does the Inertia of a Body Depend upon Its Energy Content?
"The Energy of Radiation"[1]

The results of my recently published electrodynamic investigation lead to a very interesting conclusion, which is here to be deduced. . . .

Let a system of plane waves of light, referred to the system of co-ordinates (x, y, z), possess the energy l; let the direction of the ray (the wave-normal) make an angle ϕ with the axis of x of the system. If we introduce a new system of co-ordinates (ξ, η, ζ) moving in uniform parallel translation with respect to the system (x, y, z), and its origin of co-ordinates moving along the axis of x with the velocity v, then this quantity of light— measured in the system (ξ, η, ζ)—possesses the energy

$$l^* = l \, \frac{1 - \dfrac{v}{c} \cos \phi}{\sqrt{1 - v^2/c^2}}$$

where c denotes the velocity of light. We shall make use of this result in what follows.

Let there be a stationary body in the system (x, y, z), and let its energy— referred to the system (x, y, z)—be E_0. Let the energy of the body relative to the system (ξ, η, ζ), moving as above with the velocity v, be H_0.

1. Reprinted, by permission of the publisher, from "Does the Inertia of a Body Depend upon Its Energy Content?" *Annalen der Physik* 18 (1905): 639–41, trans. by Gustav Wiedemann. Copyright by J. A. Barth.

Let this body send out, in a direction making an angle ϕ with the axis of x, plane waves of light, of energy $\frac{1}{2}L$ (measured relatively to (x, y, z)), and simultaneously an equal quantity of light in the opposite direction. Meanwhile the body remains at rest with respect to the system (x, y, z). The principle of energy must apply to this process, and in fact (by the principle of relativity) with respect to both systems of co-ordinates. If we call the energy of the body after the emission of light E_1 or H_1 respectively, measured relatively to the system (x, y, z) or (ξ, η, ζ) respectively, then by employing the relation given above we obtain

$$E_0 = E_1 + \frac{1}{2}L + \frac{1}{2}L,$$

$$H_0 = H_1 + \frac{1}{2}L \frac{1 - \frac{v}{c}\cos\phi}{\sqrt{1 - v^2/c^2}} + \frac{1}{2}L \frac{1 + \frac{v}{c}\cos\phi}{\sqrt{1 - v^2/c^3}}$$

$$= H + \frac{L}{\sqrt{1 - v^2/c^2}}.$$

By subtraction we obtain from these equations

$$H_0 - E_0 - (H_1 - E_1) = L \left\{ \frac{1}{\sqrt{1 - v^2/c^2}} - 1 \right\}.$$

The two differences of the form $H - E$ occurring in this expression have simple physical meanings. H and E are energy values of the same body referred to two systems of co-ordinates which are in motion relatively to each other, the body being at rest in one of the two systems (namely, (x, y, z)). Thus it is clear that the difference $H - E$ can differ from the kinetic energy K of the body, with respect to the other system (ξ, η, ζ), only by an additive constant C, which depends on the choice of the arbitrary additive constants of the energies H and E. Thus we may place

$$H_0 - E_0 = K_0 + C,$$
$$H_1 - E_1 = K_1 + C,$$

since C does not change during the emission of light. So we have

$$K_0 - K_1 = L \left\{ \frac{1}{\sqrt{1 - v^2/c^2}} - 1 \right\}.$$

The kinetic energy of the body with respect to (ξ, η, ζ) diminishes as a result of the emission of light, and the amount of diminution is independent of the properties of the body. Moreover, the difference $K_0 - K_1$, like the kinetic energy of the electron, depends on the velocity.

Neglecting magnitudes of fourth and higher orders we may place

$$K_0 - K_1 = \frac{1}{2}\frac{L}{c^2}\,v^2.$$

From this equation it directly follows that:—

If a body gives off the energy L in the form of radiation, its mass diminishes by L/c². The fact that the energy withdrawn from the body becomes energy of radiation evidently makes no difference so that we are led to the more general conclusion that:

The mass of a body is a measure of its energy-content; if the energy changes by L, the mass changes in the same sense by $L/9 \times 10^{20}$, the energy being measured in ergs, and the mass in grams.

It is not impossible that with bodies whose energy-content is variable to a high degree (e.g. with radium salts) the theory may be successfully put to the test.

5. Marcel Duchamp, *Nude Descending a Staircase, No. 2,* **1912**
Janson, p. 724, ill. 1009

Marcel Duchamp, *Bride Stripped Bare by Her Bachelors,* **1915–23**
Gardner, p. 976, ill. 22:26

Henry Ford, Letter to the Editor, *The Automobile:* "One of the Absolute Necessities of Our Later Day Civilization," 1906
Henry Ford, *My Life and Work:* "The Experiment of an Assembly Line," 1923

Twentieth-century life was revolutionized by new forms of transportation and manufacture. An almost immeasurable impact was made by the automobile and the assembly line, a manufacturing technique that was first developed for the automobile and then applied to the production of almost all other industrialized goods.

The automobile was not invented overnight. Its history can be traced to the late eighteenth century, when Nicholas Cugnot (1725–1804) drove the first self-propelled road vehicle, powered by a steam-driven engine, through the streets of Paris at nearly three miles per hour. The first gasoline-fueled motor vehicles were built within a few months of each other, in 1885 and 1886, by two Germans, Karl Benz (1844–1929) and Gottlieb Daimler (1834–1900). By the end of the nineteenth century, the automobile was being produced for upper-class markets in France, Germany, and other European countries.

In the United States, the automobile would soon develop along independent lines. Americans saw the potential of the car to serve as more than a wealthy person's acquisition. In a continent in which travel was restricted by the great distances that

had to be covered, Americans realized that the car offered the possibility to become a method of mass transportation.

The introduction of cheap, gas-powered cars was pioneered by Henry Ford (1863–1947). Ford developed a working gasoline automobile in 1892 and founded Ford Motors in 1903. He brought out the economical Model T, or "Tin Lizzie," in 1908. In 1913 Ford initiated mass production techniques that utilized standardized parts and conveyor-belt assembly lines. Although opposed to unionization, Ford introduced the eight-hour day, with a five-dollar-a-day minimum wage. Ford's innovations, which made inexpensive cars available on an enormous scale, turned the automobile into the mechanical servant of ordinary people.

Two selections about the automobile and its production are presented here. The first, "One of the Absolute Necessities of Our Later Day Civilization," is an excerpt from a letter written in 1906 by Henry Ford to the editor of the magazine *The Automobile*. In the letter, Ford describes his project to build a low-priced car that would be available to the majority of the population. The second selection, "The Experiment of an Assembly Line," is a description from Ford's autobiography, *My Life and Work* (1923), of his efforts to devise a low-cost production technique for the automobile.

The paintings of the French artist Marcel Duchamp (1887–1968) exalt the newly emergent world of speed, flight, and industry. His most famous work, *Nude Descending a Staircase, No. 2* (1912), shocked the public when it was exhibited in New York City in 1913. Attacked as an extreme example of the madness of modern art, the painting represents the human figure as a machine that moves through space with unstoppable force and staccato speed.

Henry Ford, Letter to the Editor, *The Automobile*[1]
One of the Absolute Necessities of Our Later Day Civilization

There are more people in this country who can buy automobiles than in any other country on the face of the globe, and in the history of the automobile industry in this country the demand has never yet been filled. . . . In spite of increased facilities and a marked improvement in the construction of automobiles, the prospect of filling the demand this season is exceedingly slim, and for this reason most of the factories building cars claim that prices should be maintained and to put out a low-priced car is unjustifiable and suicidal.

The assertion has often been made that it would be only a question of a few years before the automobile industry would go the way the bicycle went. I think this is in no way a fair comparison and that the automobile, while it may have been a luxury when first put out, is now one of the absolute necessities of our later day civilization. The bicycle was a recreation and a fad. The automobile, while it is a recreation, is in no way a fad. The greatest

1. Reprinted, by permission of the publisher, from John B. Roe, ed., *Great Lives Observed: Henry Ford* (Englewood Cliffs, N.J.: Prentice-Hall, 1969), pp. 18–19. Copyright by Prentice-Hall.

need today is a light, low-priced car with an up-to-date engine of ample horsepower, and built of the very best material. One that will go anywhere a car of double the horsepower will; that is in every way an automobile and not a toy; and, most important of all, one that will not be a wrecker of tires and a spoiler of the owner's disposition. . . .

It must be a handy car, not too cumbersome, and one where a chauffeur will not be absolutely necessary either as a driver or because of his mechanical skill; a car which the owner can leave in front of his office and which will be ready to start at any time and take him wherever he wishes to go. . . .

We are today in a position to build and deliver 10,000 of our four-cylinder runabouts. I am now making arrangements whereby we can build and deliver 20,000 of these runabouts, and all within twelve months.

Henry Ford, *My Life and Work*[2]
The Experiment of an Assembly Line

Along about April 1, 1913, we first tried the experiment of an assembly line. We tried it on assembling the fly-wheel magneto. We try everything in a little way first—we will rip out anything once we discover a better way, but we have to know absolutely that the new way is going to be better than the old before we do anything drastic.

I believe that this was the first moving line ever installed. . . . We had previously assembled the fly-wheel magneto in the usual method. With one workman doing a complete job he could turn out from thirty-five to forty pieces in a nine-hour day, or about twenty minutes to an assembly. What he did alone was then spread into twenty-nine operations; that cut down the assembly time to thirteen minutes, ten seconds. Then we raised the height of the line eight inches—this was in 1914—and cut the time to seven minutes. Further experimenting with the speed that the work should move at cut the time down to five minutes. In short, the results of this: by the aid of scientific study one man is now able to do somewhat more than four did only a comparatively few years ago.

6. Umberto Boccioni, *Unique Forms of Continuity in Space*, 1913
Gardner p. 966, ill. 22:14; Janson, p. 761, ill. 1069

Filippo Tommaso Marinetti, *Let's Murder the Moonshine:* "Oh! The Joy of Playing Billiards with Death," 1909

2. Reprinted, by permission of the publisher, from Henry Ford and Samuel Crowther, *My Life and Work* (Garden City, N.J.: Doubleday, Page, 1923), p. 81. Copyright by Doubleday, Page and Co.

Futurism began in Italy in the first decade of the twentieth century. A rebellion of young intellectuals against the cultural traditions of the nineteenth century, Futurism saw life as a constant change and regarded individuals as parts of a dynamic system of forces propelled forward by progress. Writers of the Futurist movement called for the destruction of the libraries, the museums, the academies, and the cities of the past—institutions that they ridiculed as mausoleums. Instead, they extolled the beauties of revolution, of war, and especially of the speed, power, and dynamism of modern technology.

Much of the spirit of Futurism reflected the flamboyant personality of the Italian poet Filippo Tommaso Marinetti (1876–1944), who defined the movement and guided it throughout its existence. Marinetti voiced the extreme indignation that his generation felt over the cultural and political decline of Italy. The Futurism of Marinetti and his followers was rooted in the philosophies of Friedrich Nietzsche and other intellectuals, and in the prevalent atmosphere of anarchism. Futurism not only attacked the economic and political injustices of an aristocratic society, but in the ensuing decades it also became a propagandistic organ of Italian fascism.

In 1909 Marinetti published his first Futurist manifesto in a Paris newspaper. In the same year, he published *Let's Murder the Moonshine*. In this essay, in which he assumes the voice of a modern prophet, he exhorts his followers to adopt his credo of mechanization and violence. He further expresses contempt for the ordinary populace and exults in the thought of circling high above distant parts of the globe, such as the Ganges River, and strafing the crowds below. A selection from *Let's Murder the Moonshine* (1909), "Oh! The Joy of Playing Billiards with Death," is presented here.

The poet Marinetti aided a number of painters and sculptors. He was drawn to artists who concentrated on thematic portrayals of speed and change, as manifested in modern events and urban scenes. One of the most prominent of these artists was Umberto Boccioni (1882–1916), whose name was included by Marinetti in his invocation of "great incendiary poets." Boccioni created monumental works that celebrated the qualities of violent action, speed, and sheer power. One such work, *Unique Forms of Continuity in Space* (1913), gives visual form to Marinetti's prediction of the evolution of a mechanized human type. Boccioni entered World War I at its onset, and was killed in an accident in Verona in 1916.

Filippo Tommaso Marinetti, *Let's Murder the Moonshine*[1]
Oh! The Joy of Playing Billiards with Death

Hot pursuit—now the Ganges is overleapt! Finally our impetuous breathing put to flight the shuffling clouds and their clinging hostility, and on the horizon we caught sight of the dark-green throb of the Indian Ocean, over

1. Reprinted, by permission of the publisher, from R. W. Flint, ed., *Marinetti,* trans. by R. W. Flint and Arthur A. Coppotelli (New York: Farrar, Straus and Giroux, 1972), pp. 51–54. Copyright by Farrar, Straus and Giroux.

which the sun was fitting a fantastic golden muzzle. . . . Languishing in the gulfs of Bengal and Oman, it was treacherously preparing an invasion of the land.

At the far end of the promontory of Cormorin, edged with a rubble of gray-white bones, behold the colossal fleshless Ass, whose grayish parchment rump has been hollowed by the delicious weight of the Moon. . . . Behold the learned Ass, its wordy member patched up with writings, as from time immemorial it rattles its asthmatic rancor against the mists of the horizon where three great motionless vessels advance, their spars looking like human spines in an X ray.

Suddenly, the immense troop of wild beasts ridden by madmen had spread numberless snouts over the waves, under a whirling flare of manes that called on the Ocean for help. And the Ocean answered their appeal, arching a mighty back and shaking the promontories before it sprang. For a long time it tested its strength, moving its haunches and flexing its sonorous belly between its vast, elastic foundations. Then, with a great heave of the loins, the Ocean succeeded in lifting its whole mass and flooded the crooked line of its shores. . . . Thus did the fearful invasion begin.

We were marching in the wide waves' pawing embrace, great globes of white spume that rolled and toppled, soaking the lions' backs. . . . And they, drawn up in a semicircle around us, added their fangs to the fangs of the sea, the hissing spray and the howling. Sometimes from hilltops we watched the Ocean slowly stretch its monstrous profile, like an immense whale that drives ahead on a million fins. And it was we who led it up to the Himalayan chain as we spread open the fleeing hordes like a fan, whom we meant to shatter on the sides of Gorisankar.

"Hurry, my brothers!—Do you want the beasts to overtake us? We must stay ahead, despite our slow steps that pump the earth's juices. . . . To the devil with these sticky hands and root-dragging feet! . . . Oh! We're nothing but poor vagabond trees! We need wings!—Then let's make airplanes."

"Make them blue!" the madmen shouted, "blue, the better to hide us from the watchful enemy and confound us with the blue of the sky, the sky that chatters against the wind-blown peaks like an immense banner."

And, to the Buddha's glory, the madmen seized sky-blue mantles from ancient pagodas, to build their flying machines.

We cut our Futurist planes from the ocher-colored cloth of sailing ships. Some had balancing wings and, carrying their motors, rose like the bloody vultures that lift thrashing heifers into the sky.

Here it is: my own multicellular biplane steered by the tail; 100 HP, 8 cylinders, 80 kilograms. . . . Between my feet I have a tiny machine gun that I can fire by pushing a steel button. . . .

And we take off, in the intoxication of a keen maneuver, a lively, snapping flight, rhythmic and graceful like a song of invitation to drink and dance.

"Hurrah! Finally we're worthy to command the great army of the mad and the unchained beasts! Hurrah! We master our rearguard, the Ocean with its tangle of foaming cavalry! . . . Forward, madmen, madwomen, lions, tigers, and panthers! Forward, you squadrons of waves! . . . For you our biplanes will be as war banners and passionate lovers. Delicious lovers who swim with open arms on the undulating leaves, or who gently idle in the breeze's seesaw!—But look down there, to the right, those azure shuttles . . . they're the madmen cradling their monoplanes in the south wind's hammock! . . . I, meanwhile, sit like a weaver before his loom, weaving the sky's evening blue!—Oh! All the fresh valleys, all the wild mountains beneath us! How many flocks of rosy sheep scattered on the slopes of the green hills that offer themselves to the sunset! . . . My soul, you have loved them! . . . No! No! Enough! No more, never again will such insipidities please you! . . . The reeds that once we shaped to shepherds' pipes make the armor of this plane! . . . Nostalgia! Triumphal intoxication! . . . Soon we'll overtake the inhabitants of Gout and Paralysis because the headwinds give us speed. . . . What says the anemometer? . . . The wind from ahead has a speed of one hundred kilometers an hour!—Who cares? I climb to two thousand meters to surmount the high plateau. . . . Look! There are the hordes! There, there, ahead of us, already beneath our feet! . . . Look down, straight down, among the masses of greenery, the riotous tumult of that human flood in flight!— This uproar?—It's the crash of trees! Ah! Ah! The enemy hordes are already thrown against the high walls of Gorisankar! . . . And the battle is joined! . . . Do you hear, do you hear how our motors applaud? . . . What ho, great Indian Ocean, to the rescue!"

Solemnly the Ocean followed us, leveling the walls of venerated cities and casting illustrious towers from their seats. Old horsemen with sounding armor toppled from the marble arches of temples.

Finally! Finally! So there you are ahead of us, great swarming populace of Paralysis and Gout, disgusting leprosy devouring the mountainsides. . . . Swiftly we fly against you, flanked by the galloping lions our brothers, and behind us the menacing friendship of the Ocean that follows closely to foul the foot-draggers! . . . That's a mere precaution, because we don't fear

you! . . . But you are numberless! . . . And we might use up our ammunition and grow old in the slaughter! . . . Let me direct the fire! . . . Up 800 meters! Ready! . . . Fire! . . . Oh! the joy of playing billiards with Death! . . . This is something you cannot take from us! . . . Still hanging back? We'll soon be over this plateau! . . . My airplane runs on its wheels, skates along, and then up again in flight! . . . I'm flying against the wind! . . . *Bravissimi,* madmen! . . . Continue the massacre! . . . Watch me! I seize the stick and glide smoothly down, magnificently stable, and touch ground where the fight rages hottest!

See the furious coitus of war, gigantic vulva stirred by the friction of courage, shapeless vulva that spreads to offer itself to the terrific spasm of final victory! It's ours, the victory . . . of that I'm sure, because the madmen are already hurling their hearts toward heaven, like bombs! . . . I raise my sights to a hundred meters! . . . Ready! . . . Fire! . . . Our blood?—Yes! All our blood, in waves, to recolor the sick dawns of the Earth! . . . Yes, we will warm you again between our smoking arms, O pitiful, decrepit, and shivering sun, trembling on the summit of Gorisankar!

7. Oskar Kokoschka, *Self-Portrait,* 1913
Janson, p. 714, ill. 994

Ernst Kirchner, *Street, Berlin,* 1913
Gardner, p. 970, ill. 22:19

William II, Speech: "We Take Up the Sword," August 4, 1914
Raymond Poincaré, Message: "France Has Become the Object of a Brutal and Premeditated Aggression," August 14, 1914

On June 28, 1914, Archduke Franz Ferdinand (1863–1914), heir to the Austro-Hungarian throne, was assassinated in Sarajevo, Bosnia, by a Serbian nationalist. One month later, Serbia rejected Austria-Hungary's ultimatum demanding the right to investigate Serbian terrorists. On July 28, 1914, Austria declared war. The conflict soon became a general European war between two alliances of nations. Austria-Hungary was joined by Germany and Turkey in an alliance known as the Central Powers, while Serbia was joined by Russia, France, Belgium, and Great Britain in an alliance known as the Allied Powers.

Although Serbian terrorism provoked the onset of war, the stage for conflict had been set by long-standing economic tensions, imperialistic rivalries, and militaristic ambitions. The British were jealous of the rapid German growth. At the same time that German industrialists were outstripping English manufacturers, German mer-

chants were wresting foreign marketplaces away from their British counterparts. In its desire to increase access to natural resources as a base for its industrialism, Germany embarked upon an ambitious policy of foreign imperialism. It challenged France's increasing colonial strength in North Africa, and it checked the expansion of Russia's sphere of influence in Eastern Europe. Between 1870 and 1914 all the great powers engaged in arms races. The size of their standing armies grew from 2,473,000 to 4,416,000, and their naval tonnage increased from 1,813,000 to 8,065,000.

In the first days of the conflict, the government heads of the belligerent nations issued statements to their citizens. These statements were intended to justify the military actions of the governments and to arouse popular feeling in support of the struggle ahead. Selections from two government statements made at the outbreak of World War I are presented here. The first, "We Take Up the Sword," is an excerpt from the speech of the German emperor, William II (lived 1859–1941; emperor 1888–1918), delivered on August 4, 1914. The second selection, "France Has Become the Object of a Brutal and Premeditated Aggression," is an excerpt from the message of the French president, Raymond Poincaré (lived 1860–1934; president 1913–20), made on August 14, 1914.

Still another cause of World War I was the internal dissension that wracked virtually every large nation. The English faced an uprising because of their failure to solve the Irish problem. Russia was already in the throes of major political and social changes, marked by violent outbreaks. The nationalistic problems caused by ethnic and religious hatred in Austria-Hungary convulsed the empire.

The cult of violence that emerged in the late nineteenth century increased the tendency of individuals and ethnic groups to try to settle disputes by direct action rather than by reason and compromise within the framework of the law. Events of the 1980s and early 1990s demonstrate that solutions have yet to be found for these violent conflicts.

The anxious atmosphere of the years preceding World War I pervades the art of Oskar Kokoschka (1886–1980) and the art of Ernst Kirchner (1880–1938). Born in Vienna, Kokoschka went to Berlin in 1910. The German-born Kirchner moved to Berlin in 1913. In both Kokoschka's *Self-Portrait* (1913) and Kirchner's *Street, Berlin* (1913), an emotional intensity is evident in the figures. Kokoschka served as a soldier for the Central Powers, and was seriously wounded in World War I.

William II, *Speech*[1]
We Take Up the Sword

Honored gentlemen, at a time of such importance I have assembled the elected representatives of the German people about me. For nearly half a century we have been allowed to follow the ways of peace. The attempts to

1. Reprinted, by permission of the publisher, from Ralph Haswell Lutz, *Fall of the German Empire, 1914–1918* (Stanford, Calif.: Stanford University Press, 1932), vol. 1, pp. 8–9. Copyright by Stanford University Press.

attribute to Germany warlike intentions and to hedge in her position in the world have often sorely tried the patience of my people. Undeterred, my Government has pursued the development of our moral, spiritual, and economic strength as its highest aim, with all frankness, even under provocative circumstances. The world has been witness that during the last years, under all pressure and confusion, we have stood in the first rank in saving the nations of Europe from a war between the great powers.

The most serious dangers to which the events in the Balkans had given rise seemed to have been overcome—then suddenly an abyss was opened through the murder of my friend the Archduke Franz Ferdinand. My lofty ally, the Emperor and King Franz Josef, was forced to take up arms to defend the security of his empire against dangerous machinations from a neighboring state. The Russian Empire stepped in to hinder the allied monarchy from following out her just interests. Not only does our duty as ally call us to the side of Austria-Hungary, but it is our great task to protect our own position and the old community of culture between the two Empires against the attack of hostile forces. . . .

The present situation is the result of an ill will which has been active for many years against the power and the prosperity of the German Empire.

No lust of conquest drives us on; we are inspired by the unalterable will to protect the place in which God has set us for ourselves and all coming generations. From the documents which have been submitted to you, you will see how my Government, and especially my Chancellor, have endeavored even to the last moment to stave off the inevitable. In a defensive war that has been forced upon us, with a clear conscience and a clean hand we take up the sword.

Raymond Poincaré, *Message*[2]

France Has Become the Object of a Brutal and Premeditated Aggression

Gentlemen of the Chamber of Deputies, France has become the object of a brutal and premeditated aggression which is an insolent defiance of international law. Before a declaration of war was addressed to us, before even the German ambassador had asked for his passport, our territory was invaded. . . .

For more than forty years the French, in a sincere love of peace, have stifled the desire for legitimate reparation. They have given to the world the

2. Reprinted, by permission of the publisher, from George H. Knoles and Rixford K. Snyder, eds., *Readings in Western Civilization* (New York: J. B. Lippincott, 1960), p. 750. Copyright by J. B. Lippincott.

example of a great nation which, definitively resurrected from defeat by strength of will, by patience and work, has used its renewed and revived force only in the interest of progress and for the good of humanity.

Since the Austrian crisis opened up a situation threatening to the whole of Europe, France has set herself to follow and to recommend everywhere a policy of prudence, wisdom, and moderation. No one can charge her with an act, with a gesture, with a word which has not been peaceful and conciliating. In this hour of the first combats, she has the right to credit herself with the fact that she made supreme efforts up until the last moment to avoid this war which has just broken out and for which Germany will bear before history the crushing responsibility. . . .

In the war which has begun, France will have on her side that right whose eternal moral force no people, no individual can defy with impunity. She will be heroically defended by her sons, whose sacred unity before the enemy nothing can break and who are today joined in the same indignation against the aggressor and in the same patriotic faith. She is faithfully seconded by Russia, her ally; she is supported by the loyal friendship of England.

Already from all parts of the civilized world come to her expressions of sympathy and good wishes. Because she represents again today before the universe liberty, justice, and reason.

Haut les coeurs et vive la France!

8. Ernst Barlach, *War Monument*, Güstrow Cathedral, 1927
Gardner, p. 972, ill. 22:22

Erich Maria Remarque, *All Quiet on the Western Front:* "We See Men Living with Their Skulls Blown Open," 1929

In the nineteenth century, most European wars were short conflicts, decided by one or two important battles. The heads of state who committed their countries to World War I presumed that the conflict that began in 1914 would be similarly brief. Had they envisaged the years of carnage that would stretch ahead, they would almost certainly have done more to avert war.

After the declaration of war on July 28, 1914, German troops moved quickly. On August 4, the German army swept into Belgium. By September 9, German forces had advanced to the Marne, where their offensive was finally halted by the French and British. In the stalemate that developed, the two enemy forces dug themselves in. The Western front became a network of trenches that ran from the English Channel to the

Swiss frontier. To protect their positions in the trenches, troops erected barbed-wire fences and used murderous machine-gun fire. Officers, trained in the nineteenth-century traditions of warfare, were unable to devise strategies appropriate to the new weapons and the new approach to warfare. They hurled their men toward enemy lines without regard for the appalling loss of life. In 1915 the French suffered 1,430,000 casualties in offensive actions that won them fewer than 3 miles. In 1916 the Germans assaulted the French in an action that cost 600,000 lives in five months. Similarly, one British attack cost 20,000 dead on the first day alone and won virtually no territory. Actions along the Eastern front were equally bloody and resulted in devastating numbers of casualties, particularly for the Russians.

Appalled at the carnage caused by the war, the American president Woodrow Wilson (1856–1924) made efforts in 1915 and again in 1916 to mediate a solution. However, his proposals were rejected by the Central Powers and the Allies, both of which were still hopeful of victory. German submarine attacks on United States ships in 1917 provoked outrage among the American people. In April 1917, Wilson asked Congress to declare war. By March 1918, 300,000 American troops had arrived in France. By September, their numbers had swelled to 2,000,000. A massive Allied offensive of 1,030,000 troops—80 percent of whom were Americans—was launched on September 26, 1918. The German high command, finally convinced that the war was lost, sued for peace. A peace armistice was signed on November 11, 1918.

For generations of Europeans, World War I became a symbol of slaughter and senseless destruction. More than 10 million soldiers had died, and twice that number of soldiers were wounded. The brutality and futility of the war was described by the German novelist Erich Maria Remarque (1898–1970). Remarque had served as a soldier in the trenches of the Western front, where he had been seriously wounded. In 1929 he published *All Quiet on the Western Front*. In this novel, the appalling devastation and horrors of modern warfare are described in the matter-of-fact language of the average soldier. All heroic impulses have been extinguished, and there is only spiritual disillusionment and emotional exhaustion.

Remarque's novel was banned in Germany, and in the 1930s the writer settled in Switzerland. A selection from *All Quiet on the Western Front*, "We See Men Living with Their Skulls Blown Open," is presented here. In this selection, Remarque describes the savagery of an attack and counterattack experienced during trench warfare.

The human toll of World War I is also reflected in the sculpture of the German artist Ernst Barlach (1870–1938). The *War Monument* (1927) for Güstrow Cathedral suggests the anguish of death that Remarque confronted. At the same time the sculpture suggests hope for a spiritual peace that evaded the novelist.

Erich Maria Remarque, *All Quiet on the Western Front*[1]
We See Men Living with Their Skulls Blown Open

The brown earth, the torn, blasted earth, with a greasy shine under the sun's rays; the earth is the background of this restless, gloomy world of automatons, our gasping is the scratching of a quill, our lips are dry, our heads are debauched with stupor—thus we stagger forward, and into our pierced and shattered souls bores the torturing image of the broken earth with the greasy sun and the convulsed and dead soldiers, who lie there—it can't be helped— who cry and clutch at our legs as we spring away over them.

We have lost all feeling for one another. We can hardly control ourselves when our hunted glance lights on the form of some other man. We are insensible, dead men, who through some trick, some dreadful magic, are still able to run and to kill.

A young Frenchman lags behind, he is overtaken, he puts up his hands, in one he still holds his revolver—does he mean to shoot or to give himself up?—a blow from a spade cleaves through his face. A second sees it and tries to run farther; a bayonet jabs into his back. He leaps in the air, his arms thrown wide, his mouth wide open, yelling; he staggers, in his back the bayonet quivers. A third throws away his rifle, cowers down with his hands before his eyes. He is left behind with a few other prisoners to carry off the wounded.

Suddenly in the pursuit we reach the enemy line.

We are so close on the heels of our retreating enemies that we reach it almost at the same time as they. In this way we suffer few casualties. A machine-gun barks, but is silenced with a bomb. Nevertheless, the couple of seconds has sufficed to give us five stomach wounds. With the butt of his rifle Kat smashes to pulp the face of one of the unwounded machine-gunners. We bayonet the others before they have time to get out their bombs. Then thirstily we drink the water they have for cooling the gun.

Everywhere wire-cutters are snapping, planks are thrown across the entanglements, we jump through the narrow entrances into the trenches. Haie strikes his spade into the neck of a gigantic Frenchman and throws the first hand-grenade; we duck behind a breastwork for a few seconds, then the whole section of trench before us is empty. The next throw whizzes obliquely over the corner and clears a passage; as we run past we toss handfuls down

1. Reprinted, by permission of the publisher, from Erich Maria Remarque, *All Quiet on the Western Front,* trans. by A. W. Wheen (New York: CBS Publications, 1975), pp. 119–21, 128–31. Copyright by Little, Brown and Co.

into the dug-outs, the earth shudders, it crashes, dully and stifled, we stumble over slippery lumps of flesh, over yielding bodies; I fall into an open belly on which lies a clean, new officer's cap.

The fight ceases. We lose touch with the enemy. We cannot stay here long but must retire under cover of our artillery to our own position. No sooner do we know this than we dive into the nearest dug-outs, and with the utmost haste seize on whatever provisions we can see, especially the tins of corned beef and butter before we clear out.

We get back pretty well. There has been no further attack by the enemy. We lie for an hour panting and resting before anyone speaks. We are so completely played out that in spite of our great hunger we do not think of the provisions. Then gradually we become something like men again. . . .

The days go by and the incredible hours follow one another as a matter of course. Attacks alternate with counter-attacks and slowly the dead pile up in the field of craters between the trenches. We are able to bring in most of the wounded that do not lie too far off. But many have long to wait and we listen to them dying.

For one of them we searched two days in vain. He must be lying on his belly and unable to turn over. Otherwise it is hard to understand why we cannot find him; for it is only when a man has his mouth close to the ground that it is impossible to gauge the direction of his cry.

He must have been badly hit—one of those nasty wounds neither so severe that they exhaust the body at once and a man dreams on in a half-swoon, nor so light that a man endures the pain in the hope of becoming well again. . . .

He grows gradually hoarser. The voice is so strangely pitched that it seems to be everywhere. The first night some of our fellows go out three times to look for him. But when they think they have located him and crawl across, next time they hear the voice it seems to come from somewhere else altogether.

We search in vain until dawn. We scrutinize the field all day with glasses, but discover nothing. On the second day the calls are fainter; that will be because his lips and mouth have become dry. . . .

It is easy to understand what he cries. At first he called only for help—the second night he must have had some delirium, he talked with his wife and his children, we often detected the name Elise. To-day he merely weeps. By evening the voice dwindles to a croaking. But it persists still through the whole night. We hear it so distinctly because the wind blows toward our line. In the morning when we suppose he must already have long gone to his rest, there comes across to us one last gurgling rattle.

The days are hot and the dead lie unburied. We cannot fetch them all in, if we did we should not know what to do with them. The shells will bury them. Many have their bellies swollen up like balloons. They hiss, belch, and make movements. The gases in them make noises.

The sky is blue and without clouds. In the evening it grows sultry and the heat rises from the earth. When the wind blows toward us it brings the smell of blood, which is very heavy and sweet. This deathly exhalation from the shell-holes seems to be a mixture of chloroform and putrefaction, and fills us with nausea and retching. . . .

We see men living with their skulls blown open; we see soldiers run with their two feet cut off, they stagger on their splintered stumps into the next shell-hole; a lance-corporal crawls a mile and a half on his hands dragging his smashed knee after him; another goes to the dressing station and over his clasped hands bulge his intestines; we see men without mouths, without jaws, without faces; we find one man who has held the artery of his arm in his teeth for two hours in order not to bleed to death. The sun goes down, night comes, the shells whine, life is at an end.

Still the little piece of convulsed earth in which we lie is held. We have yielded no more than a few hundred yards of it as a prize to the enemy. But on every yard there lies a dead man.

9. **Kasimir Malevich, *Suprematist Composition: White on White*, c. 1918**
Gardner, p. 994, ill. 22:48; Janson, p. 722, ill. 1006

Kasimir Malevich, *Black Quadrilateral*, c. 1913–15
Janson, p. 122, ill. 1005

Leon Trotsky, *The History of the Russian Revolution:* "The Revolution Makes Another Forward Step," 1932
Vladimir Lenin, Speech: "The Workmen's and Peasants' Revolution," c. November 1917

The Russian Revolution of 1917 was a momentous event in world history. Precipitated by World War I, the revolution not only transformed Russia but also affected Europe, Asia, Africa, and Latin America. To admirers, the revolution seemed to promise the advent of Marx's socialist vision. To detractors, the revolution seemed to presage the triumph of dictatorship. To all, the revolution represented an experiment in creating a radically new kind of state and society.

Russia had gone to war reluctantly in 1914. Its poorly equipped and badly

trained army was in no condition to face German forces. Early enthusiasm for the war waned as casualties mounted. Over 2 million Russian soldiers died in 1915 alone. Although the peasant army continued to fight courageously, the Russian population became weary of war and skeptical of the competence of the czarist regime.

Food shortages increased popular discontent. On March 8, 1917 (or February 23 in the old calendar), rioting broke out in Saint Petersburg. Women thronged into the streets in demand of bread. Their spontaneous demonstration was joined by factory workers, disaffected bureaucrats and intellectuals, and mutinous troops. Ten days later, the last czar of the Romanov dynasty, Nicholas II (lived 1868–1918; czar 1894–1917), abdicated.

A struggle between competing political factions ensued. The Bolshevik, or Communist, Party was led by Vladimir Lenin (1870–1924). Involved with revolutionary movements in Russia since his days as a student at the University of Kazan,[1] Lenin spent three years as a political prisoner in Siberia and seventeen years as an exile in Europe. In April 1917 the Germans provided a sealed train for Lenin to return to Russia and to assume leadership of the Bolsheviks.[2]

Lenin immediately attempted to incite an insurrection against the provisional government that had been established to provide a transition to constitutional rule. When his complicity in the plot was revealed, Lenin was forced to flee to Finland. In his absence, Leon Trotsky (1879–1940) organized a Bolshevik seizure of power on the night of November 6, 1918.

Many people expected that the new Russia would be ruled by democratically elected assemblies, called soviets. However, election results demonstrated that the Bolshevik Party had attracted fewer voters than the Social Revolutionary Party, an agrarian-populist and peasant-oriented party. Lenin, with Trotsky's assistance, reacted by repudiating majority rule and imposing dictatorial control. After two years of civil war, the Communist Party emerged as the victorious ruler of the Soviet Union.

Two documents related to the Russian Revolution are presented here. The first, "The Revolution Makes Another Forward Step," is an excerpt from *The History of the Russian Revolution* (1932), an account written by Leon Trotsky. In this selection, Trotsky describes the events of 1917. The second selection, "The Workmen's and Peasants' Revolution," is an excerpt from a speech delivered by Lenin in November 1917.

In 1917 Lenin and Trotsky directed a small party that had only 23,000 members; within a few years they had led it to a dominant position in the largest country in the world. In 1922 Lenin suffered a severe stroke, and in 1924 he died. Expecting to succeed Lenin as premier, Trotsky found himself outmaneuvered by Joseph Stalin (1879–1953). In 1927 Trotsky was expelled from the Communist Party, and in 1929 he was forced to leave the Soviet Union. Although he lived in Mexico in a house that was a virtual fortress, Trotsky was assassinated in 1940 by Stalin's agents.

1. A city on the Volga River in western Russia.
2. Members of the more radical majority of the Social Democratic Party, 1903–1917; since 1918 members of the Russian Communist Party.

At the same time that revolutionary political movements toppled the czarist regime, revolutionary artistic currents swept away nineteenth-century Russian academicism. The Russian painter Kasimir Malevich (1878–1935) advocated the rejection of realism and embraced complete abstraction. A devout mystic like Kandinsky, Malevich was convinced that his experimentation with geometric abstraction was a spiritual vision rooted in the traditions of agrarian Russian society. He regarded the visual contemplation of paintings such as *Black Quadrilateral* (c. 1913–15) and *Suprematist Composition: White on White* (c. 1918) as a stimulus for inner revelation.

Between 1918 and 1921 Malevich enjoyed the support of the Communist regime. The official reaction against abstract art in 1921, however, caused the painter to withdraw into seclusion until his death.

Leon Trotsky, *The History of the Russian Revolution*[3]
The Revolution Makes Another Forward Step

Thus the fact is that the February revolution was begun from below, overcoming the resistance of its own revolutionary organizations, the initiative being taken on their own accord by the most oppressed and downtrodden part of the proletariat—the women textile workers, among them no doubt many soldiers' wives. . . . A mass of women, not all of them workers, flocked to the municipal duma[4] demanding bread. It was like demanding milk from a he-goat. Red banners appeared in different parts of the city, and inscriptions on them showed that the workers wanted bread, but neither autocracy nor war. Women's Day passed successfully, with enthusiasm and without victims. But what it concealed in itself, no one had guessed even by nightfall.

On the following day the movement not only fails to diminish, but doubles. About one-half of the industrial workers of Petrograd[5] are on strike on the 24th of February. . . . New districts and new groups of the population are drawn into the movement. The slogan "Bread!" is crowded out or obscured by louder slogans: "Down with autocracy!" "Down with the war!" Continuous demonstrations on the Nevsky[6]—first compact masses of workmen singing revolutionary songs, later a motley crowd of city folk interspersed with the blue caps of students. . . . Throughout the entire day, crowds of people poured from one part of the city to another. . . .

3. Reprinted, by permission of the publisher, from Leon Trotsky, *The History of the Russian Revolution,* trans. by Max Eastman (Ann Arbor: University of Michigan Press, 1974), vol. 1, pp. 102–3, 105, 107, 109, 124–25. Copyright by University of Michigan Press.
4. The legislative assembly of a city in Russia at that time.
5. Saint Petersburg.
6. A public square in Saint Petersburg named after Alexander Nevsky. A prince in the thirteenth century, Nevsky repulsed an invasion of the Swedes and stopped German expansion into Russian territory. Canonized as a saint in the fourteenth century, Nevsky became a national hero for the Russian people.

It seems that the break in the army first appeared among the Cossacks,[7] those age-old subduers and punishers. . . .

On the 25th the strike spread wider. According to the government's figures, 240,000 workers participated that day. . . . A great rôle is played by women workers in the relation between workers and soldiers. They go up to the cordons more boldly than men, take hold of the rifles, beseech, almost command: "Put down your bayonets—join us." The soldiers are excited, ashamed, exchange anxious glances, waver; someone makes up his mind first, and the bayonets rise guiltily above the shoulders of the advancing crowd. The barrier is opened, a joyous and grateful "Hurrah" shakes the air. The soldiers are surrounded. Everywhere arguments, reproaches, appeals—the revolution makes another forward step. . . .

[On the 27th] One after another, from early morning, the Reserve Guard battalions mutinied before they were led out of the barracks. . . . In the early hours of the 27th, the workers thought the solution of the problem of the insurrection infinitely more distant than it really was. . . . The revolutionary pressure of the workers on the barracks fell in with the existing revolutionary movement of the soldiers to the streets. During the day these two mighty currents united to wash out clean and carry away the walls, the roof, and later the whole groundwork of the old structure.

Vladimir Lenin, Speech[8]
The Workmen's and Peasants' Revolution

Comrades, the workmen's and peasants' revolution, the need of which the Bolsheviks have emphasized many times, has come to pass.

What is the significance of this revolution? Its significance is, in the first place, that we shall have a soviet government,[9] without the participation of bourgeoisie[10] of any kind. The oppressed masses will of themselves form a government. The old state machinery will be smashed into bits and in its place will be created a new machinery of government by the soviet organizations. From now on there is a new page in the history of Russia, and the present, third Russian revolution shall in its final result lead to the victory of Socialism.

7. Members of various tribes of Slavic warriors living in southeast Russia and in czarist Russia, forming an elite corps of military horsemen.
8. Reprinted, by permission of the publisher, from Frank Alfred Golder, ed., *Documents of Russian History: 1914–1917*, trans. by Emanuel Aronsberg (Gloucester, Mass.: Peter Smith, 1964), pp. 618–19. Copyright by The Century Company.
9. A government based on elected legislative councils.
10. Members of the middle class, such as merchants or businessmen; in Marxist theory, the class opposed to the proletariat.

One of our immediate tasks is to put an end to the war at once. But in order to end the war, which is closely bound up with the present capitalistic system, it is necessary to overthrow capitalism itself. In this work, we shall have the aid of the world labor movement, which has already begun to develop in Italy, England, and Germany.

A just and immediate offer of peace by us to the international democracy will find everywhere a warm response among the international proletariat[11] masses. In order to secure the confidence of the proletariat, it is necessary to publish at once all secret treaties.

In the interior of Russia a very large part of the peasantry has said: Enough playing with the capitalists; we will go with the workers. We shall secure the confidence of the peasants by one decree, which will wipe out the private property of the landowners. The peasants will understand that their only salvation is in union with the workers.

We will establish a real labor control on production.

We have now learned to work together in a friendly manner, as is evident from this revolution. We have the force of mass organization which has conquered all and which will lead the proletariat to world revolution.

We should now occupy ourselves in Russia in building up a proletarian socialist state.

Long live the world-wide socialistic revolution.

10. Vladimir Tatlin, *Model for the Monument to the Third International*, 1919–20
Gardner, p. 1019, ill. 22:76; Janson, p. 762, ill. 1071

First Manifesto of the Third International: "The Socialist World Order," 1919.

Lenin (1870–1924) and Trotsky (1879–1940) believed that the Russian Revolution was only a local phase of world revolution—of the revolution of strict Marxist doctrine. The Bolsheviks gave all possible aid to the leftist socialists of Europe and even considered sending Russian troops in 1919 to support a revolutionary effort in Hungary. But the chief instrument of world revolution, created in March 1919, was the Third International, which was also known as the Communist International or Comintern.

The First International was founded by Karl Marx to promote worldwide unity of the proletariat. The Second International was founded in 1889. It represented socialist parties and labor organizations of all countries. When it refused to endorse

11. People of the working class, especially those who do not possess capital and must sell their labor.

violent revolution or to repudiate moderate socialism, Lenin founded the Third International.

The first congress of the Third International met in Moscow in 1919. Within a year, the extreme leftist parties of thirty-seven countries were represented. The Russian party was supposedly only one component. Actually, it supplied most of the personnel and most of the funds. The Executive Committee of the Third International consisted almost entirely of members of the Central Committee of the Communist Party in the Soviet Union. Acting according to its directives, the Third International attempted to propagandize labor unions, to infiltrate armies, to discredit moderate socialism, and to disrupt elections. The goal of promoting world revolution was clearly stated in the *First Manifesto of the Third International* (1919). An excerpt from it, "The Socialist World Order," is presented here.

Despite its stridency, the Third International met with little success. The organization became inactive in the late 1920s. In the mid-1930s the Third International changed direction and instructed all Communist parties in their respective countries to enter into coalitions with socialists and advanced liberals. During the Second World War, to placate its allies, the Soviet Union abolished the Comintern entirely. But it reappeared for a few years, from 1947 to 1956, under a new name, the Communist Information Bureau, or Cominform.

For much of the twentieth century the Communist Party in Russia tried to present itself as the leader of world revolution and to exert control over Communist parties in other countries. Communist revolutions triumphed in China and Cuba. However, tensions from within the Soviet system itself proved more effective in the breakdown of Communist power in the former Soviet Union than any opposition presented by capitalist or bourgeois forces.

The Russian artist Vladimir Tatlin (1895–1956) was an eager proponent of Communism. Unlike Kandinsky and Malevich, Tatlin remained in high political favor until his death. *Monument to the Third International* (1919–20) reveals Tatlin's advocacy of Communist principles for all nations. In this project, Tatlin combined his interest in engineering and architecture with his abilities in sculpture. Only a twenty-foot model (now destroyed) for *Monument to the Third International* was actually constructed. However, the proposed height of the projected structure—approximately 1,300 feet—was intended to symbolize the dominant, worldwide position that Tatlin hoped the Communist Party would attain; the revolving motion of the tower was intended to express the changes that the Third International would effect.

First Manifesto of the Third International[1]
The Socialist World Order

We, the Communists assembled in the Third International, feel ourselves to be the direct successors of the heroic efforts and martyrdom of a long series

1. Reprinted, by permission of the publishers, from Raymond William Postgate, *The Bolshevik Theory* (London: G. Richards, 1920), pp. 188–90, 193–94, 199–200. Copyright by G. Richards.

of revolutionary generations. . . . As the First International foresaw the future development and pointed the way, as the Second International gathered together and organised millions of the proletarians, so the Third International is the International of open mass action, of the revolutionary realisation, the INTERNATIONAL OF DEEDS. Socialist criticism has sufficiently stigmatised the bourgeois world order. The task of the International Communist Party is now to overthrow this order and to erect in its place the structure of the Socialist world order. We urge the working men and women of all countries to unite under the Communist banner, the emblem under which the first great victories have already been won. . . .

Democracy, so-called—that is, bourgeois democracy—is nothing more nor less than veiled dictatorship by the bourgeoisie. The much-vaunted "popular will" exists as little as a unified people. In reality there are the classes, with antagonistic, irreconcilable purposes. However, since the bourgeoisie is only a small minority, it needs this fiction of the "popular will" as a flourish of fine-sounding words to reinforce its rule over the working classes and to impose its own class will upon the people. The proletariat, on the contrary, as the overwhelming majority of the people, openly exercises its class power by means of its mass organisation and through its Soviets,[2] in order to wipe out the privileges of the bourgeoisie and to secure the transition, rather than the transformation, into a *Classless* Communist Commonwealth.

The main emphasis of bourgeois democracy is on formal declaration of rights and liberties which are actually unattainable by the proletariat, because of want of the material means for their enjoyment; while the bourgeoisie uses its material advantages, through its Press and organisations, to deceive and betray the people. On the other hand, the Soviet type of Government makes it possible for the proletariat to realise its rights and liberties. The Soviet power gives to the people palaces, houses, printing-offices, paper supply, etc. for their Press, their societies and meetings. And in this way alone is actual proletarian democracy made possible.

Bourgeois democracy, with its parliamentary system, uses words to induce belief in popular participation in government. Actually, the masses and their organisations are held far out of reach of the real power and the real State administration. In the Soviet system the mass organisations rule, and through them the mass itself, inasmuch as the Soviets draw constantly increasing numbers of workers into the State administration, and only by this process will the entire working population gradually become part of the government. . . .

The growth of the revolutionary movement in all lands, the danger of

2. Elected government assemblies.

suppression of this revolution through the coalition of capitalistic states, the attempts of the Socialist betrayers to unite with one another and to give their services to the Wilsonian League, finally, the absolute necessity for co-ordination of proletarian action—all these demand the formation of a real revolutionary and real proletarian Communist International. This International, which subordinates the so-called national interest to the interests of the international revolution, will personify the mutual help of the proletariat of the different countries, for without economic and other mutual helpfulness the proletariat will not be able to organise the new society. On the other hand, in contrast with the Yellow International of the social patriots, the Proletarian Communist International will support the plundered colonial peoples in their fight against Imperialism, in order to hasten the final collapse of the Imperialistic world system.

The growth of the revolutionary movement in all lands, the danger of suppression of this revolution through the coalition of capitalistic states, the attempts of the Socialist betrayers to unite with one another . . . finally, the absolute necessity for co-ordination of proletarian action—all these demand the formation of a real revolutionary and real proletarian Communist International. This International . . . will personify the mutual help of the proletariat of the different countries. . . .

The capitalist criminals asserted at the beginning of the World War[3] that it was only in defence of the common Fatherland. But soon German Imperialism revealed its real brigand character by its bloody deeds in Russia, in the Ukraine and Finland. Now the Entente States[4] unmask themselves as world despoilers and murderers of the proletariat. Together with the German bourgeoisie and social patriots with hypocritical phrases about peace on their lips, they are trying to throttle the revolution of the European proletariat by means of their war machinery and stupid barbaric cannibals. . . . Against this the proletariat must defend itself, defend at any price. The Communist International calls the whole world proletariat to this final struggle.

DOWN WITH THE IMPERIALIST CONSPIRACY OF CAPITAL!

LONG LIVE THE INTERNATIONAL REPUBLIC OF THE WORKERS' SOVIET!

3. World War I.
4. The United States.

11. Giorgio de Chirico, *Sooth-Sayer's Recompense*, c. 1913
Gardner, p. 980, ill. 22:31

Giorgio de Chirico, *Mystery and Melancholy of a Street*, 1914
Janson, p. 723, ill. 1007

Benito Mussolini, Speech: "It Is Blood Which Moves the Wheels of History," December 13, 1914

Fascism became an important ideological and political force in Europe between World Wars I and II. With its fusion of reactionary nationalism and political authoritarianism, Fascism gained the support of a wide spectrum of the population, particularly in Italy and Germany.

Italy emerged from World War I with its national pride humiliated by military defeats and its economy jeopardized by wartime debts, unemployment, strikes, and acute depression.

Against a background of increasing social unrest, parliamentary government broke down, and Benito Mussolini (lived 1883–1945; premier 1922–43) rose to power. A socialist ex-schoolteacher, Mussolini had been interested in the Italian revolutionary movement since his youth. He had also immersed himself in the pessimistic philosophy of Nietzsche, which had led him to believe that humanitarian ideals were the weapons of the weak and the feeble, that violence was the fundamental element of social transformation, and that Italy could be restored to greatness only by a plan of vigorous action, even a "bath of blood," directed by a strong leader. In 1914 Mussolini advocated Italy's entry into World War I. He himself served in the trenches and was badly wounded. Upon recovery, he began to organize ex-soldiers into anti-socialist *fascios* to combat left-wing groups with strong-arm methods. Within two years, there were more than eight hundred branches of the "black shirt" organization, the Fasci di Combattimento.

In October 1922 the "March on Rome" took place. Mussolini mobilized the Blackshirts for a threatened coup, which ended when he became premier. Opposition to his political reign as Il Duce, The Leader, was crushed by assassination, police terror, Fascist militia violence, press control, and, in 1928, the suspension of parliamentary government. During the 1920s Mussolini tried to resolve Italy's economic difficulties by increasing state intervention. During the 1930s Mussolini sought to expand Italy's political influence by invading Ethiopia, by aiding Francisco Franco (1892–1975) in Spain, and by forming an alliance with Germany. Il Duce waited until France fell before bringing Italy into World War II in 1940. The failure of his military campaign resulted in Mussolini's temporary fall from power in 1943. Restored to power by German forces, Mussolini had little support within Italy after the German defeat. In 1945 he was captured, tried, and executed by Italian partisans.

Mussolini owed much of his rise to power to his abilities as a spellbinding orator.

In a speech delivered in Parma, Italy, on December 13, 1914, the young Mussolini not only advocated Italian entry into World War I but also derided the sentiments of "brotherhood and love" and declared that war was of "divine origin." A selection from Mussolini's speech, "It is Blood Which Moves the Wheels of History," is printed here.

Giorgio de Chirico (1888–1978) was an Italian painter whose landscapes and cityscapes suggested the mood of early twentieth-century Italy. Like Mussolini, de Chirico was influenced by the philosophy of Nietzsche. In paintings such as *Sooth-Sayer's Recompense* (1913) and *Mystery and Melancholy of a Street* (1914), de Chirico uses exaggerated perspective to create a disturbing atmosphere. The silent and virtually empty city spaces become haunting images of loneliness and isolation. At the same time, they realize Nietzsche's concept of art as a symbolic vision.

Benito Mussolini, Speech[1]
It is Blood Which Moves the Wheels of History

Citizens,—

The last great continental war was from 1870 to 1871. . . . From '70 onwards there were only remoter wars among the peoples of Eastern Europe, such as those between Russia and Turkey, Serbia and Bulgaria, Greece and Turkey, or wars in the colonies. There was, in consequence, a widespread conviction that a European or world war was no longer possible. The most diverse reasons were put forward to maintain this argument.

It was suggested, for example, that the perfecting of the instruments for making war must destroy its possibility. Ridiculous! War has always been deadly. The perfecting of arms is relative to the progress—technical, mechanical and military—of the human race. In this respect the warlike machines of the ancient Romans are the equivalent of the mortars of 420 calibre. They are made with the object of killing, and they do kill. The perfecting of instruments of war is no hindrance to warlike instincts. It might have the opposite effect.

Reliance was also placed on "human kindness" and other sentiments of humanity, of brotherhood and love, which ought, it was maintained, to bind all the different branches of the species "man" together regardless of barriers of land or sea. Another illusion! It is very true that these feelings of sympathy and brotherliness exist; our century has, in truth, seen the rapid multiplication of philanthropic works for the alleviation of the hardships both of men

1. Reprinted, by permission of the publisher, from Bernardo Quaranta di San Severino, ed. and trans., *Mussolini as Revealed in His Political Speeches* (New York: Howard Fertig, 1976), pp. 9–13, 16–17. Copyright by J. M. Dent.

and of animals; but along with these impulses exist others, profounder, higher and more vital. We should not explain the universal phenomenon of war by attributing it to the caprices of monarch, race-hatred or economic rivalry; we must take into account other feelings which each of us carries in his heart, and which made Prou'dhon[2] exclaim, with that perennial truth which hides beneath the mask of paradox, that war was of "divine origin."

It was also maintained that the encouragement of closer international relations—economic, artistic, intellectual, political and sporting—by causing the peoples to become better acquainted, would have prevented the outbreak of war among civilised nations. . . . Another illusion laid bare! Lack of observation. The purely economic man does not exist. The story of the world is not merely a page of book-keeping; and material interests—luckily—are not the only mainspring of human actions. It is true that international relations have multiplied; that there is, or was, freer interchange—political and economic—between the peoples of the different countries than there was a century ago. But parallel with this phenomenon is another, which is that the people, with the diffusion of culture and the formation of an economic system of a national type, tend to isolate themselves psychologically and morally.

Side by side with the peaceful middle-class movement, which is not worth examination, flourished another of an international character, that of the working classes. At the outbreak of war this class, too, gave evidence of its inefficiency. The Germans, who ought to have set the example, flocked as a man to the Kaiser's banner. The treachery of the Germans forced the Socialists of the other countries to fall back upon the basis of nationality and the necessity of national defence. The German unity automatically determined the unity of the other countries. It is said, and justly, that international relations are like love; it takes two to carry them on. Internationalism is ended; that which existed yesterday is dead, and it is impossible to foresee what form it will take to-morrow. Reality cannot be done away with and cannot be ignored, and the reality is that millions and millions of men, for the most part of the working classes, are standing opposite one another to-day on the blood-drenched battlefields of Europe. The neutrals, who shout themselves hoarse crying "Down with war!" do not realise the grotesque cowardice contained in that cry to-day. It is irony of the most atrocious kind to shout "Down with war!" while men are fighting and dying in the trenches. . . .

But *we* want the war and we want it at once. . . . Let us take up again the Italian traditions. The people who want the war want it without delay.

2. Pierre-Joseph Prou'dhon (1809–1865), a French social theorist.

In two months' time it might be an act of brigandage; to-day it is a war to be fought with courage and dignity.

War and Socialism are incompatible, understood in their universal sense, but every epoch and every people has had its wars. Life is relative; the absolute only exists in the cold and unfruitful abstract. Those who set too much store by their skins will not go into the trenches, and you will not find them even in the streets in the day of battle. He who refuses to fight to-day is an accomplice of the Kaiser, and a prop of the tottering throne of Francis Joseph. Do you wish mechanical Germany, intoxicated by Bismarck, to be once more the free and unprejudiced Germany of the first half of last century? Do you wish for a German Republic extending from the Rhine to the Vistula? Does the idea of the Kaiser, a prisoner and banished to some remote island, make you laugh? Germany will only find her soul through defeat. With the defeat of Germany the new and brilliant spring will burst over Europe.

It is necessary to act, to move, to fight and, if necessary, to die. Neutrals have never dominated events. They have always gone under. It is blood which moves the wheels of history!

12. Paul Klee, *Twittering Machine*, 1922
Gardner, p. 989, ill. 22:42; Janson, p. 733, ill. 1025

Carl Jung, *Psychology of the Unconscious:* "Phantastic Thinking," 1912

Psychological explorations of human thought and behavior expanded rapidly in the decades following World War I. The psychoanalytic theories developed by Freud were fervently debated and were significantly modified by many investigators, most notably Carl Gustaf Jung (1875–1961).

Jung, a Swiss psychiatrist, became renowned for his profound investigations of the unconscious mind. Initially an admirer of Freud, Jung departed from Freudian ideas concerning the makeup of the personality, the interpretation of myths and dreams, and the nature of sexuality. Jung identified a series of basic personality types in terms of opposed tendencies, such as extroversion and introversion, feeling and thinking, sensing and intuiting. He viewed the healthy individual as the person who has reconciled the tension between these tendencies. He attributed mental disorders to an exaggeration of one or more of these tendencies.

Jung was convinced that, in addition to the particular consciousness unique to an individual, the human personality also consisted of a basic collective unconscious shared by all humankind. In Jung's view, the collective unconscious contains deep

psychic predispositions, which are inherited and which predispose an individual to certain common patterns of thought, emotion, and action. These predispositions find expression in archetypal images and themes that emerge spontaneously in dreams, fantasies, delusions, and myths. Some major archetypal images include the hero, the child, God, the demon, the old wise man, and the earth mother; some major archetypal themes include birth, death, and rebirth.

Jung was also convinced of human bisexuality. He designated the man's feminine archetype as the anima and the woman's masculine archetype as the animus. The archetypes function in two ways: they influence each sex to manifest characteristics of the opposite sex, and they act as collective images that shape the perceptions, misperceptions, and fantasies regarding the other sex.

Jung presented his ideas in *Psychology of the Unconscious* (1912). In this text Jung interprets a wide range of mythological materials and reveals striking parallels between ancient myths and psychotic fantasies. An excerpt from *Psychology of the Unconscious,* "Phantastic Thinking," is presented here.

Psychology, with its study of the subconscious, dream symbolism, instinct, and emotion had great importance for artists seeking new modes of expression. One such artist was the painter Paul Klee (1879–1940), who, like Jung, was born in Switzerland. Between 1921 and 1931 Klee taught at the Bauhaus, a center for modern art, in Weimar, Germany. He returned to Switzerland after his art was confiscated by the Nazis and labeled degenerate. Klee defined the creative process of the artist as a fusion of the intuition of the individual artist with the collective experience of humankind. In works such as *Twittering Machine* (1922), Klee combined childlike lines with delicate color harmonies to express a world of personal fantasy.

Carl Jung, *Psychology of the Unconscious*[1]
Phantastic Thinking

It is a well-known fact that one of the principles of analytic psychology is that the dream images are to be understood symbolically; that is to say, that they are not to be taken literally just as they are presented in sleep, but that behind them a hidden meaning has to be surmised. . . . The dream arises from a part of the mind unknown to us, but none the less important, and is concerned with the desires for the approaching day. . . . That dreams may be full of import, and, therefore, something to be interpreted, is certainly neither a strange nor an extraordinary idea. . . .

As the old belief teaches, the Deity or the Demon speaks in symbolic speech to the sleeper, and the dream interpreter has the riddle to solve. In

1. Reprinted, by permission of the publisher, from Carl Jung, *Psychology of the Unconscious,* trans. by Beatrice M. Hinkle (London: Routledge & Kegan Paul, 1951), pp. 4–6, 11, 19–20. Copyright by Routledge & Kegan Paul.

modern speech we say this means that the dream is a series of images, which are apparently contradictory and nonsensical, but arise in reality from psychologic material which yields a clear meaning. . . .

Why are dreams symbolic? Every "why" in psychology is divided into two separate questions: first, for what purpose are dreams symbolic? We will answer this question only to abandon it at once. Dreams are symbolic in order that they can not be understood; in order that the wish, which is the source of the dream, may remain unknown. The question why this is so and not otherwise, leads us into the far-reaching experiences and trains of thought of the Freudian psychology.

Here the second question interests us, viz., How is it that dreams are symbolic? That is to say, from where does this capacity for symbolic representation come, of which we, in our conscious daily life, can discover apparently no traces? . . .

Whoever attentively observes himself will find the general custom of speech very striking, for almost every day we can see for ourselves how, when falling asleep, phantasies are woven into our dreams, so that between the dreams of day and night there is not so great a difference. Thus we have two forms of thinking—directed thinking and dream or phantasy thinking. The first, working for communication with speech elements, is troublesome and exhausting; the latter, on the contrary, goes on without trouble, working spontaneously, so to speak, with reminiscences. The first creates innovations, adaptations, imitates reality and seeks to act upon it; the latter, on the contrary, turns away from reality and sets free subjective wishes. . . . The latter form of thinking, presupposing that it were not constantly corrected by the adapted thinking, must necessarily produce an overwhelmingly subjectively distorted ideal of the world. . . . It lies in our individual past, and in the past of mankind.

With this we affirm the important fact that man in his phantastic thinking has kept a condensation of the psychic history of his development. . . . By means of phantastic thinking, directed thinking is connected with the oldest foundations of the human mind, which have been for a long time beneath the threshold of the consciousness. The products of this phantastic thinking arising directly from the consciousness are, first, waking dreams, or daydreams . . . then the dreams which offer to the consciousness, at first, a mysterious exterior, and win meaning only through the indirectly inferred unconscious contents. Lastly, there is a so-called wholly unconscious phantasy system in the split-off complex, which exhibits a pronounced tendency towards the production of a dissociated personality.

Our foregoing explanations show wherein the products arising from the

unconscious are related to the mythical. From all these signs it may be concluded that the soul possesses in some degree historical strata, the oldest stratum of which would correspond to the unconscious. . . . The conscious phantasies tell us of mythical or other material of undeveloped or no longer recognised wish tendencies in the soul.

13. Joan Miró, *Painting,* 1933
Gardner, p. 985, ill. 22:37

Joan Miró, *Composition,* 1933
Janson, p. 732, ill. 1024

James Joyce, *Ulysses:* "yes I said yes I will Yes," 1922

The insights from psychology fascinated many twentieth-century writers and artists. The interior realm of human consciousness—its vitality, its imagination, its intuitive insights, and its humor—was a field for investigation by the writer James Joyce (1882–1941) and the painter Joan Miró (1893–1983). Both men created exterior expressions of the inner human dimension that were indebted to concepts of psychology yet were independent of any theoretician's views.

James Joyce was an Irish novelist. Educated by Jesuits, Joyce renounced Catholicism and left Ireland in 1904 to live in various European cities, including Paris. In his novels, Joyce combined a variety of styles and techniques. His most important innovation was the introduction of the stream of consciousness method, which allowed him to reproduce the richness of his characters' interior memories, emotions, and desires, as well as to describe their response to the drabness and dreariness of the modern cities in which his novels are set.

One of Joyce's most famous novels is *Ulysses.* Published in 1922, the novel is an attempt to recapture, as completely as possible, the sights, sounds, and people of Dublin, Ireland, in the year 1904. Crafted by means of a series of parallels to the Odyssean myth, Joyce's novel reshapes the Greek heroes of Homer as lower-middle-class Irish people. Leopold Bloom is a transposed Ulysses;[1] Molly Bloom, his wife, a Penelope;[2] and Stephen Dedalus, a disillusioned teacher, a Telemachus.[3] The novel recounts a single day in which the lives of Leopold Bloom and Molly intersect haphazardly with that of Dedalus. During this day, Bloom and Dedalus are drawn by their business and personal activities to crisscross the Dublin landscape. As each

1. In Homeric legend, Ulysses was the king of Ithaca and the wisest and shrewdest of the Greek leaders in the Trojan War.
2. Penelope was the wife of Ulysses, who remained faithful to him during his absence at Troy in spite of having numerous suitors.
3. Telemachus was the son of Ulysses and Penelope, who helped Ulysses to kill the suitors of Penelope and to regain control of his kingdom.

goes about his sojourn, Dedalus reflects on his discouraging lot as a teacher of unruly boys while Bloom sadly ruminates about his wife's love affair with a concert tour manager and simultaneously continues a discreet flirtation by mail with another woman. The day concludes with Bloom rescuing a drunken Dedalus from the streets and bringing him home for the night. As Bloom drifts off to sleep by the side of his wife, Molly lies awake. She thinks of her girlhood, of people she has known, of lovers she has had, and finally of Bloom's courtship of her.

An excerpt from *Ulysses*, "yes I said yes I will Yes," is presented here. In this excerpt, Molly recalls her joyous response to Bloom on the day when they stood close together under a Moorish arch and he asked her to marry him.

Just as Joyce allowed the thoughts of the internal consciousness to surface onto his written pages, so too, the artist Joan Miró permitted the images of the interior mind to emerge onto his canvases. A Spanish artist who lived for many years in Paris, Miró simplified forms into amoeba-like organisms that appear to float in ambiguous spaces. In works that he titled in abstract terms, such as *Painting* (1933) and *Composition* (1933), Miró attempted to free his hand from the directives of his conscious mind and to permit his lines and shapes to emerge as spontaneous and intuitive clues from the submerged, subconscious mind.

James Joyce, *Ulysses*[4]
yes I said yes I will Yes

. . . the day we were lying among the rhododendrons on Howth head in the grey tweed suit and his straw hat the day I got him to propose to me yes first I gave him a bit of seedcake out of my mouth and it was leapyear like now yes 16 years ago my God after that long kiss I near lost my breath yes he said I was a flower of the mountains yes so we are flowers all a womans body yes that was one true thing he said in his life and the sun shines for you today yes that was why I liked him because I saw he understood or felt what a woman is and I knew I could always get round him and I gave him all the pleasure I could leading him on till he asked me to say yes and I wouldnt answer first only looked out over the sea and the sky I was thinking of so many things he didnt know of Mulvey and Mr Stanhope and Hester and father and old captain Groves and the sailors playing all birds fly and I say stoop and washing up dishes they called it on the pier and the sentry in front of the governors house with the thing round his white helmet poor devil half roasted and the Spanish girls laughing in their shawls and their tall combs and the auctions in the morning the Greeks and the Jews and the Arabs and the devil knows who else from all the ends of Europe and Duke street and

4. Reprinted, by permission of the publisher, from James Joyce, *Ulysses* (New York: Random House, 1946), pp. 767–68. Copyright by Nora Joseph Joyce.

the fowl market all clucking outside Larby Sharons and the poor donkeys slipping half asleep and the vague fellows in the cloaks asleep in the shade on the steps and the big wheels of the carts of the bulls and the old castle thousands of years old yes and those handsome Moors all in white and turbans like kings asking you to sit down in their little bit of a shop and Rhonda with the old windows of the posadas[5] glancing eyes a lattice hid for her lover to kiss the iron and the wineshops half open at night and the castanets and the night we missed the boat at Algeciras[6] the watchman going about serene with his lamp and O that awful deepdown torrent O and the sea the sea crimson sometimes like fire and the glorious sunsets and the figtrees in the Alameda[7] gardens yes and all the queer little streets and pink and blue and yellow houses and the rosegardens and the jessamine and geraniums and cactuses and Gibraltar as a girl where I was a Flower of the mountain yes when I put the rose in my hair like the Andalusian[8] girls used or shall I wear a red yes and how he kissed me under the Moorish wall and I thought well as well him as another and then I asked him with my eyes to ask again yes and then he asked me would I yes to say yes my mountain flower and first I put my arms around him yes and drew him down to me so he could feel my breasts all perfume yes and his heart was going like mad and yes I said yes I will Yes.

14. Henry Moore, *Reclining Figure*, 1939
Gardner, p. 756, ill. 17:44

Henry Moore, *Recumbent Figure*, 1938
Janson, p. 759, ill. 1066

D. H. Lawrence, *Women in Love:* "A Dark Flood of Electric Passion,"
1921

Recognition of the human sexual drive as a potential source of healthy emotional energy emerged not only in the writings of twentieth-century psychoanalysts such as Sigmund Freud (1856–1939) and Carl Jung (1875–1961), but also in the writings of the British author D[avid] H[erbert] Lawrence (1885–1930) and in the sculpture of the British artist Henry Moore (1898–1986).

Lawrence, the son of a coal miner, regarded himself as a working-class intruder

5. Inns.
6. A seaport in southern Spain, on the Strait of Gilbraltar.
7. A public walk shaded with trees; a town square.
8. A region in southern Spain, bordering on the Atlantic Ocean and the Mediterranean Sea.

in the upper-middle-class world of genteel English art and literature. After several years of work as a schoolteacher, Lawrence went to Europe in 1912 with Frieda von Richthofen Weekley, a German noblewoman and the wife of one of his college professors. During World War I, because of his pacifism and his marriage, by then, to the German-born Frieda, Lawrence was suspected by many people of being a spy. In 1919 Lawrence and his wife left England to live in Europe, as well as to stay more briefly in Ceylon, Australia, New Mexico, and Mexico.

Lawrence believed that modern Western society was dehumanizing and that people were losing their awareness of their basic physical and sexual selves. Just as he had been determined to liberate himself from all prudish restraints, Lawrence set out to liberate literature from constraints in subject and language. In his writings, Lawrence addresses his readers with ecstatically phrased paeans about primeval human instincts and fundamental earth forces. The novel *Women in Love* (1921) recounts the emotional and physical desires experienced by two sisters, Gudrun and Ursula. In one scene, set in a room in a village inn, Lawrence describes the rapture that is awakened in Ursula by her lover, Birkin. An excerpt from *Women in Love*, "A Dark Flood of Electric Passion," is presented here.

Like Lawrence, the English sculptor Henry Moore was the son of a coal miner. Through his studies at the Royal College of Art, Moore received classical training in the sculptural traditions of Western art. But, although he admired artists such as Masaccio, Michelangelo, and Rodin, Moore, like Lawrence, attributed to non-Western culture a more vital consciousness of the fundamental urges of human nature. One of Moore's most frequent subjects was the nude female body, which he made monumental in proportions, abstract in features, and dignified in presentation. The elemental human instincts of sexual love and emotional warmth that transcend time, place, and circumstance are strongly sensed in such sculptures by Moore as *Recumbent Figure* (1938) and *Reclining Figure* (1939).

D. H. Lawrence, *Women in Love*[1]
A Dark Flood of Electric Passion

[Ursula and Birkin] sat together in a little parlor by the fire.

"Is it?" she replied, laughing, but unassured.

"What?"

"Everything—is everything true?"

"The best is true," he said, grimacing at her.

"Is it?" she replied, laughing, but unassured.

She looked at him. He seemed still so separate. New eyes were opened in her soul. She was a strange creature from another world to him. It was as

1. Reprinted, by permission of the publisher, from D. H. Lawrence, *Women in Love* (New York: Viking Press, 1967), pp. 305–6. Copyright 1920, 1922 by D. H. Lawrence. Copyright by Frieda Lawrence.

if she were enchanted, and everything were metamorphosed. She recalled again the old magic of the Book of Genesis, where the sons of God saw the daughters of men, that they were fair. And he was one of these, one of these strange creatures from the beyond, looking down at her, and seeing she was fair.

He stood on the hearth-rug looking at her, at her face that was upturned exactly like a flower, a fresh, luminous flower, glinting faintly golden with the dew of the first light. And he was smiling faintly as if there were no speech in the world, save the silent delight of flowers in each other. Smilingly they delighted in each other's presence, pure presence, not to be thought of, even known. But his eyes had a faint ironical contraction.

And [Ursula] was drawn to [Birkin] strangely, as in a spell. Kneeling, on the hearth-rug before him, she put her arms round his loins, and put her face against his thighs. Riches! Riches! She was overwhelmed with a sense of a heavenful of riches.

"We love each other," she said in delight.

"More than that," he answered, looking down at her with his glimmering, easy face.

Unconsciously, with her sensitive finger-tips, she was tracing the back of his thighs, following some mysterious life-flow there. She had discovered something, something more than wonderful, more wonderful than life itself. It was the strange mystery of his life-motion, there, at the back of the thighs, down the flanks. It was a strange reality of his being, the very stuff of being, there in the straight downflow of the thighs. It was here she discovered him one of the sons of God such as were in the beginning of the world, not a man, something other, something more.

This was release at last. She had had lovers, she had known passion. But this was neither love nor passion. It was the daughters of men coming back to the sons of God, the strange inhuman sons of God who are in the beginning.

Her face was now one dazzle of released, golden light, as she looked up at him and laid her hands full on his thighs, behind, as he stood before her. He looked down at her with a rich bright brow like a diadem above his eyes. She was beautiful as a new marvellous flower opened at his knees, a paradisal flower she was, beyond womanhood, such a flower of luminousness. Yet something was tight and unfree in him. He did not like this crouching, this radiance—not altogether.

It was all achieved for her. She had found one of the sons of God from the Beginning, and he had found one of the first most luminous daughters of men.

She traced with her hands the line of his loins and thighs, at the back, and a living fire ran through her, from him, darkly. It was a dark flood of electric passion she released from him, drew into herself. She had established a rich new circuit, a new current of passional electric energy, between the two of them, released from the darkest poles of the body and established in perfect circuit. It was a dark fire of electricity that rushed from him to her, and flooded them both with rich peace, satisfaction.

"My love," she cried, lifting her face to him, her eyes, her mouth open in transport.

"My love," he answered, bending and kissing her, always kissing her.

She closed her hands over the full, rounded body of his loins, as he stooped over her, she seemed to touch the quick of the mystery of darkness that was bodily him. She seemed to faint beneath, and he seemed to faint, stooping over her. It was a perfect passing away for both of them, and at the same time the most intolerable accession into being, the marvellous fullness of immediate gratification, overwhelming, outflooding from the source of the deepest life-force, the darkest, deepest, strangest life-source of the human body, at the back and base of the loins.

After a lapse of stillness, after the rivers of strange dark fluid richness had passed over her, flooding, carrying away her mind and flooding down her spine and down her knees, past her feet, a strange flood, sweeping away everything and leaving her an essential new being, she was left quite free, she was free in complete ease, her complete self. So she rose, stilly and blithe, smiling at him. He stood before her, glimmering, so awfully real, that her heart almost stopped beating. He stood there in his strange, whole body, that had its marvellous fountains, like the bodies of the sons of God who were in the beginning. There were strange fountains of his body, more mysterious and potent than any she had imagined or known, more satisfying, ah, finally, mystically-physically satisfying. She had thought there was no source deeper than the phallic source. And now, behold, from the smitten rock of the man's body, from the strange marvellous flanks and thighs, deeper, further in mystery than the phallic source, came the floods of ineffable darkness and ineffable riches.

15. Kurt Schwitters, *Merz 19,* **1920**
Gardner, p. 979, ill. 22:29

Franz Kafka, *The Metamorphosis:* "His Little Legs Fluttered in the Air," 1915

The disillusionment with Western civilization after World War I was deep and pervasive. It permeated the literature of Franz Kafka (1883–1924) and the art of Kurt Schwitters (1887–1948), as well as the output of many other European writers and artists.

The Austrian novelist Kafka was the son of a successful Jewish businessman. Although Kafka died before his country was absorbed into the Nazi empire, he wrote disquieting premonitions of disasters yet to come. Kafka's short stories and novels are steeped with the sense of bewilderment and alienation felt by Europeans when their traditional beliefs and values vanished in the mayhem of World War I and its chaotic aftermath. Kafka's religious identity also made him acutely conscious of the growing contempt that his society exhibited toward outsiders and misfits, while his feelings of personal inadequacy, accentuated by the aggressive behavior of an intimidating father, left him filled with self-loathing toward his physical body and gripped by fears of emotional degradation.

The modern person's fate of being trapped in an incomprehensible, nightmarish world is captured by Kafka in the short story *The Metamorphosis* (1915). In this story the central character, Gregor Samsa, awakes one morning to find that he has been transformed into a giant insect. Gregor is gripped by a mounting sense of despair as he fails in his efforts to perform even the simplest normal task and as he realizes that he cannot even control his ceaselessly waving little legs. In imagining the plight of Gregor and in describing the response of Gregor's family, Kafka caricatures the response of society to deviations from accepted norms. In the conclusion of the story, the father uses a newspaper and a walking stick to beat the fleeing Gregor back into his room. Inexperienced in crawling backward, the unfortunate Gregor is already bleeding profusely, even before his vermin-like body is jammed through the narrow bedroom doorway. A selection from *The Metamorphosis*, "His Little Legs Fluttered in the Air," is presented here.

The German artist Kurt Schwitters created bitter mockeries of Western cultural values and traditions. Describing himself as painting pictures by hitting nails, Schwitters composed collages, such as *Merz Picture 19* (1920) from trash that he scavenged from streets and garbage cans. The accumulation of discarded tickets, newspapers, product labels, and paper scraps is an indictment of a society that Schwitters believed had gone mad. The rise of the Nazi Party drove Schwitters from Germany to Norway; the Nazi invasion of Norway several years later drove Schwitters from Norway to England, where he died three years after the conclusion of World War II.

Franz Kafka, *The Metamorphosis*[1]
His Little Legs Fluttered in the Air

Had [Gregor] been able to turn around, he could have reached his room quickly, but he feared to make his father impatient by the slowness of his

1. Reprinted, by permission of the publisher, from Franz Kafka, *The Metamorphosis*, trans. by A. L. Lloyd (New York: Vanguard Press, 1946), pp. 34–35. Copyright by Vanguard Press.

turning and feared also that at any moment he might receive a mortal blow on his head or his back from this menacing stick. Soon Gregor had no choice; for he realized with terror that when he was going backward he was not master of his direction and, still fearfully watching the attitude of his father out of the corner of his eye, he began his turning movement as quickly as possible, which was really only very slowly. Perhaps his father realized his good intention for, instead of hindering this move, he guided him from a little distance away, helping Gregor with the tip of the stick. If only he had left off that insupportable whistling! Gregor was completely losing his head. He had nearly completed his turn when, bewildered by the din, he mistook his direction and began to go back to his former position. When at last, to his great joy, he found himself facing the half-opened double doors, he discovered that his body was too big to pass through without hurt. Naturally, it never occurred to his father, in his present state, to open the other half of the double doors in order to allow Gregor to pass. He was dominated by the one fixed idea that Gregor should be made to return to his room as quickly as possible. He would never have entertained the long-winded performance which Gregor would have needed to rear up and pass inside. Gregor heard him storming behind him, no doubt to urge him through as though there were no obstacle in his path; the hubbub no longer sounded like the voice of one single father. Now was no time to play, and Gregor—come what may— hurled himself into the doorway. There he lay, jammed in a slanting position, his body raised up on one side and his flank crushed by the door jamb, whose white paint was now covered with horrible brown stains. He was caught fast and could not free himself unaided; on one side his little legs fluttered in the air, on the other they were painfully pressed under his body; then his father gave him a tremendous blow from behind with the stick. Despite the pain, this was almost a relief; he was lifted bodily into the middle of the room and fell, bleeding thickly. The door was slammed by a thrust of the stick, and then, at last, all was still.

16. Edward Hopper, *Early Sunday Morning*, 1930
Janson, p. 737, ill. 1033

T. S. Eliot, *Prufrock:* "Preludes," 1917

The sense of personal isolation that haunted intellectuals in Continental Europe during the decades following World Wars I and II was also felt in the United States

and Great Britain. The emptiness of contemporary life was reflected in the work of the American-born poet T[homas] S[tearns] Eliot (1888–1965) and the American painter Edward Hopper (1882–1967). Eliot chose to expatriate himself to Great Britain to find an intellectual climate that he hoped would be more congenial than that in the United States; Hopper, by contrast, after several long trips to France, chose to remain in the United States and to explore its urban features in his art.

Dissatisfied with the lyrical tradition in poetry, Eliot was eager to proclaim entirely new principles for verse. He rejected the notion that the poet's chief task was to console and uplift the human spirit by the creation of beauty. Instead, he defined the purpose of poetry as exploring and encompassing the whole of reality. Underlying this concept of poetry was the notion that the artist must seek truth before poetry and must, therefore, engage in the fullest experiences of modern life.

Eliot's poetry was experimental in language, style, and content. Believing that traditional conventions of diction, rhyme, and imagery were exhausted, Eliot strove to create a new type of imagery and to achieve a new level of verbal precision. The images that he presents are intended to recapture experience completely, yet simultaneously to leave the interpretation as open and resonant as it would be in life.

Among T. S. Eliot's early works are the poems collected together under the title *Prufrock,* published in 1917. In these poems, which consist of stanzas of varying length, Eliot traces the weariness felt by individuals of his generation. This weariness arose from the perception that all possibilities for the attainment of heroism or nobility in thought and action had been suffocated by the tawdriness of modern urban life. The poem "Preludes," from the volume *Prufrock,* is presented here.

Like the poetry of Eliot, the paintings of Hopper reveal an emphasis upon truth before beauty and an insistence upon concrete, yet evocative, imagery. Hopper's stark paintings convey the isolation of modern life, the sordidness of urban existence, and the boredom, frustration, and loneliness felt by contemporary individuals. In paintings such as *Early Sunday Morning* (1930), Hopper depicts the tawdry surface of the industrial city and, at the same time, achieves a classical sense of order and harmony.

T. S. Eliot, *Prufrock*[1]
Preludes

I

The winter evening settles down
With smell of steaks in passageways.
Six o'clock.
The burnt-out ends of smoky days.
And now a gusty shower wraps
The grimy scraps

1. Reprinted, by permission of the publisher, from T. S. Eliot, *The Complete Poems and Plays: 1909–1950* (New York: Harcourt, Brace & World, 1962), pp. 12–13. Copyright by T. S. Eliot.

Of withered leaves about your feet
And newspapers from vacant lots;
The showers beat
On broken blinds and chimney-pots,
And at the corner of the street
A lonely cab-horse steams and stamps.
And then the lighting of the lamps.

II

The morning comes to consciousness
Of faint stale smells of beer
From the sawdust-trampled street
With all its muddy feet that press
To early coffee-stands.
With the other masquerades
That time resumes,
One thinks of all the hands
That are raising dingy shades
In a thousand furnished rooms.

III

You tossed a blanket from the bed,
You lay upon your back, and waited;
You dozed, and watched the night revealing
The thousand sordid images
Of which your soul was constituted;
They flickered against the ceiling.
And when all the world came back
And the light crept up between the shutters
And you heard the sparrows in the gutters,
You had such a vision of the street
As the street hardly understands;
Sitting along the bed's edge, where
You curled the papers from your hair,
Or clasped the yellow soles of feet
In the palms of both soiled hands.

IV

His soul stretched tight across the skies
That fade behind a city block,
Or trampled by insistent feet

At four and five and six o'clock;
And short square fingers stuffing pipes,
And evening newspapers, and eyes
Assured of certain certainties,
The conscience of a blackened street
Impatient to assume the world.

I am moved by fancies that are curled
Around these images, and cling:
The notion of some infinitely gentle
Infinitely suffering thing.

Wipe your hand across your mouth, and laugh;
The worlds revolve like ancient women
Gathering fuel in vacant lots.

17. Dorothea Lange, *Migrant Mother, California,* 1936
Gardner, p. 1018, ill. 22:75; Janson, p. 802, ill. 1136

John Steinbeck, *The Grapes of Wrath:* "The Scraped Kettle," 1939

In Europe the years between 1918 and 1938 were dominated by economic depression, social unrest, and political instability. The United States, however, enjoyed an unprecedented period of prosperity in the 1920s. Elation over the successful outcome of World War I combined with economic expansion to create a hectic social climate that has been termed the "roaring twenties."

As a result of the war, the United States became the major creditor nation for Europe. A large percentage of the world's gold reserves flowed into the United States Treasury in Fort Knox, Kentucky. This wealth provided the basis for rapid growth. Rising consumption and easy credit further fueled the boom.

The expanding economy of the late twenties was brought to a sudden halt by the Wall Street crash of October 1929. A downturn in the economic indices during the summer of 1929 signaled the coming collapse. Sliding stock prices during the autumn of 1929 contributed to the panic. Unemployment soared as credit dried up, consumption declined, and bankruptcies multiplied.

For the next three years, the depression deepened, not only in the United States but in the rest of the industrialized world as well. Between 1928 and 1932 the national income declined from $83,326 billion to $39,963 billion, and the number of unemployed increased to more than 12 billion people.

Even the agricultural sector of the economy collapsed. As farm prices fell and

drought overtook much of the Midwest, rural families with shrinking incomes were forced off their lands and into the ranks of the urban unemployed or the growing pool of migrant laborers.

The destitution faced by the agrarian poor was recorded by both artists and writers. Employed in the 1930s by the Farm Security Administration, an agency established by President Roosevelt to relieve rural poverty, the photographer Dorothea Lange (1895–1965) crisscrossed the country in her determination to document the hardships endured by agrarian workers in America. In Nipomo, California, she found a camp of 2,500 virtually starving migrant workers. One worker was Florence Thompson, the widowed mother of two children, whose tired, anxious, but courageous face is captured in the photograph *Migrant Mother, California* (1936). When published as an illustration to a news story describing the plight of these workers, this photograph stirred the sympathy of the nation. Food was hurriedly sent in by the government, and improved conditions for migrant camps were mandated.

The sufferings of the agrarian laborer were also described by the American writer John Steinbeck (1902–1968). Born in Salinas, California, Steinbeck wrote fiction characterized by realistic dialogue and a sympathy for the downtrodden. *The Grapes of Wrath* (1939) is a realistic, brutal novel about an American family forced from their Oklahoma farm in the Great Depression. In one scene the family is camping in a shantytown. Ma kneels beside a fire outside her tent to make stew for her family. A crowd of small hungry children from other families gathers around her in hopes of being fed. An excerpt from *The Grapes of Wrath*, "The Scraped Kettle," is presented here.

John Steinbeck, *The Grapes of Wrath*[1]
The Scraped Kettle

Ma knelt beside the fire, breaking twigs to keep the flame up under the stew kettle. The fire flared and dropped and flared and dropped. The children, fifteen of them, stood silently and watched. And when the smell of the cooking stew came to their noses, their noses crinkled slightly. The sunlight glistened on hair tawny with dust. The children were embarrassed to be there, but they did not go. Ma talked quietly to a little girl who stood inside the lusting circle. She was older than the rest. She stood on one foot, caressing the back of her leg with a bare instep. Her arms were clasped behind her. She watched Ma with steady small gray eyes. She suggested, "I could break up some bresh if you want me, ma'am."

Ma looked up from her work. "You want ta get ast to eat, huh?"

"Yes, ma'am," the girl said steadily.

1. Reprinted, by the permission of the publisher, from John Steinbeck, *The Grapes of Wrath* (New York: Viking Press, 1940), pp. 344–45, 349–51. Copyright by John Steinbeck.

Ma slipped the twigs under the pot and the flame made a puttering sound. "Didn' you have no breakfast?"

"No, ma'am. They ain't no work hereabouts. Pa's in tryin' to sell some stuff to git gas so's we can git 'long."

Ma looked up. "Didn' none of these here have no breakfast?"

The circle of children shifted nervously and looked away from the boiling kettle. . . .

It was crowded now. The strange children stood close to the stew pot, so close that Ma brushed them with her elbows as she worked. Tom and Uncle John stood beside her.

Ma said helplessly, "I dunno what to do. I got to feed the fambly. What'm I gonna do with these here?" The children stood stiffly and looked at her. Their faces were blank, rigid, and their eyes went mechanically from the pot to the tin plate she held. Their eyes followed the spoon from pot to plate, and when she passed the steaming plate up to Uncle John, their eyes followed it up. Uncle John dug his spoon into the stew, and the banked eyes rose up with the spoon. A piece of potato went into John's mouth and the banked eyes were on his face, watching to see how he would react. Would it be good? Would he like it?

And then Uncle John seemed to see them for the first time. He chewed slowly. "You take this here," he said to Tom. "I ain't hungry."

"You ain't et today," Tom said.

"I know, but I got a stomickache. I ain't hungry."

Tom said quietly, "You take that plate inside the tent an' you eat it."

"I ain't hungry," John insisted. "I'd still see 'em inside the tent."

Tom turned on the children. "You git," he said. "Go on now, git." The bank of eyes left the stew and rested wondering on his face. "Go on now, git. You ain't doin' no good. There ain't enough for you."

Ma ladled stew into the tin plates, very little stew, and she laid the plates on the ground. "I can't send 'em away," she said. "I don' know what to do. Take your plates an' go inside. I'll let 'em have what's lef'. Here, take a plate in to Rosasharn." She smiled up at the children. "Look," she said, "you little fellas go an' get you each a flat stick an' I'll put what's left for you. But they ain't to be no fightin'." The group broke up with a deadly, silent swiftness. Children ran to find sticks, they ran to their own tents and brought spoons. Before Ma had finished with the plates they were back, silent and wolfish. Ma shook her head. "I dunno what to do. I can't rob the fambly. I got to feed the fambly. Ruthie, Winfiel', Al," she cried fiercely. "Take your plates. Hurry up. Git in the tent quick." She looked apologetically at the waiting children. "There ain't enough," she said humbly. "I'm a-gonna set this here kettle out,

an' you'll all get a little tas', but it ain't gonna do you no good." She faltered, "I can't he'p it. Can't keep it from you." She lifted the pot and set it down on the ground. "Now wait. It's too hot," she said, and she went into the tent quickly so she would not see. Her family sat on the ground, each with his plate; and outside they could hear the children digging into the pot with their sticks and their spoons and their pieces of rusty tin. A mound of children smothered the pot from sight. They did not talk, did not fight or argue; but there was a quiet intentness in all of them, a wooden fierceness. Ma turned her back so she couldn't see. "We can't do that no more," she said. "We got to eat alone." There was the sound of scraping at the kettle, and then the mound of children broke and the children walked away and left the scraped kettle on the ground. Ma looked at the empty plates. "Didn' none of you get nowhere near enough."

18. George Howe and William E. Lescaze, Philadelphia Savings Fund Society Building, Philadelphia, 1931–32
Gardner, p. 1008, ill. 22:62; Janson, p. 783, ill. 1109

Franklin D. Roosevelt, *First Inaugural Address:* "The Only Thing We Have to Fear Is Fear Itself," March 4, 1933

The Great Depression had important political repercussions for the United States. Dissatisfaction with the conservative fiscal policies pursued by Herbert Hoover (1874–1964; president 1929–33) mounted steadily throughout his presidency. In 1932 the presidential election was won by Franklin Delano Roosevelt (1882–1945; president 1933–45), who promised a "New Deal" to the American people.

A man of wealth, established family traditions, and social position, Roosevelt had the imagination and the willingness to experiment with economic theories that most other world leaders regarded as radical. Roosevelt's goal was to manipulate currency, credit, taxes, and national spending so that the government could steady the economy, prevent boom and bust cycles, ensure social justice, and, at the same time, preserve the capitalist system and protect democratic institutions. Roosevelt stated his determination to guide the nation along a path of economic and social recovery in his first inaugural address, delivered on March 4, 1933. An excerpt from this address, "The Only Thing We Have to Fear Is Fear Itself," is presented here.

Immediately after entering the presidential office, Roosevelt embarked upon the most ambitious and revolutionary set of social and economic reforms in the nation's history. The New Deal established government programs designed to improve conditions for industry and business, labor, the poor, retired persons, widows, and orphans. Through government-sponsored programs of employment, schools, parks,

hospitals, and other public buildings were constructed. Through other government actions, low-cost electrical power was brought to homes and industry, and steady water supplies became available to farmers.

Among Roosevelt's most important actions was the reform of the banking system. In order to restore public trust in the nation's banks, Roosevelt established the Federal Deposit Insurance Corporation, which insured bank deposits up to $5,000. At the same time he created the Securities and Exchange Commission, to supervise the stock market and to prevent the abuses that had contributed to the Wall Street crash of 1929.

The success of such financial institutions as the Philadelphia Savings Fund Society owed much to Roosevelt. In 1931 alone no fewer than 2,294 banks failed as frightened depositors withdrew their money. Designed by George Howe and William E. Lescaze, the Philadelphia Savings Fund Society Building (1931–32) shows structural daring and stylistic innovation at the same time that Roosevelt brought new approaches to national government.

The New Deal cannot be credited with ending the Depression. It was the defense spending of World War II that finally brought prosperity again to the United States. However, Roosevelt's programs were extremely important in restoring the confidence of the people during the 1930s, in quelling social unrest and political turbulence, and in relieving the worst effects of the Depression. Most of the New Deal programs have remained in effect, and have been broadened by the policies of succeeding Democratic administrations, including the Fair Deal of Harry S Truman, the New Frontier of John F. Kennedy, and the Great Society of Lyndon B. Johnson.

Franklin D. Roosevelt, *First Inaugural Address*[1]
The Only Thing We Have to Fear Is Fear Itself

This is a day of national consecration, and I am certain that my fellow-Americans expect that on my induction into the Presidency I will address them with a candor and a decision which the present situation of our nation impels.

This is pre-eminently the time to speak the truth, the whole truth, frankly and boldly. Nor need we shrink from honestly facing conditions in our country today. This great nation will endure as it has endured, will revive and will prosper.

So first of all let me assert my firm belief that the only thing we have to fear is fear itself—nameless, unreasoning, unjustified terror which paralyzes needed efforts to convert retreat into advance. . . .

In such a spirit on my part and on yours we face our common difficulties. They concern, thank God, only material things. Values have shrunken to

1. Franklin Delano Roosevelt, "Inaugural Address," March 4, 1933, *New York Times*, March 5, 1933, 1:5–6.

fantastic levels; taxes have risen; our ability to pay has fallen, government of all kinds is faced by serious curtailment of income; the means of exchange are frozen in the currents of trade; the withered leaves of industrial enterprise lie on every side; farmers find no markets for their produce; the savings of many years in thousands of families are gone.

More important, a host of unemployed citizens face the grim problem of existence, and an equally great number toil with little return. Only a foolish optimist can deny the dark realities of the moment.

Yet our distress comes from no failure of substance. We are stricken by no plague of locusts. Compared with the perils which our forefathers conquered because they believed and were not afraid, we have still much to be thankful for. Nature still offers her bounty and human efforts have multiplied it. Plenty is at our doorstep, but a generous use of it languishes in the very sight of the supply.

Primarily, this is because the rulers of the exchange of mankind's goods have failed through their own stubbornness and their own incompetence, have admitted their failure and abdicated. . . .

They have no vision, and when there is no vision the people perish. . . .

The measure of the restoration lies in the extent to which we apply social values more noble than mere monetary profit.

Happiness lies not in the mere possession of money; it lies in the joy of achievement, in the thrill of creative effort. . . .

Our greatest primary task is to put people to work. This is no unsolvable problem if we face it wisely and courageously.

It can be accomplished in part by direct recruiting by the government itself, treating the task as we would treat the emergency of a war, but at the same time, through this employment, accomplishing greatly needed projects to stimulate and reorganize the use of our natural resources.

Hand in hand with this, we must frankly recognize the overbalance of population in our industrial centers and, by engaging on a national scale in the redistribution, endeavor to provide a better use of the land for those best fitted for the land.

The task can be helped by definite efforts to raise the values of agricultural products and with this the power to purchase the output of our cities. . . .

The basic thought that guides these specific means of national recovery is not narrowly nationalistic. . . .

It is the insistence, as a first consideration, upon the interdependence of the various elements in, and parts of, the United States—a recognition of the

old and permanently important manifestation of the American spirit of the pioneer. . . .

In the field of world policy I would dedicate this nation to the policy of the good neighbor—the neighbor who resolutely respects himself and, because he does so, respects the rights of others—the neighbor who respects his obligations and respects the sanctity of his agreements in and with a world of neighbors.

If I read the temper of our people correctly, we now realize as we have never before, our interdependence on each other; that we cannot merely take, but we must give as well; that if we are to go forward we must move as a trained and loyal army willing to sacrifice for the good of a common discipline, because, without such discipline, no progress is made, no leadership becomes effective.

We are, I know, ready and willing to submit our lives and property to such discipline because it makes possible a leadership which aims at a larger good.

This I propose to offer, pledging that the larger purposes will bind upon us all as a sacred obligation with a unity of duty hitherto evoked only in time of armed strife.

With this pledge taken, I assume unhesitatingly the leadership of this great army of our people, dedicated to a disciplined attack upon our common problems. . . .

I am prepared under my constitutional duty to recommend the measures that a stricken nation in the midst of a stricken world may require.

These measures, or such other measures as the Congress may build out of its experience and wisdom, I shall seek, within my constitutional authority, to bring to speedy adoption.

But in the event that the Congress shall fail to take one of these two courses, and in the event that the national emergency is still critical, I shall not evade the clear course of duty that will then confront me.

I shall ask the Congress for the one remaining instrument to meet the crisis—broad executive power to wage a war against the emergency as great as the power that would be given me if we were in fact invaded by a foreign foe. . . .

We face the arduous days that lie before us in the warm courage of national unity; with the clear consciousness of seeking old and precious moral values; with the clear satisfaction that comes from the stern performance of duty by old and young alike. . . .

We do not distrust the future of essential democracy. The people of the

United States have not failed. In their need they have registered a mandate that they want direct, vigorous action. . . .

In this dedication of a nation we humbly ask the blessing of God. May He protect each and every one of us! May He guide me in the days to come!

19. Max Beckmann, *Departure*, 1932–35
Gardner, p. 973, ill. 22:24; Janson, p. 735, ill. 1029

Adolf Hitler, *Mein Kampf:* "Pure Blood," 1924

In Germany the Nazi Party (National Socialist German Workers' Party) was founded in the atmosphere of disillusionment and economic distress that followed World War I. Its transformation and expansion into the dominant political force in Germany was due to Adolf Hitler (1889–1945) more than to any other person.

Born in Austria, Hitler did not complete high school. For a time he made his living painting postcards in Vienna. There, Hitler eagerly absorbed virulent anti-Semitism and hatred of the Slavs. He also soaked up the crudest, most distorted forms of social Darwinism. Hitler's interpretation of the theory of survival became an ideological means to promote the superiority of the Germanic peoples, to create a master race through breeding practices, and to justify racial conflict and ethnic extermination.

Moving to Munich in 1913, Hitler served in the German army in World War I, where he was promoted to corporal and was decorated for bravery. He began his political career in 1919, when he joined the Nazi Party, then no more than a tiny extremist group. In 1923 Hitler tried unsuccessfully to overthrow the German national government, headquartered in Munich, in an armed uprising known as the Beer Hall Putsch. Hitler received a sentence of nine months' imprisonment for his role in the putsch.

Upon his release, Hitler worked to revive the Nazi Party. The economic depression of 1929 swelled party ranks with the young and unemployed; with the middle class, which was frightened about job security; and with the conservatives. Parliamentary government foundered, and street violence, fomented largely by the Nazis, increased to alarming proportions. In January 1933, Hitler was appointed chancellor of Germany. Moving quickly to assume dictatorial power, Hitler consolidated his rule through a purge in which he liquidated possible rivals in both the party and the state.

The massive campaigns of rearmament and public works that Hitler instituted did much to provide Germany with a solution to unemployment. However, the reign of terror that Hitler established through his use of the Gestapo, the secret state police, gave the Nazi regime a vicious character.

During his imprisonment following the Beer Hall Putsch, Hitler turned to writing. He recounted his life and set out his extreme racist and nationalist views in his

two-volume work entitled *Mein Kampf,* or *My Struggle* (1924). An excerpt from *Mein Kampf,* "Pure Blood," is presented here. *Mein Kampf* came to be regarded as a bible by the Nazi movement.

Nazism profoundly affected the life and work of the German painter Max Beckmann (1884–1950). Infuriated by the artist's uncompromising opposition, Hitler labeled Beckmann's art "degenerate" and banned it from public viewing. In the triptych *Departure* (1932–35), Beckmann depicted Nazi acts of sadism and intimidation. In the side panels, defenseless individuals are brutally beaten, maimed, and tortured. The flight of the royal family, depicted in the central panel, presages Beckmann's own flight from Germany three years after this painting was completed.

Adolf Hitler, *Mein Kampf*[1]
Pure Blood

It is idle to argue which race or races were the original representative of human culture and hence the real founders of all that we sum up under the word "humanity." It is simpler to raise this question with regard to the present, and here an easy, clear answer results. All the human culture, all the results of art, science, and technology that we see before us today, are almost exclusively the creative product of the Aryan[2] This very fact admits of the not unfounded inference that he alone was the founder of all higher humanity, therefore representing the prototype of all that we understand by the word "man." He is the Prometheus[3] of mankind from whose bright forehead the divine spark of genius has sprung at all times, forever kindling anew that fire of knowledge which illumined the night of silent mysteries and thus caused man to climb the path to mastery over the other beings of this earth. Exclude him—and perhaps after a few thousand years darkness will again descend on the earth, human culture will pass, and the world turn to a desert.

If we were to divide mankind into three groups, the founders of culture, the bearers of culture, the destroyers of culture, only the Aryan could be considered as the representative of the first group. From him originate the foundations and walls of all human creation, and only the outward form and color are determined by the changing traits of character of the various peoples. He provides the mightiest building stones and plans for all human

1. Reprinted, by permission of the publisher, from Adolf Hitler, *Mein Kampf,* trans. by Ralph Manheim (Boston: Houghton Mifflin, 1962), pp. 290, 294–96, 327. Copyright by Houghton Mifflin Co.
2. In ethnological terms, a member or descendant of the prehistoric people who spoke Indo-European, but in Nazi doctrine, a non-Jewish Caucasian.
3. In classical mythology, a Titan who stole fire from Mt. Olympus and gave it to humankind in defiance of Zeus.

progress and only the execution corresponds to the nature of the varying men and races. . . .

We see this most distinctly [that] the race which has been and is the bearer of human cultural development—the Aryans. As soon as Fate leads them toward special conditions, their latent abilities begin to develop in a more and more rapid sequence and to mold themselves into tangible forms. The cultures which they found in such cases are nearly always decisively determined by the existing soil, the given climate, and—the subjected people. This last item, to be sure, is almost the most decisive. The more primitive the technical foundations for a cultural activity, the more necessary is the presence of human helpers who, organizationally assembled and employed, must replace the force of the machine. Without this possibility of using lower human beings, the Aryan would never have been able to take his first steps toward his future culture; just as without the help of various suitable beasts which he knew how to tame, he would not have arrived at a technology which is now gradually permitting him to do without these beasts. The saying, "The Moor has worked off his debt, the Moor can go," unfortunately has only too deep a meaning. For thousands of years the horse had to serve man and help him lay the foundations of a development which now, in consequence of the motor car, is making the horse superfluous. In a few years his activity will have ceased, but without his previous collaboration man might have had a hard time getting where he is today.

Thus, for the formation of higher cultures the existence of lower human types was one of the most essential preconditions, since they alone were able to compensate for the lack of technical aids without which a higher development is not conceivable. It is certain that the first culture of humanity was based less on the tamed animal than on the use of lower human beings.

Only after the enslavement of subjected races did the same fate strike beasts, and not the other way around, as some people would like to think. For first the conquered warrior drew the plow—and only after him the horse. Only pacifistic fools can regard this as a sign of human depravity, failing to realize that this development had to take place in order to reach the point where today these sky-pilots could force their drivel on the world.

The progress of humanity is like climbing an endless ladder; it is impossible to climb higher without first taking the lower steps. Thus, the Aryan had to take the road to which reality directed him and not the one that would appeal to the imagination of a modern pacifist. The road of reality is hard and difficult, but in the end it leads where our friend would like to bring humanity by dreaming, but unfortunately removes more than bringing it closer.

Hence it is no accident that the first cultures arose in places where the Aryan, in his encounters with lower peoples, subjugated them and bent them to his will. They then became the first technical instrument in the service of a developing culture.

Thus, the road which the Aryan had to take was clearly marked out. As a conqueror he subjected the lower beings and regulated their practical activity under his command, according to his will and for his aims. But in directing them to a useful, though arduous activity, he not only spared the life of those he subjected; perhaps he gave them a fate that was better than their previous so-called "freedom." As long as he ruthlessly upheld the master attitude, not only did he really remain master, but also the preserver and increaser of culture. For culture was based exclusively on his abilities and hence on his actual survival. As soon as the subjected people began to raise themselves up and probably approached the conqueror in language, the sharp dividing wall between master and servant fell. The Aryan gave up the purity of his blood and, therefore, lost his sojourn in the paradise which he had made for himself. He became submerged in the racial mixture, and gradually, more and more, lost his cultural capacity, until at last, not only mentally but also physically, he began to resemble the subjected aborigines more than his own ancestors. For a time he could live on the existing cultural benefits, but then petrifaction set in and he fell a prey to oblivion.

Thus cultures and empires collapsed to make place for new formations.

Blood mixture and the resultant drop in the racial level is the sole cause of the dying out of old cultures; for men do not perish as the result of lost wars, but by the loss of that force of resistance which is contained only in pure blood.

All who are not of good race in this world are chaff. . . .

If we pass all the causes of the German collapse in review, the ultimate and most decisive remains the failure to recognize the racial problem and especially the Jewish menace.

The defeats on the battlefield in August, 1918, would have been child's play to bear. They stood in no proportion to the victories of our people. It was not they that caused our downfall; no, it was brought about by that power which prepared these defeats by systematically over many decades robbing our people of the political and moral instincts and forces which alone make nations capable and hence worthy of existence.

In heedlessly ignoring the question of the preservation of the racial foundations of our nation, the old Reich disregarded the sole right which gives life in this world. Peoples which bastardize themselves, or let themselves be bastardized, sin against the will of eternal Providence, and when their ruin

is encompassed by a stronger enemy it is not an injustice done to them, but only the restoration of justice. If a people no longer want to respect the Nature-given qualities of its being which root in its blood, it has no further right to complain over the loss of its earthly existence.

Everything on this earth is capable of improvement. Every defeat can become the father of a subsequent victory, every lost war the cause of a later resurgence, every hardship the fertilization of human energy, and from every oppression the forces for a new spiritual rebirth can come—as long as the blood is preserved pure.

The lost purity of the blood alone destroys inner happiness forever, plunges man into the abyss for all time, and the consequences can never more be eliminated from body and spirit.

20. Pablo Picasso, *Guernica,* 1937
Gardner, p. 1026, ill. 22:83; Janson, p. 728, ill. 1015

Ernest Hemingway, *For Whom the Bell Tolls:* "The Fascists Purified the Town" and "The Sickles and the Reaping Hooks," 1940

Fascism found an apt pupil not only in Germany, in the person of Adolf Hitler, but also in Spain, in the person of Francisco Franco (1892–1975). Spain was traditionally ruled by the Bourbon[1] monarchy. But in 1931 political upheavals drove the Bourbon ruler Alfonso XIII (lived 1886–1941; king of Spain 1886–1931) from Spain, and led to the establishment of a democratic form of government. Although the new government embarked upon a program of reform, it was unable to assuage long-standing hostilities between churchmen and local leaders and between great property owners and peasants. The threat of the government's growing influence caused all elements of the political center and the left—republicans, socialists, anarchists, communists, and syndicalists[2]—to unite in the election campaign of 1936 and to defeat it and its conservative allies—the monarchists, clerics, and army officers. Soon afterward, in July 1936, a group of military men led an insurrection against the elected Republican government. Franco, an army general, emerged as the leader of the coup and as the head of the Falange, the Spanish Fascist Party. The opposition parties refused to submit to the Falange rule, and the whole country fell into civil war. It was the most devastating war in all Spanish history; over 600,000 people lost their lives.

1. Members of the Bourbon family ruled France (1589–1792) and Spain (1700–1931). The Bourbon prince Juan Carlos (b. 1938) was restored to the Spanish throne by Franco in 1974.
2. The doctrine of syndicalism was one of revolutionary trade unionism, developed chiefly in the late nineteenth century, advocating principally the abolition of the state, which was to be replaced by a loose federation of industrial workers.

Extreme cruelty was practiced on both sides. Spain became the battlefield of contending ideologies. The Spanish Civil War split the Western world into Fascist and anti-Fascist camps. Thousands of sympathizers from Europe and the United States went to Spain to serve as volunteers with the Republican forces, while the Soviet Union sent political advisers and military technicians. Germany and Italy sent troops to aid the Fascists and tested their tanks and planes on Republican towns. For nearly three years the Republican forces mounted a successful resistance before finally succumbing to the Fascist forces of Franco.

In Spain and elsewhere, artists sympathized with the Republican cause. The Spanish Civil War was described in heroic fashion by the American writer Ernest Hemingway (1899–1961). Hemingway covered the Spanish Civil War as a news correspondent. A witness to atrocities committed both by Fascist and Republican forces, Hemingway drew upon his personal experiences in order to write the novel *For Whom the Bell Tolls* (1940). Two selections from *For Whom the Bell Tolls* are presented here. In the first selection, "The Fascists Purified the Town," the Republican guerrilla leader Joaquín recounts the fate of his family in the Spanish city of Valladolid.[3] In the second selection, "The Sickles and the Reaping Hooks," the woman Pilar recalls an execution of suspected Fascists by a crowd of drunken townspeople.

The Spanish Civil War was also memorialized in dramatic terms by the Spanish-born artist Pablo Picasso (1881–1973). Commissioned to paint a mural for the pavilion of the Spanish Republic at the Paris International Exposition in 1937, Picasso chose to depict the bombing of the defenseless town of Guernica. This bombing had been carried out in 1937 by German planes in support of the Falangists in the civil war. Elements of the mural *Guernica* (1937), such as the dead child held by the weeping mother and the corpse of the heroic resistance fighter, reveal Picasso's intense partisanship with the Republican cause.

Ernest Hemingway, *For Whom the Bell Tolls*[4]
The Fascists Purified the Town

"How was this shooting of thy family?" Pilar was saying to Joaquín.

"Nothing, woman," Joaquín said. "They were of the left as many others in Valladolid. When the fascists purified the town they shot first the father. He had voted Socialist. Then they shot the mother. She had voted the same. It was the first time she had ever voted. After that they shot the husband of one of the sisters. He was a member of the syndicate of tramway[5] drivers. Clearly he could not drive a tram[6] without belonging to the syndicate. But he

3. A city in northern Spain.
4. Reprinted, by permission of the publisher, from Ernest Hemingway, *For Whom the Bell Tolls* (New York: Charles Scribner's Sons, 1940), p. 138. Copyright by the Ernest Hemingway Foundation.
5. A crude railroad of wooden rails or wooden rails capped with metal treads.
6. A vehicle on rails, often a streetcar.

was without politics. I knew him well. He was even a little bit shameless. I do not think he was even a good comrade. Then the husband of the other girl, the other sister, who was also in the trams, had gone to the hills as I had. They thought she knew where he was. But she did not. So they shot her because she would not tell them where he was."

Ernest Hemingway, *For Whom the Bell Tolls*[7]
The Sickles and the Reaping Hooks

"Just then, a yelling went up from the lines and, looking up the arcade, I could not see who it was that was coming out because the man's head did not show above the heads of those crowded about the door of the [hall]. All I could see was that some one was being pushed out by Pablo and Cuatro Dedos with their shotguns but I could not see who it was and I moved on close toward the lines where they were packed against the door to try to see.

"There was much pushing now and the chairs and the tables of the fascists' café had been overturned except for one table on which a drunkard was lying with his head hanging down and his mouth open and I picked up a chair and set it against one of the pillars and mounted on it so that I could see over the heads of the crowd.

"The man who was being pushed out by Pablo and Cuatro Dedos was Don Anastasio Rivas, who was an undoubted fascist and the fattest man in the town. He was a grain buyer and the agent for several insurance companies and he also loaned money at high rates of interest. Standing on the chair, I saw him walk down the steps and toward the lines, his fat neck bulging over the back of the collar band of his shirt, and his bald head shining in the sun, but he never entered them because there was a shout, not as of different men shouting, but of all of them. It was an ugly noise and was the cry of the drunken lines all yelling together and the lines broke with the rush of men toward him and I saw Don Anastasio throw himself down with his hands over his head and then you could not see him for the men piled on top of him. And when the men got up from him, Don Anastasio was dead from his head being beaten against the stone flags of the paving of the arcade and there were no more lines but only a mob. . . .

"As I watched, this man turned away from the crowd and went and sat down and drank from a bottle and then, while he was sitting down, he saw Don Anastasio, who was still lying face down on the stones, but much trampled now, and the drunkard got up and went over to Don Anastasio and

7. Reprinted, by permission of the publisher, from Ernest Hemingway, *For Whom the Bell Tolls* (New York: Charles Scribner's Sons, 1940), pp. 121, 125. Copyright by the Ernest Hemingway Foundation.

leaned over and poured out of the bottle onto the head of Don Anastasio and onto his clothes, and then he took a matchbox out of his pocket and lit several matches, trying to make a fire with Don Anastasio. But the wind was blowing hard now and it blew the matches out and after a little the big drunkard sat there by Don Anastasio, shaking his head and drinking out of the bottle and every once in a while, leaning over and patting Don Anastasio on the shoulders of his dead body.

"All this time the mob was shouting to open up and the man on the chair with me was holding tight to the bars of the window and shouting to open up until it deafened me with his voice roaring past my ear and his breath foul on me and I looked away from watching the drunkard who had been trying to set fire to Don Anastasio and into the hall of the *Ayuntamiento* again; and it was just as it had been. They were still praying as they had been, the men all kneeling, with their shirts open, some with their heads down, others with their heads up, looking toward the priest and toward the crucifix that he held, and the priest praying fast and hard and looking out over their heads, and in back of them Pablo, with his cigarette now lighted, was sitting there on the table swinging his legs, his shotgun slung over his back, and he was playing with the key. . . .

"Pablo said something to the priest but the priest did not answer. Then Pablo leaned forward, picked up the key and tossed it underhand to the guard at the door. The guard caught it and Pablo smiled at him. Then the guard put the key in the door, turned it, and pulled the door toward him, ducking behind it as the mob rushed in. . . .

Looking through the bars, I saw the hall full of men flailing away with clubs and striking with flails,[8] and poking and striking and pushing and heaving against people with the white wooden pitchforks that now were red and with their tines broken, and this was going on all over the room while Pablo sat in the big chair with his shotgun on his knees, watching, and they were shouting and clubbing and stabbing and men were screaming as horses scream in a fire. And I saw the priest with his skirts tucked up scrambling over a bench and those after him were chopping at him with the sickles[9] and the reaping hooks[10] and then some one had hold of his robe and there was another scream and another scream and I saw two men chopping into his back with sickles while a third man held the skirt of his robe and the priest's arms were up and he was clinging to the back of a chair. . . .

8. Instruments for threshing grain by hand, consisting of a handle with a freely swinging bar attached to one end.
9. Implements for cutting grain, consisting of a curved, hooklike blade mounted on a short handle.
10. Sickles or curved blades attached to a long handle and used to harvest grain.

"That was the end of the killing of the fascists in our town and I was glad I did not see more of it and, but for that drunkard, I would have seen it all. So he served some good because in the [hall] it was a thing one is sorry to have seen.

21. Arshile Gorky, *The Liver Is the Cock's Comb,* 1944
Janson, p. 738, ill. 1034

Kurt Gerstein, *Report from Belzec:* "Breathe Deeply," c. 1943
Mrs. Liuba Daniel, *Deposition on the Stutthof Concentration Camp:* "She Wanted to Eat Only the Liver," 1945

By 1934 Germany had become a totalitarian state characterized by a frightening dynamism. To ensure obedience, Hitler smashed all independent organizations, including trade unions, professional associations, and opposition political parties, and he brought publishing houses and universities under his control. To guarantee Aryan purity, Hitler began the systematic persecution and ruthless extermination of peoples he considered "subhuman," including Communists, Jehovah's Witnesses, Gypsies, Slavs, the physically and mentally handicapped, and, most especially, Jews.

By 1939 German Jews had lost all their civil rights. After the fall of Warsaw, Poland, the Nazis began deporting German Jews to Poland. There, they and Jews from all over Europe were packed into ghettos, forced to wear the Jewish star, and used as slave laborers.

In 1941 Hitler ordered his elite troops to carry out "the final solution of the Jewish question"—that is, the murder of every single Jew and of all other peoples whom Hitler despised throughout the territories controlled by Germany. Hitler's program of human persecution and extermination is now known as the Holocaust.

The Holocaust was carried out in concentration camps built throughout Germany and German-occupied territories. These camps, which were notorious death camps, included Auschwitz, Bergen-Belsen, Dachau, and Treblinka. Jews and others were arrested, herded like cattle into freight trains, and eventually killed in gas chambers at these death camps. In Poland alone about 3,350,000 citizens, most of them of Jewish descent, were interned in ghettos, deported to concentration camps, and slaughtered. By 1945, when Nazi Germany was defeated, more than 6,000,000 persons had been executed in cold blood.

Many accounts of the Holocaust have been recorded. One account was given by Kurt Gerstein, a captain in the SS.[1] Gerstein's sister-in-law had been a victim of Hitler's euthanasia program against the handicapped. Perhaps in an effort to gather

1. Abbreviation for *Schutzstaffel,* the security echelon of the Nazi government. Members of the SS wore black-shirted uniforms.

evidence, Gerstein joined the concentration camp service at Belzec, where he provided the death gas. *Report from Belzec* (c. 1943) is an eyewitness account of what Gerstein saw. An excerpt from it, "Breathe Deeply," is presented here.

A second account of the Holocaust, *Deposition on the Stutthof Concentration Camp* (1945), is by a survivor of a concentration camp, Mrs. Liuba Daniel. An excerpt from her account, "She Wanted to Eat Only the Liver," is presented here.

The terror of the Holocaust was understood by the artist Arshile Gorky (1904–1948). Born in Armenia, Gorky was sixteen when he fled the Turkish campaign of genocide against his people. Arriving in the United States in 1920, Gorky developed a painting style that expressed emotional shock and turmoil. *The Liver Is the Cock's Comb* (1944) suggests the chaos that results from unbridled human passions.

The tragedy of the Holocaust was not only the result of one country's action but also the consequence of many other countries' inaction. Kurt Gerstein made valiant efforts to alert world attention to the Holocaust. Gerstein took his report first to a papal representative in Berlin, who refused to see him. Later he approached a Swedish diplomat, who took the report to Stockholm. There its contents were kept secret until after the war. Gerstein gave himself up to the Allied troops at the end of the war. While in prison, he committed suicide.

Kurt Gerstein, *Report from Belzec*[2]
Breathe Deeply

Then the march began. To the right and left, barbed wire; behind, two dozen Ukrainians with guns. Led by a young girl of striking beauty, they approached. With Police Captain Wirth, I stood right in front of the death chambers. Completely naked, they march by, men, women, girls, children, babies, even a one-legged person, all of them naked. In one corner, a strong SS man told the poor devils in a strong voice: "Nothing whatever will happen to you. All you have to do is to breathe deeply; it strengthens the lungs. This inhalation is a necessary measure against contagious disease; it is a very good disinfectant." . . .

Mothers with babies at their breasts, naked; lots of children of all ages, naked, too; they hesitate, but they enter the gas chambers, most of them without a word, pushed by the others behind them, chased by the whips of the SS men. . . .

Within the chambers, the SS press the people closely together; Captain Wirth has ordered: "Fill them up full." Naked men stand on the feet of the others. Seven hundred to eight hundred crushed together on twenty-five square meters, in forty-five cubic meters! The doors are closed! . . .

2. Reprinted, by permission of the publisher, from Azriel Eisenberg, *Witness to the Holocaust* (New York: Pilgrim Press, 1981), pp. 250–52. Copyright by Azriel Eisenberg.

The diesel engine started. . . . Twenty-five minutes went by. Many of the people, it is true, were dead by that time. One could see that through the little window as the electric lamp revealed for a moment the inside of the chamber. After twenty-eight minutes only a few were alive. After thirty-two minutes, all were dead.

From the other side, Jewish workers opened the wooden doors. In return for their terrible job, they had been promised their freedom and a small percentage of the valuables and the money found. The dead were still standing like stone statues, there having been no room for them to fall or bend over. Though dead, the families could still be recognized, their hands still clasped.

It was difficult to separate them in order to clear the chamber for the next load. The bodies were thrown out blue, wet with sweat and urine, the legs covered with excrement and menstrual blood. Everywhere among the others were the bodies of babies and children. . . .

The bodies were then thrown into large ditches about one hundred by twenty by twelve meters located near the gas chambers. After a few days the bodies would swell up and whole contents of the ditch would rise two to three meters high because of the gases which developed inside the bodies. After a few more days the swelling would stop and the bodies would collapse. The next day the ditches were filled again, and covered with ten centimeters of sand. A little later, I heard, they constructed grills out of rails and burned the bodies on them with diesel oil and gasoline in order to make them disappear.

Mrs. Liuba Daniel, *Deposition at the Stutthof Concentration Camp*[3]
She Wanted to Eat Only the Liver

We were loaded standing up in small open railway freight cars, and rode to Stutthof. . . . The sight of Stutthof, surrounded by high double fences of barbed wire with watchtowers, hundreds of SS men and trained dogs was shattering. . . . Inside the camp, one's first view was fixed on a mountain of children's shoes. To tell the truth I did not understand what that meant. Then we noticed hundreds of shadowy female figures. They were Hungarian women with shaved heads, barefoot, in gray prison uniforms. I should like to stress that these Hungarian Jews had left their homes only four months before.

We were driven into huge barracks where we were assigned with shouts

3. Reprinted, by permission of the editor, from Raul Hilberg, *Documents of Destruction* (Chicago: Quadrangle Books, 1971), pp. 225–27. Copyright by Raul Hilberg.

to our beds of wooden planks. Next morning we went to the delousing station. . . .

We stood trembling, but not because we were cold and not even because of shame, between SS men who strolled back and forth trying their whips on their polished boots. Various uniformed women and women in civilian clothes (who later turned out to be inmates) shoved us in various directions. Mouths, hair and other places were examined for valuables. (Our luggage had already been taken from us.) Then we came to the doctor and he too looked for jewels. Thereafter we were subjected to an ice cold dripping shower with soap as hard as stone (of questionable origin), and given striped rags. We were now full-fledged inmates of a German concentration camp.

We stayed for three weeks in the barracks where some members of my group were not even able to find wooden planks for sleep. Everything was so full that we slept on the floor in the so-called dining area of the barracks. We saw very few uniformed Germans in the camp. They of course sat in their watchtowers, and every approach to the electrified barbed wire—which did not even lead to freedom, but only to another part of the camp area—was greeted with wild laughter and a salvo of bullets. Corpses were hanging on the fences like drying laundry. . . .

[Winter] The prison garb, which we were given for our civilian clothes, had been washed, but all the same it harbored eggs of lice. Everyone had diarrhea at best and often it was dysentery. No one dreamt of the end of the war anymore—only of a piece of wet bread or another potato and a day without beatings. For the capos beat us without mercy, when we were lined up for food or during the count. . . .

The corpses in front of the blocks accumulated daily. We passed them with indifference. Even the glimpse of a familiar face that had belonged to a person with whom one had conversed only a few days before produced no reaction. It wasn't even hunger the way normal people feel it, but an indescribable emptiness.

It came to the point that a woman was discovered trying to open the belly of a corpse with a rusted knife. When we heard the sudden commotion and loud crying in front of our barracks, curiosity conquered our physical weakness and we shuffled to the scene just as the inmate block elders were about to drag away the woman whom they had almost beaten to death. When she was brought to the Germans and asked why she had opened the corpse, she replied that she had been so hungry that she wanted to eat only the liver. Apparently that was too much for the German masters; the woman was dismissed without a word and then came instructions that she should be given a second portion of soup.

22. Jackson Pollock, *Lucifer,* **1947**
Gardner, p. 1033, ill. 23:1

Jackson Pollock, *Autumnal Rhythm: Number 30,* **1950**
Janson, p. 739, ill. 1035

United States Strategic Bombing Survey: "A Blinding Flash," 1947
Hara Tamiki, "Glittering Fragments," c. 1951

On December 7, 1941, Japan launched a surprise attack on the United States naval fleet at Pearl Harbor in the Pacific and forced the immediate entrance of the United States into World War II. The first half of 1942 witnessed the Axis forces—consisting of Germany, Italy, Japan, and minor allies—reaching the pinnacle of their powers.

At the urging of Albert Einstein (1879–1955), the United States began work on a nuclear weapon. The work, which was known by the code name Manhattan Project, was conducted in great secrecy by teams of scientists working at several locations. The result was the development of the atomic bomb, a devastating weapon from which an enormous explosive force is derived from nuclear fusion or fission reaction.

Because it served the Japanese military forces as regional headquarters, Hiroshima was selected as the first target of the atomic bomb. The explosion at 8:15 A.M. on August 6, 1945, at Hiroshima illustrated the awesome power of the new weapon. Two thousand times more powerful than any bomb used during the entire war in Europe, the atomic bomb instantly killed approximately 60,000 people, destroyed 62,000 out of 90,000 buildings, and created a firestorm that lasted for six hours and burned out an area of four square miles. Of the 1,780 nurses in the city, 1,654 were killed immediately or were too badly hurt to work; similarly, most doctors were killed or wounded. By the afternoon of August 6, people who seemed to have escaped unharmed from the bomb blast began to die from radiation. In the decades that followed, the death toll would surpass 130,000 people.

Selections from two documents related to the effects of nuclear weapons are presented here. The first selection, "A Blinding Flash," is an excerpt from the *United States Strategic Bombing Survey.* The *Survey,* which was published in 1947, reported upon the impact of the war in Japan. The second selection, "Glittering Fragments," is a poem by the Japanese poet Hara Tamiki (1905–1951). Hara Tamiki was in Hiroshima when the atomic bomb was dropped. In 1951 he committed suicide when he was diagnosed with the "atom disease."

In contrast to the terrifying release of atomic energy, the American artist Jackson Pollock (1912–1956) created a new style of painting through his release of physical and psychic energy. Instead of working with a brush, Pollock dripped, poured, flung, and spattered paint on canvas. Only through the dynamic coupling of the artist's body movements and the viscosity of paint could surfaces as sensuously rich and visually stimulating as *Lucifer* (1947) and *Autumnal Rhythm: Number 30, 1950* be created.

United States Strategic Bombing Survey[1]
A Blinding Flash

In order to appreciate the conditions at the time of the blast and immediately thereafter it will be well to reconstruct the scene in Hiroshima as best it can be determined from talking with survivors.

The morning of 6 August 1945 began bright and clear. . . . At about 0815 there was a blinding flash. Some described it as brighter than the sun, others likened it to a magnesium flash. Following the flash there was a blast of heat and wind. The large majority of people within 3,000 feet of ground zero were killed immediately. Within a radius of about 7,000 feet almost every Japanese house collapsed. Beyond this range and up to 15,000–20,000 feet many of them collapsed and others received serious structural damage. Persons in the open were burned on exposed surfaces, and within 3,000–5,000 feet many were burned to death while others received severe burns through their clothes. In many instances clothing burst into spontaneous flame and had to be beaten out. Thousands of people were pinned beneath collapsed buildings or injured by flying debris. Flying glass particularly produced many non-lethal injuries at greater distances from the center of the blast. . . .

Shortly after the blast fires began to spring up over the city. Those who were able made a mass exodus from the city into the outlying hills. There was no organized activity. The people appeared stunned by the catastrophe and rushed about as jungle animals suddenly released from a cage. Some few apparently attempted to help others from the wreckage, particularly members of their family or friends. Others assisted those who were unable to walk alone. However, many of the injured were left trapped beneath collapsed buildings as people fled by them in the streets. Pandemonium reigned as the uninjured and slightly injured fled the city in fearful panic. Teams which had been previously organized to render first aid failed to form and function. Those closer to ground zero were largely demobilized due to injuries and death. However, there were physically intact teams on the outskirts of the city which did not function. Panic drove these people from the city just as it did the injured who could walk or be helped along. Much of the city's fire-fighting equipment was damaged beyond use so that soon the conflagrations were beyond control. . . .

An amazing feature of the atomic bombings to one going into the areas later was the poor recuperative powers of the population towards the restora-

1. "The Effects of Atomic Bombs on Health and Medical Services in Hiroshima and Nagasaki," in United States, *The United States Strategic Bombing Survey* (Washington, D.C.: 1947), pp. 2–4. Courtesy of the Department of the Air Forces.

tion of all types of facilities. Though this was probably less so in the medical field than in others it was still alarmingly apparent. The panic of the people immediately after the bombing was so great that Hiroshima was literally deserted. . . . The colossal effects of the bomb and the surrender following shortly thereafter seemed to have completely stunned the people.

Since the most outstanding feature of the atomic bombs was the high rate of human casualties, it was natural that this was the greatest problem in the areas following the bombing. But even in this regard the progress was astoundingly slow and haphazard. Other evidences of restoration were almost completely absent. For instance, at the time the Medical Division visited Hiroshima, 3 months after the bombing, the first street car was beginning operation, people wandered aimlessly about the ruins, and only a few shacks had been built as evidence of reoccupation of the city. No system for collection of night soil or garbage had been instituted. Leaking water pipes were seen all over the city with no evidence of any attention. It was reported that following the bombing several days were required for disposal of the dead and then they were simply piled into heaps and burned without attempts at identification or enumeration. Street cars were burned as a method of cremating the bodies within. All in all, there appeared to be no organization and no initiative.

The care of the wounded immediately after the bombing was essentially nil in Hiroshima. Beyond the sphere of family ties there seemed to be little concern for their fellow man. It is true that essentially all of the medical supplies were destroyed by the bombing, and that there were no hospitals and little with which to work. For the first 3 days there was no organized medical care. At the end of this time the Prefectural Health Department was successful in getting a portion of the surviving physicians together and to begin ministering to the wounded who remained in the city. Up until this time all nursing and medical care had been on an individual basis. The more seriously injured were placed in the few remaining public buildings on the outskirts of the city. Many of them died but many seriously burned cases remained. Small stocks of medical supplies which had been stored in caves outside the city were brought out but were soon exhausted. With all medical supplies gone and practically none being brought in the treatment of the injured seemed to have consisted largely of offering a place of refuge. There is no doubt that many died who might have been saved by modern, competent medical care. . . .

Most of the fatalities due to flash burns and secondary injuries occurred within a few days after the bombing. The peak of deaths due to radiation effects was not reached until late August or the early part of September. Very

few cases suffering from radiation died after 1 October and deaths due to other causes had practically ceased by this time. Thus during October the essential medical care was directed almost exclusively toward burn cases, most of which were flash burns. A large number were still in hospitals but the vast majority of these patients could be treated as out-patients. By 1 November adequate hospital space was available but it was still of emergency nature and medical supplies were inadequate. Many of the burns remained unhealed. Inadequate medical care, poor nutrition, and secondary infection were important factors in this delayed healing.

Hara Tamiki
Glittering Fragments[2]

Glittering fragments
Ashen embers
Like a rippling panorama,
Burned red then dulled.
Strange rhythm of human corpses.
All existence, all that could exist
Laid bare in a flash. The rest of the world
The swelling of a horse's corpse
At the side of an upturned train,
The smell of smouldering electric wires.

2. Reprinted, by permission of the publisher, from *The Penguin Book of Japanese Verse,* trans. and intro. by Geoffry Bownas and Anthony Thwaite (New York: Penguin Books, 1964), p. 221. Copyright 1964 by Geoffry Bownas and Anthony Thwaite.

X

Later Twentieth-Century Art

1. Alberto Giacometti, *City Square*, 1948
Gardner, p. 1051, ill. 22:27

Alberto Giacometti, *The Palace at 4 A.M.*, 1932–33
Janson, p. 763, ill. 1073

Jean-Paul Sartre, *Existentialism and Humanism:* "Existence Comes
Before Essence," 1946
Albert Camus, *The Plague:* "This Business Is Everybody's Business,"
1947

During the first half of the twentieth century, the terror and uncertainty that filled the world seemed to belie the optimistic beliefs of earlier generations. One response to the profound moral crises of the twentieth century was formulated by a group of intellectuals known as existentialists. Many existentialist thinkers of the twentieth century have rejected traditional religious structures. In the view of existentialists, the universe, instead of being infused with a moral purpose, is chaotic and unordered, and human existence, instead of being guided by a supreme being, is unplanned. Since God does not exist, human beings must confront their existence by themselves. Therefore, honest human beings recognize they are terribly alone. They are hounded by despair and by the realization of the purposelessness of life.

Nonetheless, the search by existentialists for morals and values is not a futile act. Thoughtful human beings recognize that they bear an inescapable responsibility for their own behavior. By making consistent choices and by committing themselves to courageous actions, individuals can define themselves in humane and noble terms. They can overcome the absurdity of existence and can give meaning to their lives.

First developed in Germany in the 1920s, existentialism reached popular audiences during the years after World War II primarily through the writings of Jean-Paul Sartre (1905–1980) and Albert Camus (1913–1960).

Jean-Paul Sartre was a French writer who won fame as the intellectual and

literary leader of existentialism. As a member of the French Resistance movement against Hitler's forces, Sartre demonstrated a capacity to define an individual response to a contemporary moral crisis. In his essay *Existentialism and Humanism* (1946), as well as in his novels and plays, he propounded his theory that life has no meaning or purpose beyond the goals that each person sets for himself or herself. An excerpt from *Existentialism and Humanism,* "Existence Comes Before Essence," is presented here.

Albert Camus was, for a time, a close colleague of Sartre. Born in the French colony of Algeria, Camus worked in avant-garde theater and journalism. Like Sartre, Camus became one of the leaders of the French Resistance movement, which waged covert war against German occupation forces. The recurrent themes of "the absurd," of humankind's powerlessness, and of the individual's responsibility for courageous action appear in Camus' novel *The Plague* (1947). On one level, *The Plague* can be interpreted as an allegory of occupied France and French territories; at another level, it can be read as an allegory of the universal human situation. A sparsely written account of the bubonic plague in the Algerian town of Oran, the novel describes the apathy and despair that overtake most townspeople when they realize that the world is both irrational and godless. Only a few characters in the novel—the doctor Bernard Rieux, the diarist and the doctor's friend Jean Tarrou, and the journalist Raymond Rambert—have the courage and determination to define their own moral existence. In one scene, Rambert explains that he has voluntarily decided to remain in Oran in order to assist Rieux and Tarrou in treating plague victims. Rambert, in Camus' view, achieves heroic status because he is willing to risk his life and sacrifice his personal happiness to help prolong the lives of others at the same time that he acknowledges the futility of all human existence. An excerpt from *The Plague,* "This Business Is Everybody's Business," is presented here.

In 1957 Camus received the Nobel Prize in Literature. In 1964 Sartre refused the Nobel Prize in Literature; he argued that the power of the writer's words, unassisted by extraneous honors, ought to be sufficient to persuade a reader.

A new image of humankind, suggestive of the concepts of existentialism, was created by the artist Alberto Giacometti (1901–1966). Born in Switzerland, Giacometti spent much of his adult life in France. His sculptures of the human figure convey a haunting quality. In compositions such as *The Palace at 4 A.M.* (1932–33) and *City Square* (1948), the spindly figures are placed in settings that evoke the loneliness and isolation that can characterize twentieth-century existence.

Jean-Paul Sartre, *Existentialism and Humanism*[1]
Existence Comes Before Essence

What, then, is this that we call existentialism? . . . [Existentialists] believe that *existence* comes before *essence.* . . .

1. Reprinted, by permission of the publisher, from Jean-Paul Sartre, *Existentialism and Humanism,* trans. by Philip Mairet (London: Methuen, 1948), pp. 25–27, 29–30, 32–34, 39. Copyright by Methuen.

Atheistic existentialism, of which I am a representative, declares . . . that if God does not exist there is at least one being whose existence comes before its essence, a being which exists before it can be defined by any conception of it. That being is man or, as Heidegger has it, the human reality. What do we mean by saying that existence precedes essence? We mean that man first of all exists, encounters himself, surges up in the world—and defines himself afterwards. If man as the existentialist sees him is not definable, it is because to begin with he is nothing. He will not be anything until later, and then he will be what he makes of himself. Thus, there is no human nature, because there is no God to have a conception of it. Man simply is. Not that he is simply what he conceives himself to be, but he is what he wills, and as he conceives himself after already existing—as he wills to be after that leap toward existence. Man is nothing else but that which he makes of himself. That is the first principle of existentialism. . . . Thus, the first effect of existentialism is that it puts every man in possession of himself as he is, and places the entire responsibility for his existence squarely upon his own shoulders. And, when we say that man is responsible for himself, we do not mean that he is responsible only for his own individuality, but that he is responsible for all men. . . . When we say that man chooses himself, we do mean that every one of us must choose himself; but by that we also mean that in choosing for himself he chooses for all men. For in effect, of all the actions a man may take in order to create himself as he wills to be, there is not one which is not creative, at the same time, of an image of man such as he believes he ought to be. . . .

This may enable us to understand what is meant by such terms—perhaps a little grandiloquent—as anguish, abandonment and despair. As you will soon see, it is very simple. First, what do we mean by anguish? The existentialist frankly states that man is in anguish. His meaning is as follows: When a man commits himself to anything, fully realising that he is not only choosing what he will be, but is thereby at the same time a legislator deciding for the whole of mankind—in such a moment a man cannot escape from the sense of complete and profound responsibility. . . . And when we speak of "abandonment" we only mean to say that God does not exist, and that it is necessarily to draw the consequences of his absence right to the end. . . . The existentialist finds it extremely embarrassing that God does not exist, for there disappears with Him all possibility of finding values in an intelligible heaven. There can no longer be any good *a priori,* since there is no infinite and perfect consciousness to think it. . . . Nor, if God does not exist, are we provided with any values or commands that could legitimise our behaviour. Thus we have neither behind us, or before us in a luminous realm of val-

ues, any means of justification or excuse. We are left alone, without excuse. . . . As for "despair," the meaning of this expression is extremely simple. It merely means that we limit ourselves to a reliance upon that which is within our wills, or within the sum of the probabilities which render our action feasible. Whenever one wills anything, there are always these elements of probability.

Albert Camus, *The Plague*[2]
This Business Is Everybody's Business

Tarrou remarked, without turning his head, that if Rambert wished to take a share in other people's unhappiness, he'd have no time left for happiness. So the choice had to be made.

"That's not it," Rambert rejoined. "Until now I always felt a stranger in this town, and that I'd no concern with you people. But now that I've seen what I have seen, I know that I belong here whether I want it or not. This business is everybody's business." When there was no reply from either of the others, Rambert seemed to grow annoyed. "But you know that as well as I do, damn it! Or else what are you up to in that hospital of yours? Have *you* made a definite choice and turned down happiness?"

Rieux and Tarrou still said nothing, and the silence lasted until they were at the doctor's home. Then Rambert repeated his last question in a yet more emphatic tone.

Only then Rieux turned toward him, raising himself with an effort from the cushion.

"Forgive me, Rambert, only—well, I simply don't know. But stay with us if you want to." A swerve of a car made him break off. Then, looking straight in front of him, he said: "For nothing in the world is it worth turning one's back on what one loves. Yet that is what I'm doing, though why I do not know." He sank back on the cushion. "That's how it is," he added wearily, "and there's nothing to be done about it. So let's recognize the fact and draw the conclusions."

"What conclusions?"

"Ah," Rieux said, "a man can't cure and know at the same time. So let's cure as quickly as we can. That's the more urgent job."

2. Reprinted, by the permission of the publisher, from Albert Camus, *The Plague,* trans. by Stuart Gilbert (New York: Random House, 1972), pp. 188–89. Copyright 1948 by Stuart Gilbert.

2. Le Corbusier, Notre-Dame-du-Haut, Ronchamp, France, 1950–55
Gardner, p. 1038, ills. 23:9, 23:10; Janson, p. 787, ills. 1112–1114

Paul Tillich, *The Courage to Be:* "Absolute Faith," 1952

The industrialization of the modern world has been regarded by many intellectuals, writers, and artists as a dubious blessing. On the one hand, it has provided an overall standard of living higher than any experienced before. On the other hand, it has resulted in an impersonal society in which individuals feel stripped of their personal identities, divorced from their traditional familial and communal bonds, and confused by ethical and moral uncertainties. Much of twentieth-century literature and art has explored such problems of contemporary life as alcoholism, drug addiction, violence, and insanity, and has identified despair as the underlying cause of these problems.

Paul Tillich (1886–1965) is a twentieth-century theologian who has formulated responses to the individual's sense of alienation. Born in Germany, Tillich was ordained in the Lutheran church, and during World War I he served as a chaplain in the German army. Tillich's subsequent criticism of Hitler's Brownshirts resulted in his being the first non-Jewish professor to be dismissed from a university post by the Nazi government. In 1933 Tillich settled in the United States, where he remained until his death.

His ministrations to the wounded and dying in the trenches of World War I reminded Tillich of Nietzsche's pronunciations about the death of God. Throughout the rest of his career, Tillich sought to redefine the traditional concept of God and to direct persons to "the God beyond God." Tillich sought to relate Christian affirmations to existential questions. He combined such diverse traditions as classical philosophy and Christian theology with wisdom gained from the non-Western world's religions and philosophies. Tillich also stressed the interrelationships between faith and culture and between the individual and society.

One of Tillich's best-known books is *The Courage to Be* (1952). In this book he emphasized courage as the quality necessary for individuals to possess in order to shape a meaningful existence in an absurd world. According to Tillich, courageous individuals overcome alienation by simultaneously valuing their own self-centered, separate beings and participating in the larger world. An excerpt from *The Courage to Be,* "Absolute Faith," is presented here.

The search for an answer to the contemporary condition of alienation also motivated the architect Charles-Edouard Jeanneret (1887–1965), who is better known by his adopted pseudonym, Le Corbusier. Born in Switzerland, Le Corbusier studied in France and eventually shaped an architectural style of international influence.

For the chapel Notre-Dame-du-Haut (1950–55), Le Corbusier proposed an innovative design that exploited the flexibility and strength of ferroconcrete. The lower exterior is shaped of white concrete and is surmounted by the dark floating mass

of the roof. Outer towers recapture the medieval past of the Catholic Church; interior shafts of light suggest the mysteriousness of prehistoric shrines and sacred caves.

Paul Tillich, *The Courage to Be*[1]
Absolute Faith

The question then is this: Is there a courage which can conquer the anxiety of meaninglessness and doubt? Or in other words, can the faith which accepts acceptance resist the power of nonbeing in its most radical form? Can faith resist meaninglessness? Is there a kind of faith which can exist together with doubt and meaninglessness?

The faith which makes the courage of despair possible is the acceptance of the power of being, even in the grip of nonbeing. Even in the despair about meaning being affirms itself through us. The act of accepting meaninglessness is in itself a meaningful act. It is an act of faith. We have seen that he who has the courage to affirm his being in spite of fate and guilt has not removed them. He remains threatened and hit by them. But he accepts his acceptance by the power of being-itself in which he participates and which gives him the courage to take the anxieties of fate and guilt upon himself. The same is true of doubt and meaninglessness. The faith which creates the courage to take them into itself has no special content. It is simply faith, undirected, absolute. It is undefinable, since everything defined is dissolved by doubt and meaning-lessness. Nevertheless, even absolute faith is not an eruption of subjective emotions or a mood without objective foundation.

An analysis of the nature of absolute faith reveals the following elements in it. The first is the experience of the power of being which is present even in the face of the most radical manifestation of nonbeing. If one says that in this experience vitality resists despair one must add that vitality in man is proportional to intentionality. The vitality that can stand the abyss of meaninglessness is aware of a hidden meaning within the destruction of meaning. The second element in absolute faith is the dependence of the experience of nonbeing on the experience of being and the dependence of the experience of meaninglessness on the experience of meaning. Even in the state of despair one has enough being to make despair possible. There is a third element in absolute faith, the acceptance of being accepted. Of course, in the state of despair there is nobody and nothing that accepts. But there is the power of acceptance itself which is experienced. Meaninglessness, as long as it is experienced, includes an experience of the "power of acceptance." To accept this

1. Reprinted, by permission of the publisher, from Paul Tillich, *The Courage to Be* (New Haven: Yale University Press, 1952), pp. 174, 176–78. Copyright by Yale University Press.

power of acceptance consciously is the religious answer of absolute faith, of a faith which has been deprived by doubt of any concrete content, which nevertheless is faith and the source of the most paradoxical manifestation of the courage to be.

This faith transcends both the mystical experience and the divine-human encounter. The mystical experience seems to be nearer to absolute faith but it is not. Absolute faith includes an element of skepticism which one cannot find in the mystical experience. Certainly mysticism also transcends all specific contents, but not because it doubts them or has found them meaningless; rather it deems them to be preliminary. Mysticism uses the specific contents as grades, stepping on them after having used them. The experience of meaninglessness, however, denies them (and everything that goes with them) without having used them. The experience of meaninglessness is more radical than mysticism. Therefore it transcends the mystical experience.

Absolute faith also transcends the divine-human encounter. In this encounter the subject-object scheme is valid: a definite subject (man) meets a definite object (God). One can reverse this statement and say that a definite subject (God) meets a definite object (man). But in both cases the attack of doubt undercuts the subject-object structure. The theologians who speak so strongly and with such self-certainty about the divine-human encounter should be aware of a situation in which this encounter is prevented by radical doubt and nothing is left but absolute faith. The acceptance of such a situation as religiously valid has, however, the consequence that the concrete contents of ordinary faith must be subjected to criticism and transformation. The courage to be in its radical form is a key to an idea of God which transcends both mysticism and the person-to-person encounter.

3. Wallace K. Harrison and the International Advisory Committee of Architects, United Nations Headquarters, New York, 1949–51
Janson, p. 783, ill. 1104

The Universal Declaration of Human Rights: "Equal and Inalienable Rights," 1948

The United Nations Organization was created in 1945 to establish a political framework for the emerging world society of sovereign and competing nations. The charter was signed in San Francisco, California, on June 16, 1945, by fifty countries. Membership has tripled in the subsequent decades as former colonies have acquired independence.

The United Nations is not intended as a supra-state or world government. All member states retain their sovereignty. The charter provides that the United Nations respects the autonomy of every country and not control its internal affairs. Only when directed by one of its agencies, the Security Council, can the United Nations maintain or restore international peace.

The United Nations is intended as a forum in which nations can discuss disputes. During its almost fifty-year history, the United Nations has sought to negotiate peaceful solutions to international disputes and armed conflicts around the globe; it has been instrumental in easing the transition of colonies into nations; it has earmarked resources for programs that assist poorer countries to develop their own economic and human resources.

The preamble to the United Nations charter reaffirms the value of the individual human being. In 1948 the *Universal Declaration of Human Rights* was accepted by the General Assembly of the United Nations.

The direct descendant of the English *Bill of Rights,* a parliamentary act of 1689, the *Universal Declaration of Human Rights* reflects Western liberal concepts. Only eight members of the United Nations—the six members of the former Soviet bloc, Saudi Arabia, and the Union of South Africa—did not affirm the declaration. An excerpt from *The Universal Declaration of the Rights of Man* (1948), "Equal and Inalienable Rights," is presented here.

The first monument of the postwar revival in American architecture was the Secretariat Building of the United Nations Organization in New York City (1949–51). Designed by an international team of architects under the general direction of Wallace K. Harrison, the Secretariat Building is a tall rectangular slab of glass and marble, with simple, pure lines.

The Universal Declaration of Human Rights[1]
Equal and Inalienable Rights

Whereas recognition of the inherent dignity and of the equal and inalienable rights of all members of the human family is the foundation of freedom, justice and peace in the world. . . .

Now, therefore,

The General Assembly

Proclaims this Universal Declaration of Human Rights. . . .

All human beings are born free and equal in dignity and rights. They are endowed with reason and conscience and should act towards one another in a spirit of brotherhood.

Everyone is entitled to all the rights and freedoms set forth in this

1. Reprinted from Hans Kohn, ed., *The Modern World: 1848 to the Present* (New York: Macmillan, 1963), pp. 292, 293, 294, 295.

Declaration, without distinction of any kind, such as race, color, sex, language, religion, political or other opinion, national or social origin, property, birth or other status. . . .

Everyone has the right to life, liberty and the security of person.

No one shall be held in slavery or servitude; slavery and the slave trade shall be prohibited in all their forms.

No one shall be subjected to torture or to cruel, inhuman or degrading treatment or punishment.

Everyone has the right to recognition everywhere as a person before the law.

All are equal before the law and are entitled without any discrimination to equal protection of the law. All are entitled to equal protection against any discrimination in violation of this Declaration and against any incitement of such discrimination.

Everyone has the right to an effective remedy by the competent national tribunals for acts violating the fundamental rights granted him by the constitution or by law.

No one shall be subjected to arbitrary arrest, detention or exile. . . .

Everyone charged with a penal offense has the right to be presumed innocent until proved guilty according to law in a public trial at which he has had all the guarantees necessary for his defence.

No one shall be held guilty of any penal offence on account of any act or omission which did not constitute a penal offence, under national or international law, at the time when it was committed. Nor shall a heavier penalty be imposed than the one that was applicable at the time the penal offence was committed.

No one shall be subjected to arbitrary interference with his privacy, family, home or correspondence, nor to attacks upon his honor and reputation. Everyone has the right to the protection of the law against such interference or attacks.

Everyone has the right to freedom of movement and residence within the borders of each State.

Everyone has the right to leave any country including his own, and to return to his country.

Everyone has the right to seek and to enjoy in other countries asylum from persecution.

This right may not be invoked in the case of prosecutions genuinely arising from non-political crimes or from acts contrary to the purposes and principles of the United Nations.

Everyone has the right to a nationality.

No one shall be arbitrarily deprived of his nationality nor denied the right to change his nationality.

Men and women of full age, without any limitation due to race, nationality or religion, have the right to marry and to found a family. They are entitled to equal rights as to marriage, during marriage and at its dissolution.

Marriage shall be entered into only with the free and full consent of the intending spouses.

The family is the natural and fundamental group unit of society and is entitled to protection by society and the State.

Everyone has the right to own property alone as well as in association with others.

No one shall be arbitrarily deprived of his property.

Everyone has the right to freedom of thought, conscience and religion; this right includes freedom to change his religion or belief, and freedom, either alone or in community with others and in public or private, to manifest his religion or belief in teaching, practice, worship and observance.

Everyone has the right to freedom of opinion and . . . to seek, receive and impart information and ideas through any media and regardless of frontiers. . . .

Everyone has the right to work, to free choice of employment, to just and favorable conditions of work and to protection against unemployment. . . .

Everyone has the right to a standard of living adequate for the health and well-being of himself and of his family, including food, clothing, housing and medical care and necessary social services, and the right to security in the event of unemployment, sickness, disability, widowhood, old age or other lack of livelihood in circumstances beyond his control. . . .

Everyone has the right to education.

Everyone is entitled to a social and international order in which the rights and freedoms set forth in this Declaration can be fully realized.

Everyone has duties to the community in which alone the free and full development of his personality is possible.

In the exercise of his rights and freedoms, everyone shall be subject only to such limitations as are determined by law solely for the purpose of securing due recognition and respect for the rights and freedoms of others and of meeting the just requirements of morality, public order and the general welfare in a democratic society.

These rights and freedoms may in no case be exercised contrary to the purposes and principles of the United Nations.

4. Naum Gabo, *Column,* **1922–23**
Gardner, p. 995, ill. 22:49

Victor Kravchenko, *Comments Regarding the Liquidation of Kulaks:* "Herded Together for Deportation," 1946
Aleksandr Solzhenitsyn, *One Day in the Life of Ivan Denisovich:* "The Law of the Taiga," 1962

If Lenin was the creator of the new autocracy of the Soviet Union, Joseph Stalin (1879–1953) was the perfecter of the dramaturgy of terror. An ex-seminarist, Stalin was a man with neither ideals nor ideological beliefs, but, rather, with an unquenchable thirst for power. On his rise to prominence, Stalin used his position as General Secretary of the Central Committee under Lenin to fill leading posts in the Communist Party with workers loyal to himself. Lenin's death in 1924 permitted Stalin to instigate show trials of opponents, foes, and supposed counter-revolutionaries and to sanction the use of intimidation and violence by the Cheka, the secret police.

Nonetheless, Stalin was still unsatisfied by the extent of his control over the Soviet Union. He reduced the independence of the kulaks, that is, the comparatively wealthy peasants who employed hired laborers. Stalin enforced collectivization of their land and livestock. Moreover, he expanded his military power by building up industries that supported the armed forces. An eyewitness account of Stalin's repression of kulaks is provided by Victor Kravchenko, who later emigrated to the United States. An excerpt from his *Comments Regarding the Liquidation of Kulaks* (1946), "Herded Together for Deportation," is presented here.

During his decades in office, Stalin ruthlessly purged potential opponents to his dictatorship in a bloodbath that spared no one. Whether a person was a top party official, military leader, scientist, journalist, engineer, worker, or peasant, imprisonment or death were ever-present possibilities. More than ten million people perished under Stalin. Millions more spent years in work camps in Siberia.

Stalinist repression changed the lives of both Aleksandr Solzhenitsyn (born 1918) and Naum Gabo (1890–1977). A Soviet writer, Solzhenitsyn was arrested for criticism of Stalin while serving in the Red Army. He was sentenced to a forced labor camp between 1945 and 1953. Subsequently exiled in Kazakhstan, he was officially rehabilitated in 1957. Undeterred by fear, Solzhenitsyn quickly assumed the role of a spokesperson for dissident Soviet intellectuals. Growing opposition from the Soviet regime resulted in his deportation to the West in 1974. However, charges against Solzhenitsyn were dropped in 1991, and the author, who has been living near Brattleboro, Vermont, announced his intention to return to Russia in June 1993 after completing some major writing projects.

Solzhenitsyn received the Nobel Prize in Literature in 1970. Among his novels are *One Day in the Life of Ivan Denisovich* (1962). In this book, the title character, Ivan Denisovich Shukhov, functions as a symbol of the suffering that the Russian people

endured under the Stalinist system. Ivan is described as a Russian soldier who served in the Red Army for four years, and was captured by the Germans in 1945. After a few days he escaped and loyally returned to Russian lines. Ironically, he found himself suspected of treason by Stalin's secret police. When he was accused of returning only to spy for the Germans and threatened with execution, Ivan "confessed." He was sentenced to ten years in a Siberian labor camp. Solzhenitsyn's book describes one day in that camp, one day no better and no worse than any of the other days of Ivan's sentence. An excerpt from *One Day in the Life of Ivan Denisovich,* "The Law of the Taiga," is presented here.

Artistic freedom and creative experimentation were championed by the artist Naum Gabo. Gabo believed that new forms and new media should be used by artists to express the realities of twentieth-century existence. In *Column* (1922–23) Gabo utilized synthetic and natural materials—to weave a shimmering pattern of transparent shapes. Gabo was forced to leave Russia in 1922, when the principles of abstract art were deemed unacceptable by the Soviet regime. Between 1946 and his death, in 1977, Gabo lived in the United States.

Victor Kravchenko, *Comments Regarding the Liquidation of Kulaks*[1]
Herded Together for Deportation

Evening was falling when I drove into the village, with several companions. Immediately we realized that something was happening. Agitated groups stood around. Women were weeping. I hurried to the Soviet building.

"What's happening?" I asked the constable.

"Another round-up of kulaks," he replied. "Seems the dirty business will never end. The G.P.U. [the Soviet interior police] and District Committee people came this morning."

A large crowd was gathered outside the building. Policemen tried to scatter them, but they came back. Some were cursing. A number of women and children were weeping hysterically and calling the names of their husbands and fathers. It was all like the scene in a nightmare. . . .

In the back yard, guarded by the G.P.U. soldiers with drawn revolvers, stood about twenty peasants, young and old, with bundles on their backs. A few of them were weeping. The others stood there sullen, resigned, helpless.

So this was "liquidation of the kulaks as a class"! A lot of simple peasants being torn from their native soil, stripped of all their worldly goods, and shipped to some distant lumber camps or irrigation works. For some reason, on this occasion, most of the families were being left behind. Their outcries filled the air. As I came out of the Soviet house again, I saw two

1. Reprinted, by permission of the publisher, from Victor Kravchenko, *I Chose Freedom* (New York: Charles Scribner's Sons, 1946), p. 104. Copyright by Victor Kravchenko.

militiamen leading a middle-aged peasant. It was obvious that he had been manhandled—his face was black and blue and his gait was painful; his clothes were ripped in a way indicating a struggle.

As I stood there, distressed, ashamed, helpless, I heard a woman shouting in an unearthly voice. Everyone looked in the direction of her cry and a couple of G.P.U. men started running towards her. The woman, her hair streaming, held a flaming sheaf of grain in her hands. Before anyone could reach her, she had tossed the burning sheaf onto the thatched roof of the house, which burst into flame instantaneously.

"Infidels! murderers!" the distraught woman was shrieking. "We worked all our lives for our house. You won't have it. The flames will have it!" Her cries turned suddenly into crazy laughter.

Peasants rushed into the burning house and began to drag out furniture. There was something macabre, unreal, about the whole scene—the fire, the wailing, demented woman, the peasants being dragged through the mud and herded together for deportation.

Aleksandr Solzhenitsyn, *One Day in the Life of Ivan Denisovich*[2]
The Law of the Taiga

At five o'clock that morning reveille[3] was sounded, as usual, by the blows of a hammer on a length of rail hanging up near the staff quarters. The intermittent sounds barely penetrated the windowpanes on which the frost lay two fingers thick, and they ended almost as soon as they'd begun. It was cold outside, and the campguard was reluctant to go on beating out the reveille for long.

The clanging ceased, but everything outside still looked like the middle of the night when Ivan Denisovich Shukhov got up to go to the bucket. It was pitch dark except for the yellow light cast on the window by three lamps—two in the outer zone, one inside the camp itself.

And no one came to unbolt the barracks door; there was no sound of the barrack orderlies pushing a pole into place to lift the barrel of excrement and carry it out.

Shukhov never overslept reveille. He always got up at once, for the next ninety minutes, until they assembled for work, belonged to him, not to the authorities, and any old-timer could always earn a bit—by sewing a pair of

2. Reprinted, by permission of the publisher, from Aleksandr Solzhenitsyn, *One Day in the Life of Ivan Denisovich*, trans. by Ralph Parker (New York: E. P. Dutton, 1963), pp. 17–18. Copyright by E. P. Dutton.
3. A signal sounded in the early morning to assemble people.

mittens for someone out of old sleeve lining; or bringing some rich loafer in the squad his dry valenki[4]—right up to his bunk, so that he wouldn't have to stumble barefoot round the heap of boots looking for his own pair; or going the rounds of the warehouses offering to be of service, sweeping up this or fetching that; or going to the mess hall to collect bowls from the tables and bring them stacked to the dishwashers—you're sure to be given something to eat there, though there were plenty of others at that game, more than plenty—and, what's worse, if you found a bowl with something left in it you could hardly resist licking it out. But Shukhov had never forgotten the words of his first squad leader, Kuziomin—a hard-bitten prisoner who had already been in for twelve years by 1943—who told the newcomers, just in from the front, as they sat beside a fire in the desolate cutting in the forest:

"Here, men, we live by the law of the taiga.[5] But even here people manage to live. The ones that don't make it are those who lick other men's leftovers, those who count on the doctors to pull them through, and those who squeal on their buddies."

Ludwig Mies van der Rohe, Lake Shore Drive Apartment Houses, Chicago, 1950–52
Janson, p. 786, ill. 1110

Ludwig Mies van der Rohe, Seagram Building, New York, 1956–58
Gardner, p. 1044, ill. 23:17

J. D. Salinger, *The Catcher in the Rye:* "You Don't Like *Any*thing That's Happening," 1951

Social critics who had earlier been disturbed by the inequalities in American life voiced strong doubts in the 1950s about the trend toward an impersonal and uniform society. To these critics, the expanding middle-class suburbs were anathema. With their similar houses, country clubs, shopping centers, and supermarkets, the suburbs were characterized as visually banal and intellectually deadening. The exterior qualities implied to many that a loss of individual thought, wishes, dreams, talents, and abilities among Americans had occurred.

Much more variety existed in American society than the portrait drawn by its critics suggested. However, the fear of standardization provoked artists to begin a quest for identity. Among the writers who undertook a search for individual identity was J[erome] D[avid] Salinger (born 1919). Among the artists who did accept the

4. Knee-length felt boots for winter wear.
5. Taiga are the evergreen forests of subarctic lands, covering vast areas of Russia.

impersonality and uniformity of contemporary life was the architect Mies van der Rohe (1886–1969).

The most celebrated work by Salinger is *The Catcher in the Rye* (1951). This novel tells of two days in the life of a young man, Holden Caulfield. Running away from a boarding school named Pencey, Holden wanders around New York City in a late-adolescent pursuit of contacts that would prove meaningful to him. Instead he finds a panorama of adult hypocrisy, lust, sex, and perversion. The insincerity of his parents, his teachers, and even most of his contemporaries is repellent to Holden. Only in his ten-year-old sister Phoebe can Holden find genuine love. But the suspicion that sincerity cannot survive childhood leaves Holden lost in a morass of disillusionment. In one scene, Holden, who is avoiding contact with his parents, sneaks into his sister's bedroom and tries to explain his reasons for leaving school. A selection from *The Catcher in the Rye,* "You Don't Like *Any*thing That's Happening," is presented here.

The anonymity of modern society that was decried in print by Salinger has been mirrored in the architecture of Ludwig Mies van der Rohe. After fleeing Germany in 1937, Mies van der Rohe designed buildings in the United States, such as the Lake Shore Drive Apartment Houses (1950–52) in Chicago and the Seagram Building (1956–58) in New York City. By using a suspended frame system, Mies van der Rohe was able to create pure rectilinear structures, with interiors freed of interior supports and with exteriors divided into identical modules. The glass surfaces reflect the urban environment and, simultaneously, have visual elegance and proportional precision.

J. D. Salinger, *The Catcher in the Rye*[1]
You Don't Like Anything That's Happening

When I came back, she had the pillow off her head all right—I knew she would—but she still wouldn't look at me, even though she was laying on her back and all. When I came around the side of the bed and sat down again, she turned her crazy face the other way. She was ostracizing the hell out of me. Just like the fencing team at Pencey when I left all the goddam foils on the subway.

"How's old Hazel Weatherfield?" I said. "You write any new stories about her? I got that one you sent me right in my suitcase. It's down at the station. It's very good."

"Daddy'll *kill* you."

Boy, she really gets something on her mind when she gets something on her mind.

"No, he won't. The worst he'll do, he'll give me hell again, and then he'll

1. Reprinted, by permission of the publisher, from J. D. Salinger, *The Catcher in the Rye* (New York: Random House, 1951), pp. 216–20, 222–25. Copyright by J. D. Salinger.

send me to that goddam military school. That's all he'll do to me. And in the *first* place, I won't even be around. I'll be away. I'll be—I'll probably be in Colorado on this ranch."

"Don't make me laugh. You can't even ride a horse."

"Who can't? Sure I can. Certainly I can. They can teach you in about two minutes," I said. "Stop picking at that." She was picking at that adhesive tape on her arm. "Who gave you that haircut?" I asked her. I just noticed what a stupid haircut somebody gave her. It was way too short.

"None of your business," she said. She can be very snotty sometimes. She can be quite snotty. "I suppose you failed in every single subject again," she said—very snotty. It was sort of funny, too, in a way. She sounds like a goddam schoolteacher sometimes, and she's only a little child.

"No, I didn't," I said. "I passed English." Then, just for the hell of it, I gave her a pinch on the behind. It was sticking way out in the breeze, the way she was laying on her side. She has hardly any behind. I didn't do it hard, but she tried to hit my hand anyway, but she missed.

Then all of a sudden, she said, "Oh, why did you *do* it?" She meant why did I get the ax again. It made me sort of sad, the way she said it.

"Oh, God, Phoebe, don't ask me. I'm sick of everybody asking me that," I said. "A million reasons why. It was one of the worst schools I ever went to. It was full of phonies. And mean guys. You never saw so many mean guys in your life. For instance, if you were having a bull session in somebody's room, and somebody wanted to come in, nobody'd let them in if they were some dopey, pimply guy. Everybody was always *lock*ing their door when somebody wanted to come in. And they had this goddam secret fraternity that I was too yellow not to join. There was this one pimply, boring guy, Robert Ackley, that wanted to get in. He kept trying to join, and they wouldn't let him. Just because he was boring and pimply. I don't even feel like talking about it. It was a stinking school. Take my word." . . .

Old Phoebe said something then, but I couldn't hear her. She had the side of her mouth right smack on the pillow, and I couldn't hear her.

"What?" I said. "Take your mouth away. I can't hear you with your mouth that way."

"You don't like *any*thing that's happening."

It made me even more depressed when she said that.

"Yes I do. Yes I do. *Sure* I do. Don't say that. Why the hell do you say that?"

"Because you don't. You don't like any schools. You don't like a million things. You *don't.*"

"I do! That's where you're wrong—that's exactly where you're wrong!

Why the hell do you have to say that?" I said. Boy, was she depressing me.

"Because you don't," she said. "Name one thing."

"One thing? One thing I like?" I said. "Okay."

The trouble was, I couldn't concentrate too hot. Sometimes it's hard to concentrate.

"One thing I like a lot you mean?" I asked her.

She didn't answer me, though. She was in a cockeyed position way the hell over the other side of the bed. She was about a thousand miles away. "C'mon, answer me," I said. "One thing I like a lot, or one thing I just like?"

"You like a lot."

"All right," I said. But the trouble was, I couldn't concentrate. . . .

"What?" I said to old Phoebe. She said something to me, but I didn't hear her.

"You can't even think of one thing."

"Yes, I can. Yes, I can."

"Well, do it, then."

"I like Allie," I said. "And I like doing what I'm doing right now. Sitting here with you, and talking, and thinking about stuff, and—"

"Allie's *dead.*—You always say that! If somebody's dead and everything, and in *Heaven,* then it isn't really—"

"I know he's dead! Don't you think I know that? I can still like him, though, can't I? Just because somebody's dead, you don't just stop liking them, for God's sake—especially if they were about a thousand times nicer than the people you know that're *alive* and all."

Old Phoebe didn't say anything. When she can't think of anything to say, she doesn't say a goddam word.

"Anyway, I like it now," I said. "I mean right now. Sitting here with you and just chewing the fat and horsing—"

"That isn't anything *really!*"

"It is so something *really!* Certainly it is! Why the hell isn't it? People never think anything is anything *really.* I'm getting goddam sick of it."

"Stop swearing. All right, name something else. Name something you'd like to *be.* Like a scientist. Or a *law*yer or something."

"I couldn't be a scientist. I'm no good in science."

"Well, a lawyer—like Daddy and all."

"Lawyers are all right, I guess—but it doesn't appeal to me," I said. "I mean they're all right if they go around saving innocent guys' lives all the time, and like that, but you don't *do* that kind of stuff if you're a lawyer. All you do is make a lot of dough and play golf and play bridge and buy cars and drink Martinis and look like a hot-shot. And besides. Even if you *did* go

around saving guys' lives and all, how would you know if you did it because you really *wanted* to save guys' lives, or because you did it because what you *real*ly wanted to do was to be a terrific lawyer, with everybody slapping you on the back and congratulating you in court when the goddam trial was over, the reporters and everybody, the way it is in the dirty movies? How would you know you weren't being a phony? The trouble is, you *wouldn't.*"

I'm not too sure old Phoebe knew what the hell I was talking about. I mean she's only a little child and all. But she was listening, at least. If somebody at least listens, it's not too bad.

"Daddy's going to kill you. He's going to *kill* you," she said.

I wasn't listening, though. I was thinking about something else—something crazy. "You know what I'd like to be?" I said. "You know what I'd like to be? I mean if I had my goddam choice?"

"What? Stop *swear*ing."

"You know that song 'If a body catch a body comin' through the rye'? I'd like—"

"It's 'If a body *meet* a body coming through the rye'!" old Phoebe said. "It's a poem. By Robert *Burns.*"

"I *know* it's a poem by Robert Burns."

She was right, though. It *is* "If a body meet a body coming through the rye." I didn't know it then, though.

"I thought it was 'If a body catch a body,' " I said. "Anyway, I keep picturing all these little kids playing some game in this big field of rye and all. Thousands of little kids, and nobody's around—nobody big, I mean—except me. And I'm standing on the edge of some crazy cliff. What I have to do, I have to catch everybody if they start to go over the cliff—I mean if they're running and they don't look where they're going I have to come out from somewhere and *catch* them. That's all I'd do all day. I'd just be the catcher in the rye and all. I know it's crazy, but that's the only thing I'd really like to be. I know it's crazy."

6. John Chamberlain, *Essex,* 1960
Janson, p. 771, ill. 1086

Jack Kerouac, *On the Road:* "The Cars Rushed by, LA-Bound," 1957

During the 1950s the car became a standard possession in middle-class and upper-class American households. The mobility made possible by the automobile offered people greater choices for employment, residence, and travel. The automobile permit-

ted the middle class to leave the city, to live in suburbs that offered space and privacy, and to pursue recreations that were formerly restricted to the wealthy, such as golf, skiing, camping, and travel. But the same mobility that led to the development of suburban communities and to the popularity of travel also led to restless wandering and to a sense of rootlessness. This was especially true of the members of the Beat Generation.

The Beat Generation refers to a group of American writers who, in the 1950s, raised angry denunciations of American society. They refused to live in middle-class suburbs and to share middle-class values. While the Beat writers scorned middle-class vacations and leisure hobbies, they esteemed the automobile. The car, along with alcohol and drugs, allowed members of the Beat generation to set off in individual quests for spiritual insight and personal wisdom. One of the prominent voices for the Beat Generation was Jack Kerouac (1922–1969).

Born in Massachusetts, Kerouac attended Columbia University (1940–42). Leaving college before graduation, Kerouac began a wide-ranging exploration of the United States. He took odd jobs to support himself as he traveled around the country seeking experience and fulfillment. *On the Road* (1957) is Kerouac's quasi-autobiographical tale of Beat people, their disillusionment with American values, and their quest for freedom from social norms. An excerpt from *On the Road,* "The Cars Rushed by, LA-Bound," is presented here.

The automobile, driven on the roads followed by Kerouac, was reworked into metal sculptures by the American artist John Chamberlain (born 1927). Compositions such as *Essex* (1960) are shaped from welded pieces of enameled tin, which Chamberlain cut from discarded cars. These sculptures not only evoke the possessive longings of the automobile's original owners, but also suggest the ultimate futility of any consumer product to provide long-term happiness.

Jack Kerouac, *On the Road*[1]
The Cars Rushed by, LA-Bound

In the month of July 1947, having saved about fifty dollars from old veteran benefits, I was ready to go to the West Coast. . . . My aunt was all in accord with my trip to the West; she said it would do me good. . . . All she wanted was for me to come back in one piece.

I'd been poring over maps of the United States in Paterson [New Jersey] for months, even reading books about the pioneers and savoring names like Platte and Cimarron and so on, and on the road-map was one long red line called Route 6 that led from the tip of Cape Cod clear to Ely, Nevada, and there dipped down to Los Angeles. I'll just stay on 6 all the way to Ely, I said to myself and confidently started.

1. Reprinted, by the permission of the publisher, from Jack Kerouac, *On the Road* (New York: The Viking Press, 1965), pp. 11–12, 14–16, 79–82, 84. Copyright by Stella Kerouac.

It was an ordinary bus trip [to Chicago]. . . . And for the first time in my life, the following afternoon, I went into the West. It was a warm and beautiful day for hitchhiking. To get out of the impossible complexities of Chicago traffic I took a bus to Joliet, Illinois, went by the Joliet pen,[2] stationed myself just outside town after a walk through its leafy rickety streets behind, and pointed my way. All the way from New York to Joliet by bus, and I had spent more than half my money.

My first ride was a dynamite truck with a red flag, about thirty miles into great green Illinois, the truck driver pointing out the place where Route 6, which we were on, intersects Route 66 before they both shoot west for incredible distances. Along about three in the afternoon, after an apple pie and ice cream in a roadside stand, a woman stopped for me in a little coupe. I had a twinge of hard joy as I ran after the car. But she was a middle-aged woman, actually the mother of sons my age, and wanted somebody to help her drive to Iowa. I was all for it. Iowa! . . .

I went to sit in the bus station [at Davenport] and [to] think this over. . . . I decided to gamble. I took a bus in downtown Davenport, after spending a half-hour watching a waitress in the bus-station café, and rode to the city limits, but this time near the gas stations. Here the big trucks roared, wham, and inside two minutes one of them cranked to a stop for me. I ran for it with my soul whoopeeing. And what a driver—a great big tough truckdriver with popping eyes and a hoarse raspy voice who just slammed and kicked at everything and got his rig under way and paid hardly any attention to me. . . . The guy just yelled above the roar, and all I had to do was yell back, and we relaxed. And he balled that thing clear to Iowa City and yelled me the funniest stories about how he got around the law in every town that had an unfair speed limit, saying over and over again, "Them goddam cops can't put no flies on *my* ass!" Just as we rolled into Iowa City he saw another truck coming behind us, and because he had to turn off at Iowa City he blinked his tail lights at the other guy and slowed down for me to jump out, which I did with my bag, and the other truck, acknowledging this exchange, stopped for me, and once again, in the twink of nothing, I was in another big high cab, all set to go hundreds of miles across the night, and was I happy! And the new truckdriver was as crazy as the other and yelled just as much, and all I had to do was lean back and roll on. . . .

[At Des Moines], a guy with a kind of toolshack on wheels, a truck full of tools that he drove standing up like a modern milkman, gave me a ride up the long hill, where I immediately got a ride from a farmer and his son heading out for Adel in Iowa. . . .

2. Penitentiary or prison.

In Oakland I had a beer among the bums of a saloon with a wagon wheel in front of it, and I was on the road again. . . .

A man in a brand-new pickup truck picked me up. He was from Lubbock, Texas, and was in the trailer business. "You want to buy a trailer?" he asked me. "Any time, look me up." He told stories about his father in Lubbock. "One night my old man left the day's receipts settin on top of the safe, plumb forgot. What happened—a thief came in the night, acetylene torch and all, broke open the safe, riffled up the papers, kicked over a few chairs, and left. And that thousand dollars was settin right there on top of the safe, what do you know about that?"

He let me off south of Bakersfield, and then my adventure began. It grew cold. I put on the flimsy Army raincoat I'd bought in Oakland for three dollars and shuddered in the road. I was standing in front of an ornate Spanish-style motel that was lit like a jewel. The cars rushed by, LA-bound. I gestured frantically. It was too cold. I stood there till midnight, two hours straight, and cursed and cursed. It was just like Stuart, Iowa, again. There was nothing to do but spend a little over two dollars for a bus the remaining miles to Los Angeles. I walked back along the highway to Bakersfield and into the station, and sat down on a bench.

I had bought my ticket and was waiting for the LA bus when all of a sudden I saw the cutest little Mexican girl in slacks come cutting across my sight. She was in one of the buses that had just pulled in with a big sigh of airbrakes; it was discharging passengers for a rest stop. Her breasts stuck out straight and true; her little flanks looked delicious; her hair was long and lustrous black; and her eyes were great big blue things with timidities inside. I wished I was on her bus. A pain stabbed my heart, as it did every time I saw a girl I loved who was going the opposite direction in this too-big world. The announcer called the LA bus. I picked up my bag and got on, and who should be sitting there alone but the Mexican girl. I dropped right opposite her and began scheming right off. I was so lonely, so sad, so tired, so quivering, so broken, so beat, that I got up my courage, the courage necessary to approach a strange girl, and acted. Even then I spent five minutes beating my thighs in the dark as the bus rolled down the road.

You gotta, you gotta or you'll die! Damn fool, talk to her! What's wrong with you? Aren't you tired enough of yourself by now? And before I knew what I was doing I leaned across the aisle to her (she was trying to sleep on the seat) and said, "Miss, would you like to use my raincoat for a pillow?" . . .

We got off the bus at Main Street, which was no different from where you get off a bus in Kansas City or Chicago or Boston—red brick, dirty,

characters drifting by, trolleys grating in the hopeless dawn, the whorey smell of a big city. . . . I made love to her in the sweetness of the weary morning. Then, two tired angels of some kind, hung-up forlornly in an LA shelf, having found the closest and most delicious thing in life together, we fell asleep and slept till late afternoon.

7. Edward Kienholz, *The Wait*, 1964–65
Gardner, p. 1083, ill. 22:68

Edward Kienholz, *The State Hospital*, 1966
Janson, p. 775, ill. 1091

Ken Kesey, *One Flew over the Cuckoo's Nest:* "Hostility, Hostility, That's the Thanks We Get," 1962

The 1950s can be remembered as a period of unprecedented prosperity for the United States. Fueled by the emergence of new industries, such as plastics and electronics, and spurred by huge investments from business and government in research, the American economy experienced a phenomenal expansion. For the average American, this prodigious economic growth was translated into a raised standard of living.

As the economic and social patterns in America in the 1950s changed, so, too, did the personal qualities that were deemed important for success. Employers sought a new type of employee, whose talents lay primarily in adaptability and teamwork, rather than ingenuity and independence. Dominant personalities were discouraged, while conformity was encouraged. In addition, cultural differences among ethnic, racial, and religious groups were often ignored, minimized, or devalued, while homogeneity was prized.

Some observers considered the trends toward conformity and homogeneity to have an ominous impact upon mental health. American society was accused of being restrictive in individual freedom, stultifying for artistic creativity, and deadening to personal morality. The fear that mental illness and insanity would engulf those who did not assimilate themselves into a middle-class life style became a prevalent theme in American literature and art.

A strong indictment of American culture was issued by the American novelist Ken Kesey (born 1935). Kesey has worked as a ward attendant in a mental hospital, and has witnessed the anguish, illness, and insanity that has resulted from an inability or refusal to conform to social mores and cultural standards. As the subject for his novel *One Flew over the Cuckoo's Nest* (1962), Kesey chose the inmates of an insane asylum. An Indian named Chief acts as the stream-of-consciousness center and narrator-observer. A hospital attendant named Big Nurse is cast as the villain. The defiant characters of McMurphy and Taber can be seen as representatives of the struggle

between an individual's desire to be free and the fear of freedom's consequences. In one scene Taber questions the medications that Big Nurse gives him, and her assistants mete out a response that brutalizes his human dignity and reduces him to a mindless organism. A selection from *One Flew over the Cuckoo's Nest,* "Hostility, Hostility, That's the Thanks We Get," is presented here.

On one level, the novel can be read as an allegory of the subjugation of the Indian by the white man. On another level, the novel can be interpreted as a microcosm of American society. The prefrontal lobotomy performed on McMurphy at the end of the story is any physical act, social treatment, or emotional way of viewing people that limits and dehumanizes them.

The dehumanization of human beings who endure mental illness, together with the degradation of human beings who suffer physical violence, is dramatized by the sculptural work of Edward Kienholz (born 1927). Using a combination of hand-built shapes and fabricated forms, Kienholz has assembled tableaux, such as *The Wait* (1964–65) and *The State Hospital* (1966). *The Wait* represents an elderly woman whose body is partly composed of bones and a skull, as she waits for her own death. *The State Hospital* depicts, in the lower bunk, an elderly mental patient whose shriveled, naked body has been strapped to a bunk bed and whose mental life has been virtually extinguished, and, in the upper bunk, a second and equally pathetic figure. Abstraction and realism are mingled by Kienholz to intensify the impact of his art.

Ken Kesey, *One Flew over the Cuckoo's Nest*[1]
Hostility, Hostility, That's the Thanks We Get

The guys file by and get a capsule in a paper cup—throw it to the back of the throat and get the cup filled with water by the little nurse and wash the capsule down. On rare occasions some fool might ask what he's being required to swallow.

"Wait just a shake, honey; what are these two little red capsules in here with my vitamin?"

I know him. He's a big, griping Acute, already getting the reputation of being a troublemaker.

"It's just medication, Mr. Taber, good for you. Down it goes, now."

"But I mean what *kind* of medication. Christ, I can see that they're pills—"

"Just swallow it all, shall we, Mr. Taber—just for me?" She takes a quick look at the Big Nurse to see how the little flirting technique she is using is accepted, then looks back at the Acute. He still isn't ready to swallow something he don't know what is, not even just for her.

1. Reprinted, by permission of the publisher, from Ken Kesey, *One Flew over the Cuckoo's Nest* (New York: The Viking Press, 1973), pp. 32–34. Copyright by The Viking Press.

"Miss, I don't like to create trouble. But I don't like to swallow something without knowing what it is, neither. How do I know this isn't one of those funny pills that makes me something I'm not?"

"Don't get upset, Mr. Taber—"

"Upset? All I want to *know*, for the lova Jesus—"

But the Big Nurse has come up quietly, locked her hand on his arm, paralyzes him all the way to the shoulder. "That's all right, Miss Flinn," she says. "If Mr. Taber chooses to act like a child, he may have to be treated as such. We've tried to be kind and considerate with him. Obviously, that's not the answer. Hostility, hostility, that's the thanks we get. You can go, Mr. Taber, if you don't wish to take your medication orally."

"All I wanted to *know*, for the—"

"You can go."

He goes off, grumbling, when she frees his arm, and spends the morning moping around the latrine, wondering about those capsules. I got away once holding one of those same red capsules under my tongue, playing like I'd swallowed it, and crushed it open later in the broom closet. For a tick of time, before it all turned into white dust, I saw it was a miniature electronic element like the ones I helped the Radar Corps work with in the Army, microscopic wires and girds and transistors, this one designed to dissolve on contact with air. . . .

The two big black boys catch Taber in the latrine and drag him to the mattress room. He gets one a good kick in the shins. He's yelling bloody murder. I'm surprised how helpless he looks when they hold him, like he was wrapped with bands of black iron.

They push him face down on the mattress. One sits on his head, and the other rips his pants open in back and peels the cloth until Taber's peach-colored rear is framed by the ragged lettuce-green. He's smothering curses into the mattress and the black boy sitting on his head saying, "Tha's right, Mistuh Taber, tha's right. . . ." The nurse comes down the hall, smearing Vaseline on a long needle, pulls the door shut so they're out of sight for a second, then comes right back out, wiping the needle on a shred of Taber's pants. She's left the Vaseline jar in the room. Before the black boy can close the door after her I see the one still sitting on Taber's head, dabbing at him with a Kleenex. They're in there a long time before the door opens up again and they come out carrying him across the hall to the lab. His greens are ripped clear off now and he's wrapped up in a damp sheet. . . .

8. Moshe Safdie, Habitat, Montreal, 1967
Janson, p. 788, ill. 1115

Aldous Huxley, *Brave New World:* "Bokanovsky's Process," 1932

The power of twentieth-century science and technology as a destructive force of unimaginable magnitude was demonstrated in 1945 by the use of atomic weapons. A society in which individuals are in danger of being dehumanized by the advances of the laboratory appeared to many observers as more than a fantasy; it suddenly seemed like a plausible possibility for the imminent future.

One such observer was Aldous Huxley (1894–1963). Huxley, an Englishman, was the grandson of the famous biologist Thomas Henry Huxley and the grand-nephew of Matthew Arnold. During the 1920s Huxley lived in Italy; from 1940 until his death he lived in the United States.

Huxley is probably best known for his satirical novel *Brave New World* (1932), which portrays a bizarre, mechanized, emotionless society of the future. In this society, people are created from fertilized eggs in laboratory test tubes. Mass production of human beings ensures that individuality, with all its troublesome and vexatious qualities, can be eliminated and that the socially ordained qualities of community, identity, and stability can be inculcated. The few persons who have escaped social conditioning discover that human emotions could end only in tragedy in the brave new world. A selection from *Brave New World,* "Bokanovsky's Process," is presented here.

An experiment in the application of mass production to architecture was tried by Moshe Safdie (born 1938). The demonstration building, constructed for Montreal's Expo '67, Habitat, was constructed from prefabricated elements. Each apartment in the structure consisted of a single, boxlike concrete module. Precast as independent units at a plant, the apartments were trucked to the site and lifted into their designated slots in a concrete framework. Although the individual living units are standardized, the overall shape and size of the building can be adapted to any site.

Aldous Huxley, *Brave New World*[1]
Bokanovsky's Process

A squat grey building of only thirty-four stories. Over the main entrance the words, CENTRAL LONDON HATCHERY AND CONDITIONING CENTER, and, in a shield, the World State's motto, COMMUNITY, IDENTITY, STABILITY.

The enormous room on the ground floor faced towards the north. . . .

1. Reprinted, by permission of the publisher, from Aldous Huxley, *Brave New World* (New York: Harper & Bros., 1932), pp. 1–8. Copyright by the Estate of Aldous Huxley.

"And this," said the Director [of Hatcheries and Conditioning], opening the door, "is the Fertilizing Room."

Bent over their instruments, three hundred Fertilizers were plunged, as the Director of Hatcheries and Conditioning entered the room, in the scarcely breathing silence, the absent-minded, soliloquizing hum or whistle, of absorbed concentration. A troop of newly arrived students, very young, pink and callow, followed nervously, rather abjectly, at the Director's heels. Each of them carried a notebook, in which, whenever the great man spoke, he desperately scribbled. Straight from the horse's mouth. It was a rare privilege. The D.H.C. for Central London always made a point of personally conducting his new students round the various departments. . . .

"I shall begin at the beginning," said the D.H.C. and the more zealous students recorded his intention in their notebooks: *Begin at the beginning.* "These," he waved his hand, "are the incubators." And opening an insulated door he showed them racks upon racks of numbered test-tubes. "The week's supply of ova. Kept," he explained, "at blood heat; whereas the male gametes," and here he opened another door, "they have to be kept at thirty-five instead of thirty-seven. Full blood heat sterilizes." . . .

"Bokanovsky's Process," repeated the Director, and the students underlined the words in their little notebooks.

One egg, one embryo, one adult—normality. But a bokanovskified egg will bud, will proliferate, will divide. From eight to ninety-six buds, and every bud will grow into a perfectly formed embryo, and every embryo into a full-sized adult. Making ninety-six human beings grow where only one grew before. Progress.

"Essentially," the D.H.C. concluded, "bokanovskification consists of a series of arrests of development. We check the normal growth and, paradoxically enough, the egg responds by budding."

Responds by budding. The pencils were busy.

He pointed. On a very slowly moving band a rack-full of test-tubes was entering a large metal box, another rack-full was emerging. Machinery faintly purred. It took eight minutes for the tubes to go through, he told them. Eight minutes of hard X-rays being about as much as an egg can stand. A few died; of the rest, the least susceptible divided into two; most put out four buds; some eight; all were returned to the incubators, where the buds began to develop; then, after two days, were suddenly chilled, chilled and checked. Two, four, eight, the buds in their turn budded; and having budded were dosed almost to death with alcohol; consequently burgeoned again and having budded—bud out of bud out of bud—were thereafter—further arrest

being generally fatal—left to develop in peace. By which time the original egg was in a fair way to becoming anything from eight to ninety-six embryos—a prodigious improvement, you will agree, on nature. Identical twins—but not in piddling twos and threes as in the old viviparous[2] days, when an egg would sometimes accidentally divide; actually by dozens, by scores at a time.

"Scores," the Director repeated and flung out his arms, as though he were distributing largesse. "Scores."

But one of the students was fool enough to ask where the advantage lay.

"My good boy!" The Director wheeled sharply round on him. "Can't you see? Can't you *see?*" He raised a hand; his expression was solemn. "Bokanovsky's Process is one of the major instruments of social stability!"

Major instruments of social stability.

Standard men and women; in uniform batches. The whole of a small factory staffed with the products of a single bokanovskified egg.

"Ninety-six identical twins working ninety-six identical machines!" The voice was almost tremulous with enthusiasm. "You really know where you are. For the first time in history." He quoted the planetary motto. "Community, Identity, Stability." Grand words. "If we could bokanovskify indefinitely the whole problem would be solved."

Solved by standard Gammas, unvarying Deltas, uniform Epsilons. Millions of identical twins. The principle of mass production at last applied to biology.

"But, alas," the Director shook his head, "we *can't* bokanovskify indefinitely."

Ninety-six seemed to be the limit; seventy-two a good average. From the same ovary and with gametes of the same male to manufacture as many batches of identical twins as possible—that was the best (sadly a second best) that they could do. And even that was difficult.

"For in nature it takes thirty years for two hundred eggs to reach maturity. But our business is to stabilize the population at this moment, here and now. Dribbling out twins over a quarter of a century—what would be the use of that?"

Obviously, no use at all. But Podsnap's Technique had immensely accelerated the process of ripening. They could make sure of at least a hundred and fifty mature eggs within two years. Fertilize and bokanovskify—in other words, multiply by seventy-two—and you get an average of nearly eleven thousand brothers and sisters in a hundred and fifty batches of identical twins, all within two years of the same age.

2. Bringing forth living young, rather than eggs, as do most mammals, and some reptiles and fishes.

"And in exceptional cases we can make one ovary yield us over fifteen thousand adult individuals."

Beckoning to a fair-haired, ruddy young man who happened to be passing at the moment, "Mr. Foster," he called. The ruddy young man approached. "Can you tell us the record for a single ovary, Mr. Foster?"

"Sixteen thousand and twelve in this Center," Mr. Foster replied without hesitation. He spoke very quickly, had a vivacious blue eye, and took an evident pleasure in quoting figures. "Sixteen thousand and twelve; in one hundred and eighty-nine batches of identicals. But of course they've done much better," he rattled on, "in some of the tropical Centers. Singapore has often produced over sixteen thousand five hundred; and Mombasa has actually touched the seventeen thousand mark. But then they have unfair advantages. You should see the way a negro ovary responds to pituitary! It's quite astonishing, when you're used to working with European material. Still," he added, with a laugh (but the light of combat was in his eyes and the lift of his chin was challenging), "still, we mean to beat them if we can. I'm working on a wonderful Delta-Minus ovary at this moment. Only just eighteen months old. Over twelve thousand seven hundred children already, either decanted or in embryo. And still going strong. We'll beat them yet."

"That's the spirit I like!" cried the Director, and clapped Mr. Foster on the shoulder. "Come along with us and give these boys the benefit of your expert knowledge."

Mr. Foster smiled modestly. "With pleasure." They went.

9. Barnett Newman, *Broken Obelisk,* 1963–67
Janson, p. 768, ill. 1081

Robert Frost, "The Gift Outright," c. 1950
John F. Kennedy, *Inaugural Address:* "Ask What You Can Do for Your Country," 1961

On January 20, 1961, John F. Kennedy (1917–1963), the youngest person to be elected president of the United States, took office. A member of the House of Representatives between 1946 and 1953 and of the Senate between 1953 and 1960, Kennedy had been identified with the unadventurous politics of the 1950s. However, during his presidential campaign speeches, Kennedy insistently reiterated the need for sacrifice, imagination, and boldness to restore American confidence.

Once in office, Kennedy quickly proposed a domestic program, named the New Frontier, which called for increased federal involvement in civil rights, education,

urban renewal, medicine, and medical insurance. In foreign affairs, Kennedy confronted the expanding influence of the Soviet Union through a variety of actions. Some, such as his deployment of troops to Berlin after the construction of the Berlin Wall by East Germany and his demand for the removal of Soviet missiles from Cuba, had successful outcomes. Other actions, such as his approval of the attempted invasion of Cuba at the Bay of Pigs and his military buildup to support authoritarian rulers in South Vietnam, proved to be ill-fated decisions.

At the same time that he risked direct conflict with the Soviet Union, Kennedy also sought to ease Cold War tensions between the superpowers. He negotiated a nuclear test ban with the British and Soviet governments, approved a massive sale of wheat to the Soviet Union, and urged a less antagonistic attitude toward the same nation.

Despite the fact that Kennedy was able to achieve only limited gains both in domestic legislation and in foreign policy, the assassination of the president on November 22, 1963, was felt as a national tragedy. During his three years in office, Kennedy had given a distinctive tone to the White House. An author himself, Kennedy included poets, writers, musicians, and artists in presidential functions, and honored distinguished citizens, such as Nobel Prize winners, at White House dinners.

Kennedy's sense of purpose and style was visible in the brilliant winter sunshine of his inaugural day. Two selections from the 1961 inaugural ceremonies are presented here. The first selection, "The Gift Outright," is a poem by Robert Frost (1874–1963). Frost, a poet whom Kennedy particularly admired, was invited to recite the poem at Kennedy's inauguration. In this poem, Frost used the simple forms by which he phrased profound statements about life and death. The second selection, "Ask What You Can Do for Your Country," is an excerpt from the inaugural address delivered by Kennedy.

The loss and sorrow felt by the nation at the death of John F. Kennedy are suggested by the American artist Barnett Newman (1905–1970) in his steel sculpture *Broken Obelisk* (1963–67). In this work, the shape of the Egyptian funerary pyramid is surmounted by an obelisk, a form used by Egyptians to honor the gods and to commemorate burials. The jagged upper edge of the obelisk suggests the haunting absence of peace in Newman's own life and the unfulfilled promise caused by Kennedy's death.

Robert Frost
The Gift Outright[1]

The land was ours before we were the land's.
She was our land more than a hundred years
Before we were her people. She was ours
In Massachusetts, in Virginia;

1. Robert Frost, "The Gift Outright," in Louis Untermeyer, ed., *The Britannica Library of Great American Writing*, vol. 2 (Chicago: Britannica Press, 1960), p. 1230. Copyright by Lesley Frost Ballantine.

But we were England's, still colonials,
Possessing what we still were unpossessed by,
Possessed by what we now no more possessed.
Something we were withholding made us weak
Until we found out that it was ourselves
We were withholding from our land of living,
And forthwith found salvation in surrender.
Such as we were we gave ourselves outright
(The deed of gift was many deeds of war)
To the land vaguely realizing westward,
But still unstoried, artless, unenhanced,
Such as she was, such as she would become.

John F. Kennedy, *Inaugural Address*[2]
Ask What You Can Do for Your Country

We observe today not a victory of party but a celebration of freedom—symbolizing an end as well as a beginning—signifying renewal as well as change. For I have sworn before you and Almighty God the same solemn oath our forebears prescribed nearly a century and three quarters ago.

The world is very different now. For man holds in his mortal hands the power to abolish all forms of human poverty and all forms of human life. And yet the same revolutionary beliefs for which our forebears fought are still at issue around the globe—the belief that the rights of man come not from the generosity of the state but from the hand of God.

We dare not forget today that we are the heirs of that first revolution. Let the word go forth from this time and place, to friend and foe alike, that the torch has been passed to a new generation of Americans—born in this century, tempered by war, disciplined by a hard and bitter peace, proud of our ancient heritage—and unwilling to witness or permit the slow undoing of those human rights to which this nation has always been committed, and to which we are committed today at home and around the world.

Let every nation know, whether it wishes us well or ill, that we shall pay any price, bear any burden, meet any hardship, support any friend, oppose any foe to assure the survival and success of liberty.

Now the trumpet summons us . . . not as a call to bear arms, though arms we need—not as a call to battle, though embattled we are—but a call

2. Reprinted from the *Public Papers of the Presidents of the United States: John F. Kennedy, January 20 to December 31, 1961,* ed. by Wayne C. Gover, Archivist of the United States (Washington, D.C.: U.S. Government Printing Office, 1962).

to bear the burden of a long twilight struggle, year in and year out, "rejoicing in hope, patient in tribulation"—a struggle against the common enemies of man: tyranny, poverty, disease and war itself. . . .

And so, my fellow Americans: ask not what your country can do for you—ask what you can do for your country.

10. David Smith, *Cubi XVIII*, 1964; *Cubi XVII*, 1963; and *Cubi XIX*, 1964
Janson, p. 766, ill. 1078

David Smith, *Cubi XXVI*, 1965
Gardner, p. 1036, ill. 23:6

John H. Glenn, Jr., *Pilot Flight Report:* "When Lift-off Occurred," 1962

Space flight tantalized the human imagination long before the modern era. The flight of vehicles, manned or unmanned, beyond the earth's atmosphere was dreamed of by ancient Greek thinkers and by Renaissance and Baroque scientists such as Galileo Galilei (1564–1642), Johannes Kepler (1571–1630), and Christiaan Huygens (1629–1695).

In October 1957 the Soviet Union startled the world by putting a satellite, Sputnik I, into orbit around the globe. Sputnik I was the size of a football and carried little more than a radio transmitter. In November 1957, however, Sputnik II, which was six times heavier and which carried a live dog, was launched. Two years later, the Soviets scored another success, by firing a rocket past the moon.

The Soviet achievements resulted, in large part, from the construction of rockets powerful enough to launch space vehicles and to enable them to escape from the earth's gravity. This requires a velocity of about 25,000 miles per hour. One element that enables rockets to reach such speeds is the deployment of multistage rockets. The design of such rockets was first proposed by the Russian scientist Konstantine Tsiolkovskii (1857–1935).

A second element that enables rockets to reach the earth's escape velocity is the utilization of liquid fuels. The first liquid-fueled rockets were made in the United States by the American scientist Robert Goddard (1882–1945).

Spurred by the Soviet successes, the American government invested heavily in a space program. On February 20, 1962, John H. Glenn, Jr. (born 1921) piloted the first American spacecraft, *Friendship 7,* in three orbits around the world. On July 16, 1969, two American astronauts, Neil Armstrong (born 1930) and Edwin E. Aldrin, Jr. (born 1930) became the first persons to walk on the moon. Aldrin's father, then seventy-three and a veteran aviator, had been a friend of Orville Wright and Charles Lindbergh. He suggested Psalm 8 as a text for his son's mission:

When we behold the heavens, the work
of your fingers, the moon and the stars
which you set in place, what is man that
you should be mindful of him, and the
son of man that you should care for him?

Upon completion of his space mission, John Glenn wrote a *Pilot Flight Report* (1962). A selection from it, "When Lift-off Occurred," is presented here. Glenn describes lift-off, the sensation of weightlessness, and the appearance of sunset and dawn.

The moon landing was accomplished before the date set as a goal by President John F. Kennedy (1917–1963), who, in 1961, vowed that the United States would land a person on the moon "before this decade is out." Since that time, exploratory probes from the United States and the Soviet Union have orbited around or soft-landed on inner planetary bodies—that is, on Mercury, Venus, and Mars. The Voyager program has produced successful encounters with Jupiter (1974), Saturn (1980, 1981), Uranus (1986), and Neptune (1989). Now the whole solar system, with the exception of Pluto and its satellite Charon, has been explored by unmanned probes. In addition, the United States, in 1973, placed the Skylab into orbit as the first true space station.

The triumph over gravity, which was achieved by the space program, is suggested by the sculpture of the American artist David Smith (1906–1965). In his *Cubi* series of the 1960s, Smith employed only two basic components—cubes and cylinders. These geometrical forms rise high above the ground in a variety of buoyant compositions.

John Glenn, Jr., *Pilot Flight Report*[1]
When Lift-off Occurred

When the countdown reached zero, I could feel the engines start. The spacecraft shook, not violently but very solidly. There was no doubt when lift-off occurred. When the Atlas was released there was an immediate gentle surge that let you know you were on the way. The roll to correct azimuth[2] was noticeable after lift-off. I had preset the little window mirror to watch the ground. I glanced up after lift-off and could see the horizon turning. Some vibration occurred immediately after lift-off. It smoothed out after about 10 to 15 seconds of flight but never completely stopped. There was still a noticeable amount of vibration, which continued up to the time the spacecraft passed through the maximum aerodynamic pressure or maximum q, at

1. Reprinted, by permission of the publishers, from Harlow Shapley, Samuel Rapport, and Helen Wright, eds., *A Treasury of Science* (New York: Harper & Row, 1963), pp. 720–21, 728–29. Copyright by HarperCollins.
2. The arc of the horizon measured clockwise from the south point.

approximately T + 1 minute. The approach of maximum q is signalled by more intense vibrations. Force on the outside of the spacecraft was calculated at 982 pounds per square foot at this time. During this period, I was conscious of a dull muffled roar from the engines. Beyond the high q area the vibration smoothed out noticeably. However, the spacecraft never became completely vibration free during powered flight. . . .

As I looked back at the earth from space, colors and light intensities were much the same as I had observed when flying at high altitude from an airplane. The colors observed when looking down at the ground appeared similar to those seen from 50,000 feet. When looking toward the horizon, however, the view is completely different, for then the blackness of space contrasts vividly with the brightness of the earth. The horizon itself is a brilliant, brilliant blue and white.

It was surprising how much of the earth's surface was covered by clouds. The clouds can be seen very clearly on the daylight side. The different types of clouds—vertical developments, stratus clouds, and cumulus clouds—are readily distinguished. There is little problem identifying them or in seeing the weather patterns. You can estimate the relative heights of the cloud layers from your knowledge of the types and from the shadows the high clouds cast on those lower down. . . .

Only a few land areas were visible during the flight because of the cloud cover. Clouds were over much of the Atlantic, but the western (Sahara Desert) part of Africa was clear. In this desert region I could plainly see dust storms. By the time I got to the east coast of Africa, where I might have been able to see towns, the land was covered by clouds. The Indian Ocean was the same.

Western Australia was clear, but the eastern half was overcast. Most of the area across Mexico and nearly to New Orleans was covered with high cirrus clouds. As I came across the United States I could see New Orleans, Charleston, and Savannah very clearly. I could also see rivers and lakes. I think the best view I had of any land area during the flight was the clear desert region around El Paso on the second pass across the United States. I could see the colors of the desert and the irrigated area north of El Paso. As I passed off the east coast of the United States I could see across Florida and far back along the Gulf Coast.

Over the Atlantic I saw what I assume was the Gulf Stream. The different colors of the water are clearly visible. . . .

I also observed what was probably the wake of a ship. As I was passing over the recovery area at the end of the second orbit, I looked down at the water and saw a little "V." I checked the map; I was over recovery area G

at the time, so I think it was probably the wake from a recovery ship. When I looked again the little "V" was under a cloud. The change in light reflections caused by the wake of a ship are sometimes visible for long distances from an airplane and will linger for miles behind a ship. This wake was probably what was visible.

I believe, however, that most people have an erroneous conception that from orbital altitude, little detail can be seen. In clear desert air, it is common to see a mountain range 100 or so miles away very clearly, and all that vision is through atmosphere. From orbital altitude, atmospheric light attenuation is only through approximately 100,000 feet of atmosphere so it is even more clear. An interesting experiment for future flights can be to determine visibility of objects of different sizes, colors, and shapes. Obviously, on the night side of the earth, much less was visible. This may have been due not only to the reduced light, but also partly to the fact that I was never fully dark adapted. In the bright light of the full moon, the clouds are visible. I could see vertical development at night. Most of the cloudy areas, however, appeared to be stratoform.

The lights of the city of Perth, in Western Australia, were on and I could see them well. The view was similar to that seen when flying at high altitude at night over a small town. South of Perth there was a small group of lights, but they were much brighter in intensity. Inland there was a series of four or five towns lying in a line running from east to west. Knowing that Perth was on the coast, I was just barely able to see the coastline of Australia. Clouds covered the area of eastern Australia around Woomera, and I saw nothing but clouds from there across the Pacific until I was east of Hawaii. There appeared to be almost solid cloud cover all the way.

Just off the east coast of Africa were two large storm areas. Weather Bureau scientists had wondered whether lightning could be seen on the night side, and it certainly can. A large storm was visible just north of my track over the Indian Ocean and a smaller one to the south. Lightning could be seen flashing back and forth between the clouds but most prominent were lightning flashes within thunderheads illuminating them like light bulbs.

Some of the most spectacular sights during the flight were sunsets. The sunsets always occurred slightly to my left, and I turned the spacecraft to get a better view. The sunlight coming in the window was very brilliant with an intense clear white light that reminded me of the arc lights while the spacecraft was on the launching pad. . . .

The biggest surprise of the flight occurred at dawn. Coming out of the night on the first orbit, at the first glint of sunlight on the spacecraft, I was looking inside the spacecraft checking instruments for perhaps 15 to 20

seconds. When I glanced back through the window my initial reaction was that the spacecraft had tumbled and that I could see nothing but stars through the window. I realized, however, that I was still in the normal altitude. The spacecraft was surrounded by luminous particles.

These particles were a light yellowish green color. It was as if the spacecraft were moving through a field of fireflies. They were about the brightness of a first magnitude star and appeared to vary in size from a pinhead up to possibly ⅜ inch. They were about 8 to 10 feet apart and evenly distributed through the space around the spacecraft. Occasionally, one or two of them would move slowly up around the spacecraft and across the window, drifting very, very slowly, and would then gradually move off, back in the direction I was looking.

11. Helen Frankenthaler, *Blue Causeway,* 1963
Janson, p. 743, ill. 1042

Betty Friedan, *The Feminine Mystique:* "Feminine Fulfillment," 1963

Challenges to traditional stereotypes, perceptions and behavior patterns in American society were raised not only by the civil rights movement but also by the women's liberation movement. The centuries-old drive by women to obtain equal opportunities in employment, education, politics, and law achieved important successes in the early twentieth century. In 1920 women in the United States finally won the right to vote, a right for which some women had pressed without success when the American constitution had been written in the late eighteenth century. In the 1930s contraceptives were legalized. In 1946 the United Nations established the Commission on the Status of Women.

But the women's liberation movement, as it came to be called, had an upsurge of strength in the 1960s. In this decade two-thirds of new jobs were filled by women. By 1970, 43 percent of adult women were in the work force, and the trend toward increasing employment of women has continued to rise steadily over the subsequent decades. Advocates of equal opportunity succeeded in broadening the Civil Rights Act of 1964, to prohibit discrimination in employment on the basis of sex, as well as race and religion. Women legislators working together in the National Women's Political Caucus passed the Equal Rights Amendment (ERA). However, when it was submitted for ratification, ERA met with strong opposition and failed to win approval from enough states.

A wife, mother, and former editor of a women's magazine, Betty Friedan (born 1921) is a prominent feminist leader. In her best-selling book *The Feminine Mystique* (1963), Friedan prompted women to examine their traditional roles in society. Friedan subsequently founded the National Organization for Women (NOW), in which

she served as the first president (1966–70). Together with other women's groups, NOW has become an active force in pressing the federal government and state legislatures to rescind remaining legal and social barriers to equality for women. An excerpt from *The Feminine Mystique,* "Feminine Fulfillment," is presented here.

The emergence of Helen Frankenthaler (born 1928) into the foremost ranks of contemporary American painters is an indication of the increasingly prominent role played by women in the United States. Frankenthaler has achieved lyrical harmonies of color and form by staining raw canvas with thin color washes. In works such as *Blue Causeway* (1963), transparent tonal areas slide gently through the composition while traditional distinctions between foreground and background are eliminated.

Betty Friedan, *The Feminine Mystique*[1]
Feminine Fulfillment

The suburban [American] housewife [of the 1950s]—she was the dream image of the young American women and the envy, it was said, of women all over the world. The American housewife—freed by science and labor-saving appliances from the drudgery, the dangers of childbirth and the illnesses of her grandmother. She was healthy, beautiful, educated, concerned only about her husband, her children, her home. She had found true feminine fulfillment. As a housewife and mother, she was respected as a full and equal partner to man in his world. She was free to choose automobiles, clothes, appliances, supermarkets; she had everything that women ever dreamed of.

In the fifteen years after World War II, this mystique of feminine fulfillment became the cherished and self-perpetuating core of contemporary American culture. Millions of women lived their lives in the image of those pretty pictures of the American suburban housewife, kissing their husbands goodbye in front of the picture window, depositing their stationwagonsful of children at school, and smiling as they ran the new electric waxer over the spotless kitchen floor. They baked their own bread, sewed their own and their children's clothes, kept their new washing machines and dryers running all day. They changed the sheets on the beds twice a week instead of once, took the rug-hooking class in adult education, and pitied their poor frustrated mothers, who had dreamed of having a career. Their only dream was to be perfect wives and mothers; their highest ambition to have five children and a beautiful house, their only fight to get and keep their husbands. They had no thought for the unfeminine problems of the world outside the home; they wanted the men to make the major decisions. They gloried in their role as women, and wrote proudly on the census blank: "Occupation: housewife."

1. Reprinted, by permission of the publisher, from Betty Friedan, *The Feminine Mystique* (New York: W. W. Norton, 1963), pp. 18–20, 43–44, 50. Copyright by Betty Friedan.

For over fifteen years, the words written for women, and the words women used when they talked to each other, while their husbands sat on the other side of the room and talked shop or politics or septic tanks, were about problems with their children, or how to keep their husbands happy, or improve their children's school, or cook chicken or make slipcovers. Nobody argued whether women were inferior or superior to men; they were simply different. Words like "emancipation" and "career" sounded strange and embarrassing; no one had used them for years. When a Frenchwoman named Simone de Beauvoir wrote a book called *The Second Sex,* an American critic commented that she obviously "didn't know what life was all about," and besides, she was talking about French women. The "woman problem" in America no longer existed.

If a woman had a problem in the 1950s and 1960s, she knew that something must be wrong with her marriage, or with herself. Other women were satisfied with their lives, she thought. What kind of a woman was she if she did not feel this mysterious fulfillment waxing the kitchen floor? She was so ashamed to admit her dissatisfaction that she never knew how many other women shared it. If she tried to tell her husband, he didn't understand what she was talking about. She did not really understand it herself. For over fifteen years women in America found it harder to talk about this problem than about sex. Even the psychoanalysts had no name for it. When a woman went to a psychiatrist for help, as many women did, she would say, "I'm so ashamed," or "I must be hopelessly neurotic." "I don't know what's wrong with women today," a suburban psychiatrist said uneasily. "I only know something is wrong because most of my patients happen to be women. And their problem isn't sexual." Most women with this problem did not go to see a psychoanalyst, however. "There's nothing wrong really," they kept telling themselves. "There isn't any problem."

But on an April morning in 1959, I heard a mother of four, having coffee with four other mothers in a suburban development fifteen miles from New York, say in a tone of quiet desperation, "the problem." And the others knew, without words, that she was not talking about a problem with her husband, or her children, or her home. Suddenly they realized they all shared the same problem, the problem that has no name. They began, hesitantly, to talk about it. Later, after they had picked up their children at nursery school and taken them home to nap, two of the women cried, in sheer relief, just to know they were not alone. . . .

The feminine mystique says that the highest value and the only commitment for women is the fulfillment of their own femininity. It says that the great mistake of Western culture, through most of its history, has been the

undervaluation of this femininity. It says this femininity is so mysterious and intuitive and close to the creation and origin of life that man-made science may never be able to understand it. But however special and different, it is in no way inferior to the nature of man; it may even in certain respects be superior. The mistake, says the mystique, the root of women's troubles in the past is that women envied men, women tried to be like men, instead of accepting their own nature, which can find fulfillment only in sexual passivity, male domination, and nurturing maternal love.

But the new image this mystique gives to American women is the old image: "Occupation: housewife." The new mystique makes the housewife-mothers, who never had a chance to be anything else, the model for all women; it presupposes that history has reached a final and glorious end in the here and now, as far as women are concerned. Beneath the sophisticated trappings, it simply makes certain concrete, finite, domestic aspects of feminine existence—as it was lived by women whose lives were confined, by necessity, to cooking, cleaning, washing, bearing children—into a religion, a pattern by which all women must now live or deny their femininity.

Fulfillment as a woman had only one definition for American women after 1949—the housewife-mother. As swiftly as in a dream, the image of the American woman as a changing, growing individual in a changing world was shattered. Her solo flight to find her own identity was forgotten in the rush for the security of togetherness. Her limitless world shrunk to the cozy walls of home.

But forbidden to join man in the world, can women be people? Forbidden independence, they finally are swallowed in an image of such passive dependence that they want men to make the decisions, even in the home. The frantic illusion that togetherness can impart a spiritual content to the dullness of domestic routine, the need for a religious movement to make up for the lack of identity, betrays the measure of women's loss and the emptiness of the image. Could making men share the housework compensate women for their loss of the world? Could vacuuming the living room floor together give the housewife some mysterious new purpose in life?

12. William T. Williams, *Batman*, 1979
Janson, p. 746, ill. 1047

Ralph Ellison, *Invisible Man:* "That's Right, Sambo," 1952
James Baldwin, *Go Tell It on the Mountain:* "All Niggers Had Been Cursed," 1953

In the late 1960s, spasms of racial violence rocked the nation. On August 11, 1965, just five days after President Johnson signed the Voting Rights Act, race riots erupted in the Watts community of Los Angeles. The following year riots broke out in the black districts of Cleveland, Chicago, and other cities. In 1967 racial insurrections shook Newark and Detroit, where black militants set fires and sniped at police. Northern blacks, who had long exercised such rights as suffrage, protested that civil rights statutes did little to alleviate the hardships of the urban ghetto: unemployment, poor education, slum housing, and hostile police.

Although many injustices were not corrected by the civil rights movement, black writers and artists were helped to establish their presence in American cultural life. Two of the most prominent black writers are Ralph Ellison (born 1914) and James Baldwin (1924–1987).

Both Ellison and Baldwin have explored the issues of black identity in the United States. Ellison was born in Oklahoma City and educated at Tuskegee Institute, Alabama. After serving in the United States Merchant Marine during World War II, Ellison became a writer and lecturer. Ellison's reputation as a major American writer is based primarily on a single novel, *Invisible Man* (1952).

On one level the plot of *Invisible Man* is deliberately absurd in its premise. The nameless protagonist of Ellison's book spends his time crouching in a hole in the ground. But the mental journeys through time and space made by Ellison's central character are far from absurd in their purpose. The novel's protagonist observes racial identities, stereotypes, and prejudices in the southern American black middle class, northern industrial society, and the radical political movement. Confronted with confusing contradictory realities, he tries to formulate a responsible plan for living and to transform the instability of black existence into a state of freedom, which Ellison posits as the necessary precondition for a person's full development.

Throughout the narrative of kaleidoscopic events, the surreal quality of black existence becomes clear. In one section Ellison describes the experience of the valedictorian of a black high school. Invited to repeat his valedictory speech to white civic leaders, the black teenager has arrived at the hotel ballroom and discovered his half-drunk audience expectantly awaiting another form of entertainment. A group of black youths are blindfolded, led into a boxing ring, and forced to punch wildly at one another until only one is standing. The valedictorian is made to join this sport. For their pay, the participants are expected to scramble for money that has been scattered on the floor. A selection from *Invisible Man*, "That's Right, Sambo," is presented here.

Baldwin was born in Harlem in New York City. In his early twenties, he went to Europe, where he lived for most of his life, principally in Paris. Baldwin's reputation rests upon a prolific outpouring of novels, short stories, essays, and plays. Eloquently intense and morally insistent, Baldwin grapples with the destructive impact of racial prejudices.

Go Tell It on the Mountain (1953) is Baldwin's first and best novel. Plainly autobiographical, the novel centers upon the religious conversion of John Grimes on

the night of his fourteenth birthday. In the course of the evening many characters are introduced, and many personal and social conflicts are explored. The conflicts include clashes between an individual's desires, the limitations imposed by a segregated society, and the spiritual demands of evangelical black churches. The conclusion of the novel describes John's conversion on the floor before the altar. Tortured by guilt not only for personal sins but also for the very color of his skin, John alternately imagines that he can hear the voice of God raised in a curse and that he can hear the voice of his father promising to administer one more beating for his sins. A selection from *Go Tell It on the Mountain,* "All Niggers Had Been Cursed," is presented here.

Unlike Ellison and Baldwin, the African-American artist William T. Williams (born 1942) has chosen not to deal directly with the subject of black identity in American society. He has developed an abstract style of expression to create subtle surface nuances of tone and texture. In paintings like *Batman* (1979) Williams floats fascinating patterns of color and brush stroke. By incorporating the intricate rhythms of jazz improvisation in his visual designs, however, Williams refers to and enlarges upon the contributions of black culture to the American scene.

Ralph Ellison, *Invisible Man*[1]
That's Right, Sambo

Then the M.C. called to us, "Come on up here boys and get your money."

We ran forward to where the men laughed and talked in their chairs, waiting. Everyone seemed friendly now.

"There it is on the rug," the man said. I saw the rug covered with coins of all dimensions and a few crumpled bills. But what excited me, scattered here and there, were the gold pieces.

"Boys, it's all yours," the man said. "You get all you grab."

"That's right, Sambo," a blond man said, winking at me confidentially.

I trembled with excitement, forgetting my pain. I would get the gold and the bills, I thought. I would use both hands. I would throw my body against the boys nearest me to block them from the gold.

"Get down around the rug now," the man commanded, "and don't anyone touch it until I give the signal."

"This ought to be good," I heard.

As told, we got around the square rug on our knees. Slowly the man raised his freckled hand as we followed it upward with our eyes.

I heard, "These niggers look like they're about to pray!"

Then, "Ready," the man said. "Go!"

I lunged for a yellow coin lying on the blue design of the carpet, touching

1. Reprinted, by permission of the publisher, from Ralph Ellison, *Invisible Man* (New York: Random House, 1952), pp. 21–23. Copyright by Ralph Ellison.

it and sending a surprised shriek to join those rising around me. I tried frantically to remove my hand but could not let go. A hot, violent force tore through my body, shaking me like a wet rat. The rug was electrified. The hair bristled up on my head as I shook myself free. My muscles jumped, my nerves jangled, writhed. But I saw that this was not stopping the other boys. Laughing in fear and embarrassment, some were holding back and scooping up the coins knocked off by the painful contortions of the others. The men roared above us as we struggled.

"Pick it up, goddamnit, pick it up!" someone called like a bass-voiced parrot. "Go on, get it!"

I crawled rapidly around the floor, picked up the coins, trying to avoid the coppers and to get greenbacks and the gold. Ignoring the shock by laughing, as I brushed the coins off quickly, I discovered that I could contain the electricity—a contradiction, but it works. Then the men began to push us onto the rug. Laughing embarrassedly, we struggled out of their hands and kept after the coins. We were all wet and slippery and hard to hold. Suddenly I saw a boy lifted into the air, glistening with sweat like a circus seal, and dropped, his wet back landing flush upon the charged rug, heard him yell and saw him literally dance upon his back, his elbows beating a frenzied tattoo upon the floor, his muscles twitching like the flesh of a horse stung by many flies. When he finally rolled off, his face was gray and no one stopped him when he ran from the floor amid booming laughter.

"Get the money," the M.C. called. "That's good hard American cash!" ... It was as though I had rolled through a bed of hot coals. It seemed a whole century would pass before I would roll free, a century in which I was seared through the deepest levels of my body to the fearful breath within me and the breath seared and heated to the point of explosion. It'll all be over in a flash, I thought as I rolled clear. It'll all be over in a flash.

But not yet, the men on the other side were waiting, red faces swollen as though from apoplexy as they bent forward in their chairs. Seeing their fingers coming toward me I rolled away as a fumbled football rolls off the receiver's fingertips, back into the coals. That time I luckily sent the rug sliding out of place and heard the coins ringing against the floor and the boys scuffling to pick them up and the M.C. calling, "All right, boys, that's all. Go get dressed and get your money."

I was limp as a dish rag. My back felt as though it had been beaten with wires.

When we had dressed the M.C. came in and gave us each five dollars, except Tatlock, who got ten for being last in the ring. Then he told us to leave. I was not to get a chance to deliver my speech, I thought. I was going out into

the dim alley in despair when I was stopped and told to go back. I returned to the ballroom, where the men were pushing back their chairs and gathering in groups to talk.

The M.C. knocked on a table for quiet. "Gentlemen," he said, "we almost forgot an important part of the program. A most serious part, gentlemen. This boy was brought here to deliver a speech which he made at his graduation yesterday . . ."

"Bravo!"

"I'm told that he is the smartest boy we've got out there in Greenwood. I'm told that he knows more big words than a pocket-sized dictionary."

Much applause and laughter.

"So now, gentlemen, I want you to give him your attention."

James Baldwin, *Go Tell It on the Mountain*[2]
All Niggers Had Been Cursed

Then the ironic voice, terrified, it seemed, of no depth, no darkness, demanded of John, scornfully, if he believed that he was cursed. All niggers had been cursed, the ironic voice reminded him, all niggers had come from this most undutiful of Noah's sons. How could John be cursed for having seen in a bathtub what another man—*if* that other man had ever lived—had seen ten thousand years ago, lying in an open tent? Could a curse come down so many ages? Did it live in time, or in the moment? But John found no answer for this voice, for he was in the moment, and out of time.

And his father approached. "I'm going to beat sin out of him. I'm going to beat it out." All the darkness rocked and wailed as his father's feet came closer; feet whose tread resounded like God's tread in the garden of Eden, searching the covered Adam and Eve. Then his father stood just above him, looking down. Then John knew that a curse was renewed from moment to moment, from father to son. Time was indifferent, like snow and ice; but the heart, crazed wanderer in the driving waste, carried the curse forever.

"John," said his father, "come with me."

"I'm going to beat it out of you. I'm going to beat it out."

His father raised his hand. The knife came down. John rolled away, down the white, descending street, screaming:

"Father! Father!"

These were the first words he uttered. In a moment there was silence, and

his father was gone. Again, he felt the saints above him—and dust was in his mouth. There was singing somewhere; far away, above him; singing slow and mournful. He lay silent, racked beyond endurance, salt drying on his face, with nothing in him any more, no lust, no fear, no shame, no hope. And yet he knew that it would come again—the darkness was full of demons crouching, waiting to worry him with their teeth again.

Then I looked in the grave and I wondered.

Ah, down!—what was he searching here, all alone in darkness? But now he knew, for irony had left him, that he was searching for something, hidden in the darkness, that must be found. He would die if it was not found; or, he was dead already, and would never again be joined to the living, if it was not found. . . .

And the grave looked so sad and lonesome.

In the grave where he now wandered—he knew it was the grave, it was so cold and silent, and he moved in icy mist—he found his mother and his father, his mother dressed in scarlet, his father dressed in white. They did not see him; they looked backward, over their shoulders, at a cloud of witnesses. . . .

Then there began to flood John's soul the waters of despair. *Love is as strong as death, as deep as the grave.* But love, which had, perhaps, like a benevolent monarch, swelled the population of his neighboring kingdom, Death, had not himself descended: they owed him no allegiance here. Here there was no speech or language, and there was no love; no one to say: You are beautiful, John; no one to forgive him, no matter what his sin; no one to heal him, and lift him up. . . .

Then the darkness began to murmur—a terrible sound—and John's ears trembled. In this murmur that filled the grave, like a thousand wings beating on the air, he recognized a sound that he had always heard. He began, for terror, to weep and moan—and this sound was swallowed up, and yet was magnified by the echoes that filled the darkness.

This sound had filled John's life, so it now seemed, from the moment he had first drawn breath. He had heard it everywhere, in prayer and in daily speech, and wherever the saints were gathered, and in the unbelieving streets. It was in his father's anger, and in his mother's calm insistence, and in the vehement mockery of his aunt. . . . Yes, he had heard it all his life, but it was only now that his ears were opened to this sound that came from darkness, that could only come from darkness, that yet bore such sure witness to the glory of the light. And now in his moaning, and so far from any help, he heard it in himself—it rose from his bleeding, his cracked-open heart. It was a sound of rage and weeping which filled the grave, rage and weeping from

time set free, but bound now in eternity; rage that had no language, weeping with no voice—which yet spoke now, to John's startled soul, of boundless melancholy, of the bitterest patience, and the longest night; of the deepest water, the strongest chains, the most cruel lash; of humility most wretched, the dungeon most absolute, of love's bed defiled, and birth dishonored, and most bloody, unspeakable, sudden death. Yes, the darkness hummed with murder: the body in the water, the body in the fire, the body on the tree. John looked down the line of these armies of darkness, army upon army, and his soul whispered: *Who are these? Who are they?* And wondered: *Where shall I go?*

13. Jasper Johns, *Target with Four Faces*, 1955
Gardner, p. 1070, ill. 23:50

Jasper Johns, *Three Flags*, 1958
Janson, p. 749, ill. 1053

Martin Luther King, Jr., Speech: "I Have a Dream," August 28, 1963

During the post–World War II period, American society has been transformed by the efforts of minority groups to achieve equal rights. A determined campaign to dismantle legal barriers to African-American participation in society was begun in the 1950s.

The Emancipation Proclamation that freed the slaves in the United States was issued on January 1, 1863. Despite the approach of the centenary of the proclamation, African-Americans in the mid-twentieth century found themselves still regarded as second-class citizens. In both northern and southern states, African-American citizens met with many forms of discrimination that prevented them from obtaining employment, decent housing, and good education.

The conscience of the country was increasingly troubled by the contradictory commitment to equality and the simultaneous tolerance of white superiority. In 1954 the Supreme Court ruled that segregation in public education was unconstitutional. In the early 1960s President John F. Kennedy (lived 1917–1963; president 1961–63) utilized his executive powers to advance civil rights. He appointed African-Americans to high positions; he committed the Department of Justice to protect voting rights; he dispatched federal marshals to Mississippi to ensure that African-American students could register at the state university; and he mobilized the Alabama National Guard for a similar purpose. In the later 1960s, President Lyndon B. Johnson (lived 1908–1973; president 1963–69) prodded Congress into passing a series of civil rights acts that ordered integration of many other public facilities.

Among the foremost leaders of the civil rights movement was Dr. Martin Luther

King, Jr. (1929–1968). Pastor of a Baptist church in Montgomery, Alabama, King was only twenty-five years old when he gained national prominence. King, who was an admirer of the Indian leader Gandhi, vowed to wear down resistance to racial inequality by demonstrating a capacity to accept imprisonment and to endure suffering without seeking retaliation or resorting to violence. In 1955 he led an African-American boycott of his city's segregated transport system. The success of the boycott attracted the country's attention to King's strategy of nonviolent resistance.

To further national desegregation, King founded the Southern Christian Leadership Conference. On August 28, 1963, he organized a peaceful march on Washington, D.C., to urge a reluctant Congress into action on civil rights legislation. Over 200,000 people attended the march and listened to a speech in which King described his vision for a just and egalitarian American society. An excerpt from King's speech, "I Have a Dream," is presented here.

An opponent of all forms of oppression, King had begun a national campaign against poverty when he was assassinated in Memphis, Tennessee on April 4, 1968. Despite considerable legal, social, and economic progress, King's dream has remained unrealized.

Jasper Johns (born 1930) appeared on the New York art scene in 1955, the same year that Martin Luther King, Jr., led the Montgomery transit boycott. Just as King challenged the conventional attitudes and practices toward minorities in American society, Johns has challenged the traditional perceptions of familiar objects and images in American popular culture. In paintings such as *Target with Four Faces* (1955) and *Three Flags* (1958), Johns has removed commonplace icons from their familiar settings and usages and has challenged the viewer to reinterpret their meaning.

Martin Luther King, Jr., Speech[1]
I Have a Dream

Five score years ago, a great American, in whose symbolic shadow we stand, signed the Emancipation Proclamation. This momentous decree came as a great beacon light of hope to millions of Negro slaves who had been seared in the flames of withering injustice. It came as a joyous daybreak to end the long night of captivity.

But one hundred years later, we must face the tragic fact that the Negro is still not free. One hundred years later, the life of the Negro is still sadly crippled by the manacles of segregation and the chains of discrimination. One hundred years later, the Negro lives on a lonely island of poverty in the midst of a vast ocean of material prosperity. One hundred years later, the Negro is

1. Reprinted, by permission of Joan Daves, from Jane M. Hatch, ed., *The American Book of Days* (New York: H. W. Wilson, 1978), p. 11. Copyright by the Estate of Martin Luther King, Jr.

still languishing in the corners of American society and finds himself an exile in his own land. So we have come here today to dramatize an appalling condition.

In a sense we have come to our nation's Capitol to cash a check. When the architects of our republic wrote the magnificent words of the Constitution and the Declaration of Independence, they were signing a promissory note to which every American was to fall heir. This note was a promise that all men would be guaranteed the unalienable rights of life, liberty, and the pursuit of happiness.

It is obvious today that America has defaulted on this promissory note insofar as her citizens of color are concerned. Instead of honoring this sacred obligation, America has given the Negro people a bad check; a check which has come back marked "insufficient funds." But we refuse to believe that the bank of justice is bankrupt. We refuse to believe that there are insufficient funds in the great vaults of opportunity of this nation. So we have come to cash this check—a check that will give us upon demand the riches of freedom and the security of justice. We have also come to this hallowed spot to remind America of the fierce urgency of *now. . . . Now* is the time to rise from the dark and desolate valley of segregation to the sunlit path of racial justice. *Now* is the time to open the doors of opportunity to all of God's children. *Now* is the time to lift our nation from the quicksands of racial injustice to the solid rock of brotherhood. . . . 1963 is not an end, but a beginning. . . .

But . . . we must forever conduct our struggle on the high plane of dignity and discipline. We must not allow our creative protest to degenerate into physical violence. Again and again we must rise to the majestic heights of meeting physical force with soul force. . . . We cannot turn back. . . . I say to you today, my friends, that in spite of the difficulties and frustrations of the moment I still have a dream. It is a dream deeply rooted in the American dream.

I have a dream that one day this nation will rise up and live out the true meaning of its creed: "We hold these truths to be self evident; that all men are created equal."

I have a dream that one day on the red hills of Georgia the sons of former slaves and the sons of former slaveowners will be able to sit down together at the table of brotherhood.

I have a dream that one day even the state of Mississippi . . . will be transformed into an oasis of freedom and justice.

I have a dream that my four little children will one day live in a nation where they will not be judged by the color of their skin but by the content of their character.

I have a dream today.

I have a dream that one day the state of Alabama, whose governor's lips are presently dripping with the words of interposition and nullification, will be transformed into a situation where little black boys and black girls will be able to join hands with little white boys and white girls and walk together as sisters and brothers.

I have a dream today.

I have a dream that one day every valley shall be exalted, every hill and mountain shall be made low, the rough places will be made plains, and the crooked places will be made straight, and the glory of the Lord shall be revealed, and all flesh shall see it together.

This is our hope. . . . With this faith we will be able to hew out of the mountain of despair a stone of hope. With this faith we will be able to transform the jangling discords of our nation into a beautiful symphony of brotherhood. With this faith we will be able to work together, to pray together, to struggle together, to go to jail together, to stand up for freedom together, knowing that we will be free one day.

This will be the day when all of God's children will be able to sing with new meaning

My country 'tis of thee,
Sweet land of liberty,
 Of thee I sing:
Land where my fathers died,
Land of the Pilgrims' pride,
From every mountainside,
 Let freedom ring.

And if America is to be a great nation this must become true. So let freedom ring from the prodigious hilltops of New Hampshire. Let freedom ring from the mighty mountains of New York. Let freedom ring from the heightening Alleghenies of Pennsylvania!

Let freedom ring from the snowcapped Rockies of Colorado!

Let freedom ring from the curvaceous peaks of California!

But not only that; let freedom ring from Stone Mountain of Georgia!

Let freedom ring from Lookout Mountain of Tennessee!

Let freedom ring from every hill and molehill of Mississippi. From every mountainside, let freedom ring.

When we let freedom ring, when we let it ring from every village and every hamlet, from every state and every city, we will be able to speed up that day when all of God's children, black men and white men, Jews and Gentiles,

Protestants and Catholics, will be able to join hands and sing in the words of the old Negro spiritual, "Free at last! free at last! thank God almighty, we are free at last!"

14. Robert Indiana, *The Demuth Five*, 1963
Janson, p. 750, ill. 1054

Lyndon B. Johnson, News Conference: "This Is a Different Kind of War," July 28, 1965
J. William Fulbright, Speech: "We Are Fighting a Double Shadow in Indochina," April 2, 1970

In his State of the Union message in January 1965, Lyndon Baines Johnson (lived 1908–1973; president 1963–69) considered the international scene so good that he placed his main emphasis on domestic concerns. Johnson, a populist politician with considerable experience in Congress, hoped to use federal programs to eradicate poverty and to forge what he termed the "Great Society." But prospects for reform were quickly undermined by Johnson's fateful decision to commit the United States to war in Southeast Asia.

In 1954 an international conference convened in Geneva, Switzerland, to negotiate a settlement to the war in Vietnam that was being waged between the French and the Communist-dominated Viet Minh[1] forces. The agreement of the Viet Minh to the partitioning of Vietnam was based upon the promise that reunification elections would be held in 1956. When the anti-Communist regime in the south, under the leadership of Ngo Dinh Diem (1903–1963), blocked reunification elections, the Communist leader in Hanoi, Ho Chi Minh (1890–1969), gave the order for armed struggle.

In the autumn of 1961, President John F. Kennedy (lived 1917–1963; president 1961–1963) reluctantly agreed to send a large contingent of military advisers to South Vietnam. They did not turn the tide of insurgency, and on February 8, 1965, President Johnson ordered the bombing of North Vietnam to deter the movement of soldiers and supplies to the south. But the ground war continued, and Johnson felt forced to commit growing numbers of American troops to the fighting. In March 1965, two battalions of Marines, the first American combat units, landed in Vietnam. By the middle of 1968, the total of American forces had passed half a million, and at the end of the year, American casualties exceeded 30,000 dead and 100,000 wounded. During many weeks, American casualties were greater than those of the South Vietnamese.

The longest and the fourth largest war in United States history, the Vietnam War bitterly divided American society. In Congress, conservatives urged the president to

1. A coalition of Communist and nationalist groups that opposed the Japanese during World War II, the French colonial powers, and United States troops.

be even more bellicose, while "doves" favored a variety of options, including an end to the bombing and the withdrawal of troops. Among the doves, whose numbers steadily grew, was J. William Fulbright (born 1905), the highly respected chairman of the Senate Foreign Relations Committee.

Outside Congress, public opinion became increasingly hostile to continued United States involvement in Vietnam. In 1968 opposition to his war policy forced Lyndon Johnson to abandon his plans to seek reelection. In 1969 massive anti-war demonstrations shook Washington. When the war was expanded into Cambodia by President Richard M. Nixon (born 1913; president 1969–74), college and university campuses from coast to coast were embroiled in turmoil, and martial law was proclaimed in a number of states.

Two documents related to the Vietnam War are presented here. The first, "This Is a Different Kind of War," is an excerpt from President Johnson's news conference of July 28, 1965, during which Johnson defended his policy of United States involvement in Vietnam. The second document, "We Are Fighting a Double Shadow in Indochina," is an excerpt from J. William Fulbright's speech of April 2, 1970. In this speech, Fulbright asserted the need for peace in Vietnam.

The United States police and military forces appear to be the target of criticism from Robert Indiana (born 1928). Displayed below the sequence of numeral fives in *The Demuth Five* (1963) are the letters USA. In addition, four commands are inscribed on a pentagonal field. These commands, "Hog, Eat, Err, and Die," suggest the disillusionment felt by the artist in American society.

A peace agreement ending American involvement in Vietnam was signed on January 27, 1973. In 1976 North Vietnam and South Vietnam were formally reconstituted as one nation by the Communist government in Hanoi.

Lyndon B. Johnson, News Conference[2]
This Is a Different Kind of War

Why must young Americans, born into a land exultant with hope and with golden promise, toil and suffer and sometimes die in such a remote and distant place?

The answer, like the war itself, is not an easy one, but it echoes clearly from the painful lessons of half a century. Three times in my lifetime in two world wars and in Korea Americans have gone to far lands to fight for freedom. We have learned at a terrible and a brutal cost that retreat does not bring safety and weakness does not bring peace.

It is this lesson that has brought us to Viet-Nam. This is a different kind of war. There are no marching armies or solemn declarations. Some citizens

2. Reprinted from the *Weekly Compilation of Presidential Documents,* vol. 1, no. 1, August 2, 1965, p. 15. (Office of the Federal Register: Washington, D.C.)

of South Viet-Nam at times with understandable grievances have joined in the attack on their own government.

But we must not let this mask the central fact that this is really war. It is guided by North Viet-Nam and it is spurred by Communist China. Its goal is to conquer the South, to defeat American power, and to extend the Asiatic dominion of communism.

There are great stakes in the balance.

Most of the non-Communist nations of Asia cannot, by themselves and alone, resist the growing might and the grasping ambition of Asian communism.

Our power, therefore, is a very vital shield. If we are driven from the field in Viet-Nam, then no nation can ever again have the same confidence in American promise, or in American protection.

In each land the forces of independence would be considerably weakened and an Asia so threatened by Communist domination would certainly imperil the security of the United States itself.

We did not choose to be the guardians at the gate, but there is no one else.

J. William Fulbright, Speech[3]
We Are Fighting a Double Shadow in Indochina

How have we come to inflate so colossally the importance of Indochina to our own security? The answer lies in that hoariest, hardiest, most indestructible myth of them all: the myth of the international Communist conspiracy. . . .

The myth distorts our perceptions. It has made it difficult for us to see the Soviet Union for what it has become—a traditional, cautious, and rather unimaginative great power, jealously clinging to its sphere of domination in Eastern Europe but limited to methods of pressure and persuasion in its dealings with other Communist movements, especially in Asia. China has engendered a myth all its own: If there is not a world Communist conspiracy—so we are told—then there is surely an Asian one, and the unshakeable faith in it of some of our recent leaders has permitted them to brush aside the fact that China, after all, has kept its combat soldiers within its own borders.

The obsession with the ideological aspects of the struggle which began about 21 years ago has overwhelmed our common sense in this respect. The Chinese have been extremely cautious in engaging people abroad. The only

3. Reprinted from the *Congressional Record,* 91st Congress, 2d Session, pp. 10150–51, 10157.

case of any significance was when we went up to the border in Korea, and they had warned us that they would intervene. I expect that we would react the same way if the Chinese were to approach our borders from Mexico. It is a normal reaction. . . .

We are fighting a double shadow in Indochina—the shadow of the international Communist conspiracy and the shadow of the old, obsolete, mindless game of power politics. Armed with weapons that have given war a new dimension of horror, and adorned with the sham morality of ideological conflict, the struggle for power and influence has taken on a deadly, new intensity at exactly the time when it has lost much of the meaning it once had. All the old power politics bromides[4]—about "stability," "order," and "spheres of influence"—are largely without meaning to a global superpower armed with nuclear weapons. The world balance of power on which our security depends is a nuclear balance involving Russia, China, Western Europe, and the United States. The preservation of a non-Communist—as against a Communist—dictatorship in South Vietnam is not going to protect us, or anybody else, from Soviet or Chinese missiles. It simply does not matter very much for the United States, in cold, unadorned strategic terms, who rules the states of Indochina. . . .

We have one great liability and one great asset for negotiating a political settlement. The liability is our peculiar devotion to the Saigon dictators. Since they survive at our sufferance, the handicap could be removed by the simple expedient of putting Mr. Thieu and Mr. Ky on notice that they either join us in negotiating a compromise peace or make some arrangements of their own. Of all the options open to the Thieu government, the only one we can and should remove is their present veto on American policy.

I have always been puzzled—I might mention parenthetically—by our gratuitous tender-heartedness toward right-wing dictators who need us far more than we need them. It is one thing to tolerate such regimes, because it is not our business to be overthrowing foreign governments anyway. But in the case of such unsavory military dictatorships as those in Greece and South Vietnam, we have been much more than tolerant; we have aided and supported these regimes against their own internal enemies. I do not think this is done out of softheartedness—although our Embassy in Saigon has seemed extravagantly solicitous to Mr. Thieu, even to the extent that Ambassador Bunker has staunchly refused to intercede on behalf of Tran Ngoc Chau, the South Vietnamese deputy who was sentenced by a kangaroo court to 10 years at hard labor for maintaining contact with his brother, a North Vietnamese

4. Platitudes

agent—despite the fact that Chau reported these contacts to the CIA and the U.S. Embassy.

It takes more than Realpolitik to explain such gratuitous friendliness toward right-wing dictators. Here again I suspect that the explanation lies in that attitude of crusading anticommunism which has colored so much of American foreign policy over the years. The charm of the right-wing dictators has been their staunch anticommunism, and that appears to have been enough to compensate for such trivial defects as their despotism and corruption. I recall a member of the Senate, not so long ago, going so far as to defend the Greek colonels as democratic on the ground that they were resisting Communism.

This is not the hardheaded de factoism favored by the old school diplomats. It is ideological obsession on the part of old school cold warriors. I am not against tolerating these right-wing dictators any more than I am against tolerating Communist regimes. But our attitude over the last 25 years has not been one of toleration; it has been one of intolerance of Communist regimes giving rise to excessive friendliness toward right-wing regimes. The inspiration for such an outlook comes not from the practical Metternich but from John Calvin, or from the religious crusades.

To return to my theme: if devotion to Thieu and Ky are the obstacle to a compromise political settlement, the asset we have is our remaining force of over 400,000 men in Vietnam—and our freedom to take them out. The Communists want them out, and it is supremely in our interests to get them out. That would seem a promising basis for doing business. . . .

Our country very much needs a political settlement in Indochina. For reasons mostly traceable to the war things are already coming unstuck in America; young people are losing confidence in the country's institutions and resorting to dangerous and disorderly forms of protest. Encouraged by high officials, a nasty vigilantism against dissent has arisen in reaction on the right. . . . A disaster of great proportions to American foreign policy in Asia would induce a wave of recrimination at home, which in turn could set off a chain of events culminating in a disaster to American democracy. What a price to pay for the myth that Vietnam ever really mattered to the security of the United States.

15. Robert Smithson, *Spiral Jetty,* 1970

Gardner, p. 1089, ill. 23–76; Janson, p. 769, ill. 1083

Rachel Carson, *Silent Spring:* "Soil Exists in a State of Constant Change," 1962

It has been only in the past century that the public consciousness has been alerted to the importance of the conservation of the world's natural habitats, as well as to the preservation of the countless species of animal and plant life. The world's first national park, Yellowstone in Wyoming and adjacent parts of Montana and Idaho, was established in 1872. Through the highly visible and extremely vocal efforts of Theodore Roosevelt (lived 1856–1919; president 1901–9), land reclamation and conservation laws were passed. By the third quarter of the twentieth century, the conservation movement had grown dramatically in size and gathered in momentum. It now includes large organizations, such as the Sierra Club and the National Wildlife Federation, which often tackle global problems, and hosts of smaller societies, which are often devoted to studying specific types of birds or lichens or reptiles, or to acquiring land for as specialized a goal as the preservation of a single species. Operating on the local, regional, and national levels, environmental groups are capable of making a significant impact on United States opinion and of exerting strong pressure on the United States legislature.

Beyond the borders of the United States, the conservation movement has become an international effort.

The establishment of Yellowstone National Park set a global precedent for saving animals and plants by safeguarding the habitat itself. The United Nations List of National Parks and Equivalent Reserves currently includes 1,200 million acres in one hundred countries. These parks, plus countless other smaller protected areas, include game reserves, nature reserves, forest reserves, sites of special scientific interest, areas of outstanding natural beauty, and marine reserves. The parks vary in size from the vast ranges of the North-East Greenland National Park, which includes 275 million acres, to nature reserves of less than an acre. While many obstacles exist for full implementation, a strategy for saving wild plants, animals, and habitats for future generations is recognized as an important global priority.

The critical need for conservation was brought to popular attention in the 1950s and 1960s by Rachel Carson (1907–1964). A biologist and science writer, Carson was born in Springdale, Pennsylvania. Employed by the United States Bureau of Fisheries, Carson became known to the public for her books on pollution, wild life, and the sea. One of her most influential books was *Silent Spring* (1962), which identified pesticide pollution as an ever more ominous cause for the extinction of species. A selection from *Silent Spring*, "Soil Exists in a State of Constant Change," is presented here.

Awareness of the environment was the primary focus of the art of Robert Smithson (1938–1973). Using earth and rocks as his medium, Smithson designed projects that extended over many miles. *Spiral Jetty* (1970), jutting out into the Great Salt Lake in Utah, required the manipulation of vast quantities of natural materials. The result was a harmonious integration of sculpture and site, of human intervention in the landscape, and of natural forces of wind, water, and erosion.

Rachel Carson, *Silent Spring*[1]
Soil Exists in a State of Constant Change

The thin layer of soil that forms a patchy covering over the continents controls our own existence and that of every other animal of the land. Without soil, land plants as we know them could not grow, and without plants no animals could survive.

Yet if our agriculture-based life depends on the soil, it is equally true that soil depends on life, its very origins and the maintenance of its true nature being intimately related to living plants and animals. For soil is in part a creation of life, born of a marvelous interaction of life and nonlife long eons ago. The parent materials were gathered together as volcanoes poured them out in fiery streams, as waters running over the bare rocks of the continents wore away even the hardest granite, and as the chisels of frost and ice split and shattered the rocks. Then living things began to work their creative magic and little by little these inert materials became soil. Lichens, the rocks' first covering, aided the process of disintegration by their acid secretions and made a lodging place for other life. Mosses took hold in the little pockets of simple soil—soil formed by crumbling bits of lichen, by the husks of minute insect life, by the debris of a fauna beginning its emergence from the sea.

Life not only formed the soil, but other living things of incredible abundance and diversity now exist within it; if this were not so the soil would be a dead and sterile thing. By their presence and by their activities the myriad organisms of the soil make it capable of supporting the earth's green mantle. . . .

The soil exists in a state of constant change, taking part in cycles that have no beginning and no end. New materials are constantly being contributed as rocks disintegrate, as organic matter decays, and as nitrogen and other gases are brought down in rain from the skies. At the same time other materials are being taken away, borrowed for temporary use by living creatures. Subtle and vastly important chemical changes are constantly in progress, converting elements derived from air and water into forms suitable for use by plants. In all these changes living organisms are active agents.

There are few studies more fascinating, and at the same time more neglected, than those of the teeming populations that exist in the dark realms of the soil. We know too little of the threads that bind the soil organisms to each other and to their world, and to the world above.

1. Reprinted, by permission of the publisher, from Rachel Carson, *Silent Spring* (Boston: Houghton Mifflin, 1962), pp. 53–54. Copyright by the Estate of Rachel Carson.

Bibliography

I: Italian Renaissance Art of the Fifteenth Century

Baxendall, Michael. *Painting and Experience in Fifteenth Century Italy: A Primer in the History of Pictorial Style* (Oxford: Oxford University Press, 1988).

Baron, Hans. *The Crisis of the Early Renaissance,* 2 vols. (Princeton: Princeton University Press, 1966).

Beck, James. *Italian Renaissance Painting* (New York: Harper & Row, 1981).

Brucker, Gene. *Renaissance Florence* (Berkeley and Los Angeles: University of California Press, 1983).

Goldwaithe, Richard. *The Building of Renaissance Florence: An Economic and Social History* (New York and London: Penguin Books, 1980).

Gombrich, E. H. *Symbolic Images: Studies in the Art of the Renaissance* (New York: Phaidon, 1972).

Hale, J. R. *A Concise Encyclopedia of the Italian Renaissance* (New York: Oxford University Press, 1981).

Hale, J. R. *Florence and the Medici: The Pattern of Control* (London: Thames & Hudson, 1977).

Hartt, Frederick. *History of Italian Renaissance Art: Painting, Sculpture and Architecture* (New York: Harry N. Abrams, 1987).

Hughes, Norbert and Wolfgang Wölters. *The Art of Renaissance Venice, 1460–1590* (Chicago: University of Chicago Press, 1990).

Heydenreich, Ludwig H. and Wolfgang Lutz. *Architecture in Italy: 1400–1600* (New York: Penguin Books, 1974).

Phillips, William D. and Carla Rahn Phillips. *The Worlds of Christopher Columbus* (Cambridge, UK: Cambridge University Press, 1992).

Shearman, John. *Painting in Italy: 1400–1500* (New York: Penguin Books, 1984).

II: Sixteenth-Century Italian Art

Freedburg, S. J. *Painting in Italy: 1500–1600* (New York: Penguin Books, 1983).

Freedburg, S. J. *Paintings of the High Renaissance in Florence,* 2 vols. (Cambridge: Harvard University Press, 1961).

Hale, J. R. *A Concise Encyclopedia of the Italian Renaissance* (New York: Oxford University Press, 1981).

Hale, J. R. *Florence and the Medici: The Pattern of Control* (London: Thames & Hudson, 1977).

Hale, J. R. *Renaissance Europe: The Individual and Society, 1480–1520* (New York: Harper & Row, 1972).

Hartt, Frederick. *History of Italian Renaissance Art: Painting, Sculpture and Architecture* (New York: Harry N. Abrams, 1987).

Hughes, Norbert and Wolfgang Wölters. *The Art of Renaissance Venice, 1460–1590* (Chicago: University of Chicago Press, 1990).

Heyendreich, Ludwig H. and Wolfgang Lutz. *Architecture in Italy: 1400–1600* (New York: Penguin Books, 1974).

Murray, Linda. *The High Renaissance and Mannerism in Italy, the North and Spain* (New York: Oxford University Press, 1977).

Partner, Peter. *Renaissance Rome 1500–1559: A Portrait of a Society* (Berkeley and Los Angeles: University of California Press, 1976).

Pope-Hennessey, John. *Italian High Renaissance and Baroque Sculpture,* 3 vols. (London: Phaidon, 1963).

Shearman, John. *Mannerism* (London: Penguin Books, 1967).

III: Fifteenth-Century Northern European Art

Benesch, Otto. *The Art of the Renaissance in Northern Europe* (London: Phaidon, 1965).

Butler, Pierce. *The Origin of Printing in Europe* (Chicago: University of Chicago Press, 1940).

Cormans, Paul, ed. *Flanders in the Fifteenth Century: Art and Civilization* (Detroit: Detroit Institute of Art, 1960).

Friedländer, Max J. *From Van Eyck to Brueghel* (Ithaca: Cornell University Press, 1981).

Hind, Arthur. *History of Engraving and Etching* (New York: Dover, 1963).

Huizinga, Johan. *The Waning of the Middle Ages* (New York: Doubleday, 1954).

Meiss, Millard. *French Painting in the Time of Jean de Berry: The Limbourgs and Their Contemporaries,* 2 vols. (New York: Braziller, 1974).

Müller, Theodor. *Sculpture in the Netherlands, France, Germany and Spain: 1400–1500* (New York: Penguin Books, 1966).

Panofsky, Erwin. *Early Netherlandish Painting,* 2 vols. (Cambridge: Harvard University Press, 1953).

Snyder, James. *Northern Renaissance Art: Painting, Sculpture and the Graphic Arts from 1350 to 1575* (New York: Harry N. Abrams, 1987).

IV: Sixteenth-Century Northern European Art

Bakhtin, M. M. *Rabelais and His World,* tr. Hélène Iswolsky (Bloomington: Indiana University Press, 1984).

Benesch, Otto. *The Art of the Renaissance in Northern Europe* (London: Phaidon, 1965).

Christensen, C. *Art and the Reformation in Germany* (Ohio: Ohio University Press, 1979).

Dickens, A. G. and John Tonkin. *The Reformation in Historical Thought* (Cambridge: Harvard University Press, 1985).

Filipcak, Zirka Zaremba. *Picturing Art in Antwerp, 1550–1700* (Princeton: Princeton University Press, 1987).

Friedländer, Max J. *From Van Eyck to Brueghel* (Ithaca: Cornell University Press, 1981).

Gombrich, E. H. *Symbolic Images: Studies in the Art of the Renaissance* (New York: Phaidon, 1972).

Hall, Rupert A. *The Revolution in Science, 1500–1750* (New York: Longman, 1983).

Huizinga, Johan. *Erasmus and the Age of Reformation* (Princeton: Princeton University Press, 1957).

Murray, Linda. *The High Renaissance and Mannerism in Italy, the North and Spain* (New York: Oxford University Press, 1977).

Osten, Gert von der and Horst Vey. *Painting and Sculpture in Germany and the Netherlands 1500–1600* (London: Penguin Books, 1969).

Snyder, James. *Northern Renaissance Art: Painting, Sculpture and the Graphic Arts from 1350 to 1575* (New York: Harry N. Abrams, 1987).

V: Baroque Art in Italy, France and England

Blunt, Anthony. *Baroque and Rococo: Architecture and Decoration* (New York: Harper & Row, 1978).

Dickens, A. G., *The Counter Reformation* (New York: Harcourt, Brace and World, 1969).

Haskell, Francis, *Patrons and Painters: A Study in the Relations Between Italian Art and Society in the Age of the Baroque* (New Haven: Yale University Press, 1980).

Hatton, Ragnhild Marie. *Europe in the Age of Louis XIV* (London: Thames & Hudson, 1969).

Hibbard, Howard. *Caravaggio* (New York: Harper & Row, 1983).

Magnuson, Torgil. *Rome in the Age of Bernini.* Vols. I, II. (Stockholm: Almqvist and Wiksell International, 1982).

Martin, John Rupert. *Baroque* (New York: Harper & Row, 1977).

Olin, John C. *The Catholic Reformation: Savonarola to Ignatius Loyola* (New York: Harper & Row, 1969).

Rosenberg, Pierre. *France in the Golden Age* (New York: Metropolitan Museum of Art, 1982).

Souhthorn, Janet. *Power and Display in the Seventeenth Century* (Cambridge: Cambridge University Press, 1988).

Waterhouse, Ellis. *Painting in Britain, 1530–1790* (London: Penguin Books, 1978).

Wittkower, Rudolf. *Studies in Italian Baroque* (London: Thames & Hudson, 1975).

VI: Baroque Art in the Netherlands and Spain

Ackley, Clifford. *Printmaking in the Age of Rembrandt* (Boston: Museum of Fine Arts, 1981).

Bernt, Walter. *The Netherlandish Painters of the Seventeenth Century* (London: Phaidon, 1970).

Brown, Jonathan. *Images and Ideas in Seventeenth Spanish Painting* (Princeton: Princeton University Press, 1978).

Elliot, John Huxtable. *Spain and Its World, 1500–1700: Selected Essays* (New Haven: Yale University Press, 1989).

Filipcak, Zirka Zaremba. *Picturing Art in Antwerp, 1550–1700* (Princeton: Princeton University Press, 1987).

Haak, Bob. *The Golden Age: Dutch Painters of the Seventeenth Century,* tr. E Willems-Treeman (New York: Harry N. Abrams, 1984).

Held, Julius. *Rubens and His Circle* (Princeton: Princeton University Press, 1981).

Kahr, Madlyn M. *Dutch Painting in the Seventeenth Century,* 2nd edition (New York: Harper & Row, 1983).

Knipping, J. B. *Iconography of the Counter-Reformation in the Netherlands,* 2 vols. (Nieuwkoop and Leiden: B. de Graaf, 1974).

Gerson, H. and E. H. Ter Keule. *Art and Architecture in Belgium, 1600 to 1800* (London: Penguin Books, 1960).

Olin, John C. *The Catholic Reformation: Savonarola to Ignatius Loyola* (New York: Harper & Row, 1969).

Schama, Simon. *The Embarrassment of Riches: An Interpretation of Dutch Culture in the Golden Age* (Berkeley and Los Angeles: University of California Press, 1988).

VII: Eighteenth-Century Art

Boime, Albert. *Art in an Age of Revolution* (London and Chicago: University of Chicago Press, 1987).

Bosher, J. F. *The French Revolution* (New York: W. W. Norton & Co, 1988).

Crow, Thomas. *Painters and Public Life in Eighteenth-Century Paris* (New Haven: Yale University Press, 1985).

Gay, Peter. *The Enlightenment, an Interpretation: The Science of Freedom* (New York and London: Knopf, 1970).

Gerson, H. and E. H. Ter Keule. *Art and Architecture in Belgium, 1600 to 1800* (London: Penguin Books, 1960).

Hazard, P. *European Thought in the Eighteenth Century* (New Haven: Yale University Press, 1954).

Hampson, Norman. *The Enlightenment* (London: Penguin Books, 1976).

Hempel, Eberhard. *Baroque Art and Architecture in Central Europe* (New York: Penguin Books, 1965).

Jarrett, Derek. *England in the Age of Hogarth* (London: Viking Press, 1974).

Kalnein, Wend Graf. and Michael Levey. *Art and Architecture of Eighteenth-Century France* (London: Penguin Books, 1972).

Porter, Roy. *English Society in the Eighteenth Century* (London: Penguin Books, 1982).

Waterhouse, Ellis. *Painting in Britain, 1530–1790* (London: Penguin Books, 1978).

VIII: Nineteenth-Century Art

Frascina, Francis, et al. *Modernity and Modernism: French Painting in the Nineteenth Century* (New Haven: Yale University Press, 1993).

Friedländer, Walter. *From David to Delacroix* (New York: Schocken, 1968).

Gay, Peter. *The Bourgeois Experience: Victoria to Freud* (New York: Oxford University Press, 1984).

Herbert, Robert L. *Impressionism: Art, Leisure and Parisian Society* (New Haven: Yale University Press, 1988).

Hitchcock, Henry Russell. *Architecture: Nineteenth and Twentieth Centuries* (London: Penguin Books, 1971).

Honour, Hugh. *Neo-Classicism* (London: Penguin Books, 1977).

Honour, Hugh. *Romanticism* (New York: Harper & Row, 1979).

Houghton, Walter E. *The Victorian Frame of Mind, 1830–1870* (New Haven: Yale University Press, 1968).

Knight, David M. *The Age of Science: The Scientific World View in the Nineteenth Century* (Oxford: Blackwell Press, 1986).

Markowski, Gene. *The Art of Photography: Image and Illusion* (Englewood Cliffs, NJ: Prentice-Hall, 1984).

Nochlin, Linda. *Realism* (London: Penguin Books, 1971).

Rewald, John. *Post-Impressionism from Van Gogh to Gauguin* (New York: Museum of Modern Art, 1962).

Rheims, Maurice. *Nineteenth-Century Sculpture* (New York: Harry N. Abrams, 1977).

Rich, Norman. *The Age of Nationalism and Reform, 1850–1890* (New York: W. W. Norton and Co., 1977).

Rosenblum, Robert and H. W. Janson. *Nineteenth-Century Art* (New York: Harry N. Abrams, 1984).

Woodward, E. C. *The Age of Reform* (Oxford: Clarendon Press, 1962).

IX: Early Twentieth-Century Art

Curtis, William J. R. *Modern Architecture Since 1900* (Englewood Cliffs, NJ: Prentice-Hall, Inc., 1987).

Eberle, Matthias. *World War I and the Weimar Artists: Dix, Grosz, Beckmann, Schlemmer* (New Haven: Yale University Press, 1985).

Gay, Peter. *The Bourgeois Experience: Victoria to Freud* (New York: Oxford University Press, 1984).

Munro, Eleanor. *Originals: American Women Artists* (New York: Simon and Schuster, 1982).

Osborne, Harold, ed. *The Oxford Companion to Twentieth-Century Art* (Oxford: Oxford University Press, 1981).

Overy, Paul. *De Stijl* (London: Thames & Hudson, 1991).

Richter, Hans. *Dada: Art and Anti-Art* (Oxford: Oxford University Press, 1978).

Rosenblum, Robert. *Cubism and Twentieth-Century Art* (New York: Harry N. Abrams, 1976).

Russell, John. *The Meanings of Modern Art* (New York: The Museum of Modern Art/HarperCollins Publishers, 1981, 1991).

Shapiro, Theda. *Painters and Politics: The European Avant-Garde and Society, 1900–1925* (New York and Amsterdam: Greenwood Press, 1976).

Teed, Peter. *Dictionary of Twentieth-Century History* (Oxford University Press, 1992).

Teich, Mikulas and Roy Porter, eds. *Fin de Siècle and Its Legacy* (Cambridge: Harvard University Press, 1990).

Thomson, David. *World History from 1914 to 1968* (Oxford: Oxford University Press, 1969).

Vogt, Paul. *Expressionism: German Painting 1905–1920* (New York: Harry N. Abrams, 1980).

Whitford, Frank. *Bauhaus* (London: Thames & Hudson, 1984).

Winter, J. M. *The Experience of World War I* (New York: Oxford University Press, 1988).

X: Later Twentieth-Century Art

Ashton, Dore. *American Art Since 1945* (New York: Oxford University Press, 1982).

Calvocoressi, Peter. *Total War: The Causes and Courses of the Second World War* (London: Penguin Books, 1989).

Castleman, Riva. *Prints of the Twentieth Century* (London: Thames & Hudson, 1988).

Curtis, William J. R. *Modern Architecture Since 1900* (Englewood Cliffs, NJ: Prentice-Hall, 1987).

Lippard, Lucy R. *Pop Art* (London: Thames & Hudson, 1970).

Lovejoy, Margot. *Postmodern Currents: Art and Artists in the Age of Electronic Media* (Ann Arbor: UMI Research Press, 1989).

Lucie-Smith, Edward. *Movements in Art Since 1945* (London: Thames & Hudson, 1984).

Marrus, Michael. *The Holocaust in History* (Hanover, NH: University Press of New England for Brandeis University, 1987).

Nichols, C. S., ed. *A Political History of the Twentieth Century* (New York: Oxford University Press, 1990).

Osborne, Harold, ed. *The Oxford Companion to Twentieth-Century Art* (Oxford: Oxford University Press, 1981).

Russell, John. *The Meanings of Modern Art* (New York: The Museum of Modern Art/HarperCollins Publishers, 1981, 1991).

Teed, Peter. *Dictionary of Twentieth-Century History* (Oxford: Oxford University Press, 1992).

Thomson, David. *World History from 1914 to 1968* (Oxford: Oxford University Press, 1969).

Other

Ariès, Phillipe and Georges Duby, general editors. *A History of Private Life* (Cambridge: The Belknap Press of Harvard University Press, 1988–1991). Vol. II: *Revelations of the Medieval World;* Vol. III: *Passions of the Renaissance;* Vol. IV: *From the Fires of Revolution to the Great War;* Vol. V: *Riddles of Identity in Modern Times.*

Baigell, Matthew. *A Concise History of American Painting and Sculpture* (New York: Harper & Row, 1984).

Bogdanor, Vernon, ed. *The Blackwell Encyclopedia of Political Science* (Oxford: Blackwell Publishers, 1991).

Bronowski, J. and Bruce Malish. *The Western Intellectual Tradition from Leonardo to Hegel* (New York: Harper & Row, 1975).

Campbell, Lorne. *Renaissance Portrait Painting in the Fourteenth, Fifteenth and Sixteenth Centuries* (New Haven: Yale University Press, 1990).

Chadwick, Whitney. *Women, Art and Society* (London: Thames & Hudson, 1990).

Dunan, Marcel, ed. *Larousse Encyclopedia of Modern History from 1500 to the Present Day* (New York: Harper & Row, 1964).

Flew, Antony. *A Dictionary of Philosophy* (London: St. Martin's Press, 1984).

Fulbrook, Mary. *A Concise History of Germany* (Cambridge: Cambridge University Press, 1990).

Gowing, Sir Lawrence, ed. *A Biographical Dictionary of Artists. The Encyclopedia of Visual Arts* (Englewood Cliffs, NJ: Prentice-Hall, 1983).

Hampsher-Monk, Iain. *Modern Political Thought: Major Political Thinkers from Hobbes to Marx* (Oxford: Blackwell Publishers, 1992).

Kristeller, Paul Oscar. *Renaissance Thought and the Arts* (Princeton: Princeton University Press, 1990).

Roth, Leland M. *Understanding Architecture: Its Elements, History and Meaning* (New York: HarperCollins Publishers, 1993).

Simon, Robin. *The Portrait in Britain and America, with a Biographical Dictionary of Portrait Painters, 1680–1914* (Boston: G.K. Hall & Co., 1971).

Smelser, Marshall and Joan R. Gunderson. *American History at a Glance* (New York: Harper & Row, 1978).

Weber, Eugen. *A Modern History of Europe: Men, Cultures and Societies from the Renaissance to the Present* (New York: W. W. Norton & Co., 1971).

Index

SMALL CAPITALS indicate authors of readings in the text

Abbott, Gilbert, 271
Absolutism, Age of, 132–33
Abstract art, 317, 330, 373, 401
Act of Supremacy: "The Supreme Head of the
　Church of England" (British
　Parliament), 110, 112
Adventures of Telemachus (Fénelon), 187–88,
　188–90
Africa
　European colonization and crisis of identity,
　　289–90
　and Russian Revolution, 315
　slave trade, 233–35
African-Americans
　discrimination in 1960s, 405–6
　writers and artists, 400–401
The African Slave Trade and Its Remedy
　(Buxton), 234–36
Against the Rapacious and Murdering Peasants
　(Luther), 107, 108–9
Agrarian poor, 340
ALBERTI, LEON BATTISTA, 23–24
　On the Family
　　"Conditions of Marriage," 27–28
　　"*Virtù* Has Its Own Reward," 25–27
　Palazzo Rucellai, Florence, 24
Albizzi, Rinaldo degli, 12–13
Alcoholism, 263–64
Aldrin, Edwin E., 392
Alexander VI, Pope, 38, 53, 69
Alfonso XIII, King of Spain, 350
Ali Pasha, 240, 240n
Alienation, 366
All Quiet on the Western Front (Remarque),
　311, 312, 313–15
All Saints Eve (Halloween), 266
Altarpieces:
　Ghent, by Hubert and Jan van Eyck, 87, 88
　Isenheim, by Grünewald, 106–7

Madonna in a Rose Garden, by Lochner, 82
　Portinari, by Hugo van der Goes, 90, 91
Ambrogini, Angelo (Poliziano), 46–48
American Revolution, 210
Anabaptists, 162–63
Anarchism, 248, 304
Anatomical Observations (Leonardo da Vinci),
　44, 45–46
Anatomy, human, 45–46, 57–58, 59–61
Anesthesia, 271–72
Anne of Austria, Queen of France, 133
ANTHONY, SUSAN BROWNELL
　Trial Transcript: "This High-Handed
　　Outrage upon My Citizen's Rights,"
　　276–77, 279–81
Anti-Semitism, 347
*An Antiseptic Principle of the Practice of
　Surgery* (Lister), 271, 272, 274–75
Antiseptics, 271–75
Antwerp, 152–53
Aphrodite, 19n, 188
Apocalypse, 164, 164n
Apollo, 100–102, 254n
Architecture:
　Banqueting House at Whitehall, London, by
　　Jones, 139–40
　Chiswick House, by Boyle and Kent, 177,
　　178
　Crystal Palace, London, by Paxton, 228–29
　Die Wies, Bavaria, by Zimmermann, 185,
　　186
　Guaranty (Prudential) Building, Buffalo, by
　　Louis Sullivan, 281, 282
　Habitat, Montreal, by Safdie, 386
　Il Gesù, Rome, by della Porta and da
　　Vignola, 127
　Lake Shore Drive Apartment Houses,
　　Chicago, by Mies van der Rohe, 375,
　　376

Architecture *(cont.)*
 Louvre, East Facade, Paris, by Perrault, Le
 Vau, and Le Brun, 132, 133
 Monticello, Charlottesville, by Jefferson, 207
 Notre-Dame-du-Haut, Ronchamp, by Le
 Corbusier, 366–67
 Philadelphia Savings Fund Society Building,
 by Howe and Lescaze, 343
 Saint Paul's Cathedral, London, by Wren,
 144, 145
 Saint Peter's Basilica, Colonnade, Rome, by
 Bernini, 121, 122
 Saint Peter's Basilica, Rome, hemispherical
 dome by Michelangelo, 57–58
 Saint Peter's Basilica, Rome, original plan by
 Bramante, 49
 Seagram Building, New York, by Mies van
 der Rohe, 375, 376
 Secretariat Building, United Nations, New
 York, by Harrison et al., 368–69
 Strawberry Hill, Twickenham, by Walpole,
 216–17
 Vierzehnheiligen, Bavaria, by Neumann,
 185–86
ARETINO, PIETRO
 Dialogues, 70–73
ARIOSTO, LUDOVICO
 Orlando furioso, 65–68
Aristotle, 20, 157, 157*n*
Armstrong, Neil, 392
ARNAULD DE POMPONNE, SIMON NICOLAS
 The East India Company, 170–72
Arnold, Matthew, 386
Arouet, François-Marie. *See* Voltaire
Ars Versificandi et Carminum (Celtis), 100–102
Aryan concept, 347*n*, 347–49, 354
Ash Wednesday, 79, 79*n*
Ash Wednesday Supper (Bruno), 79
Asia
 and Jesuit missionaries, 127
 and Russian Revolution, 315
"Ask What You Can Do for Your Country,"
 from Kennedy's Inaugural Address, 390,
 391–92
"Aspiration," by Colonna, 62, 63
Assembly line, 302
Astronomy, 57–59, 121–24, 166–69
Atomic weapons, 358
 and dehumanization of individuals, 386
Augustine, Saint, 186
Augustinians, 88, 88*n*, 102
Auschwitz concentration camp, 354
Austria, 224
Austria-Hungary, 308–9
Automobiles, 302
 mobility, rootlessness, and Beat Generation,
 379–80
AYER, WASHINGTON
 The First Public Operation Under Anesthesia,
 271, 272, 273–74

Bacteria, 271
BALDWIN, JAMES
 Go Tell It on the Mountain, 399, 400–401,
 403–5
Ballet, classical, 260–62

Banquo (character in *Macbeth*), 140, 142–44
Baptism, of infants, 162–63
Barlach, Ernst
 War Monument, Gustrow Cathedral, 311, 312
"The Battle of Quebec" from *Journal* (Knox),
 204–6
BAUDELAIRE, CHARLES
 The Flowers of Evil, 253, 254–55
Bay of Pigs, 390
BAYEZID II, SULTAN
 The Unwashed Gyaours and Their Ways,
 69–70
Beat Generation, 379–80
Beckmann, Max
 Departure, 346, 347
BEECHER, CATHERINE
 Treatise on Domestic Economy: "Duties of
 Subordination," 276, 277–79
Beer Hall Putsch, Munich (1923), 346
Belgium, 223
 and World War I, 308, 311–12
Belzec concentration camp, 355–56
Benedict XIII, Pope, 82–83
Benz, Karl, 302
Bergen-Belsen concentration camp, 354
Berlin Wall, 390
BERNAY, BERTHE
 La Danse au théâtre, 260, 261–62
Bernini, Gianlorenzo
 The Ecstasy of Saint Theresa, 124, 125
 Saint Peter's Colonnade, Rome, 121, 122
Blackshirts, 323
BLAKE, WILLIAM
 Ancient of Days engraving, 219, 220
 Europe: A Prophecy: "Finite Revolutions,"
 221–22
 Songs of Innocence: "The Chimney
 Sweeper," 219, 220–21
The Blasphemy of John of Leiden (Simons),
 162, 163–65
Bloodletting, 270, 272
Bloom, Leopold and Molly (characters in
 Ulysses), 329–30
Boccioni, Umberto
 Unique Forms of Continuity in Space, 304,
 305
Bohemia, 83
BOIARDO, MATTEO MARIA, 28–29, 66
 Orlando innamorato, 29–31
"Bokanovskification," 386–89
Boleyn, Anne, 110, 140*n*
Bolsheviks, 316, 316*n*
Bonaparte, Joseph, 226
The Book of the Courtier (Castiglione), 54,
 55–56
Bordeaux, 182
Borgia, Cesare, 53, 53*n*
Bosch, Hieronymus
 The Garden of Earthly Delights, 97
BOSSUET, JACQUES-BÉNIGNE, 132–33, 178
 Politics Drawn from Holy Scripture, 133–34
Botticelli, Sandro
 The Birth of Venus, 33, 35
Bourgeoisie, 249, 251–53
Boyle, Richard
 Chiswick House, 177, 178

Bramante, Donato
 Saint Peter's Basilica, original plan, 48–49
Brancacci Chapel, Santa Maria del Carmine,
 Florence, 8–9
BRANT, SEBASTIAN, 97–98
 The Ship of Fools
 "Fool's Caps," 98–99
 "A Temporal Pleasure," 98
Brethren of the Common Life, 88, 90
Brittany, 266–69
Brouncker, W., 165
BRUNI, LEONARDO, 1, 2–4
 The Laudatio of the City of Florence, 2–4
BRUNO, GIORDANO, 78, 79
 The Expulsion of the Triumphant Beast,
 79–81
BURKE, EDMUND, 214–15
 *Philosophical Enquiry into the Origin of Our
 Ideas of the Sublime and Beautiful,*
 214–16
BUXTON, THOMAS FOLWELL, 233–34
 The African Slave Trade and Its Remedy,
 234–35
BYRON, GEORGE GORDON, 239–40
 "Song to the Suliotes," 240–41

Calculus, 145, 185
CALVIN, JOHN, 112, 113
 Institutes of the Christian Religion, 13–14
Cambodia, 410
CAMUS, ALBERT
 The Plague, 362, 363, 365
Canada, 204
Candide (Voltaire), 193–94, 194–97
Canons and Decrees of the Council of Trent, 74,
 75
Capitalism, 229, 249, 250, 320
Caravaggio, Michelangelo da
 The Calling of Saint Matthew, 129–30
 The Conversion of Saint Paul, 129, 130
Carmelite Order, 124, 124n
Carnegie, Andrew, 282
CARSON, RACHEL
 Silent Spring, 413, 414, 415
Cassatt, Mary
 The Bath, 276, 277
CASTIGLIONE, BALDASSARE
 Book of the Courtier, 54–56
The Castle of Otranto (Walpole), 216–17,
 217–19
Casualties
 in Hiroshima and atomic bomb, 358, 359–61
 in Vietnam War, 409
 in World War I, 312, 316
Catcher in the Rye (Salinger), 376–79
CATHERINE OF ARAGON, Queen of England, 140n
 Speech Protesting Marriage Dissolution, 110,
 111
Catholic Church, 150n
 and Anabaptists, 162–63
 Council of Constance (15th c.), 83–87
 Council of Trent (16th c.), 74, 76, 79
 Counter Reformation, 124
 doctrine of transubstantiation, 74–75
 "Four Fathers of . . . ," 5, 5n
 Francis I and, 112–13

Henry VIII and papal authority, 110
 and heresy, 83, 85–87
 and indulgences, 102–4
 Luther's *Ninety-Five Theses,* 102, 104–6
 Luther's stand on Peasants' Revolt, 106–7
 and Molière's comedies, 137
 Puritans' hatred of, 148–50
 temporal power expanded, 48–49, 51
 and Thomas à Kempis, 90–91
 See also Christ; Christianity; Inquisition;
 Jesuit Order
CATS, JACOB
 Moral Emblems, 154–57
Cattaneo, Simonetta, 34–35, 47
CELTIS, CONRAD
 Ars Versificandi et Carminum, 100–102
"The Cerebrum and Cerebellum," by Vesalius,
 57, 60–61
CERVANTES, MIGUEL DE
 Don Quixote, 173–76
Chamberlain, John
 Essex, 379, 380
Chardin, Jean-Baptiste-Siméon
 Back from the Market, 190
 Grace at Table, 190
Charlemagne, 223
CHARLES I, King of England
 "I Am the Martyr of the People," 148–49,
 151
Charles I, King of France, 117n
Charles II, King of England, 177
Charles IV, King of Spain, 225–26
Charles V, Holy Roman Emperor, 64
Charles VII, King of France, 63
Charles IX, King of France, 115
Charles X, King of France, 241–42, 243n
Chigi, Agostino, 47
Child labor, 228–33, 236
"The Chimney Sweeper," by Blake, 220–21
China, 320
Chiswick House (Boyle and Kent), 177, 178
Christ
 divine nature of, 163–65
 and the Eucharist, 74–75
 fighting with the sword for, 163–65
 and Fra Michele, 7–8
 imitation of, 87–92
 and Luther's doctrine, 103, 104
 and peasants' petitions, 107
Christianity
 and Anabaptist doctrine, 163–65
 Bruno on the concept of God, 79
 Calvin on, 112, 113–14
 and existentialism, 366
 Ficino and Neoplatonism, 34, 42
 and Nietzsche's "slave morality," 295
 in northern Europe (14th c.), 82, 87–88
 Orlando furioso and, 66
 spread into Africa, 289
 and witchcraft, 95–96
 See also Christ; God
The Chronicle of the Council of Constance
 (Richental)
 "How Hus Came to Constance and Was
 Burned," 82, 85–87
 "Unity of Holy Christendom," 82, 83–85

Church of England, 110, 112, 140n
Civil Rights Act of 1964, 396
Civil rights movement, 396, 400, 405–6
Clement VII, Pope, 110
Clouet, Jean
 Francis I, 112, 113
Colbert, Jean-Baptist, 136, 136n
Coligny, Admiral Gaspard de, 115
Collective unconscious concept, 326–27
Colleoni, Bartolomeo, 29, 71, 71n
COLONNA, VITTORIA
 "Aspiration" (sonnet), 61–63
Comintern (Communist International), 319–20
Commentary on Plato's Symposium on Love
 (Ficino), 33–34, 35–37
Comments Regarding the Liquidation of Kulaks
 (Kravchenko), 372, 373–74
Communism
 and Nazis, 354
The Communist Manifesto (Marx and Engels),
 248, 249, 251–53
Communist Party (Soviet Union)
 First Manifesto of the Third International,
 319–20
 and Stalin, 372
 and Trotsky, 316
The Compendium of Revelations (Savonarola),
 37, 38–40
COMTE, AUGUST, 244–45
 The Course of Positive Philosophy, 245–47
Condottieri (mercenary soldiers), 28–29
Confucius, 157, 157n
Conservation movement, 414–15
Constable, John
 The Haywain, 235, 236–37
 Stoke-by-Nayland, 235, 237
Constance, Council of (1414–18), 83–87
Constantinople, 68
Cook, James, 266
COPERNICUS, NICOLAUS, 121
 On the Revolution of the Heavenly Bodies,
 57–59
Corday, Charlotte, 211, 211n
Corpus hermeticum texts, 79
Correggio
 Jupiter and Io, 65–66
Cossa, Baldassare. See John XXIII.
Counter Reformation, 124, 129–30
The Courage to Be (Tillich), 366, 367–68
Courbet, Gustave
 Burial at Ornans, 248, 249–50
 The Stone Breakers, 248, 249–50
The Course of Positive Philosophy (Comte),
 244–45, 245–47
Cranmer, Thomas, 140, 140n
Cromwell, Oliver, 149
Crystal Palace, London (Paxton), 228–29
Cuba, 320
 missile crisis, 390
Cubism, 299
Cugnot, Nicholas, 302
Cunegund (character in Candide), 194–96

da Montefeltro, Guidobaldo, Duke of Urbino,
 54, 55

da Vignola, Giacomo
 Il Gesù, Rome, 127–28
DA VINCI, LEONARDO
 Anatomical Observations: "The Cause of a
 Death So Sweet," 44, 45–46
 Embryo in the Womb, 44
 The Last Supper, 42, 43
Dachau concentration camp, 354
Daimler, Gottlieb, 302
DANIEL, MRS. LIUBA
 Deposition on the Stutthof Concentration
 Camp, 354, 355, 356–57
D'ARGENSON, MARQUIS
 The Misery Within the Kingdom, 190–93
DARWIN, CHARLES
 Origin of Species, 281, 282–84
DATI, GREGORIO
 History of Florence, 5, 6–7
Daumier, Honoré
 The Third-Class Carriage, 244, 245
David (Hebrew king), 2, 163, 163n
David, Jacques-Louis
 The Death of Marat, 210, 211
de Chirico, Giorgio
 Mystery and Melancholy of a Street, 323, 324
 Sooth-Sayer's Recompense, 323, 324
DE SAUSSURE, CÉSAR
 Letters: "An Extraordinary Combat," 181,
 182, 183–84
Declaration of Independence (Jefferson), 207–10
Dedalus, Stephen (character in Ulysses),
 329–30
Degas, Edgar
 Ballet Rehearsal (Adagio), 260, 261
 Prima Ballerina, 260, 261
Dehumanization, 332, 383–84, 386
Delacroix, Eugène
 Greece on the Ruins of Missolonghi, 240
 Liberty Leading the People, 241, 242
 The Massacre of Chios, 239, 240
della Porta, Giacomo, 58
 Il Gesù, Rome, 127–28
Deposition on the Stutthof Concentration Camp
 (Daniel), 355, 356–57
DESCARTES, RENÉ, 157, 177
 Discourse on Method, 158–61
Despair, 286–87, 362–63, 366
d'Este, Ercole I, 29
Devotio Moderna (New Devotion), 87–88
di Cosimo, Piero. See Piero di Cosimo
Dialogue Concerning the Two Chief Systems of
 the World (Galileo), 122
Dialogues: "What Nanna Spied in the
 Convent" (Aretino), 70–73
Die Wies (Zimmermann), 185–86
Dinteville, Jean de, 110
Diogenes, 157, 157n
Discalced, or Barefooted, Carmelites, 124
Discourse on Method (Descartes), 157–58,
 158–61
Discourse on the Origin and Foundations of
 Inequality Among Men (Rousseau),
 197–198, 198–200
Divine right of kings concept, 133, 178
Don Quixote (Cervantes), 173, 174–76

Donatello
 David, 1–2
 Saint George, 14
The Dram-Shop (Zola), 262, 263, 264–65
Dublin, 329
Duchamp, Marcel
 Bride Stripped Bare by Her Bachelors, 301
 Nude Descending a Staircase, 301, 302
Dürer, Albrecht
 Adam and Eve, 100–101
 The Four Apostles, 102–3
Dutch. *See* Netherlands
Dynamics, laws of, 145

Eakins, Thomas
 The Gross Clinic, 270, 271
"The Ear of Obedience" (Neri), 130–31
East India Company, 170, 171–72
"The East India Company" Report (Arnauld
 de Pomponne), 170, 171–72
Easter, 92
Eastern Europe, 309
Edward VI, King of England, 140*n*
Église de Dôme (Hôtel des Invalides), Paris
 (Hardouin-Mansart), 136
EINSTEIN, ALBERT
 and atomic bomb, 358
 *Does the Inertia of a Body Depend upon Its
 Energy Content?,* 298–301
El Greco
 The Burial of Count Orgaz, 76
ELIOT, T. S.
 Prufrock, 336, 337–39
Elizabeth I, Queen of England, 139, 140*n*
ELLISON, RALPH
 Invisible Man, 399, 400–403
Empiricism, 177
ENGELS, FRIEDRICH, 248, 249
 Communist Manifesto, 251–53
England
 achievements of 16th and 17th centuries, 139
 beginnings of modern science, 144–45
 Charles I and civil war, 148–49
 child labor, 228–33, 236
 country estates (18th c.), 200–201
 defeat of French in Quebec, 204–6
 Henry VIII, and Church of England, 110,
 112, 140*n*
 and industrial revolution, 228–29
 Locke, and Age of Enlightenment, 177–78
 and papacy (15th c.), 82
 Puritans' hatred of Catholicism, 148–50
 slave trade and anti-slavery movement,
 233–34
 Stuart rulers of, 139, 148–49
 textile industry, 228–29
 urban life (18th c.), 182
 Wordsworth, and Romanticism, 236
 and world trade (17th c.), 170
 See also Great Britain; PARLIAMENT, BRITISH
Enlightenment, Age of, 177, 281, 295
 and Locke, 177–78
 scientific and technological advances, 197–98
 and Voltaire's satire, 193–94
Environmental movement, 414–15

Epidemics, 270
Equal Rights Amendment (ERA), 396
Equality, for women. *See* Women
ERASMUS, DESIDERIUS, 48, 49–51
 Julius Excluded from Heaven, 49–51
Ethics (Spinoza), 157–58, 161–62
Ethiopia, 289, 323
Eucharist, 74–75
Europe
 absolute rulers (17th c.), 132–33
 colonial empires, 289–90
 country estates (18th c.), 200
 dance halls and theaters (19th c.), 257–58
 disillusionment and isolation after world
 wars, 336–37
 divisions in Catholic Church, 82–83
 economic depression (early 20th c.), 339
 and Fascism (early 20th c.), 323
 Greek revolt against Turks, 239–40
 and Hitler, 296
 and humanitarianism, 236
 industrial and technological advances, 228
 and Jesuit missions, 127
 new ideas (18th c.), 177
 Protestant Reformation and, 74, 102–3
 revolutions of 1848, 244
 Russian Revolution and, 315
 and Saint Theresa, 125
 Spanish civil war and, 351
 trade routes, 68, 170
 wars in 19th c., 311
 and witchcraft (15th c.), 95
 World War I, 308–9, 311–12
 See also Eastern Europe; Italian city-states;
 names of countries; Northern Europe
Europe: A Prophecy (Blake), 220, 221–22
"Everyone Pays His Proper Share" (Giugni), 9,
 10
Evolution, theory of, 281–86
Existentialism and Humanism (Sartre), 362–63,
 363–65
The Expulsion of the Triumphant Beast (Bruno),
 78, 79, 80–81
"An Extraordinary Combat," from *Letters* (de
 Saussure), 182, 183–84

Factories
 English textile industry, 228–29
 social dislocation of workers, 245, 247–48
Factory Act of 1833, 229
Fair Deal, 343
Falange (Spanish Fascist Party), 350
Fascism, 296, 304, 323, 350
The Feminine Mystique (Friedan), 396–99
FÉNELON, FRANÇOIS DE SALIGNAC DE LA MOTHE,
 187–90
 Adventures of Telemachus, 188–90
Ferdinand VII, King of Spain, 225, 228
Ferrara, 29
FICINO, MARSILIO, 33–37, 42
 Commentary on Plato's Symposium on Love,
 34, 36–37
"Finite Revolutions," by Blake, 220, 221–22
First Manifesto of the Third International,
 319–20, 320–22

The First Public Operation Under Anesthesia
 (Ayer), 271, 272, 273–74
Florence
 banking practices, 9–11
 business and economy, 8–9
 Ghiberti's doors for Cathedral Baptistery,
 4–5
 Machiavelli and, 51
 Medici family, 12–13, 34, 38, 46–47
 rivalry with Milan, 1–2
 Savonarola and, 38–41
 taxation system, 9
A Florentine Diary from 1450 to 1516
 (Landucci), 37, 39–41
The Flowers of Evil (Baudelaire), 253, 254–55
FOCILE, PIETRO
 "I Went Out Full of Consolation," 130,
 131–32
For Whom the Bell Tolls (Hemingway),
 351–54
FORD, HENRY
 Letter to the Editor of *The Automobile,* 301,
 302, 303
 My Life and Work, 301, 302, 303–4
Fourteenth Amendment, 276
Fra Angelico
 Annunciation, 17, 18
Fragonard, Jean-Honoré
 The Bathers, 193
 The Swing, 193
France:
 and absolute rule, 133
 African colonies, 289
 Catholics vs. Huguenots, 115
 Charles I and war against, 148
 Comte on revolutions, 244–45
 defeated at Quebec, 204–6
 and first automobiles, 302
 German occupation and, 363
 hardships of 18th c. peasantry, 191–93
 invasions of Italy, 63, 65
 July Ordinances (1830), 241–42
 Louis XIV's governing style, 134–36
 Napoleon and, 223–27
 and papacy (15th c.), 82
 scientific advances, 144
 Spanish occupation and, 226–27
 Tahiti and, 266–67
 and Vietnam, 409
 World War I, 308–12
 World War II, 323, 363
 See also French Revolution; LOUIS XIV;
 Paris
"France Has Become the Object of a Brutal
 and Premeditated Aggression," message
 of President Poincaré (August 14, 1914),
 309, 310–11
Francis, Saint, 5
Francis I, King of France, 111
FRANCIS XAVIER, SAINT, 127
 "They Are the Best Race Yet Discovered,"
 128–29
 "To Hold Forth in the Streets," 129
Franciscans, 5, 38
Franco, Francisco, 323, 350

Frankenthaler, Helen
 Blue Causeway, 396, 397
Franz Ferdinand, Archduke of
 Austria-Hungary, 308
Fraticelli, 5
French and Indian Wars, 204
French Revolution, 211–12, 224, 228, 236
FRESNEL, AUGUSTIN-JEAN
 Memoir on the Diffraction of Light, 255–57
FREUD, SIGMUND, 326, 331
 On the Origin of Psychoanalysis, 292–95
FRIEDAN, BETTY
 The Feminine Mystique, 396–97, 397–99
The Friend of the People (Marat), 210–11
FROST, ROBERT
 "The Gift Outright," 389, 390–91
FULBRIGHT, J. WILLIAM
 "We Are Fighting a Double Shadow in
 Indochina," 409, 410, 411–13
Fuseli, John Henry
 Nightmare paintings, 214, 215
Futurism, 304

Gabo, Naum
 Column, 372, 373
Gainsborough, Thomas
 Mrs. Richard Brinsley Sheridan, 200
 Robert Andrews and His Wife, 200
GALILEI, GALILEO, 166, 168n, 392
 *Dialogue Concerning the Two Chief Systems
 of the World,* 122
 The Starry Messenger, 121–22, 122–24
Gascoigne, George, 152–54
 The Spoyle of Antwerpe, 153–54
Gauguin, Paul, 266–67
 Offerings of Gratitude, 265, 267
 Spirit of the Dead Watching, 265, 267
 The Vision After the Sermon, 265, 267
Gaulli, Giovanni Battista
 Triumph of the Name of Jesus, 127–28
Géricault, Théodore
 Mounted Officer of the Imperial Guard, 223,
 224
Germany
 African colonies, 289
 automobiles in, 302
 and existentialism, 362
 and Fascism, 323
 and Hitler, 346–47
 invasions of Italy (16th c.), 65–66
 Mussolini and, 323
 Mussolini on going to war with (1914),
 325–26
 Napoleon and, 223
 and papacy (15th c.), 82
 Peasants' Revolt and Luther's stance, 106–9
 Protestant rulers and papal authority, 110
 sack of Rome (1527), 64
 Spanish civil war, 351
 ties with Italy, 100–101
 World War I, 308–9, 311–12
 World War II, 358, 363
 See also Nazi Germany
GERSTEIN, KURT
 Report from Belzec, 354, 355–56

Ghiberti, Lorenzo
 Jacob and Esau (Isaac and His Sons) bronze
 doors for Cathedral Baptistery, 4–5
Giacometti, Alberto
 City Square, 362, 363
 The Palace at 4 A.M., 362, 363
Giangaleazzo Visconti, 1–2, 9
GIUGNI, DOMENICO
 Letter to Francesco Datino: "Everyone Pays
 His Proper Share," 9, 10
Gladiatorial combats, 182, 183–84
GLENN, JOHN H., JR.
 Pilot Flight Report: "When Lift-off
 Occurred," 392–93, 393–96
"Gloomy Sacredness Is That Indeed!"
 (Tahitian chant), 267, 269–70
Go Tell It on the Mountain (Baldwin), 400–401,
 403–5
God, 38, 76
 Bossuet on divine right of kings, 132–34
 Bruno's concept of, 79
 Calvin and predestination, 113–14
 Descartes on existence of, 158, 161
 and existentialist thinkers, 362
 Ficino on, 34
 Leibniz' theory on human reason and, 185,
 186–87
 Luther and indulgences, 102–5
 Manetti on human dignity and, 31–33
 Neoplatonic concept of, 21–23, 34–36
 Pico on dignity of man and, 42–44
 Saint Theresa and, 124, 125–26
 Thomas à Kempis and, 90–92
 Tillich and "the God beyond God," 366
Goddard, Robert, 392
Gonzaga, Federico, 54
Gorky, Arshile
 The Liver Is the Cock's Comb, 354, 355
Gothic novels, 216–17
Goujon, Jean
 Nymphs, 117, 118
Goya y Lucientes, Francisco José de
 The Third of May, 225, 226–27
Grapes of Wrath (Steinbeck), 340–42
Gravity, forces of, 145–48
Great Britain
 African colonies, 289
 Bill of Rights, 369
 intellectuals after world wars, 336–37
 and Napoleon, 224
 population, 228
 World War I, 308–9, 311–12
 See also England
Great Schism, 82–83
Great Society, 343, 409
Greco-Roman civilization
 concept of the sublime, 214
 and Italian Renaissance, 1, 20, 31, 64, 88
 Jefferson's admiration for, 206–7
 mythology and, 329
Greece
 fight for independence, 239–40
Gregory XII, Pope, 83
Gregory XIII, Pope, 130
Gregory XV, Pope, 125, 127

Greuze, Jean-Baptiste
 The Return of the Prodigal Son, 198
 The Son Punished, 197, 198
 The Village Bride, 197, 198
GROOTE, GEERT, 87–88
 On Patience and the Imitation of Christ,
 89–90
 Resolutions and Intentions, 88–89
Gross, Samuel, 271–72
Grünewald, Matthias
 Crucifixion from Isenheim Altarpiece, 106–7
Guillotine, 210
Gypsies, 354

Hals, Frans
 Malle Babbe, 154, 155
Hardouin-Mansart, Jules
 Église de Dôme (Hôtel des Invalides), Paris,
 136
 Versailles Palace, 134–35
Harrison, Wallace K.
 Secretariat Building, United Nations, New
 York, 368, 369
Heliocentric universe, 121–22
HEMINGWAY, ERNEST
 For Whom the Bell Tolls, 350, 351–54
Henrietta Maria of France, Queen of England,
 148
Henry, Duke of Orléans, 111
Henry, Teuira, 267
Henry III, King of France, 115
Henry IV (Henry of Navarre), King of France,
 115, 116n
Henry VIII, King of England, 110–11, 140,
 140n
Henry VIII (Shakespeare), 139, 140–42
Hercules, 47, 47n
Hiroshima, 358
The Histories of Gargantua and Pantagruel
 (Rabelais), 117–20
The History of the Russian Revolution
 (Trotsky), 316–18
HITLER, ADOLF, 296
 Mein Kampf, 346, 347–50
Ho Chi Minh, 409
Hogarth, William
 Breakfast Scene from *Marriage à la Mode,*
 181, 182
 The Orgy, Scene III of *The Rake's Progress,*
 182
Holbein the Younger, Hans
 The French Ambassadors, 110–11
Holland. *See* Netherlands
Holocaust, 354–57
Homer, 329, 329n
Hoover, Herbert, 342
Hopper, Edward
 Early Sunday Morning, 336, 337
Hôtel des Invalides (Hardouin-Mansart), 136
Howe, George
 Philadelphia Savings Fund Society Building,
 342, 343
HUGO, VICTOR
 "Written After July 30, 1830," 241–44
Huguenots, 115

Human nature
 D. H. Lawrence on, 331–32
 Poliziano on, 47
 Rousseau on, 197–200
 Strindberg on, 286–87
Humanism, 28, 37–38, 95, 100
 and existentialism, 362–63
Humanitarianism, 236, 323
Hungary, 319
Hus, John, 83, 85–87
HUXLEY, ALDOUS
 Brave New World, 386–89
Huxley, Thomas Henry, 386
HUYGENS, CHRISTIAAN, 165, 166, 392
 light as wave phenomenon, 255
 Systema Saturnium, 167–69

"I Am the Martyr of the People" from Last
 Words of Charles I, 149, 151
"I Have a Dream" (King), 406–9
"I think, therefore I am" (Descartes), 158, 160
"I Was King and Born to Be One" from
 Letters of Louis XIV, 135–36
Idomeneus (character in Adventures of
 Telemachus), 188–90
IGNATIUS LOYOLA, SAINT, 127
 Spiritual Exercises, 76–78
The Imitation of Christ (Thomas à Kempis),
 90–92
India, 170
Indiana, Robert
 The Demuth Five, 409, 410
Individualism
 and dehumanization, 383–84, 386
 Rabelais and, 117–18
 Renaissance intellectuals and, 42–44
 vs. conformity and standardization, 375–76
Indochina, 409–13
Indulgences, 102, 103–4
Industrial revolution, 228–29, 233
Innocent III, Pope, 31–32
Inquisition
 and Fraticelli, 5, 7–8
 and Galileo, 122
 and heresy, 78–79
 and Vittoria Colonna, 62
Institutes of the Christian Religion (Calvin),
 112, 113–14
Intellectuals
 after world wars, 336–37
 and Inquisition, 79
 in Netherlands (17th c.), 158–59
 of Renaissance, and individuality, 42–44
International Advisory Committee of
 Architects
 Secretariat Building, UN, 368, 369
Invisible Man (Ellison), 400–403
Ireland, 309
Islam, 290
Italian city-states, 1–2, 28, 63, 100
 French and German invasions of, 64–65
 Venice and wars with Turks, 68–69
 See also Florence; names of cities
Italy
 African colonies, 289

aid to Fascists in Spanish civil war, 351
 and classical ballet, 260
 economic and political ties to Germany,
 100
 and Fascism, 296, 304, 323
 and Futurism, 304
 and the Inquisition, 78–79
 Napoleon and, 223
 World War I, 323
 World War II, 323, 358
 See also Italian city-states

James I, King of England, 139, 141n, 148
Japan
 atomic bomb dropped on Hiroshima, 358,
 359–61
 Francis Xavier's letters from, 127–29
JEFFERSON, THOMAS
 Declaration of Independence, 206–7, 207–10
 Monticello, Charlottesville, 206, 207
Jehovah's Witnesses, 354
Jerome of Prague, 85, 85n
Jesuit Order, 76, 127
Jews, 354
John III, King of Portugal, 127
John XXIII (Baldassare Cossa; antipope),
 Pope, 82–83
John of Leiden, 163–65
John the Baptist, Saint, 5
Johns, Jasper
 Target with Four Faces, 405, 406
 Three Flags, 406, 495
JOHNSON, LYNDON B., 343, 400, 405
 News conference: "This Is a Different Kind
 of War," 409, 410–11
 Vietnam War and, 409–10
JOHNSON, SAMUEL
 Rambler, 200–201, 201–3
Jones, Inigo
 Banqueting House at Whitehall, London,
 139–40
Journal (Knox), 203–6
Journal and Memoirs (Marquis d'Argenson),
 190–93
Jousting tournaments, 15
JOYCE, JAMES
 Ulysses: "yes I said yes I will Yes," 329–30,
 330–31
Juan Carlos, King of Spain, 350n
Julius Excluded from Heaven: A Dialogue
 (Erasmus), 49–51
Julius II, Pope, 48–49
JUNG, CARL, 331
 Psychology of the Unconscious, 326, 327–29
Juno, 119, 119n
Jupiter, 66

KAFKA, FRANZ
 The Metamorphosis, 334–36
Kandinsky, Wassily, 320
KENNEDY, JOHN F., 343, 405
 Inaugural Address, 389–90, 391–92
 military advisers sent to Vietnam, 409
 nuclear test ban negotiations, 390
Kenneth Macalpine, King of Scotland, 139

Kent, William
 Chiswick House, 177, 178
Kepler, Johannes, 392
KEROUAC, JACK
 On the Road, 379, 380–83
KESEY, KEN
 One Flew Over the Cuckoo's Nest, 383–85
Kienholz, Edward
 The State Hospital, 383, 384
 The Wait, 383, 384
KING, MARTIN LUTHER, JR., 405–6
 "I Have a Dream" speech, August 28, 1963,
 406–9
Kirchner, Ernst
 Street, Berlin, 308, 309
Klee, Paul
 Twittering Machine, 326, 327
Klimt, Gustav
 Death and Life, 292
 The Kiss, 292
KNOX, JOHN
 "Battle of Quebec" from Journal, 203–4,
 204–6
Kokoschka, Oskar
 Self-Portrait, 308, 309
KRAMER, HEINRICH
 The Witches' Hammer, 95–96
KRAVCHENKO, VICTOR
 Comments Regarding the Liquidation of
 Kulaks, 372, 373–74
Kulaks, 373–74

La Danse au théâtre (Bernay), 260, 261–62
LANDUCCI, LUCA
 A Florentine Diary from 1450–1516, 37, 39,
 40–41
Lange, Dorothea
 Migrant Mother, California (photograph),
 339, 340
Last Words (Charles I), 148, 151
Latin America, 127, 315
The Laudatio of the City of Florence (Bruni),
 2–4
LAWRENCE, D. H.
 Women in Love, 331, 332–34
Le Brun, Charles
 Louvre, East Facade, Paris, 132, 133
Le Corbusier
 Notre-Dame-du-Haut, Ronchamp, France,
 366–67
Le Tellier, François-Michel, 136, 136n
Le Vau, Louis
 Louvre, East Facade, Paris, 132, 133
 Versailles Palace, 134–35
LEEUWENHOEK, ANTON VAN, 165–66
 This Vast Number of Animalcules,
 166–67
LEIBNIZ, GOTTFRIED WILHELM
 Theodicy, 185–87, 194
Leiden, John of, 163–65
LENIN, VLADIMIR, 319, 372
 "The Workmen's and Peasants' Revolution,"
 315–16, 318–19
Leo X, Pope, 51–52, 55
LEONARDO DA VINCI. See DA VINCI, LEONARDO

Lescaze, William E.
 Philadelphia Savings Fund Society Building,
 342, 343
Let's Murder the Moonshine (Marinetti), 304,
 305–8
Letter of a Florentine Citizen, 5, 7–8
Letters:
 Arris's "The Wretched, Miserable, and
 Ill-Fated City of Rome," 64–65
 "Christ Possessed Nothing" from Letter of a
 Florentine Citizen, 7–8
 de Saussure's "An Extraordinary Combat,"
 182, 183–84
 Ford's "One of the Absolute Necessities of
 Our Later Day Civilization," 301, 302,
 303
 Giugni's "Everyone Pays His Proper Share,"
 10
 Leeuwenhoek's "This Vast Number of
 Animalcules," 166–67
 Louis XIV's "I Was King and Born to Be
 One," 135–36
 Philip Neri's "The Ear of Obedience," 129,
 130–31
 Saint Francis Xavier's, from Japan, 127
Liberia, 289
Life (Saint Theresa of Avila), 124, 125–26
Life-expectancy (end of 18th c.), 270
Light, theories of, 255–56
Lindbergh, Charles, 392
Lines Composed a Few Miles Above Tintern
 Abbey . . . (Wordsworth), 236, 237–39
The Link (Strindberg), 286–88
Lionne, Hugh de, 136, 136n
LISTER, JOSEPH
 An Antiseptic Principle of the Practice of
 Surgery, 271, 272, 274–75
Literature:
 All Quiet on the Western Front, by
 Remarque, 312–15
 Castle of Otranto, by Walpole, 217–19
 The Catcher in the Rye, by Salinger, 376–79
 Don Quixote, by Cervantes, 173–76
 For Whom the Bell Tolls, by Hemingway,
 351–54
 Go Tell It on the Mountain, by Baldwin,
 400–401, 403–5
 Grapes of Wrath, by Steinbeck, 340–42
 The Histories of Gargantua and Pantagruel,
 by Rabelais, 117–18
 Invisible Man, by Ellison, 400–403
 Johnson's essays in Rambler, 201
 The Metamorphosis, by Kafka, 335–36
 On the Road, by Kerouac (Beat Generation),
 380–83
 One Day in the Life of Ivan Denisovich, by
 Solzhenitsyn, 372–73, 374–75
 One Flew Over the Cuckoo's Nest, by Kesey,
 384–85
 Orlando furioso, by Ariosto, 66–68
 Orlando innamorato, by Boiardo, 30–31
 The Plague, by Camus, 363
 poetry and prose of Victor Hugo, 241–42
 Symbolists, and Baudelaire, 253
 Ulysses, by Joyce, 329–30

432 INDEX

Literature *(cont.)*
 Voltaire's *Candide,* 194–95
 Women in Love, by Lawrence, 332–34
Lochner, Stephan
 Madonna in a Rose Garden (altarpiece),
 82
LOCKE, JOHN, 185, 206
 An Essay Concerning Human Understanding,
 177, 178–80
 Two Treatises of Civil Government, 177,
 180–81
Louis, Duke of Burgundy, 187
Louis XII, King of France, 63
Louis XIII, King of France, 133
LOUIS XIV, King of France, 133–34, 187
 "I Was King, and Born to Be One," 135–36
 and Molière's comedies, 136–37
Louis XV, King of France, 191
Louis XVI, King of France, 241
Louvre, East Facade, Paris (Perrault, Le Vau,
 Le Brun), 132, 133
Love, 47–48, 70
The Lovelorn Doctor (Molière), 137
Lower class. *See* Working classes
LOYOLA, IGNATIUS. *See* IGNATIUS LOYOLA, SAINT
Lucifer, 92–93
LUTHER, MARTIN, 74, 102–3, 106–7, 110, 113
 *Against the Rapacious and Murdering
 Peasants,* 108–9
 Ninety-Five Theses, 104–5

Macbeth (Shakespeare), 139, 142–44
MACHIAVELLI, NICCOLO
 The Prince, 51–54
Malevich, Kasimir, 320
 Black Quadrilateral, 315, 317
 Suprematist Composition: White on White,
 315, 317
Manet, Edouard
 Déjeuner sur l'herbe, 253, 254
MANETTI, GIANNOZZO
 On the Dignity of Man, 31, 32, 33
Manhattan Project, 358
MARAT, JEAN-PAUL
 The Friends of the People, 210–11
Margarita, Princess of Spain, 173
Maria Vittoria, Letter to (Philip Neri), 130–31
MARINETTI, FILIPPO TOMMASO, 304–5
 Let's Murder the Moonshine, 305–8
Marriage
 selection of wife, 26–28
 and wife's subordination to husband, 276
Martin V, Pope, 62, 83
MARX, KARL, 248, 249, 319
 Communist Manifesto, 249, 251–53
 and Russian Revolution, 315
Marxism, 249
Mary I, Queen of England, 140*n*
Masaccio, 332
 The Tribute Money mural, 8–9
Masques, 139–40
Mathematical Principles of Natural Philosophy
 (Newton), 144, 145–48
Mathematics
 Newton's laws of dynamics and gravitation,
 145

philosophy of Descartes and Spinoza, 158,
 159
Renaissance artists and, 20–23
Medici, Catherine de', 111, 115
MEDICI, COSIMO DE', 12–13, 34, 79
 Oration to the Signory, 13–14
Medici, Giuliano de', 47
MEDICI, LORENZO DE', 33–35, 38, 42, 51
 "O, Lucid Star," 37
Medici, Piero de', 38
Medicine, 44–45, 270–75
Mein Kampf (Hitler), 347–50
Memoir on the Diffraction of Light (Fresnel),
 255–57
Memoirs (Duke of Sully), 115, 116–17
Memoirs (Napoleon), 223–25
Memoirs (Simpson), 270, 271, 272–73
Mental illness
 Freud's ego and superego, 292–93
 Jung's collective unconscious, 326
 Kesey on dehumanization of patients, 383–84
Mentor (character in *Adventures of
 Telemachus*), 188–90
The Metamorphosis (Kafka), 335–36
MICHELANGELO, 332
 The Last Judgment, Sistine Chapel, 61, 62
 Saint Peter's Dome, Rome, 57–58
 "Tell Me, O Soul" (sonnet), 61, 63
MICHELET, JULES, 244, 245
 The People: "Factory Workers," 247–48
Michelozzo di Bartolommeo
 Palazzo Medici, Florence, 13
Microscopes, improvements in, 166
Middle class
 Beat Generation in 1950s, 379–80
 Europe in 18th c., 182
 Marx on exploitation of working class, 249
 Nietzsche on, 295
 standardization and conformity, 383
 suburbs in 1950s, 375–76, 383
Mies van der Rohe, Ludwig
 Lake Shore Drive Apartment Houses,
 Chicago, 375, 376
 Seagram Building, New York, 375, 376
Milan, 1–2, 29
Milton, John, 202, 202*n*
Miró, Joan
 Composition, 329, 330
 Painting, 329, 330
The Misery Within the Kingdom (Marquis
 d'Argenson), 190, 191–93
Missolonghi, 240
"Mnkabayi, Daughter of Jama" (Zulu poem),
 289, 290, 292
Model T ("Tin Lizzie"), 302
MOLIÈRE
 Tartuffe, 137–38
Monadology, 185
Monarchy
 and divine right of kings, 133, 178
 Locke on responsibilities of, 178
 Louis XIV's governing style, 135–36
 and Machiavelli's *Prince,* 52–54
Monet, Claude
 The River, 255, 256
 Rouen Cathedral, 255, 256

Montcalm, Marquis de, 204
Monticello, Charlottesville, Virginia (Jefferson), 206, 207
Moon landing, 392–93
Moore, Henry
 Reclining Figure, 331, 332
 Recumbent Figure, 331, 332
Moral Emblems (Cats), 154, 155–57
Morality, 214, 295
 Robespierre on, 211–13
Mortal sin, 104, 104n
Morton, William, 271
Munch, Edvard
 The Scream, 286, 287
Münserite sect, 163
Münzer, Thomas, 106
Murals:
 The Proving of the True Cross, by Piero della Francesca, 20, 21
 The Tribute Money, by Masaccio, 8, 9
MUSSOLINI, BENITO
 "It Is Blood Which Moves the Wheels of History," 323–24, 324–26
Mutualism, 248
My Life and Work (Ford), 301, 302, 303–4

Nanna (character in Aretino's *Dialogues*), 70–73
Nantes, Edict of, 115
NAPOLEON, 211, 223–24, 225n
 Memoirs: "Save the General," 224–25
 and Spanish uprising, 225–26
National Organization for Women (NOW), 396–97
National Wildlife Federation, 414
Natural selection, 281–83
Naturalism, 253
Nature, 200–201, 236–37
Nazi Germany, 296, 335, 346–47
 and French Resistance, 363
 and Klee's art, 327
 persecution of Einstein, 299
 "subhumans," concentration camps, and Holocaust, 354–57
 and Tillich, 366
Neoplatonism, 21–23, 34–36, 42
NERI, PHILIP, 129–30, 132
 Letter to Maria Vittoria, 130–31
Netherlands, 87–88, 90
 Anabaptists in, 162–63
 flourishing of philosophy, 157
 intellectual activity and commercial power, 154, 170
 Protestants vs. Spanish domination, 152–53
 scientific discoveries, 165–69
 world trade and East India Company, 170–71
Neumann, Balthasar
 Vierzehnheiligen, Bavaria, 185–86
Nevsky, Alexander, 317n
New Deal, 342–43
New Frontier, 343, 389–90
Newman, Barnett
 Broken Obelisk, 389, 390
NEWTON, ISAAC, 144–45, 185
 Mathematical Principles of Natural Philosophy, 145–48
 theory of light, 255–56

Ngo Dinh Diem, 409
NICHOLAS OF CUSA, 20–21
 On Learned Ignorance, 21–23
Nicholas V, Pope, 48
Nicholas II, Czar of Russia, 316
NIETZSCHE, FRIEDRICH, 304, 323–24, 366
 Thus Spake Zarathustra, 295, 296n, 296–98
Ninety-Five Theses (Luther), 102–3, 104–5
Nixon, Richard M., 410
Nolde, Emile
 The Last Supper, 295, 296
North Africa, 309
Northern Europe
 humanism and Italian Renaissance, 100–101
 independent character and religion of, 88
 and satire, 97–99
Notes on Paris (Taine), 257, 258–60

Ode to Spain—After the Revolution of March (Quintana), 226–28
On Learned Ignorance (Nicholas of Cusa), 21–23
On Patience and the Imitation of Christ (Groote), 87–88, 89–90
On the Dignity of Man (Manetti), 31–32, 32, 33
On the Family (Alberti), 24, 25–26, 25–28
On the Misery of Human Life (Innocent III), 32
On the Origin of Psychoanalysis (Freud), 292, 293–95
On the Revolutions of Heavenly Bodies (Copernicus), 57, 58–59
On the Road (Kerouac), 379, 380–83
One Day in the Life of Ivan Denisovich (Solzhenitsyn), 372–73, 374–75
One Flew Over the Cuckoo's Nest (Kesey), 384–85
"The Only Thing We Have to Fear Is Fear Itself" from Roosevelt's First Inaugural, 343–46
Optimism (18th c.), 185–86, 187–88
 Nietzsche's challenge to, 295
 and present happiness, 190
Or San Michele, Florence, 15
Oration on the Dignity of Man (Pico della Mirandola), 42–44
Oration to the Signory (Cosimo de' Medici), 13–14
Oratorians, 130
Origin of Species (Darwin), 281, 282–84
Orlando furioso (Ariosto), 65, 66–68
Orlando innamorato (Boiardo), 29, 30–31, 66
Orsmond, J. M., 267
Ottoman Turks, 239–40
Ovid, 150, 150n

Pacher, Michael
 Coronation of the Virgin, 92, 93
 Saint Wolfgang Forces the Devil to Hold His Prayerbook, 92, 93
Paintings:
 Adam and Eve, by Dürer, 100–101
 Ambroise Vollard, by Picasso, 298, 299
 Annunciation, by Fra Angelico, 17, 18
 Autumnal Rhythm: Number 30, by Pollock, 358
 Bacchanal, by Titian, 70, 71

Paintings *(cont.)*
Back from the Market, by Chardin, 190
Baldassare Castiglione, by Raphael, 54–55
Ballet Rehearsal (Adagio), by Degas, 260, 261
The Bath, by Cassatt, 276, 277
The Bathers, by Fragonard, 193
Batman, by Williams, 399, 401
The Birth of Venus, by Botticelli, 33, 34
Black Quadrilateral, by Malevich, 315, 317
Blue Causeway, by Frankenthaler, 396, 397
Breakfast Scene from *Marriage à la Mode,* by Hogarth, 182
Bride Stripped Bare by Her Bachelors, by Duchamp, 301
Burial at Ornans, by Courbet, 248, 249–50
The Burial of Count Orgaz, by El Greco, 76
The Calling of Saint Matthew, by Caravaggio, 129, 130
Charles I Dismounted, by Van Dyck, 148, 149
Christ in the House of Levi, by Veronese, 78, 79
Composition, by Miró
The Conversion of Saint Paul, by Caravaggio, 129, 130
Crucifixion, by Grünewald, 106–7
Death and Life, by Klimt, 292, 293
The Death of General Wolfe, by West, 203, 204
The Death of Marat, by David, 210, 211
Déjeuner sur l'herbe, by Manet, 253, 254
The Demuth Five, by Indiana, 409, 410
Departure, by Beckmann, 346, 347
The Discovery of Honey, by Piero di Cosimo, 37–38
Early Sunday Morning, by Hopper, 335, 336
The Elevation of the Cross, by Rubens, 152, 153
Embryo in the Womb (sketch), by Leonardo da Vinci, 44, 45
Escorial *Deposition (Descent from the Cross),* by van der Weyden, 87, 88
The Four Apostles, by Dürer, 102–3
Francis I, by Clouet, 112, 113
The French Ambassadors, by Holbein the Younger, 110
The Garden of Earthly Delights, by Bosch, 97
Grace at Table, by Chardin, 190
Greece on the Ruins of Missolonghi, by Delacroix, 240
The Gross Clinic, by Eakins, 270, 271
Guernica, by Picasso, 350, 351
The Haywain, by Constable, 236–37
Jupiter and Io, by Correggio, 65, 66
The Kiss, by Klimt, 292, 293
The Last Supper, by Leonardo da Vinci, 43
The Last Supper, by Nolde, 295, 296
The Last Supper, by Tintoretto, 74
Le Moulin de la Galette, by Renoir, 257, 258
Les Demoiselles d'Avignon, by Picasso, 289, 290
The Letter, by Vermeer, 165, 166
Liberty Leading the People, by Delacroix, 242

The Liver Is the Cock's Comb, by Gorky, 55, 354
Lucifer, by Pollock, 358
Madonna in a Rose Garden, by Lochner, 82
Madonna of the Pesaro Family, by Titian, 68, 69
Madonna with the Long Neck, by Parmigianino, 63, 64
The Maids of Honor (Las Meninas), by Velázquez, 173
Malle Babbe, by Hals, 154, 155
Massacre of Chios, by Delacroix, 239, 240
Merz 19, by Schwitters, 334, 335
The Miraculous Draught of Fishes, by Witz, 82
At the Moulin Rouge, by Toulouse-Lautrec, 262, 263–64
Mounted Officer of the Imperial Guard, by Géricault, 223, 224
Mrs. Richard Brinsley Sheridan, by Gainsborough, 200
Mystery and Melancholy of a Street, by de Chirico, 323, 324
Nude Descending a Staircase, by Duchamp, 301, 302
Offerings of Gratitude, by Gauguin, 265, 267
The Orgy, scene from *The Rake's Progress,* by Hogarth, 182
Painting, by Miró, 329, 330
Pope Leo X with His Nephews Giulio de' Medici and Luigi de' Rossi, by Raphael, 51–52
Portinari Altarpiece, 90
Prima Ballerina, by Degas, 260, 261
The Proving of the True Cross, by Piero della Francesca, 20, 21
Return from Cythera, by Watteau, 187, 188
The Return of the Prodigal Son, by Rembrandt, 157, 158
The River, by Monet, 255, 256
Robert Andrews and His Wife, by Gainsborough, 200
Rouen Cathedral, by Monet, 255, 256
Sacred and Profane Love, by Titian, 70, 71
Saint Anthony Tormented by the Demons, by Schongauer, 95–96
Saint Wolfgang Forces the Devil to Hold His Prayerbook, by Pacher, 93
The Scream, by Munch, 286, 287
Self-Portraits, by Rembrandt, 162, 163
Sooth-Sayer's Recompense, by de Chirico, 323, 324
Spirit of the Dead Watching, by Gauguin, 265, 267
Still Life with Chair Caning, by Picasso, 298, 299
Stoke-by-Nayland, by Constable, 235, 237
The Stone Breakers, by Courbet, 248, 249–50
Suprematist Composition: White on White, by Malevich, 315, 317
The Swing, by Fragonard, 193
Target with Four Faces, by Johns, 405, 406
The Third-Class Carriage, by Daumier, 245
The Third of May, by Goya, 226
Three Flags, by Johns, 405, 406

Triumph of the Name of Jesus (ceiling of Il Gesù), by Gaulli, 127–28
Twittering Machine, by Klee, 326, 327
View of Haarlem from the Dunes at Overveen, by Ruisdael, 170–71
The Vision After the Sermon, by Gauguin, 265, 267
Young Woman with a Water Jug, by Vermeer, 166
Palaces:
 Louvre, Paris, 133
 Medici, in Florence, 13
 Rucellai, in Florence, 23, 24
 Versailles, outside Paris, 134–35
Palatine, Elector of, 139, 139*n*
Papacy
 German and British rulers challenge to, 110
 and Great Schism, 82–83, 83*n*
 See also Catholic Church; names of popes
Paris, 267, 329
 and classical ballet, 260–61
 Daumier depictions of poverty, 25
 in 18th c., 182
 entertainment of working class, 258–60
 insurrection of 1830, 241
 massacre of Huguenots, 115
 and Miró, 330
 Molière's comedies, 137
 Rabelais and, 118
Paris Opera, 261
Paris (Trojan prince), 19, 119, 119*n*
PARLIAMENT, BRITISH, 148–49
 Act of Supremacy, 110, 112
 Report . . . on the Bill to Regulate the Labor of Children in Mills and Factories, 228–33
Parmigianino
 Madonna with the Long Neck, 63, 64
Passion plays, 92–95
Pasteur, Louis, 271
Paul, Saint, 163–64
Paul III, Pope, 74, 76, 78
Paxton, Joseph
 Crystal Palace, London, 228–29
Peasants' Revolt, 106–8
 Luther's condemnation of, 108–9
The People (Michelet), 244, 245, 247–48
Perrault, Claude
 Louvre, East Facade, Paris, 132, 133
Pesaro, Jacopo, 68–69
Philip II, King of Spain, 152–53
Philip IV, King of Spain, 173
Philosophical Enquiry into the Origin of Our Ideas of the Sublime and Beautiful (Burke), 214, 215–16
Philosophy:
 Burke's essay on aesthetics, 214–16
 Comte's Positivism, 244–45
 Descartes' "I think, therefore I am," 158–61
 Ficino and Neoplatonism, 34, 42
 Humanism, 28, 37–38, 95, 100, 362–63
 Leibniz and optimism, 185
 Locke on human understanding, 177–80
 Newton's *Mathematical Principles of Natural Philosophy*, 145–48

Rationalism, 177, 214–15, 217, 219–20, 236
Rousseau and the theory of natural man, 197–200
Sartre's *Existentialism and Humanism*, 362, 363–65
Spencer's *Principles of Ethics*, 281–82, 284–86
Spinoza's *Ethics*, 158, 161–62
The Philosophy of Poverty (Prou'dhon), 249
Phocylides, 157, 157*n*
Photography:
 Migrant Mother, California, by Lange, 339, 340
Physics, 298–99
Picasso, Pablo
 Ambroise Vollard, 298
 Guernica, 350–51
 Les Demoiselles d'Avignon, 289, 290
 Still Life with Chair Caning, 298–99
PICCOLOMINI (PIUS II), 17–18
 "Is All This Pleasure True?," 19–20
 "Lucretia's Beauty," 18–19
 The Tale of Two Lovers, 18–20
PICO DELLA MIRANDOLA
 Oration on the Dignity of Man, 42–44
Piero della Francesca
 The Proving of the True Cross (mural), 20, 21
Piero di Cosimo
 The Discovery of Honey, 37–38
Pilon, Germain
 Descent from the Cross, 115
Pilot Flight Report (Glenn), 393–96
Pitt, William, 204
Pius V, Pope, 122
The Plague (Camus), 362, 363, 365
Planets, 122–24
Plato, 20, 34, 157, 157*n*, 177
Poetry:
 "Aspiration," by Colonna, 62–63
 "The Chimney Sweeper," by Blake, 220–21
 "Finite Revolutions," by Blake, 221–22
 "Fool's Caps," by Brant, 97, 98–99
 "The Gift Outright," by Frost, 389, 390
 "Glittering Fragments," by Tamiki, 361
 "I Love the Thought," by Baudelaire, 254–55
 "Mnkabayi, Daughter of Jama," Zulu poem, 290, 292
 "None Can Clean Their Dress from Stain . . . ," by Cats, 155–57
 "O Lucid Star," by Lorenzo de' Medici, 37
 "Preludes" from *Prufrock*, by Eliot, 337–39
 "Song of the Souls in Pain," Breton ballad, 266, 267–69
 "Song to the Suliotes," by Byron, 239, 240–41
 "Tell Me, O Soul," by Michelangelo, 63
 "A Temporal Pleasure," by Brant, 98
 "To Look on Nature" from *Tintern Abbey*, by Wordsworth, 237–39
 "The Tyrants Are No More," by Quintana, 227–28
 "Written After July 30, 1830," by Hugo, 242–44
 "Zulu, Son of Nogandaya," Zulu poem, 290–91

POINCARÉ, RAYMOND
 "France Has Become the Object of a Brutal and Premeditated Aggression" (August 14, 1914), 309, 310–11
Poland, 354
Politics and government:
 Bossuet's divine right of kings theory, 133–34
 Fénelon's utopian vision, 187–88
 Jefferson's *Declaration of Independence*, 207–10
 Locke's theories, 178, 180–81
 Machiavelli's *The Prince*, 51–54
 Marx and Engels's *Communist Manifesto*, 249, 251–53
 Nietzsche's *Thus Spake Zarathustra*, 296–98
 Optimism of 18th and 19th c. and equal rights, 295
 Prou'dhon's socialism and mutualism, 248–51
 Socialism, 248–49, 319–22, 325–26
 Susan B. Anthony and voting rights for women, 276–77, 279–81
Politics Drawn from Holy Scripture (Bossuet), 132, 133–34
POLIZIANO, 46–47
 Stanze, 47–48
Pollaiuolo, Antonio del
 Hercules and Antaeus, 31, 32
Pollock, Jackson
 Autumnal Rhythm: Number 30, 358
 Lucifer, 358
Polyphemus (character in *Stanze*), 47n, 47–48
Pomare IV, Queen of Tahiti, 266
Poquelin, Jean-Baptiste (Molière), 137–38
Portugal
 Asian colonies and Francis Xavier, 127
 and world trade (17th c.), 170
Positivism, 244–45
The Poverty of Philosophy (Marx), 249
Predestination, 113
The Prince (Machiavelli), 51–54, 55
The Principle of Art and the Social Destiny (Prou'dhon), 249–50
Principles of Ethics (Spencer), 281–82, 284–86
Proletariat, 249, 251–53, 319, 319n
Prometheus, 347, 347n
Protestant Church:
 and Anabaptist doctrine of baptism, 162
 in France, and Edict of Nantes, 115
 in Netherlands, and Spanish domination, 152–53
 and Ovid's poems, 150
 Reformation, 74, 102–3
 Calvin and, 112–13
 Cranmer and, 140n
PROU'DHON, PIERRE-JOSEPH, 248–49, 325, 325n
 What Is Property?, 250–51
Prufrock (Eliot), 337–39
Prussia, 224
Psalm 8, 392–93
Psychoanalysis, 292–95
Psychology, 281
 Joyce and 20th c. writers, 329
 Jung and, 326–27
 See also Psychoanalysis

Ptolemy, 58, 58n
Purgatory, 102n, 102–4
Pythagoras, 20

Quebec, battle of (1759), 204–6
QUINTANA, MANUEL JOSE, 225–26
 Ode to Spain, 227–28

RABELAIS, FRANÇOIS, 117–18
 The Histories of Gargantua and Pantagruel, 118–20
Race riots, 400
Racial discrimination, 405–6
Radiation, 358
Rambler (Johnson), 200, 201–3
Raphael, 47, 51–52, 54–55
 Baldassare Castiglione, 54
 Galatea, 46, 47
 Pope Leo X with His Nephews Giulio de' Medici and Luigi de' Rossi, 51–52
Rationalism, 177, 214–15, 217, 219–20, 236, 295
Realism, 253
Redentin Easter Play: "Brace Up, Brace Up, Mr. Dominie!," 92, 93–95
Reformation. *See* Protestant Church
Reign of Terror, 210–11
Relativity, theory of, 298–99
Religion:
 Calvin's doctrine of predestination, 113–14
 Groote's writings, and independent character of northern Europeans, 88–90
 "I Went Out Full of Consolation" and Neri's rehabilitation of the priesthood, 129, 131–32
 Loyola's "Meditation on the Agony of Death" and spiritual discipline, 76–78
 Luther's *Ninety-Five Theses*, 104–5
 Tetzel's *Sermon on Indulgences*, 103–4
 Thomas à Kempis's *Imitation of Christ* and mysticism, 90–92
 "The Two Venuses" and heavenly and earthly love, 34, 35–37
Religious liberty, 115
REMARQUE, ERICH MARIA
 All Quiet on the Western Front, 311, 312, 313–15
Rembrandt van Rijn, 158
 The Return of the Prodigal Son, 157, 158
 Self-Portrait (1658), 162, 163
 Self-Portrait (1659), 162, 163
Renaissance, 1, 4
 depiction of space and perspective, 20–21, 299
 in French literature, 117–18
 and Hermetical texts, 79
 in Italian literature and Piccolomini, 17–18
 Manetti and the dignity of man, 31–32
 in northern Europe, 82, 100–101
 resurgence of science and inquiry, 42–45
 study of Greek and Roman principles, 1, 20, 31, 64, 88
 study of mathematics, 20
 Venetian prominence, 68, 70
 Venus, and Christian philosophy, 33–35

Renoir, Pierre-Auguste
 Le Moulin de la Galette, 257, 258
Report from Belzec (Gerstein), 355–56
*Report of the Parliamentary Committee on the
 Bill to Regulate the Labor of Children in
 Mills and Factories,* 228–33
Report on the Principles of Public Morality
 (Robespierre), 210–11
Resolutions and Intentions, But Not Vows: "A
 Useless Waste of Time" (Groote), 87,
 88–89
Revolutions of 1848, 244
RICHENTAL, ULRICH, 82–83
 The Chronicle of the Council of Constance,
 83–87
ROBESPIERRE, MAXIMILIEN, 210–11
 Report on the Principles of Public Morality,
 211, 212–13
Rockefeller, John D., 282
Rodin, Auguste, 332
Romanticism, 219–20, 236, 239
 and Victor Hugo, 241
Rome, 1
 Catholic Church in, 48, 76
 Europe's rulers and papal authority, 110
 sacked by German mercenaries, 64–65
 spiritual revival and Philip Neri, 129–30
 See also Greco-Roman civilization
ROOSEVELT, FRANKLIN DELANO, 340
 First Inaugural Address, 342, 343–46
Roosevelt, Theodore, 414
Root and Branch Petition (Puritans, to British
 Parliament), 148, 149–50
ROUSSEAU, JEAN-JACQUES, 197–98, 206
 *Discourse on the Origin and Foundations of
 Inequality Among Men,* 198–200
Rovere, Francesco Maria della, 54–55
Royal Academy of Dancing, Paris, 260
Royal Society of England, 145
Royal Society of London, 165–66
Rubens, Peter Paul
 The Elevation of the Cross, 152
Rucellai Palace, Florence (Alberti), 24
Ruisdael, Jacob van
 View of Haarlem from the Dunes at Overveen,
 170–71
Russia
 Napoleon's defeat in, 223–24
 Revolution of 1917, 315–19
 World War I, 308–9, 315–16
 See also Soviet Union

SACCHETTI, FRANCO
 Three Hundred Tales, 15, 16–17
"The Sacrament of the Eucharist" from *Canons
 and Decrees of the Council of Trent,* 74,
 75
Safdie, Moshe
 Habitat, Montreal, 386
Saint Bartholomew's Day Massacre, 115,
 116–17
Saint John Lateran Church, Rome, 130
Saint Paul's Cathedral, London, 144, 145
Saint Peter's Basilica, Rome
 Colonnade by Bernini, 121, 122

Michelangelo's hemispherical dome, 57–58
 original plan by Bramante, 48–49
Saint Petersburg, 316, 317
SALINGER, J. D.
 The Catcher in the Rye, 375–76, 376–79
Santa Maria della Vittoria, Cornaro Chapel,
 Rome, 124, 125
Santa Maria delle Grazie, Milan, 43
SARTRE, JEAN-PAUL
 Existentialism and Humanism, 362–63,
 363–65
Saudi Arabia, 369
SAVONAROLA, GIROLAMO, 37–41, 47
 The Compendium of Revelations, 39–40
Schlick, Gaspar, 171
Schongauer, Martin
 Saint Anthony Tormented by the Demons,
 95–96
Schwitters, Kurt
 Merz 19, 334, 335
Science:
 advances in 19th c., 270–71, 286
 anesthesia and antiseptics, 270–71
 and Comte's sociology, 244–45
 Copernicus on *Revolutions of Heavenly
 Bodies,* 58–59
 Darwin's theory of evolution, 281–82, 282–84
 Einstein's "Energy of Radiation," 298,
 299–301
 Einstein's theory of relativity, 299
 Galileo's astronomical discoveries, 121–24
 Huygens' lenses and astronomical
 discoveries, 166, 167–69
 Leeuwenhoek's discovery of spermatozoa,
 165–66
 theories of light by Newton and Fresnel,
 255–57
 Vesalius's *Structure of the Human Body,*
 59–60
 Voltaire vs. Rousseau, 197–98
SCIPIONE, ARRIS, 63, 64
 "The Wretched, Miserable, and Ill-Fated
 City of Rome," 64–65
Sculpture:
 African, and Picasso, 290
 Bartolommeo Colleoni, by Verocchio, 28, 29
 Broken Obelisk, by Newman, 389, 390
 City Square, by Giacometti, 362, 363
 Column, by Gabo, 372
 Coronation of the Virgin, by Pacher, 93
 Cubi Series, by Smith, 392, 393
 David, by Donatello, 1, 2
 Descent from the Cross, by Pilon, 115
 The Ecstasy of Saint Theresa, by Bernini,
 124, 125
 Essex, by Chamberlain, 379, 380
 Hercules and Antaeus, by Pollaiuolo, 31, 32
 Jacob and Esau, Florence Baptistery, by
 Ghiberti, 4–5
 *Model for the Monument to the Third
 International,* by Tatlin, 319, 320
 Nymphs, by Goujon, 117, 118
 The Palace at 4 A.M., by Giacometti, 362,
 363
 Reclining Figure, by Moore, 331, 332

Sculpture *(cont.)*
 Recumbent Figure, by Moore, 331, 332
 Saint George, by Donatello, 14, 15
 Spiral Jetty, by Smithson, 413, 414
 The State Hospital, by Kienholz, 383, 384
 Unique Forms of Continuity in Space, by Boccioni, 304, 305
 The Wait, by Kienholz, 383, 384
 War Monument, by Barlach, 311, 312
Secretariat Building, United Nations, New York (Harrison et al.), 368, 369
Selden, Henry R., 280
Selve, Georges de, 110
Seneca, 156, 156n
Serbia, 308
Serfdom, 107, 107n
Sermon on Indulgences (Tetzel), 102, 103–4
SHAKESPEARE, WILLIAM
 "The High and Mighty Princess of England" from *Henry VIII,* 139, 140–42
 "Thou Shall Get Kings, Though Thou . . ." from *Macbeth,* 139, 142–44
The Ship of Fools (Brant)
 "A Temporal Pleasure" and "Fool's Caps," 97, 98–99
Sigismund, Holy Roman Emperor, 83, 83n
Silent Spring (Carson), 414, 415
SIMONS, MENNO
 The Blasphemy of John of Leiden, 162, 163–65
SIMPSON, JOHN
 Memoirs, 270, 271, 272–73
Skylab program, 393
Skyscrapers, 282
Slavery, 233–34, 236, 296
Slavs, 346, 354
Smith, David
 Cubi Series, 392, 393
Smithson, Robert
 Spiral Jetty, 413, 414
Social Darwinism, 347
 and Spencer's "survival of the fittest," 281–82, 284–86
Socialism, 248–49, 325–26
 in Europe, and Bolsheviks, 319–22
Sociology, 244–49
Soderini, Piero, 51
Solomon, 164, 164n
SOLZHENITSYN, ALEKSANDR
 One Day in the Life of Ivan Denisovich, 372–73, 374–75
"The Song of the Souls in Pain" (Breton ballad), 266, 267–69
"Song to the Suliotes" (Byron), 240–41
Songs of Innocence (Blake), 220–21
South Africa, 369
South Pacific, 266
Soviet Union, 369
 beginnings of, 316, 319–20
 and Communist Party, 316
 Kennedy's counteractions to, 390
 space program, 392
 and Spanish civil war, 351
 and Stalinism, 296, 372–73

 and UN human rights declaration, 369
 See also Russia
Space flight, 392–96
Spain, 65
 Catholic Church and Jesuits, 76
 Civil War, 350–51
 and Franco, 323
 life in 17th c., 173–74
 and Protestants in Netherlands, 152–53
 resistance to French occupation, 226–27
 and Saint Theresa, 124–25
Speech Protesting the Marriage Dissolution (Catherine of Aragon), 110, 111
SPENCER, HERBERT
 Principles of Ethics, 281–82, 284–86
Spermatozoa, discovery of, 165–66
Spice trade, 170
SPINOZA, BARUCH, 157–58
 Ethics, 161–62
Spiritual Exercises: "Meditation on the Agony of Death" (Ignatius Loyola), 76–78
The Spoyle of Antwerpe (Gascoigne), 152, 153–54
SPRENGER, JAMES, 95–96
 The Witches' Hammer, 96–97
Sputniks I and II, 392
SS (Schutzstaffel), 354, 354n
Stalin, Joseph, 316, 372
Stalinism, 296, 372–73
Stanley, Henry Morton, 289
Stanze: "The Bittersweet Cares That Are Born of Love" (Poliziano), 46, 47–48
The Starry Messenger (Galilei), 121
STEINBECK, JOHN
 Grapes of Wrath, 339, 340–42
Strawberry Hill, Twickenham (Walpole), 216–17
Stream of consciousness method, 329–30
STRINDBERG, AUGUST
 The Link, 286–87, 287–88
The Structure of the Human Body (Vesalius)
 "The Cerebrum and Cerebellum," 57, 60–61
 "The Vital Spirit," 57, 59–60
Stutthof concentration camp, 355, 356–57
Sublime, concept of the, 214, 216
Suliotes, 240, 240n
Sullivan, Louis
 Guaranty (Prudential) Building, Buffalo, 281, 282
SULLY, DUKE OF
 Memoirs, 115, 116–17
Superman, concept of the, 296
Surgery, 270–72
"Survival of the fittest," 281–82
Symbolists, 253
Systema Saturnium (Huygens), 165, 166, 167–69

Tahiti, 266–67
TAINE, HIPPOLYTE
 Notes on Paris, 257, 258–60
The Tale of Two Lovers (Piccolomini), 17–20
TAMIKI, HARA
 "Glittering Fragments," 358, 361
Tartuffe (Molière), 137–38

Tatlin, Vladimir
 Model for the Monument to the Third International, 319, 320
Telemachus, 187–90, 329, 329n
Telescopes and lenses, 165–66
"Tell Me, O Soul" (Michelangelo), 62, 63
TETZEL, JOHANN
 Sermon on Indulgences, 102–4
Theodicy (Leibniz), 185, 186–87
THERESA OF ÁVILA, SAINT
 Life, 124, 125–26, 127
Thermidorean Reaction (July 1794), 210
Third International of Communist Party
 First Manifesto of . . . , 319–20, 320–22
Thirty Years' War, 132
THOMAS À KEMPIS
 The Imitation of Christ, 90–92
Thompson, Florence, 340
Three Hundred Tales (Sacchetti), 15, 16–17
Thus Spake Zarathustra (Nietzsche), 295–98
TILLICH, PAUL
 The Courage to Be, 366, 367–68
Tintoretto
 The Last Supper, 74
Titian
 Bacchanal, 70, 71
 Madonna of the Pesaro Family, 68, 69
 Sacred and Profane Love, 70, 71
Totalitarian rule, 296
Toulouse-Lautrec, Henri de
 At the Moulin Rouge, 262, 263–64
Transubstantiation, doctrine of, 74–75
Travels (von Uffenbach), 181, 182–83
Treatise on Domestic Economy (Beecher), 276, 277–79
Treblinka concentration camp, 354
Trent, Council of (16th c.), 74, 76, 79
Trismegistus, Hermes, 79
Trojan War, 19n, 119n, 329n
TROTSKY, LEON, 319
 The History of the Russian Revolution, 315–16, 317–18
Truman, Harry, 343
Tsiolkovskii, Konstantine, 392
Turkey
 and Greek revolt, 239–40
 wars with Venice, 68–70
 World War I, 308
Turner, Joseph Mallord William
 The Slave Ship (painting), 233, 234
Twelve Articles: "Our Humble Petition and Desire," 106, 107–8
"The Tyrants Are No More," from *Ode to Spain* (Quintana), 226, 227–28

Ulysses, 187
Ulysses (Joyce), 329–31
Unemployment, 339–40, 346
Unionization, 302
United Nations
 creation of, 368–69
 list of parks and reserves, 414
 and status of women, 396
United States
 African slave trade, 233–34

American sympathy for Greek independence, 239
automobiles, 302, 379–80
Congress, public opinion, and Vietnam War, 409–10
Continental Congress, 206–7
equal rights movement, 276–77, 405–6
Great Depression, 339–40, 342
humanitarianism, 236
intellectual isolation after world wars, 336–37
Locke's influence on Constitution, 177
prosperity and social conformity (1950s), 383–84
racial prejudice and violence, 400–401
Roosevelt and the banking system, 343
rural poor and migrant camps, 340
social Darwinism, 282
space program, 392–93
Spanish civil war, 351
standardization and quest for identity, 375–76
World War I, 312
World War II, 343, 358–61
United States Strategic Bombing Survey, 358, 359–61
The Universal Declaration of Human Rights (United Nations charter), 369–71
"The Unwashed Gyaours and Their Ways" (Bayezid II), 69–70
Upper classes, 182, 245, 248–49, 302
Urban VI, Pope, 82
Urban society
 class differences in Europe (18th c.), 182
 European discontent (end of 19th c.), 266
 Gauguin and, 266–67
 isolation and weariness (20th c.), 337
 middle-class life in Florence (14th c.), 15–17
 Rousseau and, 198
 working-class entertainments and alcoholism (19th c.), 257–58, 262–64
Urbino, 54–55
Utopia, 187–88

van der Goes, Hugo
 Portinari Altarpiece, 90
van der Weyden, Rogier
 Escorial *Deposition,* 87, 88
Van Dyck, Anthony
 Charles I Dismounted, 148, 149
van Eyck, Hubert and Jan
 Ghent Altarpiece, 87, 88
Velázquez, Diego
 The Maids of Honor (Las Meninas), 173
Venice, 29, 68–70
Venitiano, Giovanni Battista, 130
Venus, 19, 19n, 33–37, 47, 119, 119n
Vermeer, Jan
 The Letter, 165, 166
 Young Woman with a Water Jug, 165, 166
Verocchio, Andrea del
 Bartolommeo Colleoni, 28–29
Veronese
 Christ in the House of Levi, 78, 79
Versailles Palace (Le Vau and Hardouin-Mansart), 134–35

VESALIUS, ANDREAS, 57–58
 The Structure of the Human Body, 59–61
Vienna, 182
Vierzehnheiligen Church, Bavaria (Neumann),
 185–86
Viet Minh, 409
Vietnam War, 390, 409–13
Villa Farnesina, Rome, 47
Virgin Mary, 18, 64, 82
Virtù, quality of, 23–24, 28
Visconti, Giangaleazzo, 1–2, 9
VOLTAIRE, 193–94, 197
 Candide, 194–97
VON UFFENBACH, ZACHARIAS KONRAD, 181, 182
 Travels, 182–83
Voting rights, 276–77, 396, 400, 405

Wall Street crash (October 1929), 339, 343
Wallis, Samuel, 266
WALPOLE, HORACE
 The Castle of Otranto, 216, 217–19
 Strawberry Hill, Twickenham, 216–17
Warren, John Collins, 271
Waterloo, battle of (1815), 224
Watteau, Antoine
 Return from Cythera, 187, 188
Weekley, Frieda von Richthofen, 332
West, Benjamin
 The Death of General Wolfe, 203
West Indies, 233
What is Property? (Prou'dhon), 248–49,
 250–51
Whitehall, Banqueting House, London (Jones),
 139–40
William I, Prince of Orange, 152–53
WILLIAM II, German Emperor
 "We Take Up the Sword" (August 4, 1914),
 308, 309–10
Williams, William T.
 Batman, 399, 401
Wilson, Woodrow, 312
Witchcraft, 95–96
The Witches' Hammer (Kramer and Sprenger),
 95, 96–97
Witz, Conrad
 The Miraculous Draught of Fishes, 82
Wolfe, General James, 204
Women
 Alberti on selection of a wife, 27–28

Beecher on marriage and subordination, 276,
 277–79
equal rights movement (19th c.), 276–81
exploitation of, 236
in textile industry (19th c.), 229
United Nations commission on status of, 396
See also Women's Liberation Movement
Women in Love (Lawrence), 331, 332–34
Women's Liberation Movement, 396–99
WORDSWORTH, WILLIAM, 235–36
 *Lines Composed a Few Miles Above Tintern
 Abbey . . .* , 237–39
Working classes
 alcoholism and social dislocation, 262–64
 under communism and socialism, 249–50
 in England and child labor, 228–33, 236
 entertainments (19th c.), 257–58, 262–63
 expansion of social and political rights, 295
 Michelet on factory work, 245, 247–48
 Prou'dhon on, 248–51
"The Workmen's and Peasants' Revolution"
 (Lenin), 315–16, 318–19
World War I, 366
 aftermath, 335, 346
 causes, 308–9
 D. H. Lawrence and, 332
 and Russia, 315
 Western front casualties, 311–12
World War II, 320
 atomic bomb dropped on Hiroshima, 358–61
 defense spending and prosperity, 343
Wren, Christopher
 Saint Paul's Cathedral, London, 144, 145
"The Wretched, Miserable, and Ill-Fated City
 of Rome" (Scipione Arris), 63, 64–65
Wright, Orville, 392
"Written After July 30, 1830" (Hugo), 242–44

Young Woman with a Water Jug (Vermeer),
 165, 166

Zarathustra, 296*n*, 296–98
Zimmermann, Dominikus
 Die Wies, 185, 186
ZOLA, EMILE
 The Dram-Shop, 262, 263, 264–65
Zulu, 289–92
"Zulu, Son of Nogandaya" (Zulu poem),
 290–91